LOUISE NEVELSON

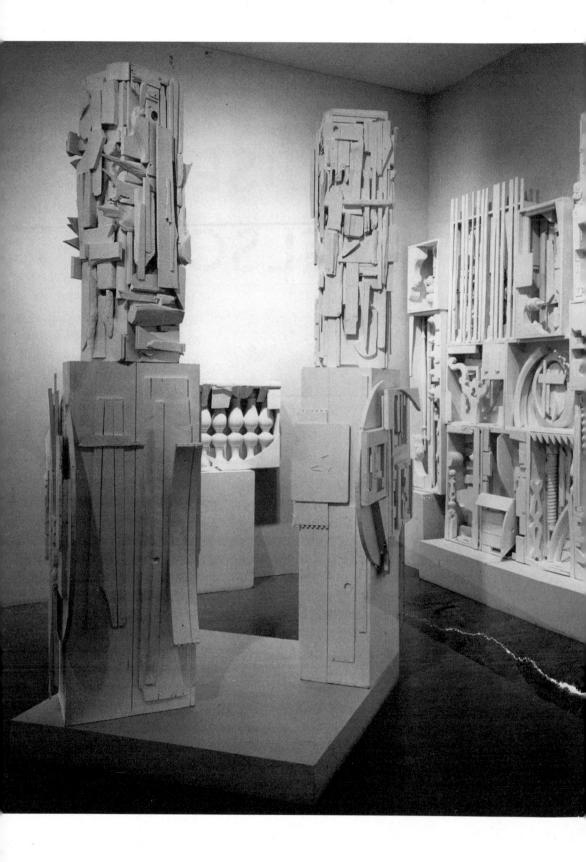

LOUISE NEVELSON

LIGHT AND SHADOW

LAURIE WILSON

 Thames & Hudson

First published in the United States of America in 2016 by
Thames & Hudson Inc., 500 Fifth Avenue, New York, NY 10110

thamesandhudsonusa.com

Published in the United Kingdom in 2016 by
Thames & Hudson Ltd, 181A High Holborn, London, WC1V 7QX

www.thamesandhudson.com

Library of Congress Catalogue Number
2016932142
British Library Cataloguing-in-Publication Data:
A catalogue record of this book is available from the British Library.

ISBN: 9780500094013

Design by Jonathan D. Lippincott

Printed and bound in China

Frontispiece: *Dawn's Wedding Feast* (Installation view, Museum of Modern Art, New York), 1959 – 60. Painted wood. Photograph courtesy of Pace Gallery, © 2016 Estate of Rudy Burckhardt / Artists Rights Society (ARS), New York

CONTENTS

LOUISE
NEVELSON

INTRODUCTION

"My work is the mirror of my consciousness."
—**Louise Nevelson, 1974. Barbaralee Diamonstein, "Louise
Nevelson at 75 'I've Never Yet Stopped Digging Daily for
What Life Is All About,'" *Art News* (October 1974)**

Who is the woman on the cover of this book? A Russian princess? A gypsy queen? No. She is Louise Nevelson, or "Mrs. N," as she was known in her downtown neighborhood in New York City. (And her royal residence, *Mrs. N's Palace*, is at the Metropolitan Museum of Art.)

During her long life, which stretched from 1899 to 1988, Nevelson was considered to be one of the greatest women artists of the twentieth century and, along with David Smith, Isamu Noguchi, and Alexander Calder, one of the four greatest American sculptors. For twenty-five years, from the time she began to exhibit her work, critics praised her art but she sold almost nothing. Then in 1958, at age fifty-nine, she hit the big time. And during the next twenty-eight years of non-stop work she churned out thousands of sculptures, collages, drawings, and prints, and she became a star. She "changed the way we look at things" wrote Hilton Kramer, chief art critic of *The New York Times*. [1] No matter the fame she earned and the attention she attracted, she was always happiest in her studio. Her indefatigable energy was poured into her work.

I met with Louise Nevelson a number of times in 1976 and 1977, as she was the subject of my doctoral dissertation in art history from the City University of New York. I knew a fair bit about the New York scene, so I thought I was well equipped to write about Nevelson, who had gone to the same art school

I had—the Art Students League. At our first meeting in 1976, Nevelson told me that my task would be to show the world that—after Picasso—she was the most important artist of the twentieth century. She loved to talk about herself and was remarkably open with me. I concluded that she was grandiose and self-centered—a classic narcissist. We met again in 1979, when I was writing five catalogue essays for her forthcoming exhibition at the Whitney Museum, *Atmosphere and Environments.*

I continued to be fascinated by her work, especially by the trajectory she had traversed before arriving at her signature style in the late 1950s—walls of black boxes, creating both an atmosphere and an environment. She had become the ground-breaking and unique artist whose sculpted environments started a tsunami that is still ongoing. But now it is called installation art.

By the time I met her in 1976, she had also become famous, "the doyenne of American artists." [2] Lightbulbs flashed when she walked into a room. Reporters gathered around her, ready to report her every move, pithy remark, or controversial opinion (on everything from the joys of "freelance sex" to the perils of motherhood and marriage). She was often at the White House. That year, at the age of seventy-six, she had a New York City park named for her, and she filled it with seven large steel and aluminum sculptures. On the occasion of her eightieth birthday, New York City gave her a huge party. She looked far younger than her chronological age, and her astounding energy made it possible for her to produce forty to fifty sculptures a year—some of them large-scale steel works.

She was the only woman artist in America to make it entirely on her own. She separated from Charles Nevelson in the early 1930s, so no rich husband. No supportive lover, either—the men in her life were younger, drank more heavily, and were no match for her professionally or personally. While she was friendly with the most famous members of the New York School—Mark Rothko and Willem de Kooning—she faced significant challenges in order to be taken as seriously as them. Some women artists, especially those who failed where she succeeded, hated her. But she had learned in early childhood that she would have to fend for herself if she wanted anything of life.

To be sure, Nevelson was not completely alone. All artists need intermediaries to promote their art and to make it possible to develop a career. Since the middle of the nineteenth century, galleries or art dealers have been the most common intermediaries between artist and public. Louise Nevelson had four major dealers—Karl Nierendorf, Colette Roberts, Martha Jackson, and, most famously, Arnold "Arne" Glimcher. Each played a crucial role. They helped her achieve international status as one of America's most important woman artists.

The version of herself that Nevelson created and presented to the world often had her saying, "I am not bright." But anyone foolish enough to believe

that soon discovered that Louise Nevelson was highly intelligent. Her pseu-do-"dimness" was a defense against being seen as undereducated or inarticulate.

Louise Nevelson was unique, a one-off. She had her own style of dressing, of living, and of sculpting. Her work looked like no one else's. She never looked the way artists were supposed to look; even when she was broke, she managed to look like a million dollars. In the 1930s and '40s she became known as "The Hat" because she wore gorgeous chapeaux—sometimes stolen and sometimes purchased by lovers for her favors.

Despite her later reputation as a fashionista, Nevelson almost always selected clothes for multiple purposes. When she was poor, she took a rare bit of extra money and spent it on a wool dress—by an expensive British designer—at Bergdorf Goodman's. It was a long-sleeved, full-skirted black jersey, perfect for England's damp, cold weather (as well as an unheated loft on New York's Lower East Side). She bought it for its warmth as well as its beauty, and she wore it all winter to elegant parties and slept in it at night.[3]

What kind of a person was Louise Nevelson? How did her wit and warmth get conveyed in her work, when to some she had an aloof, even regal presence? In public she was most comfortable with a proud, straight-backed stance, though among close friends she could be wonderfully witty, warm, and down-to earth. She said that she couldn't bend, that she was like a cigar-store Indian, made of wood. But she had many admirers and friends—Dorothy Miller of MoMA, Edward Albee, Merce Cunningham, and John Cage loved her.

Long before the women's movement got underway, Nevelson was living the life she wanted, sleeping with the men she was attracted to, swearing like a sailor to prove her populist credentials, and never taking a day job—since that would keep her from the thing she cared most about. Making her art was the only thing that really mattered to her. At one point I thought about titling this book *Vissi d'Arte*, the aria Tosca sings to the world telling it in glorious melodic tones that, above all else "I lived for art."

As Nevelson herself said: "I needed something to engage me, and art was that something. . . . It was my entire life."[4] "[W]hat accommodates me to fulfill myself, are things that I have made. . . . I feel that work is basically fulfilling my awareness of life. . . . My whole work constitutes a total world."[5]

In the course of eight years working on this biography, I had no idea how many surprises I would encounter. Recalling the antipathy I had felt for her thirty years earlier when her self-centeredness seemed so offensive, I was amazed to discover entirely justifiable reasons for that "egotism." She was a lone woman in a man's world who needed not only to find herself as a person well before feminism, but she also had to make a place for herself as a strong artist in the crowded art world of the twentieth century. I finally came to see that without her

concentrated focus on her work and her self, she would never have made it. For Nevelson, self-discovery was the exact same thing as becoming the best artist she could be.

In the years since I had written my dissertation, Louise Nevelson's work had continued to change and progress, sometimes in fits and starts and other times with lightning-like speed. As she often said, "I jumped around"—working in various media and styles throughout her life. Though she earned her first celebrity through wood sculpture, in her seventh decade she turned to steel and aluminum, making large-scale public works that are now spread all across America, and she kept on making wood sculpture and drawing and doing collages.

As Nevelson explored many new media and materials and was touched by several new "isms," including minimalism, she continued to come out ahead of her compatriots in her reputation and the quality of her work. Despite the evolving styles she coursed through over twenty-five years, her work always looked like it could only have been done by Louise Nevelson. As her eye for compositional power and harmony sharpened over her lifetime, she kept finding new ways to edit and refine her work. She would happily recycle parts of previous works when she found what she deemed better places for them in her most recent work. She delighted in mixing the old with the new, whether it was a single wood scrap or a whole steel assemblage that she had used before. She came to so fully trust her eye that she was ultimately liberated to dare all—combining lace with glass, or a broom with wooden bric-a-brac.

Writing in 1971 in *The New York Times,* John Canaday noted: "Louise Nevelson's new exhibition . . . proves once again that the woman simply cannot be trusted. For several years now, from show to show, she has implicitly capped off her career with a final demonstration of her powers of invention, but each following year she comes up with something new. This refusal to settle into a rut is very wearing for us art reporters."[6]

"When I say that Louise Nevelson's sculpture is, for me, an affirmation of faith," Canaday observed, "you can put it that she has taken much of the detritus of our civilization and has not simply recombined it; she has completely transformed it. You may recognize a balustrade . . . a moulding, a dowel, planks of wood . . . but they are so transformed that their original function is simply no longer there. . . . They are . . . transformed . . . into what I would call a spiritual expression. There are a very few special people who have the capacity to create, to bring together all they have assimilated and produce from it a play, a poem, a sculpture, a painting. They tell us more about what we are doing and what we are all about than we ever realize until we see their expression of it."[7]

Very soon after Nevelson started making sculpture she produced a group of witty creatures in the Surrealist manner of the times. These sculptures were

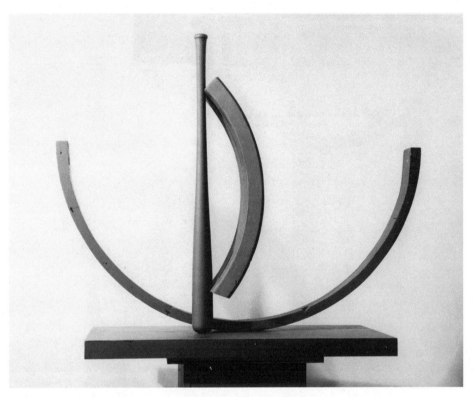

Sailing, 1957. No longer extant. Photograph © Geoffrey Clements

made from found wood in the early 1940s. The clever combination of furniture parts were turned into comedic contraptions that showed that she could match the Surrealist wit of the moment. Soon afterwards she combined simple wood pieces into evocative abstract compositions, which were much praised by art critics.

Some works from this golden era are very spare, such as *Sailing*, which is made up of only three parts: a barrel stave, a baseball bat, and a portion of a thickish curved arc. When the same elements were put together differently and the title changed to *The Game,* we struggle to comprehend that these two works are made up of the exact same elements at different moments in time. Both are masterworks. The constant is the extraordinary sense of balance. In *Sailing,* the perpendicular bat stands when it shouldn't, and the short, thick, curved piece of wood attached to it doesn't seem at all strangely connected—though it is. Together they become a mast and sail which symbolically carry the upward curve of the ship's shape into its wind-filled surge.

In *The Game,* we experience an entirely different composition. The large curving piece of wood has become like upraised arms greeting the sun. The

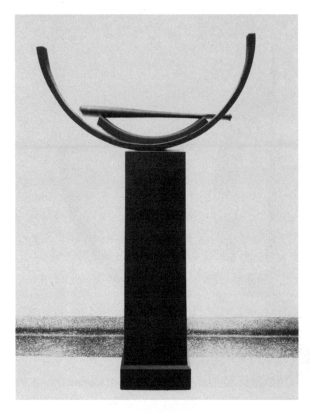

The Game, 1957. No longer
extant. Photograph by Jeremiah
Russell, Archives of American
Art, Smithsonian Institution

smaller curved piece with its attached bat rests a bit uneasily at the bottom of
the larger one. The bat's handle, jutting just beyond the framing curve, upsets
the easy comfort of curves nesting together. Likewise, the negative shape formed
by the tip of the bat, the fatter edge of the short curve and the long slope of the
larger curve slightly destabilizes the work, giving it a similar vitality to the one in
Sailing. In these two works we see the brilliance, wit, and the freedom of a master
artist who—with a Picasso-like elegant economy of means—managed to see a
bull in a bicycle seat.

Nevelson's first foray into exhibiting at a major museum in New York City
was the all-white *Dawn's Wedding Feast,* which helped set her course as the twen-
tieth century's pioneer environmental artist (creating works that were whole
environments, in which viewers were immersed). No other sculptor was doing
anything like this. As Nevelson repeatedly said: "Art is everywhere, except it has
to pass through a creative mind."[8] And, "Art is part of living, and sculpture is
living. Naturally, you want all of life, so you make an environment—and that
environment is sculpture too."[9]

One of Nevelson's most beautiful walls, *Sky Presence I,* in black-painted wood,
was first seen in an exhibition in Baden-Baden, Germany, in 1961. The cura-

tor wanted a large wall for his museum show, and she was ready to work very big. She worked fast, combining boxes she had made a few years earlier with boxes made the day before yesterday, to produce a masterwork of composition: twenty-four boxes, nine and a half feet high and more than twenty feet long, in three-and-a-half weeks.

Like any artist touched by Surrealism's ethos, working fast meant allowing one's unconscious to make its contribution. Consider this detail—a single box from *Sky Presence I*:

The artist joined together a clump of curved wedges on top of an oval frame and made them look as though they were about to tip the whole thing over. Or had she made them look as though they were rising up to roll the oval to the right? Or both? This little piece of liveliness is typical Nevelson. She called it "livingness." Even the nail holes play a part in this rhythmic dance. Likewise the shadows, deep at the top and pointed at the bottom, combine with the negative spaces behind the wedges to punctuate the whole work. Nevelson exhibited *Sky Presence I* at the 1962 Venice Biennale, where she was one of four artists representing the United States.

In the late 1960s and early 1970s Nevelson began to work in metal, mostly Cor-Ten steel. At first she worked with a grid format, but she soon left that behind as she extended the scrap-steel works into space. Even near the end of her life, Nevelson did not stop inventing new formal compositions. In her last series of wood sculptures, *Mirror Shadow*, the frame disappears and the grid becomes a witty part of the composition, while all the parts seem to shoot out into space.

Any consideration of Nevelson's eighty-eight years of life necessarily leaves us with questions, the first of which is how to select, from the various versions of her life story that she recounted, which is the most likely to be accurate. Her family, as well as her close friends, could not always tell the difference between one of her fictional narratives and the probable facts. She was shameless about constructing aspects of her biography. Who else but she had a right to do so? I came to understand that behind such constructions there was usually a kernel of truth that was better revealed by the "story" than a strict reporting of the "facts." Keeping in mind that Nevelson was constantly crafting and re-crafting the particulars of her life, including her age and birthplace, one can begin to move on to asking the more typical biographical questions. How did she carry on with such confidence during the thirty years she spent in the art-world wilderness—from 1929 when she began art school to 1959, when her work was recognized as groundbreaking, even historically significant?

One could devote an entire book solely to Nevelson's relationship with her feminine identity: how it helped and hindered her career, her thoughts on Women's Liberation—even why, like many women artists, she donated so much of

her work, perhaps affirming the conception that it wasn't valuable enough to command a high price. Ditto her relationship to spirituality, which was similarly conflicted.

Still another volume could focus solely on the movements and figures who influenced her—there are still mysteries there to be solved. Why, even though her long term friendships with Mark Rothko, Adolph Gottlieb, and Willem de Kooning placed her smack in the middle of the Abstract Expressionists, was she rarely considered one of them? Nevelson came of age artistically in the 1930s and 1940s, and she always said that her artistic hero was Pablo Picasso and that Cubism was her foundation: How did that manifest in her work? And what about Surrealism, which swirled around every artist in New York in the 1940s: How much and for how long did it touch her?

Most significant, especially in the years since her death: What is the relationship between the public face of Louise Nevelson—"The Nevelson," as her friend Edward Albee called it—and the flesh-and-blood woman? Anyone who knows even a little about Nevelson is aware of "the Persona"—the mink eyelashes, the chinchilla coat, the turbans, clunky jewelry, and idiosyncratic way of dressing—which almost invariably brought out sparks, positively and negatively charged, when she entered a room. Did her persona, as Albee and others said, overshadow her art?

Which brings us back to the image of Nevelson as fundamentally a self-serving, self-inflating, and self-congratulating person. I believed that that was her true nature in 1976; but I do not believe it now. That she learned how to remain centered on her work and was reluctant to engage in anything that would distract her from her focus doesn't mean she was selfish but rather—and it was a term she often used to describe herself—self-aware. Fueling her conviction that she should only do exactly what made sense to her was her lifelong study of the Indian mystic Jiddu Krishnamurti and his empowering words about the self and freedom. She came to that astonishingly liberating study from a Jewish immigrant's background that subtly championed individual rights in contrast to local conventional constrictions. Though her mother had not been able to fight for her own free choices, she entrusted that vision to her three daughters. When she was young, Louise looked for champions for her individual vision in school —one of these was Lena Cleveland, her art teacher. As she matured she had to face stultifying challenges to her identity as an artist, whether it was marriage, motherhood, or just being "only a girl" in a crowd of many macho male artists. She kept going despite the difficulties, finding powerful female mentors along the way; she studied with drama with Princess Norina and and dance with Ellen Kearns. Others she read about or observed from a distance—Edith Sitwell and Jennie Churchill. And sometimes it was male mentors who opened doors for

her—Diego Rivera, Karl Nierendorf, and Arne Glimcher. But it was always her art that kept her moving forward.

Because I have training both in art history and psychology, I look at the artist's inner life. I aim to understand the major themes (conscious and unconscious) underlying her signature style, especially the environmental exhibitions of the late 1950s. I explore the links between Nevelson's childhood and her adult life as an artist. I also seek to clarify the complexity of Nevelson's multiple motivations and the repetitive patterns that could not be explained away by external factors. But I never see her as a case. She is an artist, a woman, and a very complex human being.

The past and present were constantly intertwined in Nevelson's life and especially in the ways she told her story. Nevelson's narrative is therefore slippery. Sometimes she confused and confounded events and her role in them. Sometimes she stood firm about facts that she later claimed were absolutely not factual. Like all of us, there were things about herself she did not want to know and had to deny. If one accepts her surreal "jumping around," as she described her storytelling, it all seems comprehensible, even profoundly interesting. If, however, we need to know the whole truth and nothing but the truth, we shall be alternately irritated, confused, or severely disappointed.

For the most part, Nevelson's narrative is conveyed aloud. She did not write letters, but she talked. She loved to talk—to friends, family, journalists—almost anyone willing to listen. Many of her words were recorded in print or on tape, giving me ample opportunity to get to know her again, in a different context, long after her death.

Just as useful were the reviews from the art critics in New York who came to know her work very well and described it in considerable detail every time she exhibited. Their published write-ups in many cases both "locate" her work in the contemporary art-world context and help a biographer pin down when she did what. This problem of dating and sequence exists for most artists, except Picasso, who put the date and even the time of day on almost every work he made. Nevelson confounds the scholar by cannibalizing old works—combining parts from decades past, adding new elements, painting or repainting, making whatever revisions suited her at the moment. Photos of her work that she or her dealers had taken, especially those linked to dated illustrations from the press or catalogues, make for some degree of certainty.

When she died at eighty-eight, John Russell wrote in *The New York Times* that "Mrs. Nevelson was . . . among the most arresting women of her time" and "a pioneer creator of environmental sculpture who became one of the world's best-known women artists."[10] As I write this, a renewed appreciation of formalist art—which emphasizes how a work is made, as well as how it looks—and a

growing focus on the contributions of women artists in the twentieth century have spurred a revival of interest in her work, resulting in large international solo exhibitions in Italy, Germany, and Belgium. Furthermore, sold-out exhibitions at galleries and widely attended shows at prestigious American museums make it clear that what Russell said in 1988 is just as true in 2015, and beyond. Nevelson was not just "the most arresting" and "best-known" woman artist of her time, but one the greatest American artists of the twentieth century.

RUSSIAN ROOTS

1899 – 1905

"This child is destined for greatness." —Sholem Aleichem

A few days after she was born in the ancient Ukrainian city of Pereyaslav, Leah Berliawsky had a visitor.[1] Sholem Aleichem, the renowned writer of Yiddish tales, had come to visit his sister and stopped in at the Berliawsky home next door to greet the new baby.[2]

"This child is destined for greatness,"[3] the famous man declared when he saw her. Not surprisingly, the prophecy became legendary in the Berliawsky family, and Leah's mother repeated it to her often. It became a talisman for the young woman decades later when she worried about her future success as an artist.

Because birth records of Jewish children in Russia in the late nineteenth century are difficult to trace, it is impossible to know exactly *when* Leah Berliawsky (later Louise Nevelson) was born. She knew very well *where* she came into the world, but the girl who became Louise Nevelson reckoned that, while few people outside Russia would have heard of Pereyaslav, everyone would know Kiev. So in her thirties, she claimed that she was born in Kiev—and in the year 1900. When did she come to the United States? More prevarication. She repeatedly said, "When I was four and a half." But it is more likely she was five and a half. Either way, she was a young child when she arrived in America.

Entering school in Rockland, Maine, at approximately six years of age, Louise Berliawsky would have been confused about her birthdate as well as the fact that at birth she had a different given name. The effect was profound and lifelong. "I don't remember names, I don't remember dates," recalled the artist

in her mid-seventies. "I've always had a block about names, and I think it was the whole [lack of knowledge about my] background."[4]

During her first retrospective—the acclaimed show at the Whitney Museum of American Art in 1967—Nevelson told a reporter "Art was all that mattered to me . . . right from the very beginning. My father and mother thought this was wonderful."[5] Her parents' hopeful vision of what was possible for immigrants in America was an important part of her heritage. She told this version of the story of little Louise:

> I was an artist when I was four. (Artists are born, you know. They have to have the right equipment. Once you know you have it, life is not easier; but you are working on the positive side.)[6]
>
> We were a very handsome family. My father was tall, slender. My mother was beautiful. I adored her. She was God to me. Her greatest pleasure was dressing us four children cleanly and fashionably. We were very free and uninhibited.[7]
>
> I remember going to the library . . . with another little girl. I couldn't have been more than nine. The librarian was a fairly cultivated woman, and she asked my little girlfriend, "Blanche, and what are you going to be?" And she said that she was going to be a bookkeeper
>
> The librarian asked me what I was going to be, and of course, I said, "I'm going to be an artist." "No I added, . . . I want to be a sculptor. I don't want color to help me." I got so frightened, I ran home crying. How did I know that? When I had never thought of it before?[8]

Louise was the oldest of the three Berliawsky girls and the only one who remembered that their mother had lain in bed crying all the time when they first arrived in Rockland. Sympathy for this always unhappy, always unwell parent marked Louise Nevelson for the rest of her life. It forced her to grow up fast and to accept that she would have to find her own way in the new world. "Her own way" would always be an original creation—whether it was when and where she was born or how she rearranged the living-room furniture as a child, made a hat for herself as a teenager, or produced one of her brilliantly composed walls as a mature artist.

"She had all the confidence in the world in herself," Anita recalled.[9] No one in the family, least of all Louise, doubted her ability and drive to be an artist. Her siblings also recalled that, "She was never discouraged about her art. In everything else, in people, the way they acted, what they did—but never in herself as an artist."[10]

The turn of the twentieth century saw millions of Jewish families coming to

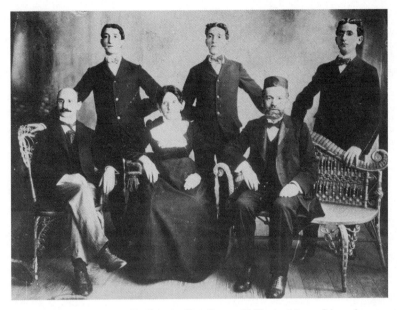

Photographer unknown. Berliawsky Family, ca. 1900. Archives of American Art, Smithsonian Institution

America from central Europe, especially from what was then called the Russian Empire.[11] What gave Louise Berliawsky the belief in herself and the determination to overcome the many obstacles she would face on her path to success as a woman artist in a new world, a man's world? Some of the answers may be found in a careful study of her first years in America. But we must go back even further, to her parents' youth, the heritage they shared with their children, and how they themselves adapted to their new home. Like all children, but especially children of recent immigrants, perception of their parents' way of being in the world had great significance. Louise Nevelson, née Leah Berliawsky, was always an intense observer of the world around her. What she saw and absorbed as a child she would eventually transform into the art that made her famous as an adult.

Louise's father, Isaac Berliawsky, was born in 1870 in Pereyaslav, sixty miles south of Kiev in the Kiev province of central Ukraine. He was one of the middle sons in a Jewish family of thirteen children, seven of whom died in childhood, either from epidemics or pogroms. He came from a well-educated, middle-class family, not wealthy but comfortable. His mother was a merchant's daughter. His father was the town scribe and a dealer in vodka and lumber, which involved buying stands of trees and then processing and transporting the lumber to market.[12]

Jews were not always allowed to own land in some parts of the Russian Empire, but according to Louise's sister Lillian, their "father's father owned woodlands in Russia," and their own father "had worked with him in the woodlands." The Ber-

liawskys "owned land in my mother's town. That's how my parents met. So wood has always been our thing."[13] This version of family history accords well with the high status the family had in Pereyaslav during most of the nineteenth century. As can be seen from photographs taken in Russia, the Berliawskys were urbanized "enlightened Jews" who did not wear traditional dress. They did not follow Orthodox practices or have Chassidic mystical beliefs. Unlike the majority of the Jews in Ukraine, they were part of a growing number of "forward-thinkers," who sought assimilation with Russian culture and a secular education.

For many hundreds of years Jews had lived in the Russian Empire, specifically in Ukraine, where the Berliawskys lived, and for the most part, relations between Christians and Jews were satisfactory. Jewish communities in the Russian Empire were allowed to govern themselves, and they had developed a rich and complex culture: Yiddish-speaking, pious, and proud of their cohesive culture as the chosen people of God.

At the end of the eighteenth century, Catherine II (the Great) conquered the territory that became the Pale of Settlement—"dozens of large cities, hundreds of small towns and thousands of villages"[14] in specific territories in Lithuania and Ukraine. The actual borders of the Pale and the regulations applying to the Jewish populations within it changed many times over the next 125 years. While movement was not restricted for the other cultural groups who also lived in the area, Jews were generally not allowed to travel or live "beyond the Pale." Depending on the czar and the year, Jews were either forbidden or allowed to live in rural areas, forbidden or allowed to own land, forbidden or encouraged to study or to serve in the military. Jews in the cities seemed to fare better than those in the shtetls or rural villages, where life was hard and often dangerous.

Subsequently Czar Nicholas I, who reigned from 1825 to 1855, curbed the rights of many Jews, whom he considered to be "an anarchic, cowardly, parasitic people, damned perpetually because of their deicide and heresy . . . best dealt with by repression, persecution and, if possible, conversion."[15] He ordered the expulsion of Jews from some areas bordering Austria and Prussia and imposed severe restrictions on the large and dense Jewish population in Kiev. His government enacted over 600 anti-Jewish decrees. His order for the conscriptions of 70,000 Jewish soldiers included the selection of 50,000 Jewish children, wrenching boys aged six to eighteen from their families for the standard term of twenty-five years.[16] The poor and unemployed, who were most likely to be conscripted, were set against the more successful members of the community who often helped their children evade the draft. Instead of holding together against a common enemy as they had from the beginning of the exile, Jews were being divided from one other.[17]

Traditional, cohesive Jewish life became less and less secure as the burdens of massive conscription and exorbitant taxes were combined with the weakening of the autonomous governance of Jewish communities. In addition, from the end of the eighteenth century until nearly the end of the nineteenth century, members of the Haskalah movement, many of whom saw the Chassidic tradition and the Kabbalah as unnecessary and destructive anachronisms, sought to educate Jews to fit into modern society.[18]

Ironically, the efforts of the Russian government to undermine Jewish communities, combined with the spread of the Haskalah and the increase in conversions, led to a rise of Orthodox Judaism and the development of Chassidic dynasties within the Pale. By the mid-nineteenth century, to paraphrase Michael Stanislawski—a professor of Jewish History who has also written about Louise Nevelson—Russian Jewry was split into two new groups: the traditionalists and the enlightened.[19] Louise Nevelson's parents represented exactly this divide.

The Berliawsky family was part of the self-conscious, self-confident Russian intelligentsia who believed that the evils plaguing Jews would disappear if they would only shed their superstitious and outmoded customs. Louise's mother's family, the Smoleranks, on the other hand, followed the traditional customs, wore traditional clothing, and embraced Judaic mystical traditions.

During the second half of the nineteenth century, during the enlightened reign of Alexander II (1855–1881), the virulent anti-Semitism that had often characterized parts of the Russian Empire briefly abated. Some Jews were allowed to study at universities, travel outside the Pale—which was now home to five million Jews, approximately forty percent of the world Jewish population—and move to the cities, primarily St. Petersburg and Moscow.[20]

One of the few treasures Isaac Berliawsky carried with him to America in 1902 was a photograph of his great uncle Issaye Berliawsky from Dnepropetrovsk, southeast of Kiev—"the only Jew ever decorated by the Czar of Russia."[21] Though Isaaye was not unique—a fair number of Jews were actually decorated by the czars—he was exceptional. The photograph, which resided in Louise's parents' bedroom, portrayed a bearded man wearing many medals and a sword. Depending on which sibling told the tale, Isaaye was either a sculptor, a musician to the czar, the designer of one of the czar's palaces and apartments, or one of the painters of the local synagogue.

In fact this extraordinary man was a talented engineer whose specialty was designing and constructing cathedrals throughout Ukraine—an unusual occupation for a Jew in the 1880s. When his work came to the attention of the Czar, he was knighted and given a small private army, which he used to fight Cossacks and their anti-Semitic pogroms.[22] Issaye was certainly an icon of the past glory of the family and a significant figure for his great-great-niece Louise Nevelson,

who, as a child, would have seen him as a person who had gained distinction through art.

Another Berliawsky uncle was visible in a different, but equally prized, family photograph showing a distinguished man in a Cossack uniform wearing a silver star and carrying a sword. He was, according to Louise, "a so-called governor; he had the highest honors and position that our people could have in Russia at that time."[23] Nevelson's father had told the family that his uncle had been in charge of all the banks for the czar.[24] Her son, Mike Nevelson, had heard that he was one of the guards of the czar.[25] Since this Berliawsky relative had no children, he "adopted" each of his nephews (allegedly a hundred) so that they could live on his estate and avoid the dreaded conscription into the army.[26] It was another family legend recounted in various and sometimes contradictory ways.

Terrible times for Jews in Russia came back with a vengeance after Alexander II was assassinated in 1881. Peasant riots and pogroms erupted throughout Ukraine and lasted for four years.[27] Falsely accused of having assassinated the czar, Jews were attacked in their homes and shops in the bloodiest outbreak of anti-Semitism in Russia in centuries. By the end of the 1800s, it no longer seemed possible that Jews—even middle-class, enlightened, Russified artisans and intellectual Jews like the Berliawsky family in Pereyaslav—could expect they would fare well in their homeland.

Between 1881 and 1914, in the largest migration of modern history, millions of frightened but hopeful Jews left the Russian Empire for America—the new country that welcomed the tired, the hungry, and the poor.[28] Most went to New York (690,291); many others went to Massachusetts (66,023) and Pennsylvania (108,534). Only 1,835 moved to Maine.[29] The hopeful immigrants spread around the world—millions to America, a much smaller number to Palestine.[30]

Not always allowed the luxury of owning land or any material objects, Russian Jews knew that their only secure possessions were those hidden away in the mind and heart. Intellectual brilliance, ingenuity, cultural knowledge, and aesthetic taste, along with any portable skill, could make the difference between survival or failure wherever they would wander. Many, if not most, of these young emigrants brought with them a deep respect for the arts, especially music, as well as an awareness of the importance of appearances. How one looked to strangers could shape one's destiny. Louise Nevelson held true to this precept to the last day of her life.

By the end of 1901, five of Isaac Berliawsky's siblings had already left Pereyaslav for the United States. Two brothers—Nathan and Hyman—had moved to Maine via Canada. Another brother married a gentile and was henceforth no longer considered part of the family. One sister, Mindel, the eldest child, moved to Fall River, Massachusetts, where her younger sister, Sadie, eventually joined her. Isaac was

the last son to leave Europe. He had stayed in Pereyaslav to care for his parents, and once his father had died of cancer, he too could emigrate. He left for America in the spring of 1902, along with his mother, who would live with his sisters in Massachusetts. It would take him two years to save enough money to send for the rest of his family—his wife and three young children.

Isaac ended up in Rockland, Maine, where he started his new life from scratch. He thought his stay would be brief, just long enough to get himself to New York City, but he adapted well to Rockland and remained there for the rest of his life.

It had not been part of his plan to marry before leaving the Old World, but he fell in love with a beautiful young girl from a rural village. The story took on mythical proportions when it was passed down to the children. Louise Nevelson recalled the tragically romantic story in her autobiography:

> My mother lived in the country in a small town near Kiev where my father's family owned land. . . . He was a bachelor in his twenties . . . and he was on a white horse. And he sees on the street this beautiful girl. She was only sixteen. . . . He never wanted to marry, but he took one look and he found out who she was and where she lived and he fell desperately in love with her. Nothing on earth could stop him.
>
> She liked another boy and she didn't want to get married [to my father]. He pursued her so desperately, he just was not going to take no for an answer. She had an older sister who lived in another small town [Rzhyschiv], and the Dnieper River was between them. That river usually froze so they could go over the ice. And this was the one year in one hundred years that the river didn't freeze, so she couldn't get over on the other side [and get away from my father].
>
> So she married my father and then was unhappy with him. He was a handsome man, but he didn't suit her, and also I think it's hard to be happy when you're making a transition.[31]

The childhood of Nevelson's mother Minna was very different from her husband's. She was a farmer's daughter—a peasant really—brought up in Shusneky, a village on the eastern bank of the Dnieper River. Shusneky was typical for many Jews in Ukraine during the nineteenth and twentieth centuries. Despite ongoing external dangers, village life was warm and embracing: a jumble of wooden houses clustered closely together around a lively marketplace where Ukrainian peasants brought their fish and hides, wagonloads of melons, grain and garlic to sell. In exchange, Jews sold them "city produce" in the form of hats, shoes, lamps, and dry goods of all kinds.

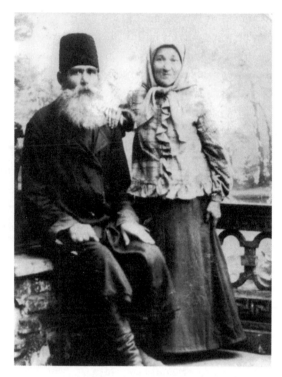

Photographer unknown. Maternal
grandparents Irving and Golde
Smolerank, in Shusnecky, not dated.
Courtesy of Barbara Fishman

The outside world of gentiles meant hostility and sacrilege. But within the
confines of village life everyone was connected to one another through an unset-
tling combination of constant fear of external attack and closeness to a mythical
past and redeeming future. A common language—Yiddish—and a common
faith with its familiar rituals held Jewish inhabitants together.

Following the Torah's 613 commandments for pious Jews brought a sense of
security and intimate connection with God. They had survived persecution and
exile for thousands of years and were convinced that ultimately their Messiah
would come. Each day brought that event closer. Only a jubilant faith and sense
of being the "chosen people" could mitigate the unrelenting poverty and dan-
gers of everyday life.

Those dangers were a living memory for Louise Nevelson's maternal aunt,
Eva Smolerank, who was born in 1870. She remembered Cossack pogroms and,
specifically, how the marauders stabbed and killed her neighbors as they rode
through her town of Rzhyschiv (population ca. 1,600).[32] Her younger sister,
Minna, born in 1877 just across the Dnieper River, could have experienced
the same horrors during her childhood—Jews throughout the Pale were vividly
aware of the menace stalking every Jewish community.[33]

Minna Smolerank was four years old when Alexander II was assassinated
in 1881, and the scourge of violent anti-Semitic pogroms erupted through-

out the Ukraine. In cities and villages, Jews were attacked, homes destroyed, families killed, and women ravished. From April 26 to May 4, 1881, the most severe attack was a pogrom lasting several days, leaving 762 dead in Kiev, only 60 miles from Shusneky. Throughout that spring and summer over thirty villages and hamlets were attacked. "By the time the violence triggered by Alexander II's assassination began to subside in 1883, thousands of Jewish homes and businesses had been devastated by roaming mobs, several dozen Jews murdered, and unknown numbers assaulted and raped."[34] A childhood marked by constant danger was the traumatic foundation on which Minna's later life would rest.

Golde, Minna's mother and Louise's grandmother, was thirteen when she married, shaved her head, and for the rest of her life wore a wig, like all wives in the Orthodox Jewish households of Ukraine. Her first babies were stillborn so she followed the advice of her rabbi when she was once again pregnant. He had told her to collect metal and have it welded into a hoop through which her babies should pass in order to come live into the world.[35] Golde's daughter, Minna, would carry some of her mother's tradition of Chassidic mysticism and magical thinking, as well as her superstitiousness, into the New World.

From this insular life, Isaac Berliawsky snatched Minna because of her beauty. After their marriage in 1897, he took Minna home to his family in Pereyaslav, a city with a Jewish community that dated back to the early seventeenth century. By comparison with Shusneky, Pereyaslav—whose population numbered some 5,800 Jews, nearly 40 percent of the total population—was a large metropolis.[36]

Shortly before leaving for America in the late spring of 1902, Isaac took his wife (again pregnant) and their two young children back to her parents' home in Shusneky. There seven months later, Minna gave birth to their third child, Anita, née Chaya.

Minna's stay there coincided with the Kishinev pogrom only three hundred miles away in April 1903. News of that horrendous three-day event spread fast and far. A report was even published in *The New York Times*. On Easter Sunday over eight thousand teenagers and adults rampaged through the Jewish quarter of Kishinev—where fifty thousand people, a third of the town's residents lived.[37]

When the pogrom had ended nearly fifty Jewish men, women, and children had died, nearly five hundred were wounded, and over two thousand were homeless.[38] In the dispatch from St. Petersburg, *The New York Times* reported that the "anti-Jewish riots in Kishinev, Bessarabia, are worse than the censor will permit to publish."[39]

Not long after her father left for America, Louise Berliawsky refused or was unable to speak for six months. It has always been assumed that her muteness

was a direct result of her father's departure. What has not been considered are other factors, such as the move from a comfortable home in a city to a more crowded home in a small village; the birth of a new sibling; the death of her paternal grandfather; and the loss of her paternal grandmother, who had gone to America with her father.

Just as important as any of these factors, the little girl may well have witnessed pogroms and even attacks by Cossacks on the village where she lived with her mother and siblings for three years, beginning at age two and one-half. Even if she didn't witness it herself, she surely would have heard first-hand reports about the violence from neighbors and relatives, including her aunt Eva who lived just across the river. In her very young life, Leah Berliawsky had almost certainly absorbed the fear of the adults all around her. So much had happened so quickly that all the separations and fear may have tipped the toddler into a traumatic reaction. By not speaking, she had found a way to control one of the very few aspects of her life that was within her power.

Louise Nevelson never mentioned a word about any of those early events in her autobiography.[40] Nor did she tell either of the two people closest to her during the last twenty-five years of her life, Arne Glimcher and Diana Mac-Kown.[41] Louise Berliawsky's dramatic response to the loss of her father, paternal grandparents, and "safe" home presaged her later denials of painful experiences. She did not go to the funeral of either her mother in 1943 or her father in 1946. And shortly before she died, she herself stopped speaking again. Shutting out unpleasant reality had become a way of life—an archaic way of dealing with loss, binding overwhelming sadness and anger.

According to his youngest daughter, Lillian's recollection, Isaac Berliawsky "had gotten to Rockland by accident. Everyone liked him and he loved Rockland. First he got a little store, then a bigger one, he bought some real estate with a partner—the mayor's wife—and at one time he owned half of Rockland."[42] The family story about how their father succeeded in America was classic. But, as usual, the reality was different.

Quarreling with his brother Nathan, who had come to America before him and become successful in Waterville, a thriving town in central Maine, Isaac Berliawsky decided to go it alone in his adopted country. After saving enough money and learning enough English, he allegedly gave his hard-earned cash to a train conductor or a ticket seller and said that he wanted to go as far from Waterville (and his brother) as the money would take him.[43]

Whatever the truth, he got off the train sixty miles away in Rockland. With his restless and independent nature, strong work ethic, resourcefulness and, especially, his expectation that with his background and education he would survive and eventually prosper, Isaac did exactly that.

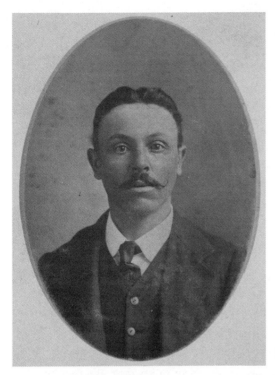

Photographer unknown. Isaac
Berliawsky, ca. 1903. Archives of
American Art, Smithsonian Institution

In early 1905, twenty-eight-year-old Minna Berliawsky and her three young
children set out for America. Leaving the home of her childhood for the last
time, she must have believed that she would never see her parents again, a
wrenching separation from which she never recovered. However terrifying her
childhood and adolescence, she had been surrounded by familiar faces and reli-
able religious rituals. Though she was now going to a much safer place, it would
never feel like home.

The Berliawskys went via the standard route for Ukrainian Jews—by train
through Kiev and on to Hamburg, from there by boat to Liverpool, and finally
on to Boston, a three-month voyage to the new world, a perilous and difficult
journey marked by crowding and deprivation, including a six-week period of
quarantine in Liverpool because of an outbreak of measles. Yet, for the bright and
very visual five-and-a-half-year-old Louise it was an adventure that impressed
her with many new sights and sounds.

In her autobiography, Nevelson claimed that her "earliest memory" dated
from that momentous trip—a candy store in Liverpool: "There on the shelves I
saw every color of hard candies in jars. And then the lights—it was glass that had
reflection. So it looked like heaven. . . . It was very magical. . . . An impact that
even now, seventy years later, still thrills me."[44] Evidently the candy store in Liv-
erpool was not her actual first memory, because Louise had a vague earlier rec-

ollection of her maternal grandmother, Golde Smolerank, in Shusneky, dying wool: "Different colors with vegetable dyes . . . a faint recollection of the house . . . the stove . . . built in the wall."[45] The knowledge of her maternal grandmother's talent was carried to the New World, since Minna Berliawsky often said to her children that her own mother "had the most beautiful sense of color."[46]

Earliest memories tend to be composites of important early experiences. Always significant and rarely actual, they provide a revealing glimpse into an individual's early life and major concerns. Freud's observations on the subject of childhood memories are instructive here:

> It may indeed be questioned whether we have any memories at all *from* our childhood: memories *relating to* our childhood may be all that we possess.[47]
>
> [C]hildhood memories . . . are only elicited at a later age when childhood is already past; in the process they are altered and falsified . . . so that generally speaking they cannot be sharply distinguished from fantasies.[48]
>
> Indeed, it usually happens that the very recollection to which the patient gives precedence, which he relates first, with which he introduces the story of his life, proves to be the most important, the very one that holds the key to the secret pages of his mind.[49]

Color played a strong role in Louise Nevelson's earliest visual memories; the lights and reflections in the glass she so vividly recalled as a five year old would much later become a central theme in her formal vocabulary, and yet she almost completely eliminated color from her mature and signature style, which fit her pattern of denial and reversal. Perhaps more remarkable is the fact that at both the beginning of her career and at its end Louise Nevelson turned to work in color.

Another pleasant recollection in Liverpool involves playing with children in the street and her first encounter with "a doll that shuts and opens its eyes." "That was almost the first thing to make me an artist. . . . Because of the wonder of it."[50] It must have seemed like magic to the little Russian girl. The black bristled eyelashes reappeared many decades later as her own furry fringe of false eyelashes, an important part the public persona the artist developed in her mid-sixties.

The six-week stay in Liverpool could have been quite frightening, not only because of the danger of illness but because a quarantine had the potential to put the entire trip in jeopardy. Yet, of this time Louise Nevelson recalled only pleasant memories. Perhaps by comparison to the two-and-a-half years in the village of Shusneky, Liverpool felt safe.

Joseph Dondis, a Russian-born relative of Isaac's, met the newcomers at the boat in Boston. He christened the Berliawsky family with Americanized names, "Nathan," "Louise," and "Anita." Then Dondis put them on the last stage of their journey to join their father—an overnight steamship trip to Rockland, Maine, where Isaac Berliawsky had settled three years earlier. They arrived, dressed for the important encounter, wearing Persian lamb coats and hats.[51] Isaac greeted them at the wharf and transported them to the rooming house on the rough waterfront Sea Street in which he was living. The area was known for its brothels and bars catering to fisherman and sailors. The Berliawskys' fellow roomers were from the humble working class in Rockland—servants, sailors, a mason, a waiter, and a rabbi. For at least five years the family lived on Sea Street.

The location on the water gave the children a chance to play near the ship-yards and watch the big boats being built—sometimes as many as four or five at a time.[52] Rockland was not a sleepy village but rather a lively town of 8,000, the biggest American port next to San Francisco, according to tonnage and numbers of ships, sending lime, wood, and granite all over the world. Mining, smelting, and fishing were the major industries of the day. Not far away was Ban-gor, Maine, then known as "the lumber capital of the world,"[53] no doubt making the whole region a draw for a young Russian whose father and grandfather had been lumbermen.

Even after they moved to their next home on Linden Street at the corner of Tillson Avenue, the Berliawsky family was still only a few blocks from the water, and the children recalled sitting with their mother watching ships trying out the Rockland breakwater. "Look and see how beautiful everything is," Louise's sister, Lillian, recalls her mother saying to the children.[54]

The four new arrivals in 1905 were transported into a community whose cli-mate was much like the old country, and whose landscape was not so different, except that Rockland bordered the ocean. But the crucial shift was away from a warm, closely integrated community where everyone was familiar and spoke Yiddish, the common language, and shared a common culture. In Rockland, Maine, Minna was a foreigner—as was anyone not born and bred there—and she felt unwelcome in her new home, despite the presence of twenty-two other Jewish families living in the town, some of them also recent immigrants.

Not long after his wife and three children had arrived, Isaac Berliawsky collapsed. As Louise recalled: "I remember my mother saying that he was never lazy in Europe, yet when we first came, he lay in bed for months. He went through transition, not knowing what to do."[55] The arrival of his unhappy peas-ant wife and three young children, combined with the loss of his freedom, must have stopped him in his tracks. Whether her father's depression lasted weeks or months, his oldest daughter knew that he had not been available to help her

newly arrived, non-English-speaking mother for what must have seemed like a long time. But once he recovered his equilibrium and settled his family into the humble housing he could then afford, he went back to work with a will. He was up at dawn, back for lunch and then not back until late at night, when he ate his dinner after the family was done, making do with leftovers.

When he first arrived in Rockland, Isaac lived in the house of a Russian-speaking young widow, Mrs. Bloom. According to his grandson Mike Nevelson, he had a child with her.[56] Another of his conquests, also a rich widow, was a Mrs. Brown, who introduced him to the Jewish community and helped him get work.[57]

Thirty-one-year-old Isaac began by doing any job he could find. He was a paper-hanger; he had a grocery store; he made bullets from scrap metal during the First World War; he bought and sold property; he bought and sold timber—coming in spring to "wake people out of their winter sleep," to pull out the logs and sell them to lumber mills, and in winter he chopped wood.[58] Always ambitious, he started small but thought big. He went back and forth in his varied jobs, always resourceful. He prospered first in the Jewish community and then, in time, in the general community.[59]

Like many other recent Jewish immigrants, especially those from the Pale, he also worked as a peddler, walking door-to-door, selling whatever he could find—scrap metal, rags, and old clothes—at a profit.[60] Later he began to collect antiques, recognizing their aesthetic appeal before most others did. Eventually, he had barns full of antiques and turned what had started out as a sports palace into yet another warehouse for his goods. His youngest daughter Lillian noted that Louise was "just like her father—always collecting things, keeping pebbles and marbles, anything she'd find. She would put it on the floor, or anywhere."[61] The same aesthetic impulse that had him collecting antiques propelled Isaac Berliawsky to buy the town's first Victrola—as the early record players were called—and recordings of the most famous opera singers of the time—Enrico Caruso and Amelita Galli-Curci. He was sensitive to beautiful objects and loved art and music. Better educated with a greater appreciation of culture than many other Jews in Rockland, he taught his children to look for quality.

When Anita and Louise were ten and twelve, respectively, he would send them "to look at a house he was thinking of buying and tell him what it's worth—that's how he taught us to value."[62] Lillian recalled her father's always saying, "'Isn't this house beautiful? Look how it was made.' That's why architecture is second nature to Louise."[63] The family's favorite houses were the big palatial ones on Beech Street, and Louise knew every one of them. "For her, the bigger the better. Our father wanted to buy one for us, but my mother raised such a ruckus that we didn't buy it."[64] His daughter Anita recalled: "He always wanted to move into another house, better, better, better."[65]

Isaac "Belofski" was listed as a grocer in the 1906–07 Rockland Directory, a junk dealer in the 1910 national census, and a peddler in the 1912–13 and 1917 editions of the directory. As he grew accustomed to life in America, he gradually moved toward work that repeated his family's success in the old country—owning land. His previous education helped. "He was admired for his knowledge of Hebrew by Mr. Rosenberg [a wealthy realtor] who lent him money to buy land when most banks were not lending money on land."[66] In 1907 he bought his first parcel of land on Linden Street in the South End of town and after that he never stopped. By 1912, with the help of his son, he had built a home for his family on that plot. He built other houses, using his own lumber and land. His one grocery store turned into five, and his early land purchases led to his owning most of Main Street. Between 1910 and 1920, he bought fifty-one parcels of land in Rockland. He went into partnership in a real estate firm with his one-time companion Mrs. Brown; Brown, Blaisdale and Berliawsky became successful, and Isaac became one of the largest landholders in Rockland and the fourth-highest taxpayer.[67] His pride was evident in the heading on his stationery: "Isaac Berliawsky, Real Estate Dealer and Broker, est. 1907."

Though he prospered, he was never rich, since all his property was mortgaged. As his daughter Anita recalled, "With twenty dollars, he would borrow another twenty dollars and buy yet another house."[68] It was as if he had to make up for all the generations of Jews who hadn't been able to own their own land.

Diana MacKown. Berliawsky House on Linden Street, ca. 1960. Courtesy of Diana MacKown

Isaac was widely known for his generosity and honesty. His grandson Mike Nevelson recalled stories he learned growing up in Rockland: that his grandfather "never collected rent and was tender-hearted, giving anyone anything they needed," Jew and Gentile alike. "When his lessees were hungry he would bring chicken soup, and he would keep people on even when there was no work for them."[69] He wouldn't use chainsaws, because they not only made too much noise and "disturbed the trees," but also because they would deprive men of work. During the Depression, even though he lost much of his money, he took care of the poor in Rockland.[70] He was also very generous with his girlfriends.[71]

Isaac was a colorful character to his family. Mike Nevelson recollected the sight of his grandfather, "pockets stuffed with deeds, the biggest trader of real estate, bottle of whiskey in one pocket, deeds in the other, or/and sardines and crackers."[72] He had to carry the bottle in his pocket because, "my grandmother used to break them whenever she found where he had hidden them in the house."[73] His taste for simple food (sardines and crackers) as well as alcohol was carried down to his oldest daughter, Louise.

His children also remember him for being outspoken, stubborn, and having "a bad temper—a real Russian."[74] All the children knew of his angry outbursts and were scared that their mother would complain to him about their misdeeds.[75] But Louise recognized the fragility underneath his ferocity: "If you did this [knocking wood], he jumped."[76] In retrospect we can imagine the stress Isaac Berliawsky must have felt making his way in his new world. Louise recalled: "When he came home it was like an engine. I always felt like it was a furnace downstairs going chuga-chuga-chug. So we didn't communicate much."[77] He used to run to work "because he didn't have time to get into a car and drive."[78] His son called him "high-strung and very eccentric."[79] His grandson described how he could be "troublesome, a kind of radical."[80] For example, he refused to become a passive part of the small Jewish community in Rockland. In a quarrel with some members of the tiny local synagogue he went so far as to refuse to be buried next to them, donating a plot of his own land for a separate family cemetery—Berliawsky-Small Cemetery—in 1931, and joining with a few friends to start a new synagogue. A year later the split was healed, and Isaac was named president of the Adas Yoshurun Synagogue in 1932. But the separate cemetery remained.

Like many first-generation immigrants, all his ambition was for his family and their future. He wanted the best for them and never complained when his wife spent money shopping for clothes for herself or the children. "He was very proud of his girls and the fact that so many people in Rockland would stop him on the street and tell him, 'You have such beautiful children.' Or: 'Lillian and

Louise are gorgeous.'"[81] He himself was tall and handsome (according to Louise he weighed 140 pounds and was "dashing"). But despite his good looks he cared nothing about clothes or spending money on himself. His wife had to buy him new clothes and burn the old ones lest he try to wear them yet again.

All in all, Isaac Berliawsky had made an excellent adjustment to his life in the New World. As Louise recalled: "He thought he would be the one who wouldn't like a small town and that we'd all move to New York. But he was much more contented than my mother."[82] "He adjusted, but my mother never did."[83]

Like all children, Louise Berliawsky identified with both parents; just as all children feel ambivalence for both parents. "I always thought my father was a piece of genius," Nevelson later wrote. "That has given me my strength."[84] From Isaac she learned to stand on her own two feet, to work hard and play hard, to appreciate culture and creativity, to look carefully and use her eyes to assess value and beauty, to speculate, to always aim for the highest and best, to be generous, to not worry about money, and to ignore deprivation. Most of all, from her apparently fearless father, she learned to be a fighter and not to fear controversy and to have confidence in herself over time. But she also learned from him how to deal with depression—by working maniacally and drinking too much.[85] The admiration Nevelson felt for her father was mixed with ambivalence. He had, after all, abandoned her when she was very young—leaving her behind when he went to America. He could be difficult, irascible, and angry, and she must have noted that he was not faithful to her mother and that there was little affection between them.

TWO

ROCKLAND CHILDHOOD

1905 – 1918

"It is how you shine in your own family first that makes you a star I was the star because I wanted to be."
—Louise Nevelson. *Vogue*, June 1976

Whatever Minna Ziesel Berliawsky had seen or known in Russia, coming to Rockland, Maine, she was thrust into a kind of loneliness that never abated and sealed her off from making connections in her new home. It seemed as though she felt no safer in New England than in the Ukrainian village in which she was born. She was totally unprepared to deal with life in Rockland, and as a result she didn't. She had not only lost her entire family when she left Russia, she had lost her bearings. Within a month of her arrival in Rockland, Minna was again pregnant. On January 13, 1906, her last child, Lillian, was born. From that time on she avoided intimacy with her husband. She was done with childbearing and done with sharing a bed with a spouse, whom she soon learned was a philanderer. Their marriage further deteriorated. The children were aware of their parents' incompatibility, though Louise was the only child who could recall her mother's daily tears, which went on for months after they arrived.

"I don't think she was too much in love with my father," Anita explained, "and when she knew she was leaving her mother for good, she became like an invalid neurotic. She cried in bed."[1] Anita recalls that she was "always in bed. She used to have severe headaches and backaches and only came down for Friday [Sabbath] dinner if she felt well enough."[2] She was calm and slow and rarely spoke above a whisper, a characteristic of the depression she suffered and the control she used to hide it. Her grandson recalled, "She was a very unhappy

Photographer unknown. Berliawsky family portrait, ca. 1907. Archives of American Art, Smithsonian Institution

woman, always sick, neurasthenic I think. But she was very kind. She used to cook and bake and wash my socks by hand so that they would be soft on my feet. But I *hated* living in that house."[3]

These eyewitness accounts of Minna Berliawsky's sad and lonely life describe a kind of paranoid isolation. It could have been the result of survivor's guilt or post-traumatic stress due to the violent pogroms in her childhood, or to the rupture of the intense bond with her parents and extended family in Russia. All of these could have been exacerbated by her husband's infidelities and the vast difference in status between them.

In another interview, Mike Nevelson told a revealing story about her personality: "My grandmother never liked anyone. She would march down to the store like a general. She had no friends but grand airs. . . . She saw most people as beneath her. She was overtly polite to merchants but scorned them behind their backs. She could be coarse and put the evil eye on merchants, giving them the finger. . . . She always felt she was being robbed but never argued and wouldn't discuss prices."[4] Bearing the burden of feeling both inferior and defensive, Minna Berliawsky armored herself with sardonic humor, defiance, and silent superstition, in which she had been schooled by her mother and her upbringing in Shusneky.

Even though many of the Jewish families in Rockland had also emigrated from the Pale of Settlement and spoke her native Yiddish, Minna held herself aloof from them and did little to make herself at home in the welcoming community or adapt to the ways of her new country. She made almost no friends, "would not mix with the WASPs," rarely ventured out except for necessary errands and was "almost a recluse," Louise recalled.[5] "She didn't communicate with the community. She retreated, staying more at home with the house and her children. She probably always dreamt of flying away but never quite made it because she married young and had so many children. I think she probably lived a great deal in her fantasies."[6] By turning her back on everyone in Rockland—except her children—Minna could establish her superiority and defend her injured pride.

This was one of the principal lessons Minna Berliawsky taught her children and one that Louise took to heart because she, too, lived "a great deal in her fantasies."[7] Louise had "great sympathy" for her mother, because she knew she was "misplaced socially . . . misplaced in every conceivable way. . . . Marriage made her very unhappy. . . . And she was sick all her life. . . . She was so ill-adjusted and so beautiful."[8]

Like many daughters of depressed mothers, Louise felt her task in life to be her mother's mother and to take on both her mother's sorrows as well as her hopes. "I never saw her happy. But I always felt so sympathetic to her that I was determined to open every front door. . . . And to walk right through the door[.] I didn't care if I had to build the house myself."[9]

Whatever happened outside the house was beyond her control, but inside the house Minna was lord and master. She wouldn't allow her husband's antiques into her house. Her son recalled: "She didn't like antiques and wanted everything new.[10] She was an old-fashioned woman who liked overstuffed furniture—nice to look at but don't sit on it."[11] She also became a fanatic housekeeper. Her daughters reported running home from school on Fridays to wash the floors before the beginning of Sabbath at sundown. (And this was in addition to a cleaning woman who came twice a week.) They recalled she was so particular that they could not use mops to clean but had to be on their knees using hairpins to pick dirt from the corners of the floor.[12] Minna aimed to banish every last speck of dust. Her anger, her disappointments, her past pain and present sadness—all could be channeled into a whirlpool of making perfect household order.

Her daughter Louise carried on her mother's tradition of fanatical housekeeping, and to the end of her long life she could be found sweeping the street in front of her building or mopping floors inside it early in the morning before her helpers were even awake. But, unlike her mother, she found a way to make a creative new order in her studio.

Did Isaac Berliawsky know how badly his wife was faring in her new home? Did he care? He may have been aware of how much harder it was for women whose life was centered around home and family to adapt to a new community, but he could not have realized that without a strong mother to guide and protect them, his daughters would always be at a disadvantage in that era, especially in a rigidly Protestant New England community. The Berliawsky females were obliged to mutely accept social separation in Rockland, where the prejudice against outsiders was silent but certain. "If you tried to break in, you would not be successful—even if you just came from the offshore islands. . . . Rockland society was completely closed, even to a person from Massachusetts," remarked a schoolmate of the Berliawsky children.[13]

Minna not only failed to help her daughters break through the social barriers, she wasn't even able to help them at school. Anita, the most academically successful of the three sisters, was upset when, at age twelve, she was not skipped a grade at school though she was convinced she deserved it. Knowing that she couldn't expect any help from her parents, she wrote directly to the school principal, telling him that she was "smarter than Grace Norword, and if she skipped I think I ought to skip. The next day they skipped me."[14] Anita knew that when she got home her mother would probably be in bed and usually turned to Louise for help and encouragement. "Louise made me study and take drawing lessons from her teacher."[15]

A staunch believer in equal rights for women, her husband may have hoped that Minna would be less stuck in her old ways and more like the venturesome widow Brown. He masked his disappointments with his wife by putting her on a pedestal (one of his daughters said he "adored" her), but he feared her displeasure and conceded most domestic decisions to her. The children never turned to him for advice, knowing that he would automatically second whatever she said.

With its deep harbor and nearness to the elegant summer resorts on Mount Desert Island, such as Bar Harbor and Seal Harbor, Rockland was a tourist town in the summer when wealthy families from Washington, New York, and Boston arrived by yacht, steamship, or private train on their way to the luxury hotels or palatial summer homes along the coast. "We were really conscious of their wealth."[16] Frequently the wealthy families and their many maids (according to Lillian, some families had as many as "sixty")[17] stopped for breakfast on the wharf. The Berliawsky family was well aware of another world—broader and richer than Rockland and very exclusive—and Louise especially noted the elegance and extravagance of the wealthy summer visitors. Though she knew she could never be invited to socialize with the upper-crust families coming though Rockland, much less the old local families in town, as a young girl look-

ing in from the outside, when a realistic entry into the majority culture was not an option, fantasy took over. Whether or not she was conscious of her wishes, Louise Berliawsky dreamed—even as a child—of wealth and an extravagant lifestyle, of becoming a princess and living in a palace. In her autobiography *Dawns + Dusks*—compiled transcripts of recorded interviews made by her personal assistant Diana MacKown—Nevelson said about her mother: "A woman who should have been in a palace. I think that's my idea for myself."[18]

According to Louise, once her father was successful, her mother shopped for herself and her daughters at Fuller Cobb, the most expensive department store in Rockland, frequented by New York's elite on their way to Bar Harbor: "We'd go into the stores in town that catered to the Morgans, the Vanderbilts who summered there—and they had the best of everything. I was the oldest daughter, and no dress was too expensive for me."[19] Dressing up her pretty daughters became Minna's "art, her pride and her job. . . . My mother wanted us to dress like queens."[20] That was one of Minna's few ways of feeling superior.

She had always been aware of her own beauty and seems to have relied on it for comfort and strength. Emerging rarely from her house, she made a resounding splash when she did—reminding everyone how truly different and attractive she could be. Despite the characteristically understated Yankee fashion in which American women in Rockland clothed themselves, Minna Berliawsky always appeared in public dressed magnificently—fashionable, her face rouged (which, according to Louise, was "something of a scandal in town"), and on her head an elegant hat. That was the way they did it in the old country, especially in Ukraine.

Her grandson's version of this story: "She didn't like the people in Maine at all. She had delusions of grandeur so she would dress up in a fur coat and march down the street and she wouldn't look right or left or talk to anybody. . . . She didn't like anybody—very Russian. Russians are paranoid and suspicious."[21]

"When it came to buying clothes, she didn't buy many, just once in a while . . . she would go and buy the best and the most expensive. But it would last for years. She had to have the best, otherwise, she didn't want anything."[22] Her oldest daughter learned the lesson well. Whenever Louise Nevelson was looking for a hat, a teacher, an art dealer, anything of importance, it would have to be the best. Nothing else would do.[23]

Preparing for her infrequent forays into downtown Rockland, Minna Berliawsky would take her time. "Before she'd get dressed it would take her five hours," recalled Anita.[24] Louise later commented, bemusedly: "When she dressed up, it would take her a month."[25] But the final effect was astonishing. When she walked down the street, "Everyone came out to look," Lillian remembered.[26] Louise added, "People would say, 'There goes the most beau-

tiful woman in Rockland.'[27] When it came my turn to be the star, I just took what I felt was my heritage."[28]

While Louise may have been embarrassed as a young girl by her mother's need to put on a front of fancy finery, she absorbed the lesson her mother's conduct conveyed. No matter how you feel inside, what you show to the world is what counts. "[M]y mother knew fashion. She knew the line. And that gives me a feeling of rightness to do what I did,"[29] recalled Louise. Like her mother, she developed a taste for fashion that often made her notorious—while her mother's style was conventional, her oldest daughter's style was always original. In both cases, reliance on how one looked could hide how one really felt.

Louise's taste for ingenious improvisation started early, and throughout childhood she tended to extemporize, wrapping fabric around herself in novel ways, pinning white embroidered aprons or linen yard goods in remarkable ways, or creating hats out of unexpected items. Though Minna was a fanatic about never using pins to hold anything together, she was tolerant of Louise's ways and referred lovingly to *"Leykah mit di schmattes"* ("Louise with her rags").[30]

Like many immigrants, both Berliawsky parents knew that their children had opportunities in America undreamed of for Russian Jews. "When we came here, my father and mother were very aware that it was a new world. Each one . . . had an equal opportunity So my parents believed the children, no matter what sex, should be educated and they felt we had the same opportunities that anyone had."[31]

A factor supporting the idea that women had a right to lead independent lives was the significant number of gifted female teachers in early twentieth-century America. Professional opportunities for women were limited, and many of the most talented young women taught school precisely because it was known to be a woman's profession where they were not likely to be jeered at or discriminated against.

"When I told [my parents] at an early age that I wanted to be an artist," Louise declared in her autobiography, "he was as proud as he could be. And she was [too]. And so they helped in every possible way. . . . I didn't feel being a female was any handicap. I felt it was one's ability that counted. And I just thought I had it."[32]

Isaac Berliawsky's choice of Rockland, Maine, as a base from which his immigrant family could rise was fortuitous—especially for Louise, who found so much support and so little direct opposition to her youthful ambitions. Part of that good fortune was the fact that the principal of Rockland High School was an ardent suffragette. The early recognition of her artistic ability by her art teacher, Miss Lena Cleveland, bolstered her innate self-confidence: "In the first grade, I already knew the pattern of my life. I

drew in childhood and went on painting and moving everything daily. I felt that that was my strength. And my good fortune was that even in a small town in Maine, every teacher knew it too. All the way through school I was fed by these art teachers. I was the gifted one," she continued. "I was considered to be A plus, so that gave me great confidence and built me up to know that [art] was my natural direction."[33]

Louise's sisters remember: "In kindergarten Louise was fighting with the art teacher who didn't believe her half the time that she was doing things freehand."[34] Apparently the young girl soon won the confidence of that same art teacher. Nevelson's recall of her earliest recognition by her teacher is rather glorious:

> When I was about seven years old our art teacher . . . brought in her own crayoned drawing of a sunflower . . . and . . . wanted each of us to make a sunflower drawing for . . . the assignment. I drew a large brown circle for the center and surrounded it by tiny yellow petals. . . . She picked mine and held it up to the class and said it was the most original because I had changed the proportions of her drawing.[35]

At the time of this event the young girl did not know what original meant, but hearing her teacher's praise made her "feel very good." Miss Cleveland, the small school system's one and only art teacher, became Louise's principal cheerleader throughout her thirteen years as a student, and the triumphant overturning of her initial doubts about the girl's talent set a precedent. Louise would overcome the same hurdle three more times as she proved herself to her future art teachers. This helps explain the foundation of her belief in herself as an artist in the face of future discouragement.

As Nevelson recalled in her autobiography:

> So I loved this particular teacher. . . . I think she also went to Pratt. A woman about fifty-five. Never married. Conventionally she certainly wasn't beautiful, she was an old maid and behaved like it. . . . And what appealed to me even then was, she had a beautiful purple hat and purple coat. . . . And so I said, "Miss Cleveland, you have a beautiful hat and coat." So we started to talk about it . . . and she said, "Well, I bought the hat because I *liked* it. And then I found the coat." . . . So that pleased me.[36]

Nevelson followed this story about her mentor with one about herself when she was fourteen.[37] She tells of buying a hat frame, some linen, and then stenciling butterflies and painting them onto the linen. "I wore it to school every day, and

no one said a word about it. I was the only one in Rockland who ever thought of doing it. . . . What made me do it? I think it's the funniest thing I did. I wore it to school every day, and no one said a word about it."[38]

It seems clear in retrospect why the shy fourteen-year-old girl would have done something so "funny." Miss Cleveland's example of non-conformism had inspired her. Twenty years later, still identifying with her most significant childhood heroine, Louise Nevelson would be known in the art world as "The Hat."

In high school Miss Cleveland continued to tell Louise that "she would make a name for herself as an artist."[39] Edgar Crockett, a high school classmate, recalled that, "She surpassed us in color. She found that art came naturally to her." He also recalled that she always won the competitions for being the best artist.[40]

In another passage of her autobiography Nevelson recalled that all the art teachers in her school had gone to Pratt: "And they all seemed different from the rest of the teachers, more human. They looked different and behaved differently. And they had a distinction about their clothes."[41] Again Nevelson makes a glancing reference to the humanity of her art teachers—*teachers*, though she had only one—but she quickly reduces the depth of her admiration by switching to a more superficial topic—their clothes and general appearance. Throughout her life Nevelson turned to fashion or to observations about an individual's appearance when confronted with a dealer, potential buyer, or art writer who had a genuine interest in her and her talent. It was a safe, familiar, and comforting association. Similarly, increasing the alleged number of supportive art teachers was a confirmation of her childhood talent.

Apart from getting top grades in art, Nevelson did not do particularly well in her other classes. She had difficulty with numbers and names and did badly in grammar, earning C's on her report cards. Because she was a slow reader, she read only the minimum required. Her own fantasies were always more interesting than anything she had read.[42] Louise Nevelson's odd speech patterns, which became evident later in her life, might have originated from an identification with her mother, an uneducated immigrant, who spoke heavily accented English and never learned to read it. Her parents never pressured her about school, and the whole family seemed to acknowledge that her strength would always be in art. Excelling there made her lesser abilities in other areas acceptable. "I knew that I was going to be an artist," she told an interviewer. "As long as I wasn't so smart, I was going to be great! What else could I do?"[43] But she actually was "so smart." It just wasn't evident during her school days.

Louise's sister Anita (nicknamed "Books" by her family), who was an outstanding student and went on to college and graduate school to study English literature, explained that Louise "wasn't dumb, she was smart. I'm literary, she's

visionary."[44] Their older brother, Nate, was also not academically inclined. He was outgoing, resourceful, highly energetic like their father, protective of his younger sisters, and athletic. He saw his job as always watching his siblings, making sure they didn't get into any trouble.[45]

Throughout her school years, Louise Berliawsky was self-conscious and socially uncomfortable. "I sat in the back My hand didn't go up too much. Why was I shy? . . . Partly because I was the tallest. Partly because . . . I was the most attractive girl in Rockland. But I wasn't a WASP. So I couldn't get the prize. Every year we had a Lobster Festival. There was a Lobster Queen. And every year, everyone said, 'Oh, you're going to be Queen. . . .' Every year they said that, since I was a little girl."[46] And because she was never selected, she suffered every day. "I wanted to commit suicide."[47] Decades later when Nevelson became the charismatic art world star, afraid of no one and supremely poised, she would recall her early diffidence and how hard she had to work to overcome it.

At the same time she saw herself as the prizewinner. Though as a child Nevelson was very shy, and looked different from the other local girls, she nevertheless won many prizes and was the captain of the high school basketball team.

Not being a reader, not having a mother who could instruct her in the ways of the world, not trusting her father, despite their shared love of music and culture, moved Louise Berliawsky to turn to Lena Cleveland for comfort and support. "I always thought the art room was warmer than all the rooms in the school," she wrote. "And so I couldn't wait to get [there]. . . . We generate heat toward the thing we like or the thing we are close to. . . . I knew all my life that that's where I wanted to be."[48] The girl recognized the "different behavior" and "graciousness" of her art teacher and realized that she had "something that no one around me had." Perhaps her art teacher recognized how alone and sensitive the shy, talented, young Jewish girl was. Perhaps she saw Louise's otherness and identified with it, having herself been "other" by virtue of being "creative" and "artistic" and having grown up in the nearby and equally Puritanical town of Camden, Maine.

Throughout childhood Louise Berliawsky's absolute conviction about her artistic talent is understandable. Indeed, her earliest known work is prescient, at least about the content of the image. Furniture, carefully drawn and arranged on the page, outshines the image of the little girl seated on a big chair. Nevelson would make her name and fame as a mature artist using furniture—broken into bits and pieces. Louise's early ability is especially evident in her studies from nature. One of the most remarkable is a watercolor of a forest scene with the tree bark as the starring attraction. The subtle gradations of brown, beige, and silver shimmer along the surface of the birch trees portrayed in this work from her teenage years. Likewise, the textures of the bark—sometimes smooth,

sometimes broken with shadowy dark patterns that are entirely persuasive—are witness to the young girl's already highly refined aesthetic perceptions. So too is the complex and vital composition she has created with the leaning tree trunks that crisscross and yet hold tautly together. That she could make the large, long forms of the tree trunks harmonize with the configuration of surface textures seems well beyond the usual gifts of adolescent artists.

When she was far along the road to artistic success, Nevelson gave her adolescent drawings to the Archives of American Art, the largest collection of primary resources documenting the history of visual art in America. She must have had some notion of what they would reveal to a discerning eye. Was she as certain as she liked to think about how good she was at art during her childhood and adolescence? Maybe. But she did know that she was ambitious, creative, and in a hurry to get out of town. And she hated being ignored.

Her adolescent drawings—at least the ones she saved and gave to the Archives of American Art—all appear to be work done for her art class at Rockland High School. They include landscapes, detailed drawings of antique furniture (several of which are labeled and historically defined), four interiors, and some small watercolor miniatures of exotic landscapes, which seem to be copies. In addition there are several figures copied from Leonardo, Rubens, and Dürer; a Chinese sculpted figure; and the image of an unidentified sailor. None of the drawings shows the hand of a highly skilled young artist. They are carefully done—after all they are school assignments—but some awkwardness and lack of linear elegance are visible. However, her watercolors demonstrate that she had a fine color sense and a gift for composition.

The interiors show several rooms of the Berliawsky house on Linden Street in exquisite detail. Each is an idealized interior landscape in which the artist has the last word on where every item in the room will be placed and from which angle the viewer is invited to see it. The earliest of the set—drawn when Nevelson was about sixteen—shows the kitchen (1916), with its large commanding stove given pride of place. She created a fairly daring composition in the spatially odd kitchen, which should feel constricted but doesn't. The linear patterns set up by the in-and-out weaving of the ceiling molding, door edge, and window frame create a sense of movement.

Her depiction of the library of the Berliawsky home done a little bit later reveals a more complex composition, though not much improved in linear elegance. The curved staircase leading upstairs with its rhythmic lights and darks allowed the young artist to open a door into another space. Miss Cleveland had certainly taught her students about the dramatic value of cropping objects, and both the table and the brightly patterned easy chair in the front part of the watercolor are cut drastically on a diagonal as though they were a Japanese woodcut.

Louise Berliawsky was probably better at art than other children in her class, perhaps better than most children in the Rockland school system. But it is likely that her most important artistic gift was not yet apparent in her earliest drawings or paintings. It was, however, evident in the way she moved things around. She may have been drawing as soon as she was able to hold a pencil, and she may even have drawn and painted during all her free time in childhood, but her siblings recalled that "every five minutes she rearranged the furniture in all the rooms of our house."[49] This hint of Nevelson's future gift for composition seems to have remained mostly under the radar of her own consciousness, too fragmented to be understood clearly.

That she had a strong drive to move everything daily may not be as remarkable as the fact that her very particular mother allowed her to do it. Minna Berliawsky was passive about her children's activities outside the home, yet she was a fanatical housekeeper. How did her oldest daughter persuade Minna to let her constantly reposition the furniture in the house—including the furniture in her parents' bedroom?

This activity was not restricted to the Berliawsky household—Louise Berliawsky practiced it in her imagination on the many occasions when she would look through the windows of the nearby homes to figure out better arrangements of chairs, tables, and sofas. Her sister recalled that, "She was always interested in knowing what was inside, how the neighbors had the house decorated, what kind of furniture they had."[50] Did her compulsively neat mother's concern with cleaning encourage her eldest daughter's lifelong fascination with order, particularly the masterful sense of order that exists in many of her later sculptures and is notable even in her high school watercolors?

However skilled she was or was not as a result of her school classes, Louise Berliawsky realized early on that she was "a very visual person." "As a young child," she said, "I could go into a room and remember everything I saw. I'd take one glance and know everything in that room. That's a visual mind."[51] In her autobiography she tells of several incidents in which she was deeply moved by what she saw "going to school [around ten or eleven years old] . . . I saw a black horse. It . . . had a *big torso*. . . . It seems to me that the torso was just bigger . . . than most of the horses I'd seen. And this *color* of black against nature of green . . . everything was in foliage, everything was in bloom . . . and this horse was *right* for this environment. . . . It had the *energy* of all of nature and had *symmetry* in its body. . . . I never forgot the image."[52]

Though this forceful memory of a powerful visual experience sounds exciting and dramatic, it took place in nature, and Nevelson often claimed that she had never much liked "nature," and everyone who knew her well agreed.[53] It could be that her dislike was a transmutation of feelings of outside versus inside.

Inside her home—however troubled her parents' marriage—she was respected and loved; she was the leader. Outside, she might face many kinds of hurts and insults—terrors even.

Every morning, lunchtime, and at the end of the school day, the Berliawsky children walked or ran the mile or so between home and school through forested roads. Nevelson saw more nature during her childhood and adolescence than ever afterwards.

> In spring, I remember, the trees were so rich, the foliage was so rich that when we were running through it, practically all we could see was this *green*, above our heads like umbrellas. *Big* umbrellas, weighing down. And you recognized that if a branch fell, it would *kill* you. There was a sense of insecurity about it. We accepted it, but I always felt a kind of terror.[54]

Could Louise Berliawsky have been transmuting the many insecurities of the outside world, especially the ones related to the community—in between the warmth of the art room and the known world of her home—into a view of terrifying nature? Or could it be that her memories of life in the rural village of Shusneky from age two and a half to five and a half were traumatic but repressed, emerging primarily as "a kind of terror" of the forest and of all raw nature? These two experiences that Nevelson recalls from her childhood of being in nature and being either excited or frightened suggest a powerful conflict. Sometimes what she saw was wonderful, exciting, and life-enhancing. At other times a powerful visual experience could frighten her half to death.

The one time Louise Berliawsky recalled being very emotional during her young life in Rockland was when, at age fourteen, she saw five hearses go past as she was returning from school. She had read in the local paper that a distinguished Englishman, whose adored wife had recently died, was so devastated that he killed his four children and himself. When she got home she "shed a ton of tears," surprising her mother who "was overwhelmed to see the power of her daughter's feeling."[55] The depth of sorrow unleashed suddenly at the sight of so many hearses drawn by so many black horses would be an upsetting experience for any child who knew that the father had been the agent of these deaths. But an additional weight of sorrow on a child whose traumatic early experiences were usually repressed could have been burdensome.

Given that Isaac Berliawsky loved music and that a musical education was an essential part of their Russian Jewish heritage, all the Berliawsky children—especially the girls—learned to play an instrument and sing. Well-brought-up girls of that era, whether immigrant Jews or Protestant Yankees, were expected

to provide musical entertainment for the family. Anita learned to play the violin, and all three girls played the piano. As adolescents they participated in concerts given at the elegant home of their music teacher, the aristocratic Miss Madeleine Bird. The early schooling in public performance was intended to make the Berliawsky daughters more comfortable in their new world and would serve Louise Nevelson well in years to come.

"There was no elocution teacher in town but my mother agreed to let me take singing lessons [which would include elocution]. For two years I passed the voice teacher's house almost daily but was afraid to go in to see her. It was a very painful experience but one day I broke through it. She began to teach me some of the rudiments of opera singing, especially breathing techniques."[56] This story illustrates Louise's tendency to break through the crust of her nervousness after a long period of wanting and waiting to do something—skittishly avoiding it and then suddenly plunging forward—which became a pattern later in her life. When she left Maine for New York, both her sisters knew that she would do something and become somebody. At the time they thought of her as a singer who would make her name and fame on stage. Her brother later recalled, "She had a great drive in her. She wasn't going to be an average idle person."[57]

Against the background of being "the gifted one," "the star pupil" in her art classes, the feeling of alienation as the daughter of lower-class Jewish immigrant parents—as the Berliawskys were considered by the locals, despite her father's success in business—was ever present. According to the seventy-six-year-old Louise Nevelson: "[Rockland] is a small town. It was eight thousand when we got there. Eight thousand now. . . . [It] was a WASP Yankee town, and look, an immigrant family pays a price. Even if you were Jesus Christ Superstar, you were still an outsider. . . . So I was an outsider. I *chose* to be an outsider and I knew what I had."[58]

Turning passive into active, Nevelson recalled her painful childhood and adolescent experience of social exclusion as something she herself determined. But it was not so. The town's anti-Semitism and snobbish rejection of anyone at all different was deep-rooted and thoroughgoing. It was not life threatening as it had been in Russia, but its effects were searing, sufficiently so for her sister Anita to tell me: "Louise never felt part of America."[59] The warmth Louise Berliawsky felt in the art room contrasted markedly with the cold she felt elsewhere in school and the community. Because of her admittedly different ways, her religion and her foreignness, she felt like an outcast. "I was never accepted. I was always on the outside. We never went to Sunday school like the rest."[60] Years later Nevelson recalled: "I never made friends because I didn't intend to stay in Rockland, and I didn't want anything to tie me down."[61]

Louise was the only "foreigner" in her high school class of seventy. She was outstanding in three areas—art, basketball, and singing. She experienced her height—five feet seven and a half inches—as both an asset and one more feature that made her different from everyone else. She claimed that she identified with "the wonderful neoclassic colonial houses in Maine, like the captains' houses that had four big columns that were white. I felt that I was related, that my arms and legs related to those columns."[62] And indeed, columns later played a significant role in her work. Her height and high energy level made Louise a natural basketball player: "All I had to do was take the ball and throw it in the basket—I never missed."[63] She was captain of the high school team. She was also vice-president of the glee club. Both activities opened doors.

As captain of the basketball team she was invited to an end-of-year social event, but when a boy from her class was told that he would have to be her partner, she overheard his complaining about having to take "that Jew" to the party.[64] She felt similarly humiliated when she overheard Helen Snow, a member of the class in-group who was giving a going-away party for the team, explain that she had to invite Louise because, despite her being Jewish, she was team captain.

Anti-Semitism was part of the fabric of the town, and there had always been an inbred suspicion of people who seemed foreign.[65] Though the Ku Klux Klan was not present in Rockland and Maine until 1921, the year after Louise Berliawsky left for New York, its appearance was a spark that rapidly lit the ready tinder of anti-Catholicism and anti-Semitism that had long roots in Maine history. The hated targets of the local citizenry who so readily joined the KKK were foreigners and other outsiders, like all the Russian Jewish immigrants, including the Berliawskys. Knowing how many of the town's "leading citizens"—businessmen, doctors, Protestant ministers, theology students, politicians, and even university professors—were part of the organization must have added to the fear of all "outsiders and immigrants." In May, 1923, the *Boston Herald* reported that twenty thousand Klan robes had been sold in Maine. Cross burnings and racial and religious discrimination were all ways the Klan worked to protect the white Protestant supremacy in the state.[66] As of 1925 Maine had more than 150,000 enrolled Klansmen—more than in any Southern state.

Fifty years after the fact, Louise's younger sister, Lillian, described her experience of anti-Semitism in Rockland as a first grader: "I remember as clear as day having to stand in the corner and kids throwing things at me."[67] Anita recalled: "I never feel as if I belong[ed] here." Lillian recalled, "I don't think Nate felt the same way, because when I tell him how they didn't like us and how they used to throw apples at me, he tells me that it wasn't true—that I never did experience those things. So, I don't think he had to deal with as

much anti-Semitism as we girls did. He would fight his way through. He was a fighter even at five years of age."[68]

For Louise as the oldest daughter, the rejection and prejudice was the most difficult, as she was the first girl in the family to brave her way.[69] According to Anita: "She was very beautiful. If she were gentile, she would have been the queen of Rockland. But being Jewish, she was different. She was made to feel different, and she couldn't express herself or spread herself out She always felt like a stranger there. She has no love for Rockland because there was no love given her there.[70] Anita reiterated, "She could have been popular, but she was Jewish." And Lillian chimed in: "Jewish people were separate. They were not invited to the homes of their classmates, even in elementary school." As time went on, the ostracism waned a little and Lillian, the youngest girl, who was born in Rockland, was most accepted. While their brother could and did model himself after their gregarious father, the girls were more isolated because without their mother's help they couldn't forge friendships with neighbors. The result was a closeness between the three sisters that endured their entire lives. "We stuck together, all of us."[71]

Louise Nevelson almost never spoke about the anti-Semitism of her youth and its effects on her. "I recall that I didn't get too involved emotionally with local color," she stated, on one such rare occasion. "I knew I was very emotional, but I guess my emotions were in another place. I was interested in art. I was interested in music. . . . Somehow I was removed as I was growing up."[72] Herein is a perfect description of an effective way of defending oneself against pain. "Being removed" from the daily insults by living in a fantasied and glorious future in a faraway place achieved through her beauty and talents was easier to bear than the every-day reminders of her reality as an outsider. And perhaps her lifelong interest in metaphysics—in connection, on another plane—emerged from the same desire to belong to a larger community that was denied her during her childhood.

Jews were not the only or even the lowest outcasts in Rockland. As noted earlier, Irish and Italians immigrants also faced fierce discrimination by New England Protestants and fear-mongering by the KKK, because of their origin and their religion. Many decades later, Nevelson spoke about her identification with Native Americans and how it traced back to her childhood and the Indi-ans in Rockland. The Indians in Rockland were a few proud individuals who were different and looked different. They were in America first, and yet they were shunned and belittled by the latecomers, the Yankees of Rockland. "They weren't the highest. They were already the poorest,"[73] as Nevelson recalled. It seems natural that a shy recent immigrant living in the poorest part of Rockland would identify with them—and have them be "a personal image of this coun-try." "I somehow felt I knew these people as if they were as close as close can

be. . . . I only know that when I look at them they're related to me. They're not apart. They are in me . . . if I had to choose a reincarnation, I probably would say I'd like to be American Indian."[74] Not surprising that the minority girl would look at fellow outcasts and see their strengths and the injustice done to them.

The Native Americans in Maine did not live in the town but would show up in the summer and sell their wares in the fields next to the elegant Samoset Hotel. In the caste system of WASP New England, the Indians were well below the Catholic and Jewish immigrants, but they were still on a rung higher on the ladder than the itinerant "gypsies."

Tribes of gypsies had been showing up every summer throughout Maine for over a century. "From the middle of the 19th century to just after World War II gypsy caravans were a common sight in Maine."[75] Their gaily painted carts and wagons came down the main streets of town, headed often to settle for a while at seaside resorts until they were chased away. The women wearing long colorful "gaudy dresses, jewelry and spangles"—necklaces of gold coins—earned money by telling fortunes. The men bred and traded horses and entertained crowds with their dancing bears. A late nineteenth-century account of "Gypsies in Maine" notes that, "Just how large the tribe was we were not able to ascertain, though we saw that it comprised 50 at least. Nearly all the horses . . . were fine animals, for the Gypsies are sharper than the cutest Yankee in a bargain, and hamper themselves with no cheap stock."[76]

A book on "the Romanies of the United States" published in 1924, provides a vivid image of their sensuous allure: "girls dressed with all the radiance of the

Photographer unknown. Gypsies, Biddeford Pool, ME, 1917. Collections of McArthur Public Library, courtesy of www.VintageMaineImages.com

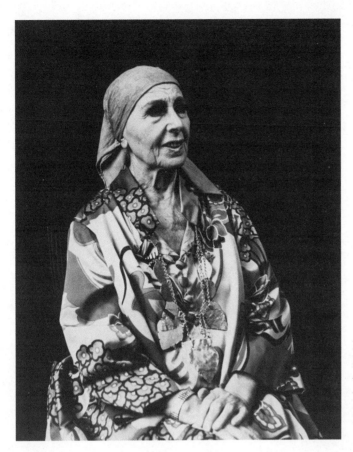

Renate Ponsold.
Louise Nevelson, 1979.
Archives of American
Art, Smithsonian
Institution. © Renate
Ponsold

autumn landscape—orange and green gowns, scarlet silk kerchiefs over their smooth black hair, and against their golden skins necklaces of gold coins."[77] We can be certain that one very visual youngster in Rockland, Maine, never forgot the sight. Whether Nevelson would have acknowledged their influence is uncertain, but a comparison of her outfits after 1970 shows remarkable similarity.

MARRIAGE AND MOTHERHOOD

1920 – 1929

"When I was married and could not work to my full capacity, I got abscesses and sciatica. My blood boiled as though on a stove. . . . If you have talent and don't use it, it makes you neurotic and you die."

—Louise Nevelson, 1973. Patricia Coffin, "Louise Nevelson, *Artiste solitaire*," *Single* 1, no. 4 (November 1973): 94

Creativity was the key to freedom for young Louise Berliawsky, and it remained the highest value for her entire life. "Art was all that mattered," she declared in her autobiography.[1] She had some reason to hope that art could lead to a better future for herself, just as it had for her ancestor Issaye Berliawsky, the czar's painter or sculptor or musician, as she knew the story, whose talent had propelled him to a position of high status in a hostile land.

Like her father, the oldest Berliawsky daughter looked forward. Only by keeping her focus on the future and its possibilities could she leave the lonely, limiting world of her mother and Rockland, Maine. Her father had overcome much more difficult odds to bring his family to safety and prosperity in America. She may have been naïve about the level of her artistic talents and how far they would carry her, but she was not unrealistic in sensing that if she could make her way to New York, as Miss Cleveland had done as a young woman, there would be no limits to what she could achieve.

Louise Berliawsky's high school years were overshadowed by the First World War, and in her graduating class the girls outnumbered the boys three to one.[2]

Louise would have known that the remaining eligible young men in Rockland could never help her fulfill her dreams. Neither the New England Yankees nor the Catholics would wed her, and the few available local Jewish boys were not ambitious enough. In any case, Jewish males and females of marriageable age were expected to look outside Rockland for a possible mate.[3] And so she found someone from New York who could give her both a new name and a chance to become the person she longed to be.

Like most of the girls in her senior class, Louise was encouraged to enroll in the commercial course directed toward office jobs rather than college. She took courses in stenography, bookkeeping, and typing and earned low grades in all of them. As part of her training she also worked for six weeks as a legal stenographer for a local lawyer, Arthur Littlefield.

The war had made Rockland again into a busy port, as ships were built, repaired, and camouflaged for the war effort. In the spring of 1918, Bernard Nevelson, president of the Nevelson Brothers shipping business in New York City, was in town to see about repairs to one of his ships. Needing legal documents to take the vessel out of the harbor, he stopped into Littlefield's law office. As Louise recalled in her autobiography: "He was interested enough to want to know if there were some people of our kind [meaning Jews] in this city, and he met my father, and so I suppose there were some kind of inquiries made. I don't quite remember."[4] Or, as her sister Anita recalls, once he was in the office, Louise asked him in Yiddish whether he was Jewish, and he said yes.[5]

Bernard Nevelson then introduced himself, made inquiries about her family and invited her to dine with him and the French captain of his ship at the elegant Thorndike Hotel, where they were staying. Although nervous about dining in a hotel—a first—much less being alone with two men, she walked to the hotel, accompanied by her brother. During the course of the dinner, Louise charmed the forty-eight-year-old New York ship-owner. Her youngest sister tells her version of the story. "So he [Bernard] took one look at her and wrote to his brother [Charles], 'Come up. There are beautiful girls here.'"[6]

Abram Chasins, a young pianist and a lifelong friend of Bernard Nevelson, recalls a dinner with Nevelson and his wife shortly after Bernard returned from that trip to Rockland. "He spent the whole evening talking about the Berliawskys and especially about Louise. He sounded like a man deeply in love with the beautiful and talented young woman, calling her 'a born artist, who had done some painting.'"[7]

Once he had returned to New York, Bernard Nevelson sent her a number of letters that she did not answer. Though he had told Louise that he was married and that his wife was expecting their first child, she was worried about his intentions. "I had heard about robber barons having young mistresses and so forth,"

Louise explained later, "and I wasn't about to venture into that kind of life."[8] Her parents may have calmed her fears by explaining the way things usually work in Jewish matchmaking. First, the families meet and approve of the prospective bride and bridegroom, and only then does the couple meet to see if they get along. At that point, the match can go forward.

Bernard Nevelson was the head of the Nevelson family, not just because he was the oldest but because he was a dominating man who had to be right about everything.[9] He had come to America in 1891 at the age of sixteen from Riga in Latvia, where his father had a timber business. He was hard-driving, ambitious, intelligent, intellectual, and formal. By 1915 he had started the first of three successful shipping companies with two of his younger brothers, Charles and Harry. By supplying the United States with ships during the war, he had become rich and powerful. He referred to Woodrow Wilson so often during his conversations with the Berliawsky family that his future sister-in-law believed that they were personally acquainted.[10]

Bernard returned to Rockland a few months after having met Louise, this time with his wife. Louise and her parents were invited to call upon them. Apparently the Berliawsky family passed muster, because soon afterwards Bernard wrote to Louise that his youngest brother Charles would be coming up to Rockland to see about one of their ships and was looking forward to meeting her. Given the continual warmth of Bernard's response to her and her awareness that he, as oldest and most enterprising sibling, was the powerhouse in the family, she suspected that his younger brother would be coming to Rockland to propose marriage.

Though she had always claimed that she was dead set against living a conventional life as a married woman, she had listened to her mother's warnings. No matter how much Minna and her husband supported their daughter's ambition and talent, in the early twentieth century, with the uncertain state of the world one year after the ending of the "war to end all wars," it would be impossible for a respectable young Jewish woman to live on her own in New York City in order to study art.[11]

The summer after high school graduation Louise was working as a ticket-taker in a local movie house. Long after the fact, Louise Nevelson claimed that she was determined to go to Pratt Art Institute in New York City that fall—just as her mentor Lena Cleveland had done decades earlier. Yet she was clearly contemplating other options, and marriage may have been more in her thoughts than she later admitted. An anecdote tells the tale:

While working at the movie theater, Obadiah Gardner, a former U.S. Senator living on their street, came to buy a ticket and said: "My, what

a pretty face, what a pretty girl! What is your name?" She responded, "Louise Berliawsky." He observed that her name was as homely as his face, and she responded tartly that she, at least, had hopes of changing her name.[12]

However much she may have been grateful to Lena Cleveland for recognizing her talent, she nevertheless saw her mentor as "an old maid"[13] and was well aware that her own good looks—and a rich husband—were her best chance of winning a way to New York City and staying there. Since she knew that divorce was not an acceptable option for a Jewish woman at that time, getting to New York by marrying a wealthy New Yorker was a guaranteed one-way ticket to the big city.

By the time Charles Nevelson arrived, Louise had made up her mind: He would become her "pass boy out of poverty."[14] On their first date, he proposed. As soon as he had arrived at the Berliawsky house to escort her to dinner—or, in the alternate story, as soon as he called and asked her out to dinner—Louise took her mother into the kitchen and said: "Mr. Nevelson is here, and he's going to propose to me this evening, and I'm accepting."[15] Which is exactly what happened.

Their conversation at dinner allegedly included a discussion of her wish to study art and pursue a creative life. According to her autobiography, Charles Nevelson "said that was all right and there was no reason I couldn't continue. We could still get married." She also recalled that he had agreed during their engagement that they would not have children.[16] It seemed like the perfect deal. He was going to have a beautiful, vibrant, well-brought-up, artistic wife, and she was going to have the opportunity to pursue all her cultural interests in the biggest, most glamorous American city. Finally, marrying Charles would give Louise Berliawsky American citizenship, making her the first in her family—aside from Lillian who had been born in Maine—to achieve that important status.[17] As it turned out, the deal proved to be far from perfect for both members of the couple.

The apparently amiable and decent Charles Nevelson was short—five feet four—plump and beginning to go bald, and more than twice Louise's age. When they met, she was eighteen and he thirty-seven. He was, however, charming, a fine dresser with excellent manners and a genteel air; as far as Louise Berliawsky was concerned, he was a Wall Street millionaire. Not unlike his fiancée, Charles Nevelson embroidered his own history and presented himself as having a more illustrious past and being more successful than he actually was. For example, he claimed to have courted President Wilson's daughter.

A rich Jewish ship-owner who wanted to marry her and take her to New York—it may have seemed almost too good to be true. She had been hugely

ABOVE: Photographer unknown. Charles Nevelson, not dated. Archives of American Art, Smithsonian Institution

LEFT: Photographer unknown. Louise Nevelson, 1922. Courtesy of Pace Gallery

impressed with the wealthy out-of-towners who came to Rockland every summer and had longed to live like them. Now, suddenly, the dream looked like it could become a reality. Whatever misgivings she may have had about marriage melted in the face of golden opportunity. Her mother, who had married at the same age, encouraged the match. She could see how meager her daughter's prospects would be if she stayed in Rockland.

Many years later it seemed to Nevelson that her meeting and marrying Charles Nevelson was more than coincidence. "He came with the car and chauffeur, took me for a ride and I got a proposal. Sometimes I feel I willed it on him. It had nothing to do with intellect. It was almost like a vision. I think that you project the fulfillment of your wishes."[18]

Bernard Nevelson's friend, Abram Chasins, met Louise Berliawsky and her family and recognized immediately that the beautiful and vibrant oldest Berliawsky girl would not have a successful marriage with Charles Nevelson. They didn't love each other and, for all his pretensions as a passionate amateur and member of the Russian intelligentsia, Charles was stuffy, pompous, and mannered. "Charlie," according to Chasins, was not an intellectual and was aesthetically unaware. More to the point, he didn't have a clue about the real nature of the young woman to whom he had just proposed.[19] She was disappointed that her groom was so restrained in his choice of an engagement ring—a mere one-carat diamond from a conventional jeweler, while she was hoping for a big diamond, more fitting to her new status.[20]

As part of his courtship, Charles invited Louise and her mother for a three-week trip to New York, installing them at the Martha Washington Hotel for women. The stated aim of the visit was to introduce Louise to her future in-laws and their friends as well as to give the couple an opportunity to get to know each other. It was probably also true that Charles wanted to impress his beautiful, tall, intense, and potentially unruly fiancée. Louise was thrilled by the visit. They began at the Nevelsons' imposing home at 300 Central Park West, a grand, elegant European-style apartment building. She was taken to a Broadway show, the Century Club, and many nightclubs. They dined at the St. Regis Hotel and visited the Statue of Liberty. They were out every evening and she loved it all. Louise's mother liked Charles and was pleased that her daughter had found a good opportunity for a grand life and for reaching her dream of living and studying art in New York. Louise's move to the city would be a big step up for the whole family, and it was assumed that once Louise was safely ensconced in her new life that she would find ways to help her siblings get out of Rockland—and she did.[21]

Louise visited her fiancé's family in New York one more time during the two years before they married, and Charles made a number of trips to Rockland. In the meantime she prepared herself.

The engagement period in those days involved assembling a trousseau. Given what we know about the way her mother shopped and the fastidious preparations she made for any public outing, we can easily guess how much time and energy went into buying the clothes her daughter would need for the wedding itself (the bride-to-be chose an expensive lace gown and hat) and for her glamorous post-nuptial life in New York. The marriage ceremony was to take place in Boston—halfway between the two families—at the elegant Copley Plaza Hotel.

Louise Berliawsky may have had some misgivings about the intimate aspects of married life. She had no direct knowledge of sexuality and had grown up with parents who hadn't slept together since she was six years old. Though she had been briefly courted by a "Navy man" stationed in town, she had not had boyfriends or even dates in Rockland, knowing that any doubt about her virginity would doom her chances of leaving Rockland as a respectable wife. Her sexual inexperience combined with her mother's evident antipathy for intercourse made her a typically repressed woman of the early twentieth century. She was, as a result, quite unready for marriage. But off she went into matrimony, and even her father bent enough to invite his brothers and their relatives, whom he had avoided for decades, from Waterville. The couple honeymooned in New Orleans and Cuba, where pleasure could be combined with the business of buying more steamships.

According to Louise's sister Anita, Louise had several reasons for marrying Charles Nevelson: "In the first place, she was a country girl, and she felt New York would give her an opportunity. Second, he was a rich man. Also, he was a nice man and my people were mad about him—gentle, refined, cultured. As for love—I don't know whether she loved him, I don't know whether any of us four children actually loved."[22] Unfortunately for Charles Nevelson, who wanted a conventional upper-middle-class Jewish wife, the young woman he had just married was too vital and ambitious ever to be satisfied with that role.[23]

Louise Nevelson's first home in New York City was on Riverside Drive near 155th Street in Washington Heights, an elegant Jewish neighborhood in the early years of the twentieth century. She and Charles moved into a sizable apartment on the twelfth floor, and she jumped feet first into haut-bourgeois life. As she recalled it, she was now a resident of the same city as the Vanderbilts, who lived in one of the "*big* private houses . . . that seems to have stamped itself most strongly on my mind at that time. That was the true New York."[24]

As a young matron in a wealthy community, Louise did as other young women in her circle did: shopping, luncheons, tea parties, even playing cards and mahjong. In the evening the Nevelsons usually went out—to the theater, the Metropolitan Opera, or concerts at the New York Philharmonic. They visited nightclubs and attended lectures with like-minded friends and family from the Jewish intelligentsia. In the summer they would visit the Berliawsky family in Maine, traveling in a chauffeured car or by train and arriving in the style Louise had always dreamed of.

However much Louise Nevelson loved living the high life in Manhattan when she first arrived, she soon felt bored and constricted. "I didn't like the whole performance. We were born free in the country, and all of a sudden I learned I had to be home for dinner at seven p.m. We had a maid, and I said to my husband: 'Why can't *she* give you dinner?' I mean, I was what you called hemmed in a little bit, and I was too young to understand a lot of things."[25] Not only were there a maid and a cook, but soon there would also be a German nursemaid for her child.[26]

Her parents' dysfunctional marriage—with a husband always out and a wife always sickly and depressed at home—had left the children largely on their own. Louise had no model to prepare her for the kind of life expected of her. In Rockland, Louise had been a creator of events, the natural leader among her siblings. Her older brother recalled: "Louise was the primary influence on my sisters and me."[27] Her sister Lillian's version was that: "Louise saw to it that we had everything. She was always ambitious about culture, music, dance, clothes."[28]

Being relegated to the role of an observer and appreciator of culture did not sit well with the young woman. She repeatedly remarked about the Nevelson

family's ethos: "You could know Beethoven, but God forbid if you were Beethoven."[29] Decades later, in a conversation with her friend and dealer Arne Glimcher, she described Bernard Nevelson, the *de facto* head of the Nevelson family, as distinguished but over-refined. "You couldn't be a creator," she observed. "You are just supposed to be an audience."[30] Louise's new family considered themselves to be sophisticated and highly cultured people. The over-refinement of the Nevelsons consigned her to the inferior status of a country girl unfamiliar with big city life. Their dismissive and patronizing attitude toward her desire for a creative life added to her frustration.

Much to her amazement and dismay, Louise, like her mother, became pregnant within a year of her marriage. It was not part of her plan. Myron Irving Nevelson was born on February 23, 1922.

Nevelson had a Caesarean delivery, which she said she had requested because she had not wanted the baby to be born vaginally, perceiving regular childbirth as "revoltingly animalistic."[31] Instead of quieting her restless temperament, motherhood made her anxious. "Soon after Mike was born in 1922 I went into a depression, right down to the tip of my toe."[32] In retrospect we could call this a postpartum depression, which was exacerbated by Nevelson's expressed intent never to be a mother.

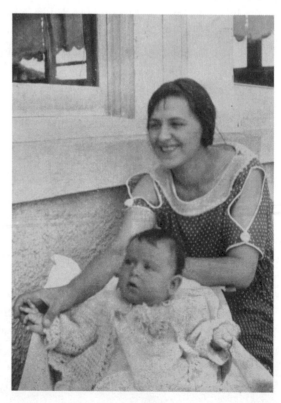

Photographer unknown. Louise Nevelson and Myron (Mike) Nevelson, after 1922. Archives of American Art, Smithsonian Institution

Years afterwards, Nevelson was able to acknowledge that she wasn't equipped for this new responsibility: "I don't even think I understood what being a mother meant."[33] She gave her son little attention in his early years, relegating him to the care of a succession of nannies and governesses. One of the boy's earliest recollections was of pleading with his father not to leave for work in the morning because he dreaded being left along with his distracted, unavailable mother. He was tested for retardation when he was slow to speak, only for his parents to learn that the boy was simply inexperienced in verbal exchange, as his mother rarely talked to him. His father was at his office during the day, and his nannies usually spoke only German. Despite these tales of Louise Nevelson's dismay about having a child, photographs of her with her young son show her smiling. No doubt her feelings were more mixed than she later acknowledged.

Having taken singing lessons, as well studying piano and elocution in Rockland, Louise wanted to return to these pursuits once she was in New York. It was socially acceptable and also satisfied her intense personal need for creative expression. A few months after her son was born, she selected the renowned singing coach Estelle Liebling as a teacher. She later recalled that she had never stopped studying voice after starting lessons in Rockland.[34] Along with her later study of dance, Nevelson's vocal study was motivated by a desire to overcome her shyness. Her Rockland upbringing had burdened her with a conflicted combination of confidence within the family and fearfulness outside her home. "I was a shy person and I couldn't confront all these things and I was terribly nervous, and consequently I recognized that I had to free my body, had to free my throat and had to free my being."[35]

Estelle Liebling had sung at the Metropolitan Opera and been decorated by English royalty. And her studio was studded with photographs of her famous pupils, including Amelita Galli-Curci, whose records Isaac Berliawsky had eagerly purchased and often played at their home in Rockland. Now Liebling was training singers not only for the Met but also for the new medium: radio. She taught breathing, diction, and the usual vocal skills. But, most important for Louise Nevelson's future, she encouraged her pupils to develop presence, poise, and confidence—necessities for singers who would be performing for huge, invisible audiences.

The bored young woman had some hopes for a performing career, and she auditioned unsuccessfully at local radio stations for singing roles. Her voice was not up to the job, but she found parts in amateur theatricals and opera, including a studio performance of *La Traviata*.

While Nevelson herself did not recall those early, frustrated ambitions, her sisters did, and they were convinced that, had she had a more tolerant husband, she could have made a successful career in theater or music. Abram Chasins,

the young musician whom she met through the Nevelson family, recognized that though she may have wanted to be a professional singer, it would never happen because she had "a screechy soprano voice with a permanent wave."[36] In addition, the very correct, genteel Charles Nevelson did not approve of his wife's ventures into public life. She had to sneak to her singing lessons. He opposed much of what she wanted to do, recalled her sister Anita, because he was so afraid of losing her:[37] "Charles was . . . really a sweet man, but he dominated. He wouldn't let her breathe. I remember one day she came home from shopping with a little coat, it was so becoming—she looked gorgeous. But he said: 'I don't like it. You take it right back. I don't want my wife to look like a whore!' He was so jealous."[38]

Within six months of her marriage, Abram Chasins, who had admired Louise Berliawsky's earlier vitality, already saw her frustration and emerging anguish. Once her son was born "she looked absolutely sunk."[39] Though she never expressed it directly to Chasins, "It was obvious that she was trying to conceal her bitterness, her disillusion, her dissatisfaction with everything and everyone, starting with Louise. . . . Her eagerness, her growing enthusiasm had all but been extinguished. She was much less sure of her self than she had been before."[40]

Chasins, who was by then well on his way to becoming a successful pianist, saw that Louise Nevelson had not yet found herself but, knowing that divorce was "unthinkable" in their social circle, worried that she had no way of getting out. He was astonished to see her a few months before she left for Europe in 1930 with a new determination, courage, and the desire to fight and win.[41] He could not have known—not even Charles Nevelson knew—that behind the scenes her mother had given her permission to break the shackles that were binding her.

During the mid-1920s Nevelson also studied visual art, but periodically and in short spurts. In November and December 1924 she attended Saturday afternoon drawing classes for beginners at the Art Students League with Anne Goldthwaite. Goldthwaite was the only female instructor at the League, and though she was a respected portrait painter—a Southerner trained partly in Paris and an early advocate of civil rights—she did not inspire Nevelson, who could only learn from someone with whom she could identify. As she told me in 1976: "I didn't study; I identified with a person."[42] In 1926 she took painting lessons with Theresa Bernstein, a prize-winning artist only nine years older than Louise and the wife of the painter and etcher William Meyerowitz. Bernstein and Meyerowitz gave private classes at their studio in the fashionable Hotel des Artistes on West Sixty-Seventh Street. Nevelson said she worked with Bernstein for only a few months (it might have been longer, but her memory invariably shortened her periods of study), and the focus was on watercolor.[43] The work— what little of it remains from the art classes Nevelson took when she first moved

to New York—is below the level she assumed was her natural right as best artist in her class.

Nevertheless, Bernstein and Meyerowitz recalled Nevelson as "a column of vibrating development." She had a "glowing personality" and she seemed to "immediately come forward and express herself."[44] They noted that she seemed to have innate confidence. Bernstein's recollection of Nevelson as a student was quite specific: "She had an unusual feeling for form. She was always piling things up on canvas, striving to get structure into her ideas."[45] Bernstein recalled: "I thought she was very talented and I told her so. The way she used her palette knife and put the accumulated paint together—I said to her 'You must sculpt.'"[46]

Bernstein and Meyerowitz had good reputations as artists, and Nevelson remembered them as "very well known." They were famous for, among other things, their portraits of Albert Einstein. She had learned from both her parents the importance of going to the best—or at least the best known. Nevelson was sometimes taken in by good advance billing—perhaps she had some difficulty discerning glitter from gold. Or perhaps it took her a long time to trust her intuitive sense of quality. When that failed her, she relied instead on reputation.

Though the unhappiness she experienced in her early years in New York is usually linked to the constrictions her conventional husband and in-laws placed upon her, that is only partially true. Her crisis of confidence is likely also to have been related to the distressing discovery that her artwork and her skills were below the standards of a big-city scene. While she had gone from being the eldest daughter of a family of "foreigners" to the young wife of a wealthy Jewish man in a city that had welcomed Jews in large numbers, she had lost and gained at the same time. She was no longer Miss Cleveland's best student and she was beginning to feel out of her league among the vast number of talented individuals with whom she was competing.

As early as the year of their wedding, the Nevelson family's fortunes began to decline. The shipping business was hit by a severe depression, and the value of the Nevelson brothers' fleet had dropped precipitously. By the summer of 1921 the United States Shipping Board had repossessed the last of the ships it had sold them for failure to pay. The family also owned 150,000 acres of mahogany forests and banana plantations in Nicaragua, but was forced to sell them at a huge loss to the rapacious but increasingly successful United Fruit Company. As Nevelson recalled it: "Along came the United Fruit Company which was a powerful monopoly and made [the Nevelsons] an offer. They said, 'We want to buy you out. If you don't sell to us, we'll break you.' They rejected the offer, and the United Fruit Company put them out of business."[47] Bernard's absolute refusal to be taken over doomed all of them. The autocratic elder brother couldn't face that his world, his business, was collapsing.

Photographer unknown. Louise Nevelson, Mike, and Charles on porch, ca. 1924.
Courtesy of Nevelson llc / Art Resource, New York

By 1924 Louise and Charles's diminishing finances forced dispiriting moves
to increasingly less elegant and smaller quarters. The first move was to a small
house in the suburban community of Mt. Vernon, New York, near the home of
Charles's brother, Bernard. Louise and her sisters later referred to this home as
"a mansion." But Louise found that living in the suburbs—despite lengthy visits
from her sister Anita and taking the occasional sketch class—was suffocating.
Her distress took the form of psychosomatic ailments, including severe sciatica,
migraines, and boils. The vibrant and forceful young woman with beautiful
flashing eyes who couldn't wait to get the hell out of Rockland, Maine, had
become a lost soul.[48]

Repeating her mother's pattern of dissatisfaction with and withdrawal from
married life, Louise Nevelson refused to have sex with her husband. His jeal-
ously and suspicions of infidelity increased, as did her paralyzing depression. It
seemed that one of the few things that could lift her spirits was the acquisition
of beautiful objects. Like her father, she was entranced with antiques, so she
studied brochures and frequented the New York auction houses to teach her-
self about *objets d'art*. She was an impulsive acquisitor and deeply resented her
husband's strictures on spending money. They had numerous fights about sex
and money. Their son recalls his parents running around the dining room table
screaming at each other.[49]

Bernard Nevelson and his wife Lily did not approve of their sister-in-law's
negligent attitude about domesticity or her ambitions for artistic achievement.
Bernard lectured Louise, and Lily, when not making condescending remarks,
presented an icy exterior. Despite the culturally narrow life she had lived in

Rockland, Louise's confidence had been propped up there by the ever-faithful Lena Cleveland and near-total support of her parents and her siblings. Now she found herself in an environment that was psychologically desolate, with fewer hopes, and a greater feeling of alienation than she had ever had in Rockland.

When they had married, neither Charles nor Louise Nevelson had fully realized how potentially divisive were the differences between them. As time passed and the financial stresses grew, those differences became almost intolerable. "I had recognized right from the beginning that truly I didn't have very much in common with my husband. I was never married in the true soul sense. Oh, he was very sweet with the child. But under the turmoil of my life at that given time, I was kept in a highly nervous state and if ever I had an inferiority complex—that was the time."[50] Charles Nevelson loved music and played the flute, mandolin, and piano. Bored by his endless focus on music-making, his wife threw plates at him and refused to accompany him at the piano.[51]

The worst of their years together was 1926, as the family made ready for yet another move, this time to Brooklyn, near Prospect Park and Flatbush, where Charles had started a metal-stamping business. Six years earlier and full of hope for her future, Louise had married a millionaire, but now she was reduced to living in an unstylish part of New York City, without money to pay for domestic help and resentful of having to do her own cleaning and cooking. Even worse, she was tied to a man who neither trusted her nor had much sympathy for her cultural interests and ambitions.

Throughout these years Louise Nevelson received moral support and regular companionship from her two sisters, Anita and Lillian, who moved to New York and lived alternately in the Nevelson household or very nearby.[52] They would accompany her to museums, galleries, concerts, or shopping expeditions.[53] She introduced them to the cultural life of New York and encouraged them to join her avid pursuit of art and music exactly as she had done in Rockland. If she took singing lessons, so must Lillian. If she waxed enthusiastic about an art exhibition, so must Anita. Her brother, Nate, who lived with them while he worked for a time with Charles, recalled: "You had to be an artist for her to have much respect for you. If you paint, she likes you. She's been after me to paint for years. . . . But I wouldn't. I've seen that girl go through so much suffering."[54]

The fact that both Anita and Lillian helped out with the caretaking of Mike is another instance of the closeness among the three sisters. At one point Lillian was Mike's kindergarten teacher at a nearby private school. At a moment that must have seemed dark and desperate for the twenty-six-year-old woman, a bright spotlight suddenly shone on a path that would eventually lead her back to the hopeful dreams of her childhood. In February and March of 1926 Nevelson visited the International Theatre Exposition, in the Steinway Hall Build-

ing on West Fifty-Seventh Street, where there was an exhibition of avant-garde set design. The exhibition, which had been created by Frederick Kiesler, a renowned Viennese architect and one of the most innovative set designers in Europe, included many examples of Russian constructivism and futurism and modern art: Twenty pieces by Picasso were shown, as well as works by Picabia, Tzara, and Moholy-Nagy. Nevelson was so excited about what she saw that she visited it at least three times, each time insisting that her sisters accompany her.

Everything about the exhibition at Steinway Hall—and especially the thunderous public-relations campaign as the exhibit went into an extra week—spoke of the glorious future in theater, the art form to which Nevelson had already been attracted.[55] The headlines on March 15, 1926, in the *New York World* shouted: "FOURTH DIMENSION PLAYS FOR MASSES: Director Kiesler Explains and Princess Interprets Plan to Unchain Drama." The article went on to explain: "Kiesler announced that in cooperation with Princess Matchabelli— an internationally famous actress . . . he would conduct a school for teaching the drama of and for the masses The Fourth Dimension would enter as a factor in projecting the art of the new theatre across the footlights to strike a responsive chord in audiences. . . . Frederick Kiesler, interpreted by Princess Matchabelli, explained that he was the exponent of the free theatre as contrasted with the drama 'which was chained to the old standards of imperialism.'"[56]

Nevelson would have read Kiesler and Matchabelli's explanations of the fourth dimension in the evening paper. Matchabelli's words are vague and largely incomprehensible. "The idea is to have all the elements of the theatre function toward the fourth dimension. The fourth dimension is the will and the emotion, a purely subjective thing to be thrown out as radio waves." Kiesler added his perception of the fourth dimension in the same article: "the theatre of tomorrow in which fourth dimension acting will be offered on a 'space stage.' Seats in the new theatre will be . . . set on a spherical eminence resembling an ant hill, with each member of the audience in full view of every other member, that they might have mutual enjoyment of each other's reaction to the play."[57] However confusing or unintelligible their words may have seemed, Nevelson was fascinated by both Matchabelli and Kiesler and knew she wanted to learn more from both of them. Whatever the two of them had to say about the fourth dimension, there were other ways she could have learned about it, living in New York and becoming acquainted with the art world. While Nevelson most likely did not have a coherent understanding of the idea of the fourth dimension in the 1920s, she was aware that it was important to progressive artists and thinkers. Much later she would elaborate her own views on the subject.

The fourth dimension was a stimulating concept in the art world as early as 1910 and had at least two different but sometimes related meanings.[58] The

first referred to non-Euclidian geometry, where an imagined spatial dimension represented an ideal realm—a hyperspace differing from the more ordinary materialistic three dimensions known to all. Some of the cubists around Picasso were fascinated by the idea and saw the multiple perspectives surrounding a three-dimensional object as representing the fourth dimension.

As the pre-eminent scholar on the subject Linda Henderson explains:

> During the first three decades of the twentieth century, the fourth dimension was a concern common to artists in nearly every major modern movement. . . .
>
> Like non-Euclidian geometry, the fourth dimension was primarily a symbol of liberation for artists. . . . Specifically, belief in a fourth dimension encouraged artists to depart from visual reality and to reject completely the one-point perspective system that for centuries had portrayed the world as three-dimensional. The late nineteenth-century resurgence of idealist philosophy provided further support for painters to proclaim the existence of a higher, four-dimensional reality, which artists alone could intuit and reveal.
>
> Among those who subscribed to this were the Cubists, Kupka, the Futurists Boccioni and Severini, Max Weber, Malevich and his Russian colleagues, and Mondrian and Van Doesburg. For the artists in this group whose distrust of visual reality was most deep-seated, belief in a fourth dimension was an important impetus to create a totally abstract art.[59]

Nevelson always admired Picasso and the Cubists and would have learned about them from various people in the New York art world, including her friend Max Weber, a Russian émigré artist in New York who published, in 1910, an influential article, "The Fourth Dimension from a Plastic Point of View."[60] Weber brought the ideas and images of the Parisian Cubists to New York, where he became a central figure transmitting the most recent events and ideas from Europe.

The second meaning of the fourth dimension was mystical and became a common concept for theosophists and esoteric writers, such as P. D. Ouspensky. For them and the artists whom they influenced, notably Malevich, Kandinsky, and Mondrian, the fourth dimension represented "cosmic consciousness"—an inner awareness that allowed them to both transcend and represent the everyday imperfections of the human condition through their art. Weber was also inspired by the spiritual aspects and was striving in his painting and theorizing for a transcendent and spiritual fourth dimension. It was this second meaning

that Nevelson could have learned from Matchabelli, who was deeply involved with spirituality.

A princess working alongside a social revolutionary! How could such a dramatic pairing not touch Nevelson's heart? Two weeks later, the *New York Review* announced Kiesler's plan to open a school which would be "a laboratory of the modern stage. . . . Matchabelli will develop in the psychological department of the laboratory the fourth dimensional power of the actors and the audience."[61] It would soon open in a four-story brownstone in Brooklyn Heights, only a few subway stops away from where she now lived. Just at the moment she most needed it, Louise Nevelson had found a golden combination—an opportunity to learn from enlightened, liberated teachers as well as to escape from her dreary downward-sliding world.

The founding genius of the new International Theatre Arts Institute, as it was soon named, was the beautiful Italian actress Norina Matchabelli. Born Norina Gilli, a naïve, untrained young woman, she had fifteen years earlier played the part of the Madonna in the widely known and frequently performed spectacle-pantomime play *The Miracle*, written by Karl Vollmoeller and directed by Max Reinhardt. By the time she came to New York, the actress had married and divorced Vollmoeller and subsequently married an impoverished Russian prince and diplomat named Matchabelli.[62]

Nevelson followed the public-relations push and unfolding story of the new venture founded by a woman who epitomized her highest aspirations: beauty, charm, aristocracy, creativity, and public acclaim. Many decades later she would speak about her own goals and aesthetic intentions in language much like that of Norina Matchabelli in her opening speech in the ballroom of the Hotel Astor on October 3, 1926, honoring the new educational venture: "The ideal is to develop the power of a methodical will to modify and multiply human forces. . . . To vitalize and stimulate imagination and free creative powers. To awaken the authority of instinct and intuition . . . and consciousness of soul, brain and body in a co-ordinated whole."[63]

Nevelson's recollections about Matchabelli reveal how forcefully the Italian actress had impressed the Jewish girl from Rockland, Maine:

> She had a great mind. . . . Maybe she wasn't a great artist, but she was a wonderful woman, a great beauty. . . . I'd probably say she and Garbo were the two greatest beauties that I have ever seen. . . . Now we're talking about exquisite, sophisticated people. She had this dark mink coat and a big hat, and she never touched the earth when she walked— and that's the truth. Even when she was fifty-eight I saw her once [in 1938]—she never walked like others.[64]

After explaining to an interviewer how the beguiling actress, with her excitable Italian personality, had alienated the impresario who had brought her to New York, which left her stranded, Nevelson continued: "So her husband and she were broke, and Kiesler was broke. Since they knew each other, they started a little school just up the street in Brooklyn. So I joined them."[65]

Nevelson's new circle of teachers and mentors gave her a foundation on which she could once again find her footing. When Nevelson called the Institute to register for classes that October, she must have been delighted to find herself among not more than six or eight other students. Thus began a lifelong identification with another inspiring mentor. As had been the case with Lena Cleveland, an older woman offered her answers when she was most confused and distressed. There were many ways she would have been able to see herself in Norina Matchabelli—the statuesque beauty, the enterprising and ambitious woman, the dramatic spiritual person, and the successful divorcée.[66] Though Nevelson was not ready to divorce her husband in the mid-1920s, she was certainly unhappy in her marriage and could well have been inspired to think about eventually taking such a dramatic step by her contact with Matchabelli.

Matchabelli's ideas about the "Fourth Dimension" soon became Nevelson's, and were always associated for her with spirituality. They appear again thirty years later when the artist articulated her aesthetic notions as she found her signature style. "I've never thought of myself as an intellect," Nevelson said when she was seventy-seven years old,[67] but, as she noted in her autobiography, "I have had strong desires. My desire was really to delve into life. We can tap it and say reincarnation, we can say metaphysics, we can say a lot of things. But that is not the ultimate. . . . It's still unknown. I feel even at this point that if I could find an added dimension I would pursue it."[68]

Given her history of depression and confusion, Nevelson was susceptible to purportedly profound "answers," which seemed authoritative, persuasive, and capable of simplifying the challenges she faced. Neither of her parents had believed in organized religion, and they had not been able to provide their children with satisfactory responses to questions about life's meaning or a base on which to build a spiritual life. Louise Nevelson had discovered for herself that marriage and maternity did not bring her the gratification it offered to many other women. She had also discovered how ephemeral the "good life" could be and how empty she could feel when she had no access to expressive and creative activity.

The International Theatre Arts Institute was the beginning of freedom for Nevelson. Her study at the Institute with Matchabelli and Kiesler lasted the several years she lived in Brooklyn, and what she learned there transformed her. Nevelson later claimed that she studied acting with Matchabelli only because she

was very inhibited at that age and knew she had to free herself.[69] But behind her "shyness" was a combination of frustrated rage, ambition, and paralyzing help-lessness, as she, together with her unsuccessful husband, lost their fortune and social standing. She felt trapped in a marriage with a husband and a son, neither of whom she really wanted in her life. Mostly, she was unable to pursue her art. So the frustration may have been less about the family losing their social standing and financial security, and more about her own unsatisfied artistic ambitions.

For the rest of her life—after working with and modeling herself on the princess—Louise Nevelson had a commanding, charismatic presence with an astonishing reserve of poise and self-assurance. She could stand and walk with pride and confidence and go anywhere in the world, certain to make a smashing personal appearance.

An anecdote shows how quickly and naturally Nevelson learned how to entrance a crowd. In 1930 a young woman named Lillian Mildwoff, who would eventually be Louise Nevelson's sister-in-law, was celebrating her eighteenth birthday.[70] She described how, very soon after Louise, wearing beige and sable, walked into the party with Charles Nevelson, "All the young boys and girls gathered around her . . . Louise just took us over. It was marvelous, thrilling. She would just talk, you know. She was interesting, she was a thriller. She was so *dynamic*."[71]

Charles must certainly have noticed how frequently his wife took center stage wherever she was, as the battle continued between her desire for a creative life and her husband's stern disapproval. Her new friends and mentors offered her acting roles, but Charles Nevelson "wouldn't let her go on stage or do any-thing creative." Her sister Lillian said, "That's why she left him. . . . Marriage was horrible for her. She wasn't going to sit still and be a wife to a very jealous husband. She was like a bird in a cage."[72] According to her sister Anita, "Charles dominated her and wouldn't let her breathe. She had a good voice, and they wanted her on stage. Louise had an opportunity to be in the opera *Carmen* at the Institute where she was studying, but Charlie wouldn't allow it."[73]

In the summer of 1926, Louise took her four-year-old son Mike to Boothbay Harbor in Maine, where she had planned to take classes in landscape paint-ing. After a few days, the director of the school advised her to leave, telling her that she wasn't ready for the program and was far behind the other students. He offered to refund her tuition, but she refused to leave and kept working to develop her skills.

She had learned the value of persistence as a child, and once again it paid off. A few weeks later, the director praised her work as "the most vital, because it was so dynamic and colorful. Now had I left when he suggested, I would have felt so defeated. But I stayed. I never ran."[74] This capacity to stay and not run

when it came to artistic endeavors would prove to be one of Louise Nevelson's greatest assets.

Through Norina Matchabelli, Nevelson heard about Jiddu Krishnamurti, the Indian wise man who traveled the world as a speaker and educator on the workings of the human mind. Krishnamurti's central message was always the same: People need to find their own way to a true and vital life of freedom. "My only concern is to set men absolutely, unconditionally free," he said.[75] This remained his focus throughout his long life.

In the spring of 1928 Krishnamurti came to New York and lectured at Town Hall, and Nevelson was in the audience. The handsome young mystic delivered his lecture in an elegant upper-class British accent, and inspired Louise Nevelson to persist in her efforts to find her own way in a lifelong quest for spiritual succor. "I already leaned toward metaphysics and had read that he rejected the superimposition of being labeled a Messiah. . . . And he wanted to free humanity so that each individual could claim their total being."[76] She went to hear Krishnamurti speak on several later occasions, and his liberating mantra became her foundational philosophy. Six decades later, in the last year of her life, she was still reading Krishnamurti's writings.[77]

Nevelson's later focus on the self is foreshadowed in Krishnamurti's words and likely takes them as its ideological base:

> I have only one purpose: to make man free . . . to help him to break away from all limitations, for that alone will give him eternal happiness, will give him the unconditioned realization of the self. . . .
>
> As an artist paints a picture because he takes delight in that painting, because it is his self-expression, his glory, his well being, so I do this and not because I want anything from anyone
>
> I maintain that the only spirituality is the incorruptibility of the self, which is eternal, is the harmony between reason and love. This is the absolute, unconditioned Truth, which is Life itself. . . .
>
> So you will see how absurd is the whole structure that you have built, looking for external help, depending on others for your comfort, for your happiness, for your strength. These can only be found within yourselves.[78]

During that Town Hall address in 1928, Nevelson "saw a vision of moving lips superimposed on [Krishnamurti's] heart, which was a visual projection outside of him but placed in front of his heart. That was the strangest experience I ever had," she said. "And it lasted during the whole lecture."[79]

The incident helped Nevelson realize that she could not yet claim her true

heritage as an artist totally devoted to her art, because she was responsible for her son, who was then six years old. In time, Krishnamurti's message of freedom would ripen, and she would give herself permission to let her son go. But that was still several years away.

The startling experience she had listening to Krishnamurti was not the first or last time Nevelson would be deeply moved by a visual hallucinatory event. As she reports in her autobiography, her life seems to have been marked by such events, which usually occurred at moments when she felt unable to move in any direction. She reports on two later events in which a visual sensation became overwhelming—both occurring when she was feeling depressed and paralyzed by marriage and motherhood. The first took place immediately after describing in her autobiography how disoriented she felt as a young mother: "Here I had a son and I didn't feel like living. I just felt like I was lost. One day I walked down Fifty-Seventh Street, and at the time they had many stores with antique furniture. Well, somewhere along the line I spotted, like a sunburst, two antique French chairs in the window. They had yellow satin covers with no design at all. The shade of yellow and the touch of satin and the softness of that satin was an instantaneous healing."[80]

Beauty, elegance, and an intensely tactile experience reconnected Nevelson to herself. When she was very depressed she tended to focus on the bad feelings that burdened her. She hadn't wanted to be a mother, and she felt guilty about her lack of loving concern for her son. She ignored him as much as she could—which was possible at first because the German nursemaids could replace her. She mostly wanted to be out and about in the exciting city to which she had moved, but her husband wanted her home. Seeing beautiful objects in a store window reminded her of her own strengths and talent, balancing out her bad feelings: "It cured me more than anything else could have cured me."[81]

The second event occurred in 1929, shortly after the Nevelsons moved back to Manhattan, to an apartment at 108 East Ninety-First Street,[82] and Louise visited an exhibition at the Metropolitan Museum of Art. Again, the sight of something beautiful lifted her out of what appears to have been a severe and paralyzing depression. She later recalled:

> You know how we humans get into suspended animation? Like a trance.
> . . . You're so unhappy that you get frozen and you don't even know
> you're unhappy. And I saw no way of breaking this state of mind.
> I didn't live very far from the Metropolitan Museum. . . . So I walked
> to the museum one day and walked in and they had an exhibition of
> Japanese Noh robes. Let me say that there are things in us that we find
> parallel outside us, so these Noh kimonos . . . each robe was a universe

in itself. . . . Some had gold cloth with medallions, and the cloth was so finely woven that the likes of it I never saw, and then the medallion was gold, so it was gold on gold. I looked and I sat down without thinking, and I had a barrel of tears on the right eye and a barrel of tears on the left eye. . . . And so I sat there and sat and wept and wept and sat.

The thing that hit me was that they used it with such elegance. It was the reverse of what people think, that gold material was a little vulgar. It was made out of . . . sheer-thin thread. . . . The light and shade. . . . It was the height of human refinement. . . . And I thought, well, if there's been a civilization of this development, then we have to recognize that there is a place on earth that is an essence. I went home and it gave me a whole new life.[83]

The Noh robes were on exhibit at the Metropolitan Museum throughout the winter of 1928–29.[84] Nevelson had been teetering between exhilaration—in her study with Matchabelli and Kiesler, and her discovery of Krishnamurti—and mind-numbing depression at home. She eloquently describes how paralyzed she could be, unable to feel anything, "frozen and you don't even know you are unhappy." Seeing the beauty of the fabric designed by an exotic and refined civilization—fabric that must have recalled her mother's exotic clothing and how fabric could confer status, lifting poor immigrant Jews above the common lot, above the Yankee aristocracy, even if only for an afternoon—recalled Nevelson to the opportunities beauty itself could provide.

She knew how lovely Norina Gilli had risen above hundreds of trained actresses to become a famous star and eventually a princess. She knew how her own ability to reproduce something "beautiful" in art class lifted her above her classmates, at least in Lena Cleveland's eyes. And she had personally experienced how her own beauty had enabled her to move to her longed-for mecca New York City, by attracting and winning her husband Charles, the former millionaire.

His family would probably not have recognized the beauty in the super-refined Japanese fabric. It might have seemed "vulgar" to them. But for Louise Nevelson it touched a chord and finally freed her to weep, and to move on. Pushing oneself to the very edge could signify "the height of human refinement." Beauty could be an escape, a solution and, most certainly, a reversal of the despair she now felt.

Her "barrels of tears" marked the end of a dream—that being a wife could satisfy her needs, that a rich husband could help her achieve her goal of fame and fortune. Now she would have to find her way alone. Since her depression seemed so overpowering, it is no wonder that the antidote would be a work of

art—such as a Noh kimono—which was extravagant and grandiose in comparison with an ordinary object. If the beautiful woven gold fabric could lift her above her sadness, she could find a way of making beauty with her own hands. This is what Nevelson meant when she wrote of "things in us that we find parallel outside us." The knowledge of her own ability to create art offered her a solution, and making art would be Nevelson's way of finding the inner core of who she really was and what meant most to her. She had tried what turned out to be a false self: being a bourgeois wife and mother. It didn't work, and she would spend the rest of her life on the path to her true self—a creative individual who would find her unique way as an artist.

And so in the fall of 1929, she enrolled at the Art Students League and set herself onto a path from which she would never again lose her way.

ART AT LAST

1929 – 1934

"Charles Nevelson gave Louise ten dollars a week to live on, try-
ing to force her to come back to him by making her uncomfort-
able. He didn't know what to do with her and wanted to stop her.
He wanted a beautiful woman for a domestic relationship. He
didn't know he had a genius."
—Marjorie Eaton, interview with author, August 25, 1976

In the late 1920s the Art Students League was a vital force in the American
art world. Some of the most celebrated American painters and sculptors had
studied or taught there, including William Merritt Chase, Thomas Eakins,
John Sloan, and Thomas Hart Benton. From the time of its founding in 1875, it
was—and still is—a remarkably democratic institution where neither students
nor instructors are graded or earn degrees. The students come to study purely to
learn their craft, and they can enroll for any period of time with any instructor
they choose. The faculty members, initially hired because of their reputation in
the art world, are invited to stay based on the number of students they attract
and retain. Popular instructors may have crowded classes, though less serious
students soon weed themselves out. An atmosphere of informality combined
with dedication has always been the order of the day, as instructors and students
frequently socialize with each other.

Kenneth Hayes Miller, in whose Life Drawing and Painting class Louise
Nevelson enrolled in September 1929, was considered a leading urban real-
ist and was one of the first American painters to have his work exhibited at
the newly opened Museum of Modern Art.[1] His goal as an artist as well as

a teacher was to combine the best of classical tradition with a wholehearted openness to modernity. One of the most admired but not necessarily most popular painting teachers of the 1920s and 1930s, Miller was long the dominating force at the Art Students League, and an influential member of the board of the institution for ten years.[2] Though a forceful personality himself, he did not push his students into his own mold and successfully propelled many of them, ranging from Isabel Bishop to Reginald Marsh, to find their individual styles.[3]

Though Lena Cleveland had gone to Pratt Art School, the Art Students League was "the big prestige school in the professional art student's horizon," and Louise had to have the best.[4] At first Nevelson attended only morning classes with Miller because, as she explained, "I had a household myself."[5] Within three months she added afternoon drawing classes with Kimon Nicolaïdes, a former Miller student who had developed a sizable following.[6] Students typically took classes with both teachers, because they were seen as useful counterpoints. With Miller, students tightened up their techniques and knowledge of the old-master traditions. With Nicolaïdes, they were introduced to the latest in European trends and a liberating series of drawing exercises.[7]

Nevelson remained in Miller's class for two years and established a close relationship with him that continued through to 1933.[8] She recalled him as "very sympathetic" and said, "We became very good friends."[9] Austere, articulate, and handsome, hailing from Oneida in upstate New York, Miller may have reminded Nevelson of the proud Yankee natives she knew from Maine. In retrospect, one can see much in Miller's philosophy and teaching style that would have appealed to Nevelson. He de-emphasized technical instruction and encouraged students to develop their own intuitive experiences, putting great emphasis on each person's finding his or her own artistic self.[10]

Possibly more important for Nevelson was the way Miller inspired his students to embrace a total devotion to art as a way of life. Nevelson's diverse cultural training and experience had not yet placed her on a sure path as a visual artist. Miller was a man of iron will, a skillful technician, and was seen as "one of the most clear-headed speakers and thinkers on art . . . a philosopher on art who continually thought about form, about the design, about these elements as they occurred in the art of the ages."[11] A teacher such as Miller, whose complete devotion to art had brought him prominence, helped restore in Nevelson the earlier self-confidence nurtured by Miss Cleveland.

Another facet of Miller's teaching, significant for Nevelson's later development, was his interest in the sculptural qualities of painting. "His insistence on finding the bulk and structure of the figure as well as the more obviously sensuous qualities of light and color, his urging to 'reach around' the object, all

suggested the three-dimensional medium of sculpture."[12] A number of Miller's students, in addition to Nevelson, eventually became sculptors.

In his earlier teaching Miller had been on the side of experimentation, but by the late 1920s, the time Nevelson was studying with him, he was focused primarily on the old masters and tradition. As she recalled in the last year of her life, "When I went to art school it was all figurative art; we drew skulls made of white plaster, and we worked from models."[13]

Students had to look elsewhere for information about the latest developments in modern art, especially in Europe.[14] Enter Kimon Nicolaïdes, one of the most popular teachers at the League. He became known as a "second father" to the hundreds of students who flocked to his innovative drawing classes. Though she received her foundational art training in painting and composition from Miller, Nevelson's eighteen months in Nicolaïdes' afternoon drawing classes may have had a more lasting effect on her work. Dorothy Dehner, who later married David Smith, remembered his alerting students to the most exciting and avant-garde exhibits in the city.[15] "The best artists in America were teaching at the League. It was a very yeasty place, and the most yeasty students were studying with Nicolaïdes."[16] When Nevelson talked about her relatively brief study with Nicolaïdes, she reported, as she often did when discussing her training, his having discovered her giftedness: "I went to him for a short while. The first week I was there he took mine [drawings as] choice things for the week and put them on the board. So already he recognized my talent."[17]

Nicolaïdes, who worked painstakingly slowly and rarely exhibited, had trained as an artist at the Corcoran School of Art in Washington, D.C., and at the League. The son of Yankee mother and Greek father, he studied and lived in Europe for a year and was given a one-man exhibition at the well-known Bernheim-Jeune Gallery in Paris. He began teaching at the League in 1923, and his innovative methods became standard fare in art schools around the world.[18]

Nicolaïdes combined a rigorous way of training the eye and hand by insisting that students exactly follow the contours of the object without lifting their hand from the drawing or moving their eyes away from the object being drawn. An exercise, which was meant to counterbalance these slowly achieved contour drawings, was a "gesture drawing"—a sketch done in a few seconds aimed to capture the living movement of the model. Nikolaïdes advised students to do both types of drawing repeatedly so that their skill would become automatic. He argued that, "There is a vast difference between drawing and *making* drawings. The things you will do—over and over again—are but practice. They should represent to you only the result of an effort to study. . . . Your progress is charted, not on paper, but in the increased knowledge with which you look at life around you" (my italics).[19] Nicolaïdes' ideas fit perfectly with Nevelson's recent lessons in

dramatics, and it must have been a relief to know that she would not be judged by a single drawing but, rather, by the knowledge that came with practice.

The fluid line quality evident in almost all of Nevelson's figure drawings is a testament to her classes with Nicolaïdes, as well as her appreciation of Matisse. Likewise, her assertion of the artist's right to distort whatever body parts needed to be changed for aesthetic reasons speaks to what Nicolaïdes wanted his students to learn from the repetition process. (It also speaks to Nevelson's lifelong appreciation of Picasso, whose drawn and painted bodily distortions look natural.) What Nevelson added to these homages to earlier masters was a playful perceptual quality, which made tiny heads seem just right on big bodies, and negative spaces that artfully intertwined with anatomical truths. Hands, heads, and feet usually played second fiddle to torsos and thighs. But a sculptural solidity was always present.

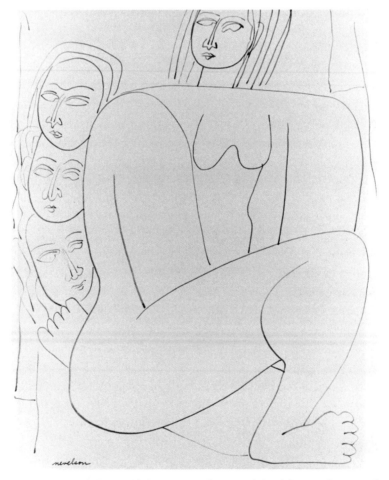

Four Figures, 1930. Pen and ink on paper. Farnsworth Art Museum, bequest of Nathan Berliawsky 1980.35.34

Nevelson mentioned neither Miller nor Nicolaïdes in her autobiography, speaking instead of her short-lived and artistically inconsequential lessons with the Baroness Hilla Rebay and her few weeks in the watercolor class at Boothbay Harbor. Yet it was her experience in Miller's class that provided her with basic artistic skills and her work with Nicolaïdes that gave her the foundation for all her later drawings.

Nevelson was a hard worker, and by dint of her energy and effort she achieved more than competence in both drawing and painting. The fact that "I did about ten thousand of them [figure drawings]" in the course of her career "gave me a kind of strength"[20]—a statement which she repeated at various times in her later years—fits with both Nicolaïdes' admonitions about the value of practice and Nevelson's inclinations to produce vast quantities of work. But this comment should be taken with a bucketful of salt. There are perhaps a hundred extant line figure drawings done by Nevelson between 1929 and 1940, not many more. Her sister Lillian remembered: "If Louise ever made a mistake on a drawing, she wouldn't throw it away. She wouldn't erase it, she'd make another. According to her point of view, you never spoil anything. I don't think she ever destroyed a drawing."[21]

After two years of studying with Miller and Nicolaïdes, Nevelson knew that the new and modern in the visual arts were her future, but they were not yet truly accessible in New York City. This compelling reason was combined with her personal need to get away from the constrictions of being a wife and mother, and to come to some decision about how to go forward with her life. She was close to fully committing herself to the life of an artist. But she wasn't quite there. Ten years of marriage with a man to whom she felt culturally and socially inferior and who had discouraged any attempt to build a life based on her own talent had taken its toll.

Despite later avowals of her early certainty that she would be an artist, until 1929 Louise Nevelson's life in New York showed her to be a society matron with diverse cultural aspirations. While her experience at the Art Students League helped her find her way to a profession that matched what she felt were her native abilities, she wasn't ready to build a life based on her talents alone. Nevelson fit into the youthful student body at the League, though she was well aware she was at least a decade older than most. Her personal magnetism and energetic work habits disguised the difference between her actual life as a wife and mother and the less conventional lives of most of her fellow students.

When asked by an interviewer: "Who were your art friends at the League?" Nevelson responded: "Look, darling, I had a husband and a child, a household and everything. I wasn't about to make many friends. I had a few, not many."[22] Nevelson tended to make friends with the students who came from a similar

social background—such as Dora Lust, a divorcée from Chicago, who lived on New York's Upper East Side near the Metropolitan Museum of Art. "I'll tell you why. I'd already had a taste of diamond bracelets and things; it wasn't quite what I wanted, but it was pretty good. I couldn't quite make it in the world of art students. It was only later, when I left my husband and began this struggle, that I could communicate. But that took a little doing."[23]

The "little doing" would include two trips to Europe: in 1931, for a painfully abbreviated period of study with the painter Hans Hofmann in Munich, and again in 1932, when she became more confident than ever in her calling to be an artist. But mostly it was the struggle with her conscience about leaving her son. While Louise was studying at the Art Students League, Charles Nevelson's finances kept deteriorating. The Depression which devastated so many people at all levels of society had hit the Nevelson family hard, though their downward slide started well before 1929. When Louise began to take drawing classes at night—instead of making dinner and presiding at table—she precipitated even more heated fights at home. Finally, surrounded by many art students who raved about Hans Hofmann, the master art teacher from Munich, she succumbed to the siren call of Europe and the possibility of studying with the person who could teach her what she most wanted to learn.

Whether she saw the trip abroad as a departure from her marriage or just an extension of her studies is not clear. It was an important departure and she was aware on a symbolic level that it was a leave-taking, marking the beginning of the end of her married life.[24]

Why Hofmann and why Munich? Among the students in Nicolaïdes' classes were some of the more conservative Miller students like herself. There were also others who were the followers of Jan Matulka, a Czech painting teacher recently returned from Europe. Matulka was a close friend of the painter Vaclav Vytla-cil, an American artist of Czech ancestry who had studied for four years with Hofmann in Munich and was largely responsible for spreading his reputation of "the best and most inspiring teacher in Europe."[25]

Over the objections of the older guard at the League, which included Kenneth Hayes Miller, Vytlacil had established a beachhead of the modern movement at the Art Students League in 1928–29, teaching and giving a celebrated series of lectures during that winter.[26] Nevelson had just arrived at the League in 1929 when Matulka carried forward his friend's fiery message of modernity by teaching about the latest in European painting, especially the work of Picasso and Matisse and the magically gifted teacher, Hans Hofmann, in Munich who knew how to translate the secret of those masters to serious students.

Born in a small town in Bavaria, Hans Hofmann had lived in Paris between 1904 and 1914, absorbing the principles of Modernism, witnessing the evolution

of Cubism, and meeting Picasso and Braque, as well as Matisse and Delaunay, with whom he shared a passion for color and line. At the beginning of World War I he returned to Munich where he started an art school.

Always alert to the new and the best, Nevelson paid close attention to the buzzing excitement about a teacher who could open doors to the most important developments in modern art. "I had seen reproductions of the Cubist works of Picasso and knew their power," Nevelson later recalled. "At the League I heard of Hofmann. Everyone was talking about this great teacher in Germany who taught the subtleties of Cubism—I knew then that I had to go to Germany."[27]

The cube was a fundamental principle for Nevelson—both visually and philosophically. Her understanding of metaphysics, to which she devoted many years of study, was always based upon the visual and the spontaneously intuitive:

> When you square the circle, you are in the place of wisdom. . . . [Cubism] gave me definition for the rest of my life about the world. Before that . . . when I studied at the League . . . we knew that there was a shadow, but . . . I didn't [understand] that that shadow was as valid as the light. . . . We wouldn't see light without shadow. We wouldn't see shadow without the light. . . .
>
> Cubism gives you a block of space for light. A block of space for shadow. Light and shade are in the universe, but the cube transcends and translates nature into a structure.
>
> I felt that the Cubist movement was one of the greatest awarenesses that the human mind has ever come to.[28]

The fundamental reason Nevelson went to Munich to study with Hofmann is that he taught the cube: the push and pull, positive and negative. According to his students, Hofmann regarded Cubism as a kind of basic grammar which was related to classicism.[29] His particular gift was teaching how to bridge the gap between Cézanne and classical painting, as well as between Cubism and more recent post-Cubist developments in modern art. He concentrated his pedagogy on a description of the plastic structure of the object. The German Gothic masters—Dürer, Cranach the Elder, Holbein—as well as Cézanne and Picasso were held up as model draftsmen.

At the Art Students League Nevelson had been exposed to the classical rational approach to art through Miller. She had been exposed to a version of the spontaneous Surrealist approach through Nicolaïdes—and even earlier through her contact with Frederick Kiesler. She was searching for the bedrock wisdom that would give her both the rational and the intuitive foundation for her work. She wanted something that would combine the two and allow her to

find herself, metaphysically and visually. She was sure that Hofmann was the one teacher who could show her how to do this.

Despite the darkening political situation in Germany, studying the master-pieces of art and architecture in Europe was a powerful goal for any serious American art student in the early 1930s. The respect for the brightest lights of the cultural past had been instilled at home and at school. It would have been an especially powerful draw for Nevelson, who had been consistently attracted to other stars from Europe such as Norina Matchabelli and Frederick Kiesler.

Moreover, in an article published the year Nevelson left for Germany, Hofmann discussed the importance of the fourth dimension in art. "All pro-found content in life originates from the highest phenomenon of the soul: from intuition, and thereby is found in the fourth dimension. Art is the expression of this dimension, realized through the other dimensions."[30] While we cannot be sure that she read this statement, Nevelson would surely have found it compati-ble with her growing interest in the fourth dimension.

Having determined to go to Munich to study with Hofmann in the fall of 1931, Nevelson went back to Rockland with her son. She was about to disrupt any semblance of stability in Mike's life and ask her parents to stand in for her with her child. According to Nevelson's sister Anita, at this crucial turning point in her daughter's life and completely remarkable for the times, Minna Berliawsky gave Louise encouragement not only to study in Europe, but to leave her marriage. Lillian recalled: "My father and my mother both loved my sis-ter's husband, and when Louise came home and said she wanted to leave they were heartbroken. But they wanted to do what she wanted. Momma was very understanding."[31]

Her family agreed to take over the care of her son while she was away and to finance the trip. Although the Depression had much reduced her father's resources, her brother's hotel business was thriving, and supporting Louise's artistic career was not seen as too heavy a burden.

The major obstacle was her mother's illness and an impending operation. Trying to calm her daughter's doubts, as Anita recalls, Minna told Louise, "If I die, what's the difference. If I live, I'll see you when you get back."[32] Nevelson's recollection comprises more of a commitment on her mother's part, and is also more comforting: "Louise, you must go. You always wanted to continue in your art. If I don't survive, it will make no difference. You go and study. We'll send you an allowance, and we'll take care of Mike and see that he has everything he needs. . . . Look, you don't have to stay married. Before that you were so vital."[33] Nevelson continues her recollection: "My mother was very sympathetic—she thought I had lost my soul. She . . . had suffered through her own life. And so she was the one who really gave me the courage to take my freedom."[34]

The bond between mother and daughter was strong, and Minna's words helped Louise take the steps away from an unhappy marriage and toward the kind of independence the older woman had never been able to achieve, even as both of them may have unconsciously recognized that the young woman was leaving her child behind, just as Isaac Berliawsky had left his wife and children behind when he departed for America.

Louise Nevelson had been married for eleven years, and at thirty-one years of age she was being given a new start as a single woman on a family allowance.[35] Her new start was not without complications and pressures. When she left for Germany in September 1931, her husband was frantic. He didn't know where she was, and his wife's family would not tell him, even when he sent someone to Rockland to find out or when he tried to persuade Nate not to send her money.[36] Her family did not want Charles to interfere with what they knew to be a very difficult decision for her.

Mike stayed in Rockland until mid-December when his father arranged for him to live with him in an apartment at 230 East Seventy-First Street in New York, where he had hired "an intellectual woman who had many years experience in teaching." Her job was to keep house and prepare meals for the boy—"the only proper thing to do under the circumstances. Surely, Rockland

Photographer unknown. Louise Nevelson, 1932. Archives of American Art, Smithsonian Institution

was not the right environment for Myron."[37] This postscript from Charles was added to "Two-Gun Mike's" letter telling his mother that he was "now in New York where Daddy hired an English lady to help me with piano [and] school . . . She is one of the Catholic Missioners but I like her. I am very happy here and everything is OK."[38]

But everything was not OK, and Mike, also known as Myron, was clearly unhappy. He expressed concern that his mother was putting too many high-priced stamps on her letters to him. His missives are full of bravado: "I hope you are as fine as I am" . . . "I go to school alone every day but sometimes Daddy takes me"; "I have lots of friends and go to the park and make more friends. I am a regular mixer." But belying that is his closing line in this letter dated April 24, 1932: "I hope you come back soon as I'm getting lonesome. With a big hug and three kisses. Your Loving Son Myron."[39]

A month later, he writes to his mother that he is having a fine time because Daddy got a new car. But only after he had observed: "You state that you expect to leave for America soon but don't say when."[40]

The next letter is from Maine, thanking his mother for the new tie she sent him but notes that, "It's too nice to wear every day." He adds that he "likes the hat [which is either for him or his cousin George] too, although most boys of my age don't wear them. I would like to have it for a relic of Germany. I don't want to make you sorry you sent it cause there wont be any quarl [sic]. Just write who is to have it, but I don't want you to buy another, because times are hard, and you shouldn't spend [your money] when you need it for paints. Nathan will send some money soon."[41]

At ten Mike is presenting himself as a precocious grown-up with a youthful mixture of bravado and bullying. His missives are sprinkled with, "I'm very sorry I did not write, but you know how a boy is." And, "How are you? Is your apartment nice and clean and modernistic? I don't understand your address. You say your [sic] in Munich, but your address is Munchen. . . . I received your photographs. Grandma thinks you look crazy, but she's old and don't know much. I think you look good, just like a great artist."[42]

His letters suggest he was paying a high price for his mother's freedom and trying to disguise his anguish with false cheerfulness, and that he was imitating his father's paternalistic stance toward his wife, whom he believed would not be able to manage on her own.

The combined separations from husband, child, and family weighed heavily on the thirty-one-year-old woman. She may not have wanted to be a mother, and she certainly knew that marriage and motherhood had cost her her soul, her vitality, her very self. But she also felt guilty leaving her child,[43] knowing that leaving him with her parents—whom she knew would be very imperfect

guardians of a young boy—would have lifelong repercussions. She had begun the journey to be the artist she had always suspected she might become, but she had also irreparably damaged her relationship with her son. She would never stop paying the price for that damage. Nor would he.

In addition, her timing was unfortunate. She had arrived in Europe in the fall of 1931, full of hope and optimism. Instead of support she found painful rejections and frightening surroundings. She could not have missed the implications of what was happening in Germany, especially in Munich, where Hitler's power was growing stronger and where, she had told her sisters, "People were starving, eating dry bread or had nothing to eat or wear."[44]

She began to attend the small life drawing classes daily at Hofmann's school just as he was working on his plans to leave for America. She recalled that he paid attention only to the students who could help him with emigration—students currying favor with him, repeatedly bowing and saying "Herr Professor Hofmann."[45] Nevelson claimed to be averse to this kind of obsequious behavior: "I wasn't about to bow down to anybody."[46]

This turn of events would have been discouraging enough for the would-be artist, but Hofmann added a more devastating blow by asking Nevelson to leave the class, telling her not only that she would never be a great artist but that she would never be an artist, period, and that she was wasting her time.[47] Both of her sisters clearly recalled this unexpected event. "She was heartbroken. She told us time and time again that she felt pretty rotten about it but thought he didn't know what he was talking about."[48]

While Nevelson never publically admitted that Hofmann had sent her away, her description of her experience with him in Munich makes the actual events clear, and demonstrates how easily she could reverse a painful rejection later on by recalling anecdotes in which a disparaging teacher inevitably ended up recognizing her talent and originality. She did the same in her recollection of the rejection and reversal she encountered with her first art teacher, Lena Cleveland (although the guidance and encouragement Cleveland later provided suggests that that first reversal was not Nevelson's invention). Whether or not there is evidence that Nevelson's other art teachers actually did reverse their opinions, these narratives indicate that Nevelson learned early that, if she persisted in the face of "failure," she would eventually succeed. With Hofmann, she translated *his* rejection of *her* into *her* rejection of *him*. "I'd made a great sacrifice. I'd left my son with my family, and I expected more than I found. . . . I wasn't in tune with his vibrations. It wasn't my fault. He was just looking another way. He didn't give us much attention because he knew he was coming to America. . . . I didn't stay as long as I intended because I didn't care for that."[49]

In 1970, it was easy for Nevelson to tell Arne Glimcher, as she summarized

her education as an artist, "Art was the thing that pleased me from the day I started school. And then I went through school in Maine. And after I moved to New York I went to the Art Students League. And then I went to Munich to study with Hofmann. And they all gave me one hundred plus. Well, you are always going to stay somewhere where you shine and are happy."[50]

Six years later she completed the narrative with a story of Hofmann's ultimate about-face. Recounting an evening she spent with him years later at her sister Lillian's, she recalled him saying: " 'Do you know,' he said, pointing to one of my walls, 'this is original. It is personal. I haven't found myself, so now that I've retired and have money I will work for myself. Teaching has taken so much out of me.' "[51]

After Hofmann's rebuff, Louise Nevelson was not ready to come back home and turned briefly to the activities she had pursued in New York with Estelle Liebling and Norina Matchabelli: singing and acting. In Munich she spent her evenings in cafés and nightclubs and was frequently invited to sing the then-popular American spirituals and folk songs. Her vocal and acting talents were sufficient and her personality was winning, and, by her own account, she was offered parts in films by theatrical friends she had met in Munich.[52]

Seeing acting as the means of supplementing the funds she received from her family, she took small parts—mostly as an extra—in Munich and then in Vienna. But she soon discovered that being "in the movies" was too passive for her type-A personality. "You sit there for hours," waiting for the few moments on camera. "Some people would knit. In Europe I sang in nightclubs—no audience, just actors. They wanted to engage me and to write in parts for me, but I had other commitments. . . . I knew I couldn't fulfill what I wanted this way."[53] Her sisters recalled: "When Hofmann kicked her out she went right into the movies for money . . . she could have been on stage forever. They wanted her to be a star but she said 'no' for art."[54]

Her movie experience merely confirmed what she had already realized. She needed to be in control—total control—of her environment: "To project yourself there [in a film] you have directors and other people playing the game too. Here [as an artist] I am all alone. If I want to stand on my head, I can."[55]

Her faith in herself somewhat restored, she traveled to Italy, visiting Rome, Pisa, and Florence, admiring early Renaissance artists like Giotto, whose works she had studied in Miller's class. Nevelson ended her first trip to Europe with a brief stay in Paris, visiting the Louvre and the Musée de l'Homme.

While she studied the old masters on her first trip to Europe, Nevelson was not yet confident enough to meet the new masters. Her claim that she did not approach Pablo Picasso in Paris because she did not want to intrude on his time sounds very unlike a bold, beautiful young woman striking out on her own.

It may be that her encounter with Hofmann, as well as the months of being alone in foreign territory amidst an increasingly turbulent political situation, had taken a greater toll on her self-confidence than she could admit.

In the early summer of 1932 she had been in Europe almost eleven months, traveling mostly with friends she had met in Munich but sometimes by herself. She was ready to return home and deal with her guilty feelings about having left her son for such an extended time with her father and ailing mother. When she arrived in June she found her son well and her mother recovered. Shortly afterward, back in New York City, she found that the long absence from her husband had done nothing to resolve her marital discontent, and she decided about six weeks later—again with her mother's encouragement—to return to Paris.[56] She rationalized that she had not seen enough of the city's artistic treasures on her previous visit and that she needed to get away from the stifling roles of wife and mother.

In order to make the second trip to Europe, Nevelson claimed to have pawned a diamond bracelet.[57] Her sisters remembered a different story. She called her brother-in-law Ben Mildwoff and said that she urgently needed $250. Thinking she had to have the money for an unmentionable purpose—an abortion—he gave it to her right away. That same evening she was on a ship heading back to France. A photograph taken of her on board shows a well-dressed young woman, wearing an elegant suit, white gloves, hat, and necklace, and carrying a clutch bag.

During her second stay in Paris, Nevelson learned more about art, spending her daytime hours visiting Versailles, Chartres, and the Louvre, and "all the cathedrals . . . all the museums."[58] In the evening she would frequent the café-restaurant Le Dôme, meeting artists and intellectuals—at least the ones who could speak English. Beyond the intellectual stimulation it provided, the Paris trip was also a period of intense sadness and self-doubt, during which she faced her moral and personal dilemmas. She scribbled barely comprehensible poetry on hotel stationery, pouring out her longing and confusion:

> Must I wait for immortality to be at the home that is my destiny . . .
> I'm afraid
> I am tired, oh say tired searching, hunting just to be in the place I
> hope is for me
> In that land where . . . man at last is free to be himself in reality. . . .
> I am willing to try to fly but it seems too far for even I. . . .
> I continue to be at sea. . . .
> I do not know which shore to come too [sic]. . . .
> I do not know which land to land at for all I see are worshipping dead
> ideality not reality.[59]

About her poetry and period of distress in Paris, Nevelson described in her autobiography: "This time in Paris I was freer in a way, mentally. And yet I was discouraged. I was discouraged with friendships and I was up a dead end. . . . I *was* desperate and I was at sea, because everything seemed to me so disjointed and I wasn't connected with anything. . . . It seemed that everything I touched was negative . . . it threw me *back* on myself. It gave me a kind of determination *not* to look too much out. . . . It was a tough lesson. . . . And slowly what happened through searching was a rebuilding into myself and constantly taking full responsibility for my life."[60]

Alone in Paris, Nevelson clearly questioned her ability, and willingness, to stay connected to other human beings, specifically to her husband and her son. So far, those connections had led to disappointment and frustration. Read one way, her actions are those of a selfish woman, who abandoned her responsibilities in order to pursue her passions. And yet it's evident, from her letters and poetry at that time, and her later recollections, that in the depths of her anguished ambivalence she believed that her only way forward in her life was to search for her true self: to find "the home that is my destiny" and to "wait for immortality."[61]

The daunting prospect of becoming her own person was conceptualized into the idea of projecting her self and her ideas onto the world, as she had learned from Krishnamurti. The need to discover her unique self—not the various identifications she had been assembling—and to create her own reality was the main realization of these two trips.

It was a dark time for her, and, as she later said, she comforted herself by recalling Sholem Aleichem's prophetic words: "She was destined for greatness."[62] The second trip to Europe did little to blunt the painful experiences of the first trip. At the end of July 1932, the Nazi party had triumphed in Germany, and Nevelson would have been aware of the fear and pessimism among the artistic and intellectual crowd she knew in Paris. Most European artists followed politics closely and were awake to the implications of the rapid rise of Nazism and of the terrible things to come for all Europeans, especially for Jews.

The "dead ideality," as she described it, that she saw being worshiped by people around her could have been the art she had been soaking up in Paris, with its many monuments to the past glory of France: "French art is too cultivated; each brushstroke contains a tradition of greatness."[63] It might also have been a reference to the old guard's conventional way of being in the world—the Bernard and Charles Nevelson way, maybe even the Kenneth Hayes Miller way. By the end of the summer of 1932, Paris no longer held her, and she returned to her true home in the New World. "I could be a leaf on the tree in Paris," she observed, "but I could be that tree in America."[64]

She was also on the verge of discovering that in order to create her own reality—as a woman and as an artist—she could never again let a life partner intrude on her freedom. She sensed that her self-exploration through art would eventually lead her to her "destiny," however painful the journey. The second Paris trip was an ending and a beginning, a culmination of all she had learned from her mother, Minna; her art teacher, Lena Cleveland; and her guide in dramatics and metaphysics, Norina Matchabelli.

> It was night and she was crying. The wall was white and she was
> crying.
> Wings of spirit why don't you get nearer it.
> Wings of flight it is getting night and I have fright—in the soul of the
> night
> It is dark and. . . .
> I too must have light so my soul can be bright.
> But no, it is dark and how I feel the wall in search of day which may
> never come. Yet it is always dark for me. God must have chosen it
> to be and
> I am tired . . . searching, hunting just to be in the place I hope is for
> me.
> Oh it's cold and I want to get warm. Warmer and warmer but it's cold.
> Must it always be cold for me? Do you all see it's cold for me?
> Higher and higher maybe some day I too will go and find my way.[65]

Whether she realized it at the time, Louise Nevelson had finally begun to find her way. It was a path on which the only firm footing would be her art. Nothing, absolutely nothing else, would satisfy her deepest needs. Her mother had given her permission to leave her marriage and even to separate from her son. Her family had supported these moves emotionally and financially. From this time on Louise Nevelson would rely on them to help whenever necessary so that she could concentrate on finding her way as an artist.

Judging from the work she had produced up to that point, Nevelson was not yet certain where her true talent and genius lay. She knew that she had something inside her that was right—sometimes she would call it "style," more often she recognized it as an intuitive sense of what *looked* right. But she didn't yet know how to identify or express it. It would take her almost twenty-five more years to do that. In the meantime she worked and worked and worked. She believed in herself, but in her art she was still at sea.

By late summer or early fall of 1932, Louise Nevelson had returned to New York fully determined to move forward as a visual artist. She partially moved

back with her husband to an apartment at 39 East Sixty-Fifth Street, within walking distance of the League, and she signed up for two months of evening classes with Hofmann, who was teaching painting and composition. It was a characteristically courageous and bold step. She knew that she still had things to learn from him and would not let his earlier rebuff get in the way. At the League she was in control. If she wanted to study with Hofmann, she was a paying art student and (unlike in Munich) he could not kick her out of class.

In March 1933, back at the League for another month of study with Hofmann, she met Marjorie Eaton, a lively, elegant young woman from a wealthy California family whose interest in the arts paralleled her own. Telling Eaton about her experience in Munich, Nevelson characteristically reported Hofmann's extremely positive response to her work. "Then Marjorie invited me to something and we became friends."[66]

As usual there are inconsistencies in the story of their first becoming friends. Eaton recalled that Louise was a woman of great style and impressive concentration. "Louise seemed to be aware of everyone in class without looking at them. . . . She invited me to tea, and we walked back to her house on the corner of Park Avenue—the apartment she still shared with the husband whom she had recently left. She went back once a week to see to his laundry. It was a large, handsome, high-ceilinged room, and everything was covered with sheets. She undid his laundry and put it away, then she prepared tea."[67] It is unclear exactly where Louise Nevelson was living during this transitional period. At times she stayed at the apartments of friends, a rooming house on East Sixty-Fifth Street, and other times in the apartment with Charles.[68]

Eaton was impressed with Charles Nevelson but realized how different he was from his wife: "Louise left him for the creative life. He was conventional and didn't have the depth of feeling she did. He wanted to put her back into Aladdin's lamp. She didn't know that about him when she married him. She just wanted to get to New York. Her parents understood and knew why she had to leave him."[69]

Eaton witnessed the complicated relationship Louise had with her husband, and she watched with amazement as Charles obdurately maintained that his wife would not be able to manage on her own, even as his own financial situation deteriorated.

Though Eaton would shortly select the theater as her major interest, at the time she met Louise she was studying painting and was able to introduce her to Diego Rivera and Frida Kahlo when they arrived in New York in the spring of 1933. Rivera, who had known Eaton from her time in Mexico and his time in San Francisco, had invited Marjorie Eaton to lunch, and she brought Louise along.[70]

Rivera was very impressed by the attractive young woman. "He saw her greatness" is the way Eaton recalled that first meeting.[71] After Marjorie explained about the difficult time Louise was having finding a place to live and work, Diego invited both women to move into a first-floor studio in a building he had just rented on West Thirteenth Street. The transition from married life may have been eased at first by the invitation to share digs with Marjorie Eaton. "Marjorie was one of those people who would always do what she wanted to do, when she wanted to do it, and how she wanted to do it."[72] She was a model for Louise's future independence.

Whenever Diego and Frida would go out to dinner in Chinatown they would pass by and invite the two young women to join them. Rivera also invited both women to assist him on the murals he was working on during the summer and fall of 1933 for the New Workers School.[73] The two women were not only artistic assistants for Rivera, but they also served as hostesses for the couple, whose English was limited.

When she shared the studio with Marjorie in 1933, Nevelson was painting with such fervent concentration that she ignored the seasons. Eaton recalled: "She was impervious to hot or cold; she didn't know seasons. . . . She was so strong. She got up early, having been out most of the night with beaus. She'd sleep a while and start early in the morning."[74] Marjorie Eaton and Louise Nevelson remained close for the rest of their lives, and Eaton remembered numerous telephone conversations and meetings with her friend after she herself moved back to California. "Louise was always talking and trying to analyze whether she had done the right thing by leaving her husband and sending her son away.[75] Eaton told Glimcher: "I was impressed by her independence and her ability to remove herself from a destructive situation."[76]

Mike Nevelson, in the meantime, was growing up. After his mother had begun to live completely on her own in late 1933, he lived eighty percent of his time with his grandparents in Maine and about twenty percent with his mother in New York. They had settled into a somewhat comfortable but unconventional relationship, which Marjorie Eaton much admired: "They were like pals, brother and sister. She didn't push him down. They would have fun together. Staying with her was like a haven for him. She never dominated him—not at all like a typical Jewish mother."[77]

A letter from thirteen-year-old Mike in Rockland demonstrates how torn he felt—being passed back and forth between his parents—and how much he was suing to be his mother's pal.

I don't really wish to go to camp as I am bigger now and would enjoy myself more in the city [with you]. . . . My father is coming up but he

won't influence on me. He'll probably want me to go back with him but I won't go because I'll probably get sick listening to him "gab." I will write to you at a later date when I'm coming to live with you (and if the old buzzard doesn't like that he can lump it.) Nevelson doesn't deserve any "sympathy." He didn't give you any when you lived in a cellar! Then, I didn't know much, (I admit) and I was influenced by him to do as he did. But now I realize how he abused you and I am set to defend you.

Hoping for the Best your son and Best Friend,

P.S. If we can't make the two ends meet, grandmother will send about $20 monthly to help, she said.

P.P.S. Keep going as usual and we will talk things over when I get back.[78]

As the most famous Mexican artist of the time—and the leader of the Mexican Renaissance—Rivera had been invited to paint a large mural for the entrance to the RCA building in Rockefeller Center in New York, which he began in March 1933. In keeping with Rivera's political beliefs, the work included a portrait of the fiercely anticapitalist Lenin. When Nelson Rockefeller asked him to remove it and Rivera refused, the artist was dismissed. To avoid a lawsuit, however, Rivera was paid in full.[79] The mural was first covered and later destroyed. The scandal that ensued gave the Communist cause unprecedented publicity, and the murals themselves became the rallying point for the WPA mural projects a few years later.

Rivera used the Rockefeller money to paint a set of twenty-one murals on portable panels and promised to give them to whoever offered the best public space. The series was entitled *Portrait of America,* and it told, Rivera said, "a story of American revolutionary traditions and tendencies, in general the struggle of labor against capital from colonial times to the present day."[80] Rivera did the work, which covered seven hundred square feet of wall space, over a six-month period at the New Workers School at 51 West Fourteenth Street. The school was open all day, and "Artists, art students and interested others" were invited to watch the work.[81] The press reported the artist's progress. When the murals were completed, there was a three-day grand opening with lectures by Rivera.[82]

Though Eaton and Nevelson were invited to participate in the project, it is not clear how much actual work Nevelson did. David Margolis, who had worked with the Mexican artist on the RCA mural recalled: "Louise was a beautiful creature. . . . She used to come around and watch the painting. She didn't help— the physical work was for the men—she was just watching and making friends with all of us."[83] Most likely she was one of the many assistants who helped with the technical and research aspects of the projects. Nevelson later claimed to

have mixed paint and applied washes. She also claimed to have hated doing the menial work but needed the money.[84] Her sister Lillian recalled that Rivera was the only artist for whom Nevelson ever worked and that she did it in order "to learn." Lillian added that her sister loved both Rivera and Frida Kahlo and that they remained lifelong friends. Marjorie Eaton remembered: "He really loved Louise and took her to a trading post in the village where he would buy her jewelry, which she would then pass along to Frida."[85] Perhaps in return for his generosity, she gave Rivera one of two portraits she had made of him.[86]

Rivera's contretemps with the Rockefeller family was the talk of the day. At the center of the tumult was the man—liberated, ebullient, generous, possessed of enormous energy and zest, and totally devoted to "Art." Like most people who met him, Nevelson adored Rivera: "I only tell you that objectively he was one of the most unique men in the world. . . . He was brilliant but not too analytical . . . and he wasn't *bound* by anything."[87] Having lived for a few months in the same building with Rivera, she saw firsthand how a successful artist could be lionized by elite society. And through him, Nevelson met and made friends with such artists and musicians as Lion Feuchtwanger, John Flannagan, Boris Margo, and Ernst Bloch.

However much she liked him personally, neither Rivera's subject matter nor his fresco technique appealed to Nevelson. "There was grandeur there, honest thinking and generosity," she said, "but his feeling for illustration prevailed and I had to seek my own way of communicating."[88] Nonetheless, at a critical moment in her life she had found another artist with whom she could identify—someone whose lifestyle and personality she admired tremendously.

Rivera's admirers saw him as the leader of a new Renaissance in mural painting—with an importance equal to Giotto's. For the young and fervently leftist community, Rivera was a rallying point for both the Communist cause and artistic and intellectual freedom. Though it is never mentioned, Frida Kahlo's elaborate and dramatic public persona would not have gone unnoticed by fashion-conscious Nevelson.

This brief but dynamic episode while Frida and Diego were in New York City had many repercussions. First of all, she never again faltered in her decision to be an artist. Second, her taste for pre-Columbian and Indian art was probably intensified by both the presence of Rivera and Kahlo in her daily life and the two-month-long exhibition of Aztec, Mayan, and Inca Art at MoMA in the summer of 1933 (*American Sources of Modern Art*). Third, following one of Rivera's favorite maxims—that bad art was more educational than good art— she learned to look at everything. And finally, though eschewing his devotion to politics, she admired and adopted his social egalitarianism.[89] Nevelson recalled: Rivera and Kahlo's house was "always open in the evening, and anyone who

wanted to would come. They were very serious about people; they didn't make distinctions. . . . Princesses and Queens, one lady richer than God. And workmen, laborers . . . all were treated like one body of people."[90] Rivera was a great storyteller, an inventor of fantastic tales—it's tempting to think Nevelson may have learned that from him as well.[91]

After the public showing of the completed mural at the New Workers School, Rivera and Kahlo left for Mexico in December 1933.[92] Marjorie Eaton had already returned to Mexico via Taos in the late summer of that year, leaving Louise Nevelson alone in the West Thirteenth Street studio. For the first time in her life she was truly on her own as an artist and as a woman, and she plunged fully into the world of struggling painters and sculptors in New York. Her sisters recalled that, "It was the hardest time for her as an artist. Until then, she had been taken care of."[93]

For the next four years Nevelson would continue to stay somewhat connected to her husband, helping out with the cleaning, laundry, and childcare even though they lived separately through most of this period. But she would never again allow her personal life to interfere with her "destiny."

At the end of 1937, finally convinced that his wife would never return to him, Charles Nevelson left for Galveston, Texas, where he joined his brother, Harry, and never returned to live in New York. Charles and Louise were officially divorced in 1941. Too proud to ask for alimony, and also aware that her husband had no money to give her, Nevelson managed to get by any way she could during the difficult years of the 1930s. She started by hocking her diamond jewelry.[94] Her brother, Nate, with his flourishing hotel, was her principal financial mainstay. In return, she gave him her paintings and started work on a mural for the hotel.[95] The paintings show how much she had learned from Miller and, perhaps, even from Hofmann.

THE BEGINNING OF SCULPTURE

1934 – 1940

"My life is an open book, but there is a subterranean life I don't
want to reveal to anyone. And why the hell should I?"
—Louise Nevelson, Katrine Ames, "Gothic Queen,"
Newsweek, December 4, 1972

In 1964, in the first monograph on the artist, which quoted her extensively,
Nevelson described the significance of movement in her work and her life:
"I studied modern dance in 1930 and have never stopped since. I felt a body
discipline was essential to harmonious creation and to help me solve the plastic
problem, as I saw them both made of alternative equilibrium and tension."[1]
The "plastic problem" to which Nevelson referred was the aesthetic relationship
of objects in space. But it was not just this problem that she solved with dance.
More crucially, dance helped her explore her self, and unlock her sexuality and
her spirituality.

In the early 1930s, Nevelson was one of the many hopeful artists who pop-
ulated downtown Manhattan. She ended the decade as one of the few singled
out as especially gifted. Though she was still not making a living from her art (at
that time almost no one did), she was making something of a name for herself
as an artist.

During this time she was also searching for models and mentors. She found
two—Isadora Duncan and Martha Graham—in the world of dance, which she
saw as "a vital force . . . *carrying* America at that time."[2] For Nevelson, Duncan
"was like a breath of fresh air . . . because . . . *she brought this great, pioneering
spirit into movement*." About her other heroine, she said, "Martha Graham, by the

nature of her spirit, by the nature of her energy, by her presence and intensity, reflected our times. Graham . . . was a pioneer."[3]

In the late 1920s and early 1930s dance in America had undergone a revolution. The pioneers of the modern movement had thrown off the fetters of both the balletic tradition and the exotic approach of Denishawn. Martha Graham, Doris Humphrey, Charles Weidman, Helen Tamiris, and Edwin Strawbridge were developing and presenting to a small but wildly enthusiastic audience their new vision of dance with its freedom to explore and express the "drives, desires and reactions of alive human beings" unencumbered by decorative conventions.[4]

Some of the most ardent supporters of this new direction were the visual artists based in New York City, who had the greatest access to these new works. Graham had begun her independent dance company in the mid-1920s and presented her work regularly—thirty new pieces between 1926 and 1937. Nevelson went weekly to performances and knew all of Graham's work.[5] Her admiration for Graham was probably enhanced by the knowledge that the dancer had commissioned contemporary composers, such as Aaron Copland and Gian Carlo Menotti, to write the music and artists, sculptors even, like Isamu Noguchi, to design her sets.

Nevelson's enthusiasm for modern dance inspired her to take up the study of the new art form herself, but it was not the mastery of technique that intrigued her. Rather it was the promise of freedom that modern dance held out to its devotees. Despite—or perhaps because of—her admiration for Graham, Nevelson chose as her teacher Ellen Kearns, a forty-something non-performing dancer and masseuse, someone who might now be called a dance therapist, whom she had met through Diego Rivera.[6] This remarkable woman served as her next strong female role model and something of a maternal imago.[7]

> [Ellen] was a good ten years older than I . . . everything about her physically was wrong for dance. She was fat . . . she didn't have one part of the body that was beautiful. But basically she was such an innocent, such a unique person. . . .
>
> So I started and I studied dance with [her] several times a week, basically evenings. . . . And I question whether I'd have had the energy I have without [it]. . . .
>
> I studied with Ellen for a good twenty years or more. . . . There wasn't a student that she didn't bring to a higher consciousness. And she gave creative energy to anyone who touched her. . . .
>
> Ellen was one of the most unique people on earth.[8]

Through her study with Ellen Kearns, Nevelson found not only her energy and her higher consciousness but her true artistic vocation—sculpture. Ellen

taught her to slow down, reach to her roots, reconnect with her center, move with her own inner rhythm, and find the confidence and courage she needed for her art.[9]

Developing the freedom she desired and the ability to move with complete spontaneity was the core reason Nevelson worked for so many years with Ellen Kearns. She also intuitively recognized the link between the way her body could move and her work in three dimensions. As she later explained to her son: "Dancing frees your mind and opens it to sculptural possibilities."[10]

At least fifteen of the approximately thirty or forty sculptures she made between 1934, when she began to show her work, and 1941–42, when she exhibited at the Nierendorf Gallery, show figures in movement—in many instances the kind of movements Nevelson was doing with Ellen Kearns. Some of these sculptures portray Martha Graham in one of her characteristic highly expressive poses; others highlight the sexual features of the female figures. The handwritten titles include *Flight, Position* (1939) and *Dancing Lady* (1941).

Dancer (1938), like a number of the earliest sculptures, is focused on apply-

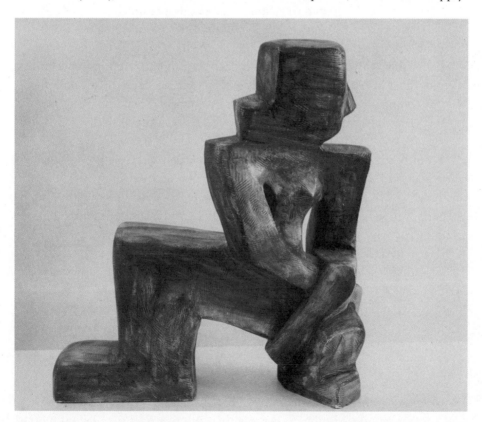

Dancer, 1938. Bronze. Photograph by John D. Schiff, courtesy of the Leo Baeck Institute

ing Cubism to work in three dimensions. Chunky, even a bit clunky as befit the times, the figure has traces of grace, gravity, and wit. The elegant position of the crossed arms is combined with her firmly upright overall stance. The dancer's head turns the opposite way from her right thigh, leg, and foot, as though she were exercising at the barre. However, the simple cubic thickness of the right leg and thigh are counterpoised against the much more dynamic arms, slim torso, and tense contraction of the left leg.

Classes with Kearns were small—no more than ten (mostly) women. Nevelson also studied privately with Kearns, and of course, also persuaded her sister Lillian to attend some classes.[11] Over time Nevelson became Ellen Kearns's assistant and close personal friend.

Mary Farkas, a fellow student, described the classes:

> The lessons would begin with a long sequence of floor work, stretching and quieting. Then slowly lifting up, vertebra by vertebra, ending in a grand opening spiral. The emphasis was on waiting or doing slow movements often self initiated that would encourage spontaneity.
>
> Other exercises were done for complete relaxation, which you would do in a descending spiral to mood music. Or hanging over from the hips doing things that would eventually lead to jumping, running or leaping. Ellen would hold a person while they exercised and make continuous comments accompanied by meditative music. Ellen's teaching also helped women to become more relaxed and sexually released.[12]

From Norina Matchabelli Nevelson had learned some of the rudiments of movement and presence. From Ellen Kearns she learned the entire alphabet and how to work poetically with her body. She recalled in 1967 that, as a young woman, "I took dancing too because I was tight and frightened and it gave me freedom. My whole way of living was geared to creativity."[13]

The hallmark of all the teachers to whom Nevelson was attracted in the 1930s and 1940s was their devotion to spontaneity and originality—her ultimate gauge of whether a teacher or a situation could promote her growth. It likely grew out of her experience of relative freedom in childhood. "Freedom," "uniqueness," "spontaneity," and "creativity" were the words she repeatedly used as high praise. They were words she had also heard from Krishnamurti in 1928 and the reason his teachings interested her for the rest of her life.

Nevelson felt that she had paid her dues to dutifulness and conventionality by spending nearly two decades of her life in the conservative town of Rockland and another ten years in the, to her, highly restrictive roles of wife and mother. By the time she definitively left her marriage in the early 1930s (probably 1933–

34) she would never again let herself be bound by someone else's ideas or someone else's subject matter. Finally living entirely on her own, Louise Nevelson had become an ardent individualist on a mission to find the best way to express her creative talents. Her growing freedom and originality would become evident in the way she looked and in her artwork.

During the life-changing years of the 1930s, Nevelson developed some aspects of her self-presentation that remained constant throughout her life. She never stopped attending to her personal appearance—it was a mainstay that helped her stand upright, above the crowd, despite the many rejections an artist must inevitably face while building a career. She also never stopped using her good looks to live a liberated life. Nevelson's personal appearance as a very attractive and sexy woman opened the door to behaviors that would have embarrassed and shocked her mother, as well as her former husband (now that they were no longer editing her wardrobe). It was the beginning of what some would label her promiscuous behavior. She saw it as her personal freedom to have as many and as many different kinds of lovers as she wanted. From then on it would be her choice to be with either a wealthy and successful or an impoverished but creative man.

Mary Farkas, her fellow Kearns student, saw the artist's promiscuity as an attempt to find herself as a woman and noted that Nevelson's sexual interests woke up at this time partially as a result of her study with Ellen Kearns. Thirty years later, Nevelson observed: "Isadora Duncan said that the absolute center is the solar plexus, but we studied that the center was in the sex organs."[14]

The disparity throughout the 1930s between her elegant self-presentation as a wealthy divorcée and the actual facts of her straitened financial situation created confusion for the young artists who met her and distrusted her as a dilettantish society lady—a repeat of her experience at the Art Students League. "So the great contradiction . . . always made a problem for me," she later declared.[15]

The people who knew her well—her family, some of her various lovers, even her fellow students at Ellen Kearns's classes—were aware that she was living close to the edge. They recognized the desperation behind the bravado and were always impressed with her constancy to her lodestar—that she would eventually succeed as an artist and was therefore justified in doing anything to advance toward that goal. Her sisters were especially sympathetic to her inclination to use whatever money she got, from whatever source, to buy expensive finery when she had barely enough resources to pay for food and heat. They may have also remembered—as Nevelson certainly did—their own days of poverty during their early childhood.

Dressing well with flair was part of Nevelson's aesthetic training. When she appeared at a meeting of impoverished downtown artists in one of her stun-

ning outfits—large hat, bright colors, odd combinations of fabrics and finery, or the latest in elegance—everyone recognized her, some with envy, some with admiration.

The attention fueled her "healthy narcissism," which Freud had described as like the preening of a contented cat, which draws others by virtue of her confidence and self-assurance.[16] In Louise Nevelson's case, the preening would have a positive effect on her finances, since some of the many men she slept with during this period would give her spending money she might never admit to needing, as well as some of the luxuries she always craved. She developed a flagrant promiscuity, picking up taxi drivers and having sex with many different men.[17] Sleeping around was not uncommon behavior in the New York art world of the time, and Nevelson pursued it with her usual vigor. "I could have played the role of the down-and-out artist," she later said, "but I wanted to have fun . . . I think I fed on it. It was exciting. . . . I liked to swear and I liked to drink and have romances. . . . I was very sure of what I was doing. I believed in myself and I was utterly satisfied with what I believed in. I wasn't going to let a soul on earth judge my life."[18]

One friend reported that, "Louise tried to shock us at the time with her earthy behavior and vulgar and dramatic language"—most likely as an attempt to appear sophisticated,[19] as well as a reaction against the polite, correct way she was supposed to speak as Mrs. Charles Nevelson. Nathaniel Kaz, an American sculptor who knew her well in the 1940s, disparagingly claimed that "she slept with anyone she was involved with and had a fucking room at her Thirtieth Street house."[20]

One of Nevelson's lovers from the time described her as "a strong personality who radiated beauty." He recalled: "There was no one with whom she didn't sleep. Anyone she met, she slept with."[21] Louise Nevelson could be a complicated lover. On the one hand, she could accept five dollars a week from Richard Kramer, one of the men who adored her, an impoverished émigré from Austria. On the other hand, she tried to persuade him that he too was an artist, encouraging him to write poetry when he was barely surviving by peddling shoelaces and underwear on the streets of New York.[22]

While Nevelson was closest to her mother and youngest sister, Lillian, and rarely mentioned her father, it was in her father's philandering footsteps that his now-liberated daughter trod. Some of her many lovers from this period were not so generous in their retrospective assessment. For example, David Margolis, a young artist, bitterly recalled: "She was like an older sister to me [he was twenty-three; she was thirty-five]. Whatever she asked me to do, I gladly did for her. I helped her out with money a great deal. . . . She never paid back. In the years I knew her she had many boyfriends, but no intimacy. There was no love, just a

façade."[23] And yet her sister Lillian, the person she saw most often at the time, saw her as "puritanical in a way. . . . You could count her serious boyfriends on one hand."[24] Nevelson herself described her amorous behavior as a kind of camouflage.

Alice Neel recalled that an attractive woman artist "had to have a double life."[25] At most, an attractive woman artist was supposed to look inconspicuous, like Georgia O'Keeffe, whose tailored black-and-white outfits became the model of sartorial appropriateness. Being the wife of the artist, photographer, and dealer Alfred Stieglitz gave O'Keeffe immunity that Nevelson never attained. Likewise, Frida Kahlo could wear her startling folkloric outfits. She was after all, a native-born Mexican. But more importantly, she was the wife of the world-famous Diego Rivera. By the time Louise Nevelson was trying to make it as an artist, she was divorced and determined to remain unattached. The protection she might have obtained from a husband or famous lover wasn't worth the risk of once again being subordinate to a man.

Nevelson had seen and understood how Diego Rivera had managed the contradiction of being a man of the people and a bon vivant who entertained royalty, how he could have many lovers, high-class and low, and also be seen as heroic and worthy of adoration, how he could be devoted to his work and nevertheless enjoy his evenings out with pleasure. Yet when she tried to do likewise—being periodically attracted to celebrities and high-society types—she was scorned for not being true to the leftist ideals of the downtown art world. That is, she was criticized, once again, for not fitting into the identity her compatriots had defined for her. Rivera was a man in a man's world, and, despite what she had learned from her parents about the equality of the sexes in America, it was simply not socially acceptable for women to act like men.

Nevelson's stylish self-presentation, combined with her ferocious ambition and self-confidence, contributed to her reputation as a prima donna. Many of the artists who knew her during the '30s—particularly the men—distrusted her and her work. They saw her, as Robert Cronbach, a fellow artist, put it, as "always trying to get into the Sculptors Guild without great success. . . . Other sculptors liked her work but not enough to vote her in."[26]

Though she toiled just as hard as her fellow male artists during the difficult years of the 1930s, Nevelson was not invited to join any of the cliques—like "The Ten"—that eventually formalized themselves into artist groups, with power to exhibit.[27] Looking backwards at the years of exclusion, Nevelson felt that she had been treated unfairly. However, it is just as likely that she walked away from some opportunities for inclusion, given the evidence that, when she decided to be a crowd joiner in the 1950s, there were few groups she was not a part of, much less ones in which she did not have a leadership role.[28]

It would make sense, then, that Nevelson herself determined that she should go solo in whichever direction her fancy took her. That was a family tradition. After all, her father had made it on his own in a foreign land, away from his brothers and the other Jewish families in Rockland. As her sister Anita claimed, "I think we're loners. I like to be alone, and I think Louise does also. We're not club people."[29] The same held true for politics. Like most of the downtown artists she attended some political meetings, stood on some picket lines, had the requisite leftist tendencies but was not a committed activist. She remained aloof from the strife surrounding her and, except for meetings about art, did not participate in most of the demonstrations that characterized the period and the place (such as the many marches and protests against Fascism in Europe or unbridled capitalism in America).[30] Why should she want to be part of a group that would have tried to impose its moral, aesthetic, or any other standard on her newly liberated self? Why divert to the political sphere the energy and finances she husbanded solely for her work? It was diversion enough that she had to deal with day-to-day survival and the responsibilities of parenting a teenage son—not to mention the physical impositions the new materials and new sculptural techniques forced upon her.

In April 1934 Nevelson moved into a small studio at 51 West Tenth Street, a well-known building of artists' studios where there was good light but no central heating. Here she continued painting and drawing. Some time that year—or perhaps the previous year—she began to sculpt. She might have felt rudderless during this period if she hadn't had the constant support in New York City of her sister Lillian and her brother-in-law Ben Mildwoff, a young commercial artist whose home had become a meeting place for their artist friends. It was there that Louise met the rising young sculptor Chaim Gross, who invited her to attend his classes at the Educational Alliance.[31] Nevelson's and Gross's accounts differ markedly about the length of time she studied with him—varying from two months to two years[32]—but Gross recalls that her talent in sculpture was evident from her first evening in his class.

His low fees and well-known generosity toward students certainly appealed to Nevelson, but she had other reasons for wanting Gross as a teacher. He was considered one of the major young talents on the New York art scene. His chunky, somewhat cubistic wood work was characteristic of the "modern" style of American sculpture in the mid-1930s, and he had had two solo exhibitions by 1935 and had been in several group shows. He had also received a Tiffany fellowship. He had greatly promoted the art of wood carving,[33] and his work in this medium was increasingly illustrated in art magazines.[34]

In any event, Nevelson discovered in his classes that she was a natural-born sculptor, immediately at home with three-dimensional work. Gross recalls tell-

ing her that she was very talented and would be a great artist.[35] With his instruction, Nevelson developed rapidly enough as a sculptor to exhibit at the newly established Gallery Secession in 1934[36]—the same year she began studying with Gross—and again in May 1935 at the Brooklyn Museum's *Sculpture: A Group Exhibition by Young Sculptors*. For that exhibit she submitted a plaster, *Two Figures*, and described herself as "self taught."[37]

Nevelson's transition from student to professional would, however, occur over a period of several years, which coincided with her participation in the WPA—or Works Progress Administration—the most ambitious of Roosevelt's New Deal agencies. Between 1935 and 1943, the WPA hired over eight million unemployed Americans to work on public projects, building or repairing infrastructure around the country.

The visual arts arm of the WPA was the Federal Art Project, and its goal was to employ out-of-work artists who would teach, make art for public buildings, or do art research. The WPA paid them about twenty-five dollars a week (then a living wage) for about twenty-five hours of work and, when possible, arranged for exhibitions of their paintings and sculpture. It provided jobs to approximately five thousand artists and lifted the boats of all creative people in the United States, especially those in New York City.

Of the many young people trying to catch the brass ring, only a few who worked or exhibited alongside Nevelson became world famous and helped establish New York as the new center of modern art. Those few included Adolph Gottlieb, Arshile Gorky, Alice Neel, Mark Rothko, David Smith, Jackson Pollock, and Willem de Kooning. Most of the others have vanished into obscurity.

The government program, which not only saved but created a generation of American artists, had stipulated that women be treated equally with men. That unprecedented step went far toward equalizing the playing field, which, for centuries, had privileged men. Forty percent of the painters, illustrators, and designers on the WPA were women, though the male-oriented bias continued with regard to sculpture, as only men were deemed strong enough to handle the manual labor.[38]

The first five years of the WPA were the golden age for thousands of American sculptors, particularly those in New York City. And the technical innovations and stylistic experimentation of this period ended the long period of stagnation under which American sculpture had been languishing. Special demonstrations of new sculptural techniques—put on at WPA project workshops or at venues sponsored by the Artists' Union—were held frequently.[39] It was at one such government workshop on West Thirty-Ninth Street, run by Louis Basky, a sculptor, that Nevelson claims to have learned the techniques of sculpture as part of her training in the WPA.[40] Basky ran a foundry and provided much of the techni-

cal expertise and labor for sculptors in the 1930s and early 1940s.[41] He fired clay pieces, did plaster castings and, along with his apprentice, Alexander Tatti, developed new techniques and aggregates for casting in both plaster and metal. Many of Nevelson's works from the late 1930s on were made or cast in "tatti-stone," an aggregate of marble dust, color, stone chips, and hardening agents, which was invented by Tatti.[42]

Lacking the prestige needed to be placed on the WPA's list of fine artists, Nevelson was initially hired as an art teacher. Her first job, in March 1935, was as a teacher of mural painting at the Flatbush Boys' Club.[43] One of her last assignments was teaching painting three days a week, four hours a day, at the Contemporary Art Center housed in the 92nd Street YMHA. The ease with which an artist on the project might switch media or even categories, such as painter-teacher-sculptor, had to do with the informality of the arrangements made by supervisors.[44]

Announcements in the local press informed people about the upcoming free classes at the Boys' Club and introduced the distinguished teacher: "Miss Nevelson is in charge. She has studied in France and Germany as well as the United States and enjoyed the advantage of working with Diego Rivera, the noted Mexican artist."[45] In June, she wrote an article for *Flatbush Magazine*, illustrated by the children's drawings and a photograph of herself. The attractive young teacher expressed her enthusiasm for teaching and her views on creativity: "I joined the Flatbush Boys' Club staff a few months ago, so, for the first time in my life I took a job, and since then I have a continuous flow of artistic material. . . . I won't call it teaching to let children express themselves in a natural way. . . . After all color and form [are] what the world consists of, and to me they are as alive as I am."[46]

Tales of the glorious past abound in the recollections of those who were leftist intellectuals or artists in the downtown circle where Nevelson thrived in the 1930s. The WPA brought everyone together. Most people helped each other, and the easy camaraderie was infectious. All faced a common enemy—the philistines and anti-intellectuals of the exploiting class—but for once the creative men and women had the government on their side.[47] They were enthusiastic and hopeful about the future.

Dorothy Dehner, the wife of David Smith and Nevelson's lifelong friend, recalled that, because of the WPA, "A whole generation of artists got their entire training in America." They might have been inspired by French artists, but "they didn't have to go to France in order to be artists."[48] Years later, Nevelson observed that, "Without the WPA New York would not be the number one art center today."[49]

One of the thousands of young unknown artists involved in the WPA was Lillian Mildwoff, who showed her work next to her sister's watercolors in 1936

at an exhibition put on by the Municipal Arts Committee. "We were all poor," she remembers. "Louise would bring the food over to my house. I had the wine, and we would have dinner. I was the only one working because I was a college graduate and I was able to get a job at Macy's for eighteen dollars a week. Everyone was generous. The artists would go to the cafeteria and get salads and then we'd make something out of that. Now if you struggle, you struggle alone. At that time, you had a group to struggle with you. If one person was in trouble, all of us were in trouble."[50]

To become part of the ever-growing group of artists working for the WPA, one had to declare poverty and the total absence of family support. Contrary to Nevelson's later assertions that she only joined the WPA in its last year of existence, her employment record notes that she was a participant from its inception in 1935 until the massive layoffs in 1939.[51] She later claimed that she was reluctant to expose her family to the fact that she was on relief. But she was willing, like most young aspiring artists, to make a false claim in order to get government support.

In June 1936 Nevelson exhibited twelve drawings and five small polychrome plaster sculptures, including images of ducks and dancers, in the First Annual Competitive Exhibition sponsored by the American Artists' Congress held at the A.C.A. Gallery on West Eighth Street.[52] Competing in a pool of 175 artists—most of whom had never had a one-person exhibition—Nevelson was among the four prizewinners selected for a further competition and an exhibition to be held that September. Her works were especially praised by both Genauer and Devree, art critics working respectively in the *New York World-Telegram* and *New York Times*.

A few months later Louise Nevelson and her sister Lillian Mildwoff exhibited paintings in the Tenth Exhibiton of the Municipal Art Committee in July 1936—a remarkable example of how persuasive Louise Nevelson could be when it came to encouraging people close to her to engage in their own creative pursuits.[53]

A year later, the American Artists' Congress again winnowed the field of hundreds of eager young artists who submitted their work in a competition that would culminate in a one-person show. Nevelson made the first cut. While she was not selected as the winner, she was one of only five sculptors mentioned by a critic reviewing the exhibition. Her "polychromatic abstraction" was cited along with the three other representational artists whose subjects were either heavy-handed social realism ("factory workers, a gaunt refugee and a newsboy") or an inoffensive and timely topic (a "gently caressed dancer").[54]

In July 1938 she exhibited with other WPA artist-teachers in a show of over a hundred works at the Federal Art Gallery on West Fifty-Seventh Street. The

reviewer observed that Nevelson was among the few familiar names.[55] Six months later her sculpture was included, along with the work of eighty other artists, in "The First Union Sculpture Show" at the New School for Social Research in New York City. In all of these exhibitions, Nevelson had been selected by juries of distinguished artists, highly praised by some critics, and at least mentioned by others. She had good reason to feel pleased and confirmed in her sense of her own talent.[56]

Richard Kramer recalled: "She was convinced that she would become a great artist, and if you tried to tell her she wouldn't, she would have laughed at you. She didn't need any encouragement."[57] Her conviction and determination propelled her forward, and her energetic efforts got her the press any ambitious artist would have hoped to get. In this regard she embraced a closely held belief for generations of her father's family: that persistence and talent would inevitably lead to success.

Between December 1935 and June 1939, the WPA had sponsored forty exhibitions, and Nevelson had participated in at least seven of them. She had been selected by juries for honors and had won notice by the press, even the lofty *New York Times*. Then it was over. In July 1939, along with seventy-five percent of the artists on the WPA in New York, Louise Nevelson received her pink slip from the government.[58]

What was it about Nevelson's work that won her attention from juries and critics? The artist's earliest sculptures that can be identified and dated with certainty are the four pieces that were photographed for the WPA archives in 1939 and 1940—*Girl Reading, Mother and Child, Two Head Composition*, and *Cat*. That they were photographed strongly suggests that Nevelson was, at some time, in the Sculpture Division of the WPA.[59] All are polychrome plaster pieces, which have been squared off—or rather cubed off—in a compositionally interesting and, in some instances, compelling way. At least so they seemed to Howard Devree at *The New York Times*, who stated that "Miss Nevelson caricatures duck and dancer in water-colored plaster and reveals strength."[60]

Emily Genauer, then a young critic at the *New York World-Telegram*, misidentified the plasters, which she describes as "small wooden sculptures conceived abstractly and . . . coated with multicolored paints." Nevelson applies color "as though she were working on a canvas instead of in the round. She uses it plastically and structurally, to emphasize some planes and de-emphasize others, to increase the volume of a certain section as it stands in relationship to another."[61]

The chunky works were figurative, often representations of women, sometimes specifically self-portraits. They were forceful and many displayed an originality that was unexpected from a newcomer.

Mother and Child, dated 1934, has a pyramidal solidity much like the works of Henry Moore and the pre-Columbian pieces that Nevelson would have been

seen in New York museums. Her originality was visible in the cubed-off forms of the plaster, which are piled on one another in a more dynamically vital way than they seem at first glance. When one considers what cannot be seen in the black-and-white photo—the color variations of each face—it's easy to understand why critics selected Nevelson's early "cubistic" work for praise. This seemingly stolid chunky sculpture hinted at Nevelson's future mastery in subtle composition. Anti-formalist social realism was so much in the air in the New York art world at the time that Nevelson's early experiments seem daring by comparison with the work of other successful sculptors, such as Aaron Goodelman.

Girl Reading, also dating from the WPA period, is a polychrome plaster with planes outlined by broad dark lines. This work conveys a sense of the rhythmic fluidity Nevelson was learning from Ellen Kearns through the masterful management of large rounded shapes: The thighs make a platform for the arms and torso, which are moving back and forth in a kind of rocking rhythm as they comfortably support the expressively painted head and heavy chunk of hair at the top of the sculpture. A viewer can kinesthetically identify with the girl's position while wondering how on earth she maintains her balance at the bottom of the steps, which are her feet.

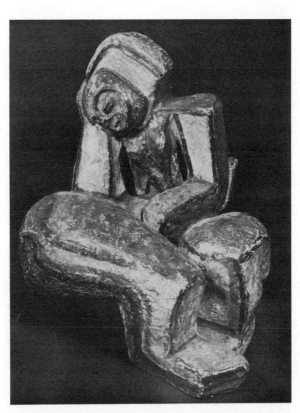

Girl Reading, 1936. Plaster, 4 ½ x 4 ½ in. No longer extant. Source unknown.

It seems that most of the early pieces were reworked, either painted over or cast with a patina, so that the color, and the resulting "cubist" effect noted in reviews from this period is largely lost. About these works, the artist noted, "I painted each plane a different primary color so that the form would be as clear a line as architecture."[62] Nevelson's words are consistent with her belief that color and form were both vital and equal in importance. As time passed and the fashion for monochrome sculpture predominated in the art world, Nevelson gave up the use of color in her sculpture. She would not return to it for another fifty years.

By painting each major surface plane a different primary color, Nevelson was working with the vocabulary of synthetic Cubism, but her way of adapting what she saw differed greatly from the European inheritors of the Cubist tradition in sculpture. Instead of restructuring the object by reassembling planes in complex juxtaposition, Nevelson took some surface planes and flattened them, thereby reducing the structure of the figures to a relatively small number of cuboid shapes. In the process, she set up some powerful planar tensions. This "misreading" and simplification of Cubist sculpture was common in American sculpture in the mid-to-late 1930s.

Nevelson's search for a formal vocabulary was always couched in her discussion of the importance of Cubism. Sometimes her ideas about Cubism link up with her ideas on metaphysics, but they always lead back to her admiration for Picasso: "Picasso found the cube—that's wisdom tripled. I love Picasso. It doesn't matter whether or not he studied metaphysics; he was born into this wisdom. . . . The cube was like my *grandfather*. I was born with this objective form in me."[63]

It was Picasso's exceptional capacity as a master of composition that she particularly hoped to achieve. In what she considered a courageous act, Picasso had broken with the norm in order to participate in the invention of Cubism, and for her, this outstripped his many other contributions to art:

Now three dimensions is physical, the world of reality, so-called. But I think the Cubists went beyond. Take something like a chair or a cube. You can only see three sides. . . . We assume that a fourth side must be there or it wouldn't stand up. Our eye can never take in that dimension, but the mind does. It's not what you see, it's what you are assuming to *finish* what you are seeing that is, for lack of a better definition, the fourth dimension. Cubism gave us that assumption.[64]

Titanic as he was for European artists, Picasso loomed even larger to the American art world. He had changed the image of a modern artist through his prodigious capacity for invention and production. Nevelson perceived him as a

kindred spirit: "Picasso and I work on the same wavelength. I think it's in us."[65] She saw herself as a master of the horizontal and vertical in sculpture, with a talent akin to Picasso's gift as a Cubist painter.

The freedom Nevelson exhibited in her earliest sculptural work—the range of ways in which she chopped up, put back together and painted planes with different colors—echoed her understanding of Picasso's Cubism, both analytic and synthetic. While her planar divisions tended to be larger and fewer than Picasso's work from the early and mid-1930s—closer to the primitive or pre-Columbian sources that inspired both of them—there are striking parallels. In her intuitive way, Nevelson understood Picasso's grasp of the freedom of primitive art in combination with the sophisticated break with pure representation he had learned from Cézanne. She saw how this allowed him to move rapidly through the various stages of analytic and then synthetic Cubism.

During the 1930s and early 1940s, Nevelson's most formative years, Geometric Abstraction, an offshoot of Cubism, vied with Surrealism for position as the most advanced style on the New York scene. Nevelson was part of the modernist group in New York, and her sources, like other American modernists, were coming from Europe. Cubist work of the Paris school, as well as Constructivist works, De Stijl, and Neo-Plastic pieces,[66] all could be seen in New York during the 1930s and early 1940s at the Museum of Modern Art, Albert Gallatin's Museum of Living Art at New York University, and Solomon R. Guggenheim's Museum of Non-Objective Art. In addition, a number of small galleries, usually run by European dealers, kept the most important and often the latest works of abstract art on view.[67]

As was true with Surrealism, the arrival in New York in this period of major abstract artists such as Mondrian, Léger, and Lipschitz spurred great interest among New York painters and sculptors.

From the mid-1930s through the early 1940s, Nevelson was experimenting both socially and artistically. She had moved many times between 1934 and 1939, living first on York Avenue, then West Tenth Street, then Bleecker Street, then on East Fifteenth Street. By the summer of 1939 she had moved into a three-room "railroad" flat at 311 East Twenty-First Street. During this turbulent time, her son, Mike, spent one year (1935–36) at the Peekskill Military Academy, which he initially liked but was very glad to leave in order to stay with his mother while attending Stuyvesant High School in Manhattan. While he preferred staying in New York, his presence created awkwardness for his sexually liberated and hard-working mother, and she sent him away much more often than he wanted. In the end, he opted to finish high school in Rockland, "where I can support myself and graduate with little effort."[68] He knew that in the summer he would see more of her, since she often came for long visits to her parents' home.

Mike's letters to her from Rockland alternate between claiming to be just fine—working for his uncle Nate at the Thorndike Hotel, swimming, boating with friends, dating local girls, and riding his motorcycle—and wanting to come to New York as soon as possible. Similarly, he fluctuated between writing to his mother as if she were a pal, "Dear Lou," or "Dear Mother," thanking her for a gift or money.

Taking care of her son was a difficult subject for Nevelson, who had to face her ambivalence about being a mother while being an artist.[69] Her youngest sister Lillian, by then a mother herself, tried to help by paying for Louise's appointment with a psychoanalyst—"one of the best doctors in the village." "She was going thorough a lot of hell and she came out of his office saying, 'He just told me that I know too much.'" Unsure whether her sister had actually been told that or whether the doctor had concluded that she was too resistant or simply didn't want help, Lillian only knew that Nevelson never went back for another session.[70]

The third Berliawsky sister, Anita, had also left her husband but chose to stay in Rockland, working for her brother at his hotel and taking care of her son George. Minna Berliawsky was disappointed with the unsuccessful marriages of her two older daughters, but she was usually the person at whose home they dropped off their sons, leaving her to care for them.[71]

Though Louise Nevelson had some exceptionally rewarding experiences during the 1930s—having her sculpture exhibited and well reviewed, winning honorable mention for her neophyte work, even being part of the community of professional artists on the WPA—it was also a very difficult time, psychologically. She tells of a particular moment of depression in her autobiography, which she identified as different from the despair she had felt on her second trip to Paris: Paris "was a bit of reality, and disappointment. But this was total death."[72]

Her recollection begins with a description of a young man, "very quiet and very intelligent and very gentle," who headed a dental clinic she attended. He showed interest in her and asked if he could visit. She put him off until the summer when her son would be away in Maine. "I was really looking forward to it, because I had great respect for him and his abilities. Certainly I wasn't thinking of anything too serious." When she called him and invited him over, she was amazed that, instead of the "fine relationship" she had expected, he threw her on the couch with the obvious intention of attacking her sexually. But nothing happened because he saw in her eyes how utterly shocked she was. He got angry and left. Stunned by the incident, she lay paralyzed on her bed and listened to the sound of her cat attacking a bird. "I couldn't open my eyes, I couldn't confront it. I knew what was happening. I knew that the cat had attacked the bird. I was alone, and I thought, I can't take it. I'm going to leave this place."

So she got up, and set off to see the last performance of Sherwood Anderson's play *High Tor*, starring Burgess Meredith, which, she had noted in that day's *New York Times*, was about a ship that sank with all its passengers aboard. "Well that's all I needed," she recalled in her autobiography decades later. "And it took me back into death and metaphysics, and I thought, Did I have to attract that? . . . It meant that I was attracting the bird with the cat, and I came here and there was death."[73]

Nevelson had just been through a period of promiscuity. She could have felt that her lively interest in sexuality was responsible for the attack, that she had invited it. "Drowned. The ship went down . . . I was in a terrible state . . . I saw graveyards. . . . There was death, . . . I saw fire. And I'd go to bed every night like that."[74]

The same day as she saw the play, June 5, 1937, the front page of the *Times* had carried the headline, "Germans Execute Hirsch, U.S. Citizen."[75] Despite repeated American appeals for clemency, a twenty-one-year-old Jewish man who was accused of taking part in a bombing plot against Julius Streicher, "the Reich's leading Jew hater," was guillotined. Hitler had signed the order for the death of the young man, who, though he had never lived in the U.S., was an American citizen.

Nevelson knew that Fascism was on the rise in Germany and Italy and that, at the request of Spanish General Francisco Franco, German and Italian planes had been dropping incendiary bombs during the previous six weeks, killing thousands of innocent civilians in Basque towns—the most notable being the nearly total destruction of Guernica, an ancient Basque city, on April 26, 1937.

Since 1920 she had lived in New York, a city where her friends and colleagues included creative artists and intellectuals, many of whom were Jews. Hitler's takeover in 1933 and his immediate introduction of anti-Jewish policies throughout Germany were reminiscent of what had happened in the Russian Empire under the czars. It was happening all over again in Germany and Austria. "I saw graveyards. . . . There was death . . . I saw fire."[76]

The paralysis and depression Nevelson describes that summer day was made up of many elements: her memory of *High Tor*; her memory of being attacked by a seemingly gentle man; her memory of a bird being overpowered and killed by a cat; and, perhaps most important, the death of an American Jew in Germany—all of these undergirded by traumatic childhood experiences and memories. How could she not carry silent scars of these early memories in Shusneky, which had permanently traumatized her mother?

In 1937 she could not yet know the full horrors of the Holocaust to come—how her vision of fire and cemeteries and death would become the world's vision. But when in 1976, in the pages of her autobiography, she reported her memory

of a huge cat in the process of destroying its birdlike victim, she could have ret-rospectively elided her memory of the time with the knowledge of horrors that were at that time still to come. Regardless, that summer Louise Nevelson knew enough to be very frightened about the future.

After the end of the WPA, poverty was again playing a role in Nevelson's life. It had marked her earliest childhood, and being confronted again with its gnawing dangers in her late thirties, after having lived high off the hog during her early twenties, was discouraging. Even though checks from her brother arrived regularly, it was never enough. She always needed more for her art. She consistently solicited financial aid from her family, friends, and lovers to cover these expenses and often didn't repay them until long afterward.

There was no way her family would have abandoned Louise, "the artistic one." But their help could only go so far. By the end of the thirties it was a com-bination of the restricted circumstances for artists and the chilling danger for Jews that weighed heavily on Louise Nevelson. She would have to find her own way to make it past the depression and danger that faced her and the rest of the Western world.

SURREALISM

1940–1946

"New York in the forties . . . was almost like you were breathing
the air of Surrealism."

—Louise Nevelson, *Dawns + Dusks*, 1976, p. 88

I n the summer of 1939 Nevelson moved into a three-room railroad apartment
on East Twenty-First Street, where she lived with her son Mike, who would
begin studying at New York University in September. In March 1940 she
exhibited in a show with about fifty other sculptors at the New School for Social
Research. The exhibition was reviewed in *The New York Times*, and while Nevel-
son's name was mentioned, her "color piece" was not considered a success.[1]

The contradictions in her life had not abated. In 1941 she was still pre-
senting herself as the ex-wife of a well-to-do husband while simultaneously
announcing her leftist sympathies: "I went to teas, luncheons, dinners, and I saw
women making serfs of their servants and of the people who waited on them. . . .
I saw the principle of what makes war beginning in the life around me, and it
disgusted me."[2]

During this time her brother, Nate Berliawsky, was sending her $225 a
month to keep her from starving. Appalled that she was walking around in
the winter with holes in her shoes and using layers of paper to keep her feet
dry, he gave her money to buy boots. She spent the cash on art supplies. "I
made many trips to New York to take her shopping, and she wouldn't let me
buy her anything. She would say, 'Why not just give me the money.' But I
knew she would spend it on sculpture material. She loves clothes and didn't
have to go without, but she wanted to buy paint instead of clothes. She was a

character. She liked to drink and would say, 'Come with me to the bar and buy me a drink.'"3

By the summer of 1941 Minna Berliawsky was again ill. Nevelson had not participated in any exhibitions all year, and Mike, fed up with school and unemployment, had joined the Merchant Marine, leaving home for points unknown. The threat of United States involvement in the European war, now in its second year, hung in the air. The world situation could not have looked worse, and now, because of her son's enlistment, it felt personal. In early September Nevelson impulsively—according to her—went to the gallery of the German-born dealer Karl Nierendorf, telling him that he *must* give her an exhibition.

Her published recollection explains her motivation, describing it as her reaction to a weekend spent with a wealthy, distant relative. The man's high living and ready cash were intensely appealing yet totally at odds with her everyday life. Feeling professionally and financially desperate after lunching at the Plaza Hotel with him, "I said to myself, what's the best gallery in New York? Well, I'm going in there and if I don't get a show, I'll shoot [the gallerist]."4

Nevelson didn't have far to walk, since the "best" galleries in New York at the time were a few blocks away on East Fifty-Seventh Street. Nevelson had been studying the galleries and their owners for some time, and she had already calculated that Nierendorf—ambitious, canny, and skilled at achieving meteoric success for his artists in difficult times—would be the most likely to respond to her approach.

"Now Nierendorf . . . was the one who brought and introduced Paul Klee to this country. He had Picassos, he had all of those European artists. . . . So I went in there and I introduced myself. And he said: 'What can I do for you?' and I said, . . . 'Well, you can come and see my work.'"5

This part of the story is a condensation of various versions, most of which note that she brought photographs of her work for the initial meeting. Her good looks and bold overture—she often claimed to have sat down on his desk, seductively crossing her legs—combined with his susceptibility to tall, handsome women, increased his interest in her work.

She may have known that Nierendorf had provided a monthly stipend for Paul Klee for ten years, and she certainly knew that he had successfully promoted Klee's reputation to the point that the Swiss artist had become "as important as Picasso in the U.S."6 Klee's work had strong appeal for American artists and collectors because of his ability to create a private world, utilizing the essence of both Cubist and Surrealist styles.

Her ambition to achieve Picasso's renown could have clinched Nevelson's decision to approach Nierendorf. Furthermore Nierendorf's conviction that

spirituality lay at the heart of contemporary art would have been particularly appealing to her.

Nierendorf was perennially optimistic and about the age of her former husband. He even looked a bit like Charles Nevelson. She might also have noted some similarities between Nierendorf and her father, another charming European émigré. Short, a little stout, balding, but charming, scholarly, and highly cultivated, Nierendorf was friendly with musicians, architects, and theater people who came to the gallery after hours for informal recitals, lectures, and discussions. He radiated warmth, and one of his favorite sayings was: "It's love that dominates the world."[7] His views on the connectedness of all art were in tune with Nevelson's.

Nevelson guessed correctly that the dapper German-born bachelor would be open to a connection with an attractive Russian-born American, whose passion for modern art had taken her first to Munich and later to Paris. After her years of study with Miller and Nicolaïdes, and even her brief time with Hofmann, she was firmly embedded in a formalist tradition—Cubism and its derivatives—the same qualities that had interested Klee.

Her own limited education made Nevelson susceptible to the sound of scholarly talk. Nierendorf combined learned language with intense enthusiasm, which made his gallery seem more serious and less superficially sophisticated than other more prestigious establishments on Fifty-Seventh Street run by European dealers: Pierre Matisse, Valentine Dudensing, Paul Rosenberg, or the Francophile Julien Levy.[8]

Nierendorf had been hoping to attract some of the European Surrealists who had come to New York in the early 1940s, but they saw him as being in the "other" camp—representing German Expressionists, Kandinsky and Klee. They were correct. Though Nierendorf was occasionally able to include a few works by Max Ernst or Joan Miró in specific exhibitions, his stable was solidly un-Surreal. When Nevelson wanted to move in that direction, she showed elsewhere—as she did on two occasions in 1943.

Nierendorf went to Nevelson's apartment on East Twenty-First Street the evening of the day they met (or very soon afterwards). As a result of that visit, he offered her a one-woman exhibition within a few weeks. According to her sister Lillian, "Nierendorf also bought one of Louise's sculptures, which was quite a break for her, as it was the first time she had sold to a gallery."[9]

The story Nevelson told her friends at the time may be closer to reality. According to Jan Gelb, an artist who had been friendly with Louise from the early 1930s:

She had shown some of her work to Nierendorf, and he was quite impressed with it, and he said he'd like to come and see some more. She

said, "Surely." And he came to her place, and he liked what he saw. He said, "Beautiful, beautiful. Do you have any more?"

And she said, "Yes a lot. It's down in the cellar. Do you want to see them?"

He said, "Yes." And so she started downstairs to the basement where more work was stored. She was walking in front of him. (He was a little man, and she's quite tall.) He sort of patted her on the shoulder and said, "You know, you're a fine artist. You really are a fine artist." And she turned around and said to him, "Mr. Nierendorf, are you here on art business or fucking business?"—with that crisp New England voice that she can exaggerate when she wants to. He probably stumbled the rest of the way down.[10]

By 1941 none of the U.S. galleries could obtain works from Europe, and the more open-minded ones were on the lookout for American artists. Nierendorf had been working as an art dealer in Germany since 1920. From the time Hitler was elected in January 1933, the art world deteriorated so rapidly that, by 1934, Nierendorf was torn about whether he should stay in Germany or leave. The stress led to a heart attack and a six-month hospitalization. In May 1936 he set out for America and a few months later decided to stay. He quickly learned English, and in early 1937, he opened a gallery across the street from the new Museum of Modern Art. The arrival of the Nierendorf Gallery was noted in *The New York Times*, and most of its exhibitions were reviewed. A year later he moved the gallery to an equally prestigious location, 18 East Fifty-Seventh Street, which is where Nevelson met him.

Once the war began in Europe, Nierendorf could neither maintain his connections in Paris and Berlin nor receive deliveries of artwork. He then turned to American artists, albeit in a limited fashion. A few months before Louise Nevelson contacted him, Nierendorf had opened an exhibition, *Masters and Vanguard of Modern Art*, which included all the major players from the School of Paris and German Expressionists. The few Americans in the show were non-objective abstractionists.

There were additional reasons for Nevelson to have approached Nierendorf when she did. The Nazis were on their way to Moscow and Leningrad. The fighting was going badly for the Allies, and Roosevelt was preparing America for a more active role. Broad hints of a U.S. military draft were floated in the news. Nevelson's son was nineteen, ready meat for a military call up. He had been at sea on the SS *Carib Star* since the end of May 1941 and seemed to be enjoying his new life sailing to and from the Caribbean, stopping occasionally in New York or Norfolk and proudly sending his mother ten dollars a week.

By the end of the summer, Mike Nevelson had found his sea legs and planned to attach himself to a better ship. He had also found his voice as a young man no longer emotionally dependent on his mother. In a remarkable letter dated August 29, 1941, a few days before his mother walked into Nierendorf's gallery, he apologized for speaking so severely to her during a recent telephone call, "but I could not tolerate your infantile and hysterical attitude any longer. Your dramatic threat to commit suicide was as phony and pathetic as the feeble attempts of a ham actor. If you *were* in the hospital, it was probably to remove a bunion." He then acknowledged that it is natural for her to want her "prodigal son [to] return from his wanderings and settle down to a humdrum life." But after telling her that he has sent her fifty dollars in traveler's checks, advising her not to throw this money away and warning her that he will be cutting down on her allowance so he can start saving, he states that, "you will have to learn to tolerate me and my new life. Nothing will force me to do other than I have planned. I would like to know that I still have a home to return to and a mother that I can sincerely confide in."[11] Mike Nevelson in the Merchant Marine, was staying at sea through most of the war, and often taking hazardous assignments.

It seems likely that her son's declaration of independence had a beneficial effect. It appears to have pushed her to think more maturely and behave more responsibly. She recalled: "I certainly entertained suicide. But . . . I was a parent and I just couldn't let anyone down. I certainly wanted to."[12] It is also noteworthy that, at the very moment her son was moving far away in frightening times, she was attaching herself to a distinguished older man—as a protector and a faithful supporter—a father figure. Nevelson's ostentatiously independent behavior was often contingent upon her having found some kind of close supporter —a dealer, a servitor, a lover, or a very good friend.

In her autobiography, she expressed her concern about her son. "And Mike was in the war, at sea with the Merchant Marines. When he went to Egypt or Russia and it was secret, they couldn't inform us, and for six months at a time I didn't hear from him. It threw me into a great state of despair."[13]

When it became obvious that Mike had committed himself (at least during the war) to a life at sea, Louise Nevelson moved in June 1942 to a cold-water flat at 92 East Tenth Street, in a building occupied mostly by artists at the center of what would soon be called the New York School. She lived there until the fall of 1944.

Nevelson's relationship with Nierendorf quickly became intimate, though probably not for long, and for the next six years until his sudden death in 1947, he encouraged her and helped her financially. According to her recollection, he constantly praised her artistic talent.[14] He lent her large sums of money and paid for her clothes for the openings of each of her five solo shows and two group

shows. Twenty years after he died she told an interviewer how her "dedication and drive had prompted Nierendorf to predict, 'Nevelson, you are going to have every wish of your creative life fulfilled. I know artists—that's the way you are made.' This prophecy was to be her talisman. . . . 'Nierendorf was like a godfather, and his conviction gave me strength.'"[15]

This prediction, coming during the artist's early forties, could have reminded her of Sholem Aleichem's prophecy at her birth. It fits rather neatly into an increasingly neat life story. But when the narrative of Nevelson's relationship to her first dealer is told by a more objective reporter, a more complicated picture emerges.

Some time around 1943 she "regally swept into Karl Nierendorf's office and speared that rotund little man with a fierce, almost knightly, gesture in her visage, speaking down to him: 'What do you mean by saying that you like my drawings better than my sculpture? . . . Oh well, half the time you people don't know what the hell you're talking about anyway. . . .' She changed the subject as if flying from one trapeze to another. . . . 'And for Christ's sakes, stop saying behind my back that I'm more interesting than my work.'"[16]

This exchange was described in his memoir by Jimmy Ernst, Max Ernst's son and an ardent supporter and longtime friend of Nevelson. It reveals the bittersweet bargain that fate sometimes metes out for any talented person who is also attractive and alluring. Is it the talent or the charisma that brings success? If it is both, how can the person believe in or convince others of his or her giftedness? Beautiful women and wealthy men have a similar problem: Will anyone ever love them for themselves?

Nevelson was undoubtedly *interesting* to Nierendorf. They could talk on the phone for hours. Though they never had a full-fledged or lengthy affair (he supposedly wanted one and she supposedly did not), nevertheless they had an understanding. Just as he appealed to her as the ideal combination of sophisticated, romantic European who was also passionate about self-expression and spirituality, she appealed to him as the powerful, earthy, determined, and exciting American voice of the future. They were both ferociously ambitious and hardworking. He believed in her creativity and backed that belief with professional, emotional, and financial support.

Her first show at Nierendorf's opened on September 22, 1941. The arrangements had been hurriedly made, and she requested another week to prepare. Nierendorf regretfully told her that invitations had already been mailed. He was, however, able to extend the exhibit and give a reception for his new artist and latest love interest on October 14.

In a feverish rush, Nevelson chose from pieces she had recently retrieved from the WPA. Many artists had thrown out works left over from the project,

but she had had the foresight to keep hers. She spent several weeks cleaning and repainting the sculpture and mounting the line drawings to ready them for her first solo exhibition. "All my sculpture I had in my first show at Nierendorf in 1941 I did right on the project."[17]

Though there was no press release, an article about the artist in the *New York Post* provided her with a chance to present herself—and present herself she did. First she summed up her belief: "Frankly I am ambitious. Art is a stream that flows on and on, making you do more and more."[18] Then she reflects on her current situation: "We have had hard times, but we have also had phenomenal good breaks." Finally she tells an "I've-always-been-an-artist" story that will get revised and elaborated into legend.

"I can remember as a child in school, the first thing that interested me was a beautiful teacher who brought colored chalk into the classroom. And I remember being asked in class one day what I wanted to do. I said: 'I will be an artist.' Then I amended it, 'No, I will be a sculptor. That's harder.'"[19]

Critical reaction to Nevelson's show was mostly positive, and, despite the lack of sales, both artist and dealer were delighted. Howard Devree in *The New York Times* wrote:

> Modern indeed are the forms and rhythms employed by Louise Nevelson in her first exhibition, current at the Nierendorf Gallery. Having approached her work through the medium of drawing, the artist makes her line felt even when employing heavy low masses that at times are reminiscent of Mayan and certain Near Eastern work. This linear treatment does not prevent her, at times, from indulging in solid, massive, somewhat cubistic figure effects which are embellished with color and topped off with a wax finish. A cat (wood) with thumb-tack eyes seems a trivial inclusion among the more serious and massively architectural pieces, and the color is rather a dubious benefit to some of the pieces. But Miss Nevelson has originality and a rather personal approach to her real problems and has made an interesting start.[20]

Devree's observation about "architectural pieces" is intriguingly prescient.

In the *New York Herald Tribune* a reviewer noted: "Miss Neverlson [*sic*] injects, about equally, wit and a feeling of the primitive in her work, which is stylized almost to the end of pure abstraction—but not quite. . . . [T]here is a dancing figure that symbolizes a zestful interest in movement. The work is well off the beaten track, a little mannered and cleverly done."[21]

Emily Genauer of the *New York World-Telegram* recalled the artist's polychrome abstract sculpture done mostly during her time on the WPA and observed that,

"One has the feeling that the artist is really getting somewhere." "Completely personal and original they [the works] give one something of the feeling one gets studying a Frank Lloyd Wright house. There are the same severity, the same feeling of intersecting planes, the same emphasis on mass, the same . . . horizontal feeling. For all their rigidity, however, they are full of the suggestion of flux and movement, as, one might say, a coiled spring. Color is used for stressing volume."[22] The most interesting remark in this welter of positive comments is the reference by Genauer to Nevelson's architectural inclinations.

Either tongue-in-cheek or downright misogynistic, a reviewer in *Cue* observed: "We learned the artist is a woman, in time to check our enthusiasm. Had it been otherwise, we might have hailed these sculptural expressions as by surely a great figure among moderns. See them by all means. . . . I suspect the artist is clowning—but with what excellent equipment, artistically."[23] This strange remark by an anonymous reviewer has received too much attention in the Nevelson literature (especially by feminists) and overshadows the otherwise consistently positive critical response to Nevelson's first solo show.

It was evident at Nevelson's second Nierendorf exhibit in October 1942 that her work had moved in several new stylistic directions simultaneously. The mix of animals and human figures continued, as did the alternation of wit and seriousness in both form and subject matter, which left Nevelson on her own among the three leading artistic camps: She was neither a Social Realist nor a committed Surrealist nor an abstract modernist.

No longer do the reviews mention polychromatic pieces. An installation shot, as well as accompanying photos of individual pieces, show works in plaster or tattistone, each painted white or a uniform dark color.[24] Some of the works in the 1942 exhibition continue her trajectory of cubistic volumes cut and shaped with more freedom and allowing for open spaces. Now she put together anomalous parts where Mayan-style heads are placed in Picassoesque juxtaposition with cuboid volumes that could be other body parts. The other new trend is toward an ever-greater sense of movement, where the figures—or at least some of the limbs—seem to lift off the ground and head out into space.

In retrospect one can see why Nierendorf would have endorsed Nevelson's work. He was confident about his own taste, and the reviewers' responses to Nevelson's first two exhibitions justified his support. The *Art News* critic observed that Nevelson was one of the two authentic personalities on the fall art scene.[25] Howard Devree, writing in *The New York Times*, gives her his third positive review, stating that she "carries forward the experimental promise of earlier work."[26]

The 1942 exhibition was important for Nevelson because it confirmed that she was not a flash in the pan. She was becoming known and respected in the

New York art world, and this exhibition earned her some new fans, including the sculptor David Smith. At the same exhibition, she met Ralph Rosenborg, a young (fourteen years younger than Nevelson) and gifted painter. They became lovers immediately, and their mutual respect for each other's art lasted many years. His work was sometimes compared to Paul Klee, and Nierendorf was for a time his dealer, supporting him with a monthly income.

Rosenborg, who had been exhibiting since the early 1930s, was an early member of Abstract American Artists and part of "The Ten"—a group that included Gottlieb, Bolotowsky, Schanker, and Rothko—though he never belonged to any association very long. He noted that their knowledge of what Matisse and Picasso were doing in Europe made them unique among American artists at that time.[27] He was a painter's painter but never became a commercial success. Highly respected by other artists, he was known as a maverick and a loner, and his reputation in the art world was always strained because of his outspokenness and militant independence.

"Rosenborg," according to painter and cofounder of The Ten, Joseph Solman, "did not have a single close friend. He was high-strung, spirited and spoke with wild sincerity, like someone let out of a cave. He was mercurial—a man with sudden enthusiasms—a manic-depressive type. He was elated by Louise and she was sparked by his enthusiasm. They were together all the time."[28]

Lillian Mildwoff noted: "He was very kind to her and full of admiration for Louise's work. Louise loved his paintings, thought he was a most sensitive artist,"[29] and spoke of him with the utmost respect. Lillian also recalled that Nevelson started working in wood through Ralph.

According to Nevelson: "He's not a disciplined person in his emotional life, but in his work, he's a beautiful craftsman. He came to my place on Tenth Street and helped me, showing me how to use tools for doweling and things in sculpture—the wooden things."[30]

Rosenborg was famous among his artist friends for his meticulous technique and immaculate studio—unusual qualities for abstract action painters. Nevelson especially admired his cleanliness. "He worked like a doctor—immaculate," said Lillian. "His brushes had to be the best; his paper, the best. He and Louise had a lot in common."[31] As Martika Sawin noted in *Arts*, "He lays great stress on his materials, . . . arraying them neatly beside a clean palette. Next to it stood several jars holding such an assortment of palette knives as one would have scarcely believed existed."[32]

The respect Nevelson and Rosenborg had for each other as artists seems to have transcended the harsh words he would hurl at her when drunk. She respected not only the habits and tastes they both shared but also his celebrity.[33] "I knew who he was," Nevelson told an interviewer in 1976, "because he was

very prominent then."[34] But Rosenberg's gifts as a painter were unfortunately undermined by his alcoholism, irascible temper, and adolescent-like quest for independence, which kept him moving from gallery to gallery and often from state to state.

A month after her second solo show in 1942, Nierendorf included two of her sculptures in an exhibition called *Unity in Diversity,* which was both an exhibition and a "contest" to celebrate the opening of his newly relocated gallery at 53 East Fifty-Seventh Street. The show was made up of sixty works, primarily featuring well-known Europeans, such as Picasso, Max Ernst and Paul Klee, as well as "promising young talent uncovered in the U.S."[35] Nevelson was one of the very few Americans in the distinguished group, which also included Ralph Rosenborg, Alexander Calder, Edward Weston, and Loren MacIver.

After two years in a row (1941–1942) of well-reviewed work at a prestigious gallery, Nevelson's confidence soared. This seemed to have freed her to launch herself in another new direction. By late 1942 she let loose and headed straight for Surrealism, while holding onto Nierendorf for ballast. And ballast he was for her. Over the next several years she explored and expanded as an artist more rapidly than ever. She responded to her friends' enthusiasm for the new ideas swirling around them, and she carried the clownishness of Surrealist antics and raw spontaneity as far as possible in her forthcoming *Circus* exhibit at the new, offbeat Norlyst Gallery, organized by Jimmy Ernst. And then she turned to an abstract mode using her newfound medium of scrap wood, as could be seen in her show at Nierendorf in 1944, which contained many important completely abstract works. Some of her cubistic works from the late 1930s and early 1940s approached abstraction but hadn't completely arrived there. Like her hero, Picasso, she had been reluctant to completely abandon representational imagery.

Nevelson had met Jimmy Ernst soon after he arrived from Europe in 1938—probably through Frederick Kiesler—and the young man was much taken with her. He admired her energy and talent, finding it to be similar to that of his mother, an unconventional, avant-garde Jewish art historian. Jimmy Ernst played a small but significant role in Nevelson's life, as he was one of the few discerning people who consistently believed in her talent, even when she was doing work far out of the mainstream. Nevelson was much impressed with him. The young man (he was in his early twenties) had arrived from Europe a penniless immigrant speaking no English and soon became a cultural insider as the secretary and do-all of Peggy Guggenheim, his future mother-in-law.

In the fall of 1942, Nevelson's mother became quite ill. The family realized it might be her last illness, and she was hospitalized in late January of 1943 in Massachusetts with lung cancer. It may have been an awareness of her mother's approaching death that pushed Nevelson toward manic disinhibition and

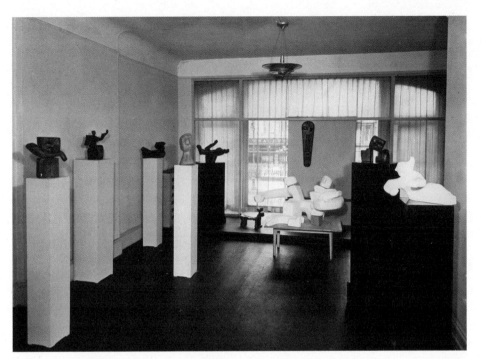

John D. Schiff. Exhibition at Nierendorf Gallery, 1942. Courtesy of the Leo Baeck Institute

intense artistic activity. She began to work with scrap wood and produced her most unconventional work thus far—work that would culminate in the *Circus* show at the Norlyst Gallery six months later. During this time Nevelson was surrounded by innovative ideas and art. Schwitters, Cornell, along with the many European Surrealists and their American counterparts, were all on display in New York City. Her artist friends in the Tenth Street lofts were daring much and aiming high, and she was no less courageous than they. The affair with Ralph Rosenborg was hot and heavy at this time, which is not at all surprising. People who know that a deeply loved person is dying often feel compelled to seek a replacement. Nevelson's relationship with Rosenborg lasted another six years, until 1948, when she passed him on to her sister Anita.

Since the mid-1920s Nevelson had been acutely aware of developments in the art world, always scouring galleries, museums, and periodicals for the latest news. Avant-garde New York artists had access to Surrealism well before the early 1940s, when the many European artists fleeing the war in Europe were landing in New York, pushing the local art world in new directions and changing the scene forever. Julien Levy mounted the first important Surrealist exhibition at his Fifty-Seventh Street gallery in January of 1932. And, throughout the 1930s, Levy continued to show major Surrealist artists such as Salvador Dalí, Max Ernst, and Alberto Gia-

cometti. He discovered Joseph Cornell and included him in two group shows in 1932 and gave him his first one-man show in 1939 and his second in 1940.

During these years when Surrealism was arriving in New York, Nevelson was in the thick of it. She had always been forward looking, and Surrealism's entrance to the local American art scene was like a shot of adrenalin. In particular, it reintroduced the flavor of Europe to an American art world, which had long been dominated by Social Realism and overtly political narratives. It also reminded American artists of their complex responsibility to society—to tell the truth and to be true to the inner life—to "serve the struggle for emancipation . . . and . . . freely seek to give artistic form to his interior world."[36]

Nevelson's relationship to Surrealism is complex. In some ways she was a natural Surrealist—fully at home with spontaneity and willing to acknowledge the power of the unconscious; fully willing to be unconventional, especially since the breakup of her marriage; inclined toward the spiritual, though there is no evidence of her interest in the kind of alchemical leanings of the core Surrealists. At the same time, however, she had allied herself with Karl Nierendorf and his stable of artists, which did not include any of the certified Surrealists.

Nevertheless, she would have absorbed Surrealist concepts in various ways, including through the works of Paul Klee, who had taken on some of the ideas of Surrealism without becoming one of that group. Most of all she would have been subject to its influence through the art-world events in New York of the late 1930s and early 1940s. The major Surrealist landmark during this period was the Museum of Modern Art's exhibit *Fantastic Art, Dada, Surrealism*, held midwinter 1936–37.[37] This huge show caused controversy in the press and was well attended by the city's avant-garde painters and sculptors. But it appeared at a time when the WPA was in full swing, and New York artists were just beginning to feel a sense of community and acceptance in their own land. The ironic and irreverent nature of Surrealism ran counter to the prevailing political mood of determined earnestness. It was not until the end of the project in 1939 that the influence of Surrealism began to take root in New York—when the young American artists began to meet the Europeans in person.[38]

European artists, both abstract and Surrealist, were arriving in ever-increasing numbers to escape the horrors of war in Europe—Matta, Tanguy, Ernst, Masson, Seligmann, and Breton. In the early 1940s the European Surrealists were masters of the scene, and European galleries such as Nierendorf and Buchholz tried unsuccessfully to include them into their rosters.[39] By 1942 New York had replaced Paris as the center of the Surrealist movement. The Museum of Modern Art continued to mount major shows of Surrealist masters—Miró and Dalí in 1942—and a group of Surrealist periodicals burst upon the New York scene, *View* in 1940, and *VVV* and *Dyn* in 1942.

Until late 1942 Nevelson's association to Surrealism was like that of many other New York artists—ambivalent. She distrusted it at first, finding it too literary. According to Jimmy Ernst: "She did not seem very impressed by any awed talk about 'biomorphic space' or quotations from André Breton's latest discourse."[40] But as she learned more about it, she found certain of its ideas useful and even sympathetic.

If Nevelson had not shown much interest in Surrealism before fall 1942, she couldn't miss the two major events that celebrated its existence in New York in 1942 and 1943. The first was the *First Papers of Surrealism,* organized by Breton and Duchamp and held at the Whitelaw Reid Mansion on Madison Avenue in October and November of 1942. The exhibition was almost entirely devoted to the European masters of the movement, particularly the eminent émigrés. The installation was designed by Marcel Duchamp and was a newsworthy sensation. It consisted of five miles of twine hung in the mansion's huge ballroom, creating a crisscrossing network of lines meant to obscure the mansion's ornate interior. On opening night, a group of children were invited to play ball, skip rope, and play hopscotch among the bewildered guests.[41]

A week later, Peggy Guggenheim opened Art of the Century Gallery in a formerly dilapidated loft space that Frederick Kiesler had transformed into an extraordinary environment.[42] Unframed paintings, projected away from curved walls on wooden brackets, were the major feature in the Surrealist gallery. In other rooms a slowly revolving wheel with seven Klees was activated by an electric eye, and Duchamp's *Valise* could be seen through a peephole. Numerous ingenious devices and lighting techniques were used to enhance the gallery visitor's active role in experiencing art.[43]

Kiesler's magical spaces created instant acclaim both for him and for Peggy Guggenheim's collection. Though meant to be an inclusive survey that accomodated the full range of modernism, including Mondrian, Kandinsky, Malevich, and Balla, the European Surrealists were heavily featured. Also given prominence were the particular interests of Max Ernst (by then Peggy Guggenheim's husband) and Jimmy Ernst—children's drawings, primitive paintings, and contemporary Native American art. It was clear to every American artist on the scene that their European colleagues knew exactly how to get the attention and the press visibility they had lost when the WPA closed down.

It was also the first major exhibition in which American artists—including William Baziotes, Alexander Calder, David Hare, Robert Motherwell, Kay Sage, and Laurence Vail—were invited to show alongside their European confreres. Nevelson knew all of them and must have watched the unfolding of the new scene with a mixture of eagerness and concern.

The incident that most clearly signals the beginning of Nevelson's public

enthusiasm for Surrealism was her "discovery" of "Joe Milone's Shoe Shine Box" in December of 1942. The local shoe-shine man in her neighborhood had made an extravagantly decorated box and stand entirely for his own pleasure. After finding the box, Nevelson immediately called her new acquaintance, Dorothy Miller, at the Museum of Modern Art. Within a half hour she had transported Milone and the extraordinary piece of folk art—in a taxi she could ill afford—to the museum. Since she appeared with it shortly before Christmas, Alfred Barr, MoMA's Director, agreed to put it on display for the holiday season, proclaiming it to be "a superbly useless object without price"[44] that was "festive as a Christmas tree, jubilant as a circus wagon."[45] The originally humble object had been elaborately bedecked with hanging geegaws and colorful stones covering every surface. With careful craftsmanship the untrained Italian had produced a remarkably original work, combining the uncombinable elements with a hand as deft as any of the most sophisticated Surrealists. Nevelson's ability to spot an aesthetic object in an unexpected place would characterize much of her future work.

The New York Times, Herald Tribune, The Christian Science Monitor, as well as Corriere d'America, Newsweek, Time Magazine, and the Surrealist journal VVV covered the story.[46] Joe Milone, his shoe-shine box, and Louise Nevelson received much publicity.

In an "exclusive" interview with a reporter from Corriere d'America (which included a photograph of the attractive artist but not the shoebox), Nevelson expressed her conception of and enthusiasm for Surrealism. She called the box "an epic, a landmark," and "the most beautiful object in the world": "It could only have been created by a man such as Joe Milone whose simplicity, pureness and integrity, combined with the sensitive inner feelings of the man's soul and heart, inspired him to build out of nothing . . . this *superbly elegant* work of art." Nevelson observed: "[I]t [is] impossible to analyze or to define the symbolism. . . . He had developed no mental picture of the finished product as is done by sophisticates."[47]

Nevelson was clearly infected by the art-world fever, but her enthusiasm had old roots. She had found specific qualities that she had always valued in the now-popular movement: creative spontaneity, humble materials, and an innocent purity in the heart and soul of the creator. Her ideas about the pure innocence of Joe Milone are a bit like nineteenth-century ideas of the "noble savage." Given her antipathy for the hyper-intellectualism and super-sophistication of the Nevelson family into which she had married, she had personal reasons for finding value in unsophisticated naïveté.

The year that followed her discovery of Joe Milone and his stupendous box was exceptionally productive for Nevelson. Her next show, in January 1943,

was Peggy Guggenheim's *"Exhibition by 31 Women,"* the art for which had been selected by a jury that included Miss Guggenheim, André Breton, Max Ernst, James Johnson Sweeney, and Marcel Duchamp. Except for Nevelson and Frida Kahlo, most of the women were relatively unknown. *The Sun's* reviewer, Henry McBride, snidely stated that it is entirely logical that there were many good women Surrealists since, "Surrealism is about 70% hysterics, 20% literature, 5% good painting and 5% just saying 'boo' to the innocent public."[48]

The New York Times reviewed the show and facetiously observed that Nevelson's "'Column' (you would call it sculpture, I guess) . . . can be dismantled at will and put together again."[49] Another reviewer noted that the wooden column had a "dadaistic character, a three-dimensional Schwitters."[50] *Column* sounds like one of Nevelson's works from the late 1950s, but there are no photographs to bear this out. In an interview decades later, Nevelson said that for *Column* she used "the natural wood but with a little face painted on it."[51]

Nevelson's contribution to the Museum of Modern Art's 1943 *Arts in Therapy* exhibit was a vaguely horse-shaped child's wooden seat. The show also included pieces by such notables as Alexander Calder and André Masson.

In March 1943 Minna Berliawsky died, after a six-month decline in her health. At precisely this moment, Nevelson showed more daring work than she would for many years. People do not always react in expected ways to the loss of a loved one, and Nevelson was no exception. Though she stated many times, "I adored my mother. As a matter of fact I dedicated my life to her," Nevelson did not attend her mother's funeral. "She died, so to speak, and I've never given it a thought."[52] Nevertheless, as became clear later, she was deeply affected.

One month after her mother's death, she had two simultaneous exhibits, facing opposite directions.[53] Her show at the Nierendorf Gallery, *Nevelson: Drawings*, was a link to her past, showing works in the style of Matisse and Picasso, which she had learned from Nicolaïdes. The other exhibition, *The Circus: The Clown Is the Center of His World*, at the Norlyst Gallery, was a leap into her future.

Louise Nevelson and Jimmy Ernst recounted the circumstances surrounding these two shows quite differently. Nevelson said that, having first arranged the presentation of her daring new sculpture at Norlyst, she asked Nierendorf for a more conservative drawing exhibition as a balance.[54] Ernst recalled that, though Nierendorf considered himself open-minded, he would not exhibit her new sculpture made from wood found in scrap heaps, and he only reluctantly agreed to show her drawings. As for his reaction to the new work being presented at the Norlyst gallery, Ernst quoted Nierendorf as saying: "'I don't care if you show those . . . sculptures. There is nothing to them . . . refugees from a lumber yard. I'm interested only in her drawings . . . and there isn't much you can say

for them either.' "[55] Nevertheless, Nevelson's drawings at Nierendorf were well reviewed in *Art Digest* and *Art News*.[56]

Nevelson participated in the first public exhibition held at the Norlyst Gallery on unfashionable West Fifty-Sixth Street, run by Elenor Lust and Jimmy Ernst, in March 1943, along with a range of artists—many of whom were barely known but would soon constitute the core of the New York School—Rothko, Gottlieb, Will Barnet, William Baziotes, and Robert Motherwell.[57] Nevelson was represented by a work called *Napoleon* made from scrap wood—probably one of her first works in that medium.

The *Circus* show at the Norlyst Gallery, which opened a month later in April 1943, was organized around eighteenth- and nineteenth-century circus posters. Ernst and Nevelson placed her new wood sculptures together, organizing them into three groups: *The Circus*, *The Menagerie*, and *The Crowd Outside*. Ernst's press release claimed that the purpose of the show was to provide the spectator with an aesthetic experience that was also psychologically profound. He wrote: "*The Clown Is the Center of His World* is such a profound psychological experience that I cannot see how anyone can fail to be moved by its majestic conception as monumental sculpture, by the personal tragedy of each one's loneliness, and by the dignity of human endeavor."[58]

The title of the circus show could have been derived from Nevelson's study of "metaphysics" with her dance teacher Ellen Kearns, who taught that all people are at the center of their own world and that the world is merely a projection.[59] Already in this, her first thematically titled exhibit, following her mother's death, Nevelson was aiming to create a world of her own. The title piece, *The Clown Is the Center of His World*, was an assemblage of wooden parts built up to form a pedestal-table surface on which the artist had placed a plaster clown's head surmounted by a large cutout and painted tin sign of a key, scissors, and saw. This incongruous combination is preserved in a postcard and stands apart from the other pieces in the show.[60]

Fortunately, at least seventeen photographs of the show exist, illustrating twenty-four works—almost the entire exhibit—enough to show how far and fast Nevelson could move forward artistically when she felt supported. Retrospectively this exhibition reveals how very much she was on track to her future signature style.

Sometimes the simplicity of the pieces was their most surprising quality—in combining corroded metal pipes with a large chunk of wood and a wheel to create the absolutely convincing image of a *Tightrope Walker*—Nevelson's deft formalist gifts are visible.

Among the more than two dozen wood figures were performers and creatures not always associated with the circus: *The Ferocious Bull*, *The Wondrous Fishes*

and Balancing Seals, The Thin Man, The Lonely Child, The Forsaken Man, and *The Riders of the Temple of Life.* Jimmy Ernst recalled *The Ferocious Bull,* which he had seen in Nevelson's studio the previous year, as the best and most memorable piece in the show and as the probable reason for Nevelson's inclusion.[61] Sparingly assembled and evocative, it recalls Picasso's bicycle seat and handlebars *Bull's Head,* which was executed in Paris a year earlier. The body of Nevelson's bull was a bed's headboard that recalls a bison's bulky body and brutish head. The creature's horns and front legs are a simple chair back. The tail, hanging loosely from the end of the headboard, was movable, recalling the typically twitching tails of animals that the artist would have seen many times in rural Maine.

 Nevelson's ideas of movable parts and rolling sculpture were in tune with the times. Equally modern, and significant in light of her later development, was her decision to cover the floor of the gallery with three inches of marbles and sand, simulating the sawdust-covered ground of an actual circus, which obliged the viewer to experience the exhibit as a unified environment.

 Nevelson may have had reason to hope that her leap into the unusual would

Ferocious Bull, 1942. Wood and metal, approximately 44 x 66 x 24 in. No longer extant. Photograph by John D. Schiff, courtesy of the Leo Baeck Institute

be accepted with the same seriousness that had been accorded the European Surrealists, and she must have been pleased that the reviewer for *Art Digest* described her "entrancing animals made of all kinds of scrap material, . . . distinctly a new art form."[62] And, according to the *Art News* critic, Nevelson was easily as inventive as her European Surrealist mentors. "Nevelson's clowns, trapeze artists, and animals are constructed of odd broken bits of bedsteads, mirrors, and even lighted bulbs. These curious contraptions, some noisy others mobile, were designed as art objects."[63]

Even though *The New York Times* reviewer, Edward Alden Jewell, gave her the unusual distinction of reviewing the exhibition twice—it turned out to be a double punch rather than a negative followed by an apologetic positive. In his first review he found her drawings at Nierendorf derivative of Picasso and Matisse, and the small sculptural pieces in the same show "inexpressive, crude, dull." He capped the bad news by observing that her "queer contraptions" at Norlyst's *Circus* "might also mark the onset of the 'Silly Season.' "[64] In the second review, five days later, Jewell referred to Nevelson's "sculptural three-ringer" as made up of "very queer objects . . . chiefly of wood roughly hammered together and often equipped with assorted gadgets calculated to assist in creating a bizarre soupçon of verisimilitude."[65]

Obviously most of the critics missed what Jimmy Ernst had seen in *The Circus* exhibition—"each piece [as] a majestic conception the live scale of which had retained the dignity of the creature or the loneliness of the clown child."[66] Nevelson's disappointment, after the exhibit closed with no work sold, was such that she destroyed the pieces and did not attempt anything so audacious for another eleven years.

While Nevelson never became part of the Surrealist inner circle—invited to exhibit with Picasso, Giacometti, and Max Ernst—the atmosphere of Surrealism had a liberating effect on her, and she recalled: "in the forties . . . it was almost like you were breathing the air of Surrealism."[67] Several of its tenets became hers. She worked quickly, for example, and assumed that speed would help her follow her intuitive and unconscious aesthetic choices. She also took her dreams seriously. For now, she had one of the best art dealers in New York backing her. And, though she had not yet achieved renown as an artist, she felt convinced that fame would eventually be hers.

But what of the larger world around her? She was certainly worried for her son and frightened by unfolding world events. During the summer of 1943, the Allies defeated the Germans in Africa, but the Warsaw Ghetto had risen up and its fifty-six thousand inhabitants had been killed by the Nazi SS. Himmler had ordered the liquidation of all Jewish ghettos in occupied Europe. Stalin's Red Army had beaten back German forces in Russia, but four thousand Polish officers

were found in a mass grave, likely victims of Stalin's death squads several years earlier. Though the war news was beginning to look more optimistic, as the Americans and British began to advance up the Italian peninsula, the military situation remained perilous.

In one of his rare letters to his mother while he was serving in the military, dated June 20, 1943, Mike Nevelson gave her total access to his bank account, "with the understanding that you will withdraw only that money which is necessary for the payment of your rent and food bills. Financial backing for your exhibitions and artists materials and entertainment will have to come from other sources."[68] He warned her that the agreement would end when the war was over and that he would then take all of his remaining savings and use them for his own education. He referred to the hardships he was enduring—the heat, the noise, the sweating away of his life in the inferno-like engine rooms in the bowels of ships. He contrasted his ongoing misery with her bohemian lifestyle, for which he had great respect and love but, at that moment, not much sympathy. He called the money he had saved since 1941 "blood money" he had earned "at great personal hardship and risk."

It is not clear whether her son's occasional letters from the war front sobered his mother or whether the art world's lukewarm response to her Surrealist work persuaded her to change direction. But her next exhibition at Nierendorf, in November 1943, was an exhibition of her paintings, *A Sculptor's Portraits in Paint*, and there was nothing Surrealist about it. Along with two portraits of Diego Rivera, it was comprised of portraits of her friends, relatives, or household helpers.

She had one more exhibit of wood sculpture at the Nierendorf Gallery, *Sculpture Montages*, in the fall of 1944, which included some abstract constructions. Perhaps in response to the critics' remarks about the roughly hammered style of the 1943 *Circus* Show, Nevelson's carefully constructed pieces now looked more like the work of a lyric abstractionist.[69] Finely sanded and smoothed pieces of wood were joined more subtly with dowels and recessed nails. Some had evocative titles such as *Before There Was a World*, *Ancient City*, *Man and His Creation*, and *Whale and Bird*. Other titles were the artist's time-tested favorites: *Cat*, *Duck*, *Circus*, and *Moons*.

Most of the reviewers were not kind. "The montages, which are compositions made up of odd bits—driftwood, bric-a-brac, things like that—have a kind of conglomerate look and are far from representing Miss Nevelson's best work," wrote Robert M. Coates for *The New Yorker*.[70] Devree at *The New York Times* was ambivalent: "Just when one thinks she is merely indulging in amusing foolery one comes upon a combination of these wooden planes, balls, parts of chair legs and decoy ducks which really seems to mean something, as in the case of 'Three-

Four Time,' with its suggestion of parts of musical instruments, and 'Ancient City,' with its reminiscence of the Near East. For the most part, however, I suspect that Miss Nevelson's errant humor is indulged in these three-dimensional contraptions."[71]

The reviewer from *Cue* observed that these works were "3-dimensional abstractions of bold conception, but I fear, only transitory worth."[72] Only from Emily Genauer did the artist receive fulsome praise. Like Devree, Genauer admired *Three Four Time*: The "machine carved motifs . . . here, used wrong side up . . . marvelously suggest, in their repetitions, the string section of the orchestra."[73] It was only the second time Nevelson had taken found objects and—by upending some, slightly reshaping others, and making unexpected combinations—claimed them as her own. Some of the works suggest—yet again—she was onto something new. However, Klee's influence was always lurking in the background. How could it not be—since on the bottom of every exhibition notice Nierendorf put the words: "Permanent Exhibition of Paul Klee's Work."

In *Three Four Time* Nevelson's compositional refinement consisted of sanding

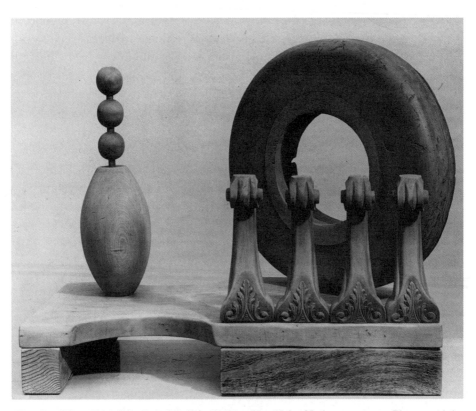

Three Four Time, 1944. Wood, approximately 24 x 36 x 18 in. No longer extant. Photograph by John D. Schiff, courtesy of the Leo Baeck Institute

the machine-carved, antique-looking chair leg parts and then carefully placing the other abstract wood elements in precarious but balanced relationship to one another. Three balls vertically suspended above an ovoid shape are set against the four leg parts to mark the rhythm of the piece.

Nevelson had learned her lessons about forceful compositions. When she pared down the constructions to three or four elements, as in *Time and Space* or *Three Four Time*—the only two works that received a positive response from critics—they became bold and complex, with a vitality and plastic interest she combined with a touch of elegance.[74] In many of the works from the 1944 exhibit, we see echoes of Giacometti's platform sculptures from the 1930s, especially *Palace at 4 A.M.*, which had been on view at MoMA since 1932.

The influence of Surrealism first appeared in the development of her wood sculpture in the early 1940s. Its influence reappeared forcefully when she returned to work in wood over a decade later and continued right up to the end of her life. Though she always emphasized the primacy of Cubism in her work, Surrealism was also very important. Cubism gave Nevelson the key to her compositional structure. Surrealism validated for her a spontaneous and playful approach to art making. Working quickly, she learned to trust her unconscious to help her make deft aesthetic decisions. It would be the integrated combination of both artistic isms that eventually led to her signature style.

In 1945, as she began planning for her next show for Nierendorf, Nevelson may have felt that she needed to reestablish her formalist credentials and show her more serious side to the art world. In a set of works in bronze she again took up themes of animals but this time with greater restraint resulting in greater sophistication.[75] As she said in 1976: "I wasn't always going forward. I drew back after having experimented a bit. I took a walk on Fifth Avenue, and then I came back and took a walk on Broadway. I didn't leave anything, I just did a little experimenting until I really hit the black."[76]

In the midst of preparation for this show, she moved into a house on East Thirtieth Street near Second Avenue. Her family had bought it for her to provide her with stable living and working quarters after fifteen years of unsettled residence in at least six different places. Before Minna Berliawsky had become critically ill in 1942, she had traveled to New York to visit her daughter. She was appalled by Nevelson's living conditions in a cold, dark walk-up. She went back to Rockland and told her son to go to New York and buy his sister a house.

As Nate told the story: "I had an old-fashioned Jewish mother, who was shocked and depressed when she visited Louise's fifth-floor loft, which had no bath or toilet facilities and home-made furniture."[77] It took another few years before Nate was feeling sufficiently prosperous, but in 1945 he kept the promise he had made to his mother. In the meantime, while the careers of her friends

and younger colleagues were churning, Nevelson had reached the point where she wanted more security—at least in her living circumstances.

Ralph Rosenborg actually found the house, a run-down, four-story, seventy-year-old brownstone down the street from Ralph's studio on Thirtieth Street and Lexington Avenue. They never lived together, but she liked having him nearby. Anita and Nate both contributed the money for the purchase and made sure the title was in Anita's name, rather than Louise's since they knew their sister's inclination to turn any asset into either art supplies or fancy clothes.[78] Nierendorf loaned Nevelson one thousand dollars, and friends and other members of the family also contributed to the down payment and renovation costs as well as ongoing expenses like the mortgage and utility bills. Ralph did most of the reconstruction that made the house livable. "Ralph . . . could do anything," Nevelson said. "If a ceiling had to be moved two inches or a wall extended or some structural change had to be made he would do it in minute. I had walls taken out and expanded the place."[79]

Like many brownstones in the area, the house was narrow and deep, with a full basement and a large backyard. It also had touches of elegance—seven marble fireplaces, a grand double parlor with parquet floors, floor-to-ceiling windows, and beautiful molding on all the lower floors. The plan, determined by her brother and sister, was that the top two floors would provide rental income on which Nevelson could live. The third floor was her living space, shared with whomever was helping her at the time. The formerly elegant salon-parlor was turned into a space for displaying her art, her collection of paintings by Louis Eilshemius, an idiosyncratic American artist, along with her assortment of American Indian artifacts and other works of "primitive" art. The large room would eventually be the scene of her busy involvement in the group activities of the art world during the 1950s. The garden, basement, and first floor were for working and living.

Nevelson had wanted a house in New York as long as she could remember. She told a close friend that she had been disappointed because her husband would not buy one for her and that she wouldn't have divorced him if he had done so. "You can leave a man, but you can't leave a house—because every little corner is part of you."[80]

While owning the house solved practical problems it also spoke to a deeper need, which only became apparent when Nevelson was threatened with its loss in the late 1950s. She especially needed a home in 1945, as the security provided by bricks and mortar would have seemed substantial while she watched the career advancement she so desired, and about which had felt so certain only a year earlier, seem to slip away.

The helper who soon moved into the second-floor apartment was "Joey,

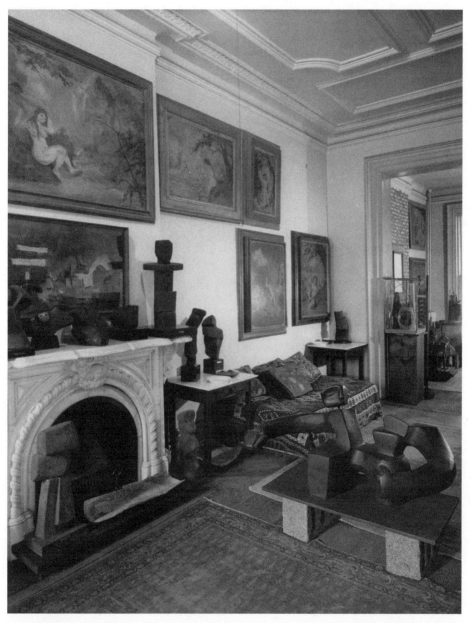

Jeremiah Russell. Thirtieth Street House, Parlor Floor, ca. 1956 – 57. Photograph courtesy of
Martha Jackson Gallery

a wonderful old Italian man," who was crippled, needed a home, and helped her for years.[81] He shopped, cooked, and did everything that needed to be done—"washing her dishes and looking after her like a mother"—so she could work without interruption. While Joey was always at Nevelson's disposal, she treated him as an equal, conversing with him, educating him, even trying to get him to be "creative." Nevelson comically demonstrated her attitude toward domestic activities, including cooking and gardening, when she "stuck all her kitchen utensils in the ground like tulips or flowers, eggbeaters, pancake turners, and the like and laid them out in rows," to create a backyard garden.[82]

Nevelson had an account at the corner restaurant and bar, from which she phoned in orders for whatever she needed, usually in quantity. That way she never had to go shopping, which she considered a waste of her energy.[83]

Once safely housed, she maintained a simple life. She had two gray sweat-shirts and pants that she wore all the time; Joey would wash one while she wore the other. She slept in them for a few hours every night, then showered and went out to get the paper, which she would read, sitting on the front stoop, watching the sunrise over the East River. It had always been her custom to read the paper every day (like her father). Though she was not a "reader" of books, she was keenly aware of what was going on in the world—especially the art world.

Nevelson's maturation as a sculptor occurred within the context of several stylistic currents. Like other American artists of her generation, she had first to absorb the lessons of the contemporary modern masters before she could build a world that would be entirely her own. What she had found in Surrealism's mirror was already at work in her earliest aesthetic efforts and lifestyle—her ramshackle way of putting together incongruous fabrics and articles of clothing, her resistance to planning ahead, and her enthusiasm for spontaneous gestures. Her admiration for the powerful simplicity of Mondrian and Brancusi is evident, but her personal sense of humor and daring—which she had been practicing in her clothing for three decades—showed hints of the powerful work she would do only a dozen years later when she returned to her natural medium—found wood. She paid no attention to Surrealism's spiritual message. She found what she wanted to find in Joe Milone's shoeboxes. What she saw as his "purity" was actually pure Louise. Ditto his desire to find beauty.

Despite her jump into Surrealism's antics, Nevelson was not ready to syn-thesize its message—or what was useful to her in its many messages—with her powerful formalist inclinations. She was still early in her trajectory of finding herself stylistically, and she had to build a foundation before she could take the next step. She might have recognized that both Picasso and Klee—her two major sources of inspiration at that point—had been much further along in their careers and artistic paths when they were in their forties, and she may have got-

ten discouraged, but she never dreamed of giving up. As she told her sister Anita: "It will take ten years at least. I'll be over fifty."[84]

Whenever asked about the early to mid-1940s, Nevelson tended to blur over the disappointments she experienced. She recalled the "fun parties" at Peggy Guggenheim's gallery and recalled that Guggenheim was thinking of renting a floor or two of her Thirtieth Street house. She retroactively shortened the three years she lived on East Tenth Street—where Abstract Expressionism had been burgeoning nearby—to a few months. She also condensed the time between her mother's death in March 1943 and the purchase of the Thirtieth Street house in March 1945 to a few months. This is understandable, since it was her mother's wish that Nate and Anita—or anyone else in the family who was solvent—buy her a home. More likely, she eliminated that time period from her memory, squashing all those years into a few months, because of the pain of humiliation and loss. Other artists, not she, were being celebrated, and her mother was dead.

She had just done some of her most original work ever, and she knew it. When she swerved away from the rawness of found wood toward the more refined style of work in wood with sculpture montages at Nierendorf's gallery, she knew she was on to something. But she was not yet in the winners' circle. Her boyfriend was thirteen years younger than she and not much more successful. And though she did not know that at the time, her son—if and when he made it home from the war—was not planning to stay in New York City. There was more loss and more pain to come.

DEATH AND RESTORATION

1946 – 1953

> "I'd rather work twenty-four hours a day in my studio . . . than do
> anything I know. Because this is living. It's like pure water. . . . The
> essence of living is in doing, and in doing, I have made my world,
> and it's a much better world than I ever saw outside."
> —Louise Nevelson, *Dawns + Dusks*, 1976, p.70.

On April 15, 1946, "Bronzes by Nevelson" opened at the Nierendorf Gallery. It would be her last exhibition there. She exhibited plaster figures, bronze sculptures, and her usual line drawings, which go practically unmentioned in reviews. Disappointed with the tepid reaction to her exhibitions of wood sculptures in 1943 and 1944, Nevelson had decided to change the medium. She prepared the clay sculptures, scratched them with wood grain and then, using money sent by her son, had them cast in bronze.[1] They were received with little enthusiasm. "Her chunky cubic animals of striated bronze have a hypnotic, primitive quality. Beady little eyes follow the spectator about the gallery, but Nevelson's beasts are not dangerous. They squat on their stands, bide their time, and stare."[2]

In one sense, these sculptures represented a step backwards—uncontroversial subjects presented with wit—*Animal Playing Ball, War-Horse, Two-Faced Cat, The Golden Calf,* and her perennial *Ducks.* The show also included one of her polychrome plaster figures, a type of work she had done a decade earlier. But by edging her blocky cubistic style toward greater abstraction, she was also moving forward. A reviewer noted: "More experimental, and probably more important are Nevelson's plaster figure pieces. Often consisting of two separate pieces, the

space is treated as cubically as are the long curved arms and legs."[3] In any event, the show proved to be no more successful than her previous exhibit. Nothing sold.

In May 1946, two days after "Bronzes by Nevelson" closed, Karl Nierendorf left for what was intended to be a short trip to Europe.[4] Though he had become an American citizen, he had been asked by the American military to help restore works of art to their original owners. He and Nevelson never met again.

Nierendorf had been gone nearly seven months and his absence weighed on Nevelson. On November 25, 1946, she finally received a letter from him. Nierendorf apologized for his silence, explaining that he had been in bad health—partly because he was traveling in the ruins of Germany—and had written nobody. He expressed his wish to return to New York but observed that there were many people in tragic circumstances who needed to get to New York before him. The main reason for his gloomy letter was to request that Nevelson return the one thousand dollars he had loaned her when she bought her Thirtieth Street home. In his usual tactful style he asked, "How is your life and your work?" And added, "You surely have developed new ideas and forms to surprise the art world."[5] Signing off with loving words, he made one last plea for her to pay her debt. She did.

Nierendorf had given Nevelson the money on short notice when she needed it. His generous and instantaneous response had surprised her. When he handed her the check, he told her she would succeed as an artist. She was shocked and said, "'Mr. Nierendorf, what makes you say that?' 'Well . . . I know Picasso and Matisse. I know all the great artists, and I know how they move.'"[6]

While this conversation may be apocryphal, Nevelson internalized his support for the rest of her life. She recalled the German dealer as the mainstay in her mind during a difficult time in the late 1940s and early 1950s. The memory of his strong backing during the early 1940s shored up her self-esteem throughout the long years when she was unable to make a name for herself or sell her work.

It was another ten months before Nierendorf returned to New York, laden with paintings and drawings by Paul Klee, which he had obtained in Switzerland. Though everyone knew he had a heart condition, it was an unexpected shock for her to learn that Nierendorf died of a heart attack on October 29, 1947, the night before they were to meet for the first time in eighteen months. He had been back almost a month before their scheduled appointment. With his death, her hopes for success crashed.

Though Nevelson had sometimes been flippant about Nierendorf and his backing when they worked together, once he was gone, she fell apart—the pro-

verbial third strike after the deaths of her mother in 1943 and her father in 1946.
It was as though he had provided the internal props holding her up for six cru-
cial years. She would not find such support again for almost a decade.

Nierendorf was not the love of her life, and at best only an occasional sexual
partner during their six-year relationship. But when he died she surrendered to
despair, taking to her bed for three or four days at a time, sleeping and barely
moving.

Along with her son, Mike, her brother, Nate, had been keeping Louise afloat
financially for years. She told him how much Nierendorf's financial backing had
meant to her career and on that basis persuaded Nate to maintain his monthly
allowance to her as a legitimate investment. Was not one of the leading New
York dealers protecting his interest by giving her shows almost every year? Even
after he bought her the house on Thirtieth Street, Nate continued to send her
$225 per month—and later said he would have sent her more if she hadn't gotten
drunk so often.[7] Nate believed that "she was doing very well with Nierendorf
alive, that he gave her encouragement and inspiration. When he died, she lost
that and everything collapsed. She stayed drunk and despondent and barely
able to work for a couple of years."[8]

When Nevelson's mother died in March 1943, she did not go to the funeral.
She was on the crest of her Surrealist high and was busy preparing for two
exhibitions. When her father died almost four years later, in October 1946, she
attended neither his funeral nor his burial in the cemetery in Rockland, which
he had built for his family. While her longstanding ambivalence toward her
father made mourning all but impossible, his death caused the impact of the
loss of her mother to resonate, like a chiming bell whose deeper, darker tones
become nearly deafening.[9] Even the birth of her first granddaughter, Neith, in
July 1946 did not attenuate her sadness, though she had rushed to the hospital to
see her grandchild even before the baby's mother had seen her.[10]

The mourning Louise Nevelson did not complete at the time of her father's
death would haunt her for at least a decade. It would only begin to find artistic
expression in 1953 with etchings memorializing both parents as royal figures
and, more fully in 1958, when the skeletal remains of *King II* appeared in a tall
coffin-shaped box leaning against the wall of her breakthrough exhibition, *Moon
Garden + One*.

Nevelson's drinking had increased during the war and was encouraged by
her constant companionship with Ralph Rosenborg. Like Ralph and her father,
Louise had begun to use alcohol as a way of staving off negative feelings. Friends
of the couple recall that he was most often "in his usual state of collapse and
inebriation off in a corner somewhere."[11] Nevelson "drank to get drunk," to
become insensible.[12] Unlike Ralph, she would emerge from her hangovers the

next day feeling cleansed and relieved. "Ralph was a good person, sensitive," Nate recalled. "He often came to Rockland with Louise. But he was an alcoholic and wasn't strong enough to break his habit."[13]

Ralph was special, one of the few men who made a mark on Louise Nevelson. "No one on earth has the touch of Ralph Rosenborg," she recalled.[14] No other lover was in tune with her in so many aspects of her life and work. Ralph had been there to catch her when she fell from her perch on the Surrealist tree. During their six years together, Ralph accompanied Nevelson everywhere, but, as her brother observed, "She was too strong for a boyfriend, too proud a woman. She'd take them and leave them. Neither boyfriends nor money meant anything to her. While she may have wanted certain things from either, she could also do without."[15] Mike Nevelson, perhaps seeing Ralph as a competitor for his mother's attention, noted, decades later: "He was like a surrogate son for her. . . . She can't stand someone who can do something better than she. She has trouble relating to men. . . . She doesn't know how to treat men, only malleable types."[16] Having a younger, "malleable"—even though irascible and often drunk—man in her bed and studio had always been balanced by the knowledge that she had an older, fatherly figure looking out for her. But after the death of her father and Nierendorf, Nevelson did no work. Throughout the winter she was stalled, and when spring came in 1948 she had an operation, a partial hysterectomy due to fibroid tumors. Following a two-week hospitalization she came back to her house but was too weak and depressed to start working again. Nevelson eventually felt weighed down by Ralph's neediness and reliance on her for financial help.

Months passed after her surgery with little change, and she no longer had Ralph's company, having unloaded him onto her sister Anita during a visit to Maine earlier that year. She had done this before with other boyfriends and usually regretted it. But Anita didn't complain because she had fond hopes of becoming the sole support of a "great artist." In the summer of 1948, however, even Anita had lost patience with Ralph, who had "cost her a fortune" and wasn't painting much.[17]

Despite her sadness and confusion during this time, Nevelson could still impress art-world friends with her vitality and forcefulness. Her electric presence and rugged constitution kept her looking ageless and attractive despite the damage she was doing to her body with alcohol. Fellow sculptor Sidney Geist remembered: "She was outgoing, very straightforward, holding nothing back and with a very physical laugh and easy way of talking. When I first met her in the nightclub of her brother's hotel, she was in the pink of health and looked like one of the most beautiful women I've ever seen."[18] Even women were impressed. Thirty years later Anna Walinska, a fellow artist and close friend during the 1950s, recalled: "I first saw Louise in the late 1940s at some meetings of the

Artists Union. I was struck by her. She was always quite a beautiful woman, her hair hanging down to her shoulders, wearing big Greta Garbo hats. She had a beautiful presence. She still does."[19]

In July 1948, Anita, who was solvent as usual, offered to finance a three-month trip to Europe (her first) with Louise. The two sisters took off immediately and had "a wonderful time," going from museums to churches and back to museums, with Louise constantly instructing her sister about the art-historical details of every monument they visited. "We walked and walked, she wore me out."[20] First London, then Paris, where Anita recalled Louise starting a conversation with Alberto Giacometti at a café.

Then the sisters went by train to Italy, where they visited Venice, Florence, and Rome. Finally they went by boat to Naples and Sicily. Louise continued to gather visual impressions—never sketching, just looking at everything and storing it away in her memory. On the boat, Anita remembers, "Louise had the captain, and I had the first mate. Then Louise wanted to get back. If she isn't sculpting or painting she feels she's losing ground."[21] Anita returned to Rockland to work with Nate at the hotel. And Louise returned to New York. Several months of travel had worked their magic, and she felt restored and eager to carry on with her life as an artist.[22]

Friends suggested that the Sculpture Center (formerly known as the Clay Club) would be an ideal place for her to work, since it provided both technical help and manual labor—something she needed after her recovery from surgery, and especially since Ralph was no longer around to assist her. A sculptor friend had said: "You don't feel so good. Come over, and we'll lift your clay for you and things."[23] Spending time there also helped Nevelson get back into the art-world atmosphere. "I had a woman's operation, and I didn't know whether I had cancer or not. I didn't want to be alone in my studio."[24]

Located on West Eighth Street, in the center of Greenwich Village, the Sculpture Center was more than a place for sculptors to work—it also provided the opportunity to show their work. For members, there was no jury, only a guaranteed exhibition space. In the hard times, when few artists and almost no sculptors could support themselves, these perks had tremendous appeal.[25]

When Nevelson began to work at the Sculpture Center in the fall of 1948, it was known for its open studio, methodological discipline, and the technical and practical help it provided. It served older sculptors who wanted to learn new techniques as well as young artists fresh out of art school. From its beginnings, clay and carving were the main focus, and José de Creeft was the master carver in residence. In addition, one of the directors, Sahl Swarz, had started a metal-working workshop, where he introduced Theodore Rozjac to welding.

Always willing to try something new, Nevelson made a few stone sculptures

in the Center's garden, "[I did] the stone pieces, because I could stay in that back yard," she explained, "and, because you nurse a stone for two or three months, I didn't have to think. You see I was trying not to think too much. I wanted to recuperate."[26] She carved the popular animal subjects she had produced for a decade. Each is a pared-down abstracted shape designed to capture the essence of the creature but never quite rising above her Inuit sources of inspiration. *Bird*, in Tennessee marble, was exhibited in 1951 after the Sculpture Center moved to East Sixty-Ninth Street. The piece with its simple, subtle silhouettes and flat surfaces shows the strong influence of José de Creeft, her old acquaintance John Flannagan, and Isamu Noguchi, whose studio was next door to the Sculpture Center.

Nevelson claimed that she worked on stone only when she was "a little exhausted creatively." When she felt in full power, she preferred terra-cotta because "it gives flight and does not retard or restrict . . . the quick response of the clay to each idea; it permits a simplicity of approach."[27]

Beginning in late 1948 through 1953, Nevelson used the newly designed kiln at the Sculpture Center to produce several hundred terra-cotta sculptures. She explained, "I have been called prolific—certainly it would have been impossible to have created the same amount of sculpture using stone or wood."[28] She also liked its durability—"More lasting even than bronze, . . . terra cottas have come down to us little changed from when they emerged from some ancient kiln." Clay is "immediately responsive to the creative impulse. . . . You can cut away or add on at will."[29] Clay was a godsend to the intuitively guided artist who considered herself to be a Surrealist who worked with abstract forms.[30]

The clay was relatively cheap to buy, and Nevelson always seemed to have enough money (provided by her siblings) to have her pieces fired or to persuade someone to do the technical work on spec. The clay she used at the Center was very porous, with large amounts of grog (pulverized bits of fired clay), which allowed her to make both solid and hollow pieces. Initially she left the works unpainted[31] but later painted them black.[32]

Dido Smith, Nevelson's friend and fellow sculptor, described her working method in an article (1954) for *Ceramic Age:* Nevelson started with a rectangular loaf of unwedged clay, building up a mass by adding bits of clay or shaping it by pounding with a wooden block. She then carved it, cutting with a curved steel plaster tool, or a brass-modeling tool. She used a serrated kitchen knife for scratching the surface, a sharp-edged kitchen knife for cutting and incising designs once the clay had hardened and, finally, a spoon for hollowing out forms.

She experiments with different, and unconventional, patinas—oil paints or stains, wax, even a white crayon—to emphasize the incised lines she

invariably draws on the forms. She believes there should be no limitation in either working or finishing the material. . . . She doesn't make small models or drawings as a guide, but has quite a definite idea of what she is going to make—a mental image. . . . [A] subtle interplay . . . exists between the material and the artist, . . . [who] seeks to let the character of the clay guide and work with her. Through her training she has become perceptive enough that when she sees a surprise, she grasps and crystallizes it.[33]

Nevelson's terra-cotta works from 1948–54, including *Maternity*, *Cow Form*, *Mother and Child*, and *Mountain Woman*, pick up almost precisely where she had left off in 1942, before her comedic surrealistic work at the Norlyst Gallery in 1943 and her abstract wood sculptures in 1944 at Nierendorf. She was returning to the limited range of themes—animals and figures—and the cubistic pre-Columbian style—with a large dash of Paul Klee—that she had exhibited in 1941 and 1942. She moved forward with the terra-cottas by playing line against mass but abandoning movement and work that involved multiple pieces. Her recent trip with Anita had reconnected her to the European artistic tradition. It had also reawakened her confidence in her own talent and taste and sharpened her eye.

When she made animal forms, her taste for elegance was in ascendance;

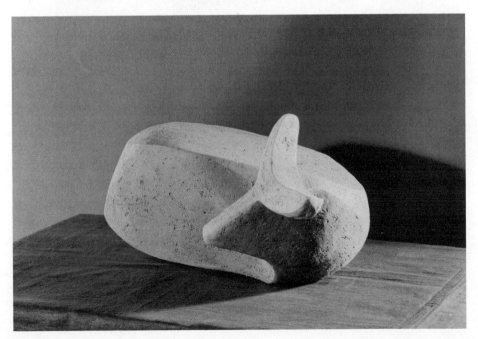

Cow Form, 1950. Terra Cotta, 12 in. Photograph by Jeremiah Russell, Archives of American Art, Smithsonian Institution

when the work was entitled "ancient" or "royal," it was most likely to look primitivistic. Consider the superbly refined work *Cow Form I.*

Nevelson and the photographer sensed precisely how to show off the startling shift of light and dark in the cow's horns and head, where the frontal bone of the head is perpendicularly joined with the curving horns. The lightness and vitality of the animal's turning head is masterfully played off against the bulky bovine body whose shape seems simple but is made up of subtle merging contours. Nevelson understood the animal form—and got the postures just right. Not for nothing had she studied the works of Inuit soapstone sculptors since the 1930s.[34] The terra-cottas are more formally sophisticated and evocative than the work of her contemporaries and the cast-stone and plaster work she had shown at the Nierendorf Gallery in 1942.

The other types of terra-cotta from these transitional years are the primi-

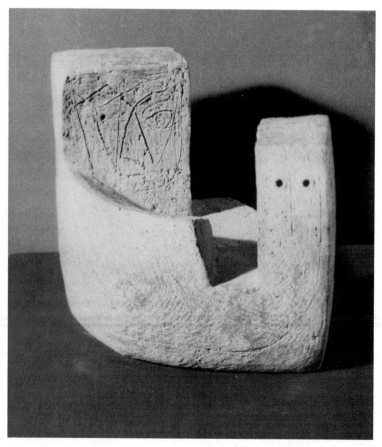

Mother and Child, 1948. Terra-cotta, 10 ½ x 12 ½ x 10 ½ in. Walker Art Center. Photograph by Jeremiah Russell, Archives of American Art, Smithsonian Institution

tivistic "ancient" pieces that could come straight out of late Klee, in both form and content. Nevelson's combinations are clever, sometimes witty and often eloquent—as in *Mother and Child*, where the forlorn child looks out at the world through empty dark-holed eyes, while the mother seems partially hidden and glum but disengaged, her two eyes varying in shape and form. That the mother's curving arm is one with, and becomes, the child's head is both psychologically revealing and formally persuasive. The child is a phallic representation of his rectangular, clunky mother, and he faces outwards, thus seeming so much more alone. She both sees and doesn't see her very own extension into the world.

About six years before Nevelson made this sculpture she mused about her relationship with her son in a notebook written in April and May 1942, during one of Mike's rare visits to New York while he was in the Merchant Marine. Clearly struggling with her ambivalence about motherhood, she wrote: "Feeling for him brought out the universal anguish of loneliness, of no future. Fear, loneliness arrests . . . universal motherhood gilt [*sic*] complex." And later: "We were too concentrated on each other, overlapped, too close, not enough outside interests . . . Mike trying to find self and always found mother. Must find self."[35] Little wonder that many of Nevelson's terra-cottas contained so much expression.

While the terra-cottas from this period range back and forth between a deliberately clunky primitivism and an exquisitely sensitive elegance—very much like the combination of crude and well crafted that would later become her signature in wood sculpture—few of them are outstanding, and none is fully original. Nevelson is still a long way from knowing how to harness the full power of that synthesis.

Sahl Swarz, one of the directors of the Sculpture Center, recalled that Nevelson's clay sculptures made no impact and weren't taken very seriously by her fellow artists.[36] She was perceived as enormously ambitious but in no way slated for success. When her work in wood appeared five years later at the Grand Central Moderns Gallery, her old friends at the Sculpture Center were amazed.

It is difficult to exactly date the works done between 1948 and 1953. Nevelson had favorites that would appear in exhibitions with different names and different dates, repainted or cast in new materials. For example, in 1953, for her first group exhibition at Grand Central Moderns, the new but already prestigious gallery directed by Colette Roberts, *River Woman* and *Mountain Woman* were both shown in terra-cotta, though they were eventually cast in aluminum.

What is evident about the majority of these terra-cottas is the artist's ingenuity and energetic experimentation. The same characteristics that often won Nevelson good reviews for the plaster and bronze sculpture in the 1940s can be seen in many of the terra-cottas of the late 1940s and early 1950s. Their clever formal passages—tried once and never again exactly the same way—are frequently

spiced with sardonic humor. For example, *Maternity Figure Within a Figure* (ca. 1950) combines the elegant and archaic. The smooth silhouettes of the mother's large torso reduce her to a single function as the large indented head of a child takes up most of the room in her body. His head with its contented look faces sideways while hers—a bit smaller in size and more sorrowful, faces away from him.

Nevelson eventually eliminated most of these terra-cottas from her official oeuvre, but in producing so many pieces, she learned how to play with three-dimensional forms in many variations. A few years later, some of the same formal elements—the play of light and dark, curved and straight, large and small, elegant and crude—would appear in her work with found wood.

In the early 1950s Nevelson had been on the art scene for over two decades. During the WPA years, and then with Nierendorf's support, she had played a lone hand. And it had worked—but only up to a point. Her last participation in the art world while she was still represented by Nierendorf was the Whitney Annual in March 1947 to which she contributed a work in plaster, *Earth Woman*, in the chunky cubistic style of the early 1940s. With Nierendorf's death, her exhibition history nearly came to a halt. Later that year her only other contribution was to an art exhibition benefiting the scholarship fund of the Downtown Community School. Beyond that, the sole public mention of the artist was by a gossip columnist, her friend and distant relative, Lee Leary, who noted her presence at the racetrack with prominent socialites.[37]

After she began to work at the Sculpture Center, Nevelson had decided that artists with big ambitions could no longer afford the luxury of a carefully winnowed number of select pieces. She made a conscious decision that would change her future work and future reputation: If she worked quickly and steadily, as she had with her drawings in the 1930s, some works would turn out very well and some would simply be steps along the way. But in the end she would have an enormous amount of art to exhibit, to sell, to study, and to make her name.

Other artists who knew her at this time were respectful and even astounded at her productivity. "She got that house full of these clay sculptures," painter Jan Gelb recalled, "mostly short chunky heads. I wasn't impressed by them—but by the number of them she was producing. Just dozens and dozens and dozens. She would fill a room with them, then put them aside and start another room—à la Picasso. I respect a worker, and I knew she would get to a place where her work would be her own work."[38]

Nevelson filled every available storage space as though replacing the missing people in her life and her multiple disappointments with masses of three-dimensional objects. Nevelson's close friend and fellow artist, Anna Walinska, recalled: "There was a time Louise said simply and frankly, 'I'll flood the market with my work until they know I'm here.' And she did just that."[39] In 1950 she was in

one group show. In 1951 she was in seven; ten in 1952; seventeen in 1953; and in 1954 at least nineteen (she had two one-person exhibitions and was part of seventeen others). "No matter how many pieces she was asked to provide, she always had enough. So she was always well represented. The cumulative effect built her reputation."[40] Sidney Geist, a sculptor who wrote reviews of group exhibitions in 1953, always praised her as best in show. "She was a little whirlwind of her own," he recalled, "trying to make it here and there."[41] [42]

The prolific outpouring of productive sculpting also confirmed the artist's faith in action and movement. "I'm a woman of great action," she said in the late 1970s. "When I'm active I feel alive."[43] And: "I just do my work. . . . I like to work. I always did. I think there is such a thing as energy—creation overflowing. In my studio I'm as happy as a cow in her stall. My studio is the only place where everything is all right."[44] She had grasped this significant piece of self-knowledge in the early thirties when she produced "hundreds" of drawings.

And so began her ascendance through accumulation. Two of the few exhibitions in which her work appeared at the end of the 1940s were the annual art auction of the ACA gallery in February 1948 and the annual Sculpture Center exhibition in 1949. All she had to do to be included in these two shows was to be a member of both groups. By the beginning of 1950 she had exhibited in numerous shows and gotten good reviews. But she had sold almost no work. The male artists who had once been her peers were now gaining major success, and she was not.

In June 1951, Nevelson's son sent his mother an intriguing letter. Empathizing with her disappointment and dissatisfaction about her place in the art world, he wrote that he "was disappointed that Devree in *The New York Times* did not mention your sculpture in the new gallery last Sunday. I know that your work is sound and exciting. Why do you think the critics make such a purposeful effort to give you the silent treatment?"[45]

Two years later Mike wrote: "I'm disappointed that the *Times* didn't credit you as chairman of the Sculptor's Guild show, but I'm beginning to agree with you that the critics and the galleries have nothing to do with ART."[46] A few weeks later Mike wrote again to his mother—a prophetic letter that surely reflected the entire family's hopes and expectations: "I keep seeing your name mentioned in every art magazine. Wonderful! I feel sure that you are arriving slow and steady and in a few years will be universally hailed as the 'Grande Dame' of American sculpture. . . . I'm sure that suddenly your work will become the rage and collectors will fight for your things. I predict that in the year 1959, you will sell more than $30,000 worth of sculpture."[47] Despite his grand and grandiose dreams—and his own straitened circumstances—Mike was still sending money to his mother in June 1953.

In May 1950, Nevelson and her sister Anita visited Mexico—another trip financed by Anita. After meeting in Mexico City with Diego Rivera and Frida Kahlo, the two sisters traveled to the principal Mayan sites in the Yucatán— Uxmal and Chichén Itzá. On their return to Mexico City they saw the ruins of Mitla and Monte Albán, near Oaxaca.

A few months after her return from Mexico, Nevelson went to the Museum of Natural History with the elderly Max Weber, a father figure in her art-world family, someone who was one of her direct links to Picasso and Matisse. Weber had been on the jury that had awarded her a prize fifteen years earlier and had remained a staunch friend and supporter. Together they visited the new Hall of Mexican and Central American Archeology, where the museum's fifty-year-old collection of art and artifacts had recently been refurbished.

Included in this collection were two thirty-foot replicas of Mayan stelae from from Quiriguá,[48] a small ceremonial center in Guatemala, near Copán. Nevelson had found the museum's monumental Mayan pieces overwhelming and decided she must immediately visit Guatemala to see the originals. Such sudden, apparently spontaneous decisions are usually triggered by a powerful emotional experience, which may or may not be conscious.

Standing beneath the two thirty-foot Mayan stelae from Quiriguá in the museum's confined space, Nevelson could have felt small and even over- whelmed. Did looking up at the monumental sculpture evoke memories from childhood of looking up at her tall and stately parents, as they paraded down the tree-lined road on their way to Rockland's main street? Memories which were so compelling that she had to make another trip to Central America right away?[49]

Shortly after their visit to the museum, Weber wrote to her:

It was grand, refreshing and reassuring to see the great Mexican Prim- itives at the Museum of Natural History. I wish I too could be a primi- tive. But . . . Primitivism can be only once. . . . It is indeed compensation enough to be privileged to understand their art—the ecstasy, exaltation, austerity they embodied in their sculpture. . . . It would be wonderful if we could recapture or discover their original spiritual conception and a key to their plastic values and processes. Their art is as fresh and as pure as the oozing water of a deeply imbedded spring or well.

All we can do is to aspire to do our own best in the environment and civilization in which we were destined to live.[50]

The note from Weber, the man who had written eloquently in 1910 about the fourth dimension, added even more impetus to Nevelson's plans to make the

trip to the barely accessible site of Quiriguá.[51] She had no trouble persuading her sister Anita to come along.

Turning fifty may have heightened the tension she was feeling in 1950. Watching her friends and colleagues make it in the art world brought her competitive juices to a boil. When Nevelson went off to Mexico with her sister "to see art," when she recognized herself in the spiritual sculptors and architects of Mexico, when she reconstructed in her imagination the mood and aims of the ancient architects, she identified her own aspiration: to create a larger spiritual experience for herself and for viewers of her work.

The two sisters set off on their second Central American adventure in the winter of 1950–51. Arriving in Puerto Barrios on a freighter, they discovered that there were not enough tourists to warrant the usual train trip to the ruins a few miles away. Nevelson, insistent that Quiriguá was the only reason for their trip to Guatemala, persuaded the officials to arrange for a private train to carry the two women into the jungle. Having conceded so much to the two American tourists, the United Fruit Company, which owned the land on which the Mayan ruins were standing, also provided the women with a fully stocked house and servants for as long as they wanted to remain at the magnificent site. Anita recalled: "We lived like queens, we had a pool, maids, all for nothing."[52]

Being treated like royalty touched a chord in the middle-aged artist, just as standing beneath the towering Mayan sculptures in the Natural History Museum had catapulted her into the jungle darkness. The full artistic effects of the feelings and memories stirred during this particular trip to Guatemala would only become clear two years later in the series of etchings that Nevelson produced in a mad dash—thirty etching plates in thirty days.

The first effect of the two trips to Central America was the shift in her thinking about the concept of "primitive," which had often been applied to her work and which she had up to then seen as a mixture of ancient, raw, unpolished, and unsophisticated. Her spontaneous response to Joe Milone's shoebox in 1942 was an earlier instance of her admiration for purity and the "primitive." What now had made her realize that the Native Americans of North and Central America should not be seen as outcasts but, rather, as heirs to an ancient high civilization?

"I think [the pyramids in Mexico] are so superior to the Egyptians'," she later said. "The sculpture, the power, and the organization was overwhelming. . . . In the past they would talk about primitive countries. But when you see their sundials and the way everything was done, truly, *we* are the primitive country. And we are. Because when you go to any of those sacred places, say to Yucatán, and see the sacred land that they had for their priests, it was roped off. . . . No one else was permitted to go on this sacred land. A larger spiritual experience would be possible then, in that arrangement. A planned arrangement."[53]

And: "In Mexico . . . the pyramids . . . have the dimensions of gravity and of weight, . . . and they are magnificent, palatial buildings with these great carvings. . . . Anyone who might say, 'That's a primitive race,' really makes me laugh, because they were so highly developed. From what they've left for us to see, you recognize the high development and their high art."[54]

As a result of her trips to Mexico and Guatemala, visiting with Rivera and Kahlo, and seeing the stunning pre-Columbian archeological sites, Nevelson gained a new way of experiencing herself, her talent, and her personal history. Since neither of her parents had hewn to the formal aspects of their religious background, Louise had been largely cut off from the ceremony and ritual of Judaism as well as from any strong connection with an ancient heritage. This was one of the key reasons she had been searching among so many diverse spiritual traditions for a bond with a heritage that could give her both spiritual succor and a sense of identity. Visiting Central America connected her past with her present and offered her a way to move forward into the future. While her artwork had often suggested her admiration for pre-Columbian art, she had not yet forged a conscious personal connection between her past hunger for a personal heritage and the discovery that an answer had been inside her all along. Going to the Yucatán jungle altered her awareness.

In the jungle darkness of Central America she discovered what would be her way to achieve grandeur. Railing against the notion that civilizations like those she found in Central America were primitive, she realized that by reversing the conventional view of high and low she could stand at the apex of civilization and be celebrated. As Nevelson explained to Colette Roberts, the woman who became her next dealer: "[Yucatán] was a world of forms that *at once I felt was mine*, a world where East and West met, a world of Geometry and Magic."[55] The phrase "at once" refers to Nevelson's characteristic way of learning: sudden, intuitive, and imperative. "That art can stand up to any art on earth. . . . I identify with Mexican art. The understructure there, and the understructure of my being are related. The order and the power there are supreme."[56] This was one of Nevelson's life-changing discoveries. High and low were suddenly and conclusively reversed. Before her trips to Mexico and Guatemala, Nevelson had not found a unique or original way of making sculpture. She was sitting on top of several older traditions—European modernism, which included Cubism and Surrealism, and American primitivism. But she was still beholden to others and not truly original.

The idea that the Mayan priests could seclude themselves in a measured space in order to tap into their spiritual depth fit perfectly with Nevelson's methods. Her sacred space was her studio. The unexpected grandeur of the Mexican pyramids, the sense of having come home to something both exotic and famil-

iar, neither European nor North American combined with the spirituality of the pre-Columbian cultures, their sacred spaces, and their awesome scale. Through her two trips to Central America, Louise Nevelson had finally found her missing identity and her proud heritage, which represented everything mainstream culture did not.

Also thanks to these travels, she refound her erotic self—in the form of a flaming new love affair with "Johnny," a handsome longshoreman she met on the cruise ship on which she and Anita returned to the United States. Nevelson had been without a steady man in her life for several years, and subsequently living with Johnny for three years put to rest her fear of aging and sexlessness that followed her surgery. He was from another world. Tough. Just out of prison for having pulled a gun on a policeman who had shot him in the stomach. Intelligent but not educated, he had great respect for her, was always polite and easy to manipulate. For Louise, he was an uncut diamond in proletarian clothes—her kind of Diego, with a big heart and a big body.

Like anyone who lived in her Thirtieth Street house, Johnny took care of many of the tasks that required a workman's skills—building a fireplace, for example. Perhaps he even helped with some of her artwork when brute

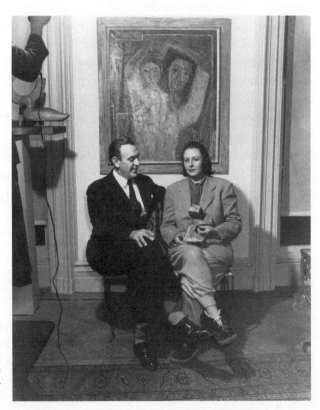

Jeremiah Russell. Louise Nevelson with Johnny, Thirtieth Street House, 1954. Photography courtesy of Pace Gallery

strength was called for.[57] He also accompanied her to some social events. Nevelson had always been able to persuade men to do her bidding. (According to Lillian, Louise "always had a good husky male around."[58]) When she needed her sculpture cast in plaster, for example, she got her brother-in-law's younger brother, Morris Mildwoff, to do the job. When she lived on Tenth Street, her son Mike recalled, the janitor of the building—a middle-aged bachelor—showed her how to work with wood dowels. Involved now with Johnny, a younger man (by ten to fifteen years) and far below her in social status, Nevelson felt both emboldened and beleaguered.

Her son badgered her about her health, in particular her gagging cough, which, according to Mike, was so repulsive that "a beautiful woman like you should be ashamed . . . to be seen and heard in such an unpleasant way. . . . How can you expect to keep a man around the house when you hang over the sink, spitting and making ugly nauseating noises as if you were strangling, suffocating and puking all at the same time?"[59] Here—in her twenty-nine-year-old son's harsh criticism with its dollop of praise—is the mixture of humiliation and grandiosity that so often characterized Nevelson's sense of herself.

In September 1952, Nevelson began to do some work at Atelier 17, a graphics workshop on Eighth Street.[60] There she learned the fundamentals of printmaking from Leo Katz, "that wonderful German man," who shared her spiritual approach to life and art and was considered a Jewish seer—"very metaphysical."[61] Nevelson's delight about the role of serendipity, which was part of her experience as a Surrealist, made her eager to work with etchings. She later explained to Roberts: "I found to my great delight that the first thing . . . you throw a little more acid in the acid bath and put your plate in, and all of a sudden it begins to pick up and before you know it something is happening independent of you which thrilled me because my eye was being introduced to things I hadn't anticipated. . . . You can call it chance . . . but the artist knows what chance is, because you seek what you want and can correct what you don't want."[62]

According to her autobiography Nevelson told one of the instructors:

"Grippi, I can't stand those tools, and I don't want to learn that thing. I'm not a dentist." He said, "You come and I will show you things where you don't need to use these tools." . . . And lightning struck me twice. He gave me two things that were the key to what I needed. One was a can opener, and the other was material, all kinds of material, lace particularly. And the first thing I did, I put it in acid and where I scratched the acid ate into it and gave me what I loved. It corroded. And so I thought, "Oh, this is marvelous, it's quick and direct."[63]

She told the same story to Jan Gelb, a longtime artist friend. Gelb noted: "She didn't work there for very long, and when she did, she'd fly in, she'd work like hell, and she'd fly out."[64]

Nevelson recalled that she "made thirty plates in probably three months. And I did the printing all myself. It was rather hard physical labor but I did like it and it was fascinating."[65] (In fact, she had the help of Ted Haseltine, a young man who would reappear in her life, turning the wheel of the press for her prints.[66]) In any event, she gave a whirlwind performance. Working with novel methods and materials, and being able to produce unique results within an age-old technique soon led to a major change of style and sparked a sense of fresh possibilities for her sculpture as well.

Minna Citron, another fellow artist and friend, recalled Nevelson's seemingly slapdash working methods:

> She arrived from her house with a bag of lovely old embroideries and laces and put a coating on a plate and put it on the etching press—and then just threw these things on top—we were all being taught to be very careful—very academic in our approach. She had her granddaughter Neith in her lap while working on the plates, talking all the time and wearing very low cut dresses. [She would] run the press and come out with something that looked like a hodgepodge. In the end she got a series of quite nice etchings.[67]

The series of etchings, done between fall 1952 and fall 1954 at the Atelier 17, includes seventeen images of majestic or divine figures, including *Majesty*, *Royalty*, *King and Queen*, *The West Queen*, *Flower Queen*, *Moon Goddess*, and *Goddess from the Great Beyond*. From Nevelson's handwritten lists of unused titles for her exhibition of these etchings come several more provocative captions: *Royal Family*, *Royalty from the Archeological Family*, *Her Majesty*, *The Ancient Queen*, and *From the Land of Magnificent Ruins*.[68] The preponderance of eleven queenly figures and six paired royal figures heralds her arrival at a significant iconographic theme. It is a common psychological truism that royal figures, especially kings and queens, symbolize parental figures. Such psychological theorizing was commonplace in the 1940s and '50s and well known to artists. Nevelson had occasionally used the word queen and royal in the titles of some of her terra-cottas but it was not until the series of etchings done in the early 1950s that these became predominant.[69] As we have seen, Nevelson had often felt the inspirational force of pre-Columbian art, but only with the titles of these etchings did her work specifically reference the pre-Columbian civilizations with which she now openly identified.[70]

The ruins in Quiriguá are situated on the Motagua River, in the midst

of thirty acres of rain forest set aside as an archeological zone. The ever-present mist at Quiriguá makes the encroachment of the jungle a constant problem and sets a constant mood.[71] Nevelson's etchings convey both the mist and jungle closeness. The meandering lines and heavily inked surfaces, which partially obscure the etched images, are like the trailing vegetation and moist air that veil the ancient stone carvings.

The nine stelae that dominate the site were carved in red-brown sandstone. Each stela has a figure of a ruler carved in low relief on the front and one of the major gods in the Mayan pantheon associated with that ruler on the back, with the heads set in deep relief near the top. Some of the towering eighth-century stelae look remarkably like huge carved coffins standing upright, high above the native populations that adored them. The heads, always in high relief, overpower the flatter royal insignia and hieroglyphics that make up the remainder of the carvings. The powerful impression made by the tall rectangular stelae with their mixture of high- and low-relief carving and especially their frontal focus would become visible in Nevelson's columnar wood sculpture a few years later.

In the guidebook on the ruins that Nevelson and her sister carried with them, the author, archeologist Sylvanus Morley, states that, "The Maya inscriptions . . . tell no story of kingly conquest, recount no deeds of imperial achievement; they neither praise nor exalt, glorify nor aggrandize."[72] This argues strongly for the idea that Nevelson's depiction of royal figures was a product of how she imagined them, which blended well with the then-popular mythological themes of ancient civilizations ruled by heroic kings and queens. Jackson Pollock, Henry Moore, and Max Ernst were models whose work she knew very well and all of them had portrayed kings and queens. By the 1970s archeologists had become aware that the figures depicted on the front of the stelae were indeed rulers of Quiriguá.[73]

Anita's recollection that the two women "lived like queens" at the jungle compound suggests why Nevelson could so easily have imagined herself as queen of this jungle realm. Taller than all the native population and even towering over her sister, she may have identified momentarily with these regal images in stone. Many of Nevelson's friends thought of her as "regal": Helena Simkhovitch, for example, to whom she was very close during the 1950s, noted that "Louise was a rare creature, regal."[74] Sidney Geist recalled her as "a Queen who ran an establishment—a presiding presence at her house."[75] Even her son noted that his mother, like her mother Minna, "thought of herself as an empress but that another side of her was naïve and very insecure."[76]

Some of the etched figures in her prints show a strong similarity to photographs of Nevelson at the time. In comparing a photograph of Nevelson and her sister in Mexico with the etching *West Queen*, the overall squarish shape of the head and body of Louise Nevelson in the photograph and the image of the *West*

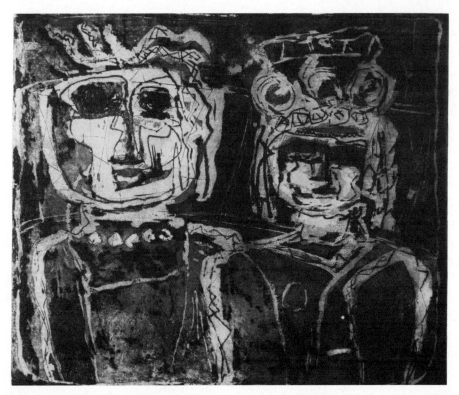

Royalty, or *Portraits,* 1952-54. Etching on paper, 20 x 26 ¾ in. Brooklyn Museum, Gift of Louise Nevelson

Queen show resemblances, as do the full cupid's-bow mouths. Nor is it coinciden-tal that the *West Queen* is associated with black—Nevelson's favorite color.[77] In Mayan lore, west as a direction was associated with death.

A second interpretation supports the first. Nevelson identified with both her mother and her father in their respective roles of beautiful woman and empire builder. Seeing them as the royal couple allowed her to imagine herself as a queen.[78] The most iconographically telling print in the group of etchings is *Roy-alty,* or *Portraits.* Louise's curly-headed father Isaac stands next to his unhappy wife Minna. Who else could this couple represent? In one state, dark tears flow down her face. In another state, her shadowed eyes are somber, sorrowful, and inward-looking, while her husband's open-eyed glance draws the viewer in.

There are five more royal couples, kings with curly hair and big-breasted women with facial features much like the artist's own. Another powerful image is the etching *Face in the Moon,* or *Moon Lady,* or *Moon Goddess.* Here the plate, which is dominated by layers of many heavily inked laces, includes a barely visible female face in the upper right-hand corner. The lunar lady so high up in the sky is hiding, just as the moon so often hides behind clouds at night. The most striking, even

startling, images in this series of etchings are several artist's proofs of *Moon Goddess I* and *II*, which did not end up in the authorized version.[79] More than merely aloof, these mysteriously distant and divine females disappear into the inky darkness, which is what Minna Berliawsky seemed to have frequently done as far as her children were concerned. But however distant and frequently unavailable she may have been, Nevelson also adored her mother and placed her high on a pedestal, often describing her as "a woman who should have been in a palace."[80]

When the women depicted in the etchings are robust and seem emotionally present, they most likely represent Louise. When they are aloof and hard to see or reach, I propose that they are the missing mother of Louise's childhood, the weeping and often unavailable wife of gregarious Isaac. But given that most daughters are prone to identify with their mothers, I also hypothesize that the females in this often neglected series are symbolic stand-ins for both her mother and herself, just as the royal figures she depicted could represent herself or her parents.

The iconography of the etchings signals a consolidation of Nevelson's sense of her self, her family, and her future as the long-wished-for star and queen or empress of the art world. The trips to Central America precipitated that consolidation and were the beginning of her recovery after the multiple losses that preceded it.

After completing the Guatemala etchings in the fall of 1954, Nevelson changed from being a loner to being a joiner, not because her personality had been transformed, but because she finally understood that if she were ever to achieve her ultimate goal—becoming as celebrated as her acknowledged artistic hero, Pablo Picasso—she and her work must be seen as often as possible. She showed her work anywhere and everywhere with as many pieces as allowed.[81] Even if no one liked her work, she was convinced that it was more important to have it seen than to wait for just the right offer from just the right gallery. As she explained in her autobiography, *Dawns +Dusks*: "I showed anywhere I was asked and I don't even want to mention names of the places I've showed. . . . I remember a critic asked me, 'How the hell did you dare to show at so and such a place?' And I said, 'They asked me.' It was just as direct as that. My feeling is, show wherever you can. I've always said it to everyone."[82]

At the same time, she joined every organization that would have her. A close friend and observer recalled: "She belonged to ten to twelve groups at a time, even when it was very difficult for her to pay dues." She worked willingly and hard for these groups and was often made an officer because of her lack of interest in gaining political clout. As a neutral voice she steered clear of the vituperation that one camp within an organization often heaped upon the opposing camp. Her whirlwind efforts to be recognized extended to a variety of social and professional activities, and she would appear, invited or not, at openings and par-

ties connected to the art world. "She had people at her house all the time. . . . It might be a party for the Sculptors Guild or a way to have people over to see her work."[83] By hosting parties for artist groups and offering her house as a meeting place to organizations like the Federation of Modern Painters and Sculptors and the Four O'Clock Forum,[84] she somewhat offset the nearly total exclusionary mode of the male-dominated art world of the 1950s, which banned women from being on panels, giving radio interviews, and more. Despite her appearance of unassailable confidence, she continued to worry throughout this period. Would she be able to sustain herself? Would her family's support be sufficient? Would her anxieties trigger a nervous breakdown?[85]

For the most part, women artists were sympathetic. Male colleagues generally saw her differently—as an attractive, ambitious woman, who was not so impressive as an artist and whom they were unwilling to include in their club—even to the point of black-balling her. Sculptor Phillip Pavia attributed this to her personality, blind to the long-standing prejudice against women artists. "She was not much with our group. We all knew her. But she wanted to do it on her own, and she did it on her own. She was standoffish. She prides herself that she was always around with us—and in a way, she was—but she had a way of being by herself."[86] A typically male statement about Nevelson's attempt to join the Sculptors Guild offers: "She was trying to get into the Sculptors Guild but without great success. She was not well known at the time. Other sculptors liked her work but not enough to vote her in. She had to fight for a long time."[87]

Nevelson was often accused by male artists of sleeping her way around the art world as a way of getting ahead, while their promiscuous behavior was considered a credential for success. One disappointed suitor had this to say about her: "She was one of the two most stunning-looking women in the art world and she slept with anyone she was involved with."[88]

As photographer Pedro Guerrero later reminisced, "In the two hours we spent at the restaurant, she revealed more about herself than many people do in a lifetime. Men often came up to her, she related, and asked 'Louise, do you remember me?' To which she would reply, 'Did I sleep with you?' If the answer was no, she would say, 'Then why should I remember you?' She was serious, funny, and ironic.[89]

Finally by 1955 she had an exclusive gallery connection with Colette Roberts, a network of contacts, a reputation as "a well-known and talented sculptress . . . a sculptor's sculptor,"[90] and notebooks full of press clippings. But she still wasn't the star she wanted to be, much less the originator of a new style. In 1953 she had begun teaching sculpture at the Great Neck Public School's Adult Education Program, working with children and their parents in the afternoon

and a group of adults in the evening. She had taught once before, in 1935, as the only way to get the WPA stipend she desperately needed. Now she was teaching as a way to meet people in a prosperous suburban area to whom she could sell her work and who could help her make connections to wealthy collectors. In addition, her earnings provided some income and it was her only certain means of making money. By 1960, when she stopped teaching, she had become sufficiently successful to believe she could support herself by her art alone.

The early 1950s were years during which mainstream American culture was being eulogized like never before. Joseph McCarthy was waging his anti-Communist crusade, unleashing a right-wing mania that spread like wildfire, destroying or damaging the lives and careers of many artists and creative people Nevelson admired. The United States was at war with Communist Korea, and Americans lived in fear of nuclear attacks. On November 9, 1952, a review of a book on secret Soviet spies appeared in *The New York Times*.[91] The book's author, Guenther Reinhardt, discussed the "typical case of Karl Nierendorf, the late art dealer," accusing him of having been "a member of the 'Bolshevik Brain Trust' in Germany since 1918." Reinhardt claimed that, while in Germany in 1946 "on a Communist mission," Nierendorf was responsible for the murder of three U.S. Army investigators. He also maintained that Nierendorf had not died of heart failure when he returned to New York in 1947 but was "actually murdered by Soviet agents." The *Times* reviewer, John Lichtblau, dismissed these claims, observing that the author's favorite targets for slander by innuendo were "refugees from Nazism," which Nierendorf certainly had been. A month later, the author rejected the reviewer's accusations but said that he was unable to provide documentation for some of his accusations because of their secret nature.[92]

Even if Nevelson had missed Lichtblau's review, a letter from her son would have brought it to her attention. Mike Nevelson writes: "Recently I read an expose in *The New York Times* to the effect that the government had disclosed that Karl Nierendorf, the late art dealer, was a Soviet agent and payoff man for Russian apparatus in this country—how fantastic!"[93]

Whether such an accusation was true or not, its mention in the newspaper of record could have suggested to the sometimes naïve artist that her "spiritual godfather" was no saint. Coincidentally, her relationship with Colette Roberts, her next dealer and new close friend, began at precisely that moment.[94]

The women had met in 1952 when Nevelson showed work at the Argent Galleries, representing the National Association of Women Artists. Colette Roberts had been the director there from 1947 to 1949. By 1952 Roberts had taken over the leadership of Grand Central Moderns Gallery and invited Nevelson to show in the Guest Sculptor's Show, which ran for three weeks in

January 1953. Nevelson had received a notice of the exhibit with Roberts's scribbled question, "Dear Louise, Would you be interested?" from Byron Browne, a painter friend of hers who was already on the gallery roster. Two of Nevelson's sculptures, *Mountain Woman* and *River Woman,* were included in that exhibition in January 1953. The reviewer for the *Herald Tribune* refers to Nevelson's aluminum-cast sculpture *River Woman* as "primitivism reminiscent of archaic Aztec forms."[95]

Letters from Colette Roberts to "Miss Louise Nevelson" later that month make clear that their relationship was only just beginning. But it was enough of a beginning to hearten Nevelson and encourage her to explore a connection with a new art dealer. Nevelson would have been intrigued as well as impressed by the fact that Colette Roberts was related to the Rothschild family in France. Over the next two years the two became very close friends. They shared a taste for fashion, quality, and hedonism. They enjoyed their affairs and the freedom now available to divorcées. Their previous husbands had both been Americans and each woman had an adult son. Nevelson had been on the lookout for a new dealer and, under Colette Robert's sophisticated tutelage, she felt free to take chances and move in new directions. Roberts was also ready for a change. Born with a heart murmur, the French gallerist knew she wouldn't live to an old age and was not wasting any time.[96]

In January 1953, with her inclusion in the group exhibition at the Grand Central Moderns Gallery, Louise Nevelson emerged from the shadows. Only a month later *Archaic Figure with Star on Her Head* (ca.1948) appeared in a small exhibition of sculptures from the National Association of Women Artists at the Argent Galleries. (Now suddenly the words "archaic" and "ancient" appear frequently in titles of her work, whether the works themselves were new or previously done.) This bronze, which had probably been included in Nevelson's 1946 Nierendorf show, was evidently one of the artist's favorite works, as it had also appeared in the 1951 exhibition at Riverside Museum.[97] The sculpture was shown under various titles, including *Self Portrait,* and Nevelson's own big-breasted, chunky figure with an aspirational star plunked on the top of her head is recognizable. Nevelson might have felt "archaic" and bordering on "ancient" going into her fifties, but she had the energy of a novice and the presence of a veritable star.

Nevelson's friendship and professional collaboration with Colette Roberts and her participation in the group show at her gallery must have seemed "destined," as it had coincided with the artist's passionate and rapid exploration of a new medium, etching. Thanks to what would soon become total support by her new dealer, it was certainly the beginning of a new stage in her career and the development of a unique style.

In a way similar to the results of her overuse of alcohol to purge painful feelings, the cumulative traumata of the 1940s were dislodged and overcome by Nevelson's huge production of terra-cottas and her several trips to exotic Central America, both of which cleared the way for her new beginning as an artist and a woman.

A FORGOTTEN VILLAGE

1954–1957

"I take full responsibility for what I've done and every time I say it I want to cry. That is true. And that is what gave me my strength and gave me my independence. And it gave me truly a great deal of sorrow. It's a total price."
—Louise Nevelson, *Dawns + Dusks*, 1976, p.137.

In 1954 Nevelson had her first solo show in eight years—at Lotte Jacobi's Gallery on Fifty-Second Street. Jacobi was a gifted and successful photographer whom Nevelson had met through Karl Nierendorf. The exhibition at Jacobi's Gallery was a mix of recent as well as older pieces, including fifteen of the etchings and aquatints she had done at Atelier 17 and six unpainted terra-cotta sculptures. Critics noted the "huge" size of some of the etchings and the fact that they were inspired by her experience in Guatemala. "Her interest in archeology and Pre-Columbian art is a part of her work as something experienced in nature rather than as a stylistic influence."[1] The critics recognized the obvious difference between an artist influenced by a popular style and one who had actually been in the jungle looking at the monumental stone sculpture left behind by the ancient civilizations.

Going backward to the "ancient, archaic" memories evoked in the Guatemalan jungle freed Nevelson to move forward and take another leap that would link her past with her present—the use of found wood—and the merging of past memories with present mood states. She was enough of a Surrealist to let herself float with her memories back and forth in time as she quickly and spontaneously worked her way through the new media.

To what degree the impending transformation of Nevelson's style was a result of her new association with a supportive dealer, Colette Roberts, is difficult to establish with certainty but, as someone who understood her and supported her emotionally no matter where she went artistically, Roberts likely made possible the next steps in Nevelson's development as an artist because she was unconditionally supportive and a gifted publicist, who, Nevelson hoped, could achieve for her what she had seen Nierendorf achieve for Paul Klee.[2]

At the time of the Jacobi exhibition Nevelson had been friendly with Colette Roberts for a year and had shown in three galleries that Colette Roberts had either directed or strongly influenced. Like Nevelson, Roberts was deeply interested in the spiritual aspects of art. She understood what Nevelson meant by the fourth dimension, but, as a good publicist, she renamed it "Nevelson's Elsewhere." She also knew intuitively to emphasize Nevelson's direct experience of Pre-Columbian art. Looking at the ancient art of Central America in situ had become part of the artist's story. It was even true.

Sometime in 1954 Nevelson had been informed by New York City of its intention to buy her property, tear down her building, and build a complex of apartments and shops called "Kips Bay."[3] That year Nevelson returned to wood as a medium for sculpture and selected cityscapes as a preeminent theme. As the buildings on her block were gradually emptied and an ultimatum from the city grew more likely every day, she procrastinated, seemingly paralyzed by indecision and the need to resolve with her family what provisions they were willing to make for her habitation, since the deed was in their name.[4]

The prospective destruction of her home was not the only separation she suffered in 1954. Johnny, who had been the strong man at her side for three years, was drinking again, which frightened her. "Too strong and out of control meant he had to go."[5] Johnny was by no means her last lover, but he was her last steady "boyfriend." She asked her son Mike to move into the house. For years Mike had presented himself to his mother as an advisor and protector, now it was his moment to make good on the offer. He arrived in November 1954 and left three months later. For the next four years, as "every building around her was being torn down and the rest of the block was just a mass of rubble,"[6] she lived and worked with the knowledge that her home was no longer a protection from the outside world.

When an artist pours her entire life into her work, the work can replace external reality. This was particularly true for Nevelson, whose dissatisfaction with the external world was sometimes particularly acute. The forced removal from her home contributed to her desperate need for a better world, one that she could entirely control.

Shortly after the series of etchings at Atelier 17—or perhaps even at the

same time she was creating them—Nevelson had begun to work again with wood. Initially the wood pieces were those she found in her studio—leftovers from the 1944 Nierendorf show. Later she would use the scraps she and her friends found on the street. Two works that appear to be her first sculpture in wood in the 1950s are *Winged City* (also called *Ancient City*) and *Bride of the Black Moon*. Both were related to the etching series. In each sculpture, Nevelson used parts from *Three Four Time,* the most praised piece in the 1944 show.[7] Two elements from the earlier sculpture—a circular tire shape and an upright ovoid knob with three balls now stained black—reappear in *Winged City*.[8][9]

Dido Smith, a ceramist who knew Nevelson well at the time, describes visiting Nevelson in 1954 when she had just completed *Winged City*: "She brought me upstairs and opened the door with a flourish, and turned on the light, and there was this particular piece. It was all black except for the underside of the wings which were red."[10]

Winged City was seminal for Nevelson. It had its origins in her past work and was a source for much of her thinking about her future work. Nevelson wrote a prose poem that was originally attached to its base. At first glance the poem seems illogical, but a closer study reveals her early ideas about the fourth dimension.

> Time is forever present. We live with the awareness of all past, present, & certainly project ourselves into the "Great Beyond," breaking all time forever.
> . . . I believe the first consciousness, the first human was aware of flight. All our heritage . . . expressed in literature, spiritual messages, mythology, the visual arts, has been winged . . . all going to just that one place. Some call that God.
> *Winged City* is elevated on three spheres=worlds. 3 represents the 3 dimensional world which represents thinking . . . the fourth elevation is straight. 4 is the cube, the 4th dim[ension].

With this work and its accompanying enigmatic statement, Nevelson expressed that she lived with an ever-present awareness of the past and a need for flight to a distant place—an "elsewhere," which she called the fourth dimension. Exhibiting this sculpture in 1955, poem attached, signaled that Nevelson was now unafraid to come out into the open with her unorthodox beliefs. What had made this possible?

By the time she was making sculpture in the 1950s Nevelson was familiar with both the spatial and the spiritual meanings of the fourth dimension discussed earlier. She sometimes merged them, speaking about a chair drawn by

Cubists that could be seen from all sides—hyperspace—as well as the shadow that reflected the higher idealized realm down in the ordinary world. As she was working her way toward developing her famous walls of black boxes, she came to believe that she was using the formal element of shadow to connect the fourth with the third dimension.

Nelson had begun to make the decisive move toward her signature style. In January 1955, she had her first solo exhibition at the Grand Central Moderns Gallery: *Ancient Games, Ancient Places*. Her first thematically titled exhibit since the 1943 *Circus* show, it included terra-cotta sculptures, wood sculpture, and etchings.[11]

The thematic section of the exhibit was built around *Bride of the Black Moon*, the other of the first two wood assemblages (with *Winged City*) made after her five-year excursion into tons of terra-cotta. The base and four furniture legs from *Three Four Time* are used as the setting for the carved figure, *Bride of the Black Moon*. Instead of the donut-shaped form that accompanied the four furniture legs in the earlier work there is now a single black sphere—a small masculine moon meant to accompany the bride who stands naked but crowned and veiled at the end of the platform. She is an archaically carved figure, primitive and almost faceless standing stoically for the ceremony. The four furniture legs have been given black ovoid heads and now seem to represent guests at the wedding.

When asked about the meaning of the exhibition's title *Ancient Games, Ancient Places* decades later, Nevelson was explicitly non-explicit: "It's known fourth-dimensionally. It gives me a private dimension. And that private dimension actually has more space. Everything's unlimited in that place."[12] By equating "Ancient Places" with the fourth dimension, Nevelson was referring to "cosmic consciousness," both as it was understood by writers on spirituality and as a vague place where she could not personally be pinned down in the here and now—and also perhaps as a not-quite-conscious reference to her own "ancient" past, the past of her childhood in Ukraine and the ancient places she inhabited there.

When asked to discuss her concept of the *Bride*, she was just as enigmatic. "I just thought that there was a whole thing. I was in the fourth dimension, and while I was there, it functioned."[13] Was the fourth dimension a means of escape from an unpleasant reality? Her own marriage had not been happy, and, as with other professional and personal disappointments she had experienced, she wasn't very good at expressing her emotions in words. The repetition of brides and bridal pairs in her work, however, suggests that, like many creative people before her, she found a way to face her pain by allowing it to inform her art. With this exhibition she was also transforming a painful voyage to a village in a foreign land that *had* to be forgotten into evocative works of art.

Nevelson wrote another poem to be attached to the base of *The Bride of the Black Moon*:

<div style="text-align:center">

A FAIRY TALE

</div>

The Bride
of the Black-Moon
goes to many continents
She plays games
She sees the Sphynx
Prometheus
Images she remembers from travels
She is soon to take another voyage
When you next visit her she will have seen
more, and more, and more . . .
And hopes to communicate to you
New seeing and new images.
The Bride of the Black Moon.[14]

Four geometric wood constructions painted entirely black represented the four continents visited by the Bride. Stuart Preston of *The New York Times* described these sculptures as "the mute fragments of some ideal scheme, now ruined but still inspiring in ruination."[15] They were *Forgotten City, Black Majesty, That Silent Place*—later also called *Cloud City*—and *Nightscapes*. Each one is an urban landscape with wood scraps positioned vertically and arranged like buildings seen at night from the city streets. Sanded and smoothed wood shapes are evocatively placed on bakelite bases, some tilting slightly as if in conversation with their neighbors. Each stately vertical element is complex, has been sawn, sanded, swiveled, and incised to give it individuality as both a shape and a force that can have a unique effect on its neighbors. The work is masterfully composed with just enough variation in the size, form, and placement of the elements that the eye never tires. As the city was tearing down buildings all around her, Nevelson was studying the profiles of the remaining structures, perhaps recalling and comparing them to the to-and-fro of the tall tilting masts of sailing ships nearby her childhood home in Rockland.

These urban wood landscapes followed one of the themes she had established at Atelier 17 with her etchings as evidenced by the print, *Ancient City* (also known as *Shadow City*), which was the first of the many cities Nevelson would create in her lifetime.

Critics noted that the etchings on the walls, "as darkly inked as the sculpture," are the "mysterious landscapes, draw[ing] the observer into an intricate,

murky texture of forms trembling against a void."[16] Of course there was a sphinx in the exhibit, but even more important than the sphinx was the *Great Beyond* (which Nevelson depicted as both an etching and a terra-cotta sculpture) and the *Goddess from the Great Beyond*. An undated poem Nevelson wrote on the subject reveals the power of that concept.

THE GREAT BEYOND
The Great Beyond is calling me
The more I am aware of her
The more I am aware of there
The Great Beyond is calling me.[17]

Nevelson's close friends knew that the Bride was an aspect of the artist—her other self. Dido Smith used to write to her, "Dear Bride of the Black Moon," knowing that Nevelson accepted the idea.[18] Notably, the "bride" of this remarkable exhibit is solitary and not paired with an adult male spouse. The sphinx in the poem can represent an aspect of her mother as silent, impassive, and enigmatic. The many etched royal couples on the wall of the exhibition lend support to such an interpretation. Through these symbolic equivalents, Nevelson revealed both her intense devotion to her mother and the painful childhood memories of her mother as often distant and emotionally unavailable. The artist's longing for the Great Beyond and its feminine nature suggests Nevelson's yearning for lost intimacy with the mother of her early childhood. Caught between devotion and disappointment Nevelson turned to a metaphysical fantasy of a fourth dimension or a Great Beyond to anchor herself in a safe and unassailable idealized realm.

Ancient Games, Ancient Places was followed a year later by *The Royal Voyage of the King and Queen of the Sea*. Stylistically and conceptually *Royal Voyage* was a continuation of *Ancient Games, Ancient Places*, insofar as both shows included a mix of black-stained terra-cottas and wood constructions with incised linear markings. As in the previous exhibit, the main female character—the queen—was Nevelson, and the voyage was to Great Beyonds.[19]

As the titles suggests, the narrative theme of *Royal Voyage* was a sea voyage made by a totemic king and queen to distant, mythical lands and undersea kingdoms. The two tall figures consisted of thin wood planks standing upright on narrow bases. The subtle variations in shape, surface, size, and perforations differentiated the king from his shorter consort, who faced him across the room. Despite their dominating silhouettes, up close the king and queen show themselves to be startlingly "primitive," with their scars, cracks, and other imperfections.

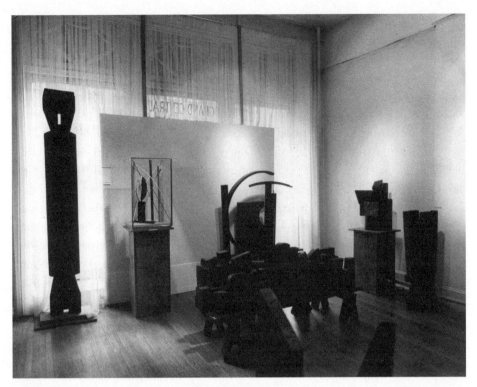

King (*Royal Voyage* installation), 1956. Photograph by Jeremiah Russell, courtesy of Pace Gallery

Around the king were the "gifts"—black pieces in concrete or terra-cotta piled up on a metaphorical shore.[20] Surrounding the queen were compositions of black wood or terra-cotta mounted on the same rectangular bases that Nevelson had used for her sculpted cityscapes the previous year.

The critics who reviewed this exhibit ignored the issue of iconography, that is, the queen's identity or her possible relationship to the artist, as well as the meaning of the voyage. Instead, they focused on Nevelson's formal achievements, "Miss Nevelson's sculpture is always cadenced and witty, juxtaposing blocky rough-hewn forms in infinitely varied relationships."[21] Installation photos show the range of Nevelson's inventiveness.

Another reviewer wrote "*Personages at Sea* carries forward the delicate interaction among the vertical parts of the previous year's cityscapes."[22] A third reviewer called Nevelson "a highly accomplished sculptor conscious of working in a medium dominated by men. Yet without affectation, she competes with men in having accepted the mass (terra cotta and wood), hewn it and worked it. Painted it black and honored the monumental as small but sturdy uprights in groups looking oddly like Manhattan's skyline. . . . Each work—like a fragile melody—must be experienced more than once to learn all its virtues."[23]

Colette Roberts described *The Royal Voyage* as: "the first apparition of Nevelson's going from studied relationship on a small scale to that of using the room as the framework for a whole, conceived as such."[24] She later explained in her book on Nevelson: "Beyond the object, Nevelson's wood construction takes us to never-to-be-reached shores and planets. She invites us to a journey into an 'elsewhere' all her own."[25]

Colette Roberts understood Nevelson's travels at a profound level. She wrote: "No matter how fascinated by her various endeavors, Nevelson feels she needs to get in closer touch with some reality, still unknown to her. She then assumes traveling may help her in her quest."[26] Up to now the voyages taken by Nevelson's sculpted creations had focused on arriving at royal realms, faraway continents, or Great Beyonds. The ambiguity of the concept of "voyage," and its frequency in Nevelson's imagery, points to its multiple meanings. Using her poetry and statements as guides for interpretation, the usual object of Nevelson's voyage was a transcendent spiritual place of refuge.

Like her dance teacher and longtime friend Ellen Kearns, and now her new dealer and close friend Colette Roberts, Nevelson was attracted to the idea of the fourth dimension as a kind of mystical transcendence, a reality beyond anything here on this earth. She often used voyages and flight as metaphors for her metaphysical beliefs. Could she at the same time be making references to her childhood history with its ocean voyage and flight from dangers? Remembering now in wood, in a realm where such memories could no longer hurt her?

Because the very concept of a voyage is so multilayered, it is worth remembering that it is also linked to the idea of death. The common phrases "one-way trip" and "the last journey" are typical examples.[27] Nevelson, as a very intuitive person, would have been aware of that linkage without necessarily stating it—or even thinking consciously about it.

Colette Roberts had moved to a studio on East Twenty-Eighth Street "to be closer to Louise"[28] and was, according to the Nevelson family, "very supportive of Louise, very sympathetic, visited her often and was a very positive person to have around."[29] The press releases Roberts put together for Nevelson's exhibitions were masterful assemblages of critics' laudatory comments. More important than her substantial assistance in building up Nevelson's career was the moral, psychological, and spiritual support Roberts provided, help for which Nevelson had been waiting since Nierendorf's death, and even longer. She was now producing some of the best and most daring work of her career and was beginning to forge her own unique style.

With Roberts helping her to find words for her thoughts and feelings, Nevelson learned to spell out her artistic creed. Sometime in 1956 she wrote an essay, "A Sculptor Speaks for His Time," for *The Christian Science Monitor*. The

essay was never published, but Nevelson kept at least three versions of it in her notebooks: "[A sculptor's] imagery stems from the creative mind. Projected outward it becomes a meeting between the creator and the spectator it reaches. In the past sculptors' works were commissioned, to fulfil religious or decorative purposes. Today the artist as every individual, feels himself more isolated, and must find his own subject matter and expression. . . . For this, he descends into his own consciousness and often his subconscious self, for t[he] images he projects."[30] Here, the artist herself is acknowledging how much she knew about and accepted her unconscious fantasies as well as her memories of the distant past as prime sources for her work, and especially for the symbolism behind the forms.

Encouraged by the excellent press that had greeted *Royal Voyage* and, more importantly, by the move of Grand Central Moderns to a much larger space, Nevelson's work became larger during 1956. Meanwhile, she was preparing for her third solo show at the gallery, *The Forest*.

The show opened at Grand Central Moderns Gallery in January 1957. The installation photo does not do justice to the exhibition and the powerful works it contained.[31] Maintaining the installation format from the previous year's show, various sculptures representing aspects of *The Forest* stood in a broad circle around a group of nine pieces representing *The Village*.[32] Five of these were in the now familiar horizontal format and were on or under a table in the center of the room. Four more, including a "seascape," were on the floor around the table.

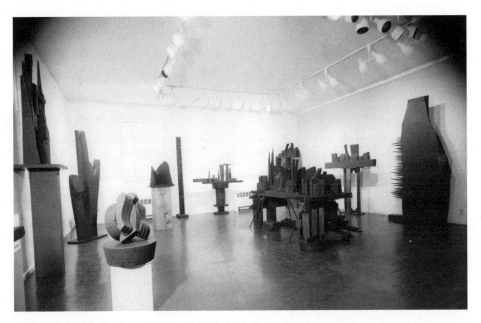

Forest Installation, 1957. *Tender Being* second from left. *First Personage* far right. Photograph © Geoffrey Clements

First Personage (detail), 1957. Brooklyn
Museum, Gift of Mr. and Mrs. Nathan
Berliawsky 57.23a-b

Nevelson's associations to *The Forest* exhibition in general and to *First Personage, The Wedding Bridge,* and *Black Wedding Cake* in particular, recalled twenty years later, suggests their underlying meanings:

> I got so involved in my work that I really was creating a novel, because I had myself being the bride . . . it was my autobiography in that sense. . . . The interesting thing, while I was filing and working away at it [*First Personage*] there was a knot where the mouth was supposed to be, just a plain knot, and I, being so concentrated, all of a sudden I saw this knot, mouth moving. And the whole thing was black by then and it frightened me. At that time I was so geared in that I . . . made . . . a black wedding cake. I'm always taking these trips, you see, and I suppose this trip I didn't have a bridegroom, but I had a wedding cake. If you're going without a bridegroom, naturally it's going to be a black wedding cake. Then I made a bridge to cross over. The bridge was a single two-inch lath, but it was about six or seven feet long. . . . To change the texture of light I glued a one-half-inch-wide ribbon of black velvet to one edge of the lath. Anyway . . . I realized . . . it was impossible for a human to go on that bridge and that there are no black wedding cakes and that personage was sculpture.

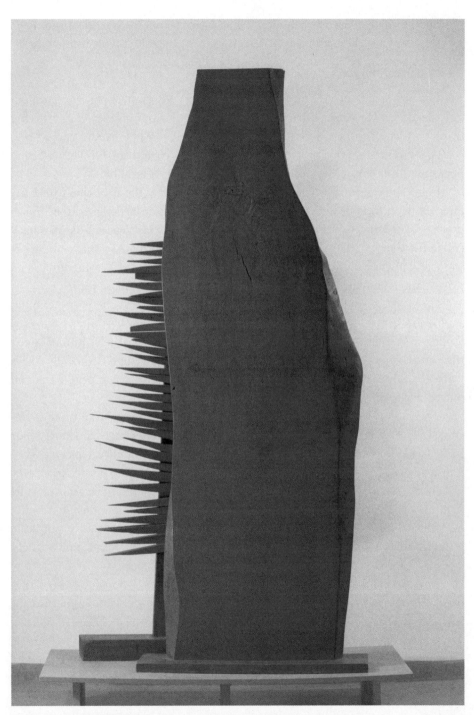

First Personage, 1957. Painted wood, a) 94 x 37 ¹/₁₆ x 11 ¼ in; b) 73 ¹¹/₁₆ x 24 ³/₁₆ x 7 ¼ in. Brooklyn Museum, Gift of Mr. and Mrs. Nathan Berliawsky 57.23a-b

But they had all become realities . . . and I didn't want those pieces around me, so I gave them all away as fast as I could. I couldn't have lived with them being in the house. Now, of course, I'm divorced from them.[33]

It is no coincidence that the village group directly confronts the monumentally sized *First Personage*, which Nevelson described to an interviewer as "this big thing," which "is somewhere identified with myself."[34] The frontal carved slab presents a quiet exterior of repose, while the constructed spike-filled pole that peeps out from behind represents the "dynamics" of "a total being.[35]

In her interview with Arlene Jacobowitz (a curator at the Brooklyn Museum), after the work was in the museum's collection, Nevelson articulated the importance of *First Personage*. "This piece was one of the very last pieces I did in what I call in the round. [Afterwards I realized] I wanted to be more secretive about my work, and I began more or less working in the enclosures. There's something more private about [an enclosure] for me and gives me a better sense of security."[36]

Nevelson's response to the feelings this piece, as well as the entire exhibit, aroused in her—a desire for privacy and the need to shield her inner feelings—found expression in a stylistic development that followed almost immediately: the construction of walls behind which she could take refuge. Ironically, these walls are mostly made up of open boxes, which, like Nevelson, appear frank and outspoken, while keeping something hidden.

The largest sculptures standing at the room's periphery were quite beautiful. Like *First Personage*, *Tender Being* (six feet eight inches high and thirty-four inches wide) was carved out of pieces of wood of superior quality, collected from a nearby high-end furniture store.[37] Powerful in its outline and elusive in its play of light and shadow, of curved and straight lines, it seems to have an inner life. With its endless complexity hinting at the play of muscles, tendons, and bones underneath the surface, it has the subtlety of a human hand. Yet it is not quite human. It has a similar combination of sharp and soft, sweet and sour, straight and curved, rough and smooth as can be seen in *First Personage*.

The grouping in the center of the room—*The Village*—included two sculptures, *The Water Place*, which Hilton Kramer singled out for illustration in his seminal review of the show, and *The Landscape* (also known as *The Village* or *Structure View*). Horizontally oriented like all her previous cityscapes, both works are made up of several registers, yet neither seems cluttered. The negative spaces created by intervals between the parts are perfectly syncopated with the complex play of light and shadow resulting from the angles of the top edges of each "scrap" of wood.

One of the compelling reasons to conclude that *The Forest* marked some inner consolidation of the death theme was the existence of a sculpture called *Forest Christ*. There are no photographs of the work, but Colette Roberts noted

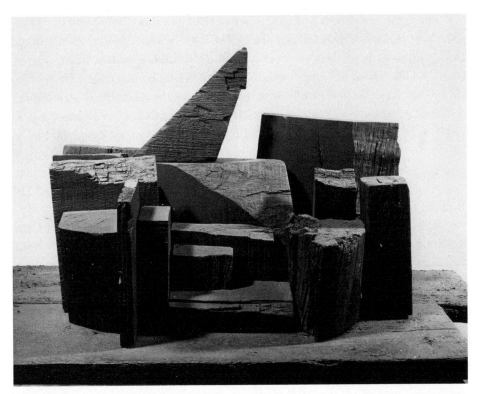

Structure View, 1956. Wood, 17 ½ x 35 ¼ x 17 ½ in. Photograph by Jeremiah Russell, Archives of American Art, Smithsonian Institution

that it was both a hanging and a relief and one of Nevelson's first pieces to be enclosed in a custom-made box, this marking a stylistic turning point.[38] The image of the enclosed Christ figure is undeniably funereal and provides a natural link to the enclosed *King II*, found the following year in *Moon Garden + One*.

The Forest was a major passageway on Nevelson's voyage to her signature style and to a partial resolution of deeply denied feelings about sexuality, death, and her early childhood. Though she had been moving toward a full realization of the importance of shadow in her work, the exhibition seems to have consolidated her momentum.

Just before the exhibition opened, Nevelson removed two works, *The Black Wedding Cake* and *The Wedding Bridge*.[39] *The Wedding Bridge* is a five-inch-wide rod, eight feet long with small wood blocks at either end representing clustered villages.[40] It was originally intended as a way of cutting the space of the recently enlarged Grand Central Moderns gallery.[41] During the installation it was placed between *First Personage* and the *Village* grouping. According to Nevelson's later explanation, the piece was inspired by her imagined fear of falling from the bridge to certain death.

The degree of danger and suggestion of sexuality represented by *First Personage* is part of what frightened the artist. *The Forest,* with its evocation of sea and woodland, recalls the landscape of Nevelson's childhood in Rockland, Maine, while the black wedding pieces may symbolize her failed marriage. *The Wedding Bridge* may have related to the story, told in her autobiography, describing her mother's betrothal and how, because of the absence of an ice bridge that would have taken her away to her sister's home across the River Dnieper, she had to marry the artist's father and was unhappy with him.[42] This tale about her mother's past assumed such importance in her own memory that Nevelson once considered using it as the title of an exhibition, which would have been called "The Body of Water Never Froze—Direct Birth, Accidental Birth."[43]

In *The Wedding Bridge,* the ice bridge, which would have provided an escape for her mother, was transformed into the long, narrow, black lath, with wood "villages" on either bank, separated by black velvet "water." The relationship of *The Wedding Bridge, The Black Wedding Cake,* and *First Personage* starts to become clear. The fact that Nevelson was frightened by the moving mouth of *First Personage* (a self-representation as a bride), and then associated that fear with two more pieces symbolizing marriage (the black-painted *Wedding Cake* and *Wedding Bridge*), suggests that the knot (mouth) could also have been a symbol for the bride's quivering trepidation, sexual fantasies, and anxieties about birth. A sudden coalescing of her frightening fantasies about marriage and maternity impelled her to remove the sculptural reminders.

When discussing *The Forest* exhibition and, particularly, her resistance to work again in the round, Nevelson suddenly began to recall her guilt and discomfort about having a child. "I was too young. . . . I had a Cesarean because I couldn't face it . . . and having a stranger project his hands—up there . . . the whole thing. It killed me. Anyway my son went into the war. And that was when I wanted to kill myself. I saw nothing but blackness. . . . Well, you can black out for many reasons."[44]

One of the many reasons for a person to black out is intense discomfort in the face of the body's raw physicality. Birth was not a safe or happy subject for Louise Nevelson. She knew her mother had been born through a metal hoop at the behest of her superstitious grandmother's rabbi. She knew that for millennia, including the 19th and early part of the 20th century, many women died in childbirth along with their newborn babies. She also knew that because of her mother's reluctance to give birth to more children, Minna Berliawsky stopped having sex with her husband when Louise was six years old. In fact, she was well aware that marriage and death were also unsafe subjects for her. "Is there anything in the extreme between a wedding and death?" she asked an interviewer in 1977.[45]

Nevelson had descended into her unconscious for some of the images in this exhibition, and one of the triggers for her fantasies could well have been her son's recent second marriage and being a new father to his second daughter, Louise's second grandchild. In December 1955 he had married again, this time to a woman from the Midwest, who had lived a sheltered life with religious Lutheran parents. Florence Klettke was ten years younger than Mike. By October 1956 they had Elspeth, the first of their two daughters. From then on Mike's letters invariably sounded the note of blissful domesticity, with Flo always in the background cooking, gardening, and caring for their daughter. Throughout the months Nevelson was preparing the show, Mike's letters to his mother were a mix of happy talk about his wife and newborn daughter and hopeful but somewhat resigned words about his own struggle with poverty and the wished-for artistic success that continually eluded him. The momentous events in Mike's life, together with the doubt and disappointment they stirred up in him, seemed to reverberate in the work Nevelson was doing at the time.

Nevelson was working on *First Personage* when Mike came to stay with her in December 1956 to settle some of his business affairs. He left abruptly, without going to see her work in a group show at the Whitney Museum. As a postscript to a letter he wrote on his return home, Mike congratulates his mother about her "great success at the Whitney Exposition" and expresses his regret that he was "too upset in NY to be able to visit the show."[46]

In his very next letter, written only six days after her solo show opened, Mike tells her of his uncle Nate's proud display in his hotel of the latest *Arts Magazine* with Hilton Kramer's fulsome praise for *The Forest*. His response: "As far as I can see, this was one of the most sensitive appraisals of your art, and this review . . . certainly places you in the top echelon of international art. As a result of this, you should really be jumping this year on more projects. Best wishes to you."[47] He ends on an optimistic note. "Actually I am in very high spirits and we are very comfortable here. Take care of yourself."

Within the next month, Mike sent greetings laced with advice: "I suppose after all the excitement of the exhibition, that now you have a little letdown, both physical and emotional, which is bound to be. Sometimes we wonder if you would be better off married to some man who could give you a sense of security, somebody personally interested in you. Of course, one might say, if that is what you wanted, that is what you would have." Nevelson's son's mixed feelings about her success and single state could have seemed rather out-of-touch with her actual condition. Louise Nevelson was in fact relieved to be single and consequently able to focus entirely on her art. But her son was acting in good faith, working hard—as a Nevelson man—to protect his mother.

An older and yet more painful set of memories is most likely also embedded

in *The Forest* exhibition, which was such a turning point in Nevelson's artistic development. Nevelson's mother had been had been born in a small village on the Dneiper River called Shusnecky. In 1902 Minna Berliawsky—took her son Nathan and oldest daughter Louise back to her parents' home and stayed there until they left for America three years later.

Between 1903 and 1905 more than sixty towns and six hundred villages in the Ukraine were beset by a series of brutal anti-Semitic pogroms, some occurring either in or very near the village of Shusnecky. Louise, née Leah Berliawsky, would have been three and a half to five and a half years old during that time period.

Nevelson never spoke publicly about her memories of her early years in Shusnecky. I interviewed Nevelson in 1977 about *The Village* as one of the groupings in *The Forest* exhibition, and she categorically denied that she had ever made such a work. Even after being shown a photograph of *The Village* in *Art News* as well as the name of *The Village* in the gallery's list of works in the show, Nevelson repeatedly (seven times) denied that she had ever done a work called *The Village* and had "never used the word 'village' in a title. No, I'm sorry to tell you I don't believe it."[48]

Nevelson's intense protest over a relatively minor point suggests that her repudiation was an unconscious effort on her part to mask and deny something significant. The entire exhibit was a personal watershed for the artist. A village—Shusnecky—was the physical environment in which many of the important events of her early childhood took place, and in the exhibit, where her memories, fantasies, and feelings found expression in architectural forms, these heretofore "forgotten" memories came threateningly close to consciousness. In *The Forest* Nevelson had created symbolic equivalents of her life story—the romantic and sexual history of her mother and herself, as well as the deeply repressed memories of the dangers connected to the actual village of her early childhood.

To suddenly, and at the last minute, remove two works from an important installation, and two decades later, to forcefully deny an indisputable fact—that she had ever made a sculpture titled *The Village*—are anomalies that make no aesthetic sense, but they make psychological sense. Louise Nevelson, née Berliawsky, had to *not* know about the bridge and the wedding cake just as she had to *not* know about the village of her past.

This exhibition marked the beginning of Nevelson's need to enclose her work and protect herself from the anxieties that often accompany memories that are too traumatic. Enclosing her subsequent work in boxes was accompanied by a new emphasis on shadow, a formal development that embodies the psychological shifts taking place within her. As we will see in the next chapter, Nevelson's next exhibition *Moon Garden + One* contained an entire wall made up of more than a hundred boxes, and she wanted it to be experienced in near-total dark-

ness. The artist herself had to remain in the dark about her own history while she simultaneously voyaged to the great beyond.

Again, reviewers of *The Forest* focused on the formal. Dore Ashton was the only reviewer to note the metaphorical use of forest imagery for human presences.[49] Hilton Kramer wrote a lengthy laudatory review of the exhibit in *Arts* magazine: "These blocky forms have taken on a more architectural character, abandoning their descriptive functions to participate in a purer abstract conception of sculpture as a mysterious orchestration of light and shadow, or rather—to put first things first—sculpture as a plastic embodiment of pure shadow to which light is admitted in a subtle and fugitive way."[50] His words—"architecture" and "shadow"—soon became the trademark terms of Nevelson's conceptual vocabulary.

Kramer goes on to say:

And while the creative process here is an additive one, the finished whole—both in imagery and effect—is artistically larger than the sum of its parts. . . . [A]ll these works are characterized by an intense and sensitive awareness of sculptural detail: all edges, corners and planes, all cracks which may be expected to emit light, every shadow which one mass may be expected to cast on another—this consciousness pervades the whole conception, and indeed supplies exactly the element of sensibility which the architectural components require as a sculptural leavening. Without grasping the presence of that consciousness and entering into it in some degree, I suspect any viewer would find Mrs. Nevelson's art merely eccentric. One must really enter the shadows here before one can *see*.[51]

Intuitively, the critic had penetrated the depths of Nevelson's work and inner life.

Kramer had not only roundly praised Nevelson's work in his insightful review, he had also named her and framed her. In identifying her concern with the play of light and shadow, which had been evident already in her etchings done at Atelier 17 in 1953, Kramer had given her the words and concepts she needed to see for herself—and thereby explain to the world—what she was already doing with forms. In his review of *The Forest*, he saw that her sense of composition—which was embedded in her lifelong fervor for putting diverse pieces of wood together in just the right way—could be called architectural. Kramer's focus on the architectural aspects of Nevelson's work struck a respondent chord. In a few years Nevelson would be calling herself an architect of shadows (1964) and connecting it with her understanding of the fourth dimension.

When she was interviewed by Dorothy Seckler for the Oral History Program at the Smithsonian in 1965, she said: "I think that the shadow . . . is the fourth dimension. That shadow I make forms out of is just not a fleeting shadow,

but it has as much form as a Cubistic form."[52] She also made clear: "I didn't want to make sculpture and I didn't want to make form as such. . . . I want something else entirely. . . . It's almost like you are an architect that's building through shadow and light and dark. . . . You don't want to make buildings for people; you are—in another dimension. . . . But it's a very real world.[53]

Had the penny dropped, and everything Nevelson had heard and read up to then about the fourth dimension fallen into place? And did shadow have another meaning for Nevelson—the more mundane but frightening role as a symbol of death and darkness? Beginning with her next and breakthrough exhibition, *Moon Garden + One*, Nevelson would ever after have to control exactly how her works should be lit or whether they should be left in shadow.

In September 1957, Sidney Baldwin, a columnist from Peoria, Illinois, wrote about his lunch with Louise Nevelson at her brother's hotel in Rockland, Maine, during the summer of 1957. Nate Berliawsky had been telling him about his sister for years and he already admired her work.

> She is not young, already has a grandchild, but she gives the impression of a youth—very appealing, slender, vivacious and buoyant. She sat down at our table and then began an hour of stimulating talk which none of us will ever forget. She is to have a show in January [*Moon Garden + One* at Grand Central Moderns]. . . . She has just developed a new mode of expression and was eager to explain it. . . . This new form came about because she found a young carpenter in New York who could and would follow her directions. He has made a series of "shadow boxes" much longer than they are wide—in which she had developed a series of designs—some in wood. They are new and so adaptable to the modern scheme of decoration that they are selling almost before they are finished, and she is as excited as anyone would be who after half a lifetime of sitting in the shadows, now feels the full force of the sun.
>
> It was a wonderful hour. We forgot to eat. It is a world none of us knew, and Louise Nevelson has the ability to make her hearers a part of her own emotion. She has a brownstone in New York, which is full of her work—she dispensed with furniture, sleeps on a cot, and lives alone. She told us of the years of uncertainty, of her lack of knowledge, of her need to live alone and to work alone and the difficulty of making people understand that need.
>
> And when success came and her sculpture began to be in demand, when another person would have been supremely contented, she confessed that she was still frightened, still uncertain, still wondering what was the matter. Do other people feel this way? Will life ever be calm?[54]

It is perhaps the first contemporary account of Nevelson's use of boxes.[55] A few months after Hilton Kramer's rave review of *The Forest*, someone was making shadow boxes for her.

Multiple stories have been written about how Nevelson started using boxes to house precious found objects, to contain her compositions or "to provide a slow admission of light on an enclosed relief."[56] Colette Roberts recalled that Nevelson had received some cases of whiskey in 1957 and their crisscross separations started her on the idea of enclosures.[57] According to other versions, Nevelson found rug boxes on the street and, liking their look, began to use them. Or, her brother-in-law, Ben Mildwoff, gave her boxes from his glass factory. Or, her assistant, Teddy Haseltine, was doing work in small Cornell-type boxes, and she learned from him.

Years later, Nevelson claimed that she first used the boxes for storage and protection, but soon discovered that they could be used to reinforce, emphasize and build upon the shadows. The boxes gave her new understanding of how she could use shadow as form and how shadow could represent the fourth dimension. They also gave her a way of controlling shadows, and the forms they created, and every thing they might mean to her, whether she was conscious of all those meanings or not.

All these versions probably contain kernels of truth. Like any momentous discovery the origin is multi-determined. No matter how it began, the diverse stories underline the fact that, by the summer of 1957, Nevelson was arranging to have shadow boxes at her disposal to use any way she liked. Eventually, doors were added. "*Moon Garden + One* was on its way."[58]

During the summer of 1957 Nevelson had been bragging to Baldwin, the columnist she met in Maine, about her increasing income and indirectly telling him and her brother that she liked living alone—despite the pressure she was getting from Nate and Mike about her need for a husband or companion.[59] By this time she had invited Teddy Haseltine to live in one of the small rooms on the fourth floor of her house. Teddy had been introduced to Nevelson the previous year by his then partner, Donald Mavros, a sculptor and ceramist whom Nevelson knew. Teddy was an attractive young man, gamin, rather a lost soul, spiritual, spirited, penniless, essentially homeless, and totally devoted to Louise Nevelson. His willingness to be her gofer, cook, companion, and helper whenever she needed him fit her needs much better than most of his predecessors.

She and Teddy were both devoted to spiritual exploration and went together to hear Krishnamurti speak whenever he was in New York. Teddy had a good eye and became exceptionally adept at picking up wood scraps for her, staining and selecting them out of myriad baskets of variously shaped pieces and nailing them exactly into the places she wanted them to be—the perfect

Head, 1961. Ink on paper, 11 x 8 ½ in. Brooklyn Museum, Gift of Louise Nevelson 65.22.50

studio assistant. Less than perfect were his problems with alcohol, drugs, and boyfriends.

Teddy's immaturity allowed Nevelson to be a beneficent maternal presence. She could provide him with structure, discipline, and pocket money. She was not bossy with her assistants, rather she tended to be uplifting and encouraging: "She makes everybody feel great who works with her."[60] Colette Roberts recalled Teddy: "He was actually quite a gifted fellow himself, an artist at heart, and so he catered to Louise the right way."[61] When they were home alone in the evening, after she had been working hard all day, they would either start dancing or she would sit and write some poetry or she would sew some little thing.[62]

Having Teddy up the stairs and Roberts down the street, and both one hundred percent supportive of her and her work, gave Nevelson the security she had been seeking since she had left Maine to marry Charles Nevelson. Then, towards the end of the year Diego Rivera died in Mexico City. Another of Nevelson's most significant father figures was gone. According to reports in *The New York Times*, he was mourned by two thousand people who attended his burial.[63] A few months later, in January 1958, her breakthrough exhibition, *Moon Garden + One*, would celebrate the way Louise Nevelson transformed death and loss into great art.

MOON GARDEN BREAKTHROUGH

1957 – 1960

"But above and beyond all it is a Universal love affair for me, and I'm in love with art."
—Louise Nevelson, speech given at Long Beach, July 25, 1954.
(LN Papers; Box 5, f 29)

In 1957, the year before *Moon Garden + One*, Nevelson knew that she would have to move out of her house on Thirtieth Street. While owning a house had solved a number of practical problems for the prolific sculptor in the mid-1940s, it had also spoken to deeper needs that became apparent only when Nevelson was threatened with its loss. Nothing definitive had happened yet, but she worried about the dwindling amount of time she had left on Thirtieth Street. She dreaded having to move all her possessions and all of her work from a home she loved.

The year before she moved, Nevelson obsessively collected found-wood fragments and used them to make so many sculptures that she had to stack and arrange the separate pieces as compositions just to make working space. The house was filled to overflowing with more than nine hundred artworks. Her close friend and fellow sculptor Dorothy Dehner recalled spending the summer of 1956 taking photographs of the house and garden. "Her house was just crammed full of sculpture, lined with it, stacked with it all over. I couldn't take photos of any separate pieces because there wasn't enough room."[1]

In January 1958 Nevelson put almost all of her furniture on the sidewalk to be carted off by the Salvation Army, keeping only a red refrigerator, a bed covered with an American Indian blanket, and a glass table with three chairs.

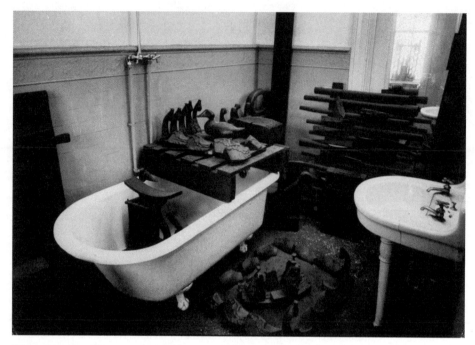

Walter Sanders. Thirtieth Street Bathroom, 1958. LIFE Picture Collection/Getty Images

She had emptied the large house that she had loved for thirteen years because, she claimed, "I needed the room . . . because I plan my shows as an ensemble, as one work. Everything has to fit together, to flow without effort, and I too must fit. . . . I never know my next move. . . . I just let it happen. When I let my inner vision guide my hands, there are no errors."[2]

Two months before the opening of *Moon Garden + One*, Colette Roberts brought a group of French artists to Nevelson's Thirtieth Street house, knowing that they would find its sculptural contents extraordinary. Georges Mathieu recalled his visit:

Imagine a nondescript three-story house of the New England style on a nondescript street. . . . You enter. You are in a Kafka-like world, the laws of which escape you. In the cellar, relics lie about, [urative and black. . . . On the first floor the relics are tabernacles. They cover the walls, carpet them. There is no place to live, no living room, no bedroom, no kitchen . . . no bed, no table. . . . Yet one finds thousands of closets; thousands of cupboards, chests, coffins, boxes; thousands of Nevelsons. . . . On the first floor, second floor, the third, the same accumulations, implacably superimposed, intertwined and piled, bewitching and overpowering.[3]

Mathieu bought one of those thousands of boxes from her studio. Roberts also brought art critic Michel Tapie from Paris and the artist and sculptor Pierre Soulages, who observed: "This is not only sculpture, it is a whole world that is opened to us."[4]

The year 1958 was an annus mirabilis for Nevelson beginning with her breakthrough exhibition in January, *Moon Garden + One*. Although the theme of a garden at night was not uncommon in the art world, the show was startlingly new. New for Nevelson, and new for the art world. It was clear to viewers that they had entered "a whole world" and were not merely seeing an accumulation of separate sculptures.[5]

Moon Garden + One was made up of 116 boxes as well as some free-standing rounded or rectangular platforms on pedestals with wood collages on top. Each of the boxes was filled with wood pieces that Nevelson had been collecting for years—driftwood found on the beaches of Maine and Long Island; wood remnants from local lumberyards and antique stores; debris from demolished houses in her neighborhood as they were being flattened in readiness for Kips Bay, the new development. She had stained all the pieces matte black, because, as she said at the time, "Black creates harmony and doesn't intrude on the emotions."[6] The monotone color masked the origins of each element as a bowling pin, piano leg, roof shingle, barrel top, and orange crate. She had

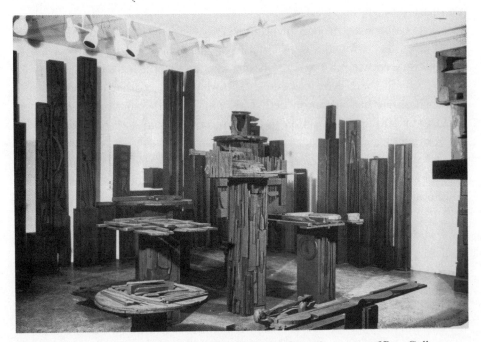

King II (Installation view), 1957. Photograph by Jeremiah Russell, courtesy of Pace Gallery

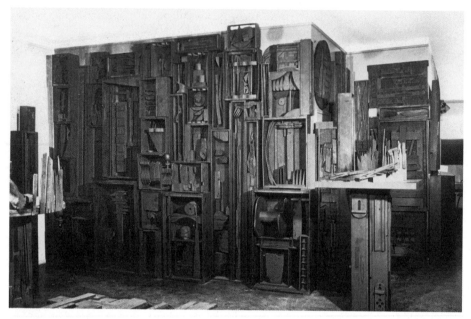

Moon Garden + One, Sky Cathedral or *Cathedral* (*Sky* Installation), 1958. Photograph by Jeremiah Russell, courtesy of Pace Gallery

cut, shaped, and partially assembled many of the wood fragments before placing them in or on the boxes.

"When she was through installing *Moon Garden + One*," Colette Roberts once said, "she stripped—well actually only her blouse—and she started to dance with Teddy, and it was really just like a dance in front of the ark . . . a ritual dance if there ever was one."[7] Both the artist and her right-hand man knew what they had accomplished. They had created something entirely new in the art world—an exhibition that completely surrounded the viewers as an environment.

A few hours before the opening of *Moon Garden + One*, Edwin Barrie, the director and manager of Grand Central Galleries, came with his secretary to see the show. Roberts recalled the details:

> I said, "Well, you know, I have a problem because she wants no light, and you can't see a thing." And he said, "I wonder if we couldn't do it like in the theater with colored light." And then he took his secretary's blue scarf and put it in front of a lamp. And I said, "Well, you have it. I'm going to get blue lights." So we changed the lamps and put as many blue lamps as we needed, and the whole thing was all right. But this was done at 11:00 am, and we opened in the afternoon.[8]

Nevelson readily accepted Barrie's suggestion, agreeing that a spare number of blue lights would allow viewers to see her work the way she saw it. But it is worth examining why she would have wanted no light at all. Since the enveloping darkness made the actual pieces of *Moon Garden + One* almost impossible to make out, we can believe the artist when she said, years later, "It was not really for an audience. It was really for my visual eye. It was a feast—for myself."[9]

She knew that an audience for her work was necessary, even desirable—her goal had long been to give her work as much exposure as possible—and yet she wanted to keep this exhibition to herself, unlit. This uncharacteristic longing for darkness was a desire for privacy with regard to particular buried fears and fantasies—especially those that had to do with death and sadness, which emerged as she was working on the exhibition.

In her press release for the *Moon Garden + One*, Colette Roberts pushed the idea of the viewer as "+ One," knowing that Nevelson was ambivalent about the inclusion of others into her mysterious inner life. Only long after and in the midst of her continued success did Nevelson begin to claim that "+ One" was herself, which was both true and false. Nevelson needed to be the prime viewer of the work that represented her inner life but she also needed others to see her art.

Everything in the exhibition spoke to a sense of enclosure. One large gallery wall was almost completely covered with *Sky Cathedral*, which was composed of thirty-six boxes. Other walls were lined with, but not concealed by, vertically aligned boxes, some totemically tall and most with hinged doors, which were opened in varying degrees to allow a play of light and shadow. The stark bright lighting of the installation photographs obscures this startling effect in the individual works as well the overall exhibition. Those who weren't there can only guess at the full effect of the installation.

The exhibition hit the art world like a bombshell. "Surely among the most dramatic exhibitions New York has witnessed in years, *Moon Garden + One* all but defies description," wrote her longtime enthusiast, Emily Genauer.[10] "On entering the gallery, one feels first a breathless, imageless stir. . . . This is a nether world Nevelson has conjured out of her enormous imagination, technical ingenuity and surging creativity. . . . The important thing is that as we allow it to envelop us we feel it, still, as a world we can enter along with the artist, a cave of the heart, a dark place of dreams and loneliness."[11]

All the critics acknowledged the show's extraordinary effects on viewers. Though Nevelson had used themes to organize some previous exhibitions she had never before so completely enveloped the viewers with her sculpture. The installation itself was a key factor in the creation of this first "environmental" exhibition. Some critics focused on the consistent use of black as macabre and frightening, painting the artist as a sorceress. Others, annoyed with the artist for making their

lives difficult, complained: "Entering this tenebrous gallery, the visitor at first can barely distinguish the walls lined with boxes. . . . Endlessly varied, but always subordinate to the deliberate theatrical atmosphere staged by the artist."[12]

Her future dealer and friend Arne Glimcher observed: "Nevelson sought to establish an unfamiliar landscape that would disorient the viewer and question the sufficiency of his perception. . . . This was a magic window that allowed the viewer to walk through into a private universe."[13]

Whatever other reviewers saw or felt, Hilton Kramer, writing in *Arts* magazine, had an entirely original perspective: "What seems to occupy [Mrs. Nevelson] the most . . . is the impulse to project on a macrocosmic scale the artistic vision which is embodied in each given work. . . . The gallery space was entirely transformed into a continuous sculptural enclosure, dominated by an enormous wall-sculpture, which in itself represented a brilliant realization of everything toward which [she] has been aspiring in her recent efforts: neither a relief nor a construction to hang on the wall, but an actual wall, in the literal architectural sense, which was at the same time a work of sculpture."[14]

Kramer noted Nevelson's evolution from the free-standing works on pedestals to the walls, observing that she was using a new medium—light and shadow: "The *Sky Cathedrals* are her Collected Works. . . . (No photograph can even approximate their appearance or suggest the feelings they induce.) They are appalling and marvelous; utterly shocking in the way they violate our received ideas on the limits of sculpture and on the confusion of genres, yet profoundly exhilarating in the way they open an entire realm of possibility." He compared Nevelson's walls with the large paintings by Rothko, Pollock, Still, and Newman. These artists "have progressively emptied their image in order to enlarge it, she insists on proliferating more and more detail, arresting the eye with a brilliant or subtle 'passage' wherever its glance falls."

Thomas Hess, writing in *Art News* was less kind: "Louise Nevelson's recent exhibition is another example of the abstract artist making his world. Hers is more theatrical and artificial, or sculpturesque, than the environments of Rothko, Pollock or Reinhardt, but perhaps, because of this, it is more easily seen as a place where art and nature become indistinguishable from each other."[15] Despite his ambivalence, Hess's inclusion of a photograph of *Sky Cathedral* with the label "Art as environment" set the stage for her future renown as the first American sculptor to create environmental art. Equally important, like Kramer, Hess noted the parallel between Nevelson's sculpted walls and the large paintings of the New York School painters.

Kramer and Hess set in motion the two views of Nevelson that would dominate the art press for years. She responded to both. Kramer's view of her work addressed the private and profound—the sculptor seeking to bring her vision of an

ideal fourth dimension into the everyday world of galleries, museums, and homes. Hess's focus on Nevelson's dramatic side appealed to her exhibitionism. As someone who had studied "dramatics" she gleefully accepted the sobriquet "theatrical."

The March 24, 1958, issue of *Life* magazine showed her crouching behind her sculpture, wearing a peaked witch's hat, illustrating the shadowy scene. The article, titled "Weird Woodwork of Lunar World," began: "Like a sorceress in her den, Louise Nevelson is peering out from an eerie world of her own making," thus expressing the spooky aspect of her work that appealed to some journalists.[16]

The illustrated article in *Time* magazine showed the artist looking more conventional[17] but noted that "The *Moon Garden + One* [is] one of the most unusual exhibitions of sculpture in many a moon."[18] Not to be outdone in using colorful language, the writer noted: "In a misty, mystic haze of blue light stands a forest of eerie, black wooden shapes."[19]

When Nevelson and Roberts discussed the work of this period, they were open about the artist's conviction that her sculpture was primarily about bringing the fourth dimension—or "elsewhere"—into the here-and-now of the third dimension.[20] That idea has usually gotten lost in the welter of formal analysis of her art. Nevertheless, as time passed, Nevelson was able to make references to the spiritual element of her work when she discussed its formal elements, such as color. In an extended riff on why she used black, the artist proclaimed: "People have identified . . . black with death or finish. Well, it may be that in the third dimension black is considered so. [But] It's a myth really."[21] She noted that, "In convention, alchemy means transformation of something into gold. Well I think that's exactly what I've done with [black]."[22] Given the somewhat conservative nature of the art world during the time in which she was working out her own style, Nevelson may have felt conflicted, wanting to keep an essential element of her identity private, yet also wanting to acknowledge the spirituality that guided much of her art. She was initially wary about telling interviewers about her ideas of the fourth dimension, though by the mid-1960s she evidently felt free enough to do so.

For the rest of her life Nevelson would shift from one self-presentation to the other—attention-getting in public, profound in private—often using the former to hide the latter, since being known as interested in spirituality might make her feel like an outsider, as she did growing up in Rockland. Her closeness to Mark Rothko was founded on their similar inclinations to place spirituality at the center of their art, though both rarely acknowledged that important issue at the time.

In their reviews of the exhibit, critics mentioned lost cultures and nether worlds, but made no attempt to specify a personal meaning for the artist. It was not a fashionable style in art criticism, which gave Nevelson cover. Whether or not she knew what unconscious fantasies lay behind her work, she certainly was not ready to reveal such personal meanings to the general public.

The thematic complexity of the exhibition is suggested by the presence of royal figures, King II, and the Court. While Nevelson resisted specific associations to Christianity, her use of titles like *Cathedral* and *Heavenly Gate* suggest a reference to a churchyard cemetery, a common sight in New England. Evidence for such an association is also provided by the placement of certain pieces in the show. *Sky Cathedral* (or *Cathedral in the Sky*) is made up of numerous units of different sizes, which resemble the many-niched church altars found throughout Catholic Europe and Latin America, and particularly noticeable in Mexico, where these places of worship still tower over most other buildings. In the space adjoining Nevelson's *Cathedral, Heavenly Gate* separates the vertical boxes from the facing wall, thus evoking a churchyard cemetery next to the church itself. Nevelson's *Moon Garden* existed in both a symbolic and a specific locale and could be understood as a sacred cemetery visited after dark.

But most significant for the establishment of a plausible iconography for this exhibit is the presence of a half-open funereal box enclosing a thin semi-figural relief entitled *King II*. This piece sets the tone of the show.[23] Building from the hypothesis that the king and queen represent parental figures, this somewhat chilling sculpture appears here as a father interred.

Knowing about the family cemetery's existence in Rockland and the artist's awareness that she hadn't attended the funeral of either of her parents funerals in the 1940s could have summoned up images of the place and the ceremonies she had avoided. Nine years before she embarked on the creation of her own tenebrous universe, Nevelson had experienced the jungle darkness of a moonlit visit to the Mayan ruins in Quiriguá, where she would have seen "Stela C," which so strongly suggests a coffin.

The huge size and awe-inspiring spectral quality of the Mayan sculptures, with their vacantly staring gazes, reinforces the association to funereal figures. I have already proposed that, in the etching series from 1953, these large stone figures had evoked parental imagery. It is a short step to perceiving them as entombed ancestors: for the Mayans, as revered ancients or deities, and for Nevelson, as recently deceased parents and parental figures.

Nevelson's use of black as the predominant color for her work began during or just after her series of etchings, the imagery of which was clearly related to her trip to Quiriguá. She must have recognized a personal affinity for this color, as she sketched her own features on the West Queen—"west" being the direction in Mayan mythology associated with black. While Nevelson claimed it was a mistake ("a myth, really") to link black with "death or finish," in Western civilization black is the color associated with death, and the terms "shade" and "shadow" connote the spirits of the deceased. Thus, a sculptor who calls herself the architect of shadows almost automatically connects herself with such imag-

Alfred Maudslay. Stela C, South Face. *Biologia Centrali-Americana* (London: R.H. Porter and Dulau & Co, 1889-1902). Courtesy of Biodiversity Heritage Library. Digitized by Smithsonian Libraries.

ery. The etching *Shadow City* (also called *Ancient City*) carried intimations of both cemetery and ghost town.[24] The rectangular structures placed in two rows across a horizontal format can be read either as buildings or headstones in a cemetery.

Yet once again, Nevelson was denying something that had powerful personal meaning for her. Black was not symbolic of death, she claimed. But she also said in autobiography that, "there was something in me drawing me to the black. I actually think that my trademark and what I like best is the dark, the dusk."[25] Another aspect of Nevelson's affinity for black, the color of perpetual mourning, is her association of darkness with the concept of merging. An undated two-line poem in her papers expressed this succinctly:

> Daylight has form
> Darkness is oneness.[26]

These words can evoke both transcendental yearnings and the child's wish to be united with the original source of warmth and safety—the mother. Another telling remark was Nevelson's response to a question about her feelings for her mother: "If my mother told me to jump out the window, I would jump. She was the closest thing in my life."[27] Nevelson's repeated expression of love for her mother, combined with her denial of sadness at her death, lend support to

understanding the artist's conflicted view of the color black. Black was linked with death and loss on the one hand and on the other with the repudiation of painful feelings.

The mourning process for her parents and Nierendorf, long denied by Nevelson at a conscious level, finally received symbolic expression in *Moon Garden + One*, through her creation of a funereal environment consisting of a holy sepulcher, a cemetery garden, and a coffin. The interment of a king within the moon's garden strongly suggests the reference to the parental imagery discussed earlier. The fact that this exhibit culminated in a crystallization of Nevelson's formal style underlines the importance that her preoccupation with death and mourning had played in her life and work.

The breakthrough was psychological as well as aesthetic and spiritual. The public success of *Moon Garden + One* confirmed for her that she had met a long-unsatisfied need. Through a partial identification with her father, the builder, she had developed a clearer sense of herself and her sculptural style. "Somewhere in my inner being I'm a builder," she noted.[28]

With *Moon Garden + One* Nevelson had created an Elsewhere; she had brought the ideal heavenly spheres down from the fourth dimension into the third-dimensional space of the gallery. She had brought the feelings from her painful past into the present where they could be transformed into masterworks. She could not fully experience the sadness of mourning her dead parents, which surely included their own sorrows at the time they actually died. Now a decade or more later she had created a world in which she could finally tolerate the pain of past losses, her own and her mother's, and was ready to say goodbye. That is the principal psychological explanation of Louise Nevelson's turn to environmental sculpture. In order to arrive at this point in her work Nevelson had to experience the psychological pain and repressed memories from her past. Once achieved, she could describe her style with perceptual and aesthetic terms—calling herself an architect of shadow.

More prosaic factors also helped Nevelson arrive at this momentous creative moment—as they always do with artists' breakthroughs to new ways of seeing and working. The zeitgeist played its role. The desire to create an entire world of one's own through the construction of works of art was an emerging phenomenon in New York during the 1940s and 1950s. In his article on Nevelson in *Arts Yearbook*, published in the late 1950s, Robert Rosenblum was not the first to note Nevelson's similarity to popular Abstract Expressionist painters who formed the vanguard of the impulse toward environmental work: "In some ways, Louise Nevelson's newest and most astonishing achievements—her vast wooden walls—recall the iconoclastic innovations of the new American painting. . . . In scale alone, the architectural magnitude of these forests of black boxes parallels the

awesomely large paint expanses of Rothko, Still, or Newman, which similarly impose upon the spectator an engulfing sensuous environment."[29]

The idea of environment was by no means the exclusive domain of painters and sculptors. Architects as well as artists seemed to be moving in new directions, and these developments provided both inspiration and support for Nevelson's work of the mid- and late 1950s. Three weeks before Nevelson's *Moon Garden + One* show, an impressive exhibition of Antoni Gaudí's architectural work had opened at the Museum of Modern Art, and both *Arts* and *Art News* covered it extensively.[30] On display were photographs of La Sagrada Familia, the extraordinary cathedral Gaudí never completed in Barcelona. While the curvilinear art nouveau style did not hold much fascination for Nevelson, the eerie surrealist quality of the Spanish architect's work appealed to her. In many ways, the accumulation of richly detailed parts organized into a façade of compartments resembled her *Sky Cathedral*.[31] Like all original artists, Nevelson's formal evolution was simultaneously at one with the zeitgeist and one step in front of it.

Martha Jackson, the director of the highly regarded Martha Jackson Gallery, approached Nevelson at about this time, and the artist also knew it was the right time to make a change—an idea that both thrilled and unsettled her.[32] Roberts's description of Nevelson's move to Martha Jackson's gallery is both astute and modest.

> Our position as a non-profit gallery was that when people reached a certain level, our ambition was to place them where they belonged. . . . [N]othing in this commercial world can be done without investment and we did not invest . . . and to do the final promotion of an artist, you need the investment. I don't think that she was happy leaving me, because she knew how well we'd worked. . . . But she was not able to afford it, because she had no money and the simple move of her pieces was something that had to be paid [for].[33]

As Roberts later explained to Arne Glimcher: "Now that the condition and the high level [in art galleries] has become so much like the stock exchange that [we could] not compete with it . . . [Louise] was not going to leave, but then the offer came with a financial subsidy. . . . We couldn't compete, there was no question."[34]

Colette Roberts's friendship with Louise did not stop, and they continued to see each other regularly.[35] Up until Nevelson signed a contract with Martha Jackson, Roberts was continuing to place Nevelson's art in eleven more exhibitions and as many collections as she could. By the time she left Grand Central

Moderns Gallery, Nevelson's work was in MoMA, the Whitney Museum, the Carnegie Institute in Pittsburgh, the Brooklyn Museum of Art, the Museum of Fine Arts in Houston, the Birmingham Museum of Art, the Sara Roby Foundation Collection, the Newark Museum, the New York University Collection, Brandeis University, the Nebraska University Collection, and the Farnsworth Museum in Rockland. Roberts had more than fulfilled the hopes Nevelson had when they first met.

Typical of Nevelson's situation in 1958 is the story of how MoMA ended up with the wall *Sky Cathedral*. Dorothy Miller, one of the Curators of Painting and Sculpture at MoMA, had been keeping her eye on Nevelson for fifteen years, particularly when she had started showing at Grand Central Moderns Gallery and begun to paint the works all black. The two women had met at openings but didn't become close friends until well after Nevelson achieved her breakthrough in the late 1950s. Roberts persuaded Miller and Alfred Barr, Senior Curator of Painting and Sculpture at MoMA, to see Nevelson's Thirtieth Street house shortly before the *Moon Garden + One* exhibition.[36] Miller and Barr were impressed with what they saw, though Nevelson's chilly reception of Barr—after so many years of his lack of interest in her work—made him reluctant to help her at MoMA. But, once Miller and Barr saw *Moon Garden + One*, everything changed, and Barr decided that MoMA had to have a big black wall despite the museum's lack of funds.[37] With Roberts's urging, Nevelson's sister and brother-in-law, Lillian and Ben Mildwoff, donated a black wall and, presto, another Nevelson sculpture entered a major museum. Ben Mildwoff said it would be part of his way of helping pay for Nevelson's move to a new house.

Nevelson had disassembled the original *Sky Cathedral*, and when MoMA sent a truck for the boxes, she said, "I'll come with my assistant, we'll assemble it at the museum, and your men can nail it together."[38] Barr was delighted to have the piece, and he wrote a letter to the Mildwoffs saying that whenever he feels blue he "goes and sits in front of the Nevelson wall."[39]

In the late spring of 1958 Nevelson found a notice in the *Times* about a building at Twenty-Nine Spring Street and sent Teddy Haseltine to check it out. He reported back that it was a five-story house in Little Italy with an occupied ground floor. The sale of the building to "Louise Nevelson, sculptress" was announced in the *Times* on September 30, 1958.[40] And so, very reluctantly, the artist moved from her secure perch into a new world. Again her family helped out, and loans from Nate and Ben made it possible for her to make the down payment.

Nevelson knew she had to move on and it wasn't as easy as it had been a decade earlier to pick up and start again—in a new home and with a new dealer. Her increased drinking around this time may have helped to ease her into it.

Nevelson's sister Lillian was convinced that the move from Thirtieth Street to Spring Street, which was almost simultaneous with the move to a new gallery, unsettled Louise and made her bitter.

When Lillian Mildwoff, who was now well off and had many friends who were millionaires, tried to persuade them to buy her sister's work—as many as they might want for two-hundred dollars—there were no takers. Despite her pleading, "not one bought anything, not one."[41] As a result many of the sculptures stored at the Thirtieth Street house had to be either stored or discarded. Nevelson had hoped to get eighteen thousand dollars for the entire "environment." Despite the extensive positive publicity for *Moon Garden + One*, she sold only seven individual boxes for ninety-five dollars each. Many of the boxes from the show were later shifted from one composition to another before they were permanently placed. Several years later some of those same boxes landed in new compositions that would be painted gold.

The family had been subsidizing Louise and her work for over twenty-five years, and it was undoubtedly Nevelson herself who decided that it was time to accept Martha Jackson's offer of a twenty-thousand dollar annual subsidy (Colette Roberts had thought the amount was thirty-thousand dollars) and change to a commercial gallery, which could help her take the next step forward. Nevelson could not have foreseen the unfortunate repercussions that would result, in the years to come, from leaving Roberts.

Martha Jackson was wealthy and had an elegant uptown gallery with a support staff that could vastly outperform Roberts's one-woman operation. By March 1959, Jackson and Nevelson had a contractual agreement, and by April, Jackson had taken over the day-to-day operations of promoting Nevelson's career.[42] And promote she did. She sent photographs of Nevelson's work to international journals. In 1959 Nevelson was included in eight group shows from Kentucky to Wiesbaden. She was nominated for, and won, cash prizes of one thousand dollars each in New York and Chicago. Not only were these large sums of money at the time, the juries for the shows were top curators from major museums and leading critics. For example, at the *Art: USA: 59* at the Coliseum in New York, the prize jury included Lloyd Goodrich of the Whitney Museum and Clement Greenberg, influential art critic at *The Nation*.

By May of 1959, David Anderson, Martha Jackson's son, was an active participant, and when his mother was distracted or ill, he stepped in to help. By August, Martha was sending checks for Louise to cash for her forthcoming European vacation. Even so, the transition to the new dealer was not an easy one.

Nevelson began the year 1959 speaking about her life and work on television, an activity that would continue for the rest of her career. Her poise and

clarity were impressive on the small screen, and her family in Rockland got up early to watch their famous relative become even more famous. When she had visited them in May, the *Portland Sunday Telegram* detailed her activities and noted that "the famous New York Woman came home to Rockland. Here she talked about her work, her family and her youth."[43]

"All my life I have felt that I knew where I wanted to go. I wanted to be an out-of-the-ordinary artist and a great one. It took me a little longer than I thought it would. . . . I did it the hard way. Others work hard to make the 'right connections.' . . . The miracle of it all is that I seem to have come through on such a grand scale."[44]

That grand scale included renting a trailer in Maine, which she filled with driftwood, old boards, a weather-beaten barber pole, antique oak, and an iron baggage cart, and having it driven down to New York. Her explanation: "These are symbols of having lived and functioned and had a life of their own." Gill writes "her creative mind takes these and gives them a type of resurrection." Equally grand is the artist's description of her home as reported by Gill: "the only private residence in Chinatown. It is an eighteen-room house largely filled with her work."[45] Like her father, Louise now collected antiques but, unlike her son who refurbished antiques to sell as a livelihood, she disassembled them to give them new life as parts of her constructions.

In August 1959, Nevelson sailed off to Europe with her sisters, Anita and Lillian, and Lillian's daughter Susan. When she returned, she had three major shows to prepare: in September, a four-year retrospective at the David Herbert Gallery as well as a group show at the Castelli Gallery; in October, a black show, *Sky Columns Presence*, her first show at the Martha Jackson Gallery; and in December, a show of white-painted sculpture, *Dawn's Wedding Feast*, at MoMA. She concentrated her efforts on *Sky Columns Presence* and *Dawn's Wedding Feast*. *Sky Columns Presence* opened at the end of October 1959 at her new gallery and the press release provided the key words "mysterious," "poetic," "magic world," and "traces of surrealism . . . now confirmed by a certain orderly mysticism."[46]

As in *Moon Garden + One*, one gallery wall was completely lined with a wall of black boxes. Facing this along the other walls were groups of tall four-sided columns covered with reliefs—totemic Sky Columns of varying height and width, some of which were suspended from the ceiling but most standing like sentinels. Colette Roberts saw these columns as particularly architectural and cited the artist's observation on the subject in her book on Nevelson. "Architecture? Architecture is everywhere order is. There is an architecture about our bodies, about the things we build and does not have to be a house."[47]

In the center of the gallery, an enclosed relief tondo, a circular work entitled *Sun* stands on a pedestal. Elsewhere in the exhibit a similarly designed *Moon* is

prominent. Unlike *Moon Garden + One*, the lighting of this exhibit was profession-
ally designed by Schuyler Watts to create a unified atmosphere and promote an
air of mystery.[48]

A telling indication of this show's Amerindian focus is the presence of the Sun
and Moon. These two prime deities of pre-Columbian culture were here incor-
porated into Nevelson's formal and symbolic vocabulary. The hanging columns,
in combination with the tall four-sided columns, represented a formal innovation
in *Sky Columns Presence*. As mentioned earlier, the four-sided columns, with their
mixture of high and low relief, recall the stelae she had seen in Quiriguá. Due to
the limited light of *Moon Garden + One*, the reliefs on the outside of the boxes had
been barely visible. Now she had made them easier to see in *Sky Columns Presence*,
the black show that followed *Moon Garden + One*.

The critical reaction to Nevelson's first show at Martha Jackson's gallery was
highly favorable. Dore Ashton, writing in *The New York Times*, called Nevelson
the "grand mistress of the marvelous," proposing that this exhibition surpassed
everything she had done before, and observing that, while other artists—like
the Constructivists, the Suprematists, and the Dadaist Kurt Schwitters—had
experimented with creating a total ambiance of sculpture, "never has anyone
saturated a room with such ideally idiosyncratic poetry." Ashton explained that
the strength of Nevelson's work is derived from "her ability to sense and ful-
fill emotional needs." She sees the boxes as "irreducible, archetypal symbols,"
which "create visual similes for a specified *état d'âme*."[49] Ashton here came the
closest of any critic so far to the idea that there might be specific personal mean-
ings embedded in Nevelson's enigmatic world of shadow boxes.

Like other critics, Ashton referred to Nevelson's mysterious means. A year
later she called Nevelson "an adept of the cryptic, of all that is secretive, all that
harbors the promise of revelation."[50] Observing that Nevelson uses half-open
doors on boxes that are partly in shadow, purposefully creating "in-between"
places, "an imagined universe . . . [an] hermetic *royaume*"[51] (or kingdom), Ashton
carried forward Hilton Kramer's observations about Nevelson's use of shadow
as a formal element in an architectural realm.

A few months later Ashton wrote a piece on Nevelson for the French journal
Cimaise, discussing both *Sky Columns Presence* and *Moon Garden + One* and referring
to the overarching goal of the artist. "If Nevelson were a writer she would be a
writer of 'romances,' spinning tales of the wonderful; tales that transcend reality by
insisting on the reality of an imagined universe; tales, in short, that strive toward
a mythos."[52] Ashton evidently did not know about Nevelson's specific fascination
with the imagined universe of the fourth dimension, but she seemed aware that
something unusual was behind the formal qualities of the work.

Nevelson's next truly innovative work for Martha Jackson would be the gold

walls—a dramatic departure from her work in both black and white—which came a year later.

In 1959 Nevelson was on top of the world and enjoying every moment. She was generous, now able to send her son weekly or monthly checks to help him with daily expenses, thus liberating him to do his own creative work. She wrote him inspiring letters about the joys of a creative life. They spoke every Sunday and, when they missed each other's phone calls, Teddy filled Mike in on her life and mood.

In a letter from Mike in early November 1959, he simultaneously thanks his mother for a check and observes plaintively, "Sometimes I think it is funny that nobody thinks much of my sculpture. But after all these years of work I have never been more secure in my own mind and I am continuing in my own line, developing new forms and making my highly personal statement."[53]

In the same letter Mike describes how, five months earlier, Teddy Haseltine appeared in Rockland with two friends where they rearranged, repainted, and relit the version of *Sky Cathedral* Nevelson had given to her brother Nate. A news item in the *Portland Sunday Telegram* had shown Mike setting up the eight-foot-high, fifteen-foot-long work in the front lobby of his hotel as best he could. In his letter to his mother on July 15, Mike acknowledged the difference Teddy and his colleagues had made. The work now "looks magnificent. I'm glad they made the improvement, because they share your mentality and understand your concept better than I. I really didn't know how to stack the pieces for the best effect."[54]

In the fall of 1959 Mike returned to Maine from his father's funeral in Texas, where he had learned that Charles Nevelson had left whatever money he had to his second wife and nothing to him.[55] Denying his disappointment with his father, by October Mike was writing with his usual mix of upbeat, happy father and protective adult son: "I was thinking of buying you a new heating pad for a gift. Would like to get you something else—something that could not be painted black or white. Don't get overtired and watch your diet."[56]

Nevelson's next major exhibit, *Dawn's Wedding Feast*, was designed to be a surprise for the art world by changing the color of her sculpture from black to white. Dorothy C. Miller was the curator of a series of MoMA exhibitions devoted to newcomers or little-known artists on the American scene. And now, on the heels of Nevelson's success with *Moon Garden + One*, she asked Nevelson to exhibit with fifteen other "young" American artists at a show in this series, *Sixteen Americans*. Nevelson surprised Miller by accepting immediately and proposing the idea of a white rather than a black show.[57]

It is possible that Nevelson's fondness for Dorothy Miller, as well as her excitement about exhibiting for the first time at MoMA and being included with a group of younger artists, inspired her to reach for greater heights. For over a

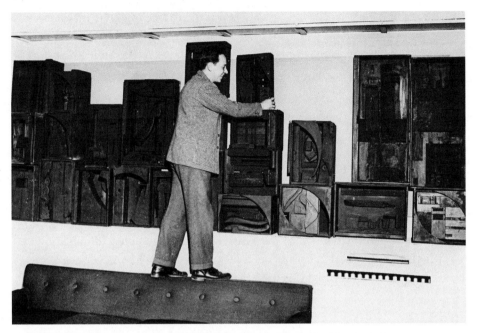

James Moore. Mike Nevelson installing *Sky Cathedral* at Thorndike Hotel, 1959.

year Nevelson had been associated with walls of black boxes—"a magical, mystical world." She had become the "grand mistress of the marvelous." Perhaps she felt the need to break out of the corner into which she and her critics had painted her and reverse her color palette.

In her autobiography, Nevelson explained her shift to white sculpture after five years of working with black-stained wood: Dorothy Miller "asked me if I would be in '*Sixteen Americans*.' I guess I was so taken by storm and surprise . . . I said that I would do a white show. . . . in a way it was an homage to her. . . . It was a kind of wish fulfillment, a transition to a marriage with the world."[58] Nevelson might have noted that her son had written to her a few months earlier (before she had decided to do a white wedding feast) that he had just painted one of his wood sculptures with two coats of white and that "the dead white gives strong shadow contrasts and makes for more visual volume."[59]

Despite being fifty-nine years old, Nevelson felt herself to be both debutante and bride. The night before the exhibition she stayed with close friend and fellow sculptor Anna Walinska, who gave her white orchids to wear at the opening.[60] Just as Dido Smith had known that Nevelson herself was the Bride of the Black Moon, Walinska knew that Nevelson was the bride-to-be at her Wedding Feast.

"I may never [use black] again," she told an interviewer, "because I've got-

ten tired of being crystallized. I've always wanted to free myself from the impact of the outside. Now I'm using another color for the Museum of Modern Art show. . . . The world is unlimited . . . the artist must never limit himself. The moment he's limited . . . he's dead!"[61]

In her autobiography she said:

> Now . . . *Dawn's Wedding Feast,* so it is early morning when you arise between night and dawn. When you've slept and the city has slept you get a psychic vision of an awakening. And therefore, between almost the dream and the awakening, it is like celestial. . . . Because the world is a little bit asleep and you are basically more alive to what's coming through the day.
>
> I feel that the white permits a little something to enter. I don't know whether it's a mood . . . probably a little more light. Just as you see it in the universe. The white was more festive.[62]

Nevelson rented a separate studio that she painted all white to prepare the work and also to keep the new development a secret. She worked intensively for three months, building the separate units: columns, boxes, and free-standing objects. She couldn't give Miller photographs of completed work for the catalogue since it was constantly changing. Two columns and a temporary wall were constructed for the photos, but they were never again placed together in the same way.

In four hours she and Teddy Haseltine, along with two helpers from the museum staff, installed the show at the museum late in the afternoon before the opening. Miller recalled: "It was like eating a beautiful dessert after preparing a splendid meal."[63]

The largest room in the MoMA exhibit had been reserved for Nevelson, and she installed a sixteen-foot-long wall of boxes against the back wall of the room. This section was called *Dawn's Wedding Chapel,* and near the center of this section was a box entitled *Dawn's Wedding Mirror.* The composition consisted of a large oval frame encircling a toilet-seat cover. To the left of the large sculpted wall— against the back and side walls—were two platforms forming an *L* on which stood ten tall, thin encrusted columns, similar to those made for *Sky Columns Presence.* The collages that covered them were as cluttered as the black ones from the earlier show, but they were easier to look at in white, as though the purity of the matte white simplified them. Several hanging columns, also similar to those in *Sky Columns Presence,* and a few more boxes made up the remainder of the exhibit. In front of one group lay a step-like set of boxes called *Dawn's Wedding Pillow.*

At a wedding feast one should expect to find the bride, but the few titled pieces in the show do not specifically identify her. In front of the *Wedding Chapel*, a platform with two large totemic columns was placed diagonally to the *Chapel* wall. The columns were unmistakably figurative, with their larger lower sections and their heavily encrusted but narrow upper parts. To each column was attached a round shield bearing a low relief. On the biggest shield the relief elements were emphatically vertical, strongly suggesting that this column was meant to be the groom. The smaller tondo on the smaller column bears three square frames, each enclosing a delicate relief, probably the bride. These central figures have not been given titles, nor are they usually discussed in terms of content. It is possible to see the two shields as differentiated, the larger representing a sun and the smaller one a moon.

The two shields in *Dawn's Wedding Feast* are similar to the Sun and Moon pieces from *Sky Columns Presence*. The variation in size and design of the two sets not only indicates the distinct celestial bodies but also strongly suggest gender differences. Thus, the black Moon from the Jackson Gallery show has wood fragments that appear like a woman's hair surrounding an encrusted circular "face." Like the two columns in *Dawn's Wedding Feast*, the Sun and Moon pieces in *Sky Columns Presence* are placed in the center of the room as focal points.

If this hypothesis is valid, and the two large columns in *Dawn's Wedding Feast* carry the respective shields of the moon and sun, then their presence in the chapel at the wedding feast implies that they are the couple in whose honor the other columnar figures have gathered.

In the installation photograph, the moon column is facing the *Chapel* wall, while the sun column faces away from both the *Chapel* and its columnar partner. This placement suggests that the moon column is in closer contact with the mirror in the wall toward which she is facing than with the sun column with whom she is presumably to be united. Although the "bride" column does not precisely face the mirror, she is aimed in its direction. It should also be noted that the pillow looks hard and uninviting, with a large sharp triangle in the center that would divide any couple brave enough to rest their heads there.

In the sequential development of Nevelson's thematic exhibitions, the moon made its first appearance in *Ancient Games, Ancient Places* in the form of etchings, *Moon Goddess I* and *Moon Lady*, discussed earlier. Part of the aesthetic merit and iconographic fascination of both etchings is the obscuring darkness, in one case achieved through the heavy overlay of lace fabric. This may be another instance in which a mythical and impersonal figure (the moon goddess) is used to symbolize Nevelson and/or her mother. Minna Berliawsky was at times distant and unavailable, like the black moon rapt in her lifelong mourning. At other times, she shone in all her finery, indeed like a goddess to a young girl.

The appearance of lunar deities on the first voyage of the *Bride of the Black Moon* in 1955 implies their complex meaning. On the one hand, the Bride is to marry the moon, and on the other, the moon goddess protects and sponsors the young bride. Nevelson, as a young child, had sought in vain to be close to her mother; as a young bride, she must have looked once again to her mother for guidance. But for both Louise Berliawsky and Minna Smolerank marriage meant leaving home, moving to a metropolis and then suffering in a mismatched partnership. Thus the Moon Goddess could symbolize both the artist's distant, wished-for mother of childhood and the equally distant mother of a young woman about to be married.

The monumental size and square-columned nature of the two shield-bearing central figures in *Dawn's Wedding Feast* might also be understood as recollected images, most recently from Quiriguá, and further back in time from childhood. The sun god and moon goddess, so pivotal in the Mayan pantheon, have returned in Nevelson's oeuvre for a celebrated marriage feast. As the early-rising Nevelson greets the dawn, that momentary union of light and shadowy darkness, she creates a magnificent white environment using artistic means to effect a resolution of her own personal conflict—much easier than the actual coming together of two people.

Nevelson's inclusion in the *Sixteen Americans* exhibit at MoMA surprised the critics. She was already "the most famous artist in the group. . . . Louise Nevelson is a prime figure in sculpture whose influence can be seen on many of her younger colleagues."[64] The critics were taken aback by the change in color, and their reaction was mixed. Thomas B. Hess called these white pieces "catalogues of obsessions."[65] Dore Ashton was both enthusiastic and sharply perceptive. She saw *Dawn's Wedding Feast* as a delightful fantasy from Victorian New England and related it to Emily Dickinson: "The baroque finery—lacey and latticed like a small Victorian town with its wooden houses and daintily fenced garden."[66] Clearly the critics had caught the mood of the exhibit, but had they divined any underlying meaning?

At the time of these exhibitions, formalism was the dominant way of looking at art. Iconography of the kind I have suggested above was reserved for medieval or early Renaissance works, where the focus was invariably religious and neither biographical nor psychological. That some of Nevelson's close artist friends recognized the personal meanings contained in her thematic exhibitions has made it easier for me to argue for the personal meanings underlying the sculptures and environments that were usually denied by the artist. Despite the artist's constant and conscious focus on the formal appearance of her work, she was nevertheless often able to imbue it with personal meaning.

Nevelson's continuing perception of herself as the bride reappeared two years later when traveling with Miller (the MoMA curator who had invited her to *Dawn's Wedding*) on their way to the Venice Biennale in 1962. Selected by the Museum of Modern Art to represent the United States, Nevelson's exhibition was made up of remnants from *Dawn's Wedding Feast* and *Sky Columns Presence*; a new white wall, which emerged in the installation, was retitled *Voyage*.[67] The remarkable statement Nevelson claims to have made—upon arriving at the airport in Venice, discovering that her suitcase had not arrived, and learning that the airport officials were not willing to act quickly to resolve the problem—is the clearest instance of her relationship to the theme of the bride expressed in her work: "'Now I'm getting married tomorrow and I've got to have my trousseau. My white wedding dress is in [the suitcase].' Well, of course, I was already sixty-two years old and that was the last thing on my mind."[68]

This remark, together with Nevelson's continued avowal that the marriage theme represents for her a union with her work or the world in general, discloses both the truth and a denial of the complex significance of marriage for the artist. About *Dawn's Wedding Feast*, Colette Roberts quotes the artist: "I've dedicated my life to my work and all it stands for. You have to be with the work and the work has to be with you, that's the marriage."[69]

Nevelson also wrote that, "I was hoping . . . *Dawn's Wedding Feast* would be kept as a permanent installation in a museum. . . . I would have almost been willing to give it away at the time in order to place it permanently."[70] When it was not purchased as a single environment, Nevelson was disappointed, but she put the separate parts together in new compositions, which eventually entered private collections and from there often found their way into museums. *Dawn's Wedding Chapel II* was sold to Jean and Howard Lipman, wealthy and influential art collectors, who eventually gave it to the Whitney Museum of Art. Likewise, there were several more *Wedding Chapels* and quite a few versions of *Sky Cathedrals*, including the one that went from Ben Mildwoff's collection to MoMA.

Nevelson was not unique in her complex personal and artistic relationship to the theme of marriage. The twentieth-century artist whose work is most closely associated to the idea of the bride is Marcel Duchamp, and few other artists in the twentieth century have attempted to deal with this subject since his early (beginning around 1913) claim upon it. His master work, the enigmatic *Large Glass*, otherwise known as *The Bride Stripped Bare by Her Bachelors, Even*, was made in New York, and knowledge of its existence had thrown decades of artists into a tizzy.

While Duchamp's brides are mechanical and beset by numerous bachelors, Nevelson's brides tend to stand alone or to turn their backs on potential spouses. Nevelson's use of this theme was intensely personal, and for many years it was a

fertile source for her art. However, one can see that Duchamp's work might have had an occasional catalytic effect on Nevelson.[71]

Whatever personal, even painful, significance might have been embedded in *Dawn's Wedding Feast*, the artist was much more ready to point to universal metaphorical meanings than to direct anyone's attention to her own life.

And then Louise Nevelson moved on. She had just exhibited at MoMA in *Sixteen Americans* with future art stars, all young men on their way up—Jasper Johns, Ellsworth Kelly, Robert Rauschenberg, and Frank Stella—and with her powerful presence had proven that age and gender were no bar to success and celebrity. Her long-frustrated ambition was about to overreach her way of life. The next development of her work—gold-painted wood sculpture—would reflect both her grandiosity and her vulnerability.

GLITTERING GLORY

1960 – 1962

"The golds are Louise Nevelson on a manic spree. It takes only a
moment to recover from the shock of shimmering surface...."
—Kenneth Sawyer, catalogue essay for *Royal Tides* Exhibition
at the Martha Jackson Gallery, 1961

Martha Jackson was an heiress to part of the Kellogg fortune and had one of the best-financed and most prestigious galleries in New York. After opening the Martha Jackson Gallery in a townhouse on East Sixty-Ninth Street with a series of exhibitions by outstanding artists, including Willem de Kooning, Jim Dine, and the Spanish artist Antoni Tàpies, she became a founding member of the Art Dealers Association and soon was known as "one of the most extraordinary women dealers in America."[1] Just as Nierendorf's gallery had been in the early 1940s, Martha Jackson's gallery was a gathering place for artists of all generations as well as New York City art aficionados.[2]

Louise Nevelson liked Jackson's frank, unconventional side. For example, when Jackson felt like it, she would stretch out and relax on the living room floor of a total stranger who had invited her to lunch.[3] Perhaps, for Nevelson, her most appealing quality was her acceptance of the artist's need for control over her work. Nevelson recalled. "Martha let me do exactly what I wanted. She was alert and open-minded—a great individualist."[4]

When Nevelson joined the Martha Jackson Gallery, the two women entered into a contractual agreement for "exclusive representation" beginning on April 1, 1959, and lasting until December 31, 1961. Jackson instantly went into action and began to make cooperative arrangements with galleries and museums around the country.

On May 6, 1959, Jackson wrote to the Bolles Gallery in San Francisco that: "Miss Nevelson has placed everything in our hands and agrees to an exhibition providing you are willing to purchase outright one-third or more of the total value of the sculpture and pay all the transport and insurance charges." She ends with: "So much is happening around Miss Nevelson now that I can assure you that by 1960 her work will be very much in the art world's eye and sought for by collectors. I hope you . . . let us know [your] decision so that your gallery will be the first in San Francisco to show NEVELSON."[5]

After her first show in Jackson's gallery, *Sky Columns Presence*, in October 1959, Nevelson was not only financially solvent as an independent woman artist for the first time in her life, but she soon had exhibitions much farther afield than ever before, and was showing in some new but prestigious avant-garde galleries, such as Leo Castelli Gallery.

Martha Jackson soon worked out a contract with Daniel Cordier in France, who would now be Nevelson's sole representative in Europe.[6] When she was wooing Cordier, Jackson used a clever sales strategy. She announced the competition. "I have a world contract signed by Louise Nevelson to represent her work. She is interested now to have a contract in Europe and wishes me to arrange this for her. As you were the first dealer to buy her work and as you plan a show for her, she wishes to hear your wishes first. Mr. Claude Haim, a dealer, is here now and is ready to make a proposal. Please cable us whether you are interested to discuss a contract or not."[7]

In another letter, Jackson told Cordier that the response to the recent exhibition *Sky Columns Presence* was phenomenal, attracting Asians and Europeans who were "outspoken in ranking Nevelson as one of the great sculptors of the world."[8] Jackson's hardball tactics succeeded. She then had to work even harder to persuade Nevelson that she should agree to sign with Cordier, who was now enthusiastic—but at a price. One of the results was increased pressure to produce. "Walls, Walls, Walls" could be the title of Jackson's June 1960 letter to the artist as she communicated Cordier's insistence that Nevelson continue to produce black wood walls. He loved them; he could sell them; they stood for her and her grand achievement. Since she was already producing mostly walls, Nevelson could accept Cordier's conditions. In fact, she had so many boxes of black-painted sculpture available that she was able to make eight different full versions of *Sky Cathedral*.

However, the relationship with Cordier changed the way Nevelson had previously worked with dealers. She would now have to do what he wanted, make work that he needed, not necessarily work she felt should come next—something that never had occurred when she worked with either Nierendorf or Roberts. For the independent Nevelson, the woman for whom freedom was absolutely

essential, producing the number of black wood walls a dealer required was hard to accept. But she did—and she eventually paid the price.

By this time Nevelson had established several styles of black-painted sculpture, both inside boxes and free standing. Some consisted of rough pieces of wood clumped together. These rough-hewn works featured old nails and broken bits of lumber. They differ entirely from the cityscapes of 1955–56, where a lineup of smoothly finished forms creates a silhouette reminiscent of an urban scene at night. In 1957–59, when she shifted almost entirely to boxed compositions, she often combined the rough elements with the smooth. For the most part, the boxed pieces were put together separately from the free-standing ones.

The next phase involved combining the boxes into a larger composition. At that point she might choose to combine opposite qualities, rough with smooth, vertically oriented with horizontal, and especially straight lines with curves. Nevelson created increasingly complex rhythms of multiple parts, experimenting her way toward mastery throughout the late 1950s and reaching an apogee in the early 1960s, capping her achievement by switching to white and gold—both of which offered new formal facets with which she could orchestrate a symphonic whole.

At the beginning of 1960 Nevelson was on a roll. *Dawn's Wedding Feast* was on exhibit at MoMA until February 15. She had a solo show of all-black sculpture at David Herbert's new Gallery on East Sixty-Ninth Street in January and was included in group shows at the Camino Gallery in New York and the Ferus Gallery in Los Angeles. With Martha Jackson handling her career, Nevelson's work appeared in top galleries around the country and Europe. All the artist had to do was produce. Her inclusion in group shows was more limited than it had been earlier because the choice of exhibitions was more focused and strategic.

As part of her gallery practice Martha Jackson also promoted loans of the artist's work to various places that could increase her visibility and sometimes lead to a purchase. By October 1960 Nevelson's work was on loan to the Riverside Museum in New York, Artists Equity, Lever House, and the Society for Ethical Culture. John Canaday of *The New York Times* noted that "Louise Nevelson, whose work seems to be everywhere at once these days, [is] . . . one of the sought-after artists."[9]

Jackson also knew how to pursue affluent collectors. By the end of 1960 the Jackson Gallery had negotiated the purchase of two white hanging columns from *Dawn's Wedding Feast* by MoMA, courtesy of the Blanchette Hooker Rockefeller Fund. The Rockefellers and the Lipmans would continue to purchase work and support Nevelson's career until the end of her life. Moreover, both families helped advance her reputation by donating her work to major museums.

Thanks to Martha Jackson, Louise Nevelson was financially secure at last,

and it was only during her representation by Jackson that Nevelson painted her wood sculpture gold. Of the many decisions Nevelson made in 1960, both personally and professionally, painting her sculpture gold was the most remarkable.

She showed the first gold-painted sculpture at Martha Jackson's daring exhibition *New Forms – New Media I* in June 1960.[10] Her tall piece, *Golden Night*, was described in the show's checklist as "the artist's conception for a gold clock tower to face the Guggenheim Museum." The Guggenheim had opened eight months before and was the talk of the town. The price for Nevelson's scrap-wood sculpture was an astounding four thousand dollars.

Nevelson had made this sculpture following a trip to Texas with her sister Lillian, where they were fêted, dined, and housed by local art patrons.[11] She had been so impressed by the amount of gold—or gold-plated metal—used in Texas homes for bathroom faucets, knives, forks, and plates that she began her brief experiment in gold-painted sculpture. According to her daughter-in-law, Susan Nevelson, the artist was thumbing her nose at the vulgarity she had seen in Texas, where money was the highest value.[12]

The June 1960 group exhibit at the Martha Jackson Gallery was regarded as being part of "the Junk Culture" (the use of unconventional materials, usually urban detritus) and was notable for its inclusion of some barely known, but soon-to-be-celebrated, young downtown artists. Jackson was prescient about showing this controversial work, and the two *New Forms – New Media* exhibitions she presented in June and September 1960 included Nevelson, as well as the future stars of Pop Art, Claes Oldenburg, Jim Dine, and Robert Indiana; Peter Forakis, who would be part of the Park Place group; the happening impresario Allen Kaprow; and the future Minimalists Ronald Bladen and Dan Flavin.[13]

By October 1960 Nevelson was ready to show more work in gold at the important avant-garde Stable Gallery, where she was included in a guest exhibition of contemporary sculptors attempting "to cross new esthetic frontiers." Stuart Preston's review of the show in *The New York Times* noted: "In a class by itself stands a wood construction by Louise Nevelson, coated with gold paint, completely out of mourning."[14] In the same month the artist included gold-painted *Royal Tide III* in *Sculpture 1960*, a Sculptors Guild show at Lever House, as well as two gold walls, *Royal Tide I* and *II*, in her solo exhibit at Cordier's gallery in Paris. Dore Ashton and Colette Roberts had prepared the way for the French public by writing long articles about Nevelson in art journals.[15]

The large solo show in Paris was Nevelson's major introduction to Europe, and it was the first time black, white, and gold works were presented together. While he was setting up the show, Cordier asked her "to disappear for a few days." When she returned the night before the opening, she was with her sister-in-law, who noted that Cordier himself was so full of emotion about Lou-

ise's work that it brought her to tears. "It was fabulous and the reception was magnificent."[16]

In December 1960 Jackson displayed *Royal Voyage* in the "Enormous Room" at her gallery.[17] The installation was written up in *The New York Times* by Stuart Preston, who observed that "Nevelson's huge gold-painted wood construction covers one whole wall like a gigantic Victorian buffet."[18]

That year, a *Look* magazine article by Charlotte Willard about women artists in America showcased Nevelson, Georgia O'Keeffe, Helen Frankenthaler, and Grace Hartigan. Nevelson's sizable income from her art for 1960 was reported to be fifty-thousand dollars, and the fact that she painted her work black, white, or gold was illustrated with a photo of the artist standing by her work in all three colors. Willard wryly evoked the suddenness of the artist's success: "Less than three years ago Louise Nevelson was living as she had lived most of her life, modestly, unrecognized and self-assured." She continued on a more serious note: "Women have not yet been given their due. . . . *Look* wonders whether, in the years to come, the center of interest will shift. Will some of the artists on these pages match their male contemporaries?"[19]

Nevelson and Jackson ended the year in Jamaica for a vacation in the sun and then on to 1961—another breakthrough year. In the spring, Nevelson participated in a panel discussion at the Philadelphia Museum College of Art, which John Canaday wrote up in *The New York Times*. The title was "Where do we go from here?" Nevelson and Marcel Duchamp were the star speakers, and Katherine Kuh, art historian and curator at the Art Institute of Chicago, was the moderator. Duchamp launched into a diatribe against materialism: "The dollar and art shouldn't mix, but they do, and since you can't destroy money, money is destroying art. . . . The great artist of tomorrow will go underground."[20]

Perhaps stung by Duchamp's attack on money now that she was finally earning some from her art, Nevelson took an entirely different tack. She declared herself "utterly optimistic [and] sympathetic" about the future of art and was "dying to see what young people are going to do." "There *is* something new under the sun. When man wants to *reach* the sun, the artist has to have parallel forms to match this ambition."[21]

Several times during the discussion "Nevelson declared a faith in extra-sensory factors as the true basis of art. 'We are in tune with the sun and the moon and the airplane. I feel just wonderful about what is taking place. . . . Consciousness isn't enough. We have to have extra-sensory values."[22]

Nevelson looked the part of a believer in the occult by wearing "fluorescent-green eye shadow, peaked hat and a black cape with silver cabalistic patterns on it."[23] Her unusual costume on this occasion was a rare exception during

a period in which she mostly wore "ordinary" clothes and looked like an attractive but conventional middle-aged woman.

In April 1961 Nevelson's second solo show, *Royal Tides*, opened at the Martha Jackson Gallery. The exhibit, which featured seven gold walls, was presented with much fanfare. A poem by Jean Arp, in which he called Nevelson the granddaughter of Kurt Schwitters, and commentary by the French painter Georges Mathieu established her European credentials with panache in the beautifully designed catalogue.

The exhibition had been carefully orchestrated by Jackson. Nevelson received an elaborate schedule months in advance warning her that: "All walls had to be constructed by March 1, all photos taken by March 3, all catalogue data collected by March 7."[24] Nothing—or at least very little—was left to chance.

The press release set out to explain the artist's new work: "The present title, *The Royal Tides*, reflects the artist's belief in the joyous maturity of these her most recent works. . . . The artist's development suggests a journey of one who has come from the darkness, mystery and depression of Night through Dawn and emerged in the splendor of the blazing noonday sun."[25]

In his eloquent foreword in the exhibition catalogue, Kenneth Sawyer noted that this was to be "the first time Nevelson's 'Black, White and Gold' works have been exhibited together in this country. . . . The avalanche of splendor that tumbles from her studio is a source of wonder—and envy—to her contemporaries, and downright bewildering to her friends. . . . 'How,' one wonders, 'can this creature sustain an army of worshipers, three studios, and a production that is often stupefying even to her most extravagant admirers?'" Sawyer gives his all to the gold—"disquieting implications in our culture, light is controlled, heights and depths are voluptuous to the eye, they are perfectly coordinated. No vulgarity here. Instead there is a quality that recalls High Baroque—a boldness and freedom."[26]

The years of arranging and rearranging furniture in every room of every house Louise Berliawsky had inhabited had now found their zenith in her walls of sculpture, which Jackson was exhibiting here in all three colors. Dore Ashton astutely noted the results: "Because Nevelson works in terms of ensembles, it is possible to overlook her extraordinary inventiveness in each unique piece. This exhibition, if seen in terms of the individual boxes, abounded in ideas, plastic ideas that never seem exhausted. Nevelson has an unfailing instinct for composition and individually, some of these units struck me as little masterpieces."[27]

Most reviewers admired the new gold-painted works. Brian O'Doherty of *The New York Times* wrote a long piece expressing his admiration for the baroque richness of the gold-painted sculptures.[28] And only one reviewer, Jack Kroll of *Art News*, had a generally negative response to Nevelson's new work. He observed

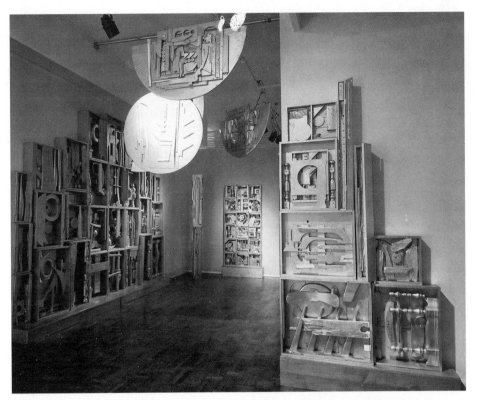

Royal Tides (Installation view, Martha Jackson Gallery), 1961. Photograph © 2016 Estate of Rudy Burckhardt / Artists Rights Society (ARS), New York

that "her vast boxed walls are like the contents of a gigantic warehouse" and that the gold work reinforces "the sense of a world embalmed."[29]

After her success with *Royal Tides*, Nevelson was ebullient. Whether she was conscious at the time of the connection, it seems highly likely her work in gold was related to her representation by Martha Jackson and the new-found prosperity that came with it. The advent of the new color came the same year as the contractual agreement with Jackson: 1959. By the fall of 1962, most of her work in gold was done—and so was the arrangement with Martha Jackson. The few gold-painted constructions made after that time were exceptions for specific purposes. More telling, perhaps, is the fact that several works initially shown as gold were repainted and subsequently exhibited in black.

Nevelson always felt free to edit her earlier work. What pleased her eye might change over time, and it never seemed to her to be a betrayal of her aesthetic principles. This is particularly true of the gold-painted sculpture, which stands out as one of the few shining miscalculations in her oeuvre. Comparing the original gold and later black versions of *Royal Tide III*, it is evident how much

more visible the individual boxed compositions become when they are black.[30] The blurring of that specificity with the gold paint makes the whole much more important than its parts, although this is not true for all the gold walls. Moreover, the shadows in the gold-painted works often don't have the power and mystery of those in the black-painted wood. Nevelson was generally better able to master these qualities as negative space with black-painted works.

Opinions vary enormously about why Nevelson went through a period of painting her sculpture gold. Rufus Foshee, a young art dealer with a desk at the Martha Jackson Gallery, was close to Nevelson throughout her time with Jackson and had strong views about her work in gold. "Things were flying high for her when she made the gold," he said. "So, why not a golden lining? It seem perfectly logical to me that the gold came when it did. She thought, 'If white will upset them, then I'll upset them even more with gold. Why should gold be considered vulgar?'[31] Much later he added: "The gold said, Here I am. Fuck you, you bastards. I am here to stay.'"[32]

Arne Glimcher has a similar viewpoint about the transgressive aspect of the gold work: "It gave her a lot of satisfaction that she had taken the detritus of society and spun it into gold—the metaphor for fine art. It wasn't money; it was a social value. She loved that she could transform toilet seats. I've often told the story about someone asking her, 'Isn't that a toilet seat?' And she

Photographer unknown. Louise Nevelson with Rufus Foshee, 1961. Courtesy of Rufus Foshee

responded: 'No, it's a halo around the Madonna.'"[33] But he also points to the perceptual and aesthetic rationale for the gold paint: "Some of the gold-painted sculptures are beautiful. Both the white and the black works absorbed light, but the gold reflected light. So instead of sucking you into the pieces, the gold pushed you away. It was deliberate; another move for her."[34]

In her 1964 book about Nevelson, Colette Roberts offered a spiritual-poetic perspective on the gold sculpture, which is at odds with the ones expressed by both Foshee and Glimcher. Her obscure, almost metaphysical, depiction of the gold-painted works refers to the paradoxical "Elsewhere," the word she had coined to describe Nevelson's fourth-dimensional world: "Her enthusiasm for gold should not be confused with a symbol of material success. It is the gold of some secret altar and of "harmony with . . . unknown forces." She concludes that the *Royal Tides* "assert a total order, order over Chaos, which does not exclude Chaos . . . a paradox of classic order encompassing romanticism."[35]

When the artist herself was asked about why she used gold, her ideas boiled down to two essential thoughts: *Gold shines like the sun. Gold is cash. I can transform one into the other.* In her words: "Gold has been the staple of the world through the ages; it is universal. The reality of gold is alchemy."[36] But the practical woman who had lived in straitened circumstances for so long was never far below the surface. Without *gelt*—"money" in Yiddish—she would not be able to continue making sculpture.

The thought is echoed in her autobiography, *Dawns + Dusks*: "Gold is a metal that reflects the great sun. . . . Really I was going back to the elements. Shadow, light, the sun, the moon. . . . And don't forget that America was considered the land of opportunity. . . . They promised that the streets of America would be paved with gold."[37]

Nevelson's view of gold was alternatively spiritual, "fourth-dimensional," or downright materialistic. Her highfalutin words about the sun and the moon—alchemical references—also speak to the strictly formal goals she reached with many of these remarkable works. *Royal Game*, for example, ranks with the best of her oeuvre and contains every bit of Nevelson's compositional legerdemain (visible to us even under the gold paint). The tensely arched slats in the top box tie the whole together, as we can see from the various verticals on both the right and left sides of the lower two boxes. The bottom box declares itself the gravitational base, with furniture legs as well as its busyness. Finally, the ovals and circular forms are carefully arranged to draw the eye around within the whole. *Royal Game*, as well *Solar Winds*, *Royal Tide I*, and *Royal Tide IV*, expressed her spiritual wishes and hopes to bring the viewers to an idealized realm.

Finally, while some reviewers were very impressed with Nevelson's development in new colors, Hilton Kramer—her most eloquent champion—was not. He

dismissed it as over-the-top and glitzy. And however pleased Nevelson was by the money and attention the gold work provided, she listened carefully to Kramer's reservations. After several years she put away her gold paint—which was actually a new product, Spray-O-Namel—and returned to her forte, wood painted black.[38] "She had stopped making gold work before she was with me," Arne Glimcher stated matter-of-factly. "I think she felt that the works she painted gold were a finite group of works."[39]

The money Nevelson received from the gallery allowed her to comfortably help her son by beginning to pay back the money he had sent to support her in the two decades before she was able to support herself. She was sending "beautiful" large checks to Mike very regularly all through 1960 and 1961. He expressed his gratitude in long, loving letters to her. He explained that the money she was sending "has really transformed our lives and we must regard it as a worthwhile investment. Not a cent of it went to self indulgence."[40]

Mike Nevelson brought his family down to New York in late January for a ten-day vacation and afterwards wrote to her about how "good it is for kids to feel they are part of a family with grandparents and all the works."[41] Two weeks later he again wrote, thanking her for the check: "Flo and I realize that even with your great success, this money is something of a sacrifice for you. We want you to know that we appreciate and think it is a wonderful thing for you to be able to do."[42] A few months later Nevelson sent another big check in honor of the birth of her third grandchild, Maria Isak, named in part for her great-grandfather.[43] Whatever unhappiness Louise or Mike Nevelson had felt about each other during the earlier hard years, that was now long past, and they both enjoyed their very positive mutual relationship.

A few months later Mike Nevelson was in high spirits because he had the prospect of an exhibition in Paris. But he didn't stop being the wise advisor and protector of his mother: "I really feel that my career is launched and on the way. Take care of yourself. Smoke less and cough less. The weather here is fine. Now back to work."[44]

For more than a decade Louise Nevelson had been known as a "sculptor's sculptor," admired by a wide group of young artists as well as many of her peers. Financially secure for the first time since her marriage forty years earlier, she was at last able to support herself. Her first work in gold, with its four-figure price, made a clear statement that she felt she could command high prices. After all, she was being represented by a commercial gallery—even better, one run by a wealthy businesswoman.

According to the deal worked out with Jackson's gallery, Nevelson received twenty-thousand dollars a year from Jackson and another twenty-thousand dollars from Daniel Cordier, for a total of forty-thousand dollars—a fortune in

the early 1960s. For the annual sum the Martha Jackson Gallery paid Nevelson, Jackson and Cordier now owned all the work she produced. If that work didn't sell quickly or for the hoped-for amount, Nevelson owed even more work to Jackson, who was overseeing the division between the two galleries. In the early 1960s, though Nevelson surely felt the pressure of having to produce large amounts of sculpture to meet the contractual arrangements with her dealers, she rode those arrangements out from a position of strength.

By the beginning of 1960, after a busy year of exhibitions, sales, and prizes, Martha Jackson worked out detailed policies for handling Nevelson and her sculptures. Jackson assigned Thomas Kendall, a sophisticated young man with an art history background, to take charge of everything having to do with Nevelson for the gallery. This included coordinating the way the work was exhibited, sold, photographed, and stored, as well as keeping the records and keeping track of Nevelson's work—where it was going and when it was sold, and so on. Kendall's salary was split fifty-fifty with the Daniel Cordier Gallery.

It soon became evident to Martha Jackson that she needed more than one person to tend to the Nevelson inventory. The photographer Rudy Burkhardt was hired to visually record Nevelson's work at every turn.

The following policies were designed to protect the artist, her work, and her reputation, to bring order out of the chaos of Nevelson's rapid working style and generous distribution of her work to family, friends, dealers, critics, and assorted causes, as well as to ensure that the gallery was adequately recompensed:

1. No one was to visit Nevelson at her studio or interrupt her work without some cash sale taking place.
2. At the gallery, sales over five hundred dollars were to be reviewed by Martha.
3. Cash deposits were required because of the fragility of the sculptures.
4. The walls that had been sold were to be set up by Louise and Ted Haseltine; the financial arrangements would be managed by Martha, who would visit the purchasers to check on their satisfaction and to settle the accounts.
5. Tom Kendall would arrange for Rudy Burkhardt to take photographs.[45]

Lists of possible purchasers and the status of their interest were detailed, as were plans for exhibitions at galleries around the country. Once Martha Jackson and Daniel Cordier had worked out their agreement, contract purchases were arranged, listing the walls by name, by number of boxes, by square footage and by price per size, for example walls that were twenty to twenty-four square feet were priced at six-thousand dollars, those twenty-four to thirty-nine square feet

were priced at seventy-five hundred, and so on. In selling art by the square foot, the gallery was stepping in a direction Nevelson would surely have found offensive if she had known about it, which it seems that she did not.[46] Was this artistry or business practice?

The Martha Jackson Gallery worked out a variety of percentages for sales at galleries to which Nevelson's works were sent. This would eventually become a contentious matter between the artist and the gallery. They ranged from a low of "10% to us, 30% to them" for large exhibits to "30% to us, 20% to them" for "small and local" galleries.[47]

As far as the gallery was concerned, all of this meticulous organization was necessary. Although Nevelson was characteristically neat and orderly, she was used to doing with her work whatever suited her on a given day at a given time. For example, sometimes the gallery would offer a wall to a client based on a particular combination in a photograph and later would discover that Nevelson had taken some of the boxes from the "original" composition without notice and used them in a different composition for a different client.

A note from Tom Kendall to Nevelson on August 23, 1961, is typical. Nevelson had proposed exchanging one of her walls for a painting by Adja Yunkers, the artist and husband of influential critic Dore Ashton. Kendall felt it necessary to remind Nevelson that, while under contract to Jackson and Cordier, she had to toe the line: "As you know both Martha Jackson and Daniel Cordier have to refuse your sculptures before you can actually part with a wall installation."[48]

It was understandably irritating when Nevelson would dismantle walls, which had been photographed in the gallery and were available for sale. It was especially irritating when she sold some of the boxes from these walls directly to collectors, since the gallery would get no cut from those transactions. Sometimes, Martha Jackson seemed to tolerate Louise Nevelson's arbitrary behavior. For example, over time the Howard and Jean Lipman changed and exchanged walls they owned, and, since they were loyal Nevelson collectors, both Nevelson and Jackson were willing to accommodate their requests.

What becomes clear in all the inventorying and planning for prospective sales is that many people were involved in supporting the artist's career development. Martha Jackson jumped in when there was need for direct personal contact with a client. Tom Kendall was the go-between for Nevelson and everybody else. Nevelson's brother-in-law, Ben Mildwoff, could be counted on to make available for sales the walls and boxes Nevelson had stored with or loaned to him. Colette Roberts was still serving as a liaison for the institutions, such as New York University, or for individuals with whom she had originally made contact.

Sometime in early 1961 Jackson's son, David Anderson, also became involved in Nevelson's dealings with the gallery. Anderson worked as a sort of

business manager and secretary for his mother. His title was vice-president and secretary, and, though he had no previous business experience, he gave himself the task of setting up a new accounting system for each of the gallery's artists, calling the previous system of accounting "rather haphazard."

In an interview in 2008, David Anderson recalled:

> The gallery's practice was to make cards and tags with numbers, titles, date, and dimensions. We had Nevelson's boxes standing on the floor. She would come in and immediately construct, deconstruct and reconstruct walls, then we called in a photographer.
>
> A wall would stand for a couple of days, and then she would come back and make a different wall. Since the tags were on the back against the wall, it became impossible to track the boxes by number, and a photographer would have to come and take new photographs.
>
> Once the show was over, there was no room to store the work, so we would return the boxes to her studio. Then she'd get a call from a collector asking her to go to their house, she'd go there and measure the space, go back to her studio, pick out the boxes she wanted and make a new wall.[49]

Once Anderson was involved, the system became much more confusing than it had been before.[50] The arrangements between the Martha Jackson Gallery and Nevelson, which had previously been comprehensible to her, were now so complicated that she asked on several occasions for a straightforward accounting.

No matter what Nevelson ultimately felt about the accounting practices of Martha Jackson's gallery, she knew that Jackson also did the difficult work of defending her artists. When a curator from the Art Institute of Chicago questioned the "permanency of Nevelson's *White Column*," stating that the piece would disintegrate in six months without museum care, Jackson instantly rode to the rescue, writing a strong letter about Nevelson, guaranteeing her work to last as long as any wood sculpture by contemporary artists, and stating that she knew of no complaints about Nevelson's sculptures. She then informed him of the other highly important and knowledgable collectors of White Columns: Dorothy Miller at MoMA, Gov. Nelson Rockefeller, and Mr. and Mrs. John de Menil. If the curator had any more doubts, Martha Jackson invited him to visit Nevelson's studio.[51]

Martha Jackson was a consummate dealmaker and a genius at working out consignment arrangements with galleries all over the United States, and her timing was usually impeccable. A prescient example was the arrangement

she made with a twenty-two-year-old neophyte who had just opened Pace, a small gallery at 125 Newberry Street in Boston. The day after Nevelson's big show *Royal Tides* closed at Jackson's gallery, on May 20, 1961, Arnold Glimcher arranged for a truck to take seventeen of the unsold pieces up to Boston, where he opened a Nevelson show nine days later. Glimcher was surprised and grateful that Martha Jackson would let him, a graduate student in art at Boston University, take on one of her important artists. "She let me pack up a truck with all these Nevelsons and drive it to Boston. No one signed a piece of paper. Martha was gracious and fantastic."[52]

The story wasn't quite as casual as Glimcher recalled, since shipping records show exactly what was sent on consignment from MKJG to Arnold "Glimshire." But in essence the story is true. Reflecting backwards, Glimcher says that Martha Jackson should never have let him do that. "I was nobody—just a kid from Boston. She was a very rich woman." He had only twenty-four hundred dollars to his name—lent by his older brother Herb—and almost no experience.

That Martha Jackson would have agreed to let an art-world novice take seventeen sculptures to Boston on consignment immediately after her own important Nevelson exhibition seems both extraordinary and in character. Jackson was allowing galleries all over the country—in fact all over the world—to show and sell Nevelson's work.

Milly Glimcher, Arne's wife, remembered a different aspect of the show:

It's indelible in my mind. Absolutely indelible. We had asked Louise to come for the show, and we told her we would put her up at the Ritz. As she came down Newbury Street, we were looking out the window and waiting. We saw her approach and were completely puzzled. She has a huge head of blond hair that didn't look like pictures of her. We couldn't believe our eyes. When she came closer we saw it was a fox hat she was wearing at the end of May. It was hot, and she had on a long flouncy Native American skirt and lots of silver jewelry. Of course she called us "Darlings" and hugged us. I will never forget that image of her coming down the street.[53]

Rufus Foshee, a man half Nevelson's age, from Alabama and aspiring to be an art dealer, had a few loyal clients who liked and bought Nevelson's work. Here is the way he recalled the sequence of events as they unfolded around Nevelson's first exhibition with Glimcher, another take on the same events:

Sometime in May 1961, Arne Glimcher came to Louise's house downtown. I worked with them on having a show in Boston. The show was

arranged for Memorial Day weekend. Louise would not go to Boston unless I went with her. We stayed at the Ritz Carlton ($15 a day then). Louise kept me up most of the night threatening to jump out the window, while waving a bottle of Scotch in one hand. I didn't think about it in those days, but later I could see how humiliating that Boston thing was for her. She had had all those shows in New York and not much was sold.

Foshee remembered other aspects of the weekend: "On Sunday at the appointed time, Louise and I went to the Pace Gallery. The gallery was packed and the show was already sold out. I am quite certain Arne had bought everything. (No matter, I knew that he would be her dealer whenever he landed in New York. It took four years.) By the time the show opened the next night, nobody would have guessed what despair the anticipation had caused the artist—but there were rewards. For the first time in her career, Nevelson had nearly a sellout show."[54]

While the 1961 Pace Gallery Nevelson show was not the sellout that Rufus Foshee recalled, it was nonetheless a big success. Approximately six or seven works were bought—far more than Jackson had managed to sell a few weeks earlier in New York.

Glimcher's gallery was named after his father Pace, who had recently died.[55] His young wife Milly, an undergraduate student in art history at Wellesley College, was his helper, as was his mother, Eva, who "babysat the gallery" while Arne and Milly attended their classes.[56] Eva Glimcher taught her son the rudiments of salesmanship, and he taught his mother all about art. The arrangement worked beautifully as the two quickly learned from each other.

Aware that his gallery had come onto the scene without fanfare, he devised a plan to gain quick renown. When he was advertising the show in art magazines, he simply put the word "PACE" in stenciled letters on the ad without much more information. That caught the attention he was aiming for.

Arne Glimcher came down to New York as often as he could. He wasn't even twenty years old in 1958, an undergraduate at Massachusetts College of Art, when he had discovered the work of Louise Nevelson at the Museum of Modern Art. He recalls having seen *Sky Cathedral* there, installed in an alcove. At the time he mistakenly read "Louis" for "Louise" and believed that the artist was a man. But by the next year, at the time of her big breakthrough show at the museum, he knew who she was. When he came down from Boston to see *Sixteen Americans* at MoMA, *Dawn's Wedding Feast* hit him like a thunderclap—an epiphany.

As an art dealer, Glimcher felt he had a gift for selecting artists who had both the talent and the confidence—"the blissful stupidity" as he called it—to

believe that they could do as well or better than their predecessors. He was open to the new and was drawn simultaneously to Pop Art, just coming on the scene, and abstract art, which was both subtle and sophisticated. Nevelson was one of his three favorites, along with Josef Albers and Claes Oldenburg. She was the first New York artist he wanted to show at his fledgling gallery in Boston.

Was it savvy of him to go after her? Yes and no. He probably couldn't stop himself. Nevelson was his ego ideal, his maternal imago personified. He wanted to be an artist himself, but he lacked the confidence in his own powers to create anything that would be either new or better.

When Louise Nevelson met Arne Glimcher, she described him as "this slip of a boy, a very slender, very bright young man,"[57] just a bit older than her oldest granddaughter. She had her doubts about his ability to take her on and make something of her career, and she was taken aback that her important work was shipped off to an unknown dealer in the cultural backwoods of Boston. But she trusted her intuition.

As Glimcher later reflected, "I was so young that I don't think I was threatening to Jackson or Teddy Haseltine. Louise took me seriously. I don't think anyone else did."[58] Long before Nevelson was represented exclusively by Pace Gallery, Glimcher was selling her work with ease.

At the time of this unusual situation, Nevelson was in treatment with a well-known psychoanalyst, Edmund Bergler, because of problems she was having with Teddy Haseltine. Bergler encouraged her to write down her dreams and note her associations to events in reality.[59] On June 12, two weeks after her show at Pace opened in Boston, Nevelson recalled that it was the forty-first anniversary of her wedding to Charles Nevelson at Boston's posh Copley Plaza Hotel. She wrote in her notebook: "Married in Boston, Returned in June to Boston 1961."[60] Turning to dreams for connections between her past and present, her conscious and unconscious thoughts led her to link her wedding to Charles in 1920 to the beginning of her relationship with Arne Glimcher. In a few years she would be united with the young entrepreneur in an exceptionally profitable, long-lasting, and creative union as artist and dealer: Glimcher, the young man whom she would later call her "little lover boy." Arne Glimcher's astute eye and boldness quickly earned him the esteem that would eventually make him one of the art world's leading gallerists. But in 1961 he was still an unknown, and Nevelson was still contractually tied to Martha Jackson.

Rufus Foshee had bonded with Nevelson when they first met at the opening of *Sixteen Americans*. Between 1961 and 1962 he and his close friend Jack Horton had bought major parts of *Dawn's Wedding Feast* and were trying to buy the missing sections from Cordier so that they could reassemble the entire composition and sell or give it to a museum. Their goal was something Nevelson had

wanted from the beginning and something she had probably resented Jackson and Cordier for not having done or even tried to do.

Carried aloft by Martha Jackson's regular support, 1961 was turning out to be another superb year for Louise Nevelson. With some help from her sister Lillian, she had bought herself another house on Spring Street, number 31, next door to the one she already owned. She was beginning to find collectors who prized her work and could place it well, and her sculpture was illustrated in prestigious journals and newspapers. In August 1961, for example, *Sky Chapel* had been included in a photograph of Howard and Jean Lipman's New York apartment in the *New York Herald Tribune* magazine. The accompanying article encouraged collectors to buy works of art for their homes. "Mrs. Howard W. Lipman, an editor of *Art in America*, and her husband devote their New York apartment to abstract sculpture that's especially good with early American and contemporary furniture. Wood wall sculpture *Sky Chapel* by Louise Nevelson dominates . . . Nevelson wall sculptures [are] about $10,000."[61] *Black Majesty*, a work from 1955—and by that time at the Whitney Museum—was also illustrated in the article. On top of each illustration we find the words, "Nevelson sculpture through Martha Jackson Gallery."

The Lipmans were among the most faithful and important collectors Nevelson ever had. That Jean Lipman was the editor of *Art in America*, an increasingly important art magazine, and Howard Lipman was one of the most powerful members on the board of the Whitney Museum helped Nevelson get exposure and excellent word-of-mouth publicity. Equally if not more important, the couple had three homes, all of which contained works by Nevelson. The fact that the Lipmans gave many of Nevelson's works to the Whitney was in no small way responsible for Nevelson retrospectives at the museum in 1967, 1970, 1980, 1987, and 1988.

As a result of Daniel Cordier's efforts, in September and October 1961 eleven Nevelson walls were included in an important solo show at the Staatliche Kunsthalle in Baden-Baden.[62] Cordier had made the case that being in that particular show would give Nevelson good reviews and great visibility in Germany. And so it did. Her huge gold-painted work, *Royal Tide IV*, was sold shortly before it was to be exhibited in Baden-Baden.

In his first letter to Nevelson announcing his plans for the exhibition, the curator, Dietrich Mahlow, director of the Staatliche Kunsthalle, requested some additional large walls from Nevelson in order to give "a comprehensive impression of your work," of that "kind of world you are living in." The large walls would be shown in a separate room. Mahlow hoped "the impression would be magnificent, and we are glad to be able to win friends for you in Germany."[63]

In less than a month, Nevelson created a collective forty-five feet of walls,

approximately nine feet high (including *Sky Presence I* and *II* and *Little Black Wall*, which were all black, and *Vision One*, which was white) and sent them to Germany, along with photographs as guides for the way she wanted them to be set up. *Sky Presence I* is one of Nevelson's most beautiful walls.[64] That she had to construct it in a hurry in no way diminishes it as a masterwork of composition. Like any artist touched by Surrealism's ethos, working fast only meant allowing one's unconscious to make its contribution.

As always in her best works, Nevelson organizes sweeping formal rhythms, which tie the many boxes together but not in a mechanical way. Thus large circular shapes and curvilinear elements echo back and forth throughout the work. The play of vertically oriented boxes against horizontal ones is measured and feels balanced. The multitude of smaller circular shapes and horizontal and vertical elements adds to the counterpoint without confusing the composition.

According to the curators' reports, the German crowds were large and enthusiastic. After Baden-Baden the show traveled to six German cities.[65] In Munich six thousand people visited the show.[66] The reviews of Nevelson's traveling exhibit in Germany include the same kind of mixed reviews as were typical in the United States: Either the critics saw that the artist was transforming discarded objects into compositions which gave them a new quality of "livingness," or they believed that she was obsessively collecting bits of junk, painting them with a monochrome color, and haphazardly shoving them together, calling the whole mess "art."[67]

In October 1961 Nevelson exhibited one large black wall in a group show at the Hanover Gallery in London. It was her first time exhibiting in London, and Martha Jackson had begun with the most progressive and important new gallery, run by Erica Brausen, who had long been interested in showing and selling Nevelson's work.

Back home, Nevelson was included in a variety of group shows, including one at the New School for Social Research in New York City, the Tanager Gallery, also in New York, and the Dwan Gallery in Los Angeles. *Great Dawn Column*, one of the large white columns from *Dawn's Wedding Feast*, was in the prestigious Pittsburgh International Exhibition.

The most important group exhibition in which Nevelson participated in the last months of 1961 was MoMA's *Art of Assemblage*, which included *Royal Tide I*.[68] Each of the eighteen boxes stands on its own as a powerful yet complex formal statement, and, when combined in this particular wall, the whole is much more than the sum of its parts. With unerring mastery, circular forms—whether solid or suggested as negative shapes—are played off against rough and smooth, vertical and horizontal, surface and depth. The light glints off of the smooth surfaces

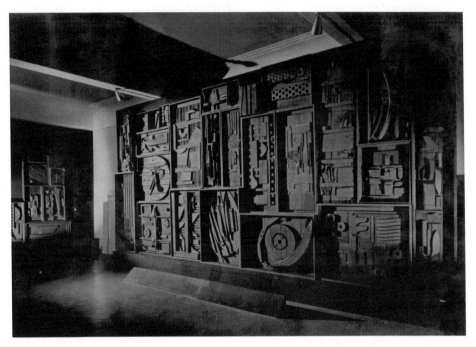

Sky Presence (Installation view, Staatliche Kunsthalle Baden-Baden), 1961. Photograph © Horst-heinz Neuendorff / Staatliche Kunsthalle Baden-Baden

and disappears behind them into dramatic depth—even though we know there can be no more than eight inches between the surface and the back of the box.

William C. Seitz, the associate curator of the Department of Paintings and Sculpture Exhibitions at MoMA, wrote the brief essay about Nevelson and *Royal Tide I* for the catalogue: "This authoritative work resembles a reredos, an altar; but its dedication is not to a spiritualized divinity. The immediacy, clarity, and tangibility of its form and surface muffle and control, though they do not obliterate, the atmosphere of mysticism and romanticism. The gold is as much that of Versailles as of Burgos."[69] Seitz's words would come back to haunt him the next year when he wrote a very similar essay for Nevelson's contribution to the 1962 Venice Biennale, where his linking Nevelson with Burgos or Versailles was seen as unrealistic as well as grandiose.

Jean Lipman bought *Royal Tide I* out of the MoMA show. The Lipmans had already bought and exchanged several black walls, but they would always keep this work. With the exception of the MoMA show, where the admiration of Nevelson's friend Dorothy Miller had been the driving force, almost all of Nevelson's extraordinary success in 1960 and 1961 had been arranged by Martha Jackson. In September of 1961 Jackson wrote to Nevelson about her plans for "a big exhibition for you in LA. UCLA is interested. I want to have it before your

prices go up, as there are a large number of collectors here who are interested and we want it to be a success."[70] Jackson did even better than she hoped. The Los Angeles County Museum gave Nevelson a show that received good reviews. It also included loans from some of the local collectors, who eventually bought additional works by Nevelson, just as Martha Jackson had planned.[71]

Despite the fact that Nevelson's contract with Martha Jackson ended on December 31, 1961, her work stayed on exhibit at the gallery for another fifteen years. Jackson had started Nevelson on the path to celebrity status, but the artist's desire to move farther and faster led her into troubled waters, where she nearly drowned.

ICARUS

1962 – 1963

"I brought this on myself. It was my hubris. I was flattered by
[Janis and Kurzman] and I fell for it. I was the first woman in the
gallery and wanted to be with the boys. If I could get 31 Spring
Street back, I would sell my walls or give them away."

—Diana MacKown, quoting Louise Nevelson,
as told to author, August 21–25, 2008

The year 1962 started out well for the artist. She was showing her work at
Reed College in Oregon, where her old friend and former lover, art critic
Hubert Crehan, was teaching.[1] One of her large gold walls was shown in
the Seattle World's Fair, and the Los Angeles County Museum was installing
some of her recent large black-and-gold walls in their newly opened Modern Art
Galleries.[2]

Martha Jackson continued to act as Nevelson's representative, though they
had not been able to work out a contract that satisfied both sides and their pro-
fessional relationship had ended on December 31, 1961. Martha Jackson did
this out of friendship, but at the same time was protecting her sizable investment
in the many Nevelson works she owned. In mid-February 1962 Jackson was
overseeing an exhibition of Nevelson's in Caracas at the Museo de Bellas Artes.

As much as Nevelson liked Martha Jackson and had been pleased by the
growing number of museums and galleries in which her work had been placed
by Jackson and Cordier, she had gradually become disgruntled by the pressures
they were placing on her. Both dealers liked Nevelson's large walls but ultimately
found that the big sculptures were not so easy to sell as smaller works. According

to Rufus Foshee, Jackson "would call Nevelson and say, 'Louise why don't you send me some small things that I can sell.' Louise would retort, 'You're nothing but a goddamned rug salesman,'" and then hang up.[3]

In addition Nevelson was not particularly happy with the way Jackson was physically handling her sculpture. While the artist always sent her work to the gallery using the finest art movers in the city, Jackson usually had her handyman, Buckley, return it to Nevelson in her station wagon. Nevelson could bear the minor humiliation of the humble transport of her work, but public embarrassment was not tolerable.

The end came in March 1962 when Jackson mounted an exhibition of Nevelson's terra-cotta sculptures from 1938–48, sending out what Nevelson saw as a "very tacky notice to potential collectors."[4] Moreover, Jackson placed the works in the hallway of the gallery. Nevelson was convinced her new reputation as a prize-winning sculptor entitled her to a more distinguished location in the gallery. Despite Nevelson's reservations, the terra-cottas were well reviewed. "It is difficult not to consider Nevelson's early sculptures as precursors of her well-known black walls of boxes filled with wood-mill ends and other found objects, but they are beautiful in their own right."[5] Months later, in June 1962, her work would soon be shown at the Venice Biennale as one of four artists, chosen by Dorothy Miller of MoMA to represent the highest achievements of the United States in the visual arts.

On March 12, 1962, Nevelson's lawyer, Elliott Sachs, wrote to Jackson stating: "The contract between Louise Nevelson, yourself and Daniel Cordier having expired on December 31, 1961, demand is hereby made on behalf of Mrs. Nevelson for the immediate return to her of all items held by you on consignment. . . . I have also been instructed by Mrs. Nevelson to advise you that the contract will not be renewed or extended."[6]

On March 15, 1962, as she struggled to decide whether she had made the right decision about leaving Jackson, Nevelson had a dream about her current situation at the gallery and made some notes about it as if she were still able to report to Dr. Bergler, her psychoanalyst, who had unexpectedly died the previous month.

According to the notes, in the dream, she saw Martha in a restaurant, went over to her table, "kissed her and gently told her that my accountant just informed me that after all my expenses had been paid I was not making any money with her. All was gentle and sweet."[7] Later in her description of the dream, Nevelson lays out before Dr. Bergler Martha's faults: Martha has been "ill and not in for three to four days to take care of the terra-cotta show"; "the catalogue for the show was 'poor'"; "Martha couldn't even sell Nevelsons to Seymour Knox, her wealthy childhood friend who had recently opened a major museum in Buf-

falo."[8] On the back of the notes about the dream, Nevelson scribbled the telling conclusion of the dreamer: "I want more freedom."

As the recent patient of a Freudian analyst and a long-time adherent of Surrealism, Nevelson took her dreams seriously. What had been brewing beneath the surface of her friendly relationship with Martha Jackson finally burst out.

David Anderson refused to accept that Nevelson was going to end her contractual arrangement with his mother.[9] Martha Jackson was more realistic and wrote to Nevelson's lawyer about closing the Nevelson account. In May 1962 legal letters flew back and forth between Nevelson and the Martha Jackson Gallery winding up the many details about works still out on consignment at the Los Angeles County Museum and Pace Gallery. It would take many more to track down all the sculptures and make sure they arrived at the right destinations.

In June, David Anderson and Tom Kendall were to "take charge of getting back to her studio all works owned by her which are now consigned to us."[10] The final list was to be made ready for the lawyers at the end of July. In mid-July 1962 Nevelson had two lawyers trying to "wind up" her contract with Martha Jackson and get back the work Jackson had on consignment to museums and galleries, as well as "a complete accounting showing all moneys due to Louise and all pieces still on your premises which belong to Louise and which you are prepared to deliver to her."[11] But the works were not to be returned to her for a long time.

By the end of May, Nevelson had said her goodbyes to Jackson. In a waking version of her dreams, she gently kissed her dealer and "really good friend," expressed her appreciation for all that Jackson had done to promote her career, but explained that her accountant had told her she was not making any money being represented by the gallery.

Being with Martha Jackson's and Daniel Cordier's galleries had lifted Nevelson up financially and professionally, and the arrangement had freed her to be productive without having to worry about her expenses. But pressure was constantly coming from Jackson or Cordier to make more black walls and to sell her sculpture whatever the size, which had never been the case with either Nierendorf or Colette Roberts.

At this crucial moment in her career she turned for help to a man whom she had known for a few years and trusted: Rufus Foshee. Nevelson knew that, as an independent art dealer at the Jackson gallery, Foshee had tried his best to sell her works. She knew that Foshee respected her, loved her work, and had bought as many of the pieces from *Dawn's Wedding Feast* as he could afford—actually more than he could afford.

Her simmering disappointment with Martha Jackson had been stirred by Foshee, who believed the artist could do better. Foshee suggested that she meet with Sam Kurzman, a lawyer who specialized in art-world business, as Kurzman had

helped an artist friend of his, Larry Calcagno, who was also showing at the Jackson Gallery. Events unfolded rapidly. When she first met with the lawyer, Nevelson did not know of Kurzman's reputation as "a wheeler and dealer in real estate."[12] What she knew very well was that Kurzman was also gallery-owner Sidney Janis's lawyer.

As Foshee's version of the story has it: "Louise wanted to get free of Martha, and her contract had just run out. It was spring 1962. I called Sam and asked if he would represent and help Louise. He said yes, and Louise and I went to see him at home one evening. We had hardly sat down when Kurzman said he would get her into the Janis Gallery, and [just] as quickly Louise said, 'And I will give you one my walls.'"[13] Soon afterwards Foshee and Nevelson went to Kurzman's home in Westport, Connecticut.

According to Foshee, "Sam and his wife Rose invited Louise and me up to Westport and insisted that we be their house guests. But Louise was much too smart for that. We stayed in a cheap motel. Driving up, she said, 'I'm not looking for small stuff, I want the big fish.' She meant that she wanted to move to the Sidney Janis Gallery." Nevelson and Foshee's visit to Kurzman in Westport set the stage for the coming disaster. Kurzman lived in a compound of four houses. His was the largest, sitting on a little knoll, and to the right of it was a smaller Cape Cod-style house. As part of the agreement to be represented by Janis Gallery, she agreed with Kurzman to buy the smaller house for forty thousand dollars, little knowing that it was not free and clear.

Nevelson had been hankering for quite a while to join the stars of the American art world—Abstract Expressionists Mark Rothko and Willem de Kooning—who had migrated to the Sidney Janis Gallery in the mid-1950s but were now on their way out. Before the meeting with Kurzman, she had not told Foshee about her long hoped-for plans. In much the same way as she had plotted and strategized to join the Karl Nierendorf gallery in 1941, she took her time figuring out what she wanted and waited for the right moment. When the right moment came—she leapt.

Without question Louise Nevelson was a careerist. She had devoted her entire life to her work and she believed that it deserved to be seen in the best possible setting. She had decided that she was finished with the Martha Jackson Gallery. She had ridden the crest of her recent popularity and landed Sidney Janis, the most prestigious dealer in New York—maybe in the world.

"Louise always wanted Janis," Arne Glimcher later observed. "As soon as the Abstract Expressionist painters were with Janis, Louise wanted to be with him too. Going to Janis meant that she could be with the boys. Louise knew Janis had never had a woman artist, and that was a big point for her too. Janis Gallery wasn't a better gallery than Martha's. She [Martha]took care of her artists and was involved in their lives. Janis had great taste but was much more interested in the money and the names."[14]

Before Louise Nevelson left for the Biennale, she had asked Arne Glimcher to meet her in Venice. Her reasoning made sense. By November 1961 Glimcher had sold approximately ten Nevelson sculptures he had on consignment from the Jackson Gallery, for approximately eleven thousand dollars. Nevelson had also heard that Glimcher almost persuaded the Boston Museum of Fine Art to purchase one of her large walls.

Glimcher remembers vividly his experience with Nevelson in Venice: "Louise liked me. I was young, and I was attentive, and she was always a flirt."[15] He recalls his experience with her in Venice:

> Everything I knew about the Venice Biennale, Nevelson told me. "You should come with me," she said and I went. Being with her was like a passport. I met many famous collectors.
>
> I was considering moving Pace to New York, and in Venice she said, "Don't worry. If you open in New York, I'll be with you." And then, "You're going to be the king of the art world."
>
> I had placed ads in all the art magazines with an image of the Pace Gallery installation. Above it said, "Louise Nevelson at the Venice Biennale." Under the photo, "The Pace Gallery." When I got to London the week before Venice, I saw Erica Brausen, [director of the Hanover Gallery], and she assumed I was Louise's dealer. "Can we do a show?" she asked. I said, "I think we probably can."
>
> She [Nevelson] had just left Jackson for Janis but in the interim everyone thought the Venice show was ours. Pace Boston suddenly became an entity because of the Venice Biennale and Nevelson. It was the first visibility for the gallery.[16]

Having seen the ads Glimcher had placed in art magazines, many Europeans already thought Glimcher was her dealer, as did some of the collectors who had been buying her work from Martha Jackson. When Erica Brausen saw Glimcher again in Venice, just before the opening of the Biennale, she introduced both him and Nevelson to her artists, chief among them was Alberto Giacometti. She was also friendly with Henry Moore, Henri Matisse, Francis Bacon, René Magritte, Max Ernst, Joan Miró, Marcel Duchamp, and Michel Leiris (whom she helped escape from Majorca during the Second World War).

Brausen's gallery in London had become the premier place for modern art, and Brausen loved Nevelson's work. She was eager to show it and work cooperatively with Arne Glimcher and proposed the idea of opening a gallery together, Hanover-Pace. For a young man just starting out, to be associated with such a prestigious dealer was a coup. But it wasn't to be.

In June 1962, when they were both in Venice for the Biennale, it is unlikely that Nevelson had already decided to have Glimcher as her future dealer. But by the time they left, he was convinced that it was a done deal. In fact, on his return from Venice, he told his wife that when he moved his gallery to New York—his plan at the time, but an event that was still over a year away—he would have Louise Nevelson as his most important artist.[17]

During the summer of 1962 the world might have seemed unreal to Louise Nevelson. Her reputation and financial status had reached new heights. Only months earlier Dore Ashton had written in *The Studio* that, "One of the wealthiest imaginations working is Louise Nevelson's."[18] The exhibition of Nevelson's walls at the Los Angeles County Museum was well reviewed.[19] She could have felt as optimistic as Icarus flying toward the sun. But the crash of the high-flying artist was coming soon. Her waxy wings were not as sturdy as she thought.

The story of Nevelson's arrival in Venice and the lost suitcase that contained the outfits—her "Chinese robes"—she had wanted to wear for the opening and parties[20] was intimately tied to her participation in the Biennale. As described in an earlier chapter, when the airline was not quick to retrieve her lost luggage, Nevelson announced that the suitcase contained the white wedding dress that she need for her marriage "on Monday," the actual opening of the exhibition. Two years earlier she had used the same metaphor of marriage when Dorothy Miller had invited her to fill a large room with her sculpture at her first exhibition at MoMA, *Sixteen Americans*. The metaphor then was public and notable—*Dawn's Wedding Feast*. In Venice it was more hidden, but for the artist it was the same union of her art with the world.

The original plan for Venice was to exhibit black, white, and gold sculptures owned by the Martha Jackson Gallery, along with some of Rufus Foshee's white works from *Dawn's Wedding Feast*. But an unexpected snafu with shipping occurred: The Museum of Modern Art had just changed its policy and wouldn't pay the cost of shipping the pieces to Venice. At the last minute, it was decided to exhibit works already in Europe—owned largely by Cordier and currently traveling to exhibitions in Germany after the show in Baden-Baden.

As Dorothy Miller recalled: "For Venice we commandeered the work from [the touring show] and used it as raw material. A million boxes came in, and were sitting on the floor, while we flushed the ants out of the building and put up new ceilings. And then Nevelson just went to work with the Italian workmen and put up a new design. It was quite wonderful."[21]

Nevelson thoroughly enjoyed installing her show with the Italian workers. "I didn't speak any Italian, and they didn't speak English. But it was a joy. Because of their efficiency and empathy to compose with me right there." Using work from the travelling exhibition, Nevelson wrote in her autobiography, "I composed environments that had never been seen before."[22]

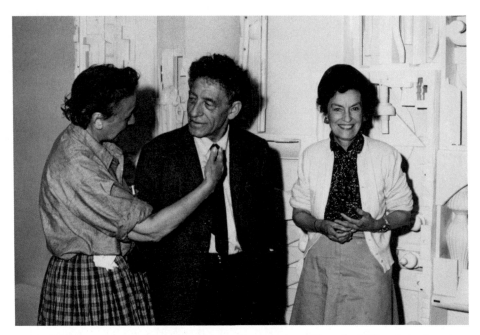

Maryette Charlton. Louise Nevelson, Alberto Giacometti, and Dorothy Miller, at the American Pavilion of the Venice Biennale, where Miller was installing Nevelson's work, 1962. From the Maryette Charlton papers, ca. 1890-2013, Archives of American Art, Smithsonian Institution. © Maryette Charlton

The artist had been given three large galleries at the Biennale. She painted the circular entrance room gold and filled it with her gold-painted sculpture. On the right side, called the camera oscura by locals, were her black-painted walls. On the left, she had created a wall of white sculpture, which she named *Voyage 1962*. She covered the glass ceilings of each of the lateral rooms with black or white fabric to match the sculpture.

Though Giacometti won the grand prize for sculpture in Venice, he claimed that Nevelson deserved it. According to Nevelson, "He went to great lengths to explain to [a dealer from Paris] how [Nevelson's work] was sculpture . . . a new form. He was very pleased with it."[23]

The catalogue essay for the Venice Biennale, written by William Seitz, shows the high regard the MoMA curators had for Nevelson's contribution:

[Louise Nevelson]'s newer work—especially the unusual "Walls" . . . are dominating environments to which a spectator must adjust.

The tall [white-painted] Cathedrals [have] an austere ceremonial presence. . . . In works painted black, families of disks, rectangles and sticks, recede into darkness. Surface becomes light and splendor on the

walls of gold; they are devotional or regal in mood, recalling St. Mark's, Burgos or Versailles. White, black or gold, the homogeneous coating seems to transform crude elements into a new substance. It is such transcendence toward which Nevelson aims.[24]

Seitz, along with several astute critics, emphasized the transcendental spiritual quality in Nevelson's walls. Michel Ragon, one of the main critics of Cimaise, refers to Nevelson's three rooms as, "A trilogy which surpasses competition. . . . With wooden débris . . . Nevelson raises great altars as rococo as those of Mexico and Spain. . . . One could pray before Nevelson's altars (yes, these are altars, shrines, relics of pioneer America)."[25]

The reviewer for *Art News*, Milton Gendel, wrote that, "most impressive [works at the Biennale] are Louise Nevelson's three room-sculptures in white, gold and black, which are like chapels for the cult of the object. The sawn and found pieces of wood are composed, framed and built up into an overwhelming fantasy architecture that arouses the esthetic desire of I-wish-I had-thought-of-that."[26]

In contrast to Seitz, Ragon, and Gendel, other critics thought the hyperbole was "disproportionate" and asked: "Can such nonsense be taken seriously?"[27] The reviewer for *L'Oeil*, Guy Habasque, noted that "the success of this artist and the abundant literature that it has engendered forces us to see her work as something beyond a perfected game of cubes." And he thought it was "unrealistic" for Seitz to have compared her walls to St Mark's, Burgos or Versailles.[28] Meanwhile, Robert Melville, an English art critic who had loved her work when he had written about it in London less than a year earlier, reversed himself. He ended his review: Nevelson's work is "a monument to what I suppose to be [her] loss of faith in everything except her own compulsive activity, and it's appropriate that an artist from the country that has the biggest dumps of discarded objects in the world should out-Schwitters Schwitters."[29]

With this mixed response from critics, it is easier to understand why Nevelson seemed out to sea on her return from Venice. The critics had tossed and turned her—some highly praising her rooms as the most sensational feature of the entire Biennale, but others damning her work as tawdry, repetitive, and self-aggrandizing.

Rufus Foshee tells the story of another meeting with Kurzman just before Nevelson and Dorothy Miller had left New York for Venice in early June of 1962:

The day Louise left for Venice, Sam came to 29 Spring Street I was there—Louise did little in those days that I was not included in. We sat down to the dining table. It was agreed that Janis would give Louise

$60,000 year. Unlike the deal with Martha, there was to be no contract. Kurzman said Janis did not do contracts. I remember that Louise was given her first advance by the Janis Gallery that day as well—and I think you will find that check for $20,000 in Janis's records—another due maybe in October. At that same meeting Sam said he was taking back the mortgage on the Westport house, and Louise was to pay him $157 a month. (I may be off fifty cents, but doubt it.)[30]

All the arrangements were made for what Sam perceived as his control of Louise's life forever. He just did not know with whom he had locked horns. Those checks were written for $157 plus, and more than one, I expect for at least the rest of 1962. Once all the business had been taken care of, we got in a cab and went off to the airline terminal where we met Dorothy Miller. That was the last peaceful moment any of us was to have for years.[31]

"Louise was so well-grounded, I had never seen her nervous. But when she came back from Venice, she was shaken. . . . She lay in her bed speechless, without moving,"[32] her old friend Marjorie Eaton observed. According to Rufus Foshee, "Almost everything went wrong after she returned. As close as I was to Nevelson, it was still difficult to know what was happening. I think two things took place. Her new dealer, Sidney Janis, decided that he liked her white sculpture more than the black or gold and, second, he and his lawyer Sam Kurzman decided they wanted Louise under contract. There was an 'important' meeting at Sam's where they got her to sign an exclusive contract."[33] Neither Foshee nor Nevelson had any idea how bad a deal she had signed. The house in Westport, which Nevelson now "owned," had a lien on it, so it was never actually hers.

By late September, realizing that she wouldn't live in the "the fancy house" in Westport she had bought from Kurzman, she invited her son Mike to move there from Rockland. By the beginning of October he had sold his house and studio in Maine and transported his family to Westport, having no understanding of the complicated mess in which he was now involved. Mike was planning to use the profit from the sale of his Rockland property to invest in a proper studio in Connecticut. He found a modest place in New Fairfield and started to fix it up.

Foshee later recounted: "As fall approached, one cold rainy Sunday afternoon,"

Nevelson called and said she needed to see me. I got there and she was in a state. Janis had not produced the rest of the money he had promised her as an advance. She asked me to go see Sam and make it very

clear that no work would be sent to Janis for her show unless she had the money. What a fool I was. But loving her work, I did it. And after all, who was I? I was thirty-one, with no credentials. I delivered the message in person to Sam in blank language. The money arrived. It probably would have been best had that exhibition [at the Janis Gallery] not taken place, but it did.[34]

In August, Jackson was putting out press releases announcing that Nevelson had won the grand prize (three thousand dollars) in the First Sculpture International of the Center of Visual Arts of the Torcuato di Tella Institute, in Buenos Aires. Later that month, Seymour Knox paid the Martha Jackson Gallery six thousand dollars for Nevelson's gold-painted sculpture, *The Royal Game*, which he gave to the Albright-Knox Gallery in Buffalo. The sale was the subject of a *Time* article titled "All That Glitters." Calling her a "scavenger-sculptress" and describing in detail the artist's gold studio and recent achievements, the critic concludes: "She is at the height of her fame, sales of her work last year amounted to about $80,000, and in the fall she will change galleries to become the first woman and the first U.S. sculptor to be handled by Manhattan's choosy Sidney Janis. For Louise Nevelson, the future looks golden."[35]

During the second half of 1962 Janis was in dispute with both Nevelson and Jackson about the ownership of Nevelson's sculpture. At the same time Arne Glimcher and Martha Jackson were still trying to sort out their respective Nevelson holdings. (Glimcher had on consignment a total of seven sculptures consisting of thirteen units.) Nevelson had signed her contract with Janis, and he simply assumed that whatever Jackson had of Nevelson's work belonged to him. Before the opening of Nevelson's first show at his gallery on New Year's Eve 1962, Janis made sure that the sculptures still on consignment to Martha Jackson had been transferred to him. And Sam Kurzman made sure that *Dawn Light I*, the wall Nevelson had promised him months earlier, was delivered to his house.

Arne Glimcher did not intend to be forgotten in the confusion. As he continued his courtship of Nevelson, he was in the process of moving his gallery to New York. He had hoped that he could open in New York with a Nevelson show in the fall of 1963, but neither he nor Nevelson was ready for that. In the meantime, he offered Mike Nevelson a three-man sculpture show in Boston in collaboration with Mike's gallery, Staempfli.[36] A few days before the opening at Janis, Glimcher sent her a note:

Milly, Mother and I wish you . . . success in your new exhibition and know that you will have it, as you so richly deserve it. I have been in New York several times this winter but haven't wanted to bother you,

as I know how hard my favorite sculptor has been working. . . . We will
be with you in spirit and share in your happiness, as happiness is what I
want most for you. . . . Arnold[37]

For her solo show at Janis the artist had once again made three rooms with
three different colors: *Night Garden* in black, *Dawns* in gold and *New Continents* in
white. But what had been acclaimed at her first solo European show at Cordier's
in 1960 in Paris and at Martha Jackson's *Royal Tides* in 1961 now drew decidedly
mixed responses from the critics, as it had in Venice. Some, like Hilton Kramer
in *The Nation*, gave her fulsome praise combined with a bit of focused criticism.
He did not like the way Janis had installed the works. "No effort has been made
to turn the gallery itself into a macrocosmic statement of the sculptor's overall
conception; each work stands separate and aloof as a discrete entity." Kramer
had a clear understanding of Nevelson's vision of her sculpture as an environ-
ment. Furthermore Kramer didn't like the white- and gold-painted work. His
explanation was persuasive: "A development which admirers of Mrs. Nevelson's
work have found hard, perhaps impossible, to reconcile to the high standard of
her own best work [is] the substitution of white and gold paint for the exclusive
and integral use of black." Without black, Kramer argued, "her essential sculp-
tural idea, so heavily dependent upon the articulation of light and shadow, could
not be realized." Innovation, in this context, was not necessarily a good thing,
and, he continued, "gold paint has the additional defect of degrading the whole
work with an air of artificiality and specious glamour."

Despite his criticism, Kramer ends with a powerful endorsement of Nevel-
son's work and its place in art history:

> Her achievement as a whole is nonetheless a large one. The new black
> wall in the Janis show is, like its predecessors, a kind of anthological
> summary of the whole Constructivist tradition. Memories of Arp and
> Schwitters live on easy terms with Cubist severities and anti-art hijinks;
> a tight Mondrianesque precision cavorts freely with Expressionist enthu-
> siasms. . . . Mrs. Nevelson has mastered a complex tradition, and left it
> transformed.[38]

Colette Roberts, who remained a fervent devotee of Nevelson and her work,
sent the artist a rough translation of the review she wrote for France-Amérique.
Roberts's encomium begins forcefully: "The expression of genius is possibly
order in the very midst of disorder. What strikes when one enters the Janis Gal-
lery is Order, a completely Nevelsonian order, where abundance, condensed this
time, seems to have expressed itself by the excellence of detail as well as the

excellence of the whole." Roberts then took up a side of Nevelson rarely mentioned by American critics: the "mystical dimension" of her work and its "deeply religious overtone."[39] Roberts always understood and respected, more than any of her other dealers, the spiritual side of Nevelson and her work.

Brian O'Doherty of *The New York Times* wrote a mostly scathing review: "Louise Nevelson, exhibiting for the first time at Janis Gallery, showed three rooms of her wooden doodles."[40]

Worse yet, her friend and former enthusiast, Dore Ashton now seemed to have doubts. Though she pointed out what was new—the regularity of the pre-made boxes of equal size, a feature that would become a consistent part of Nevelson's future work—Ashton noted that she didn't much like it. "The vertical-horizontal regularity of her divisions appears now to inhibit Nevelson's fantasy, constraining her to choke each composition and without an impulse to break out into three-dimensional space." Finally, she made clear that she was tired of white and gold—"black is always her forte."[41]

Most of the walls Nevelson had made when Martha Jackson was her dealer contained boxes of different sizes, which she would put together in various formats. Three large walls, all made in 1962, in three colors, consisting of equal-size boxes—*Dawn, New Continent,* and *Totality Dark*—were a metaphorical punctuation mark indicating the end of a stylistic phase. The regularization of the containers was the beginning of a subtle but significant change in style.

The show that opened on December 31, 1962, was Nevelson's only exhibition at the Janis Gallery. The weather that night was freezing cold, it was a holiday, and few serious collectors or art lovers showed up. When the exhibition closed at the end of the month, nothing had sold. It has gone down in (art) history as a disaster for both the artist and the dealer.[42]

Nevelson and Janis clashed almost immediately afterwards. She wanted out of her contract and to have all her work back, especially the three walls from the recent exhibition. Janis refused, claiming that she owed him the advance he had given her in the fall—at least $12,500, which was long gone.[43] He kept her work hostage in storage. There seemed no way out of the legal and financial impasse, complicated as it now was by the real-estate deal with their mutual lawyer Sam Kurzman.

Kurzman continued to demand the monthly mortgage payments, which Nevelson could not afford, and threatened her with foreclosure. In the months to come she sold back to the previous owner the two houses on Spring Street where she had been living and working (the owner agreed to let her remain on a rental basis), but the amount was still not enough to satisfy her debt to Kurzman.

The house debacle would eventually be resolved at the end of the following year, when Nevelson won her case in court. But until that happened she went

through hell. She had to contend with three different dealers. Extricating herself from Martha Jackson was complicated by their friendship and the accounting mess created largely by Jackson's son, David Anderson. Jackson and Glimcher were still sorting out their Nevelson holdings. Glimcher also had his eye on a future contract with Nevelson, which couldn't occur until she was totally free of Janis, who was holding onto her work.

Nevelson's awareness that she had created the messy legal situation in which she now found herself did not make it easier. She stopped working, started drinking, and went into a downward spiral of depression from which she could see no escape.

Her faithful assistant Teddy Haseltine was no longer much help, since he too was deteriorating daily. Nevelson knew that Teddy's depression and heavy drinking had to do with his being separated from his boyfriend, Al Argentieri, whom he saw mostly on weekends. A year earlier she had been discussing her concerns about Teddy's neurotic behavior with her psychoanalyst and had figured that having another person in the house to keep him company might be useful. In February 1963 Teddy introduced Nevelson to Diana MacKown, a recent graduate of the MFA program at Yale School of Art and Architecture, where she had studied with Joseph Albers, a great fan of Nevelson. Soon after her first visit, Nevelson invited MacKown to move in, and she quickly became studio assistant, guardian, and all-around helper. Both Teddy Haseltine and Diana MacKown believed in the world of spirituality and served Nevelson as faithful companions on her voyage to the fourth dimension. They also played poker for pennies with Nevelson and her sister Anita, who by now had moved into the second-floor studio.

Nevelson drank, drank some more, and walked around the street at three in the morning, wondering if she was going to survive. Her high-flying career had taken a nosedive, and her usual remedy for depression—work—now complicated by financial and psychological entanglements, was beyond her reach.

Watching from a distance, some envious fellow artists who had never risen as far as Nevelson took comfort in her fall. Nobody loves a loser, and it appeared that Louise Nevelson had lost everything. Art-world people saw her coming and crossed to the other side of the street to avoid her. Many critics who had supported her for years agreed that the gold-painted works were trashy, brassy, and over the top; they didn't discriminate between the good ones and the less good ones—they simply turned away. Nevelson was angry about the recent setbacks but especially angry at herself for having walked into a trap of her own making—her desire to rise yet higher than she already had—her hubris.[44]

Though Nevelson had moved away from Jackson by signing with Janis, Martha Jackson still owned a large amount of Nevelson's work, and it was in

both women's interest for Jackson to continue exhibiting it. She began to plan for an exhibition of Nevelson bronzes cast from wood sculpture in late spring of 1963, and in the fall she included *Dawn Light II* in a show titled *Eleven Americans*. Perhaps the most significant help Martha Jackson gave to the beleaguered artist was helping her get away—far away—for a while.

In April 1963 Jackson helped arrange an invitation for Nevelson to spend three months making lithographs at June Wayne's Tamarind Lithography Workshop in Los Angeles. "The Tamarind Workshop is thrilled to hear that you are definitely coming," Jackson wrote. "It will be so interesting to see your recent discoveries translated into the graphic media. Jean Lipman says that *Art in America* will be most interested in publishing an article on your graphics, and she wants to be sure that she is the first person to see them on your return from California."[45] As Nevelson later put it: "I wouldn't ordinarily have gone. I didn't care so much about the idea of prints at that time but I desperately needed to get out of town and all of my expenses were paid."[46]

Nevelson and her sister Anita went to Los Angeles in April 1963, and their youngest sister Lillian came a bit later for a visit. While she was in California, Mike Nevelson took care of things for his mother in New York, driving down from Connecticut to visit her Spring Street houses, "which appear to be in good condition," and checking up on Teddy, who, he reported, "seems calmer and saner than usual."[47] Mike Nevelson was proud of being able to help his mother at such a difficult time. It fit with his sense of himself as the happily domesticated paterfamilias and accomplished artist—a Nevelson male who could help out a suffering Nevelson female.

By May, Nevelson had settled into her work at the Tamarind Workshop, and Martha Jackson was writing short, chatty, supportive letters, with news about possible buyers of her work to "Dearest Louise."[48]

These letters make it clear that Jackson was still representing Nevelson, even though Nevelson was still under contract to Janis. There may have been some legal concern about Jackson's selling Nevelson's works to anyone, but that didn't stop either of these determined women.

After thanking her for a recent check, Mike Nevelson wrote to his mother in late May that, "Ted seems more sane and responsible than ever!"[49] Evidently acting on the advice of Nevelson's new lawyer, Harris Steinberg (an art lover whose only requested fee would be one of Nevelson's sculptures), Mike had decided to move his family out of the Westport house, which they would then return to Kurzman in order to settle up the bad real-estate deal his mother had made the year before. That transition was not going smoothly, since Mike's new house in New Fairfield was not ready, and Kurzman had rejected his request to stay a few extra months in Westport.

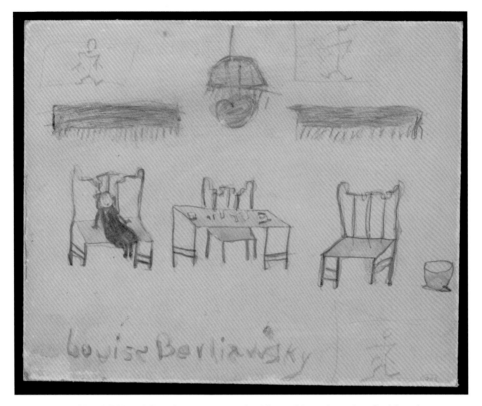

Furniture and Girl (childhood drawing), ca. 1905. Archives of American Art, Smithsonian Institution

Betty Estersohn. Marjorie Eaton with Nevelson's *Goddess from the Great Beyond*, 1977.

York Avenue, New York City, 1933. Oil on board. Farnsworth Art Museum, bequest of Nathan Berliawsky 1980.35.21

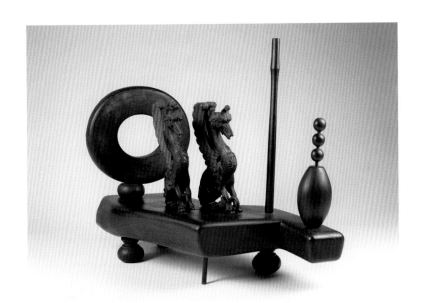

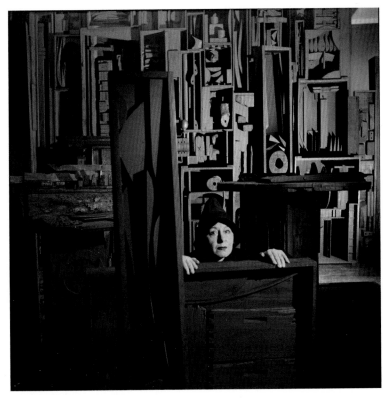

TOP: *Winged City*, 1954-55. Painted wood, 36 x 42 x 20 in. Birmingham Museum of Art, Alabama. Gift of Mr. and Mrs. Ben Mildwoff through the Federation of Modern Painters and Sculptors

BOTTOM: Walter Sanders. Louise Nevelson poised amid her environmental installation called *Moon Garden*, 1958. LIFE Picture Collection/Getty Images

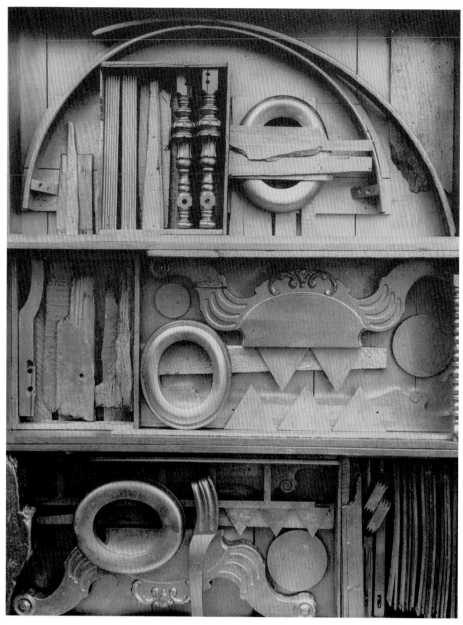

Royal Game I, 1961. Painted wood, 69 x 51 ½ x 8 ¼ in. Collection of Albright-Knox Art Gallery, Buffalo, New York, Gift of Seymour H. Knox, Jr., 1962 K1962:9

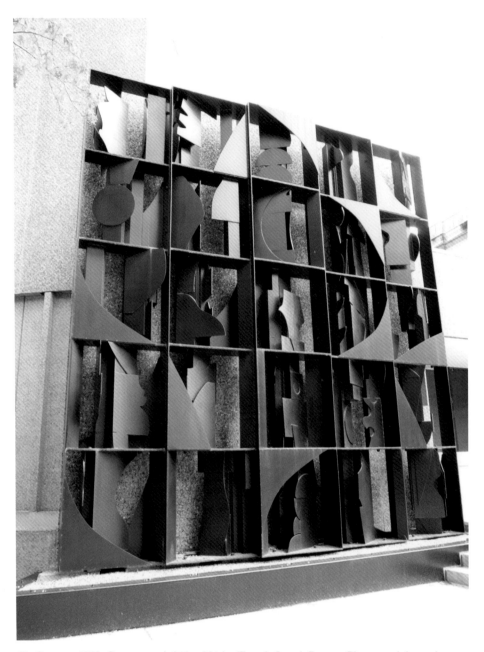

Sky Covenant, 1973. Cor-ten steel, 240 x 264 in. Temple Israel, Boston. Photograph by author

Untitled (collage), 1972. Paper, mechanical reproduction, pastel, metal foil, and embossed stamp on paperboard, 30 x 20 in. Hirshhorn Museum and Sculpture Garden, Smithsonian Institution; Gift of the Joseph H. Hirshhorn Foundation, 1979. Photograph by Lee Stalsworth

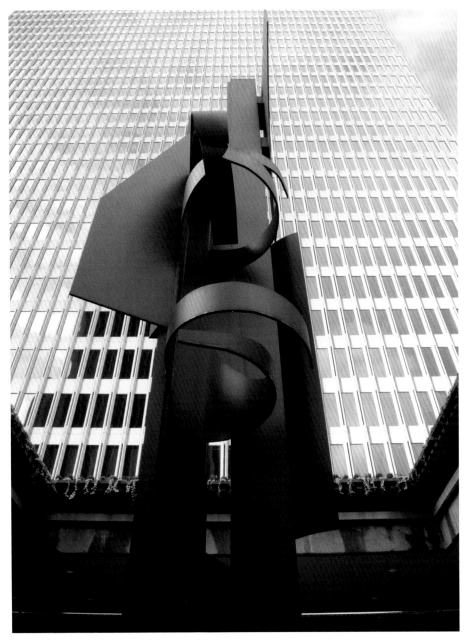

Sky Tree, 1977. Cor-ten steel, 54 feet tall. Embarcadero Center, San Francisco. Photograph by author

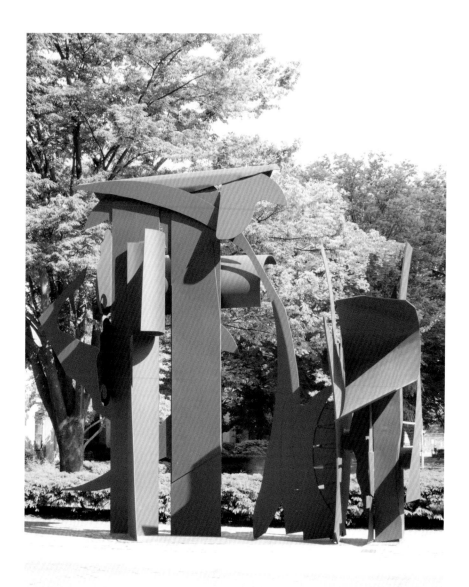

Transparent Horizon, 1975. Cor-ten steel, 240 x 252 in. Massachusetts Institute of Technology. Photograph by author

OPPOSITE TOP: Hans Namuth, Portrait of Louise Nevelson, 1977. Photograph by Hans Namuth. © 1991 Hans Namuth Estate. Courtesy Hans Namuth Archive, Center for Creative Photography, University of Arizona

OPPOSITE BOTTOM: Photographer unknown. Cover of April, 1972 issue of *Intellectual Digest*.

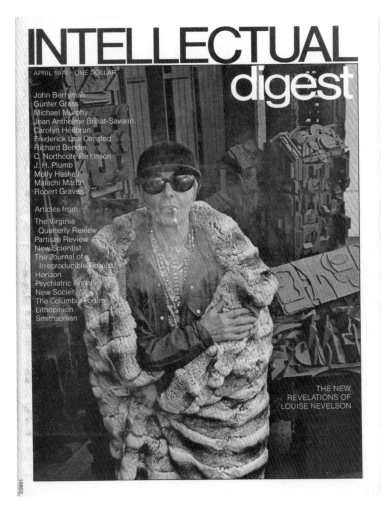

INTELLECTUAL
digest

APRIL 1972 · ONE DOLLAR

THE NEW
REVELATIONS OF
LOUISE NEVELSON

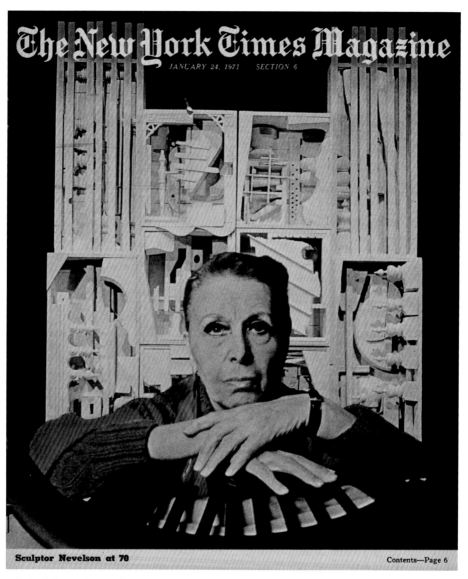

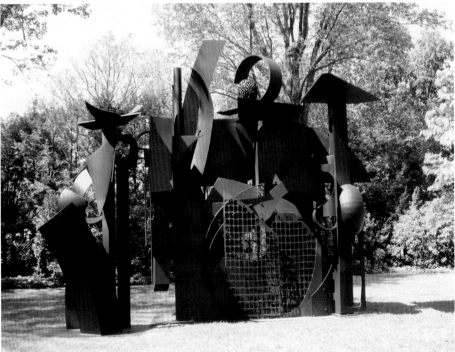

TOP: *Grapes and Wheat Lintel* (Chapel of the Good Shepherd, Saint Peter's Church), 1975. Painted wood, 43 x 94 x 3 ½ in. Photograph by author

BOTTOM: *City on the High Mountain*, 1983-84. Painted steel, 246 x 162 in. Purchase Fund © Storm King Art Center, Mountainville, New York

Diana MacKown. Louise Nevelson at the Whitney Museum of American Art, 1980. Courtesy of Diana MacKown

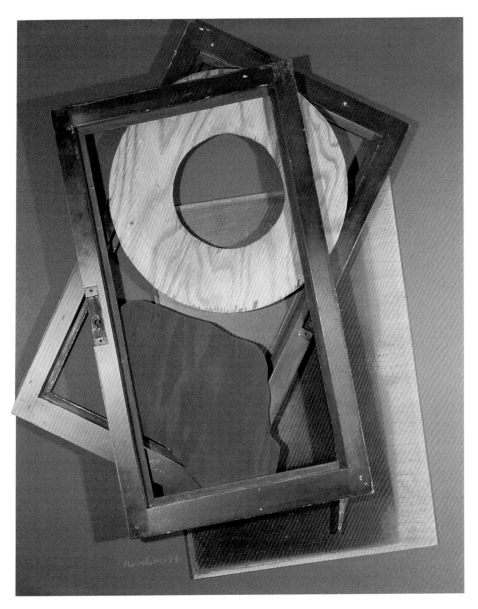

Volcanic Magic XVI, 1985. Wood and paper collage, 40 x 32 x 4 ¾ in. Farnsworth Art Museum, Gift of Louise Nevelson 1985.23.26

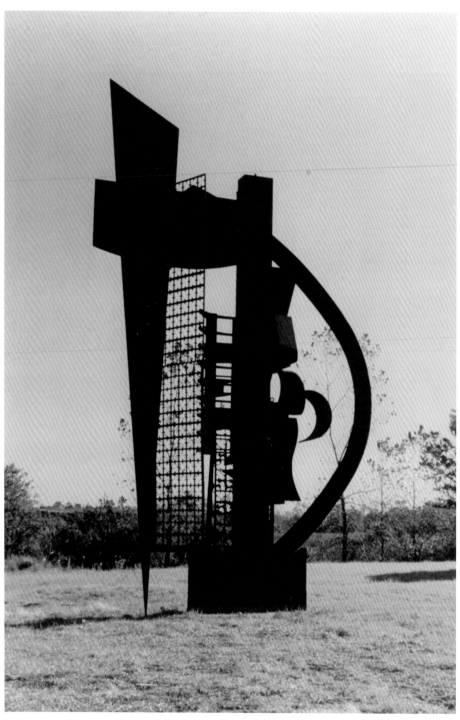

Iron Cloud or *Sky Horizon*, 1984-86. Cor-ten steel, 354 x 204 x 120 in. Gift to the National Institute of Health by John, Peter, and Susan Whitehead, the family of Edwin C. "Jack" Whitehead. Photograph © Roxanne Everett/Lippincott's, LLC, courtesy of Pace Gallery

Diana MacKown. Louise
Nevelson at Berliawsky-
Small Cemetery,
Rockland, ME, 1985.
Courtesy of Diana
MacKown

Diana MacKown. Louise Nevelson with
Willem de Kooning, 1986. Courtesy of
Diana MacKown

Diana MacKown. Louise Nevelson
with Virgil Thomson and Edward
Albee, 1984. Courtesy of Diana
MacKown

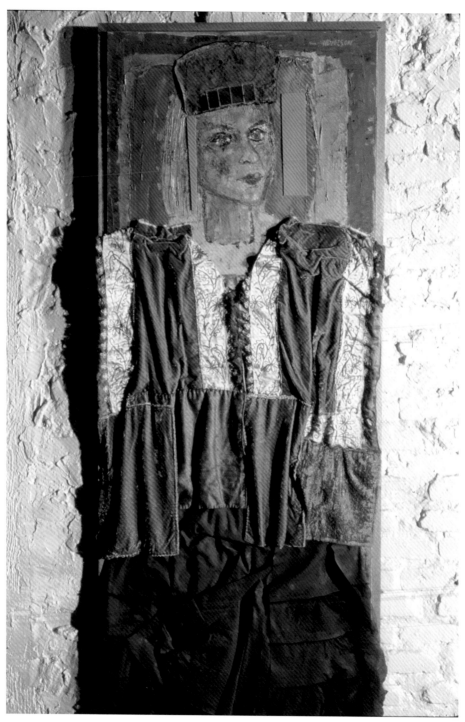

Portrait of Diana MacKown, begun 1960s; completed 1983. Collage: Oil paint, fabric, mirrors, and cardboard, 26 ¼ x 62 ½ in. Courtesy of Diana MacKown

Steinberg was negotiating for Nevelson with both Janis and Kurzman, and so far the only "deal" Janis had offered was to agree to let her out of her contract for twenty-five thousand dollars. Nothing was mentioned about the return of her sculpture. Nevelson refused his deal. Nevelson was due to pay Kurzman back $20,800 on the mortgage note in June. Additionally, Kurzman was claiming that "young Mr. Nevelson" had no right to be in the house and demanded that he "immediately vacate the premises." Mother and son were waiting for their lawyers to resolve the many problems and knew that "a long and costly court fight" was probably the only way to settle the madness.[50]

The Tamarind Lithography Workshop turned out to be ideal for Nevelson's rehabilitation. June Wayne noted that, when Nevelson came to Tamarind, "She was quite distraught. And here, she comes to a place she's never been, meets people she doesn't know, and she is the total center of everybody's attention. The entire crew was focused on making her art. She had nothing to do except be who she was and to work in the studio. . . . I was a little on the strict side with her during the day," Wayne remembered,

> because we could not afford to have an accident in the workshop. Not when you're fooling around with thousand-pound stones and presses. So she wasn't getting any booze during the day. But she would drink heavily at night. . . . And sometimes by the end of the evening, her breath would be strong enough to wither my eyebrows. . . . Well, she would be like any drunk—bleary, her language would be blurry. She might not really be responsive. You might have to herd her into an automobile. She might put her head on your shoulder, and then, as I said, the smell would be very unpleasant. She was clearly suffering. It was like she was ill.
>
> I really never left her alone. And Louise needed not to be alone. I had no way of knowing that, but you sense it when you work with people the way we worked at Tamarind. . . . And she would work very hard, very inventively. She was not verbally talented. There was a great deal of gesturing and she could not necessarily explain exactly what she wanted. If you had a tape of what she was saying, you might be quite befuddled. . . . Louise often said to me that Tamarind saved her life. [For years afterwards] we spoke to each other, sometimes for an hour or more on Sunday mornings, when she would confide to me her newest problem, whatever it happened to be.[51]

During her first stay at Tamarind, Nevelson produced just under one thousand lithographs. These are not Nevelson's best work, but they liberated her, and the kind treatment she received from June Wayne and the workers at the

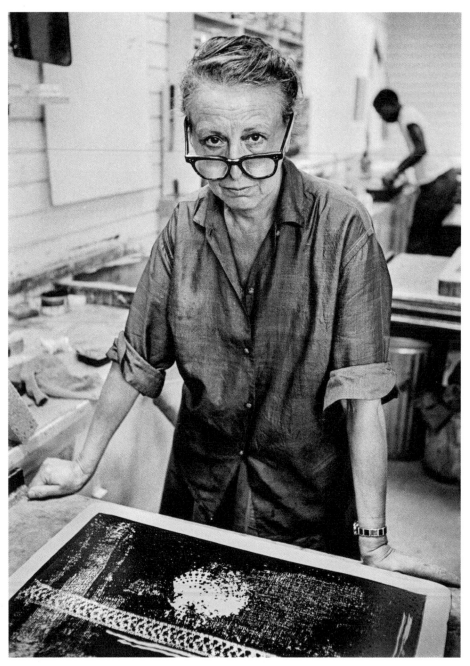

Marvin Silver. Tamarind Lithography Workshop (Los Angeles), 1963. © Marvin Silver

lithography studio made her feel at peace again. She had started her visit wearing her usual exotic outfits and makeup, but by the end she had shed her mask and comfortably worked in conventional clothes without any makeup. By the time Nevelson returned from Los Angeles to New York she had regained her sense of herself.

Arne Glimcher had visited Nevelson while she was at Tamarind to persuade her to make good on the casual agreement she had offered in Venice. By the end of his three-day visit, Nevelson agreed to join him in his new gallery when he opened in New York, and he had immediately offered her an advance of six thousand dollars, which she duly accepted and sent a portion of to her son. Friends of Nevelson, including Mark Rothko, questioned her judgment about selecting such a young untried dealer, telling her, "Nobody knows who he is." Her response was in character: "But I know who he is."[52]

Despite the verbal and financial commitment, Glimcher and Nevelson were not yet legally free to act on the new partnership. But it was enough to ground her, and she took back her life and her future.

On November 22, 1963, Nevelson won her court battle with Janis and Kurzman. Janis was obliged to return her sculpture, and she was no longer threatened by Sam Kurzman or in any way tied to him.[53] Her lawyer Harris Steinberg ended up with a beautiful white-painted Nevelson sculpture.

Decades after the event, Rufus Foshee said: "I felt then, and I feel still, that I was right in pushing Louise for a new beginning. I was right in premise, wrong in choice of lawyers. Despite the downside of the clean break, I think in the long run it gave Nevelson a new perspective."[54] But it's not so clear that Nevelson ever forgave Rufus Foshee for encouraging her to take the steps that led to what she called "the second worst mistake" of her life—her partnership with Sidney Janis. Her marriage to Charles Nevelson had been the first.

She needed to be active to regain her standing in the art world after the Janis fiasco, and it was natural for Nevelson to turn to an organization which she respected and where she had always found respect. In the spring of 1963 she had been elected the first woman president of Artists Equity, a group she had been part of since the early 1950s. She knew she had to stay visible, and this position gave her the chance to exercise her ability to think on her feet and sound both confident and authoritative even when she wasn't feeling that way.[55]

She also continued her long-standing practice of accepting most invitations to participate in art-world activities and various group shows no matter how minor. At the end of 1963 she exhibited at the East Hampton Gallery and at the Sculptors Guild annual show at Lever House in New York City. In December of that year she took part in an exhibition and auction held in Boston to benefit a group called Turn Toward Peace, which was advocating the Test Ban Treaty

and an end to the Cold War. In late January 1964 she had a one-woman show at the Gimpel Hanover Gallery in Zurich.

Nevelson spoke on panels at local galleries and universities and served on juried shows for barely known galleries, efforts which allowed her to put her money where her mouth was—she would support creativity wherever and whenever she could. They simultaneously opened new doors to possible collectors and enthusiasts. In January 1964, for example, Dorothy Miller of MoMA arranged for ten to fifteen members of the museum's Junior Council to visit her studio. These wealthy young people were being cultivated as future art buyers and donors to the museum. A few months later she participated in a panel discussion, "The New Face in Art," at New York University's Loeb Student Center in collaboration with Contemporary Arts Gallery and Granite Gallery. By making herself available for three hours on a Sunday afternoon she could reach the two hundred and fifty young college students in attendance (and, in fact, a much larger audience, since the discussion was later broadcast on the radio station WBAI). Furthermore, the wall she and Nelson Rockefeller had given NYU in 1960, *Tropical Garden I*, was on view behind the panelists. As the moderator pointed out, Nevelson's beautiful wall would be " 'the silent speaker' that will have the last word."[56]

Arne Glimcher's recollection of his early years with Nevelson are tinged with bittersweetness. She would be his star and eventually brought other artists to his firmament. But first he had to save her and persuade her that he was not too young to do the job she needed done: "Her house was empty and she wasn't working," Glimcher recalled. "She felt that her work had been taken away by Janis and that without it there was no future for her. For about six months she thought a lot about suicide. I think it was the major focus of her life. Both she and Teddy told me she was on the window ledge a couple of times. She was drinking like crazy. It wasn't that she was drunk for a day—she was drunk for two weeks. It was her way of losing herself, escaping."[57]

But Glimcher was determined to see her back in action. She was too talented—reminded him too much of his assertive mother—to disappear into the gutters of New York. After they had been working together profitably on all sides, for a time, she took care not to let him ever see her drunk again.

When she was at her lowest, Nevelson said that all she wanted were the three large walls she had shown in the ill-fated Janis exhibition. Glimcher arranged to get them from Janis and returned them to Nevelson's studio. Surrounded by her own sculptures, she could pull out of the deep funk into which she had fallen and start working again.[58] With borrowed money, Glimcher had paid Janis back Nevelson's twenty-thousand-dollar advance, and he had also given her an additional seventy-five hundred to live on while she was getting back on her feet. He took none of her work to the gallery.

After the dust settled, after her return to productivity, after she had recovered her two houses on Spring Street and her three walls from Janis, after she stopped drinking too much, after she was finally moving forward with Glimcher, Nevelson took responsibility for the nightmarish period through which she had just passed. She knew she had been ambitious and overweening and that it had clouded her judgment. The infamous meeting with Kurzman, arranged by Rufus Foshee, had given her the entrée to the Sidney Janis Gallery, and she had walked on her own two feet into the lion's den. But after her rancorous dispute with Janis and Kurzman, after her many drunken days and nights, Nevelson had to pick herself up and move forward.

As time passed, Glimcher saw himself as Nevelson's closest friend. Had he not been nearly forty years younger and not happily married to his high-school sweetheart, who knows what would have happened between them. With his support, Nevelson expanded in new directions as an artist, and became world famous. Anything she needed, he would provide. Whether it was money, limousines, stylish clothes, a chinchilla coat, access to unconventional materials, he would make it available. While some of her early supporters never forgave Arne Glimcher for what they mistakenly saw as his encouragement to wear outlandish outfits, they must have forgotten Nevelson's long time predilection for outrageous fashion. No one besides herself could influence Nevelson's idea of fashion.

Glimcher called Nevelson every day. Just as Nevelson called her sister Lillian every day. They were family to each other. And for both, that meant closeness and total reliability. Their parents and siblings had stood by them through hard times, certain of future success and certain that their individual talents would eventually bring them success. Glimcher had "made it" faster and younger; it took Louise much longer. But since it had always been harder for women in the arts, as in other professions, no one in her family was surprised or reluctant to support her for more than three decades.

An absolutely crucial feature that Nevelson and Glimcher shared was a sense of space. If she had the soul of an architect, he had the gift of installation. From the beginning of his career, Glimcher developed an extraordinary talent for positioning paintings on the wall and sculpture in space so perfectly that their aesthetic strength became stunningly visible.

Before working with Glimcher, Nevelson had almost always installed her own shows, but she quickly learned to trust his judgment and stepped aside—not far away, but aside—while he put her work on display. Their absolute faith in each other's spatial sense explains why she later chose to work closely with him in 1977 while making her first large-scale room—her magical environment—*Mrs. N's Palace*. They were both quick and certain about where and how to place objects. Nevelson called it the fourth dimension; Glimcher called it good gallery practice.

Over time Glimcher and Nevelson discovered other commonalities. They had both begun life as shy, sensitive young people; both had learned the value of self-presentation. Arne Glimcher had become an elegant, confident, sometimes mercurial, often charismatic world-renowned art dealer. Louise Nevelson gradually built up the internal confidence and courage to present herself as a magical, self-assured, and glamorous presence.

It would be a combination of Glimcher's moral and fiscal support, and the day-to-day practical support of her assistants, Teddy Haseltine and Diana Mac-Kown, that made the last three decades of Nevelson's life so harmonious. It was, of course, a two-way street: "It was thanks to her," as Arne Glimcher later said, "that I was able to bring the gallery to New York. Because of her charisma and what she saw in me, it wasn't just another gallery."[59]

Glimcher was also a marketing genius, and with his canniness and creativity Nevelson's work became increasingly important. He genuinely loved her work and was eager to share it with his friends, even in unconventional ways. Indeed, his oldest friend Dick Solomon, recalled Glimcher's showing up at his apartment in Boston at seven-thirty one morning to deliver a gold wall, which Solomon had neither seen nor agreed to purchase. "I ran into Arne that morning. I asked what he was doing there. He said he was bringing me 'a Nevelson.' (That was my first encounter with the artist.) I said that's very nice, but I have to go to work. He said, 'Don't worry about it.' So when I came home that night, there was a wonderful gold Nevelson wall, which is still in my apartment in New York."[60]

As Nevelson began to produce work for her first show at Pace Gallery in New York in November 1964, it was clear that she had learned from the Janis fiasco. However much Colette Roberts had understood and admired the gold- and white-painted work, Nevelson had gotten the message, and the Janis show would be last time she worked in three colors.

Contrary to the prevailing opinion, Nevelson's lifelong reputation of refusing to respond to critics was never accurate, and when it came to Hilton Kramer she was particularly attentive. After all, by naming her the "architect of light and shadow" almost a decade earlier, he had helped her understand and articulate what she was doing. Other reviewers now mostly repeated his mantra. And, yes, do more black. Nevelson put away her gold paint and returned to her forte: black-painted wood sculpture. But however chastened by all that had gone down in 1962 and 1963, however angry, however pressured she felt by her new and uncertain financial situation—having thrown her lot in with an unknown dealer—she did not stand still. In 1964 she began to move forward with renewed energy and renewed enthusiasm for the unknown.

ARCHITECT OF REFLECTION

1964 – 1966

"I guess I'm just a sort of one-man circus. I call myself an archi-
tect of shadow and reflection. I am not really concerned with
anything else."

—Louise Nevelson "Serene Sculptress," *Palm Beach
Post-Times*, March 6, 1971

By the end of 1963 Louise Nevelson's contractual situation with Janis, as
well as the questions about who owned which works, had finally been
resolved, and Arne Glimcher had become her legal dealer. Now that her
life had gone from chaos dominated by multiple dealers to a kind of order, in
which she was cared for but not coddled or controlled, her work reflected her
more peaceful state of mind. Up to this time she had been composing with
occasional uncertainty. She often found satisfying aesthetic solutions with her
unevenly sized boxes and randomly found bits and pieces of wood. She would
usually hit the target, sometimes after one or two tries. And once she had found a
composition that pleased her eye, she would keep it. The process might be either
exhausting or exhilarating.

But once she began using equal-size boxes, her compositional method
became like "open-sesame."[1] Because she did not have to worry about balancing
the different sizes and shapes of the boxes, she was able to focus primarily on
the formal composition within each box, in combination with that of the entire
wall. Colette Roberts had noted "the completely Nevelsonian order" in the Janis
exhibition, where the three magisterial walls containing equal-sized boxes were
first exhibited.[2] By creating these pieces in the midst of a troubled period Nevel-

son had discovered one possible means to find order in her life. Arne Glimcher understood the importance of these three walls to the artist and made sure that, in negotiating her departure from Janis, they were returned to her studio in late 1963 or early 1964. Her intense desire to have them with her confirms the reciprocity of her psychological state and her art. The sense of calm composure they gave her also foreshadowed a change in her style. For most of 1964 she continued to do work with boxes of equal size. For the rest of her working life she would alternate between boxes or grids of equal size and those of variable sizes, as her mood and box availability varied. She liked to jump around. It kept the livingness in her work.

By 1964 Nevelson had married Surrealism with Cubism and come up with a new order. Having more or less mastered that synthesis, she pushed her work toward even newer forms of order. Through three aesthetic novelties she introduced into her work that year—curving walls, huge size, and reflective elements such as mirrors and Plexiglas—she was able to work in a new dimension.[3] As she understood it, the world was not simply the concrete, visible three-dimensional universe all around us—it included the harder-to-capture, more ideal and spiritual realm of the fourth dimension.

Nevelson's first curving wall was *Silent Music VII*, which consisted of twelve boxes of equal sizes.[4] At her last Pace Gallery exhibition in Boston, in March and April 1964, Nevelson installed this work as a three-column wall, with each column set off at an angle to the one next to it; she added Plexiglas covers to each of the boxes. The Plexiglas box covers introduced the non-physical dimension of reflection, which the new angled configuration of the columns made evident: The inside of each box is reflected on the surface of the adjacent boxes, as are lights and other objects in the room. The mix of deep and shallow, rounded and rectilinear, segmented small details and large sweeping shapes becomes even more complicated when the three columns are separated and hinged against each other at different angles—it's hard to believe it is the same work of art when the curved wall is compared to a straight one. The reflections change everything.

Black (or *Black Chord*) is one of the relatively early walls made up of equal-sized boxes. Composed sometime in late 1963, most likely after Nevelson returned from Tamarind, its measured combinations of verticals and horizontal slats play with the viewers' expectation that they will find a perfect match nearby—only to be surprised by some subtle variations. The uppermost box on the right, for example, has an overlay of three wide horizontal pieces that act like a lid of light and dark lines, which arrest the eye and urge it to find the three other boxes with the exact same number of wide horizontal pieces on the surface.

Then, in the bottom register of each of these four boxes, one sees that there are witty variations in the internal composition of each box—none is an exact

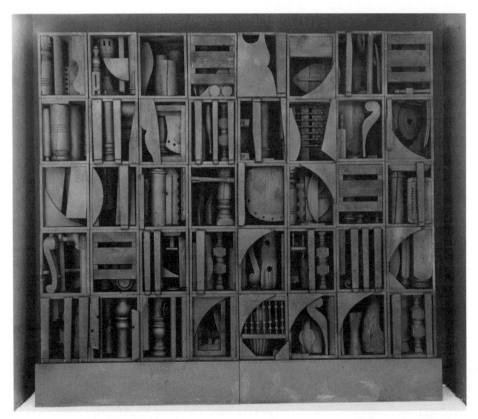

Black or *Black Chord*, 1963. Painted wood, 100 x 144 x 11 ½ in. Whitney Museum of American Art, New York; Gift of Anne and Joel Ehrenkranz. 91.1a e Photograph by Ferdinand Boesch, courtesy of Pace Gallery

match. In the first, there is a horizontal rod with a square element, which lands exactly in the center of the wall's horizontal width. Moving across the top register to the left, the second box has two flat, round pieces that reflect light as well as a pointed triangular element lit up against a dark background.

Two rows down on the right is a peep-show view of three turned spindles. The last of the group, which is down one more row and the farthest left, we see a circle and a spindle bringing the whole to a welcome balance. Because of the size of the work and because it contains so much of interest, this particular perceptual play is not immediately noticeable. Each box rewards the viewer's attentiveness, posing delicacy against stolid strength, and quickly curving linear patterns against slower, majestic planes of light and dark. As we will see below, *Black* was subjected to one of the novelties Nevelson introduced into her work in 1964, when it was transformed from a flat wall into a curving one, because of the shape of the room in which it was exhibited.

Immediately after becoming Nevelson's sole dealer, Arne Glimcher arranged

with Erica Brausen to have a big Nevelson show at the Hanover Gallery in London consisting of art from her New York studio, as well as from Cordier and other European gallerists. As in the Janis exhibition, the pieces on display were sculptural walls made up of equal-sized wooden boxes, most of which were painted black, with just a few painted gold and white. (The white and gold works were not emphasized by having a room of their own as they had been in her Janis exhibition.)

The November 1963 exhibit at Hanover received rave notices. The art critic for the *The Times* of London began his review by comparing American culture to the ancient Greeks, who "tapped off and refined the scrap and waste of the Eastern Mediterranean." He wrote that Nevelson's sculpture suggested a "dynamic, but exquisitely proportioned miniature, architecture." He ended with the statement that: "To do *surréalisme* all over again in cubist terms *sculpturally* is no mean feat."[5]

David Sylvester, one of the most astute art critics in England, was unambiguously positive about Nevelson's work in the London show.

> Louise Nevelson is a sculptor I think of as the creator of a world, a limited world but a whole world—a world, like the moon, not only because it's enigmatic, feminine but because its poetry has to do with forms passing from light into shadow. One part of this remarkable poetry is the tension between the illusion that it's organic and growing rather than an assemblage of dead wood that [has] been made and used by human-kind. . . . Today Louise Nevelson is fairly considered to be the world's leading woman sculptor. I don't think I'd want to contest that view.[6]

The sculptures in the London Hanover show, plus an additional ten pieces, went on tour with solo exhibitions at the Gimpel & Hanover Galerie in Zurich, the Galatea-Galeria d'Arte Contemporanea in Turin, and, finally, at the Kunsthalle Bern. This was the second time in two years that a solo Nevelson exhibition toured Europe. The following year four of her sculptures were included in *Documenta III,* an exhibition held in Kassel, Germany, first established in 1955.

Arnold Bode—painter, professor, and the exhibition's first artistic director—designed the huge exhibition in a mostly bombed-out industrial town, where that year (1964) he invited two hundred artists to present their work. His aim was to focus on art as the production of an individual, thereby avoiding schools and "isms." Unlike the Venice Biennale, where art-world professionals picked works supposedly representing the best each country had to offer, *Documenta* was noncompetitive and independent. It irritated or thrilled its viewers, some hailing it as so mammoth a show that it could be called anti-art. It had not been neatly organized by the art-world mainstream, which always strove to define "art."

Among the artists invited to present their work were luminaries like Matisse, Giacometti, Moore, Picasso, Arp, Lipchitz, Matta, and Laurens, who exhibited in the Alte Galerie. In addition to Nevelson, the established artists of the American contingent included Calder, Noguchi, Pollock, Rauschenberg, Motherwell, Rivers, Bontecou, David Smith, and George Rickey. The newer and younger artists were placed in an outdoor sculpture exhibit where they could be viewed against a backdrop of bombed-out buildings, mere shells of their former glorious state.

Nevelson's four black walls were assigned to be shown in a circular room, which initially she had not liked. To make the space more congenial, she had the raw stone and cement walls whitewashed and added panels of white cloth between the works. By installing the usually flat wall, *Black (Black Chord)*, made up of forty boxes of equal size, in a curved configuration to match the room's shape, she dramatically changed its appearance, just as she had done in Boston with *Silent Music VII*. The wall was ninety feet by one hundred eighteen feet, and before she altered its shape, the very size of the sculpture, both in height and length, might have overwhelmed or intimidated viewers. Now it could literally embrace them by seeming to surround them.

The reviewer for the *San Francisco Sunday Chronicle* described the gallery at *Documenta* as a "circular white-walled chapel for the black boxy, altar-like wood assemblages of Louise Nevelson."[7] More than two years after the Venice Bien-

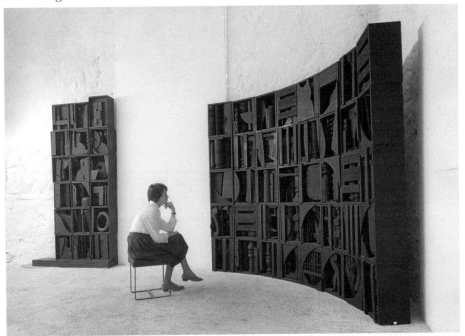

Günther Becker. Installation view of *Now* and *Black Chord* at Documenta III, 1964. © documenta Archiv

nale, these sculptures were still being seen in a metaphysical or sacred context, and the photograph in the *Documenta* archives shows a young woman seated in rapt concentration before the "altar-like" curving sculpture *Black*.

Participating in *Documenta III* marked the first time Nevelson had been in Germany since 1931 and the first time Arne Glimcher had ever been there. Though artist and dealer came expressly to set up her works, they couldn't avoid seeing that Germany was a country still marked by the war and its aftermath. Reminders of what had transpired there were everywhere. They did not visit the concentration camps only a few kilometers from Kassel and apparently did not even know of their existence. Yet they could see the stark reminder of the war in the unreconstructed ruins of the city, and they had to be aware of what their fate would have been in Germany twenty or thirty years earlier.[8] Perhaps this trip influenced the work that came next, work which suggested a reawakening of Nevelson's Jewish identity.

The artist had returned to New York from what had to feel like a triumphant exhibition at *Documenta III*. Her sculptures had been admired by many, and one of her most powerful recollections was of Henry Moore crossing the room to hug her and tell her how much he liked her work.[9] For her forthcoming solo show at the Pace Gallery in New York she picked up the thread she had been dangling and wove an entirely new opus from it.

Nevelson had recently fallen out of love with the golden sun—the world of money and materialism. After her startling success and her equally startling crash to the ground, she had found herself in debt and despair. That confrontation with cold, hard reality had opened her to spiritual depths that she could plumb whenever the physical world disappointed her. This time it had led to a new identity and a career-changing exhibition.

Preparing for her debut show at Pace in New York, she began work on a twenty-foot-wide wall, made of sixty equal-sized boxes—the largest to date—to be called *Homage to 6,000,000*. The enormity of the Holocaust was one of the motivating factors for the size of the new wall; the vast exhibition space she had witnessed at *Documenta III* was another. So was the generosity of her new dealer, who was willing to finance any project of any size she proposed. Collaborating with Glimcher, whose close-knit Jewish family resembled her own, clearly triggered memories, fears, and hopes inherent in being Jewish in the twentieth century. Nevelson's poem, written for of the dedication in Jerusalem of a similar work, *Homage to 6,000,000 II*, is a rare public testament to those feelings, which she usually kept hidden.

ONE LIVES A LIFE

The layers of consciousness are infinite
My own awareness is my own awareness

The essence and the symbols of this presence will be a living presence
 of a people who have triumphed.
They rose far and above the greatest that was inflicted upon them.
I hear all over this earth a livingness and a presence of these peoples.
I feel that they are here, and there is a song I hear and that song that
 rings in my ears and that song is here.
The depth of what I feel must remain private, I cannot speak of it out
 loud.
Their consciousness and our consciousness are one.
Reflection—exaltation—6,000,000 equals epic grandeur
Time is standing still for us in this presence.
They have given us a livingness.[10]

In her two sculptures referring to the Holocaust, *Homage to 6,000,000* and *Homage to 6,000,000 II*, "consciousness," "livingness," "reflection" all came together in works of epic grandeur. As had happened throughout her career, powerful feelings provoked an equally powerful artistic response.[11]

Nevelson had always managed to have a houseful of helpers, even when she was flat broke. In the late 1950s and early 1960s, her main helper assistant was Teddy Haseltine. When he was fading, in walked Diana MacKown, who would eventually record on tape Nevelson's autobiography *Dawns + Dusks*.

Starting in the winter of 1963–64, when Teddy was ill and again drinking too much, Diana began to assist Nevelson with her sculpture. During the summer Teddy seemed to be failing, but, after surgery and a stay in the hospital, he was thought to be recuperating. One morning in August, as was customary in Nevelson's home, he went to her room to wish her good morning. He knocked on her door, entered the room and found her asleep. At that moment he apparently fell to the floor at the foot of her bed and died. It was a shocking and tragic event.[12]

Nevelson's immediate response to the death of this young man, who had lived with her for eight years and become like a devoted son, was consistent with the way she usually dealt with the loss of someone close to her. She didn't go to his funeral and didn't speak about him, moving away from the subject as quickly as possible.[13] *Homage to 6,000,000*, on which she was working at this time, was probably part of her mourning process for Teddy. She could no more easily speak about the death of her assistant than she could about the millions of Jews who had died in Europe twenty years earlier, much less the deaths of both parents whose funerals she had declined to attend.

Diana MacKown was away visiting her family when Teddy died so suddenly, and she returned immediately. Nevelson needed to continue making preparations for her Pace show, and had no choice but to have Diana MacKown

Ugo Mulas. Louise Nevelson talking on the phone and standing with her assistant, ca. 1960. © Ugo Mulas Heirs. All rights reserved.

take over all Teddy's tasks, which included Nevelson's practical as well as spiritual needs.[14]

For the catalogue essay for the 1964 show at Pace New York, Arne Glimcher turned to the eloquent words William Seitz had written as the exhibition text for the Venice Biennale. Glimcher, like Nevelson, knew he had a lot at stake with this exhibition, and he felt he couldn't do better than the young MoMA curator had already done. Nevelson knew she had to help Glimcher make his name in New York so the gallery could succeed; she also knew she had to make a big splash to put herself beyond the Janis fiasco.

The exhibit, titled "Nevelson" consisted of at least seven walls and a large triangular work entitled *Silent Music* as well as the twenty-foot-long *Homage to 6,000,000, Silent Motion,* and seven compositions from the miniature series *Diminishing Reflection.*[15] The titles of at least four works in the exhibit referred to sound or music.

Nevelson had grown up with classical music: Her father's Victrola and records of Caruso and other opera stars were part of her personal history, as were the concerts she had attended with her husband Charles during the early years of their marriage. She had not had much spare time for music or money to attend concerts between the end of her marriage and the arrival of Diana MacKown, whose parents and sister were professional musicians.[16] Once Diana

was in the house, the amount of music Nevelson heard increased dramatically.[17] Likewise, so did the number of works whose titles or forms referred to music.

The 1964 New York Pace exhibit featured her three recent innovations: curving walls, huge scale, and use of different materials to create reflections. The curving walls and very large works would prove important in the future, but neither of these novelties was as significant as—or had the power of—her shift in medium: the use of mirrors and glass. With these two reflective elements Nevelson was aiming for a new sculptural form.

In the 1940s and early 1950s Nevelson had explored three-dimensional form with hundreds of terra-cottas. In the mid- to late 1950s she had discovered shadows and how she could use them in her wood assemblages, manipulating them with different colors and compositions. And now in the 1960s, working with mirrors and Plexiglas, she introduced reflection. Throughout, her aesthetic concerns were often as spiritual as they were concretely compositional. She made aesthetic judgments with every wall and every box she assembled, and at the same time she was frequently invoking spiritual dimensions with non-physical shadows and reflections.

Her New York Pace Gallery debut took the art world by storm. Emily Genauer, Nevelson's long-supportive critic, expressed relief that Nevelson had broken out of her stereotyped pattern of the past few years.[18] Robert Coates wrote in *The New Yorker* that her new show was "the most successful in her by now fairly long career."[19]

According to John Canaday, who reviewed the show for *The New York Times*, neither size, mirrored backgrounds, nor framed composition were responsible for the works' being "powerful in presence." The "major delight" they provided was "the sensation of absolute completeness."[20]

About her inclusion of mirrors and Plexiglas, Nevelson explained: "I took the back out of the box, then I used glass for reflection, then I used a mirror or a glass to get more reflection."[21] Looking back, Arne Glimcher had a more colorful way of describing her use of mirrors. "She suddenly blew the back out behind the wall. She was opening up and allowing herself space. The boxes were a protection, a metaphorical protection. She opened up the back of the piece—which was radical—everything else was closed. You couldn't see everything in there; it was secret."[22]

"In the early sixties," Glimcher observed: "Nevelson wanted the mirrors that she put in the boxes to extend the space behind the wall. If her walls were up against a wall, she was punching holes in them with the mirrors. . . . She was going *behind* the wall."[23] In saying "going behind the wall," Glimcher inadvertently used a standard metaphor for the fourth dimension. The mirrors went through to the fourth dimension—they allowed one to go through the wall to

the other side. What was primarily a perceptual phenomenon for most viewers carried an additional metaphysical meaning for the artist.

In the 1950s, following Hilton Kramer's lead, Nevelson had started calling herself the "architect of shadows." Now in the mid-1960s, as she began to use glass, Plexiglas, and mirrors, she anointed herself "the architect of reflection": "I have given shadow a form. And I gave reflection a form. I used glass for reflections, then I used mirrors. Now we know that shadow and reflection . . . have a form—but not really an architectural or sculptural form. . . . So I consider that I am an architect of shadow, and I'm an architect of reflection. Those are titles I gave to myself."[24]

The play of reflections beaming off many mirrors in *Silent Motion* (1964) exemplifies Nevelson's thinking. No matter how you look at this remarkable work, you see it differently, depending on your perspective and how light strikes it. Two vertically oriented rectangular frames are placed side by side within a larger black frame. In the grid on the left side, the mirror behind the wood pieces makes the wooden elements almost disappear, fragmenting them into little segments. The frame on the right side contains a forty-unit grid, and each unit or box contains a mirror. Because each mirror is differently positioned and angled, the light reflecting back makes the sculpture seem like dozens of different works when it is actually only one. The viewer is either perplexed or transported to another dimension.

The literal and the figurative meanings of the word "reflection" overlapped. She had expanded on what the reflection of an artist's self could signify: Nevelson was no longer using her art solely to reflect something of herself. With the use of multiple reflections, she sought to translate entire worlds from her own imagination into the physical realm, expanding on her practice of creating immersive environments for the viewer: "All I wanted out of this world, from the beginning, [was] to find out who I was. When you look in a mirror, you see yourself, you hope. And, of course, some people don't quite have an image of themselves, but let's assume I do. Well then, I feel that all that I have done has been a reflection of my feeling and understanding of the universe."[25]

The artist had long understood the relationship of artist to art as deeply meaningful. "It's like a marriage," she said, "you are not the total actor. You play with another actor, and my play with the other [is the way I work with] my materials. And so sometimes they tell me something and sometimes I speak to them so that there is a constant communication for a oneness, for the harmony, and for the totality."[26] The fundamentally communicative nature of her creative process freed Nevelson from the disappointment she so often felt with human beings. They could betray her, as Kurzman and Janis had done a few years earlier. Or they could die suddenly at the foot of her bed as Teddy had done only

a few months earlier. But her work would always be there for her. It could be manipulated until it mirrored back to her the harmony and connectedness she wanted to feel. Each object she used, each work she made, was an interlocutor with whom she could converse visually. The changes she saw in her work were both reassuring and fascinating. They indicated she could be one and the same person, while evolving over time. In 1964 she was at a turning point in her life, a new beginning, and she needed to have her own evolution mirrored back to her through her work.

"Now, shadow is fleeting," she said, " but when I use it, I arrest it . . . and give it a form. When I began using mirrors and recently glass, I began to feel again like the architect who is controlling reflection and for me it is very, very satisfy-ing because I make it static for myself."[27] What Nevelson saw in her work was not "fleeting"—a word she used often at this time. The shadows she saw everywhere had form and were more exciting than anything else she saw on earth. They told her that she was in the realm of the fourth dimension—an ideal place she could tune in to and find stability, totality, and harmony—all things she had not been able to find in human relationships. Her family—at least the insightful members of her family, like her youngest sister Lillian—recognized that her disappoint-ment with people was as much a result of her self-absorption and expectation that she would be disappointed by others than it was the actual failure of their behavior.[28] Only in her art could she find reliable and consistent satisfaction.

At the heart of her shift from shadow to reflection and from self to oth-ers was her new situation with Arne Glimcher and Diana MacKown, partners who would stand by her as long as she needed them. By making it possible for her to concentrate solely on her work, MacKown and Glimcher facilitated her reflection.

Nevelson saw something of herself in each of them. Glimcher and she were both formerly shy exhibitionists whose brassy ambitiousness was their common coin. As he put it: "It was more complicated than her just being an artist in the gallery. I truly loved her . . . and then there was this friendship she had with my mother."[29] From this first New York exhibition and ever afterwards, Arne Glim-cher had no trouble selling Nevelson's work. Her shows at Pace were often sold out by the end of the first opening night.

With Diana MacKown it was different—Nevelson's semi-secret spirituality was welcomed and reflected in Diana's own discoveries.[30] Diana had grown up with a talented, charismatic mother whom she often felt she had to protect. It is no surprise that she would become the assistant and devotee of another talented, charismatic woman who needed watching over. June Wayne, the director of Tamarind Workshop and a longtime close friend of Nevelson, described Diana MacKown as Louise's "irreplaceable friend, trouble-shooter, interface with the

outside world, and expediter of the inner one. Diana was like a daughter to Louise, but one that could not, would not, claim the reciprocal devotion a child claims of its mother."[31]

Nevelson had managed to translate her vision of how people should relate to each other—as equals—into her use of materials and their reflection as a place of consciousness and awareness, her metaphysical ideals. Her goal was no longer about just satisfying her own vision or creating an environment that suited her better than the ones she had found in the world, it was now about creating that place of consciousness and giving that consciousness to everything. Nevelson had grown up in a family that believed all of their children had an equal opportunity in America. She had been close to and admired Diego Rivera, who acted on his belief that all people are equal no matter their social status or financial condition. Fundamentally she agreed with that stance despite her admiration for outstanding individuals.

In December 1964 Nevelson discovered Edith Sitwell, the woman who would become, after Norina Matchabelli and Martha Graham, her new ego ideal. By absorbing some of Sitwell's look, Louise Nevelson drew closer to the way she herself would appear for the rest of her life—the persona Edward Albee would call "The Nevelson."

The death of Dame Edith Sitwell, an English poet and preeminent eccentric, was announced on the front page of *The New York Times* on December 10,

Diana MacKown. Louise Nevelson with Arne Glimcher, 1980s. Courtesy of Diana MacKown

1964, accompanied by a photograph of Sitwell in a large hat, whose profile was remarkable.[32] On the inside page was a photo by Cecil Beaton, taken in 1926, of the elegantly posed aristocrat in a long, flowery Tudor-style gown, playing a harp in front of a Baroque tapestry. The two images could have convinced Nevelson that Sitwell was a woman of her own type.

Certainly the physical description of Sitwell in the obituary could have been repeated with minor variations as a description of the later persona of Louise Nevelson herself: "An aquiline nose and heavy-lidded eyes added to her almost Plantagenet look which she accentuated with elaborate hats or turbans and long flowing gowns, sometimes of startling Chinese red, sometimes of intricate brocades. She was addicted to large jewelry and gold armlets, and her fingers were ringed with pebble-size aquamarines. She cut a cabalistic figure, enhanced as the passage of years dulled her blonde hair and made her face gaunt and bony."[33]

Diana MacKown cut out Sitwell's obituary and played for Nevelson a recording of Sitwell's poetry cycle, *Façade*, which was published in 1922, with Sitwell reciting the female role.[34] MacKown was familiar with Sitwell's work, since her own British-born mother had made a recording of *Façade* at the Eastman School of Music in the 1950s, reading the part Sitwell usually read when she toured with her poetry cycle. When MacKown urged Nevelson to do something to honor the poet, Nevelson readily responded. Within a very few days, Nevelson had created the sculpture, *Homage to Dame Edith*, out of boxes with glass covers that had been left in Teddy Haseltine's old room. The date on the work is listed as December 9, 1964—the day on which Sitwell actually died, rather than several days later, when the work was actually made.[35]

Nevelson's sudden enthusiasm for Sitwell was not out of character. In the distinguished author's poetry and life story, Nevelson had found a fellow spirit, a model for her future self. While it is relatively easy to imagine how much she would have enjoyed and admired the recording of *Façade*, it is worth wondering what could have so captivated Nevelson's attention that she was impelled to create a sculptural homage to Sitwell on the spot, a piece that *had* to be included in the final days of her show at Pace. She also insisted that the work appear, along with other photographs of her sculpture, in a forthcoming article in *Vogue* magazine.[36]

Each box in *Homage to Dame Edith* contains a series of smaller boxes, many with mirrors done in the same way as the other small works in the Pace exhibition, especially *Silent Motion* and the series *Diminishing Reflections*. The syncopated rhythms of the composition enliven the work, playing the open doors off against the mirrored boxes within boxes, so that the whole sculpture echoes the wit of Sitwell's musical poetry. It is worth noting, too, that all six sculptures entitled *Homage to Dame Edith* are characterized by a verticality that could be a reference

to Sitwell's unusual height: six feet tall. This is another point of identification for Nevelson who, for most of her youth, was the tallest girl in her class at school in Rockland.

A few years later, Nevelson's close friend and former dealer Colette Roberts asked her: "What is your personal reaction to Edith Sitwell, for whom you made this box [*Homage to Dame Edith*]?[37] Nevelson responded: "Well, if I ever get out of my own shell, I would like to parallel her. I love when a woman is seventy-seven in bed and the reporters come and ask her, 'How are you feeling?' And she says, 'Dying. Other than that I'm fine.'"[38] Famous for her barbed wit and an intolerance for fools, Sitwell's unconventionality appealed to Nevelson. The English poet had once sent a stuffed owl to a pompous member of the British parliament.[39]

The anonymous author of Sitwell's obituary referred to the idiosyncrasies of the poet: "Among her recreations, Dame Edith listed silence, but it was a luxury she rarely indulged." The writer noted that: "Dame Edith was rarely out of the news. . . . She admitted to and even gloried in eccentricity."[40] The obituary included the fact that Edith Sitwell was very close to her two younger brothers, Osbert and Sacheverell, also distinguished authors.

Façade had achieved a *succès de scandale* when the poetry cycle was first performed in London in 1923. The reciter was supposed to make his or her intonation as level as possible, turning the voice into an instrument among instruments so as to eliminate all personality. The composer William Walton, a friend of Sitwell's brothers, composed music to accompany the poetry cycle. The *Times* obituary pointed out that the poet was essentially a formalist whose word-music exploited poetry's musical qualities of sound and rhythm.[41]

Dame Edith's feelings for her siblings, her interest in metaphysics and the transcendental, as well as a focus on form over content in her chosen art, were aspects of her character with which Nevelson could identify. If all those facts were not enough to catch Nevelson's attention, the author of the obituary quoted Sitwell's claim that she had a lifelong "affinity for Queen Elizabeth [I]," about whom she had written two books, *Fanfare for Elizabeth* (1946) and *The Queens and the Hive* (1962). Her unusual appearance provoked critics almost as much as her verse. She was known to her friends as "Queen Edith."

What Diana MacKown recalls about Nevelson's admiration for Sitwell is: "She was a Plantagenet, a royal grand aristocrat, who had great style and elegance, but whose brilliance and willingness to break laws in her work made her an exceptional human being."[42] Nevelson saw Sitwell as a descendent of the true royalty of England—someone with whom Nevelson could easily identify. And she did—ever afterwards.

What Nevelson had gleaned from Sitwell's obituary as well as her autobiography, which was published in 1965, proved to be a step in the development of

her "look." It was more than a continuation of her identification with royalty. Emerging from the doldrums of her down period of 1963 and the first half of 1964, Nevelson put the past behind her and determined to have a new future. That future would not just be new sculpture. It would also include a re-creation of her public persona. With Sitwell as a model, Nevelson incorporated all her former wishes for a royal heritage into what must have seemed like a perfectly timed invitation from fate. The artist did indeed manage to parallel Sitwell, especially as she increasingly moved away from her conventional style of dressing to something more like the outrageous English eccentric.

In Sitwell's autobiography, Nevelson would have read (or had MacKown read to her) about her heroine's endearing quirks and seen them depicted in photographs. Katherine Rouse, an interviewer who met with Nevelson in January 1966, saw in the artist strong traces of Sitwell: "Miss Nevelson is rather formidable at first glance," Rouse wrote. "Her hair is hidden by a long loose cap so that only her face can be seen behind arresting eyes and superb rather Mayan, bone structure. Her skin is dark and swarthy and her eyes are accentuated by mascara. She wears a loose fitting, shaggy woolen coat of brilliant red and her hands are expressive, square chunks that seem strong and like the animate emblem of a sculptor. She at once made me think of Dame Edith Sitwell and Judith Anderson."[43]

Photographs taken of Nevelson in 1965 and 1966 by Ugo Mulas and others confirm that, though she was wearing fairly heavy eye makeup, she had not started to use the soon-to-be-famous false eyelashes. That would change—and the retrospective of her work at the Whitney Museum in 1967 marked the turning point of that change. We shall see in a future chapter the trajectory of Nevelson's arrival at a distinguished persona.

In 1967 a *Time* magazine writer noted: "Nevelson herself, a big-hatted, cigar-smoking metaphysic on the order of Edith Sitwell or Isak Dinesen, is pleased but not entirely surprised by her acclaim."[44] In 1967, when a reporter from *Women's Wear Daily* in 1967 asked Nevelson if she liked other women, whom she admired and who were her friends, she responded:

I've never understood women who can't stand other women. To me it's the mind, the personality that counts. There are interesting men and interesting women. And those I admire are not necessarily my friends.

My book of serigraphs [it goes for $1000] is dedicated to Edith Sitwell. She's one person I admired. And Marianne Moore. Martha Graham is another. And Greta Garbo, gorgeous and consistent. That's what I respect. A person who has a single line, a dedication, and sustains it through life and somehow to some degree fulfills it. It's easy to slip. But

you go back and start again. One never leaves off, just keeps adding—as with me and my sculpture.[45]

The year 1965 opened with elegance. A thirteen-page portfolio of Louise Nevelson's sculpture at Pace Gallery, subtitled "Potent and Arcane," appeared in the March issue of *Vogue* magazine.[46] The big-name photographer was Gordon Parks. Some of the gowns—the clothes for "Brilliant Evenings," as they were called—were worn by Veruschka, one of the leading models of the day.

"I am an architect of light and shadow," Nevelson told the writer, and then, tapping a glass table top, added, "You see these lights in here. . . . These are the depths and shadows, the reflections I'm interested in. . . . What do they mean when they say 'clairvoyant'? It's looking *through*. I want transparency."[47] The article named collectors who had already bought works from the show, and "Pace Gallery" was frequently mentioned. It was a win-win for the artist and her dealer. Nevelson, a long-time fashion lover, was delighted.

In May of 1965, *Homage to 6,000,000 I*, the huge wall in the Pace exhibit, had been bought by Mr. and Mrs. Albert List and was formally presented to the Jewish Museum in New York. The same month, six thousand miles away, Nevelson

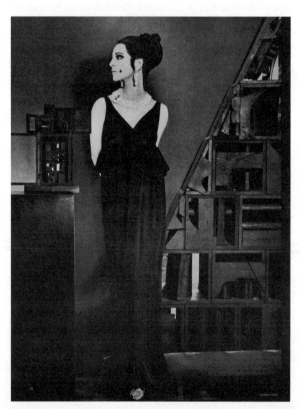

Gordon Parks. View of *Homage to Dame Edith* (with model), 1965. © Gordon Parks / Vogue

attended the dedication of her second wall honoring victims of the Holocaust, *Homage to 6,000,000 II*, at the opening of the new Israel Museum in Jerusalem.

Eva Glimcher, Arne's mother, traveled with Nevelson to Israel for the dedication ceremony. Afterwards the two women went to Jordan and Egypt—a trip that became legendary in the Glimcher family. Leaving the Israeli part of Jerusalem to enter the Jordanian sector, Mrs. Nevelson and Mrs. Glimcher had to pass through the Mandelbaum Gate. At customs at the former checkpoint, they were asked their religion. Eva Glimcher calmly said, "Ethical Culture." Nevelson was frazzled and quickly answered, "Same as hers." As the story goes, Eva Glimcher then found someone to carry their luggage, and the ladies headed into Jordan.[48]

Arriving in London after their trip to the Middle East, they were met in the lobby of their hotel by Arne and Milly Glimcher.[49] Asked by Arne to describe her first impression of the Egyptian pyramids, Nevelson answered, "Too small."[50] This became one of Arne Glimcher's favorite Nevelson anecdotes. In her defense, he explains that the artist was used to photographs showing the pyramids as huge, as they filled the space of a post card from top to bottom. Seeing the ancient monuments in person, the proportions reversed themselves, seeming to shrink in size against the Egyptian sky.[51]

In his eventual comparisons of his star sculptor with his mother, Glimcher made these observations: "They were both from Russia and both came to America as babies. Though they were the same age and similar in so many ways, my mother was the antithesis of Louise. She was this sort of 'respectable woman' who would never have led the kind of life Louise did. Louise did things my mother would normally have considered shocking and improper. But she found it acceptable because Louise was the person doing it. That wouldn't have been the case with anyone else."[52]

Milly Glimcher, Arne's wife, had a similar impression of the two women: "They were alike in having a tough inner core and not being easily dissuaded from what they wanted to do. But Eva disapproved of Louise's lifestyle—the fact that she would sleep around and have lots of boyfriends. My mother-in-law was a bit puritanical, so she didn't like that. Even in her sixties Louise would flirt and carry on with men. Eva thought that was unseemly. But the biggest difference between them was in their attitude toward their children. For Eva, her children were the most important thing in her life. Poor Mike got neglected."[53]

In 1965—at a moment in the art world when prints had become a respectable way for artists and their dealers to sell less expensive work to a larger audience—Nevelson started making silk-screen prints. She cut up photographs of some of the sculptures in the series *Silent Music* from her 1964 Pace New York show and collaged them into a portfolio entitled *Façade*, dedicated to Edith Sitwell. Though each of the twelve prints is named for one of the poems in *Façade*,

there is no direct relationship between an individual poem and the corresponding print. Speaking visually, they are less an homage to the poet, and more a continuation of Nevelson's train of thought at this time, related to *Silent Music* and to her ideas about the fourth dimension.

Arne Glimcher had commissioned the portfolio and paid for everything, also arranging for Nevelson to work with Steve Poleskie at Chiron Press, which had quickly become the premier silkscreen workshop for New York artists. With her mysterious works, executed in subtle tones of gray, Nevelson was after a complex set of images whose titles would honor the poet's work while the images themselves reflected Nevelson's current aesthetic and metaphysical interests.

Andy Warhol had started the fashion for silkscreen prints on canvas in the early 1960s with his images of Marilyn Monroe. Glimcher had shown Warhol's silkscreen paintings in 1962 in Boston and was well aware of the growing popularity of his images of Che Guevara, Elvis Presley, and Elizabeth Taylor. By 1965 silkscreens, epitomized by Warhol's Pop Art icons, had taken off.

Nevelson was enthusiastic about making the silkscreen prints and showed up daily for several months in the winter of 1965–66, producing *Façade*. Poleskie remembered Nevelson as being "easy to work with and very calm, almost mellow." He said that though she didn't talk about Edith Sitwell, whose poetry and person had ostensibly been the inspiration for the prints, "she dressed like Sitwell in big hats and a fur coat. She talked a lot with her lyrical voice and seemed to enjoy herself working on the prints. Other artists were making prints because they owed their dealers. But she had a very clear sense of purpose in her head." It was a moment in which Nevelson felt like making homages to the world, a moment of large thinking and expansive art-making. As Poleskie said, "She was aware of her presence in the art world at that moment."[54]

Since only one artist at a time worked at Chiron Press, it was a peaceful place, with no music blaring and no other artists chatting. Nevelson's modus operandi at Chiron may have started out like other artists', using silkscreen to quickly produce multiple images that would sell quickly. But true to her usual spontaneous approach, she changed the process as she went along. After reproducing the silk screens of five photographs from her 1964 show—specifically, *Sky Wave, Diminishing Reflection, Ancient Secret, Silent Music I* and *IV*—she felt they looked too flat and began to cut them up and collage the parts together into new images. She and Poleskie experimented until they figured out how to construct the collaged images on acetate, and then they photographed the result into what would be the final screen from which the twelve different original prints for the portfolio would be made.

One of the sculptures from the Pace show, which Nevelson particularly liked,

was the large pyramidal-shaped *Silent Music* (1964). It reappeared in two of the most forceful screen prints in the portfolio: *By the Lake* and *Black Mrs. Behemoth*. In both prints Nevelson has taken a portion of the photograph of *Ancient Secret*, also from the 1964 Pace show, turned it upside down and backwards, and inserted it into the new prints in front of the photo of triangular *Silent Music* as though it were a door angling into and beyond the deep space she has created with this illusion. With this complicated use of photographs Nevelson invites the viewer into the fourth dimension by creating a powerful sensation of being sucked into the image. The multiple views of the same sculpture, collaged together via her complicated and novel use of the silkscreen medium, force the viewer to shift back and forth between dimensions.

Diana MacKown, who was present when these prints were made, was similarly convinced that, through these works, Nevelson was searching for ways to depict the fourth dimension. She had been using mirrors and Plexiglas toward that goal in her 1964 Pace exhibit. She knew that Edith Sitwell also had metaphysical inclinations, but she never discussed these matters in her public statements about her portfolio of silkscreen prints.

Rarely satisfied with working on one project at a time, Nevelson continued making the series of miniatures, *Diminishing Reflection*, through 1965 and into 1966. She used the same few elemental shapes—disks, round slices of dowels, square and rectangular wood blocks—to create compositions which were similar but never exactly the same. In *Diminishing Reflections* XXVII she first made twelve small boxes, then put pairs of two small boxes inside six larger ones. Finally she put all six together, creating a square of syncopated round and irregular rhythms that defy the eyes' wish for closure and completeness. The vitality of the total is astonishing.

The inventiveness of the spontaneous moment is also evident in the small *Expanding Reflection*(s) series.[55] While she was working on the silk-screen prints at Chiron Press, some plastic boxes arrived for the artist Ernest Trova, who had a factory in St. Louis making display cases. Like the surrealist scavenger she had always been, Nevelson printed leftover silk screen elements from the *Façade* series on some of the left-over boxes. The result is a large work (thirty-six feet by seventy-six feet by three feet), *Expanding Reflection I*, which consists of a grid, with ten boxes across and twenty-three long. Each box is different: some contain compositions of small wood pieces; some are stenciled with geometric shapes derived from those wood bits and pieces; and some are silk-screened with parts of photographs she had already used in *Façade*. The total is a complex and integrated composition forcing one's eyes to flicker from surface to depth—from two-dimensional photo to three-dimensional box—and back. With this work, Nevelson carried the theme of layered reflections as far as she could go. It was

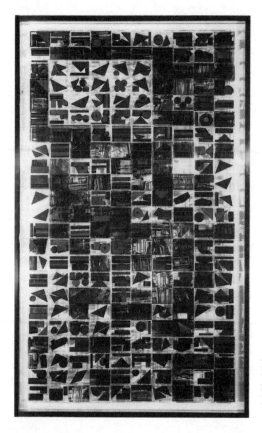

Expanding Reflection, 1966. Silkscreen on Plexiglas and wood, 75 9/16 x 45 ¾ x 5 in. JP Morgan Chase Art Collection. Photograph courtesy of Pace Gallery

a true one-off. For decades *Expanding Reflection I* remained in the office of David Rockefeller at Chase Manhattan Bank and was included in major Nevelson retrospectives, including the big show at the Whitney in 1967.

Nevelson ended the year 1965 on a high. Her exhibition in October at the David Mirvish Gallery in Toronto got enthusiastic reviews and cemented—at least in her mind—her status.[56] "The American artist, Louise Nevelson, is one of the great living sculptors," wrote *Telegram* reviewer Harry Malcolmson. "Some time ago she perfected her basic sculpture commonly known as a Wall. . . . The Nevelson Wall has now become like a Henry Moore *Mother and Child* or a Marino Marini *Horse*, an enriching addition to our basic visual vocabulary. Moreover, her work is widely admired and popular. There is likely no other non-representational artist as enthusiastically sought after and purchased as Nevelson."[57]

As she began 1966, Nevelson was rocketing back and forth between miniature and majestically huge, a lively contrast she enjoyed. It was still not quite lively enough for her. She was about to launch herself in two new directions with two new media: Plexiglas and metal.

EMPRESS OF
THE ENVIRONMENT

1966 – 1968

"So I consider that I'm actually the grandmother of environment."
—Louise Nevelson, interview with Jeanne Siegel,
Great Artists in America Today, 1967

Louise Nevelson never gave up using wood. It was her home base and a founda-
tion to which she would always return. But that did not keep her from exploring
other media. Beginning in the mid-1960s, she usually worked in more than one
medium at a time. She called it "jumping around" and, as a perennially active
artist, she loved it.

In late summer of 1966, Nevelson was off to Detroit to install her huge
wood wall, *Homage to the World*, in the J. L. Hudson Gallery. Nearly twen-
ty-nine feet long and nine feet high and weighing about a thousand pounds,
the wall was made up of a hundred units, the largest work she had ever made.[1]
The monumental sculpture was believed to have been bid for by MoMA, the
Chicago Art Institute, and the Whitney Museum. It was finally acquired by
the Detroit Institute of Arts for fifty-five thousand dollars.[2]

At the Institute's recently opened new south wing where the sculpture was
installed in a place of honor in October, Nevelson explained her "Testament,"
as she called it, to local journalists in her typically enigmatic fashion: "I had that
work in one of my studios, and for a year I couldn't even enter that studio. . . . I
became a little bit frightened of this enormous project, and so I locked the door.
And if I needed something out of that studio I sent my assistant. . . . I couldn't
encompass it. And then one day, after I had done the metal. . . . I thought, why
did this intimidate me? I had to grow to be able to confront this."[3]

What about the wall had "frightened" Nevelson? In what way did she have "to grow"? Her own words about the wall provide the crucial clue. "There it is practically one straight line. But then there's the circle off center where all the energy is. So it is controlled."[4]

Yes, we can see one straight line running almost thirty feet, and there are circles near the center. But they are not circles. They are ovals. Her "control," that is, her aesthetic eye, has set each of these forms at a slightly different angle from its neighbor, and each combination of boxes differs slightly from the others. Some are radically different—their differences almost hidden in the back of the box—or partially covered by the slat of wood attached to the front of the box. Mostly, it is the off-angle tilt of many of the ovoid shapes that obliges our eyes to bounce around as we try to take in the whole in one glance. The dynamic way Nevelson has placed them produces "all the energy." That she would have to "control" the huge horizontal expanse by the power of her compositional mastery was the frightening challenge she had to meet. She initially felt that filling such an expanse could be chaotic, but as she grew more confident about the prospect of working on such a large sculpture she realized that she could "control" it by playing a relatively few oval shapes off against the massive number of vertical and horizontal forms and shadows.

One of Nevelson's observations about this work could describe her aim as an artist: "I tell people who ask, that I don't use wood; I don't use black; I don't make sculpture. If the sum of this wall doesn't transcend wood and black and making something, then I've failed. Sculpture is like a person, who adds up to a lot more than a few cents worth of chemicals. I'm trying to communicate. Not to make something."[5] For Nevelson, this went beyond a statement about art; she was trying to articulate what she knew about the human condition: We are all alike and we are all different. And she saw her mission as expressing these contradictory truths, not in so many words, but through the formal decisions she made in her art.

George Francoeur, the reviewer for *Art News*, felt the gravitas Nevelson hoped the work would convey. "Rather than the complexity of parts playing a dominant role, the interval of space becomes the real content of the work. Her forms are limited and restrained. . . . *Homage to the World*, has the severity and mystic evocation that we find in a Gothic portal. Its scale allows us fully to realize the light that glows in the darkness without reference to a surrounding environment."[6]

Other journalists were not enthusiastic about *Homage to the World* and offered the by-now common complaint—by no means uncommon in the criticism of abstract art—that the artist was just using "inexpensive lumber and paint" or discarded scraps of wood and charging sky-high prices.[7] These two opposite

views of Nevelson's work—high praise and dismissive criticism—would continue throughout her life, and even afterwards.

Homage to the World was not quite the "finale of big wood walls" Nevelson had imagined. She would keep on making large wood pieces for the rest of her working life, but they alternated with sculptures comprised of the myriad tiny elements such as those in the *Diminishing* and *Expanding Reflections* series, which she had been working on for three years, and in the *Zag* series, which she worked on until the late 1970s.

About *Shadow and Reflection*, done at the same time and one of her favorite large walls in which she used small boxes of equal size, the artist explained: "I thought of [this work] as 'energy' and tried to concentrate the energies in one part. There is the one line, the one column and then a counter-movement to that and so that's what I call energy."[8]

Again Nevelson had created a one-off. There is nothing like *Shadow and Reflection* in her oeuvre. The central "column," taller and wider than the two side sections, pushes itself forward, making us pay attention to its rhythmically patterned vertical boxes, with their dramatic alternating light-and-shadow patterns. The boxes seem to have been stretched and widened in order to accom-

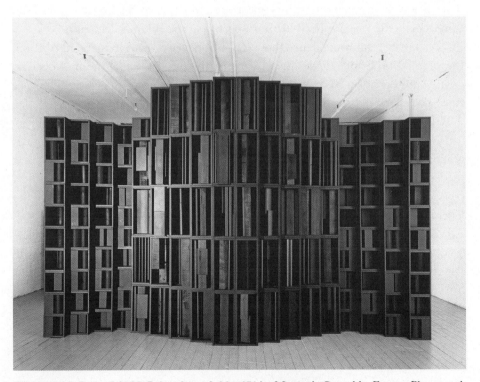

Shadow and Reflection I, 1966. Painted wood, 80 x 174 in. Musée de Grenoble, France. Photograph by Ferdinand Boesch at Documenta IV, 1968. © documenta Archiv

modate the propulsive forward movement. The countermovements from the square boxes on the left and right have their own energy, rippling sideways with their patterns of light and shade.

With her huge walls from the mid-1960s, Nevelson knew she had made monuments to something larger, more transcendent than an arrangement of wooden boxes painted black. Her work in wood had reached a culmination of sorts, and it was about to temporarily cede precedence to her work in new materials: aluminum and Plexiglas. She was finally going outdoors to create her version of an environment that worked with air, trees, and sunlight. Nevelson summed it up in an interview with Dorothy Seckler for a long feature article in *Art in America*: "At my time of life I've arrived at essences. . . . There had been the principle of the enclosed box, shadow boxed in; with the mirror, [it was] the principle of the reflection boxed in. Now I'm boxing in the outdoors."[9]

Nevelson's first sculpture in aluminum would lead to all her large-scale work over the next two decades. Though she worked only for two years with Plexiglas her work with plastic would entice her toward actual jewels as well as jewel-like sculptures—smaller-scale work that continued until her eighty-sixth year. It was exactly "the idea of bouncing around in different media"[10] and the combination of contrasts that she loved—huge and tiny, majestic and commonplace. Those elements would come together in time for her 1967 retrospective at the Whitney Museum.

Perhaps it is no coincidence that Nevelson never worked in metal until 1965, the year David Smith died—metal was the medium in which he had been so creative for decades. Nevelson and Smith had known and respected each other since the early 1940s, and one of Nevelson's closest friends during the 1950s, '60s, and '70s was Smith's first wife, the sculptor Dorothy Dehner.

Nevelson's shift to direct work in metal sculpture came initially at the suggestion of Arne Glimcher, who felt that she was ready to make a change to new media. It was also the mid-1960s, when the art world in America was at a new peak. Large-scale sculptures, in particular, were being commissioned by both the federal and state governments—between 1962 and 1966, the General Services Administration commissioned thirty-four large works of art for federal buildings. Sculptures and murals appeared in disparate locations as far reaching as Juneau, Alaska; Macon, Georgia; Jacksonville, Florida; Washington, D. C., and New York City.[11] Nevelson was perfectly positioned to be included in the vanguard of American artists receiving recognition and commissions for grand assignments.

In his 1967 essay about public sculpture in prominent sites in New York City, Irving Sandler wrote: the Sculpture in Environment show "could not have come at a better time. As it presents monuments by some of the best artists of our time, it also focuses on the fact that the artists' desire for the kind of spaces that the urban environment can provide coincides with the city's need for art.

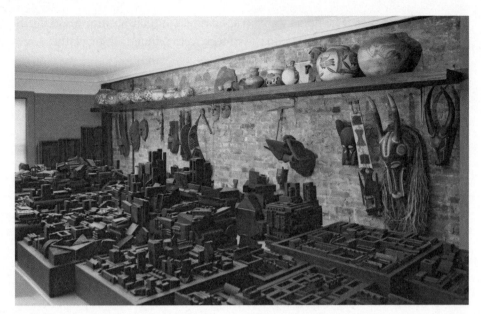

Ugo Mulas. Living room, Spring Street house, ca. 1965. © Ugo Mulas Heirs. All rights reserved.

The result may be a new birth of public art."[12] His words were prescient, and as usual, Nevelson was at the forefront.

Nevelson's decision to start working in metal came at a time when she had decided to rid herself of all the collections she had accumulated—including approximately thirty American Indian pottery pieces from the Southwest and many pre-Columbian and African sculptures, which had always been on display in the large living room. She had collected these objects one by one over a lifetime. Suddenly, she was done with them.

She sold the Southwest Indian pottery to Arne Glimcher's mother and the African sculpture and objects to Fred Mueller, the codirector at Pace Gallery. Early American tools, Japanese lacquer chests, Puerto Rican *santos*, her collection of Eilshemius paintings—everything went. It was a purging at a level and speed that matched her typical, prodigious energy.[13]

Glimcher recalls that the decision to experiment with new materials was also related to Nevelson's newfound economic security and her arrival at a seemingly stable position of eminence in the art world. Nevelson thought she had been there in 1960, when Martha Jackson and Daniel Cordier had been her dealers. After the Janis blowup, it had taken a while for her to again feel safe. Now she no longer needed props, visible evidence that she could afford to buy beautiful things from other cultures. She was ready to be on her own, exploring new territory.

Everything around her was simplified. All the furniture was either sold or

put out on the street. The floors were scraped down to their natural wood finish and waxed. The living quarters and the studios were painted white; clothes were stored in gray steel utility cabinets and personal items in filing cabinets. Nonessential items were eliminated, and room was made for her and her work—exclusively. Guests were only welcome for short stays. Deliberately uncomfortable industrial chairs were available for the few invited friends, fellow artists, family, or journalists. Nothing must interfere with the main business of Nevelson's life—making art. Almost every room in the house was dominated by Nevelson's work—completed pieces and works in progress.

"I don't like a homey home," Nevelson said. "I don't want to worry about cleaning. I bought what furniture I have from an office-supply place. . . . I don't like easy chairs—they lead to boring conversation. We don't cook much. We eat out a lot in the neighborhood."[14]

Sometime in 1965, Nevelson went with Arne Glimcher to visit Victoria Fabricators, in St. Louis, Missouri, where Ernest Trova had his sculptures made, and as a result she "began to explore the lightweight and reflective properties of black-enameled aluminum and of black and clear Plexiglas."[15] Four years later, Glimcher would take her to Lippincott's Fine Arts Metal Fabricators in North Haven, Connecticut, where she began to work directly in metal.

Nevelson started her first large metal works by making small-size models out of gray sheet cardboard and taping them together into small four-sided frames, which were open in front and back. She cut a vocabulary of forms—radiating arcs, progressive squares, S-curves, and tubes.

Some of the forms were made in Plexiglas in miniature and stacked for later use. Individual Plexiglas pieces were left loose. Nevelson "began to arrange the pieces into her familiar stack assemblages . . . changing, and adding forms almost endlessly until the interaction of the separate units reinforced their boundaries" exactly as she wanted.[16] Then she put the models on the windowsill for several days, so she could observe the variations in their light-conducting and reflecting qualities. When she was satisfied, she sent the plastic models—generally nine inches by ten inches—to Victoria Fabricators. There, they were made into full-scale pieces in enameled aluminum and painted with shining black vinyl epoxy, thus resembling the reflective surface of the small black Plexiglas models.[17] She was preparing these new works for her 1966 exhibition at Pace Gallery, where she astonished the art world by taking her work in a new direction: the beginning of the *Atmosphere and Environment* series.

Nevelson used aluminum for these first metal works because the lightness gave her great flexibility, stacking the units within the box format she was continuing to use. She had the workers slice fifteen-foot-long aluminum tubes into shorter segments, then stack and bolt them together and arrange them on a

base. Finally she had certain simple shapes—circles, squares and rectangles—cast or fabricated out of sheet metal and put into the boxes.[18]

Moving back and forth as she did between smaller Plexiglas models and the final metal sculptures, manufactured in St. Louis, as she developed the early pieces in the *Atmosphere and Environment* series, it's not surprising that Nevelson would soon turn the tables, employing the aluminum works as models for larger clear Plexiglas sculptures.[19]

Her 1966 show at Pace Gallery included four large works in black-painted enameled aluminum with titles that suggest the progression in her thinking, beginning with *Enclosure*, moving to *Offering*, and finally arriving at the first two works of the *Atmosphere and Environment* series.[20] Nevelson was starting off in a new direction, and Glimcher's theatrical canniness set the stage. The announcement of the exhibition was a photograph of the gardens at Versailles with four pop-open windows featuring each of Nevelson's new works. The sculptures were shown in a simulated outdoor space that had been created in the gallery. It included two sizable ficus trees and "ground" made of Astroturf.

Though most photographs do not do justice to the complexity of the works in this exhibition, Nevelson's ingenuity is notable. The first group of *Atmosphere and Environments* is characterized by a remarkably divergent way of perceiving the sculptures. Seen straight on, obdurate black rectangles block the view through the openwork lattice of tubes, semicircles, and hourglass shapes, which inhabit each of the grid's cubes. From an angled perspective, however, the solidity of the big black shapes disappear into the syncopated rhythms of many smaller rectangles, which seem to bounce back and forth like a fragmented mobile chessboard, and tubes are eaten by their shadowy reflections.

During 1966 Nevelson would produce approximately five more large metal sculptures in the *Atmosphere and Environment* series. By the time she created *Atmosphere and Environment VI*, she was ready to play even more dramatic tricks on the viewer.

Nevelson's sleight of hand is particularly notable with *Atmosphere and Environment V*, which Governor Nelson Rockefeller arranged to have installed on the mall in Albany. Photographs taken straight on (from the back or front of the work) make the tubes disappear into slim linear circles of dark, showing up within large light rectangles. These are counterbalanced against the large dark circles, which seem solid but on close inspection are not. They are part of a graduated series of similar shapes or separated sections that match up at differing depths to form the illusion of a singular shape. This was more of the characteristically subtle but powerful perceptual game playing that we have seen all along in Nevelson's work. Turn your head slightly and you see a different work.

Atmosphere and Environment VI, which Nelson Rockefeller commissioned for

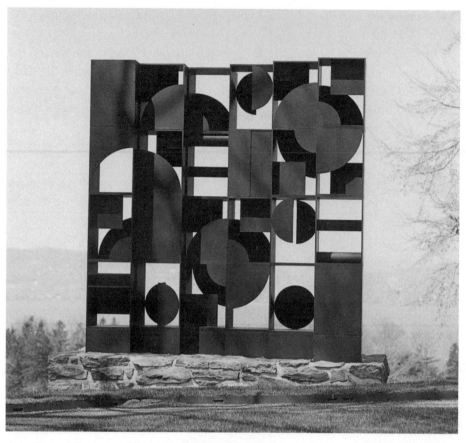

Atmosphere and Environment VI (at Kykuit Magnesium), 1966. 106 x 102 ½ x 49 ½ in. Kykuit, National Trust for Historic Preservation, Bequest of Nelson A. Rockefeller. Photograph by Charles Uht, courtesy of Pace Gallery, © Charles Uht, Rockefeller Archives

Kykuit, his home in Westchester, New York, was produced at his request in magnesium—an expensive, lightweight material—so that, unlike other versions of the series, it could be manufactured as one piece rather than in separate columns that would be soldered together.[21]

Once in place, it became more obvious that each unit is a three-dimensional shape, a box, into or onto which are placed flat pieces in circular, square, or rectangular shapes. Some of these are cut into smaller shapes—semicircular forms—placed in graduated series from large to small and vice versa. Its dark interior shapes, partially shaded shapes, and transparent light background give the composition remarkable force.

Rockefeller had *Atmosphere and Environment VI* set up on the ridge of a hill next to his house so that he could see the Hudson River and surrounding landscape through it. Depending on how the light strikes it and the angle from which

Ice Palace I, 1966. Lucite, 24 x 26 x 12 in. Kykuit, National Trust for Historic Preservation, Bequest of Nelson A. Rockefeller. Photograph by Ferdinand Boesch, courtesy of Pace Gallery

it is seen, the sculpture looks different—an ever-changing work of art, just as Nevelson had planned.

Looking straight on, it is not clear that each of the six columns that make up the work is at a different level from the one next to it. The two farthest ends are closest to the viewer, and the third from the left is the farthest away, another visual illusion that becomes more obvious when the sculpture is replicated in a smaller version in Plexiglas or Lucite.

By carefully comparing *Atmosphere and Environment VI* with *Ice Palace I* and *Transparent Sculpture IV*, two of Nevelson's smaller works in Plexiglas from the same year, it becomes evident that all three works are actually the same design—though done in different materials (transparent or opaque), at different scales, and displayed in different positions (upright or turned on one side).[22] Such a comparison forces the viewer to realize how subjectively we see. By tipping the Plexiglas work slightly or completely—or by requiring that the viewer move her head slightly or completely—Nevelson was creating, or rather capturing, entirely different perceptions, different *gestalten*. Playing with presence and absence; solidity and invisibility; permanence and mutability; temporality; and two-, three-, and four-dimensionality—she was at the top of her game, not only formally but also conceptually.

Transparent Sculpture IV, 1968. Plexiglas, 19 ²/₃ x 33 ¾ x 31 in. Albright Knox Gallery. Photograph by Ferdinand Boesch at Documenta IV, 1968. © documenta Archiv

Looking at the original Plexiglas, or Lucite, versions of *Ice Palace I* (24 feet by 26 feet by 12 feet), a careful observer will note that the base is not quite square. The spidery etched designs of radiating circular and square forms make a nearly all-over pattern, creating an integrated whole out of the separate parts. Less movement is noticeable from surface to depth and back, because, when seen straight on, a two-dimensional pattern dominates the view. Naturally that changes when the viewer moves— and changes even more when the work is tipped on its side.

Tipped on its back, it becomes *Transparent Sculpture IV,* a fully three-dimensional object. Placed on a shallow-framed mirror glass, as it usually is, it looks a bit like a human torso pulling itself upright from a reclining position. There is no sign of the linear tracery that distinguishes it from the metal version, *Atmosphere and Environment VI.* At most, the circular and square configurations inside the columns of transparent boxes give the whole a vitality it would otherwise lack.[23]

Nevelson doesn't stop gaming the viewer with this remarkable series of sculptures, which could be called an artistic trifecta. She experiments with other pairs of apparently dissimilar equations, playing with perceptions, until it is no longer clear what is up or down, large or small, near or far.

Transparent Sculpture VII in Plexiglas seems to be the twin sister of *Atmosphere and Environment VIII*, a unique black-painted aluminum sculpture made for *Documenta IV* in 1968. *Transparent Sculpture VII* fits the description of a jewel-like object, and it was treasured as such by Nelson Rockefeller, who bought it and had it enclosed in a Plexiglas box so that the glittering surfaces would never be marred. Its compositional richness is evident with careful study, which reveals how varying the heights of the columns speeds or retards their rhythmic rising up and down. It also becomes eye-catchingly clear that those partial arcs of Plexiglass could seem quite complex when they are set against the tubular shapes nearby.

Sometimes the tubes are solid, acting as horizontal accents, and sometimes their hollowness leads us through to the other side. The artist has drawn us into another dimension—whether or not we chose to follow her.

At the inaugural exhibition of Ferus/Pace Gallery in Los Angeles in December 1966, when the world encountered her new outdoor sculptures, the critic from the *Los Angeles Times* proclaimed: "Despite the deserved fame and the wide imitation that Louise Nevelson's compartmentalized constructions have brought her, this ingenious sculptress continues to change and expand her vocabulary while strengthening her idiom. . . . [She has] turned to a greater clarity and simplification without in any way contending herself with the current reductive vogue."[25] And indeed, metal would dominate Nevelson's future oeuvre.

Critics such as John Canaday of *The New York Times* were impressed with Nevelson's artistic verve: "She has reached points where she could have rested on her laurels, but with each new show she has kicked the laurels aside like so many uprooted weeds and has gone on gardening the fertile soil of her creative inventiveness."

He wrote, of the newer works, that, "when they stand in the out-of-doors you must see sky and trees and fields merged with the sculpture itself. . . . This fine conception of a unity between sculpture and site is as simple and as direct as possible—too simple and too direct to have occurred to many sculptors. Mrs. Nevelson works with a kind of ebullience that hits straight through incidental considerations to the heart of whatever problem she takes on, and she has hit the target again in her present exhibition."[26]

Many other artists were turning to new materials and styles during the 1960s. Nevelson's geometric focus was definitely in the artistic air at the 1964 *Documenta III* in paintings by Paul Klee, Piet Mondrian, and Ben Nicholson, as well as the *Cubi* by David Smith. Back at home the new work of Frank Stella, Ron Bladen, and Robert Morris was emphatically geometric. Despite the fact that other sculptors were mining the same geometric vein as Nevelson, Canaday was on target when he pointed out that the new works she was producing "are like nothing she had done before, but at the same time they are pure Nevelson."

Glimcher and Nevelson had known since December 1964 that she would have a major retrospective at the Whitney Museum of American Art in the spring of 1967.[27] Her work and many of her decisions from 1964 through 1966 occurred in the context of the promise of that large exhibit at the premier American museum.

Preparing herself for the Whitney retrospective in 1967, Louise Nevelson could tell Dorothy Seckler: "My feelings are changing—about myself, my work, the world and its work." It was not only in her new sculptures that she felt she had "pushed through into the open." . . . "I've lived with a feeling of accomplishment all my life. Still, the Whitney show will give me more freedom to continue to work on a grand scale."[28]

Nevelson knew that her friend Dorothy Miller had wanted to give her a big show at MoMA, but the artist decided that the Whitney Museum would be a better venue. There was no real competition for her favors between the two museums. Nevelson had shown in eleven Whitney Annual exhibitions and been included in some of the Whitney's major thematic shows, such as *Nature in Abstraction* (1958) and *American Sculpture Between the Fairs 1939–64* (1964). MoMA had included her in just two—*Sixteen Americans* in 1959 and *Art of Assemblage* in 1961—and had sponsored her for the Venice Biennale in 1962. These several events were the result of Dorothy Miller's endorsement, but Miller did not yet have the status or power at MoMA comparable to Howard and Jean Lipman, her enthusiastic supporters on the board of the Whitney.[29]

With the 1967 retrospective at the Whitney, Nevelson was aiming to impress on the New York art world that she should be acknowledged as the first and leading environmental artist in America. This was well prepared for. In February 1965, Arne Glimcher had written in his formal letter to Lloyd Goodrich, the director of the Whitney Museum, confirming Nevelson's retrospective: "Louise Nevelson asked me to tell you that she has always designed the mounting of her exhibitions herself and asks that she be permitted to do the installation at the Whitney."[30] Nevelson followed up with her own letter to Jack Gordon, the curator of the show, making this point abundantly clear: "I have given long and careful consideration to the installation of the exhibition, which you know is as important to me as the work itself. As I am, and will always be, an environmental artist, so must this be a retrospective environment of my total composition."[31]

Nevelson never stopped emphasizing the importance of doing her own installation. "I fought for control of the exhibit," she told a reviewer. "People say I'm tough, but if you're not in control, your work loses out. The way things are placed can change their effect. The light, the walls, the ceiling—everything is part of the art work."[32] For Nevelson, the installation of any exhibition was nothing less than the creation of an environment.

The press release for the Whitney show stated: "Mrs. Nevelson is credited with developing 'environmental' sculpture."[33] Using Nevelson's words from an interview with Colette Roberts, the curator's introduction in the exhibition catalogue repeatedly and emphatically noted Nevelson's long-standing interest in environments: "Since art, particularly sculpture, is so very living, naturally you want all of life, so you make an environment, but that environment is sculpture too."[34]

By the mid-1960s Nevelson could count eight exhibitions that might be considered "environmental"—beginning in 1943 with *The Clown Is the Center of His World* and continuing through and beyond her breakthrough show, *Moon Garden + One*, in 1958. She had not used the word "environment" as a title for any of her works until 1966, when she began the series *Atmosphere and Environments*. By the time of the Whitney retrospective, Nevelson, along with many others, believed she had successfully shown that she had been an environmental artist all along.

Each room of the retrospective presented the different facets and evolving styles of Nevelson's oeuvre. In the room with white-painted sculptures, *America Dawn* was made up of individual pieces, many of which had been exhibited as part of the famous *Dawn's Wedding Feast* (1959). Standing works were gathered on a platform, and columns hanging from the ceiling above gave the ensemble a life as a white environment. A grouping of Nevelson's best works in gold, including *Royal Tide I* (1960) and *Dawn* (1962), made for another environment.

The *pièce de résistance* was a remarkable semi-enclosed passageway—called "*Rain Forest*" (or "*Tropical Rain Forest*")—which brought the viewer from the enormous room containing Nevelson's large, black wood walls (including the huge *Homage to the World*) into the chamber with her latest works in metal and plastic.

As Nevelson had explained to the curator: "My reason for the placement of the passageway and its housing of the tropical rain garden is to allow a fluid and light movement from the present into other periods of my work and then a direct route back to the present and the crescendo of the enormous new metal sculpture as people leave my environment. This is my particular pride and joy."[35]

A reviewer described *Rain Forest*: "At one point the visitor moves out of an area of white constructions through a completely black passage with shapes and forms looming and hanging and standing majestically, some of them picked out by a strange blue spotlight, all of them placed in a mystery of shadows and reflections. Strictly this is an environment of sculptures . . . but the effect is that of a complete work. The group is called 'Tropical Rain Forest,' but the experience of walking through this place of secrecy and darkness renders titles redundant."[36]

With the Whitney retrospective, Nevelson accomplished exactly what she wanted: she was generally recognized as the founder and principal proponent of

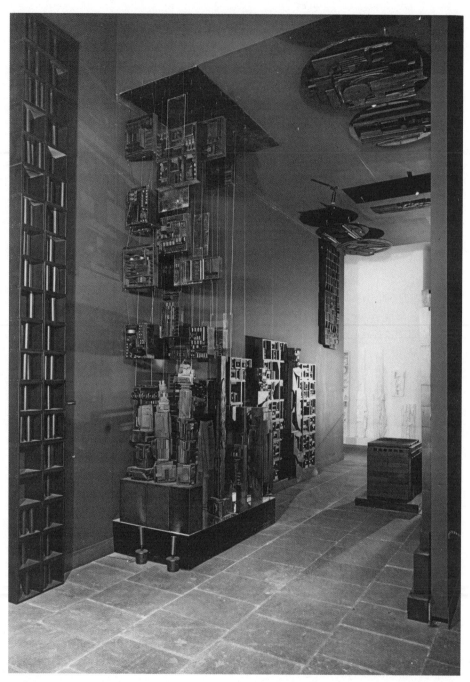

Geoffrey Clements. Installation view of Louise Nevelson retrospective at the Whitney Museum of American Art, New York, 1967. Archives of American Art, Smithsonian Institution, © Geoffrey Clements

environmental art. Grace Glueck, writing in *The New York Times*, exclaimed: "If you're Louise Nevelson, you've created an enchanted empire—a low-key metaphor for the spectacular group of her assemblages that now inhabits the fourth floor of the Whitney Museum."[37]

John Canaday was equally enthusiastic:

> The Nevelson show at the Whitney proves . . . that she is truly the top figure in two sculptural revolutions of more recent date—the technical one by which sculpture is an assemblage of objects picked up just about anywhere, and the conceptual one of sculpture as an environment rather than as an object. If we have always known this, the Whitney show has afforded Mrs. Nevelson her first opportunity to install her environmental compositions in space of satisfactory dimensions.[38]

Charlotte Willard of the *New York Post* wrote: "Credited with being the originator of environmental sculpture, Nevelson has, in any event, done the most impressive and brilliant work in this movement. . . . Strangely silent, Nevelson's work offers itself for contemplation and wins us not by an overwhelming presence but by the pervasive enchantment of its enveloping serenity."[39]

Almost a decade after her first undeniably environmental exhibit, *Moon Garden + One* (1958), the artist was emphatically claiming the territory as the First Environmental Artist. The time lapse between the formal invention and the naming of it is similar to the one that occurred between the time (1957) Hilton Kramer noted how she used shadow as a formal device and her nominating herself as an Architect of Shadow (1964). First, she intuitively discovered (or created) a formal innovation, then she figured out—usually with the help of a critic or gallerist—how to put the innovation into words.

Not everyone was entranced by the retrospective. Reviewing the opening, the art critic Emily Genauer, who had written supportively about the artist for almost thirty years, declared herself to be fatigued by too much Nevelson: "Line up a whole museum floor of her pieces. . . . Fancy becomes formula; incantation becomes rhetoric. . . . It's too little varied to reward overgenerous seeing."[40]

Four days later, however, Genauer wrote a paean to the exhibit, entitled, "A Scavenger's Black Magic." The critic had obviously gone back for another look and emerged with a very different perspective:

> It is nothing less than the creation of a special very private world of dream into which they may follow the artist and find revelations of timeless mysteries. . . . Her closely contained constructions vivify the space around them as an ancient god might, appearing on earth in impene-

trable clouds. . . . Nevelson's works wait for you to come to them. They wait with quiet and mysterious dignity. They enfold you in a new experience as completely as her boxes contain the enigmatic elements she has placed in them. . . . The living quality with which she has invested them grows ever larger, operating on a new level. This . . . is a magnification of image into an experience that the viewer not only perceives for the first time but in which he is also profoundly involved.[41]

At times, too much Nevelson *was* hard to take, even for a fan, and *could* seem repetitive. At other times it was a fabulous feast, as long as one took the time to carefully savor the individual dishes.

The flood of admiration Nevelson received as a result of the Whitney retrospective—as well as her now-established ability to elicit admiration with the use of new materials and new formal vocabularies—enhanced her reputation in the art world. An increasing number of critics as well as colleagues saw her as the most important American sculptor at the mid-twentieth century.

"She's probably the top sculptress in the country at the moment, but there's no knowing what she'll do, or say,"[42] wrote Gregory McDonald, a staffer on *The Boston Globe*. One canny reviewer for *Artforum* allowed that her new work (in plastic and metal) was "handled with geometrically icy self-assurance. Louise Nevelson is, in her sixth decade, displaying a much more strenuous investigation of her genuinely witty impulses."[43] Most of the reviewers of the Whitney retrospective noted that Nevelson's new work was taking her to a more contemporary mode, and some even argued that her older work in wood could be seen as a bridge to her present more robust accomplishment.

It was nevertheless a dicey position, given that younger artists were rapidly moving forward, and the "oldsters"—which included sixty-seven-year-old Nevelson—were meant to be left behind. By the mid-1960s "Minimalism" was one of the hottest isms in the art world. Nevelson had already absorbed its message by osmosis—just as some artists of every era absorb the vibrations of the events surrounding them—and invented her own version.

At least four of the works in her first Pace New York show, *Silent Music* in 1964, had been minimal, pared down to essences as she liked to say. Nevelson, along with David Smith, Anthony Caro, Tony Smith, Isamu Noguchi, and Ellsworth Kelly, was one of the only sculptors to produce work with such startling simplicity before 1965. Then came a tidal wave of a new generation of artists intent on creating "a new artistic spirit": Minimalism. But their elders had led the way.

When the new movement was trumpeted, as it was in the 1966 exhibition at the Jewish Museum, *Primary Structures: Younger American and British Sculptors*, Nevel-

son was left out. She hadn't been "younger" for decades. But her work was as min-imal as most of her chronological "juniors" in that famous show, which included Donald Judd, Dan Flavin, Larry Bell, Ellsworth Kelly (who, though he had been ahead of his generation in producing minimalist work before 1965, was certainly a chronological "junior") and Carl Andre. These younger artists were pushing for-ward, and they became the big names of the Minimalist movement. Still, the art world was changing faster and faster, and while Nevelson moved on, to new styles, new materials, and new challenges, many of the younger artists didn't.

Discussing the difference between her own style and the new champions of Minimalism, Nevelson had this to say: "Let me explain forever: I'm not geo-metric. Any line - straight or curved - is the same to me. I am not using [lines] in a regimented way. I can take a straight line and make it into a curve. As the creator you can make knots in it. . . . I'm not using [geometry] like other peo-ple are using it. Ellsworth Kelly and Frank Stella are wonderful, but they are working on another level. Maybe the feminine principle in me doesn't want to be that regimented. . . . If I can't encompass both geometric and baroque, I've missed the boat."[44]

Nevelson was frequently asked about where she fit with the move many art-ists were starting to make towards working with technology. Her response was classic: "I go my way, have always gone my way and always will. Technology . . . I am more of a romantic than ever."[45] Despite Nevelson's age—which should have placed her firmly in the tradition of the Abstract Expressionists and their emotionally loaded and subjectively warm work—she did not exactly fit there and had managed to stay in tune with the changing art scene while remaining true to herself.

After her Whitney retrospective in 1967, when she was included in import-ant group exhibitions of sculptors—such as at the Art Institute of Chicago, the Los Angeles Museum of Art, the Guggenheim Museum, and MoMA—she was grouped with her age-mates David Smith, Alexander Calder, Henry Moore, and Isamu Noguchi. The younger artists presented themselves as a contrast—as the next generation tends to do—to the heated emotionalism of Abstract Expressionism. Nevelson's ordered chaos, contained in many boxed walls, didn't seem to fit in either group.

The Guggenheim Museum's *Fifth International Exhibition* in October 1967, which was devoted entirely to sculpture, began with the work of Arp, Giacom-etti, David Smith, and Burgoyne Diller—all recently deceased. Then came the "old masters," including Picasso, Lipchitz, Calder, and Nevelson, among oth-ers. The show concluded with the newer generation, the "contemporary prac-titioners" who were presented as being in revolt against the ways of the older artists—George Segal, Claes Oldenburg, Donald Judd, and Robert Morris.[46]

The fact that working artists, including Nevelson, were excluded from the group of "contemporary practitioners" indicates that the definition of that group was necessarily arbitrary. Clearly the curatorial eye, which is given the freedom to editorialize and shapes the art world, just as it is shaped by the art world, was intentionally pitting the younger generation against more established artists. Perhaps the more concerning exclusion, and one that was soon to come to the fore, was that of women artists working at the time. Nevelson and Barbara Hepworth were the only women sculptors included in the collection of seventy-seven artists from around the world. Worse yet, Nevelson had been reduced to being an "old master"—did they really mean an "old mistress"?

Nevelson was completely sympathetic to the modern age. The openness of the 1960s suited her perfectly. Because of the publicity generated by the Whitney retrospective, Nevelson and her thoughts about life, fashion, and the future were reported everywhere. *Women's Wear Daily* and the *Metropolitan Museum of Art Bulletin* both interviewed her at the end of the year and her pithy comments make it very clear how she lived and what she was thinking about in 1967. She observed: "There are so many things going on. You hear about violence. The black and white problem. Reaching the moon. And yet, for me personally, these are the most exciting times on record. All the excitement of life multiplied I still say our times are better than any other. Because they're saying what they are right in the open, they're not covering up. . . . That's why I love our age—it's changing the meaning of everything."[47]

Brief though it was, the presidency of John F. Kennedy had ushered in a new hopeful era: government support for the arts, the Civil Rights Act, the women's movement, Martin Luther King's march on Washington, the Beatles, Medicare, and the space race. And just in time for Nevelson to expand her wings and fly.

After five years of growing success, Arne Glimcher had moved Pace Gallery down the street to 32 West Fifty-Seventh Street. Architect I. M. Pei designed the new gallery in a larger space. It became a "glamorous showcase for the works of far-out younger artists, whom it has carefully nurtured, as well as such stars as Louise Nevelson and Jean Dubuffet."[48]

In the late summer and early fall of 1968 Nevelson was exhibiting works in both wood and new media at *Documenta IV* in Kassel, Germany. She had a room of her own, which she filled with two Plexiglas works (*Transparent Sculptures IV and V*), the complete suite of her silk-screen prints *Façade*, and a huge wood wall, *Shadow and Reflection* (1966). In the outdoor exhibition space, she showed a large enameled-aluminum sculpture *Atmosphere and Environment VIII*, which appears to be the model for *Transparent Sculpture VII*. This indicated how intertwined the works in metal and plastic had always been—and continued to be, to the end of both series. Her work in metal continued, but for two years—from 1967 to

1968—Nevelson had pushed as far as she could go with Plexiglas works; in the end Plexiglas, where the final product was made by others, proved to be too restrictive and indirect a medium for this hands-on artist.

Along with some of the old masters, such as Josef Albers, David Smith, and Ad Reinhardt, *Documenta IV* now included the younger Minimalists and Pop artists, including Frank Stella, Tony Smith, George Segal, George Rickey, Claes Oldenburg, Ellsworth Kelly, Donald Judd, Jasper Johns, Mark de Suvero, Andy Warhol, and Tom Wesselman.

Everything—every medium, every ism—was on exhibit. Nevelson's work seemed right up to date: modern technology; Minimalist aesthetic; large out-door sculpture. She felt at one with the international group of artists gathered for *Documenta*. "Usually an artist works in loneliness. But here, one suddenly experiences the kinship one always suspects one might have with the rest of the artistic world."[49]

This time when she came back from Germany she was confronted with a mountain of work in preparation for forthcoming exhibitions in Chicago and Toronto. But her mood was not so ebullient as it had been. It was 1968. Too many deaths, too much war. The assassinations of Martin Luther King Jr. and Bobby Kennedy had broken the back of the optimism she and many others felt through most of the '60s.[50] The Vietnam War seemed endless, students were protesting everywhere she went, and riot police were putting them down all around her. It seemed that all the freedoms that had liberated so many people around the world began to close up and die. Nevelson was a fierce advocate for those unjustly mistreated or dismissed—whether it was the young Americans who were being forced to fight an unjust war, the Czechs who were fighting Russian domination, or the students everywhere who believed their authoritarian elders were holding them back and down.

Nevelson's admiration for Martin Luther King Jr. and the civil rights movement was widely known, and she was proud that her oldest granddaughter, Neith, had married a black man and had just given birth to a baby girl. Nevelson donated her art to support Jewish causes, and with the same fervor she gave her support to civil rights, peace, and Native Americans, with whom she always felt a close kinship.[51] The world around Nevelson was anything but peaceful and something somber seeped into her work.

The large works *Dark Sky* and *Silent Shadow*, both done in 1968, are ominous, the latter reminding one curator of the boxcars used by the Nazis during the Holocaust. It should be easy to dismiss *Dark Sky* as a mere match of large boxes with slats, but instead it has a beauty and haunting eloquence. While able to look deeply into the dark of some of its boxes, the viewer is kept at a distance on the surface of others. The shift from depth to surface and back again engages

the viewer's eye, as does the almost but not quite symmetrical arrangement of boxes. The small variations from one side of the composition to the other do not discomfort, but rather enliven. This calls to mind the dimensional shifts in her screen-prints.

Silent Shadow is almost impossible to register. The viewer is drawn back and forth by the vertically striped shadows caused by the space between the slats of wood—some are punctuated with bent nails, others by the stubby ends of horizontal bits of wood. The interplay between the darkly open spaces and the rough texture of the wood makes this simple sculpture into a complex and heart-breaking work. To the discerning eye there is a breathtaking difference from slat to slat. For someone ready to dismiss this work as a bunch of leftover pieces from a junk pile, those subtle differences of parts and whole are invisible.

In contrast to these two works Nevelson produced a quantity of small sculptures: little pieces, which were put together with other little pieces, and then combined with several others to become a more complete composition. Nevelson usually worked on the floor with this series, and once she pronounced the various groupings done, she had them framed. She called one series *"Zags,"* twenty-six iterations labeled from A to Z. (By March 1969 she had gotten through the entire alphabet and was starting with *Zag AA*.)[52]

An exhibit at the Arts Club of Chicago in October 1968 featured eighteen sculptures, including *Dark Sky*. Like most of her exhibits at this time, the show combines some very large walls—*Homage to the Universe* (thirty feet long, containing one hundred and two units) and *Rain Forest Wall* (twelve feet long by eight and a half feet high)—as well as much smaller works, such as *Zag A* and *B*. In between were some extraordinary "simple" works, the four *Night Visages*.

On first glance, the works in this series might look easy to comprehend with a single glance, but not so. Just as the viewer's eyes are persuaded that they will find a similar pattern in the next box over up and down the grid, they don't. The change is small and keeps you guessing: How different is it really? No manufactured object can play such tricks, no fabricator can gauge how much or how little the variations should be. As Nevelson repeatedly said: "Art is everywhere, except it has to pass through a creative mind."[53]

During the historical and psychological tumult of the late 1960s Nevelson had found a way to stay anchored and steady. She could repeatedly practice with new materials and new technology in the creation of order out of the chaos of material plenitude. Large size, enormous variation of parts—all could be organized because it passed through her creative mind.

MISTRESS OF TRANSFORMATION

1969 – 1971

"I was always most interested in what I could do for myself. I won't do anything for anyone else. One of my complaints is that I never have been selfish enough."
—Louise Nevelson, in interview with Emmett Meara, "Sculptor Louise Nevelson resents ostracism in Rockland as child," *Bangor Daily News*, June 15, 1978, 5

In the first months of 1969 Louise began to prepare for an upcoming exhibition that spring, *Recent Wood Sculptures* at Pace Gallery. As the Pace show approached, Nevelson finally tackled the ground-floor studio she had been avoiding for almost a year. It was the room she traditionally used for large-scale work. For months she had been opening the door, taking a look at the accumulation and shutting it quickly saying, "No, no, not today." Having claimed a few months earlier that she would not do any more large walls, she proceeded to make her longest one yet, *Nightsphere-Light*, and included it in the Pace show.

The huge piece (forty-eight feet wide by eight and a half feet high and eleven inches deep), which had its own room in the gallery, was set up in a gigantic arc against three walls and lit with a mysterious blue light. The Pace catalogue placed Nevelson's words from an interview (done two decades earlier) next to the illustration of *Nightsphere-Light*: "There are laws that we have to concede are standing in step with our time. Since we have them, I use them: light and dark, day and night, time and space. Maybe fifty thousand years from now they will not be needed. They are apparently necessary at our present time of evolution. I don't say they're the ultimate. They may be, but I don't think they are."[1]

Every one of the twenty-four new, black-painted wood sculptures in the show was sold.[2] The Lipmans bought *Nightsphere-Light*—one masterpiece from a year of many masterpieces—and gave it to the Juilliard School to be installed in the lobby of the Juilliard theater at Lincoln Center. It takes up the entire west wall of the lobby's upper tier, for which it seems to have been specifically designed.

The president of Juilliard observed that *Nightsphere-Light* was musical "in that its rhythmical forms express variations on a major theme."[3] In her 1982 book on Nevelson, Jean Lipman introduced photographs of the Juilliard wall with a Nevelson quote: "I use action and counteraction, like in music, all the time. Action and counteraction."[4] After the work was installed in her characteristic debunking manner, Nevelson remarked: "I don't have any ideas about its being musical. Everything that I understand about the basic things of life has gone into it."[5] However, as anyone with a sense of rhythm or melody can see, the composition is undeniably musical. The contrapuntal themes and variations combine baroque and classical musical styles, and are composed of shapes that echo silhouettes of musical instruments. Formal reversals of figure and ground shimmer across the length and breadth of the work—sometimes they are phantom undulating female shapes. They can also be jagged triangular teeth, which sharpen the eye's journey across what would otherwise have been a sensuous sweep across the long rectangular wall. James Mellow, writing in *Art International*, refers to *Nightsphere-Light* as "a marvelous orchestration of forms. . . . a beautiful piece of night-music; handsomely proportioned, calm, complex within its ordered simplicity."[6] John Gruen, writing in *New York* magazine, compared Nevelson's new works to the organ music of Bach: "Both are brilliantly contrapuntal, both are based on elaborate architectonic concepts of abstract form, both are imbued by a dark, austere lyricism, and both are nourished by strong spiritual beliefs. . . . Her works have an intense residual of sound in them."[7]

In her book on Nevelson, Jean Lipman pairs the illustration of *Night-Focus-Dawn* with the artist's words: "Art is as alive as our breathing, as our own lives, but it's more ordered."[8] It was a happy choice of words. The sculpture seems to breathe, and yet it is highly structured. The energy comes from the subtle variations that range across the four rows of boxes, which seemingly contain identical elements—two or three long, thin triangular wedges on top of a rectangular slab of wood. At one corner of each box is a large triangular wedge whose long curve frames the composition inside the box. The pattern created by the large wedges is almost hypnotic and carries the eye along akin to the sweeping power of a rhythmic musical line.

With her two most musically attuned works—*Night-Focus-Dawn* and *Night-*

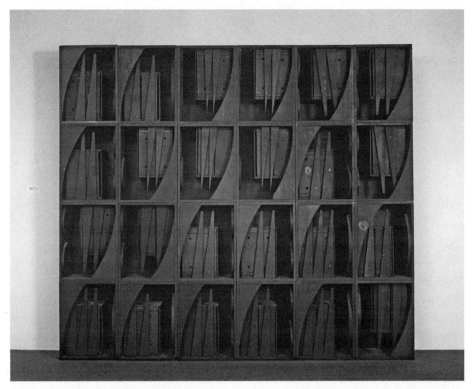

Night Focus Dawn, 1969. Painted wood, 107 ¾ x 118 ³/₁₆ x 14 in. Whitney Museum of American Art, New York; purchase, with funds from Howard and Jean Lipman. Photograph © Geoffrey Clements

sphere-Light—Nevelson had carried the somber promise of *Silent Shadow* and *Dark Sky* to new heights, depths—and lengths. Though these works were done at about the same time,[9] they are vastly different in feel, yet most critics saw their essential musicality.

No matter whether they praised or panned her, the critics concurred on one aspect of Nevelson's career: whatever she created was uniquely her own.[10] She was the grand mistress of transformation. She could take the bric-a-brac detritus of civilization and make it look fresh and vital. Just as easily, she could take freshly cut wood bits and make them look timeless. She could be an artist straight out of the romantic and highly subjective abstract expressionists or an emerging figure of the new technologically taut Minimalists. She was always herself, never just one of a group.

During the spring of 1969 some work from the recent show at the Pace Gallery in New York went to Ohio where it was subsequently shown at Eva Glimcher's new gallery, Pace Columbus, which she had opened in 1965 soon after arriving there. This was the second of eight one-person shows Nevelson

would have at Pace Columbus. By this time Eva Glimcher was well established in Columbus, and visitors to the gallery were accustomed to the artist being present at gallery openings. When Nevelson came to the openings she always stayed with Eva Glimcher for a few days.

Eva Glimcher ran her gallery with the same verve that she had used running the Boston Pace Gallery, and Pace Columbus soon gained an excellent reputation. The openings of her exhibitions were packed; her generosity and salesmanship were legendary. Her daughter-in-law, Patty Glimcher, recalled: "She could sell sand to an Arab."[11]

The role of Eva Glimcher in Nevelson's life should not be underestimated. Without Eva, Nevelson might not have believed that Arne, Eva's youngest son, could adequately represent her art. Eva was a strong woman in Arne's life—a woman who broke boundaries well ahead of the women's liberation movement. She predisposed him to trust and respect Nevelson. In addition, partly because Eva Glimcher and Louise Nevelson were so alike—the exact same age from the same part of the world—Nevelson could trust and count on Eva to stand by her through the difficulties she still experienced because she was a woman, even though a hugely successful one. As a mother of four very successful siblings, Eva was a "good" maternal figure for the artist as well as a close friend and equal.

While the exhibit at Pace Columbus was still up, Nevelson was on her way to Paris for a big show at the prestigious Jeanne Bucher Gallery, where some of her most dramatic walls—among them *Homage to the Universe, Shadow and Reflection, Silent Shadow,* and *Silent Music*—were being exhibited as well as smaller and more easily marketable works in wood and Plexiglas.

Photographs of Nevelson at the Paris opening in May show a fur-coated, heavily mascaraed, gypsy-like older woman with an obvious taste for dramatic self-presentation. No wonder reviewers were interested in her Russian origins and the extent to which they inspired either her mystical romanticism or her formal constructivism.

The reviewer for *France-Soir* observed that Nevelson was tall, still beautiful, not hiding her age, wearing false eyelashes and an elaborate headpiece that emphasized the purity of her features. She likened the artist's looks to those of Queen Tiye, the beautiful mother of Akhenaten in the eighteenth dynasty of ancient Egypt, and pointed out that Nevelson had greeted the eight hundred people who had come to the opening with "royal reserve." Almost in passing she also noted that Nevelson had produced extraordinary assemblages that combined architecture and sculpture.[12]

Few people in Paris seemed to like her Plexiglas pieces, but the matte black works were seen as rich with ambiguity and secretly paradoxical. Whether large

or small, one writer observed, the black sculptures are "always full of endless riddles and contradictions."[13]

In his review of the Bucher show in *Le Monde*, titled "Nevelson's Immaculate Bric-a-brac," Michel Conil Lacoste observed that:

> Somehow she marries [all the bric-a-brac] together to produce one of those rhythmic murals which have been astounding the art world for the past ten years. . . . Her work has a sort of grave humor, the effect of which is to steady and soothe. . . . The spell she casts: a kind of stillness which seems to accompany even the slightest of her pieces. . . . The secret lies in her remarkable character, coupled with her exceptional energy and taste for extravagance tempered as it is by a classic simplicity.[14]

In July 1969 Nevelson's friend and former dealer, Martha Jackson, died in California at sixty-two years old, after apparently suffering a heart attack while swimming in her own pool. It was one of several serious losses that year. Jackson's death was personal, the other losses were professional.

Unaccountably—given her recent many successes and celebrated stature in the art world—Nevelson was left out of several large overarching exhibitions. In June, she was left out of an extensive exhibition in New York at MoMA. The MoMA exhibition, *The New American Painting and Sculpture: The First Generation*, was organized by William Rubin and William Agee and consisted of work in the museum's permanent collection—though many works were recent acquisitions not actually made when the "First Generation" produced them.

In his scathing review of the MoMA show, Hilton Kramer attacked the museum for its insufficient coverage of some prominent painters, including De Kooning and Pousette-Dart, but he saves his worst for the "problem of the sculpture." Aside from the work of David Smith and David Hare, he finds most of the work on display to be "merely pitiable." He is outraged by the omission of Louise Nevelson—"one of the most powerful sculptors of the period." Kramer objects specifically to her being assigned to "'the nucleus of a distinct second generation.'"[15]

Nevelson's actual age combined with her actual accomplishments chronologically listed sometimes caused her to be considered the wrong age at the wrong time. Her breakthrough sculpture was being done in the 1950s at approximately the same time as the breakthrough paintings of the Abstract Expressionists, though she was five to ten years older than most of them.

The Metropolitan Museum's vast show, *New York Painting and Sculpture: 1940–1970*, from which Nevelson was also excluded, opened in October 1969 and included more than four hundred works by forty-three artists. Henry Geldzahler,

the museum's curator for Twentieth-Century Art, was widely criticized for his narrow-minded selections and significant omissions. All the prominent art critics from leading publications noted that Louise Nevelson—"hailed and exhibited the world over as one of the three or four major talents we've produced"[16]— should not have been left out. The exclusion was especially outrageous in light of the inclusion of more than forty works by Jasper Johns and another forty-two by Ellsworth Kelly. The only woman in the show, Helen Frankenthaler, was the wife of Robert Motherwell, whose work was included in the exhibit.

Critic Emily Genauer accused the thirty-four-year-old Geldzahler of selecting artists who were his friends or the favorites of the "little-magazine" critics, which she called "a closed-circuit affair" that moves along a cycle—from specifically chosen critics to select dealers who show those artists and whose collectors buy them and eventually donate them to the museum (for a tidy tax-deduction), which leads back to the curator who gets invited to all the right parties. She chided the curator for having abnegated his public responsibility.[17]

Genauer was hardly alone in seeing the show at the Metropolitan Museum as an example of behind-the-scenes wheeling and dealing. Grace Glueck, writing in *The New York Times*, quotes several prominent artists to make her point that Geldzahler's curatorial choices are essentially "clannish." She cites Richard Pousette-Dart: "This exhibition . . . distorts a whole creative period historically by its false value system of selection where hucksterism and the fast buck are signs of artistic worth."[18] David Hare is quoted by Glueck in her *Times* piece even more acerbically: "Henry's interested in going out to dinner and meeting famous people and being in . . . the selections . . . have less to do with art than with Geldzahler's career." Glueck also notes that the curator had unsuccessfully approached Nevelson's dealer two years earlier for a major donation to the museum of her work.[19] That a woman artist was expected to donate her work to a major museum rather than have it purchased will be taken up later.

In sum, Geldzahler was accused of being a single-minded, self-promoting tastemaker. Harvard- and Yale-educated, young and ambitious, he was part of the world that had made many of the artists he promoted—such as Johns and Warhol—into icons. It was a hipster's personal preferences being given the imprimatur of America's premier museum.

Hilton Kramer wrote two reviews, both blasting the show and its curator. In the first he states: "What is offered . . . is an account of reputations, which are now especially esteemed, and of individual works that happened to strike Mr. Geldzahler's fancy. . . . We are offered, for the most part, a series of random one-man shows. It is indeed doubtful if so large an exhibition about so circumscribed a period has ever succeeded in conveying so confused and arbitrary a picture of

what evolved in that period. . . . There is a shocking lack of historical intelligence in the selection and the shape of the exhibition."[20]

In his second review a day later, he presciently observes that, "This exhibition will . . . be very influential despite its grave errors and distortions. Its sponsorship by the Met[ropolitan Museum] will guarantee that. . . . For the art scene itself, [the exhibition] serves notice that modishness and the arbitrary rewriting of history are now sanctioned as policy in our greatest museum." "The omission of William Baziotes and Richard Pousette-Dart . . . is high-handed and indefensible. So is the omission of Louise Nevelson among the important sculptors of the last decade and a half," Hilton Kramer inveighed in response to Nevelson's having been omitted from this show.[21] More than a decade later, in 1981, Robert Hughes, esteemed art critic for *Time* magazine, referred to Nevelson's omission from the exhibition as "one of the most celebrated curatorial blunders in recent memory."[22]

Fortunately, to balance some of the sour notes of 1969, Nevelson was given a prestigious award. Founded in 1907, MacDowell Colony is the oldest artists' colony in the United States. In August 1969, when Nevelson received the MacDowell Colony's highest honor, the Edward MacDowell Medal "for Outstanding Contributions to Sculpture," she used the ceremony to speak up for women artists, saying: "I have never thought that to be creative you had to either wear a skirt or pants. . . . I wanted to be a sculptor from the start. Now here I am. Not because I am a woman, but because Nature gives creativity and doesn't ask that question. . . . In America we have recognized [women] in the other arts, in poetry, even in composing . . . the visual arts were the last to recognize the female in art."[23]

Nevelson had had a retrospective at the premier American museum for American artists—the Whitney Museum of American Art—and large-scale exhibitions in Europe. But she had not had a large show in America outside of New York. The progress in mounting exhibitions in the late 1960s can be tracked through the records and correspondence between all the parties involved. As a result there is much documentation about Nevelson's next major solo exhibition at the Museum of Fine Arts in Houston, Texas (MFAH), which ran from October 23 through December 14, 1969. The details of the planning and execution of this major exhibition, provide a revealing look at how Nevelson's career was built once she and Arne Glimcher were working together and how the planning of a major exhibition gave scope to their ingenuity and talents. Also evident is the polarizing effect Nevelson often had on people—everyone agreed she was a great artist but there was anything but unanimity on the topic of her human qualities.

From the start Arne Glimcher, Fred Mueller, co-director at Pace Gallery,

and Louise Nevelson were all closely involved in planning the exhibition. Mary H. Buxton, the Georgia belle transplanted to Houston with an "unbelievably charming personality," was the one who made it happen. Buxton was interim director of the MFAH between 1967 and 1969, filling in between James Johnson Sweeney and Philippe de Montebello. What was meant to be a three-month stint for the former docent coordinator in the education department became a two-year term, during which she curated several major exhibitions, including the Louise Nevelson show. Buxton saw the exhibit as a perfect marriage between Louise Nevelson and architect Mies van der Rohe, who had recently designed a new wing of the museum—Cullinan Hall.

The correspondence between Buxton, Pace Gallery, and Nevelson is extensive and reveals the curator's forceful personality—sometimes flattering, sometimes commanding, but always confident and exacting in her requests and expectations of cooperation.

Mary Buxton wrote to Arne Glimcher about her forthcoming trip to New York in October 1968 and her desire to meet with Louise Nevelson and plan for an exhibition in Houston. The next month she wrote to Glimcher, "My visit with Louise was so delightful and you were grand to arrange it," followed by her reporting that she had met with the museum's trustees who had given a go-ahead signal for the exhibition a year later.[24]

In October 1968, Buxton confided to Glimcher that she was "quite excited" about seeing Nevelson's show in Chicago the following week (at the Arts Club of Chicago).[25] But her recollection of the events almost forty years afterwards in a tape-recorded interview is totally different from what she had written to Glimcher at the time.[26] In 2005 she said:

I have never met a woman who spoke in just four letter words. I said, "Do you not know any English?" It was awful. And I don't know whether she took an immediate dislike to me or what. I had a terrible time with her, and I almost gave up. And finally I said, "You know, you and I could get along, but I'm not going to speak your language and you're not going to speak mine. There's got to be some intermediate ground we can meet on." And she [Nevelson] said, "You come to Chicago and see my show." Well, off I went to Chicago and . . . then I said, "Now will you do it?" And she said, "I'll do it."[27]

A week after getting the museum's go-ahead for a Nevelson exhibit, Buxton wrote to the artist on October 22, 1968: "Like a dutiful daughter I flew to Chicago Friday to see your show at the Arts Club, and it is one of the handsomest I've ever viewed." In her letter she also wrote: "It was such a wonderful

experience meeting and visiting with you, and the Board is thrilled over the prospect of your exhibition next fall. . . . Your black pieces are superb, but then the white group [*America Dawn* 1962] at the Chicago Institute was so exciting as well. What do you think of borrowing that group from the Institute? Here I go making suggestions, which you can ignore completely and try to understand that I'm only so excited over the prospect that it's difficult to remain subdued."[28]

The president of the Arts Club of Chicago, Rue Winterbotham Shaw, had met with Mary Buxton and told her that Nevelson's show had been "the most popular exhibition they had ever held and people were returning again and again." Not to be outdone by the Arts Club of Chicago, which was already renowned as a preeminent exhibitor of international contemporary art, Buxton wrote, "Since there were eighteen pieces in [the Chicago] show I predict that we will probably have to double or even triple the number for [ours]. This, of course, will be left entirely up to you."[29]

Thus the way was cleared for the largest American exhibition of Nevelson's works outside of New York. Texas was getting ready to outdo its competitors, with Mary Buxton at the reins.

Over the course of the next fourteen months dozens of letters passed back and forth between the curator in Houston and the New York team of Glimcher and Mueller at Pace. By spring Buxton began to pick up the pace with the gallery. In response to her telephone call to Glimcher on March 18, 1969, for an update, Glimcher wrote back that, "Mrs. Nevelson has already begun to prepare a one-man exhibition for the Museum of Fine Arts for October, 1969. It is understood that Mrs. Nevelson will design the installation and that you will carry out her plan, which will include the building of bases and the possibility of painting certain walls black."[30]

Between May 1 and May 27, Mary Buxton went from politely describing (to "Mr. Glimcher") all she would need to prepare the catalogue to telling him to "Get to Work!" after having announced that, "It is of the utmost importance that we move along as rapidly as possible."[31]

Forthwith she was sent a photograph of Nevelson and the catalogue from the recent Pace New York show for the latest bibliography and chronology. By mid-July, Buxton was working on the possibility of the show's travelling to New Orleans or Austin, Texas, asking "Dear Louise" if she would be willing to give a short lecture the day after the opening.

Buxton's letter to William Fagaly, the curator at the Isaac Delgado Museum of Art in New Orleans, is striking for Buxton's "candid" view of Louise Nevelson. "I am delighted that you wish to join us with the Nevelson, for I thoroughly feel it could be her last really great show. She is in her 70s and tires

easily, and the pieces she is working on will never have been seen before which will make the entire presentation quite unique."[32] The show ultimately went to Austin, Texas, and was certainly not Nevelson's "last really great show." She had only just turned seventy, nor did she show much evidence of tiring for the next eighteen years. Buxton had cleverly implied to Fagaly that this was a rare opportunity not to be missed, a gambit she would use several more times.

Nevelson and Glimcher made the decisions together about which works to include in the Houston exhibition. The selection set in motion a chronological trajectory for the artist that became fixed and standard ever afterwards. It begins with a number of works all dated 1955: *Night Presence I–VI*, *Relief*, and two series, *Moon Spikes* and *Moon Garden Forms*.[33]

Then the chronology picks up speed with two walls, which "were first assembled in 1959 and then added to or reassembled in 1962 and 1968."[34] Assigning a date range became the solution, for example, *Night Totality* 1959–64. Beginning in 1964, the works moved forward in orderly fashion until 1969, when they reached the grand finale of seven works that were made especially for this exhibit: three large black walls and one white grouping.

In late July, Mueller replied to Buxton that, according to the tentative plans he and Nevelson had worked out for the installation, the Houston museum needed to build a large partition wall across the front of the exhibition space, which would darken the hall. Additionally, he wrote that: "These partitions must be painted black, then black photographer's paper can be stapled to the permanent walls where necessary." Mueller explained that Nevelson was creating a large, new white work with "lots of rising towers and perhaps hanging columns." Mueller ended his letter on a hopeful note. "I think the space will work out beautifully, and if Houston doesn't swarm to the exhibition, I'll be very surprised."[35]

In October came a price list, which indicated that fifty-two of the sixty works were for sale. The two most expensive were the new white environment, *New Dawn* (priced at $100,000), and *Mirror Image I* (at $75,000). The remaining works ranged from four to sixty thousand dollars. Before the show closed Mary Buxton persuaded a donor to purchase *Mirror Image I* for the museum.[36] In an exuberant letter to the donor's wife, Alice Brown, Buxton wrote to say: "I'm still in shock over the fantastic gift of the NEVELSON! In fact, it's really difficult for me to continue working today. Philippe [de Montebello, Museum Director] is so very pleased . . . and the entire Accessions Committee is unanimously thrilled."[37]

In the days before the exhibit opened, Pace's instructions about how to handle Nevelson's fragile work flew back and forth between New York and Houston: "You may have to reglue some of the pieces when they arrive. Any good strong glue will do—something like Elmer's."[38] In her last letter to Nevelson before the

opening, Buxton reported that construction had started for the installation. She then detailed the plans for the days the artist would be in Houston, including small dinner parties, a talk by the artist, interviews with critics, and possibly a meeting with Dominique de Menil, the most prominent art patron in Houston.[39]

The evening the show opened, on October 23, 1969, Buxton sent a letter to Arne Glimcher and Fred Mueller: "I am writing you together for I am too drained emotionally at this point to 'do my thing' twice! You both are, without a doubt, the most tremendous, most adorable to have crossed my path in years, and this is what makes life such a joy to live. Your talent and sensitive taste have made you what you are, and fortunately it carried over into this show. It was incredible, and people will never cease talking about the merger of Nevelson and Mies." In a postscript Buxton asks Glimcher for his mother's address: "She's absolutely marvelous, and I must tell her on paper."[40]

In her letter to "Dearest Louise," after the show had opened, she noted that:

> Even though words are not necessary between us, I had to write! If only you could be here every day as I am and see the looks of wonder on the faces of people of all ages. I'm afraid that my work is suffering badly, for I find myself in the gallery a dozen times daily, just strolling and absorbing the beauty of your sculpture. You are indeed a genius and, thank God, a very warm and human one. The fact that you thought the installation worthy of your work is one of the most rewarding things that could have happened and I too, only wish Mies could have seen it.[41]

Nevelson came to the exhibition with Dorothy Miller from MoMA. According to Buxton, when Nevelson first walked into the show, she said, "Now I can die happy."[42]

The installation photographs demonstrate how well Nevelson's dramatic work could be displayed in a large darkened space. The lighting was sparse, theatrical, and highly focused. The goal was to rivet the attention of viewers on the work without any distraction. Eleven years earlier, Nevelson had achieved a similar effect in Grand Central Moderns Gallery with *Moon Garden + One*. She had tried over the previous decade to repeat the effect, but it was not until the Houston exhibit that she achieved exactly what she wanted. The work looked magical.

Between November 10 and 14, Buxton went into high gear trying to get art critics from the major art magazines in America to come to Houston and write about the Nevelson show. Sometimes she cannily added, "At Nevelson's age, this could be one of her last."[43] In her letter to Emily Genauer she wrote: "Now, we have what I feel is the most perfect show to have ever been held in this gallery,

LOUISE NEVELSON. . . . Since I am a deep admirer of yours, it would give me a great deal of pleasure to have you come to Houston as the museum's guest. . . . [44] Nevelson is 70 this year, and I do feel her omission by Geldzahler was a blow; however, I also feel that she has the strength to stand alone and I think you do, too."[45]

Buxton repeated far and wide Nevelson's delight: "Now I can die happy." Nevelson experienced this show as a triumph and was happy to tell anyone willing to listen how she felt. At the gala opening she proclaimed: "In all my exhibitions all over the world this is the first which I can say the sculpture and Mies van der Rohe's architecture is a marriage . . . yes, yes, it is a love affair."[46]

At the start Buxton hadn't really known with whom she was dealing. By the end of her adventure with Nevelson and company, however, she was duly impressed and could see beyond the persona Nevelson often projected. Thirty-plus years later when Mary Buxton was describing her experience with the artist and the exhibit, she still recalled the artist's off-color language and eccentricity. Buxton knew what she had accomplished by pairing Louise Nevelson with Mies. And by the end of her dealings with the artist she realized that Nevelson was an astute and often acerbic judge of people. But she could not have known that in 1969 Nevelson was just reaching her prime as one of the century's premier artists. What she was not was an "elderly" female artist in the twilight of her energy and productivity.

The story behind Nevelson's show in Houston demonstrates that during the late 1960s the artist had at least two divergent reputations: hard-drinking exhibitionist versus sober spiritual seeker. For many Nevelson was a vulgarian, who exploited her impossible charisma to make a spectacle of herself. The epitome of excess and overdress, she was under-articulate, selfish, and self-important. Her admirers (and there were many) respected her as a dedicated artist whose every effort went to bringing what she saw in the fourth dimension down into the third dimension. They knew her ostentatious, eye-catching persona and legendary toughness were mere façades, protecting her fragile self-esteem and warding off perennial despair and fear of failure. Buxton also came to see the complex picture of the artist who sometimes projected a perplexing persona and at other times was simply a hard-working person just like herself who used hyperbole to get her mission accomplished.

Following the installation of her huge beautiful wood wall, *Nightsphere-Light*, at the Juilliard School and her triumph in Houston, Louise Nevelson was gearing up for something new. She had played with aluminum and steel for the *Atmosphere and Environment* series. But that was a diversion—or, rather, an experimental extension of her now abandoned work in Plexiglas—not a full commitment to a new medium. She was about to engage in earnest with a material that would hold her attention to the end of her life.

"So we had lunch together at Bellotos," Glimcher recalls, "and I introduced her to Don Lippincott because he was making large-scale metal things for other artists. I remember she was a little cantankerous at the beginning, but she liked him. He called her, 'Mrs. Nevelson,' and she said, 'Call me Louise.' So we went to Connecticut the next week to visit Lippincott. It was a memorable trip."[47] Memorable indeed. Arne's car broke down on the way, and trying to get to a phone he cut himself on a barbed-wire fence and landed in Yale-New Haven Hospital. The injury was a serious enough to require specialized hand surgery. Remarkably, the surgeon had heard of both Louise Nevelson and Pace Gallery, fit Glimcher's surgery into his busy schedule, and was able to put his hand back together. Don Lippincott came to the hospital, and, after the surgery, the three of them went to Lippincott's metal fabrication shop so that "Louise could see the set up and make plans to work there."[48] Steely determination and denial of "minor" inconveniences were qualities that characterized the relationship between the artist and her dealer.

The first of Nevelson's works made at Lippincott's were three large sculptures fabricated in Cor-Ten steel: *Atmosphere and Environment X*, *Atmosphere and Environment XI*, and *Atmosphere and Environment XII*.[49] These sculptures were a continuation of the series Nevelson had begun in 1966 in Plexiglas and enameled aluminum and were later placed at Princeton and Yale Universities and Fairmount Park in Philadelphia. Because the earlier works had been factory-built from small-scale models, there was a long lead-time between the artist's decisions and the resulting sculpture. As a consequence, Nevelson had not had the flexibility and spontaneity that had always characterized her best efforts. Working at Lippincott's shop was different because she was able to be intimately involved in the process. The craftsmen he employed worked very closely with individual artists, even becoming specialists in the production of specific sculptors' work.

Don Lippincott had founded Lippincott Inc. in 1966 to meet the growing need of American sculptors for a place exclusively dedicated to the fabrication of large-scale work.[50] After a decade of operation, Lippincott was the country's only exclusive fabricator of sculpture for such artists as James Rosati, Ellsworth Kelly, Robert Murray, Claes Oldenburg, Robert Indiana and, now, Louise Nevelson.[51] Don's father, J. Gordon Lippincott, was the founder of Lippincott and Margulies, a successful industrial-design firm based in New York City. Instilling in his son a strong belief in urban planning, he had also introduced him to Cor-Ten steel, a new weathering steel-plate product created by one of his clients, U.S. Steel, and it soon became the staple for outdoor sculpture produced at Don's shop.

A Quaker, Lippincott brought to his work a calm steadiness that fit well with the artists who came to trust him totally. An *Art News* writer described him as "a tall, lanky, energetic, mustached master of metal crafts."[52] He was methodical

Roxanne Everett. Louise Nevelson with Don Lippincott, 1970. © Roxanne Everett / Lippincott's, LLC

and practical, taking care of all the business relationships with artists and their galleries as well as the many technical issues that came up.

James Rosati described the comfortable working atmosphere: "If there's something wrong—if something needs changing—there will be no argument. If you have to start over, then you start over."[53] Meticulously kept records, indefatigable resourcefulness, and implacable demeanor made Lippincott a trustworthy partner in the new world of public art. He became the quintessential resource for architects, planners, engineers, and art dealers. Another service Lippincott Inc. provided was the possibility of displaying an artist's finished work in the ten-acre field adjoining the shop buildings.

Don Lippincott had founded the company with Roxanne Everett, a Manhattan fundraiser who was experienced in public relations and well-connected in the New York art world. Roxanne began by finding artists who would soon come on their own when the word went out about what Lippincott Inc. could offer them. Lippincott hired craftsmen and technicians who could use industrial methods, materials and standard metal-working tools to produce big works with precision and technical prowess far beyond what most individual sculptors could make in a studio. Most of the workers had no ambitions to be artists themselves, but all of them enjoyed participating in the process—especially those working with Nevelson, who had to make adjustments in their working style to keep pace "with her incredible energy."[54]

Nevelson's first sculptures at Lippincott, the *Atmosphere and Environment* series, followed the usual working methods of the place. First, designing a layout. Next, selecting the material—either Cor-Ten steel or aluminum—and deciding how it would be put together. Then it was welded, and finally the sculpture was finished—the surface was polished to remove weld marks—and painted.

Atmosphere and Environment X, XI, and *XII* are described in Lippincott's records as similar works, with the basic structure consisting of thirty boxes in six columns of five boxes each. There are, however, a few significant differences. In *Atmosphere and Environment X* (destined for Princeton University), nine of the thirty boxes were covered by steel plates. In *Atmosphere and Environment XI* and *XII* (which landed at Yale University and at Fairmont Park in Philadelphia, respectively), nine boxes are open;[55] moreover, *XI* is also only half the size of *XII*. Once again she managed to get three works out of one design—a three-in-one deal rather similar to the Plexiglas works that inspired *Atmosphere and Environment.*

Most of the sculpture Nevelson would subsequently make at Lippincott was composed directly with the discarded scrap-metal elements she found on the shop floor or nearby. However, her earliest work there to be composed with found elements was made first with plywood, which was later translated into a metal sculpture. Having worked for over fifteen years creating sculpture by

Roxanne Everett. Louise Nevelson with Bobby Giza at Lippincott, Inc. 1975 © Roxanne Everett / Lippincott's, LLC

working directly with scrap wood pieces, it was evidently too big a leap for her to make sculpture using metal fragments at the beginning of her shift to direct work with metal.

During the third week of November and the first week of December 1970, as the work on the three *Atmosphere and Environment* sculptures was being completed, Nevelson cobbled together a model in plywood using discarded bits of wood from Lippincott's shop. She then decided to have a freestanding, three-dimensional sculpture made in Cor-Ten steel based on the plywood model of the work eventually titled *Night Tree*.

Over a period of four weeks in April 1971, the plywood model of *Night Tree* was fabricated in Cor-Ten steel in two different scales—one was eight feet eight inches high; the other full-scale version was twelve feet eight inches.[56] (Lippincott and his workers always referred to the sculpture as *Meat Ax*, as one of the elements that juts out from the central core bears an unmistakable resemblance to a cleaver.)[57]

Nevelson had been composing sculpture with wood bits and pieces for years. It was not only good engineering practice for her to begin her major move into

Roxanne Everett. Plywood model for *Night Tree*, 1970. © Roxanne Everett / Lippincott's, LLC

metal by playing with scraps of plywood but also a psychologically astute way of shifting gears. Equally astute was the idea of making the second step in the transition a little larger than life-size. The many photographs of the first Cor-Ten model of *Night Tree* underscore the awareness at Lippincott Inc. that Nevelson was trying something very new and very different.

It took a year and a fair amount of experimentation to come up with a satisfactory form of the final sculpture. Nevelson would have the workers cut and or move pieces of steel, temporarily attaching them to the work until it looked exactly the way she wanted it to look. And once arrived at, it was produced in three Cor-Ten versions, and one additional version in aluminum. Nevelson evidently liked the initial result of the *Night Tree* mockup in plywood enough to continue in the same mode of selecting discarded fragments, but from then on she worked with metal scraps instead of wood. The week after the plywood mockup was made for *Night Tree*, Nevelson began working with aluminum scraps and, with the help of the Lippincott staff, quickly produced ten sculptures in aluminum, which she called *Seventh Decade Garden*.[58]

All the attention about the beginning of Nevelson's direct work with metal tends to be lavished on the ten aluminum trees in *Seventh Decade Garden*, and the now-famous explanation of how they came into being goes like this: On a routine visit to Lippincott's in 1971 to oversee the *Atmosphere and Environment* sculptures, Nevelson was taken past a room filled with remnants of aluminum from sculptor George Sugarman's constructions, which were soon to be carted away. She turned to Don Lippincott, saying, "Dear, save these pieces for me. I'll come back and build sculpture out of them."[59]

Nevelson eventually appropriated the discarded metal fragments and ordered ten rectangular and triangular cores and bases, to which she would attach the scraps, constructing ten tall aluminum trees. Discovering that for each scrap she found, there was another that was nearly identical, she made almost exact twin pieces—five sets of two each, as can be seen in photographs taken at Lippincott.[60] Another feature of the now-legendary story was that the entire series was made in two days.[61]

Decade Garden I–X were shown at the Pace gallery in the spring of 1971. Glimcher produced a cunning flyer for the show, with flaps that opened up to show the sculpted trees concealed behind the photographed trees.

In his review of the Pace show for *The New York Times*, Canaday was enthusiastic about Nevelson's forestful of trees: Her "new exhibition . . . proves once again that the woman simply cannot be trusted. For several years now, from show to show, she has implicitly capped off her career with a final demonstration of her powers of invention, but each following year she comes up with something new. This refusal to settle into a rut is very wearing for us art reporters. This year

Mrs. Nevelson has turned up with a beautiful group of 12 tall, tree-like painted aluminum sculptures [according to Lippincott's invoice there were only ten], her first venture into direct welding."[62] Canaday also noted that Nevelson got her math wrong. At age seventy-two, she was actually in her eighth decade.

In addition to the metal works on exhibit, there were thirty small, volumetric wood sculptures, *Young Trees,* and photographs of the recently installed large-scale outdoor pieces: *Atmosphere and Environment X* and *Atmosphere and Environment XI.*

The show at Pace also included one large wood sculpture, *Black Garden Wall I,* in the shape of a parallelogram, which one *Art News* critic described as a "low relief in black painted wood which covered one whole wall." The reviewer notes that, "The rest of the exhibition seemed to be a determined effort to break away from this style."[63] He finally asks whether or not Nevelson will continue working with wood or has she now switched completely to creating metal sculpture.

Here was a question that would preoccupy critics, curators, and the art-loving public for the next fifteen years. Should Nevelson stick to what she did so well—wood sculpture—or should she branch out in yet another new direction—direct-made metal sculpture?

How we answer that question depends on whether we focus on the Cor-Ten steel *Night Tree* or the ten aluminum trees of *Seventh Decade Garden. Night Tree* is bolder than the aluminum pieces but it does not have the flashy exuberance of the aluminum trees, which were created immediately afterward, and it has none

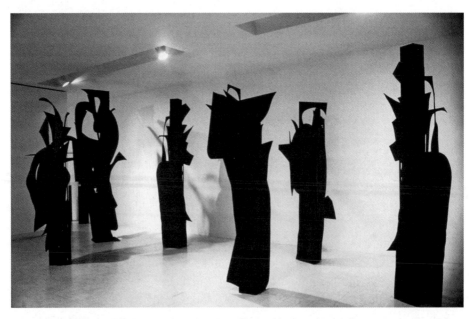

Seventh Decade Garden VII (Installation view from *Louise Nevelson: Seventh Decade Garden,* Pace Gallery) 1971. Photograph courtesy of Pace Gallery

of their anthropomorphic wit. However, its deliberative compositional style is more Nevelsonian, as it had been known for long. Ironically she had greater formal flexibility when using metal which, could be bent and shaped more easily and more eccentrically than wood fragments.

In all the chronological reports of Nevelson's development in metal sculpture, *Night Tree* has been mostly misplaced and forgotten. Its origin in wood scraps, which actually links her emerging style in metal to the old one in wood, has been completely unrecognized. Indeed, some of its blockiness may be a remnant of its plywood beginnings, but that is offset by the several powerful profiles it presents to the viewer who walks around it. Also apparent with close study is the clever complexity of the composition. The curved cutouts, which repeat the pairs of discs at differing levels, make the eye work to find the coherence of the composition. If we can get past the distraction of the very visible "meat ax," it becomes possible to see the not-quite-syncopated rhythms and play of horizontal and vertical elements in three dimensions.

As for the aluminum trees, by comparison with her later work at Lippincott's, they look as if they were done in a hurried frenzy. And, true enough, they were done very, very quickly—in two days, as legend has it[64]—and for the artist they were just the beginning of something different. The *Art News* reviewer described them this way: "In sharp contrast to the precision and order of her work of the recent past, these appear very spontaneously conceived—almost slapdash."[65] Perhaps the spiky silhouettes are what seem most careless. They do not have the harmonic cohesion or even the contrapuntal rhythms of Nevelson's best work in wood. As she became accustomed to working at Lippincott, Nevelson would find her aesthetic footing with the new medium. With the help of the willing workers there a much wider range of shapes and forms became available to her. She could ask them to twist flat steel elements into a myriad of shapes including corkscrews. Eventually she would be able to wield the metal with ease and skill, or—as she would famously say—"I can translate Cor-Ten into butter and butter into Cor-Ten steel."[66]

As her work with metal matured and as she gained confidence and grace, some of her largest works would prove to be some of her best. Nevelson loved working large. It was related to her feeling that she was an intuitive architect dealing with spaces and scale. "Working in metal has allowed me to fulfill myself as an environmental architect."[67] It was like a dream come true for the artist who had always tended to think big and act bigger.

Working large-scale was by no means unique to Nevelson in the early 1970s. It was why Lippincott Inc. had come into existence. America was ready for large-scale sculpture. Large-scale paintings had been around for several decades, introduced by the Abstract-Expressionist painters, such as Jackson Pol-

lock, Mark Rothko, and Barnett Newman. In the late 1960s and early '70s over-size prints grew naturally out of the monumental paintings, which had become both technically possible and commercially viable.

The National Endowment for the Arts (NEA) was established in 1965 and it introduced a period of dramatically increased government support for the arts, which meant reinvigorating some of the goals of the WPA and New Deal. NEA programs mandated that half to one percent of the estimated costs of construction or renovation of government buildings was to be spent for public art commissions by living American artists. The program was called Percent for Art. In addition to the governmental support on the city, state, and federal levels, corporations, private collectors, and other institutional entities jumped on the bandwagon. Thus monumental sculpture was funded, produced, and exhibited in public spaces in previously unimaginable quantity and quality.[68]

The perception that public sculpture conferred civic identity and cachet had grown rapidly in the late 1960s.[69] Colleges, corporations, cultural and religious institutions, governmental institutions, and city councils responsible for municipal buildings all began commissioning and buying large outdoor sculpture that would be seen by the largest possible audiences.[70]

The explosion in monumental public art was the source for some of Nevelson's most powerful sculpture in the 1970s and 1980s—sculpture that she was able to create because of her collaboration with Lippincott. Arne Glimcher was fully ready to help public and private entities select Nevelson's work for public spaces, and she was delighted to participate in the effort since it matched her long-held personal view that art should be at the center of life, especially urban life. Nevelson believed that everyone from secretary to CEO should have the opportunity to enjoy art, which could only happen if art was displayed in public places. More importantly, Nevelson had long seen herself as an architect, and doing large metal sculpture that would be placed outdoors in public settings gave her the chance to test herself.

As Nevelson became used to working with the crew at Lippincott's she grew increasingly comfortable with the medium and more spontaneous in her use.

> Now the longer I went up [to Lippincott's], the closer I got acquainted with this material Cor-Ten. . . . I must have been ready for it. . . . [Because] I found that in my hands . . . it was almost like butter—like working with whipped cream on a cake.
>
> I was using steel as if it was ribbon made out of satin. And somehow it gave me another dimension. It gave me the possibility of maybe fulfilling the place and space and environment that I have probably consciously, unconsciously, been seeking all my life.[71]

She tended to come up to North Haven on a Monday or Tuesday and stay two to four days. Arne Glimcher would often arrive with her or come the last day to look at her work and participate with her and Don Lippincott in the decisions about combining separate pieces into new compositions. Lippincott was always consulted on technical issues, scale, placement, and feasibility of production.

By 1971 Louise Nevelson had become the hot topic of the moment. Her dramatic look, her exotic home and studios, her astonishing productivity, and her pithy commentary on life, on art, on anything, appealed to journalists and publications looking for a striking subject.

That year would see Nevelson's arrival at a peak of publicity and consolidation in her gallery representation. Two more gallerists—one in Philadelphia, the other in Chicago—joined her team and would show and sell her work until the end of her life and beyond. At seventy-two years of age she was able to savor the success that had begun only when she was fifty-eight. She felt free and acted on her freedom with a vigor that was rarely matched by anyone even near her age. She had had over fifty one-person exhibitions and had been pronounced "one of the major sculptors of our time"[72] and one of "the most impressive and individualistic sculptors America has yet produced."[73]

In 1971 Nevelson had solo shows New York, Philadelphia, Chicago, and Columbus, Ohio. Five different colleges invited her to accept an honorary doctorate or speak at commencement. Brandeis University honored her with its "Creative Arts Award in Sculpture" and an honorarium. The University of Bridgeport offered her a visiting professorship—a named lecture also with an honorarium. She accepted all offers, especially delighting in speaking with young people about the arts and the future. Over the years, she managed to overcome her frequent awkwardness with words and was a forceful presence and articulate, if eccentric, speaker.

As part of the New York City's Sculpture in Environment Program, *Atmosphere and Environment XII*, one of Nevelson's largest works in metal (sixteen feet by ten feet by five feet of Cor-Ten steel, weighing eighteen thousand pounds) was temporarily installed, with the help of a fifty-foot crane, in front of the Seagram Building on Park Avenue. The event, in January 1971, was written up in *The New York Times* with the headline "Park Ave. Gets a Nevelson Sculpture."[74]

After six weeks the large sculpture was to be moved to Philadelphia, where it would be installed in Fairmount Park. When the word got out that the cost of the work was sixty-thousand dollars, there was some grumbling, given the poor state of the economy. But the Fairmount Park Art archivist disputed that narrow-minded view: "Even if you're desperately poor, you need a place to sit in the country. You need the art, which is just as much a part of life as bread. Otherwise you're not really civilized."[75]

This same work inspired a taxi driver in New York to give an eloquent description of Nevelson's sculpture to art critic Emily Genauer: "Last year I went many times to see [it.] You know, the one that looked like stacks of black metal boxes with open spaces here and there? That was great. It was like the sculptor had made bookcases for books that can't ever be written." Genauer saw this as a perfect way of describing "the mystery and magic of Nevelson's work, and how visual creativity can never be translated into words."[76]

In May 1971, timed to coincide with the arrival in Philadelphia and publicity about *Atmosphere and Environment XII*, Hope and Paul Makler staged the first of six solo shows of Nevelson's work at the Makler Gallery. Both the Maklers had studied at the Barnes Foundation in the late 1950s, and their education in perception grounded their aesthetic vision for the rest of their lives. After fifteen years of collecting, they opened their gallery in Philadelphia in 1960 and saw themselves as advisors and art critics as well as merchants.[77]

Arne Glimcher was impressed by the success of the Makler show and gave them free rein in the choice of works for future exhibitions. Unsurprisingly, they quickly found that the most salable works were ones "that are not too large to house."[78]

Ironically, it was this very issue of size and salability that had been a sticking point between Nevelson and Martha Jackson. In 1960 Jackson had nagged the artist about making smaller, more saleable works, and Nevelson looked down on the dealer's commercial interest in salability at the time she was trying to make her mark in the art world as a serious artist.

Later in 1971 the Maklers visited Nevelson in New York, escorted by Arne Glimcher. They had been forewarned about Nevelson's potential for being difficult and were surprised by her warmth and wit. As usual, the persona was unforgettable. As Makler noted afterwards: "The really spectacular exhibit, of course, was Louise Nevelson herself. Her clothing was obviously considered as costume. . . . Her jewelry was massive. . . . Her eyes were heavily made-up and embellished with the huge false eyelashes that are her trade mark. All this coupled with her energy, her strong opinions so vigorously expressed, and the ambience of her work in the house made an impression that was forceful to say the least."[79]

A year later Nevelson was back in Philadelphia for a TV appearance and visited with the Maklers. "She liked the two Nevelson walls in our living room; made some suggestions about rearranging our paintings and was obviously quite comfortable."[80] Clearly the artist felt very much at ease with the Maklers, and they continued to be her agents in Philadelphia for twenty years.

In August 1971 Colette Roberts died of heart failure in Paris. The obituary in *The New York Times* emphasized the importance of Roberts's support of Louise Nevelson, citing her 1964 book, her many lectures and exhibitions of Nevelson's

work.[81] Two months later, on Picasso's ninetieth birthday, October 25, 1971, as yet one more sign of her success, Nevelson was one of the three New York artists asked for their thoughts about the twentieth-century artist who stood out as the beacon of greatness. Nevelson responded: "I believe that Picasso is still doing magnificent work, and that is enough to celebrate. He brought to the visual concept the total awareness that we humans have arrived at through the ages."[82] She added: "You feel that he gives birth to himself every day." Nevelson was putting her own ideas into the mind of her mentor.

The end of 1971 and beginning of 1972 saw her fourth solo show of the year and her first exhibition at the Richard Gray Gallery in Chicago. The exhibition in Chicago was a retrospective of sorts. It included twenty works from 1958–63, many from the famous 1959 show *Sky Columns Presence* at the Martha Jackson Gallery, where Richard Gray had first seen and liked Nevelson's work.

Eventually, Gray had five more Nevelson exhibitions. Richard Gray had started his collecting and subsequent art dealing in 1963, and he, like the Maklers, enjoyed teaching his collectors how to appreciate the art he so loved. He not only admired Nevelson's work, which he had been following closely since 1959, he was very fond of her as a person: "Everyone who ever met her, saw her, spent time with her was struck with her incredible presence. The way she presented herself, the way she spoke, the way she carried herself, what she talked about— everything was much larger than life. She was unique—a one off—but lovely and warm, gentle in a way." Gray described her, as did most of her other dealers, as very easy to work with—"never difficult—I never had a harsh interchange or expression of disappointment from her. But she had no trouble letting you know what she really felt about you, her work, all the rest of it."[83]

Reflecting on the fact that he always installed her shows himself, Gray observed that he and Nevelson shared a way of seeing things. They both had "an instinctive intuitive way of operating" of moving objects to just the right place.

> It is true that part of the reason I got interested in her work was that it mirrored the kind of sensibility and visual way of seeing things that was directly connected to my own. . . . I walk into a room, see a picture or a chair [and need to move it.] It drives my wife crazy. In two seconds I . . . move the chair about an inch and a half to get it back where it belongs. I can't help it. . . . That's what her work was about—taking a disparate group of . . . objects and assembling it the way it belongs.[84]

The reviewers of Richard Gray's first Nevelson show got the point. Jane Allen and Derek Gutherie wrote in the *Chicago Tribune* of "the beautiful display of Nevelsons on view at the Gray Gallery. In a small room, Gray had placed a

truly monumental wall-sized sculpture, two large works and five or six small sculptures. They work, both as a group and individually, partly because of their placement, but primarily because of the lighting." Citing *Sky Presence II*: "A classic Nevelson at her very best, this complex assemblage is like a Bach chorale. The counterpoint of motifs, textures, and structures weave themselves into a harmonious architectural whole."[85]

Richard Gray always chose the art he included in his shows. Several years later, when he was working more closely with Arne Glimcher at Pace Gallery, he withstood Arne's inclination to make the choices of which pieces would be exhibited and where. He had a keen eye and knew he was in synch with the artist's aesthetic sense. Nevelson always agreed with his choices.

LA SIGNORA
OF SPRING STREET

1972 – 1974

"Life is a goddamn tough racket. Between [the bad] times, you
have a complete right to fulfill yourself."
—Louise Nevelson ". . . And Some of the Women Who Have Made
It to the Top in the World's Toughest City,"
London Sunday Times, November 12, 1972, 43

Women and women artists were everywhere in the news in the early
1970s. Art critics were defending themselves against charges of dis-
crimination—either maintaining that female painters and sculptors
were simply not good enough or acknowledging the bias in the gallery and
museum world that kept them from gaining the exposure and success that they
deserved.

Time magazine had reported in Spring, 1972, some startling statistics: "Of
1000 one-artist shows in 43 years at the Museum of Modern Art, five were by
women. Of 129 one-artist shows at the Whitney Museum in ten years, eight were
by women. Of nine one-artist shows in five years at the Guggenheim Museum,
none were by women."[1]

Forty-some years later, the situation for women artists in America is still
heavily biased and barely changed. Auction prices for a top male artist are more
than double the amount for a top female. In 2012: "70 percent of the reviews in
Art News or *Art in America* are of male work," and "while women in most employ-
ment make 78 cents for every male dollar, in the art world women make 10 to
30 percent."[2] In addition, eighty-six percent of modern artists on museum walls
are men.[3] Of the artists represented by galleries in New York and Los Angeles,

just thirty percent are women. Critic Jerry Saltz noted that fifteen percent of the total *Artforum* ads for solo shows in New York in September 2014 were for women artists.[4]

In her 1973 essay on "Art and Sexual Politics," Elizabeth Baker, an art critic and the longtime editor at *Art in America*, wrote that although art schools were more than half full of women and girls, the faculty was primarily male. If and when women artists were hired to teach, they took low-paying jobs in primary and secondary schools or were given last-minute peripheral jobs in colleges and universities at lower pay and without tenure.

If a woman artist hustles her work, she is seen as excessively ambitious and aggressive. And when she attempts to find a place in the world of galleries and museums she will be at a disadvantage, since most galleries limit the number of women artists to none or few. Baker cogently observed that the situation had been vastly different in the 1930s and '40s—when as much as one third of some of the large group shows had been made up of women. In that earlier era the business of art was much less lucrative than in the 1970s—so women also had a better chance of exhibiting.[5] After World War II the retreat-to-the-home movement was a huge setback for the many women, including women artists, who had paying jobs. "The only approved objective . . . for even the highly educated middle-class girl . . . was marriage," Baker pointed out. Women who did not follow the trend were labeled "frustrated, neurotic careerist[s]."[6] Betty Friedan challenged the idea that women were naturally fulfilled by devoting their lives to being housewives and mothers, famously calling such a notion the feminine mystique.[7]

Baker cites Nevelson as an exception to the difficulties facing women artists in the early 1970s: She was an art-world celebrity and, hence, not subject to the same constraints.[8] She became successful as an artist at least a decade before the feminist movement helped push other women artists up the ladder, and she was the only woman artist of her time to succeed without the help of a famous or powerful mate. Her few successful confederates were attached to successful male artists: Georgia O'Keeffe had Alfred Stieglitz; Frida Kahlo was married to Diego Rivera; Elaine de Kooning, married to Willem de Kooning; Lee Krasner, married to Jackson Pollock.

Nevelson had had a room of her own in an important show at MoMA in 1959 and one-person shows at the Whitney in 1967—a career retrospective and one of the first of a woman artist at the Whitney—and another in 1970. Indeed, she had been in demand as an artist and a speaker for at least fifteen years, and her work had been reviewed positively in major newspapers and magazines for over thirty years. Though Nevelson had less to complain about than many other women artists in this particular story, even she was not immune to discrimina-

tion and exclusion from these same institutions on the grounds of her sex and age.

As noted earlier, in 1969 and 1970 she was omitted from two major exhibitions: one at MoMA and the other at the Metropolitan Museum. The latter, entitled *New York Painting and Sculpture: 1940-1970* and curated by Henry Geldzahler, consisted of four hundred works by forty-three artists. The startling inclusion of only one woman artist (Helen Frankenthaler) provides undeniable historical context to the difficulty all American women artists were facing.

Aware of this discrimination but determined to have her work seen by a large number of people, Nevelson frequently donated her work to museums—a practice that she began when she was represented by Colette Roberts, who was sophisticated about art-world politics. Giving her work away was often her only way to have it become part of the museum's permanent collection. But her plan was not foolproof. Even today, when museums get artworks gratis rather than pay for them with their own funds, the works are more likely to end up in storage than on display.

The *Ladies' Home Journal* had cited Nevelson in January 1971 as one of "America's Most Important Women"—women who "had made the greatest impact on our civilization within the last five years and who would continue to affect us significantly . . . women who have done the most to shape and illuminate the world in which we live."[9] Nevelson's name was frequently mentioned, alongside Georgia O'Keeffe, Mary Cassatt, Marisol, and Helen Frankenthaler, as proof that women artists could succeed. In an article in *Cosmopolitan* the author went so far as to say: "If women now really do have a better—if not equal—chance in art, it is not a coincidence that the change took place in Nevelson's time but probably very much because of her."[10] Some critics called Nevelson one of the foremothers of American art, a veritable "Mother Courage." When asked if men treated her as an equal, Nevelson was quick to answer. "Originally, no—at 70 years, yes."[11]

When Nevelson was interviewed in the spring of 1970 for an article titled "The Woman as Artist" in *Aphra*, a feminist literary magazine,[12] she spoke about her personal experience with astonishing candor: "When I first started, nobody took me seriously. In the galleries—a woman! I'd look in the mirror and see the gestures they made behind my back. *Meshugganah!* A woman wanting to be a sculptor. A man sculptor said to me, 'Louise, you don't want to be a sculptor. To be a sculptor, you've got to have balls.' 'I've got balls,' I said. But it hurt inside."

How did Nevelson succeed when so many other gifted women artists failed? One answer appeared in a groundbreaking article in the January 1971 issue of *Art News*, in which art historian Linda Nochlin asked Nevelson and seven other sculptors and painters, "Why Have There Been No Great Women Artists?"[13] Nochlin noted that the usual feminist answer to this question involved, first,

digging up examples of important women artists—such as Artemesia Gentiles-chi, Rosa Bonheur, Elisabeth Vigée-Le Brun, and Angelica Kauffmann, all of whom had been historically underappreciated—and, second, pointing out that "women's art" has a distinctive style and a different kind of greatness from men's.

Nochlin dismissed both responses and offered her own. She argued that, for centuries, the church, the state, the nuclear family, and the educational system had prohibited women from participating in the day-to-day process of learning to be artists. Women were supposed to be doing other things—namely, carrying out domestic duties as wives and mothers, all with an attitude of sweet compli-ance. Thus it was impossible for them to be totally devoted to professional art production.

As an example of these stifling constraints, Nochlin pointed out that, even if they somehow found their way into an art class, women were not permitted to study the nude body. This meant they couldn't paint or sculpt the historical or mythological subjects that would allow them to compete for any of the standard prizes and stepping-stones to commercial success—including salon medals, the Prix de Rome, or the Legion of Honor. Nor could women have ateliers where they could instruct students and assistants and, thus, make a living. They could not travel widely, participate in the affairs of an academy, or establish effec-tive relationships with patrons. There were very few exceptions to these mostly unwritten rules. Each of the successful women artists mentioned above were daughters, wives, or partners of male artists.

Louise Nevelson, whose "utter, 'unfeminine' dedication to her work and . . . conspicuously 'feminine' false eyelashes" made her so interesting to present-day women was, Nochlin observed, one of those exceptions. Nevelson gave her answer to Nochlin's question in a short piece called "Do Your Work," explain-ing the dearth of important women artists: "The world has thought up to now in 'male' vocabulary," she wrote. "Now I think the door has opened. . . . Sin-gle-mindedness, concentration and absorption in one's work . . . should not have anything to do with "masculine-feminine" labels. . . . To comment further in depth [on Nochlin's essay] would mean a line-to-line analysis and that of course would interrupt my art."[14]

Beyond her response to Nochlin's essay, Nevelson had much to say about the conventional woman's role in the world vis-à-vis her life as an artist."Darling, " she told a reporter, "I think somewhere I rejected the whole experience of family and husbands. I got married because at the time I didn't quite trust my beliefs in myself. . . . [Marriage was] too confining ultimately for my kind of living. . . . It takes so much of life away, and destroys my concentration. I want to live fully through my work. I want to live with great intensity. I want to be aware as much as possible of the livingness of life. . . . This way . . . my life is totally mine.

And nobody has a claim on me."[15] To another interviewer she commented: "I wouldn't want to be in the horizontal position most of my life. Is that a terrible thing I am saying? My work made me a total woman. Otherwise I'd have been a lackey to some man."[16]

Though very proud of her success, Nevelson talked quite candidly about the price she had paid for it: "I was attractive enough, and men always flattered me from the first day I can remember, so why wouldn't I want to be a woman?" she asks. "In all those years before the sixties, women's art wasn't taken as seriously as men's. Maybe here and there they threw us a bone. I just don't know if I like to be singled out as a woman or simply as an artist. I've paid the price both ways. . . . I hated what I had to go through, but, in retrospect, while it was tough, it made me independent."[17]

Though she had previously avoided the term "feminist," by the 1970s Nevelson was in the vanguard of women artists and claimed that she had been a lifelong exponent of equal rights for women and that, while she didn't need the support of the women's movement for her career, she welcomed it. As she said to a reporter in Arizona in 1972: "Yes, I am for Women's Lib. There is a cult in New York around me. They call me Mother Courage. I was interviewed recently and the question was asked, 'Is the world male-oriented?' I answered, 'Yes— from God on down.'"[18]

Nevelson had enjoyed the support of many critics for many years—Kramer, Genauer, Canaday, Mellow, and others. When the tide of critical writing shifted in the early 1970s, new voices were heard, and Greenberg, Geldzahler, Krauss, and Fried became the new tastemakers. None of them accepted Nevelson into their canon of important American artists. She was a loner, which made her vulnerable. But she remained confident about her work—it helped that she continued to be very successful internationally. It also helped that she had continued to adopt strong women role models.

As heroines or mentors Nevelson consistently (and cannily) selected females who were comfortable and successful in the world. Although she knew Lena Cleveland, Norina Matchabelli, and Ellen Kearns personally, she had never met Edith Sitwell or Jennie Churchill, who also served as lodestars for her.[19]

In the early 1970s, Nevelson read a review of a recent biography of Jennie Churchill—the Brooklyn-born mother of Winston Churchill, and the wife and lover of many important men. She was said to be one of the most beautiful women of her time, and she was also well-respected and influential in the highest British social and political circles. On the last page of the book review, Nevelson underlined some words describing this remarkable woman with whom she obviously identified: "Jennie was part of the action and passion of her world. . . . She established her own frontiers and made her own rules. She had courage to match

her beauty and excitement to match her intelligence, energy to match her imagination."[20] Underlining these particular words about Jennie Churchill at this particular moment in her personal trajectory points to Nevelson's unchanged idea of the kind of person she wanted to be and, given the confidence with which she addressed herself to the world, believed she had become.

On March 22, 1972, the Equal Rights Amendment, or ERA, which would guarantee women the same legal standing and treatment socially, economically, and politically as men, had been passed by the U.S. House of Representatives and the Senate and was sent to the states for ratification. This should not have presented a problem in a country where women had been voting for over fifty years. Almost immediately twenty-two states (out of the thirty-eight needed for ratification) had given their approval. But right-wing and fundamentalist religious groups quickly organized opposition to halt the forward momentum, and the Equal Rights Amendment was never ratified. To this day the differential in pay between men and women for equal work continues to be a contentious issue. Data released in 2015 by the American Association of University Women makes it clear that white women only earn seventy-eight cents on the dollar earned by men. Minority women earn much less.

Later in 1972, Nevelson's interview with feminist art critic Cindy Nemser, "I Am Women's Liberation," was published in the feminist magazine *Changes*.[21] It was a sensation, and the issue quickly went out of print and was republished in the *Feminist Art Journal*. When Nemser remarked that Nevelson had been a great supporter of women's liberation, the artist's response was quick and direct: "Of course [I was], because I am a woman's liberation. . . . I feel totally female. I didn't compete with men, and I don't want to look like a man! I love being a lady and dressing up and masquerading and wearing all the fineries. . . . We should wear what we like. . . . I just got myself a chinchilla. So fuck 'um. . . . The point is that men are as enslaved as women are and it's only after they recognize it that they *too* will be free."[22]

Decades later, Nemser observed that, "Louise was not part of any movement. She was not a joiner. Her mind didn't work that way. She had already had quite a bit of recognition before the feminist movement and felt that she had made it on her own. The early groups of feminist artists were made up of people who were not that well known, and if you were not represented by a movement [such as the feminists] and you were not part of a clique, you did not get their support. Nevelson did not have to do that."[23]

Though she told Nemser that she "love[d] being a woman and not having to imitate men" Nevelson had strong views about women who used feminism to get ahead in the art world. "That does not mean that there aren't many women who are exploiting the feminist movement.[24] And when it comes to the creative

arts, it is of paramount importance to know whether they are truly qualified as artists and not just women dabbling in art."[25]

Two months after the publication of the famous Nemser interview, in December 1972, in a *Newsweek* article by Katrine Ames titled "Gothic Queen,"[26] Nevelson, referred to as "a hot interview in the art press," lashed out at what she called "the sacred cows in 'the art Mafia.'"

"Nevelson's definition of this elite is brutally specific," Ames writes. "It includes critic Clement Greenberg, the major theoretician of 'formalist criticism,' and his followers (most of them located, she says, at Harvard)"—Michael Fried and Rosalind Krauss were two of the most influential. Also on the list were "Henry Geldzahler, super-trendsetter and curator of modern American art at the Metropolitan Museum; *New Yorker* critic Harold Rosenberg; and virtually the entire staff of *Art News*."

Nevelson asked: "Who are these people to tell us what we have to do and what we have to think? There are artists who have been ignored because they didn't fit into the mold: they're angry—everybody's angry and they've had it. The anger gave me strength. I made up my mind I wanted every door in the world open when I came in."[27]

In Nemser's article for *Feminist Art Journal*, Nevelson had been quite specific about how this coterie of critics were "choking creativity."

> I have collectors, and their children go to Harvard—I could say almost a dozen young people, who are very *bright*. They wanted to write their theses on me. Well, Michael Fried telephones Greenberg every day. . . . So Fried says to the students, 'Why do you want to write a thesis on *her*?' . . . I have never met this [Rosalind] Kraus but the same thing happened. . . . I don't want to fight Greenberg. . . . And I don't want to fight Henry Geldzahler [the curator at the Metropolitan Museum who had left her out of the big 1970 show]. I don't want to fight anyone because I'm still the creator sitting on my arse and they're only critics that I don't respect.

Nemser responded to the artist's outrage: "By excluding you, Geldzahler pinpointed the discrimination which exists not only against women, but against any artist who is not of the Greenberg persuasion. You became a *cause célèbre*."[28]

The prejudice against the very successful Louise Nevelson was most likely based upon envy and the wish to discredit her. She had something they lacked—celebrity in a male-dominated world.

Always outspoken, she expanded her views on men and sex: "'I like men for mating. I was always a pretty chick. . . . But I don't have to do anything about

it any more. I sleep on a narrow bed, like a virgin,' she marvels, motioning to the upstairs where the bed is located. 'I've had moments in bed so beautiful the world could have stopped right there. But then you get up. You go on. Time goes by—weeks, months.'"[29]

Two years before she died she told journalist Amei Wallach: "I guess I've never stopped having a few male friends. . . . My mother always said 'Oh you'll be that way all your life.' I think she hit it."[30]

"Living the way I did . . . see, I broke all the traditions. If I wanted a lover, I had a lover. I didn't have to get married again. So I had courage to live as I understood it. I thought art was more important than other things."[31] "I've always had fun, felt feminine, freelanced [sexually], liked a drink, never felt tired, still get up at 4 a.m., [and] read till six then start work in my studio."[32]

Choosing to be sexually independent and having become financially independent marked Nevelson for many as a pushy dame without any class. The more successful and celebrated she became in the 1970s and '80s, the greater the attempt to bring her down with rumor and innuendo.

Unhappy members of the feminist clique found ways to malign Nevelson. They spoke of her bizarre way of dressing, they said she was a terrible mother, they gossiped about her promiscuity, arguing that she was either bisexual or just plain gay. Though no one now would care at all about this, at the time it was a cliché that "liberated" women must be gay because they could not "catch a man." Being called gay or bi was doubly damning, given the low status and ostracized position of homosexuals at the time.

According to Arne Glimcher, the talk about Nevelson's sexual identity was started by Lee Krasner, who was briefly showing at Pace Gallery at the same time as Nevelson and was envious of Nevelson's professional success.[33] Many people who didn't know her well assumed that her relationship with her assistant and friend, Diana MacKown, was sexual as well as everything else. After Nevelson's death, some of Nevelson's friends persuaded MacKown to launch a "palimony" suit in order to retrieve from Mike Nevelson work she said Louise had promised to her. That turned the rumor into "fact."

Edward Albee, who knew Nevelson for over twenty years and saw her regularly, disagrees with those who rumored that she was gay: "Louise had started to get very well known, and all sorts of rumors started floating around, including the fact that she slept with women. I knew all the rumors, but I never saw any indication of it. It doesn't seem right. I never saw any kind of physical closeness. You'd see Louise and Diana and they had both been drinking very, very late the night before, and they both would be in bed clothes but that didn't mean anything. I wouldn't have minded what their relationship was, for God's sake, but I think they were just drinking buddies."[34]

Fall 1972 was a sober moment for American artists in New York. The presidential election scene was beginning to heat up. The summer had seen more bombing and deaths in Vietnam; a burglary at the offices of the Democratic National Committee in a Washington, D.C., office complex called Watergate; an unfortunate setback for the Democratic presidential candidate George McGovern, when his pick for vice-president, Thomas Eagleton, was forced to resign once it was known that he had been treated for depression with ECT (electroconvulsive therapy).

Nevelson was among the contemporary artists who donated their works to a sale at the Pace and Janis galleries to raise funds for the McGovern campaign. As a prominent figure in the art world, she was quoted in the *Christian Science Monitor*:

> Usually artists are not that concerned about who is President but this is a time when everyone must be concerned. I read all the New York newspapers every day and I feel that if people do not choose to be aware then they have to be prepared to take the consequences. I think it is dangerous not to be aware, not to be right out there rooting for a better world. I believe McGovern will stop the war. . . . We want a President who's a democrat, not one who thinks he's an emperor.[35]

Nixon won the election by a landslide. But the seeds of his downfall and resignation were developing, and ultimately he would be forced out of office for his "dirty tricks" two years later in 1974.

In the meantime, Nevelson continued to lend her name and physical presence to causes she supported. She participated in the press conference in December 1972 on behalf of Soviet Jews who were not allowed to leave Russia, and she was a member of Artists and Writers for Peace in the Middle East.

The causes Nevelson supported at that time were not only political, however. It was an essential part of her character that she would support other artists she respected and lend them the power of her, by then, quite sturdy fame by exhibiting with them. She presented some of her work in December 1972 at a small show at an alternative downtown gallery alongside her artist friends Sari Dienes and Lily Ente, whom she had known for decades. Lawrence Campbell, who reviewed the show for *Art News*, pointed out how important but, unfortunately, unrecognized were the works of Sari Dienes and Lily Ente. He noted that Dienes's collages prefigured Rauschenberg and perhaps also those of Joseph Cornell. Campbell had been on the art scene in New York since the mid-1940s, when he studied at the Art Student's League and became its resident intellectual. Of Nevelson he wrote: "Before [she]

achieved her great fame in the 1950s she was a largely unrecognized but first-rate sculptor."[36]

One of the men with whom Louise Nevelson flirted every time they met was Howard Lipman. In March 1972 she headed out to Scottsdale, Arizona, where Lipman—industrialist, local home-owner, Nevelson collector, and friend, as was his wife, Jean Lipman—had persuaded the city's fine-arts commission to hire her to create a sculpture for the new Scottsdale Civic Center.[37] The forty-thousand-dollar commission was financed by funds matched by the National Endowment for the Arts. "Scottsdale is the first 'small city' in the US to receive such recognition" and "naturally looked for the most creative, best known environmental sculptor available to execute the piece," the local paper reported.[38]

At an informal meeting in Scottsdale's city hall, everyone involved in the project gathered to study the various sites for the artwork and to discuss possible models. All present were deferential to Nevelson. When she was asked which sculptural model she liked best, she answered: "I prefer the first one that would permit you to see the transparency—you can see the mountains, [you can see] the cactus. I think we should have it bigger than it is and of course, there will be a base of the same material. . . . I think the landscape here demands it. Arizona is part of the sculpture."[39] Though previous works in the *Atmosphere and Environment* series were transparent, their transparency had never before been so central in the mind of the artist. While discussing timing and funding, Nevelson inquired: "When do you want it—next week? I am a fast worker."[40] The group laughed, little realizing that she meant exactly what she said.

The resulting sculpture, *Windows to the West*, or *Atmosphere and Environment VIII* (1973), was a few inches smaller than the earlier works of the series but seemed considerably larger because of its placement in the wide-open spaces of Arizona. It was felicitously positioned standing in a reflecting pool of water surrounded by a large, expansive lawn. And, just as the artist had wished, one could see the palm trees and local landscape through the open spaces that were part of the work.

The city reporter for the local paper, *The Phoenix Gazette*, wrote up the visit with great fanfare. Nevelson, who had managed to fit in a press interview and the purchase of a cowboy hat between three days of meetings with the commission members, is quoted as saying: "It is fortunate that Scottsdale has attracted people who are so mature and realize how much it will mean to the environment to have good art."[41]

A year later when Nevelson went to Scottsdale to install *Windows to the West* she met a young, artistically inclined teenager who was biking around the new Civic Center Mall where her sculpture was standing. That teenager, Wendy Furman, now an acclaimed artist, recalled: "We had a discussion about art. . . .

She took me seriously. She sat down and spoke with me for about half an hour. I asked her if she was still passionate about art." Nevelson's firm answer—yes— bolstered Furman's confidence in [her own] future as an artist."[42]

Nevelson's November 1972 show at Pace Gallery, entitled simply *Houses*, introduced three new series of works: *End of Day*, *Untitled Collages*, and *Dream Houses*.[43] Two beautiful large walls and a new series of sculptures in grids, *End of Day*, were the best work in wood she had done that year. They competed for attention with the *Dream Houses*, a series that mostly failed to rise to her compositional heights. The exhibition was on two floors of the gallery. On the lower floor was *City Reflection* (1972), a somber wall of great simplicity and strength. Unlike anything else on display, it consisted of a stark series of vertical spaces— actually a repeating series of three narrow planks adjacent to empty spaces—in which the variations in the height and width of light and dark evoked stunning emotional responses. There was just enough disparity in the size of the vertical modules to keep the eye moving across the work, leading to the surprise switch to a recumbent finale as the lower portion of the last four vertical spaces was a unit turned on its side and oriented horizontally.

Upstairs was *Star Reflection* (1972). Within a grid of equal-sized boxes, the artist had created a shimmering syncopation of small boxes, each containing a combination of organic and sharp-edged shapes. The variation in depth and positioning of the elements in the boxes set off a rapid rhythmic pattern, which echoed the complexity of the stupendous *End of Day* series.

Bill Katz, a friend and neighbor of Nevelson, had recently moved into a loft that had formerly been a printing shop and saw that hundreds of printers' trays were being thrown out on the street. Knowing of her insatiable appetite for interesting shapes and forms, Katz called Nevelson and asked if she wanted the trays. She said yes, and he quickly arranged to have them delivered to her Spring Street house.[44] Over the course of the year, she worked on them—usually at night, at the end of her working day—seated at a table in her living room.

Each tray was divided into four equal-sized sections, which were further divided into forty-nine cells, seven by seven. Nevelson had ready-made grids to play with. And play she did. Somehow the grid of the printer's tray, which was itself of pleasing proportions, served as a calming frame for her huge collection of wood scraps and shapes—including spools, wheels, wooden wedges, and Lincoln Logs—which she selectively inserted in the individual cells.

Complementing the prolific display of new sculpted works were twenty stark but stunning collages—the artist's first attempt in that medium[45]—combining torn and cut color paper, foil, sprayed newspapers, and spray-painted stencil images. "To occupy her evenings . . . she took up collage last summer, producing ravishing little assemblages in colored and black paper," wrote one journalist.[46]

She had made many of the collages at a house she had rented in Stony Point in Rockland County, New York, near her friends Merce Cunningham and John Cage.[47]

John Canaday praised the collages, claiming them as "marvels of that combination of technical self-assurance and instinctive sensitivity to what is just right that marks the works of first-rate artists at the height of their powers."[48] The *Arts Magazine* critic Ellen Lubell echoed Canaday's enthusiasm for the collages: "They share the particular ambience of the constructions, that is, of entities that seem to have magically appeared whole and ready-made, so strong is the sense of completeness, unity and finish."[49] Vivien Raynor, reviewing the exhibition in *Art in America*, disagreed: She saw the collages as "merely pretty" and in total contrast to the severe and majestic *City Reflection* in the same room.[50] The collages were far from pretty, rather they were severe and startling with their unpredictable combinations of contrasting shapes and textures. In that respect they were like the best Surrealist works characterized by unexpected elements fortuitously combined.

The works in the 1972 exhibition that most caught the attention of the critics were the *Dream Houses*. Ranging in size from twenty-three and a half inches by twelve inches by twenty-three inches (*Dream House II*) to 135 inches by twenty-nine inches by twenty-three inches (*Dream House XXXVII*), they resembled dollhouses with doors and windows fixed open. Full of small parts, often with barely enough room to contain them, they were different from anything Nevelson had made before.

Canaday enthused about the *Dream Houses* but most critics were careful not to go beyond faint praise. *Artforum*'s April Kingsley was overtly critical of the show: "All the work is cluttered," she wrote. "Every cavity is filled and each surface is articulated with wooden trim, knobs, molding, furniture parts, spools, and scraps chosen from an apparently inexhaustible inventory. Her obsession to add and fill amounts to a horror vacui. The works look like jigsaw puzzles of some Surreal cityscape lining the gallery walls and occupying much of the floor space."[51]

While Nevelson was working on these sculptures in March, she had explained to drama critic Louis Botto that she had always been interested in houses. "I call these sculpture houses. . . . My father was a builder. I wasn't out to imitate him, but there's something within me that will always bend toward a house."[52] Glimcher has always argued that Nevelson's idea for these works came from having seen a production of *Tiny Alice* by her friend Edward Albee.

But there may have been an alternate motivation—probably not conscious—for these overcrowded, often claustrophobic pieces, which seem so unconnected to Nevelson's characteristic compositional talent, on display in every other work

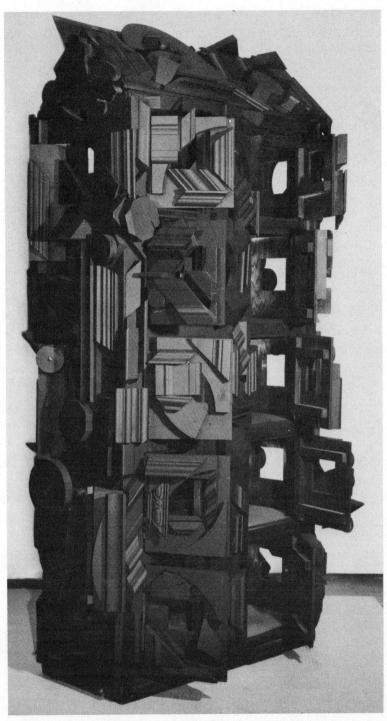

Sculpture House 2 or *Dream House XXXVI*, 1972. Painted wood, 54 x 28 x 12 in.
Private collection. Photograph by Al Mozell, courtesy of Pace Gallery

in the exhibit. Indeed, they seem to come from a frame of mind totally different from the one that made the *End of Day* sculptures, the collages, or *City Reflection*, a work of masterful minimalism. Nor can we dismiss the possibility that Nevelson's ambivalent thoughts and feelings about a woman's role as domestic ruler of the house and home played some part in their appearance.

In 1972, when Botto asked her about the origin of the boxes, she recalled the "horrible depression" she had experienced when her son was in danger during the Second World War. "I have a whole theory about motherhood—the guilts we have known."[53] Years later she expanded on this idea: "I think the greatest guilt of all is having children without thinking too much. . . . Some of us are not ready to be mothers. I have never been ready. My son is fifty-six and I still feel guilty, but I've done a great deal to overcompensate him for this."[54] The year 1972 was the beginning of her son's plan to help his mother with her bill paying, making sure that she had plenty of money in her account and was up to date on payments. Previously, when Con Edison had threatened to cut off her electricity, she had ignored the bills, stating that she would just use candles.[55] From 1972 onwards, Mike handled all Nevelson's bills, checks, credit cards, and so forth. Later Nevelson's friends would say that she was so guilt-ridden over her repeated abandonment of her son that she gave him total control of her financial affairs.[56]

Nevelson had been successful for more than a decade. By 1972 she was world famous and seemed more attached to her surrogate son, Arne Glimcher, and her surrogate daughter, Diana MacKown, than to her biological child, whom she kept at a distance. Mike was rarely included in her exciting life in New York City. But he was her only child, and he was trying to play a role in her life. She was proud of his being an artist, making wood sculptures in a style quite different from hers. It allowed them to continue their relationship as pals or comrades—as Marjorie Eaton had described the two of them in the early 1930s, but there was inevitable conflict and ambivalence on both sides.[57]

Sometimes, she would visit Mike's Connecticut home, where he would be refinishing antique furniture (which he did to make a living), and insist that he give her this or that chair or table, which she would then take back to her studio, cut up, and use the severed parts in her own work.[58]

For a decade Louise Nevelson had been giving her son money so that he would be free to make his own work. Mike's way of recompensing her had been to make boxes for her from the early 1960s. In 1972 he built the structures for the *Dream Houses*, determining where the windows and doors would be.[59] The artist had little choice about how many hinged doors and windows the *Dream Houses* would have and where they would be located. Her contribution was to add the architectural geegaws and decorative trim to the exterior and the interior of the ready-made houses. The mostly rigid regularity of the *Dream Houses*, for exam-

ple, in the size and placement of the windows and the doors—differs dramatically from Louise Nevelson's usual playfulness and unconventionality. Their bewildering over-muchness was alien to her characteristic style. Her sense of composition had never included an unmodulated series of unmodulated shapes. For a brief moment in 1972—just when Nevelson started her new series of *Dream Houses*, and at the start of a new financial arrangement between mother and son—her ambivalence about Mike seemed to overwhelm her own style, when she worked on the wood constructions he had created for her.

In early 1973, with the help of his lawyer, Mike Nevelson set up Sculptotek, a corporation that was designed to protect the money coming from Nevelson's sales. It was to be managed by Mike Nevelson and his lawyer, Maurice Spanbock. In the terms of the corporation, his mother was a worker producing art and Diana Mackown was an employee of his mother. Sculptotek paid salaries to Louise Nevelson and Diana MacKown. Effectively this meant that Mike Nevelson owned all of the work that was produced by his mother and subsequently sold to Glimcher at Pace Gallery. The existence of Sculptotek did not actually inconvenience Louise Nevelson and was evidently seen by both mother and son as just one more step in Mike Nevelson's attempt to help his mother with her finances.

One of the goals of this plan, not uncommon at the time, was to protect her estate from excessive taxes after she died. Arne Glimcher warned Mike, Mike later acknowledged, that it probably would not hold up in court.[60] According to one of Nevelson's granddaughters: "All the people involved in the new financial set up were either clueless about how to do such things or so greedy that they overreached."[61] The full consequences of this plan would not be felt until after her death.

On December 14, 1972, a huge Cor-Ten steel sculpture was installed at Fifth Avenue and Sixtieth Street.[62] *Night Presence IV* was twenty-two and a half feet high, just over thirteen feet wide and weighed approximately nine thousand pounds. Its style harkens back to her earliest works in wood from the 1940s—elegant combinations of abstract elements. Nevelson saw it as a Christmas present to the city in which she had lived for fifty years. "This city, more than Paris or Rome, is where most of the world's great minds and creative spirits are. . . . New York represents the whole of my conscious life, and I thought it fitting that I should give it something of myself."[63]

Arne Glimcher had arranged for the installation to coincide with the publication of his new book on Nevelson, entitled simply *Louise Nevelson*, which had just arrived in the bookstores. *Louise Nevelson* was praised for the stunning photographs of her paintings and sculpture and the informative text, in which analyses of her work were interspersed with her life story and her personal commentary.

April Kingsley, who had written one of the few negative reviews for the 1972 Pace Gallery exhibition, criticized Arne Glimcher for having written a book on the artist, given that he was her close friend and current dealer. "I question the ultimate wisdom of an unscholarly treatment of an artist of Nevelson's stature and would have preferred a professional's objective overview."[64]

Glimcher was not her only major proponent at this time. Martin Friedman, director of the Walker Art Center in Minneapolis and Giorgio Marconi, the young director of Studio Marconi in Milan, were about to bring Nevelson's works to the attention of thousands of Americans and Europeans through impressive traveling exhibitions in 1973 and 1974.[65]

Sometime in 1971 Giorgio Marconi, whose gallery specialized in modern and contemporary art, wrote a letter to Arne Glimcher saying he wanted to represent Louise Nevelson in Europe. Two years later Marconi held a large Nevelson exhibition in his gallery—eighty works were shown, almost evenly divided between sculptures from the 1950s and '60s, and sculpture and collages from 1972, which included nine works in aluminum. Marconi's taste tended toward the most avant-garde artists in Europe, and he was not afraid to follow Nevelson in whatever direction she went. She had made her name and fame with wood walls and wood assemblages. Marconi loved her work in wood but was also open to her work in metal, which she was just beginning to master.

The exhibit opened in May 1973 and was highly praised in the major Milanese paper, *Corriere della Sera*. "The show is a huge success," Marconi wrote Nevelson, "and the gallery is constantly crowded. . . . Sales are excellent and I think you will be happy with the results. I am especially pleased that so many of your pieces will stay behind in Italy. Thank you for giving me the possibility to get to know your work at such close quarters."[66]

Marconi arranged for the show to go to five other European cities after it closed in Milan: to Moderna Museet in Stockholm; the Nordjyllands Kunstmuseum in Aalborg, Denmark; the Palais des Beaux-Arts in Brussels; the Centre national d'art contemporain (CNAC) in Paris; and, finally, to the Neue Nationalgalerie in Berlin. Unlike many European dealers at the time, Marconi saw that a New York artist like Nevelson had important new things to say to the European art world: "It was the moment for America; Paris was in decline."[67] He saw Nevelson as a proponent of the new realism, since she was using objects from the real world, castoffs from the industrial world—and transforming them.

Nevelson and Marconi hit it off immediately. When they went out to dinner on her arrival in Milan, Nevelson gave him a silver tape measure from Tiffany's, saying, "With this, you can measure my sculpture in inches" (rather than the standard European centimeters). They both laughed and Marconi was charmed, and at the same time she jokingly made him aware that her innate

Gianni Ummarino/Studio Marconi. Louise Nevelson with Giorgio Marconi at Studio Marconi in Milan, Italy, ca. 1973. Archives of American Art, Smithsonian Institution

sense of measurement meant she would never rely on mechanical devices to tell her what her eye could plainly see. Her graciousness, elegance, and proud carriage convinced Marconi that "she was a woman who wanted to be aristocratic, a 'signora.'" But it was her determination and devotion to her art that made him love her. He recognized that "she was grasping her true moment in life with the awareness that opportunities can slip away too easily."[68]

Now, many years later, Giorgio Marconi's memories of Nevelson remain warm. "It pleased me to do things for her," he said. He understood her as an artist who had "chosen a kind of solitary life to concentrate on her work. She had the double personality of a man and of a woman—a man by temperament, but also a very feminine woman." Marconi helped build Nevelson's reputation in Europe in the early 1970s, but by 1975 he recognized that she had chosen Arne Glimcher to promote her—"Arne did everything for her. He made it possible for her to have a happy life"[69]—and understood that he should step back.

Marconi kept many of the Nevelson works he had exhibited in 1973 and regularly added to his already sizable collection. When Nevelson's son Mike was ready to sell off the estate after her death, Marconi bought thirty-five percent of the available work, which entered his Fondazione Marconi. He still promotes large exhibitions of her work—recently an exhibition in Rome in 2013, with sixty-seven works from his collection. As new movements and newer artists came along, some European dealers and critics lost their enthusiasm for Nevelson, but Marconi never did. His support was unwavering.

In Minneapolis, Martin Friedman, director of the Walker Art Center, was planning a large retrospective of Nevelson's wood sculpture that would travel to five American cities. On the first page of the exhibition catalogue for *Louise Nevelson: Wood Sculptures*, Friedman decisively sets out his agenda. The fact that the show was wood sculpture was prominently featured in the press release for the show: "Wood is indisputably Nevelson's medium. . . . Although she has . . . overseen the translation of several of her earlier wood pieces into large Cor-Ten steel sculptures, the genesis and essence of her art is in her special use of wood with which she creates seemingly weightless shapes whose iconography relates them to the past as well as to the present."[70]

Friedman's traveling American exhibition set the stage for what would become the conventional opinion in the American art world about Nevelson's sculpture: Her work in wood was superior to her work in other media.

Nearly three decades after the Walker exhibition, Friedman repeats the same story about Nevelson that he had always told the world: "She was destined to work with wood. It was more than sculpture—it was a fusion between sculpture and architecture. Her large wood works were depthless. Her best work was done in the 1950s and 1960s. She had an uncanny eye—an artist who could give substance to shadows."[71]

The catalogue includes photographs of ten details of large works from the exhibit, which allow one to experience up close her ability to transform the discarded shards of anonymous others. Friedman was the first to actually illustrate something critics had noted previously—the subtle details of Nevelson's wood sculpture warrant as much close attention as the overall compositions.

When Nevelson arrived in Minneapolis for the opening of the Walker exhibition she was good copy, and the press had been primed. Friedman had done a masterful job arranging for interviews, live TV appearances, a dinner party with major donors, and luncheons with the local journalists. One of the most savvy art writers to interview Nevelson was Don Morrison of the *Minneapolis Star.* He paid respect to Nevelson the artist and beyond this he intuited something more profound about her personality, writing that "she is grand furthermore as a person. . . . She assumes no regal pose, but radiates the unmistakable presence of one [who] worked around the clock in the most starveling years, who finally was recognized, honored and paid extremely large sums for her creations. Now 74, she still works around the clock because her work is the wholeness of her person."[72]

In his next article on Nevelson, a review of her show, Morrison spent much of the piece arguing for a cogent way to see Nevelson's assemblages—one very close to her own view. "The compelling power, the fascination, the mystery of her assemblages must lie in her gift of expressing a personal abstract vision by bringing together objects shaped by other hands for other utilitarian or orna-

mental purposes. . . . As one of the major artists of our time, her role has been to amalgamate whole histories of association and function into new configurations . . . this consolidates the million-fold detail into a single presence."[73]

While other critics and curators had noted Nevelson's gift of putting scraps of wood together in just the right way, Morrison comprehended her way of working as a collaboration with the numerous anonymous workers who had preceded her. This observation provides an interesting and new perspective on Nevelson's character. Though she united the scraps of wood made by diverse individuals with a monochrome tint, she allowed attentive viewers like Morrison to recognize the unique qualities of each piece of wood. The original scrap might be present only as a fragment divorced from its original purpose, but its shape and texture was not changed. The nails or nail holes remained. Nevelson had taken the fragment and made it part of a larger composition, like an orchestra conductor who artfully combines the many sounds issuing from many diverse instruments.

About a thousand people showed up at the Walker for the big opening, including Arne Glimcher, his wife Milly, his mother Eva, Dorothy Miller of MoMA, Mr. and Mrs. Douglas Auchincloss, and groups of wealthy art lovers from Cleveland and St. Louis.[74] Nevelson "was gracious and spoke to each and everyone of us who said hello or asked a question. Indeed her presence gave a complete aura of excitement to the entire show."[75]

Louise Nevelson: Wood Sculptures traveled to five major museums over the next two years: the San Francisco Museum of Art; the Dallas Museum of Modern Art; the High Museum of Art in Atlanta; the William Rockhill Nelson Gallery of Art in Kansas City, Missouri; and finally, at the beginning of 1975, the Cleveland Museum of Art.

Friedman had drawn his negative conclusions about Nevelson's metal work from her earliest attempts in that medium—the too-quickly-produced *Seventh Decade Garden* aluminum sculptures (1971) and the too-easily-dismissed *Atmosphere and Environment* series in aluminum and steel (1966–74). In *Seventh Decade Garden* she had not yet found her own voice; in the *Atmosphere and Environment* series, the rigid grid reduced her spontaneity, but not completely. Unless one studies those works carefully, it is hard to see her inventiveness. Ironically, she was just completing her breakthrough work in metal—*Sky Covenant*—at the time the Walker exhibition opened in the winter of 1973–74.

Nineteen seventy-three was a watershed year in American political life, as a Senate committee convened to investigate the break-in at the Democratic National Committees headquarters at the Watergate office complex. The country was mesmerized—eighty-five percent of U.S. households watched some part of the hearings that were broadcast live.

"I've been following the hearings regularly," said Nevelson. "You bet your life I have! While I'm working, I take my television and have my eye on it. I think if you don't, you're out of your mind." Nevelson understood the traumatic effect on the nation of this "second-rate burglary. . . . The issue isn't only Watergate," she maintained. "It isn't the Ellsberg case. It's the whole structure of American life. . . . What did [Nixon] want when he went to the White House? He wanted *uniforms*! And look at the way he treated the students—calling them bums. And when the veterans walked on his lawn, he was ready to shoot them. . . . For the sake of America and for the world, I would immediately demand a resignation."[76]

She offered this opinion to a reporter from *New York* magazine: "Each individual in the world, not only in America, will be influenced—as we were all influenced by, and still suffer from, the Communists, the Nazis in Germany, and the McCarthy era in America. So, of course, Watergate has affected my life totally, and I myself feel at this point in history as I've never felt on any public issue in my life."[77]

Louise Berliawsky Nevelson knew that politics could be a matter of life and death and that those who ignored the world around them might not survive very long. Cynical as she was about the many Americans who still didn't get the message about Watergate, she was nevertheless hopeful that the people she knew—many of them in power, like Nelson and David Rockefeller—would side with the truth and overturn the bad direction in which the Nixon White House had taken the country.

At almost the same moment that the show at the Walker Art Center was trumpeting the superiority of Nevelson's work in wood over her work in metal, she had just created one of her best metal sculptures, *Sky Covenant*. This pivotal sculpture has largely gone unrecognized as such in critical opinion. For the first time while using the primarily two-dimensional grid format, she began to experiment with movement in and out of three-dimensional space as never before in her work in metal.

In the previous sculptures of the *Atmosphere and Environment* series, all the cells in the grids were flat. She had played successfully with transparencies, all of which had been set up outdoors to be seen through. In *Windows to the West*, she insisted that the viewer be able to see through it to the desert. *Sky Covenant* was the first of the series designed to be set up against a solid backdrop, but she had figured out a way to dynamically offset the limitation of not having a landscape behind it.

Sky Covenant had been commissioned by the art committee of Temple Israel in Boston, of which Irving Rabb—an uncle of Dick Solomon, director of Pace Prints—was a co-chair.[78] An important art collector in Boston, he had made an eloquent and persuasive case for Nevelson and her work.[79]

Sky Covenant—twenty-one feet high, twenty feet wide, and weighing approximately twenty thousand pounds—completely covers a concrete wall to the left of the entrance to the new wing of Temple Israel. Made and installed only a month after *Windows to the West*, it bears an obvious connection to the *Atmosphere and Environment* series and is the last of that series. Like all the others in that series, *Sky Covenant* was made up of a grid of twenty-five equal-sized open boxes, each filled with Cor-Ten steel shapes. While the transparency of the overall work is not unique to this sculpture, what is original is the varied placement of the separate elements within the cells. They catch the light at different angles and complicate the overall design, which changes dramatically as the viewer walks back and forth in front of the sculpture.

Wedge-shaped triangular elements partially frame some of the cells that make up the grid. As the eye adjusts to take in the entire composition, these wedges become parts of larger circular or oval forms that echo back and forth across the whole. One result of the to-and-fro tilting is a constant flicker of light and shadow on the surfaces, silhouettes alternating with multileveled internal compositions, many of which have a formal integrity that would allow them to stand alone. Much like a kaleidoscope, each turn of the head or step along the width of the sculpture reveals new patterns that were neither evident nor even visible a moment earlier.

The artist was working with metal in much the same way she had been working for decades with wood. Flat metal scraps, which were once straightforward square or rectangular panels, now had edges with triangular bites or suggestive protrusions. These bits and pieces clearly had an earlier life as parts or remnants of someone else's sculpture. They are brought together here and transformed into a concert of glittering reflections or obtrusive outcroppings. The artist had not previously done such a symphonic syncopation in metal. By having the interior elements exceed their frames toward the viewer, Nevelson pushed herself beyond the aesthetic boundary that had constrained all her previous large-scale steel compositions. Photographs rarely make this particular innovation clear. And yet it must have been clear to the artist that she was manipulating dimensionality as never before in metal or in this series.

Perhaps the setting of the sculpture against a rough cement wall was an invitation to vary a style that was now five years old. In 1967–68 when she made her series of Plexiglas sculptures, the process obliged her to keep the variations within the grid relatively simple. With the technical expertise of the workers at Lippincott, however, Nevelson could do more or less what she wanted to do with the metal. Indeed the sculpture possessed what the Temple's architect, Greg Downes, had described as the "ordered complexity" that characterized all of her best sculpture and could in fact be considered her trademark compositional

aim—bringing order to chaos.[80] Perhaps just before she stopped using the grid format for her large-scale metal work, Nevelson felt safe enough with its familiar structure to leap off into space and launch herself into the fourth dimension.

According to the artist, *Sky Covenant* was supposed to communicate "spiritual movement."[81] In his remarks at the dedication, Rabbi Roland B. Gittelsohn observed that:

> You will not see obvious symbols when you . . . get your first look. Don't look for a menorah, don't look for a burning bush. . . . Look for the sum totality and see what kind of feeling that gives you. . . . This kind of art, at its best, is not too dissimilar from Torah. The beauty of Torah is that a person can read the same passage over dozens, scores . . . and on the hundred and first time, suddenly a new meaning, a new insight, which never occurred to him before spring literally out of the sentence or the words and grabs for his attention. . . . [T]he same thing is true of good abstract art.[82]

This extraordinary work was installed in December 1973, capping an extraordinary year for the artist. She had received three honorary doctorates: from Moore College of Art in New Jersey, from C.W. Post in Long Island, and, perhaps the most prized, from Smith College in Massachusetts, an elite women's college. By the end of her life she had been so honored thirteen times, with tributes including honorary doctorates from Harvard, Columbia, and New York University.

Nineteen seventy-four was also shaping up to be a good year for Nevelson. The Marconi exhibit was about to open at the Palais des Beaux-Arts in Brussels, after which it would go on to Paris and Berlin. The Walker show was headed to five major American museums, and Nevelson and her entourage would attend all the openings. The press coverage was fabulous, and many of her new works in the show had already been sold.

When the exhibition from the Walker Art Center arrived at the San Francisco Museum of Art, Nevelson stayed for three days, during which she appeared in her notable outfits and was wined and dined by the "crème de la crème" of San Francisco society.[83] She appreciated the warm reception, declaring: "I love it, I love it. . . . This is glamour and I love it." The day after she arrived she met with sixty reporters for a two-hour press conference in which she talked and talked and talked.

The art critic of the *Los Angeles Times*, Henry J. Seldis, devoted most of his article on Nevelson's show to the impact of her work on the viewer. "Wandering through the magic forest of Louise Nevelson's wood sculpture . . . one enters projections of spiritual essences which seem to have become ever more harmo-

Photographer unknown. Louise Nevelson during honorary degree ceremony at Smith College in Northampton, MA, 1973. Archives of American Art, Smithsonian Institution

nious. . . . Having evolved her personal mystical sculptural language, from an early concern with Cubism and a lifelong search for inner realities far more valid than overt appearance, Nevelson, at 74, has squared the circle by creating an art whose spirit is as elusive as its forms are tangible."[84]

Seldis then reported one of the most penetrating interviews the artist had given in years. Knowing of his obvious sympathy for her and his profound, respectful understanding of her work, Nevelson opened up. She made uncharacteristic observations about her childhood that illuminate her work and life. "For the most part I felt initially alienated from my environment and because of this feeling of rejection I was very shy and self-conscious. I knew that if I was going to be what I am now—a famous artist, a public person—I had this shyness to overcome." With years of study she had found her way past that shyness. Studying voice, dance, dramatics was all for the same goal: "I simply wanted to free myself." By her mid-fifties all that study had paid off. It seemed as if Sholem Aleichem's prediction of her future greatness would come to pass.

Nevelson explains to Seldis that it took her so long to achieve recognition, because of both "the public's failure to understand the need to create her own reality and . . . the negative attitude toward women artists which has been prevalent for so long." Then, just after she described how immune she was to the influence of others and how she didn't really care whether people were affected

by her work, she pivots: "I don't seek perfection or set out to make masterpieces. But I do hope that some people are moved by my sculpture just as I was moved long ago when first encountering Michelangelo."[85]

Next, Nevelson went to Paris and Dallas, following the shows organized by Marconi and Friedman. The month-long Paris exhibition, "The Permanence of Nevelson" (April 9 to May 13, 1974), was the artist's first retrospective in France. Frances Beatty and Gilbert Brownstone, who were obviously sympathetic to the artist's metaphysical notions, wrote the catalogue essay for the show. Opening with: "Each piece stands for a mystical world—a fourth dimension of endless allusion that is the essence of Nevelson. . . . Order and magic are the two principles in her work. . . . The control of animated, interacting elements through balance is the key to Nevelson—she refers to it as the skeleton of her work. . . . But it is also marvelously balanced, and filled with a purposeful tension."[86] The order that characterized her work was especially appealing to French critics as it fit well with the classical tradition in French art.

Some critics noted the blue lights in which the works were bathed. One writer, while acknowledging that Nevelson was unique and had neither antecedents nor followers, found the blue aura and the catalogue essay a bit much. He referred to the "mystical aspects" of the discourse about Nevelson with Gallic disdain.[87] Another French journalist called her "the grand priestess of American sculpture" and seemed truly respectful of her pioneer status and originality as well as her ability to inspire young artists—male and female.[88]

Michelle Motte wrote in *L'Express,* "A strange 74-year-old woman has arrived in Paris last Saturday to bring some order to her sculpture and to measure her own glory." Motte notes how well Nevelson plays her role as one of the great living American artists. The audacity of her repartee, her outrageous positions, her alluring royal gothic veneer, as much as her sculpture, are part of her art. She notes that Nevelson has become a surprising ally of women's liberation. In addition to her fight as an artist, she fights for all women: "Let us be ourselves, not slaves, but free people."[89]

Attending openings of her travelling exhibitions was not all Nevelson had on her calendar. In between Paris and Dallas, she met with her brother Nate Berliawsky in New York, where he had come with Herbert Peters, new chef at his hotel in Rockland, to discuss the festive opening of "the Nevelson room" in the dining area one month hence. The chef was astonished at Nevelson's energy. "She spent at least 15 hours in the two days with us, but she still did at least two days' work."[90] The gala opening of the Louise Nevelson Room at the Thorndike Hotel, where Nate had hung the oil paintings his sister had given him over the years, took place on June 21, 1974. In order to be at her brother's event, the artist had passed up a fête honoring Henry Kissinger at Nelson Rockefeller's Westchester estate Kykuit.

Nate had supported his sister through some of her hardest times in the 1930s and 1940s, when he was the only financially solvent member of the family. Reminiscing, Nevelson stated: "It is always nice to feel that you're well settled in your own backyard. And having the room [the Louise Nevelson Room] restores something to my brother and brings him a direct share in my particular work and accomplishments."[91]

While the socializing and traveling were going on, Nevelson was preparing for *Sky Gates and Collages*, another solo show at Pace Gallery New York, which opened in early May 1974 and filled two floors of the gallery. The largest work was *End of Day-Nightscape I*, an eight-foot-by-seven-foot wall, made up of fifteen *End of Day* panels—an enormous elegant composition made from printers' trays.

By this time Nevelson had discovered that when the individual works were combined, as in *End of Day-Nightscape*, the visual excitement reached a higher pitch. The viewer's eye was invited to dance to the visual fugues and gavottes she had created. If we let our eyes wander freely across such works, we soon discover their inherent harmony and the subtle interplay of lights and shadows, squares and triangles, rounds and rectangles. The artist seems able to guess just when we will get tired of a particular shape or configuration, so she changes the next sequence—either dramatically—or more slowly.

The newest works in the Pace show were the collages—a medium she approached with astonishing freshness every time she tried it. Now she was using corrugated cardboard and spray paint (her new toy), mixing the positive with the ghostlike negative traces of stencil shapes—an apparent randomness united with a deliberate compositional force. It seems Nevelson was repeatedly driven to create new formats and new versions, when she approached a familiar medium, as though the tried-and-true was never quite so satisfying as what had yet to be attempted or seen.

Hilton Kramer's review of the 1974 Pace show for *The New York Times* set Nevelson up as a spellbinding artist from the 1950s, who was still going strong at age 75. "Art: Nevelson Still Shines" was the title of his article, and he observed that "scarcely a week passes without some museum, somewhere, playing host to a sizable Nevelson exhibition,"[92] adding: "At 75, she remains enormously energetic and inventive, producing new work with an unrivaled copiousness."

As the year wound down, Nevelson did not. When Barbaralee Diamonstein, a long-time friend and admirer who had a weekly radio program, *Inside the Arts*, interviewed her for an *Art News* piece, Nevelson was at her candid, confident best. "John Cage told me recently . . . there's no room or desire for entertainment or vacation, and no matter how long he lives he can never do all he wants. I feel pretty much the same way. . . . My work is the mirror of my consciousness."[93]

She then said clearly and unequivocally that her work is about her feelings: "It [my work] contains the awareness of love, or sorrow, all the human emotions."

Diamonstein had great respect for Nevelson the artist and the person and, when quoting her directly, Nevelson always seemed articulate and verbally expressive. This was also the case with a few select others—either because the interviewers skillfully edited her words or because they rewrote her, intuitively understanding what she meant to say. Some people very dear to her—like June Wayne and Martin Friedman—remarked that, though they loved her and her work, they could barely understand what she was saying when she was on tape or on film. To them she seemed unable to express even the simplest concepts in an intelligible way—while many others were impressed with her profundities and her quips. A plausible answer for this paradox was the trauma in her early life that had, literally, left her speechless for six months.

At the end of 1974 the artist was preparing for a big trip to Asia and the beginning of her work on a chapel for Saint Peter's Church in New York City: an adventure and a challenge to which she could look forward with the wind at her back, given the accomplishments of the previous two years.

LARGE SCALE

1975 – 1976

"Working in the open is especially difficult as you are in competition with the scale of the universe. . . . Space is the greatest luxury whether it be in a room or out of doors."
—Louise Nevelson, *Nevelson at Purchase*, 1977

In January 1975 Pace Gallery had an exhibition of five American sculptors—Joseph Cornell, Alexander Calder, Isamu Noguchi, Louise Nevelson, and David Smith—five of the most famous American sculptors of the century. From late January to early March the Walker Art Center traveling show, *Louise Nevelson: Wood Sculptures*, was in Cleveland. In February and March Nevelson's latest work was exhibited at the Galleria d'Arte Spagnoli in Florence, a show organized in collaboration with Giorgio Marconi.

While these exhibits were up, Nevelson went with Arne and Milly Glimcher to Iran, India, and Japan—the biggest trip she had ever made. The United States Information Service (USIS) paid the expenses for Nevelson and Arne Glimcher, who gave lectures in all three countries. The USIS was the cultural arm of the United States Information Agency (USIA) and its main job was using public diplomacy to promote positive views of the United States. The travel was timed to coincide with exhibitions of Nevelson's work in Tehran, Bombay, Tokyo, Osaka, and Sapporo.[1] In a terse reference to this huge trip Nevelson simply said, "the State Department sent me."[2]

Nevelson never traveled alone but, according to the recollections of Dorothy Miller and the Glimchers, she was very easy to travel with.[3] Arne Glimcher explained that she usually solved the luggage problem by wearing all her clothes

at once (she took the rest as carry-on). "She'd put on about three outfits and then would stuff a plaid man's shirt and a fur vest in her bag. She used to say she was 'an atmospheric dresser.' It didn't matter whether it was summer or winter. What mattered was what was right for that day."[4]

The largest and most important exhibition of this international trip was held at the Minami Gallery in Tokyo. Kusuo Shimizu had developed the most avant-garde gallery in the city, showing Jasper Johns, Sam Francis, and Jean Tinguely in the 1960s, and Nevelson in the 1970s. As expected, attending the opening of Nevelson's exhibit were many well-heeled Japanese businessmen. More surprising was the sizable number of powerful Japanese women executives, including the celebrated fashion designer Hanae Mori, who was an icon for liberated women in Asia.

None of the high-status women were invited to the dinner following the exhibition. When Nevelson found this out, she was outraged and told Glimcher that she refused to go as a protest for her mistreated Asian sisters. He persuaded her that not appearing would be considered as an insult to her hosts. She agreed, knowing that she and Milly Glimcher would be the only women at the huge event.[5]

As part of the festivities the geishas who sat among the Western guests did a special dance to honor the Americans. Of course, Nevelson danced with them.[6]

Shimizu later wrote to Nevelson thanking her for her presence at the exhibit, which many considered the "best art exhibition for those several years in Japan."[7] He also expressed his gratitude for the lectures she gave in Tokyo, adding that she had impressed artists, critics, and young students "with her personality and inexhaustible strong will for creation."

The Glimchers and Nevelson traveled to Kyoto, not for an exhibit but to see the ancient city and its remarkable temples. The USIS reports on her visits were "all overwhelmingly positive."[8] In the *Hokkaido Shimbun*, one of the world's highest-circulation newspapers, Kegoro Kiji, a Japanese artist, wrote an article entitled "Louise Nevelson, Her Works and World": "Pieces of wood and fractions of furniture come to echo with each other, when collected and arranged by Artist Nevelson; they are no longer road-side wood pieces and legs of a broken chair; they start breathing by becoming an entirely different living body, and invite viewers to a world of fantasy."[9] Kiji had put into very few words what Nevelson always wanted to accomplish with her art. She felt appreciated and comfortable in Asia, convinced that her audience there understood her work better than in Europe.[10] The experience of being well understood in Asia continued to the end of Nevelson's life. She had learned that her meditative approach and metaphysical inclinations were entirely in sympathy with Asian cultures.

Aside from the warm welcome she received on her quick tour of Asia, Nevel-

son was able to visit some impressive sights, including the Blue Mosque in Tabriz, Iran; the Taj Mahal in India; and the glorious Buddhist temples in Kyoto. Seeing these very large, splendid sites expanded Nevelson's vision, and she would subsequently produce works that reflected her enlarged view. Her vision had also been expanded after visits to the towering Central American Mayan ruins in the 1950s. There she felt the magical power of Mayan and pre-Columbian art and began to identify with ancient architectural sculptors of the New World pyramids. That identification was an important, but mostly silent, influence, which led her to the first large wood walls in the late 1950s. It had also led to a new confidence in her own artistic vision. Many of the enormous artifacts of the cultures she had seen in Persia, India, and Japan were older than the pre-Columbian civilizations, and most were grander and more visible than many of the Mayan ruins hidden in the jungle. Visiting the monumental architectural works in the Middle and Far East moved her farther along the path of seeing herself as an environmental architect who could use large—even huge—works to change the perspective of the viewer. The influence of her most recent travels became evident in the large-scale steel sculptures that she made soon after her return, as well as in some of the enormous wood walls and architectural wood projects that would soon follow. In fact they informed much of her ambition and art during the next few years.

In 1975 she had three major commissions to complete: *Bicentennial Dawn* for Philadelphia; a large steel sculpture, *Transparent Horizon*, for MIT; and a chapel for Saint Peter's Church in New York City. Furthermore, she needed to produce new work for her next Pace Gallery show in New York, which would open in February 1976.

Transparent Horizon was the first of what would soon become an ongoing series of commissions for large-scale metal art.[11] The work was commissioned by MIT via their Percent-for-Art Funds. Since 1968, MIT had been using a fractional amount of the cost of all its new buildings and renovations for artistic purposes, and by 1975 it had amassed an outstanding collection of American art.

I. M. Pei, the architect for the new building, knew Nevelson through Glimcher (he had designed the latest iteration of Pace Gallery), admired her work, and selected her from a list of possible candidates to make the sculpture for MIT's new chemical-engineering building. When she met the university's Committee on the Arts, she was, according to Pei, her usual self—a presence, an imperial person—dressed in one of her striking outfits.[12] After looking at the various maquettes she had assembled for the project, Pei urged her to make the work large—something he usually asked of the sculptors with whom he collaborated.

Transparent Horizon was large—twenty feet high, twenty-one feet long—and weighed approximately ten tons. It is an amalgam of two earlier alumi-

num works, *Tropical Tree IV* and *Black Flower Series IV*, made in 1972–73. In late November 1975 Lippincott modified the two works to make them fit together as a new whole—a process Nevelson had long since mastered, and one that recalled her habit of recycling from the days of her work in wood. *Tropical Tree IV* was the smaller of the two, and *Black Flower Series IV* loomed above it, connected by a long, curving tongue-like shape. (This may be the reason why some MIT students described the work as "an elephant devouring a rhinoceros."[13])

The sculpture was installed in front of the Landau Building and dedicated on December 10, 1975.[14] Shortly afterwards, students buried it beneath a mound of snow, removing it from view for the winter. Spurred on by a zealous undergraduate who believed that art had no place at a school specializing in science and engineering, *Transparent Horizon* became a target of vandalism, a scapegoat for students looking to attack something—anything—about the university.[15]

An insightful student viewed the work several years after its installation:

> When I was an undergraduate at MIT (from 1978–1982), defacing Louise Nevelson's sculpture "Transparent Horizon" was a university tradition. It was generally known by any number of nicknames (e.g., "Transparent Hoaxes," "Random Horizons") which the irreverent residents called it. They regularly spattered it with paint, graffiti, food and, on Halloween, pumpkins in various stages of degradation. Some students griped that the sculpture had displaced the sandlot that formerly hosted a volleyball net; others complained that no one had asked the dormitory residents nearby about its siting.[16]

The students' frustration, then, had less to do with aesthetic concerns about the work, and more to do with the fact that they hadn't been consulted about its installation.

The tradition of MIT students defacing and denouncing *Transparent Horizon* quickly grew to such proportions that I. M. Pei was asked to intervene. He volunteered to bring the most vocal malcontents to meet with Nevelson in New York. When the group arrived at Nevelson's studio the artist was sitting on a dais wearing one of her elegant Chinese robes. Knowing that I. M. Pei came from an aristocratic Chinese family, she was determined to show respect by dressing in a way that honored Pei's ancestry. She was much less upset than the architect, who was very distressed that a valued work of art by someone he deeply respected had been desecrated. She surprised the students when she told them that she had no problem with their not liking the work. But according to Diana MacKown, Nevelson's underlying message was simple: "Even if you don't like it, you shouldn't damage a work of art. Protest some other

way."[17] Pei recalled that, "The meeting helped the [students] who didn't like Nevelson previously."[18]

Nineteen seventy-six was America's bicentennial year. Nevelson started on a high note, beginning with her huge commissioned white-painted wood sculpture in Philadelphia. The title of the work, *Bicentennial Dawn*, was pegged to the timing of its installation at the "dawning" of the bicentennial year in January 1976. The dedication was intended to be spectacular. And it was.

When it was time to look at the site for the sculpture, Nevelson was shown an ordinary lobby off a side street. She turned to the officials accompanying her and said: "Show me the whole building." She found a large ceremonial corridor separating the outside entrance from the inner part of the building and peremptorily declared, "I will fill it with art."[19] Given Nevelson's status in the art world at the time and her commanding presence, the architects and public officials agreed to her choice.

The contract fee was settled and she began to design the maquette, which was shipped to Washington, D.C., for presentation to Design Review Panel of the General Services Administration (GSA). Project architects along with Arne Glimcher convened with the panel, and a shouting match ensued. Karel Yasko, Assistant Commissioner for Design and Construction in the GSA, objected to the work, claiming it would be a fire hazard, a maintenance problem and an obstacle course, forcing people to zigzag around the work upon entering or leaving the building through the foyer. At the very least, Yasko wanted the bases underneath the three groupings of columns removed.[20]

Glimcher argued, convincingly, that, "Without the base, the piece doesn't work—the base is a unifying factor. If the bases are to be removed, the entire work will have to be redone."[21] As for the zigzagging, he explained that the sculptor "divided the spaces so that people are encompassed in the space and cannot avoid being exposed to creativity."[22] Yasko was overruled. A pleased Nevelson stated: "The GSA Art-in-Architecture Program allowed me to fulfill one of my major ambitions—the creation of my only major interior environmental sculptures in America."[23] It was the first but would not be the last.

Nevelson's ninety-foot-long sculpture, the most ambitious permanent work she had ever done, was designed as a "contemplative experience in search of awareness that already exists in the human mind."[24] Spread out over the glass-enclosed area, which is just over ninety feet long, the work responds to changing light from early dawn to late afternoon.

Three groups of white-painted wood columns are placed on platforms, which set them off from the brick floor. The central group is eighteen feet wide and twelve feet deep. Its total height is thirty feet, because several elements, including a half-round disk representing the rising sun, are fixed to the ceiling and descend

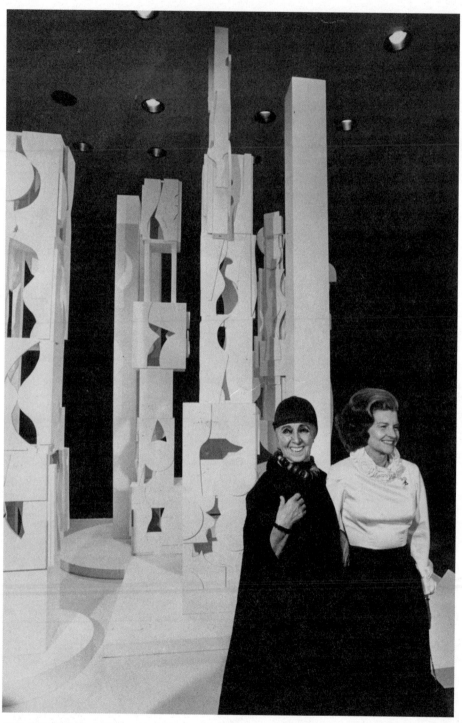

Al Schell. First Lady Betty Ford and Louise Nevelson standing with *Bicentennial Dawn*, 1976. *Philadelphia Evening Bulletin* photograph. ©Temple University Libraries, SCRC, Philadelphia, PA

to overlap the largest columnar group that rises eighteen feet above the base. The two side groupings are half as high—fifteen feet tall, twelve feet deep, and twelve feet wide. Single, tall, unadorned columns, six-by-six inches, stand in each grouping, anchoring the three separate compositions into a unified whole.

While each of the three compositional groupings has a strong aesthetic presence, the whole is remarkable as an integrated work. It is difficult, almost impossible, to see the entire composition from the front, generally a Nevelson preference. By insisting that viewers walk through and around the work, the artist forced them to experience its complexity. Each of the groupings has a complex coherence of its own, and when seen from several angles the parts work both alone and together.

The grouping on the left is sedate and compact. It contains a mix of unadorned tall rectangular columns, columns made of six boxes, and semi-humanoid vertical sculptures on bases. From some angles, the anthropomorphic figures seem to converse with their open-mouthed silhouettes facing each other—another witty Nevelsonian device. Nevelson was given to visual puns and no detail escaped her eagle eye. Most of these details are lost and seemingly unimportant in the face of the larger whole. After all, the brilliance of this work is that it works both as a sweepingly majestic ninety-foot-long structure as well as a series of intimate exchanges between a viewer and the work's details.

For the ceremonial dedication, a journalist who was present describes, "The lobby [of the courthouse] became a palm garden filled with gigantic plants; uniformed waiters and waitresses served drinks and exotic hors d'oeuvres; and a forty-two-piece orchestra played. . . . Tuxedoes and long gowns were the prescribed dress."[25]

Exactly on schedule, the five or six hundred guests moved toward the lobby area adjacent to the foyer as Louise Nevelson, President Gerald Ford's wife Betty, and other luminaries appeared on a platform from which they gave speeches praising the artist and the GSA's new administrator, Jack Eckerd. With its Art-in-Architecture Program, the GSA had just become the most important landlord and supporter of the arts in the United States.[26] The program had been mandated to spend half a percent of the construction cost of any federal building project on art. Nevelson's work cost $175,000—about one percent of the construction cost.

Together, Betty Ford and Louise Nevelson pulled the handle of a large ceremonial switch, and the orchestra played the opening notes from Strauss's *Thus Spake Zarathustra*. At the start of the music, the sculpture was in total darkness, then: "One by one, its twenty-nine columns were slowly illuminated until the entire sculpture was a blinding white. At that precise moment, the music reached a crescendo and fireworks exploded over Independence Mall in the background."[27]

Writing in the *New York Post*, Emily Genauer described the dedication of "the enormous white-wood sculpture in the new Philadelphia courthouse" as the "most exhilarating art event this week . . . in the whole country."[28] During her speech at the event, Betty Ford stated: "Our country can't go on without art and culture."[29] Louise Nevelson agreed: "The United States permitted a creation of mine to be given to the country. This is an historic thing. We can't forget. We must continue to feed the art spirit with government related art programs."[30]

Writing in his newsletter *Prometheus* about *Bicentennial Dawn*, Paul Makler addressed a phenomenon peculiar to some artists, Nevelson included, that it is difficult to fully understand or appreciate her work without actually being in its presence. "Nevelson has succeeded in making sculpture that creates an environment. Her work is at its best when one is surrounded by it. The environment she creates is full of familiar things and shapes but is still mysterious and evocative. Originally something in the artist evoked the art. Now the art functions to evoke new responses in the observer. Thus this art is a matter of interaction. Formal analysis will . . . describe the elements of rhythm, contrast and balance, but it will not address itself to the mysterious and surreal, . . . [which] gave the formal elements their reason for being."[31]

Bicentennial fever, matched by the now voguish feminism, inspired *Life* magazine in 1976 to issue a "Special Report: Remarkable American Women 1776–1976"—not just the famous ones, but rather a mixed gallery of 166 known and unknown women who had either done notable things or lived extraordinary lives. Subjects ranged from Eleanor Roosevelt to Lizzie Borden, Belva Lockwood, a lawyer, and Jeannette Piccard, at that time an illegal (in the eyes of the church) Episcopalian priest. Nevelson was included in *Life*'s "Remarkable American Women" feature, which pleased her, but she was put on the same page as Grandma Moses, which didn't. The magazine's editors recognized in both women their remarkable persistence, and quoted Nevelson: "I had no choice. Either you keep working or cut your throat. So if you wanted not to cut your throat, you kept working."[32]

Two big events dominated the fall coverage of Nevelson, adding to her sense of an enlarged status. One was Diana MacKown's book, *Dawns + Dusks*, which was effectively Nevelson's autobiography—done in the only way possible—through a compilation of many interviews she and other writers had had with Nevelson.[33] Nevelson was definitely not a writer but was almost always glad to talk, and MacKown was canny and persistent in her pursuit of Nevelson's life story via interviews.[34] MacKown described the process: "Over a period of four or five years, I'd just get out the tape recorder and record. She might get up at 4 a.m. and have a revelation. She'd start talking and I'd hit the recorder button and later transcribe the tapes and gradually I had a book."[35] The book's aim was

to capture the flow of her life and the nature of her many observations on human nature and everything else.

One of the promotional blurbs was written by *New York Times* art critic John Canaday: "I want everyone to love this book, and I hardly see how anyone who reads it can fail to."[36] Indeed, the book was a big success, not just in New York and other art-world centers but also in Rockland, Maine, where Ivy W. Dodd, publisher of the local newspaper, the *Courier-Gazette*, wrote enthusiastically to the head of publicity and promotion at the publishers Charles Scribner's Sons: "In this area where so many paint, pot or sculpt, there are many young beginning artists and I feel it's a must for them to read. To know what it really takes to be an artist and to create something worthwhile."[37]

Two years later Wendy Seller, then a twenty-nine-year-old sculptor, who has gone on to have a successful career as an artist and teacher at Rhode Island School of Design, wrote to Nevelson that she had read her book *Dawns + Dusks* twice: "I needed *right now* to know . . . that at 76 you were still on a perpetual high, and still growing, and still loving your work.[38]

It is a valuable book because it depicts the person with all her complex facets and was written (that is, spoken) by the artist herself. Sometimes the language is awkward, like that of a recent immigrant to America, but sometimes her eloquence shines through—she could be quite articulate, especially when she was passionately defending creativity. It becomes clear why Nevelson was often chosen to represent her fellow artists, as when she was president of Artists Equity.

The second big piece of news of 1976 was the public announcement and exhibition of Nevelson's model for the Chapel of the Good Shepherd to be created in Saint Peter's Church. This architectural gem would be part of the new Citicorp Center at Lexington Avenue and Fifty-fourth Street. It was not Nevelson's first commission of sculpture for a religious building, but in this instance she was being asked to design an entire chapel that would be a comprehensive sculptural environment in an important new building—Citicorp Center.

Lillian Mildwoff, the younger of Nevelson's two sisters, died on December 22, 1976, of pancreatic cancer, which was a devastating loss for Nevelson.[39] The two women had always been close, and spoke very often on the phone. But they had not seen much of each other for a long while because of Nevelson's long-lasting anger at her brother-in-law, Ben Mildwoff, as well as their very different lifestyles.[40] Nevelson visited Lillian a few times once she knew about her illness: The last time was within a day or two of her death, when she was on the way to a book signing. There was a touching moment of intimacy when Louise offered to share her cigarillo with Lillian and the dying woman took a few puffs.[41]

As with both of her parents' deaths, Nevelson was publically stoic, not

attending Lillian's funeral, but inwardly hit hard. The death of her favorite sister would have a profound sculptural resonance that became evident two years later.

For much of January 1977 Nevelson was involved in a protest action against the French government, which had released the Palestinian terrorist Abou Daoud, one of the leaders of Black September and mastermind of the murder of eleven members of the Israeli Olympic team at the 1972 Munich Olympic Games. On January 13, a few days after Abou Daoud was released, Arne Glimcher and Louise Nevelson sent a joint cablegram to the president of France, Valéry Giscard d'Estaing, urging artists, collectors, and humanitarians to withhold gifts to the new and soon-to-be opened Centre national d'art et de culture Georges-Pompidou at Beaubourg. "As Americans and citizens of the civilized world we deplore this example of official accession to terrorism."[42] Nevelson refused to send her promised work to the opening exhibition, saying that she thought the French decision recalled "the Hitler era, because it gives to the world another symbol of one person who can get away with terrorist actions."[43] Glimcher asserted that he would "never again do business with the Beaubourg."[44]

As part of their protest, Nevelson's beautiful white wall, *Homage to the Baroque*, never got to France.[45] The French art world was puzzled by the unexpected response to a pro-Palestinian policy, which had been in place in France for decades. One American dealer asked: "Doesn't anyone in New York know that for years it has been French policy to favor the Arabs at Israel's expense?"[46] Glimcher answered: "The issue is not a boycott based upon the sudden perception of the policy of France toward Israel; that policy was known. It is, rather, a protest of terrorism as a viable political tool."[47]

The Glimcher family was unequivocal in its support of Israel and all things Jewish. By joining with her dealer and friend in this protest, Nevelson took a strong public stand. Whether she would have done so without Arne Glimcher is impossible to know.[48]

Fighting for the forgotten dead of the Munich Olympics could have absorbed some of Nevelson's sadness about the recent death of her youngest sister Lillian. She also buried herself in work, her usual antidote for pain. And there was much for her to do in early 1977. A major exhibition of her metal sculpture was coming up in a few months at the Neuberger Museum in Purchase, New York, and she had to prepare twenty-two large metal sculptures. She also had to get *Sky Tree*, her largest steel sculpture to date, ready for installation in San Francisco by mid-February. In addition she was preparing a show for Pace, *Recent Wood Sculptures*, for November as well as working to complete the sculpture for the chapel at Saint Peter's Church, which would open around the same time as the Pace show.

In November 1976 Nevelson was asked to create a sculpture for the Embar-

cadero Center in downtown San Francisco. This was a $250 million, eight-and-a-half-acre redevelopment project funded by David Rockefeller and Prudential Insurance Company of America and designed and built by John Portman. The cost of the sculpture and Nevelson's fee ($250,000) would be covered as part of Percent for Art. Nevelson received the commission while the building was under construction, and when Arne Glimcher heard the news, he suggested she make "one of her trees."[49] Nevelson loved the idea.

The result was a fifty-four-foot-tall steel sculpture called, appropriately, *Sky Tree*, which would be installed in the atrium space on the ground floor and extend upwards through each of the building's five levels. Nevelson insisted that there should be vegetation—ivy or flowers—surrounding the sculpture at each level.[50]

"A Tree Grows in a Lobby" read the headline in the *San Francisco Examiner*: "A towering tree that differs in many respects from the forest variety—chiefly that it is made of steel, not wood—was planted yesterday in the interior of one of San Francisco's highest and most impressive skyscrapers. . . . The tree, which will be rooted in an atrium, will be watered by a reflecting pool. Lights underneath it will beam through the water."[51]

Before coming to San Francisco to dedicate the work, Nevelson had traveled by car from New York to Washington, D.C., for dinner at the White House. Ted Sylvester, a reporter from Rockland, writing for the *Bangor Daily News*, provided a charming anecdote about the event: "When President Carter wanted to invite her to the White House for dinner, he couldn't get through to her because of her having an unlisted phone number. Finally . . . the President convinced the phone company to contact Louise and ask her if it would be all right to release her number to him. As we hear it, Ms. Nevelson got quite a kick out of the fact that the President of the United States would go to so much trouble."[52]

"After dining with the Carters, she flew into San Francisco late Wednesday afternoon for a press preview, followed by visits to a local gallery and Gardner Tullis's experimental printmaking workshop," the *San Francisco Chronicle* reported. "The 76-year-old sculptor radiated vitality as she chain-smoked slim cigars and, alluding to Shakespeare and the bible, music and dance, talked about her most recent creation and its place within the framework of her art and life." "It's enclosed like a box," Nevelson explained to the reporter, referring to the buildings that surrounded the sculpture, towering against the skyline behind it.[53]

Sky Tree had developed from a wood maquette, which was then enlarged into a second model in Cor-Ten steel. It took its final form in February 1977 at Lippincott's, where Nevelson supervised the movements of cranes and forklifts involved in its creation. The sculpture was then hauled across the country and set up in San Francisco. Because of its immense size (twenty-nine tons), the

truck, was limited in the roads it could use, and took a zigzag route across America, covering over forty-one hundred miles.[54]

In an essay she wrote later that year, Nevelson described the process of going from a maquette to the large-scale public work: "I build up elements and tear them down and work until my eye is satisfied. When a maquette is enlarged . . . I never merely enlarge. I rethink and add and change edges and thickness of forms—as well as adding new pieces. My works are always in process until they are installed and, even then, I've made changes."[55]

Centerview, the local San Francisco paper, described the installation of the huge work in March 1977 as involving "wall-to-wall spectators . . . an excited news media . . . dignitaries from the political, business and art world . . . big band music and brass fanfares . . . picnic lunches and wine."[56]

Looking at *Sky Tree* from what appears to be its most photogenic profile, one can see how cleverly it matches the buildings surrounding and towering above it. Its curves complement the grids of the unadorned office buildings, but the straight lines and vertical thrust make it work perfectly well with its neighbors. Approaching the huge work from different levels and angles, it unfurls, at every upward step revealing new forms and shapes.

In his article in *Art News,* Thomas Albright noted: "As one moves upwards on the mall's escalators, the viewer is literally thrust inside the environment created, as one circles the sculpture on any of the atrium's three levels, an astonishing succession of vistas is presented. The gracefully organic forms of the *Sky Tree* rise in heroic counterpoint to the rigorous grid patterning of the skyscrapers, transforming and—in the best sense of this overused word—'humanizing' the view."[57] Nevelson made many trees during the 1970s beginning with *Night Tree* in 1971, the sculpture that led to her direct work in metal. Quite a few of those trees were grouped together creating environments—proverbial forests—*Seventh Decade Garden.* Some were so large, as with *Sky Tree,* that by their gigantic size they became the environment itself.

At fifty-four feet high, *Sky Tree* was the largest sculpture she had ever made—until she created a seventy-foot-high work for a plaza in New York City designed by and named for Louise Nevelson. David Rockefeller was a force behind both projects. Nothing was too big for the Rockefellers, and David Rockefeller had long been an admirer and promoter of Nevelson's work.

In March, Louise Nevelson and Claes Oldenburg were both awarded medals for artistic achievement by the American Institute of Architects. No doubt this pleased her immensely, as she had often described herself as an architect and her work as fundamentally architectural. Everything that year seemed to reinforce her enlarged vision of herself and her work.

On April 1, Nevelson took part in what was billed as "a dialogue" on "The

Artist and the Creative Process" in Cambridge, Massachusetts, with two hundred Harvard and MIT students. *The Boston Globe* noted that "she resembles a breathtaking lunar moth being stalked by an avid throng of butterfly collectors."[58]

When asked by the eager students how she got through long periods when no one was buying her work, she responded: "I never thought to question my art; it's like breathing to me. Without it, I would have to cut my throat. It is what gives me my sanity, beauty and life."[59] When asked the meaning of art she readily responded: "Art is the transcending of materials and presence—it is the highest place we can go." When asked for a comment on "feminist art," she was quick to say: "Our organs are different, so inevitably our approaches are."[60] At the same time, she observed: "What makes anyone think a woman can't do big things herself?"[61]

And, sure enough, she had just completed her largest works yet in steel and aluminum. Her recent travels had given Nevelson an impetus toward working large scale, but she had already been playing with scale when she worked with Plexiglas in 1967–68, particularly when she took the small-scale Plexiglas pieces and had them turned into large-scale steel sculptures. That process was too indirect and put the artist at too great a distance from the actual making of the sculpture, so it didn't last long. But in 1972 she or Arne Glimcher or both had had the bright idea of making a large-scale sculpture out of a small-scale wood piece, which she had done almost twenty years earlier—*Night Presence IV*.

Three years later something similar happened with *Voyage*, a work that would turn out to be a breakthrough piece. The thirty-foot steel sculpture, had started out as a "partnership" piece, which meant Lippincott and Pace Gallery each committed themselves to half the cost of the work done on spec and would split the profit once the work was sold.[62] Like *Night Presence IV*, *Voyage* was to be a blown-up version of a wood sculpture from the early 1950s, which consisted of four found-wood objects: an ax handle, a shovel handle, a piece of wood with a curved band-sawn edge, and a smaller irregular sphere penetrated vertically by an open cylinder.[63]

Sometime after the crew at Lippincott started work on it in February 1975, Nevelson and Glimcher came up to North Haven to see how it was developing. They placed the original small—relatively speaking—wood sculpture on the platform of the now-enlarged steel sculpture to see whether the change in scale worked. Nevelson decided that she liked the look of the very small piece sitting on the very large one and that she wanted a steel version of it to be part of the final work. Glimcher later called it a "rupture in scale."[64] In its Cor-Ten steel incarnation, *Voyage* was thirty feet high, roughly six times its original size as a wooden assemblage. And unlike *Night Presence IV* a miniature of itself was included in the large-scale version.

Voyage was the first documentable instance of Nevelson's play with drastic differences in scale in a single piece, and it seemed to liberate her. Soon afterwards she was doing things with steel and aluminum she had never done before. By the 1976 Pace exhibition, her works in both black- and white-painted wood were showing drastic shifts in scale.

In the early 1970s Jeffrey Hoffeld had come to the State University of New York (SUNY) at Purchase as an assistant professor of art history and director/ curator of the newly built Neuberger Museum in Purchase dedicated to contemporary art. As a college museum with ambition, it was billed as "The Art Museum of Westchester."

The Neuberger was unique. It was designed by Philip Johnson, and the largest of its many galleries (eighty-nine feet by fifty-six feet by twenty-two feet) had a black ceiling and windowless walls. Nevelson had visited the museum in 1976 to see the exhibit of theater façades done by Cletus Johnson, a young sculptor who had once worked for her. Hoffeld's policy in those early days was to show the work of unknown but promising artists, and Cletus Johnson fit that category.

As he showed Nevelson around, Hoffeld noticed that she was impressed with the building and its spacious interiors, in particular the largest gallery, which was almost five thousand square feet. He recalled, "She saw the challenge it presented to an artist."[65] Following a hunch, and though she was far from unknown, he asked her if she would be interested in having an exhibition at the museum. She accepted immediately. Hoffeld told her that she could have the large gallery to show "any group of works, as long as they had not been shown previously in a museum setting."[66] And a year later, on May 8, 1977, the first museum exhibition of Nevelson's large-scale steel and aluminum sculptures took place.

Two very large outdoor works, *Celebration II* and *Voyage*, greeted visitors. *Celebration II* (twenty-eight feet high and fifteen thousand pounds) stood at the entrance to the campus, and *Voyage* (thirty feet high and weighing fifty-six hundred pounds) was on the plaza near the entrance to the museum. Inside the building, two white-painted aluminum works—*Drum* and *Double Image*—ushered viewers into the large gallery with its grouping of monumental black-painted works. The sculpture filled four galleries and included seven Cor-Ten steel sculptures (each about eleven feet by twelve feet, with an average weight of four thousand pounds) and fourteen smaller aluminum sculptures (about four hundred pounds each).[67]

Don Lippincott and Nevelson's usual crew had put in almost seven hundred hours over ten weeks building wood platforms to accommodate the scale and weight of the sculptures and setting everything up in the large gallery. The artist and her dealer had directed the installation as well as the dramatic lighting to show these new works to best effect: "Overall darkness with spot lighting

brings out the spatial concepts that dominate Nevelson's sculpture and their relationship to surrounding space," wrote a reviewer in *Progessive Architecture*.[68] Hoffeld recalls that the works in the large gallery looked "majestic, powerful and elegant—as if the room were made for them."[69]

The effect of the whole exhibit inspired critics to heights of hyperbole. David Shirey wrote in *The New York Times*: "Like the magus she is, she has turned an enormous windowless hall . . . into something that is an entity unto itself, a singular experience, a Nevelson universe with its own beat, spirit, its own magic."[70] And, he observed, "Everything is huge One of the outstanding characteristics of this artist's sculptures is that they are monumental of scale," he wrote. "No matter what their size . . . they have such configurations, such internal thrust, such esthetic dynamism that they extend beyond their own dimensions and establish a harmonious rapport with the scale of the environment."

The Neuberger Museum at Purchase show gave Nevelson the opportunity to take her sculpture in steel and aluminum to a new level. Retrospectively there seems to be no question that the opportunity to exhibit so many large pieces in the huge gallery space coincided with Nevelson's perception of herself as an architect of work that could compete with all outdoors. Nevelson had been making large walls of wood throughout the 1960s and into the early 1970s. Going

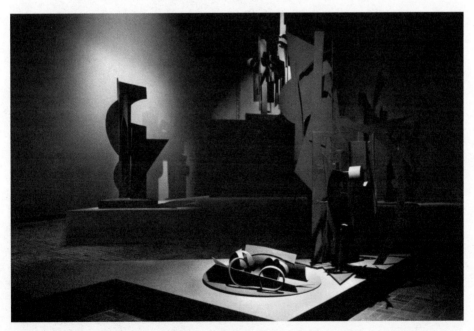

Lonny Kalfus for *The New York Times*. Installation view of Louise Nevelson exhibition at Neuberger Museum of Art, Purchase, NY, 1977. © Lonny Kalfus

from the early work in metal—the slapdash *Seventh Decade Garden* in 1971 through the laborious and not widely accepted *Tropical Trees*—Nevelson worked her way up to large, monumental pieces and the comfort of feeling that she could bring what she saw in her mind's eye into existence.

By the time the Neuberger Museum exhibit opened, she had done more than a dozen large-scale metal sculptures for outdoor spaces.

In an interview with Arne Glimcher, Nevelson described the relationship between her work with wood and metal: "In the wood, if there is a certain form I want, I will occasionally have to cut it. . . . When I'm working in metal, it is the same thing. . . . If I want a half circle, a quarter circle, or a rectangular form rolled into a curve, or whatever I want, [the men] have the technology and the machinery that can give it to me immediately."[71] She could not so readily make wood fragments curl into curved forms.

In his review of the Neuberger show, Hilton Kramer noted that Nevelson had easily made the transition from her earlier and more private work to "an essentially public art," which was entirely in keeping with the trend to large-scale sculpture appearing in the urban plazas, Government office buildings, shopping centers and huge sculpture gardens that were popping up all over the country.[72] With Lippincott's help, Nevelson had mastered the new mode. It was a perfect fit for a person who was not satisfied with the world as it was but wanted to create a different, better, and more harmonious world with her work.

No matter how grand her goals for her work, Nevelson was a warm, witty, down-to-earth, and extraordinarily energetic person with whom the craftsmen at Lippincott's shop worked with pleasure and deep respect.

The two interviews that follow, from Robert Giza and Edward Giza, came from a *New York Times* article about working at Lippincott in 1977:

> Robert Giza, 35 years old, has worked so closely with [Louise Nevelson as to be] her alter ego. Mr. Giza is a welder. . . . Before coming to work at Lippincott in 1967, he was a construction foreman and in his spare time repaired trucks. For the last three years he has worked six days a week, 50 weeks a year on sculpture, a good part of the time on Nevelson's [work].
>
> "Louise isn't like anyone else," said Mr. Giza, who has fabricated sculptures by Claes Oldenburg, Lucas Samaras, George Sugarman and other well-known contemporary artists. "She's the only one who composes on the site. Others work from models and drawings. She makes all her decisions in her head, then experiments with them in the shop."
>
> But it is Nevelson's zest for life that interests Mr. Giza almost as much as her art. . . . "I could listen to her for hours."

"She talks about everything—life, marriage, her shows, where she's been. I find it hard to believe she's 77. She has the energy of a woman half her age. There were plenty of nights when I'd go home and go right to bed. Yet she was back at 6:30 the next morning, ready to work."

Mr. Giza's older brother, Edward, 37, is the shop manager at Lippincott. . . . [He] admires Louise because, "she's in command," he said. "She doesn't like to be interrupted, and when she stops for coffee, she takes her whole crew with her. That's her crew—no one else's!"

He also likes the way she dresses. "She always wears that Indian necklace and a bandana on her head," he said. "She's got quite a flair for clothes."

But it's the way steel undergoes a metamorphosis when she's around that most fascinates him. Cor-Ten turning to butter? "Actually it's more like cardboard that's cut, folded, bent and attached," he said. "But's it's her approach that's so different. She creates as she goes along. . . . And we help her." . . .

"You grow attached to her things," Mr. Giza said, shifting his gaze to take in the full length of the 30-foot piece. "The one I like best is the other big one, [*Celebration II*], the 28 footer. It's got weight, design, everything. It also has something new in it that she's not used in her other pieces. It's a flat spring of steel. She couldn't do that with wood."

The Giza brothers take pride in "finding solutions to Louise's problems" and at times have even helped her make artistic decisions. . . . "We're craftsmen. We do the physical work, but the inspiration comes from somewhere else."[73]

In another interview with the Giza brothers, published in *The Boston Globe*, they say that they "enjoy their work because of the variety it offers and note that it has taught them to appreciate the art they once thought of as 'weird.' Now they argue with anyone who criticizes it. 'You learn quite a bit about art as time goes by,' said Edward. 'When you work with a piece, you feel like you're a part of it. Your feeling . . . is like the artist's. . . . We're like [the artist's] hands, or like seeing-eye dogs.' . . . As Giza observed, it is impossible to work with Nevelson without coming away deeply impressed by her energy and spontaneity."[74]

The huge works she had been making in steel, what she saw as their mystical, mysterious quality, were proof to the artist that she had arrived at a point in which she could create fourth-dimensional work and that others would recognize her accomplishment. As Nevelson understood her new position: "Your concept of what you put into a space will create another space."[75] Steel "gave me another dimension, . . . the possibility of maybe fulfilling the place and space

and environment that I have probably consciously, unconsciously, been seeking all my life."[76] Because *she* had made a work that went so far beyond the everyday human-size scale in which we all live, the gigantic size of Nevelson's very large-scale steel sculptures seemed to propel them into another dimension for her.

Commissions kept coming, placing her large-scale steel sculpture all over the country. At least nine works from the Neuberger exhibition later became full-scale public-art commissions and were placed in such cities as Cincinnati, Ohio; Kansas City, Kansas; Cambridge, Massachusetts; Miami, Florida; and Washington, D.C. *Celebration II*, which had stood at the entrance to the Purchase College campus, was subsequently bought by PepsiCo and installed in the corporation's sculpture garden across the street from the college.

Some of the impetus for Nevelson's large works at this time was certainly the enthusiasm for large-scale public sculpture. Many sculpture parks were established in the 1960s, '70s, and continued to be built through the '80s, and Nevelson's work was almost invariably included. But the principal reason she was eager to go big was her new understanding of herself that resulted from so many factors—the big trip at the beginning of 1975 and the many honors that followed soon afterwards, especially since they were often invitations to produce enormous works of art for the larger public.

"THE NEVELSON"

1967 – 1988

"Appearance is not skin deep. It is much deeper."
—Louise Nevelson, oral history interview with
Arnold Glimcher, January 30, 1972, Archives
of American Art, Smithsonian Institution.

Nevelson's move to the distinctive way she presented herself in public—the "persona" for which she became as famous as her art—was gradual. Its roots were in her early childhood, when her mother dressed her and her siblings for their Sunday promenade in fancy finery far beyond the acceptable garb for the puritanical town of Rockland, Maine. As a schoolgirl she continued the tradition by coming up with inventive fashion statements through hats she designed and ribbons she wore in unusual ways.

Louise Berliawsky Nevelson had gained many perks by being a beautiful young woman: marriage to a millionaire, funds to support her through the hard times after she left her husband. Eventually her good looks got her through the front door of her first art dealer's gallery. When her beauty began to fade, what had come naturally when she was young required ingenuity and flair. As she got older she became convinced that in order to lift herself up above other talented female artists and become better known, thus making her work more salable, she needed a more arresting personal appearance. Being different, she decided, meant looking different. Thus began the development of "The Nevelson," as her friend Edward Albee termed the persona she created and presented for public consumption.

Elizabeth Baker, former longtime editor of *Art in America*, acknowledged

John D. Schiff. Portrait of Louise
Nevelson, early 1940s. Photograph
courtesy of the Leo Baeck Institute

Nevelson's magnetism, her special "persona"—but described it less as a gift than
a Faustian bargain, a deal with the devil.[1] It helped her develop her career and
establish herself as a celebrity artist, but, like Faust, she paid a big price. Her
splashy gypsy-sorceress self became standard fare in her press coverage and
interviews, sometimes upstaging Nevelson the artist. Her charisma opened doors
and she as the artist walked through them. But what she found on the other side
was not always admiration and respect—but scorn, envy, and belittlement.

And yet, for a short period in her late fifties Louise Nevelson looked and
dressed almost "ordinary." Like many extremely attractive women, her fashion
goals focused mostly on turning heads whenever she appeared in public. But in
1958, as she told a reporter, she decided to change her appearance. For an article
in *Life* magazine, the photographer had her crouching behind her work with a
witch's hat and a touch of green. "I had felt I was glamorous," she explained,
"and then I saw the pictures, and I thought, Oh my gawd. . . . So I said to myself,
'Look, do you want this [notoriety], or don't you? If you don't want it, stop it. If
you do want it, forget it.' And from then on I never had another problem."[2]

By the mid-1960s, Nevelson began to show up in public in her increasingly
original combinations of clothing, jewelry, and headgear. Her sometimes out-
landish get-ups meant press coverage, and press coverage meant some attention

would be paid to her work. And if enough attention was paid to her work, Nevelson was convinced that she would succeed.

In preparation for the 1967 Whitney retrospective, Arne Glimcher arranged for Nevelson to meet Arnold Scaasi, a well-known dress designer, and asked him to create some outfits for Nevelson to wear at art openings or when giving talks around the country. When the press met Nevelson, Glimcher wanted them to see a celebrity.

Scaasi initially had fairly conventional ideas about how she should present herself—as a distinguished, older but elegant woman. He started by showing her some "little black suits."[3] She abhorred that approach, and he caught on quickly, rethinking his plan. As far as Nevelson was concerned, Scaasi was a tailor, a dressmaker. She was the designer and the assemblage artist. Together they selected the extraordinary brocades and luxurious fabrics he would put together for her—following her taste for sumptuous designs. For comfort he designed fur-lined outfits for her to wear against the cold to which she was susceptible. With Glimcher's support and encouragement, she could dress to the hilt and play the part of the "empress of art" for all it was worth without thinking about the cost.

By the time the 1967 Whitney retrospective had ended, Nevelson's persona had been set: "With her Tiparillo cigars, false eyelashes, crazy hats and the unconventional fashions she has designed for herself," wrote a *New York Post* reporter, "Louise Nevelson has clearly established that she is one of those marvelous off-beat characters who know they are characters, enjoy the image and never fail to live up to it."[4]

The story of her famous furry fake eyelashes, which became a key element of her persona, has a modest enough beginning. Arne Glimcher's wife, Milly, was wearing the newly fashionable false eyelashes one day in the mid-'60s, and when Nevelson saw them she insisted: "I have to have some of those." Milly bought the artist several pairs to try out.[5] As Nevelson later described the impact of her eureka moment to a reporter from *Women's Wear Daily*: "A magazine sent some young man down to make me up for a photograph. I saw what he did to me, and I thought 'This is insanity.' Little lines here and there. I couldn't stand it. So I got some lashes right away and I glued two, three pairs together. They just last forever and now I always wear them. I just love them!"[6]

No matter whether her work was admired or abhorred, Nevelson's persona—including her feisty frankness—often got her into trouble with some members of the small but influential realm of art critics and journalists. But everything she did, every scrap of fancy clothing she wore, every dramatic entrance she made, every outrageous statement—all of it was to get people to look at her work. Which is not to say that Louise Nevelson did not enjoy dressing up. She obviously loved it. At sixty-six, secure in her position as the grande dame of

contemporary sculpture, she proudly declared: "I've always been a little more radical than the rest."[7]

The flair for fashion that was an essential part of Nevelson's persona was formally recognized by the principal arbiter of the fashion world. On February 14, 1977, she received a letter from Eleanor Lambert congratulating her on having been named one of twelve women on the "International Best Dressed List of 1977." In the press releases, Nevelson was described as a "77-year-old American sculptor with 'immense personal style, who applies her own strong principles of art to her dress.'" The letter from Eleanor Lambert praised her for her "example of distinguished taste without ostentation."[8]

Lambert, the self-proclaimed Empress of Seventh Avenue, was a publicity genius from Indiana who had single-handedly initiated two of American fashion's most enduringly successful ideas—the forerunner to New York Fashion Week and an annual "Best-Dressed" List. During the 1930s she had been the first press director of the Whitney Museum and helped with the founding of the Museum of Modern Art. In the 1940s Lambert was a major force in elevating American fashion from rag trade to respectability, wresting the flag of fashion and haute couture from Paris and placing it firmly on the ground in New York. Her public relations firm, Eleanor Lambert Inc., had represented Salvador Dalí, Isamu Noguchi, and Jackson Pollock. A committee of magazine and newspaper fashion editors polled fifteen hundred international style experts to determine whose names would grace that year's Best-Dressed List. Lambert kept close watch on the results, which were finally determined by seven women and one man in her office—all powerful fashion insiders.[9] Tough, hard-working, and resourceful, Lambert's imprimatur made a huge difference to a designer's reputation. Being on Lambert's Best-Dressed List meant instant round-the-world acclaim, which Nevelson was delighted to receive.[10]

"Sculptor Is Stunning and Family Stunned" blared the headline in the *Beacon: The Boston Herald American* on February 20, 1977. Reporting from Rockland, reporter Ted Cohen interviewed the artist's brother and sister Anita about Louise's latest honor. Reacting with astonishment to the news, Nathan Berliawsky said, "I had no idea she was a well dressed woman. I didn't have the slightest idea. I didn't really." Her sister Anita was less surprised. "Whatever Louise wears is very expensive. I'd say she's an unusually richly dressed woman with expensive furs. I'd say Louise is one of the 12 most unusual women, but I didn't know that included the category of dress." Anita then recalled having gone to a governor's ball when she was traveling with her sister in Guatemala in 1951: "We didn't have anything to wear, so Louise went out and bought material which we draped around ourselves. Louise had taste. We looked stunning."[11]

Lillian had the keenest understanding of her sister's fashion sense: "She had

to feel attractive in what she was wearing. They could be rags, but she had to feel they looked good on her. She could pay three thousand dollars for a gown but won't wear it if she doesn't like the way it looks on her. And if she loves it, she'll wear it to death, even when it becomes rags."[12]

Nevelson had always enjoyed collecting exotic fabrics and clothes and was a master at putting together a costume that brought her attention—whether it was wrapping burlap around herself and pinning it together with a jewel, combining a caftan made of some priceless fabric with a velvet riding hat she had appropriated from her granddaughter Neith, or, more routinely, tying a babushka tightly around her head.

At first her public was fascinated and somewhat mystified by the appearance of "The Nevelson." And the reasoning she provided for her fashion choices was often quote worthy:

> "I'm like Charlie Chaplin," she said. "If I'm not dressed right. I can't talk."[13]
>
> "I learned to do this [stroking her scarf-wrapped head] so I don't have to go to the hairdresser. Think of the years I've saved myself from not going to the beauty parlor and all that."[14]
>
> "Off came the maxi to reveal a black midi dress with a [man's] Chinese mandarin smoking jacket topping it. 'I did quite a bit of the embroidery work on it myself. To be different of course.' "[15]
>
> "I enjoy the feeling of clothes growing older—developing a patina of wear—the clothes become yourself."[16]

Sometimes she openly acknowledged her desire to be glamorous and how she used it to support her right to be the center of attention. Referring to a dinner party to which she wore a Scaasi gown of embroidered Indian silk with a brown jockey cap, Nevelson said:

> "I thought my costume was grand; I wanted others to see it. I always say I'm building an empire—in art, in fashion, in life. I think that some of us are made for the grand gesture. I knew I had it, and it doesn't take much encouragement if you know you have it."[17]
>
> "Glamour counts. I don't like people to say to me, 'Mrs. Nevelson, you're a strong woman.' I turn around and say, 'I don't want to be a strong person. I want to be glamorous.' "[18]

Everything Nevelson said about her personal style was a facet of the truth, if not the whole truth. Only twice, perhaps, did her fashion mantras reveal something

deeper, not just a persona but a personality: "Art and life are the same thing to me, and fashion is part of life."[19] And "I am what you call an atmospheric dresser When I meet someone, I want people to enjoy something, not just an old hag."[20]

The dichotomy between Nevelson's reputation as an artist and her reputation as an attention-seeking fashionista could be fierce. A parallel dichotomy developed about her personality and whether she was portrayed as warm, generous, and charming, or vulgar, ostentatious, and totally narcissistic, depended on the sympathies of the writer.

In 1969, at the time of her triumphant exhibit at the Houston Museum of Fine Arts, for example, her two divergent reputations were hard to reconcile. Eleanor Freed who wrote an article about Nevelson for the *Houston Post*, described her as: "Approaching 70, she is a vital, electric sparkling woman whose entire life has been geared to the art of communication in which her work is the nerve center. . . . She communicates on the fourth dimension. Once in a while you are really moved by a person and are electrified by space."[21] By contrast Mary Buxton, the curator of the Houston exhibit, was shocked and dismayed by Nevelson's vulgarity, experiencing her as a hard-drinking, tough-talking, under-articulate exhibitionist, who was the epitome of excess and overdress.

In January 1971 *The New York Times Magazine* ran a cover story on Nevelson—"'I Don't Want to Waste Time,' Says Louise Nevelson at 70" which presents a complex portrait of the artist honoring her contradictory tendencies and dichotomies.[22] The article, written by Roy Bongartz, begins:

> There is cloistered in a secret Manhattan castle a fierce, dreamy fairy-tale goodwife in knit hat and flowing robe who has been high on her own strange arts for half a century, a benevolent witch who juxtaposes within herself old hot coals of anger and new white wedding delights of love, an indestructible great-grandmother who is completing a highly spiced, rocketing, despairing and rejoicing life by starting it all over again every morning. . . .
>
> Nevelson's great, labyrinthine walls of mystery boxes represent her spirit marvelously . . . the eerie sense that the collected whole is somehow always alive and growing combine to trouble a viewer deeply, as well as to surround him with a deep peacefulness at the same time.[23]

Then Bongartz notes what all the critics had been saying for years: "Within her are roiling unstabilized forces of arrogance and shyness, of selfishness and generosity, of disdain for the world and love for it, of anger and forgiveness, yet she contains an absolute identity in her person and in her work; even with all this going on she remains 100 per cent Nevelson."[24]

The following year Nevelson was on the cover of *Intellectual Digest*, shown standing in her studio surrounded by recent work. The photograph emphasized the most alienating and grotesque aspects of her appearance.

The accompanying article by journalist Louis Botto, however, is respectful and explains her in a way that credits her contradictory tendencies. Before commencing the requisite description of her odd attire and striking appearance:

> Nevelson . . . makes a startling appearance. . . . This very tall, very slender lady looks like a Mayan princess dressed for a Mardi Gras. She wears gold space shoes, a floor-length patchwork skirt of many colors and fabrics, a black blouse with a blue denim work shirt over it, at least a dozen necklaces (one created by her of cello tuning keys and the wheel of a child's go-cart, all painted black) and enormous silver earrings that strike her necklaces and punctuate her conversation with a tinkling sound. Her hair is completely concealed under a green kerchief. Dusky skin and long, thick false black lashes swooping over her eyes like Fuller brushes give her an almost austere look.

Nevelson was portrayed as distinctly odd looking in both the cover photograph and Botto's vivid verbal description. Nevertheless, he affirms her status as an artist "who may well be 'the most distinguished woman sculptor in America' and 'one of the great sculptors of the world.'"[25] Very likely she would not have been on the cover of the magazine or had the article written about her if she had looked like an ordinary seventy-three-year-old woman artist. One might assume that Nevelson's strategy—drawing attention to her extraordinary work by calling attention to her extraordinary self—had succeeded, much as she had hoped it would.

Consider the laudatory reviews of Nevelson's 1978 show at the Richard Gray Gallery in Chicago by critics for the two leading city papers. Writing for the *Chicago Tribune*, "Mastering the Fine Art of Being Louise Nevelson," Carol Kleiman sandwiches her acknowledgement of Nevelson's elevated status as one of the great twentieth-century sculptors—putting her in the company of Moore, Calder, and Giacometti—in between reviews of the woman herself: "She greets people warmly, although the near octogenarian, just off the plane from New York, has only had three hours sleep after a 'very late party I hated to leave.'" The predictable description of the exotic-looking artist came next, along with the customary giveaway lines: "Yet she is her own best creation. Her energy, that vast outpouring of creativity that is her daily life, permeates the respectful room." Then, without discussing any of the works in the exhibition, Kleiman provides a series of quotable one-liners about Nevelson's life choices—including,

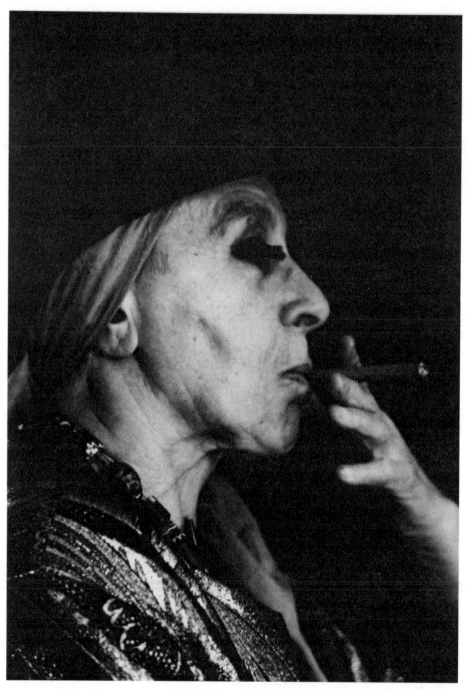

Basil Langton. Portrait of Louise Nevelson, ca. 1979. Archives of American Art, Smithsonian Institution. Photograph courtesy of Basil Langton/Photo Researchers.

"I never should have gotten married. I wanted to make art my creative act, like some women want to make babies. . . . My work made me a total woman."[26]

Kleiman starts with The Nevelson, and never gets to the art. The review of the same exhibit by David Elliot in the *Chicago Sun-Times*, makes no mention of Nevelson's persona but goes straight to her art and stays there. "Not very often have I seen a display of modern art that is so majestically assured and so ripe with the fullness of adult consolidation." Elliot describes his favorite piece in the show, *Rain Garden Zag VIII*, as a "work of great sensuality and wit, but also grave and noble like a magnetized gathering of modern totems. It sums up a great deal of modern art by achieving both distillation of form for form's sake, and also a tough unembellished strength of materials."[27]

That Nevelson's persona in combination with her art could trigger confusion in a critic's response was, in at least one case, responsible for an art critic's change of view. In early 1978 Charles Calhoun, the arts reporter for *The Palm Beach Post-Times*, had written a review of a Nevelson show at the Hokin Gallery in which he acknowledged Nevelson as "one of the greatest sculptors of her time and . . . a master of public relations."[28] Then, twenty months later, reviewing the Farnsworth exhibition when it arrived at the Norton Gallery of Art in West Palm Beach, Calhoun observed: "No one knows yet how closely tied the reputation of Nevelson's work is to her personal celebrity."[29]

Like some art-world insiders and critics Calhoun had evidently been turned off to Nevelson's art by her persona and public-relations skills. He was one of many who felt they had been caught off-guard by their own enthusiasm about her work, uneasy in the face of the spectacle that accompanied it. And, after they recovered from their initial experience with the persona, Calhoun and others were confused. Could the work and the showmanship be separated? If she were that good an artist why did she need the showmanship?

"If her work can hold its own among the best sculpture of the mid-century, then it can stand up to some de-mystification." With considerable candor Calhoun wrote that, "Partly as a result of the eccentric, mysterious sibyl-like persona she had created for herself in her later years, discussion of her work—and, even more so, of her career—is often obscured by a great deal of mush. . . . Some of the things I wrote two seasons ago . . . might qualify."[30]

Like Charles Calhoun, Edward Albee, a longtime friend and a great admirer of Nevelson's work, raised the following question in an interview in 2012. To what extent is Nevelson's reputation as an artist linked to—and dependent on—her personal celebrity?

He explained it this way: "Most people have a public personality and a private one. Part of the public personality is defense. It's a defense, but also it's fun sometimes. When she had to go out and be 'The Nevelson,' she knew how to do

it and was very good at it. It amused her. When I saw her for dinner and visiting she was never all dressed up, her hair was covered but she didn't care about all the rest."[31]

Noting that it had taken Nevelson over twenty years to be recognized as a significant sculptor, Albee spoke of the personal effect of this long-delayed success: It's fine that it took a while to be finally "recognized for the value she had."[32] But being "in the art world wilderness" for "a length of time" also produces "reactions." One was "her intense satisfaction. . . . The other was her anger." Albee implied that, "as much as she knew how to use her public personality, the accumulated resentment could have fueled an exaggerated and over-emphasized" version of it.

Albee is convinced that, "Louise the personality got in the way of appreciating Louise the artist. If you say 'Nevelson,' many people would not think of the work; they would think of the persona. She was out there selling the public personality more than anything else. That's bound to do damage. People begin to mistrust the work because the thing that is in public view—the persona— doesn't seem capable of doing anything of the value the work is supposed to have."[33]

Though Albee could certainly see how Nevelson used her persona, perhaps he could not see why she was so attached to it. He did not seem to recognize that, without the help of her splashy glamour, her art might not have achieved the success it deserved, nor could she have overcome the longstanding bias against women artists.

Richard Gray, director of the Richard Gray Gallery in Chicago, saw Nevelson differently. He was very savvy about the relationship between Nevelson's persona and her work, and understood their aesthetic power. In 2009 he observed that, "At the time Nevelson was coming up in the art world, in order to succeed she had to have an elaborate persona and be an unforgettable character. She could walk down the street and 99 percent of the people wouldn't have any idea who she was—but they would not not notice her. She was the flame surrounded by all the moths. You didn't want to touch her." He summed it up quite simply: "Nevelson was always costumed. But for her it wasn't a costume; it was an extension of herself. Just like her work, which was a conglomeration of disparate stuff with different histories."[34] Gray was clear that Nevelson had made it possible for women artists today not to have to make a spectacle of themselves to get people to look at their art.

At the end of 1983, reviews of Jean Lipman's large, lavish coffee-table book, *Louise Nevelson*, ranged from raves to pans, thus mirroring the art world's response to the artist at the time. Despite the beauty of the book, or probably because of it, many art-world people who were fed up with the limelight-seeking artist didn't

like it. Its size and production values were seen as either appropriate ("the book is as glamorous as the artist herself"[35]) or an unseemly act of hubris by both author and artist. Another writer opined: "All the books so far on Nevelson . . . are by people who seem to share at least some of their subject's mythical view of herself. [Lipman] is a close friend and avid collector of Nevelson's work and she has created the ultimate official court biography."[36] Yet another noted that, "Sculptor Louise Nevelson emerges as the arrogant grand dame, apparently a good deal more at home in *Harper's Bazaar* than in any serious forum of contemporary art."[37]

The "too muchness" of Nevelson's personality had exhausted many art-world people who otherwise admired her work. Vivien Raynor, writing in *Art in America* in 1973, noted that Nevelson has "become an instance of the artist surviving success. As we all know, one of the Catches 22 for 20th-century artists has been the premium rates paid for self-expression. It has so often made a mockery of their very inspiration, causing art lovers, if not buyers, to recoil. . . . To her, success has brought relaxation and more discrimination and, in consequence, the work no longer has to compete with the showbiz aura surrounding her and her lifestyle."[38]

Why, Raynor might have asked, couldn't Nevelson be more modest, more private, less in-your-face with a "show-biz aura?" More like Alberto Giacometti, who kept claiming that he was a failure. Or Georgia O'Keeffe, who had the good sense to live like a nun in New Mexico? But Louise Nevelson didn't give a damn what people thought of her persona or her self-confidence. If it was good enough for Picasso it was good enough for her.

In 1987 at the opening of a solo show at the Whitney Museum branch in Stamford, Connecticut, she once again stole the show. "Alighting from her limousine, she entered with her entourage . . . in a manner associated with the miraculous arrival of the Byzantine Empress Theodora," wrote a reviewer of the show. "Lights flashed from dozens of news cameras, hundreds of opening-nighters stared with awe, and a mystical moment of dumbfounded silence overtook the noisy crowd as She came into view. Swathed in a floor-length sable, layers of exotic caftans, shag-rug-thick false eyelashes, and capped with her ever-present turban, Nevelson succeeded in reducing the audience to kneeling supplicants. It was a memorable scene."[39]

THE CHAPEL
AND THE PALACE

1977 – 1979

"I was never accepted [in Rockland]. I was always on the out-
side. We never went to Sunday school like the rest. The other girls
would sleep with the sailors, then go to confession. But I would
never do anything like that, not until I was married."
—Louise Nevelson to Emmett Meara, "Sculptor Louise
Nevelson resents ostracism in Rockland as youth,"
Bangor Daily News, June 5, 1978, 5

The Erol Beker Chapel of the Good Shepherd at Saint Peter's Church in the
heart of New York City is one of the few modern religious buildings in the
world designed or decorated by an artist. The Matisse chapel at St. Paul
de Vence on the French Riviera and the Rothko chapel in Houston, Texas, are
two other well-known examples. Many factors came together to make Louise
Nevelson, a nonreligious Jewish woman, its creator.

In 1970 when New York City hovered on the brink of bankruptcy and some
corporations were moving elsewhere, Citicorp's CEO, Walter Wriston, initiated
a project to build the company's new corporate headquarters in the heart of
midtown. When one of Wriston's colleagues suggested that it was the wrong time
to be spending money in Manhattan, Wriston blew up: "This is First National
City Bank. We made a commitment to the city, and we're sticking with it."[1]
Mayor John Lindsay was delighted by the bank's plan and made it clear that he
would do everything to encourage the project.

Citibank bought the entire existing block in midtown Manhattan between
Fifty-Third and Fifty-Fourth Streets and Lexington and Park Avenues in order

to make room for what would eventually become Citicorp Center. The new building, the bank decided, would be for "mixed use" and replicate the vitality of the diverse group of smaller buildings (one of which was a strip club) that would be torn down.

At one edge of the proposed construction site, on the prime corner of Fifty-Fourth Street and Lexington Avenue, stood the seventy-year-old Neo-Gothic Lutheran Church of Saint Peter, whose innovative young pastor was Rev. Ralph Peterson. Saint Peter's staid congregation had selected Peterson because he was different from the usual Lutheran ministers and some members of the church's search committee recognized it was time for a change. They were also desperate.[2] The size of the congregation had fallen off, and only fifty to seventy-five people came to Sunday services.[3] Peterson's ebullience, vitality, and open-mindedness to new ideas fired up many in the congregation. He had been chair of the Jazz Ministry of the National Council of Churches, and the search committee knew that the arts were central to his understanding of humanity.

Soon after he became pastor in 1966, Peterson instituted some changes that established the church as a place to "celebrate joy and life." He initiated an open-house program, a noontime theater where *Jesus Christ Superstar* and *Elephant Man* were first staged and where jazz vespers and readings by poets and writers took place at night. Bringing artists into the public experience was part of his mission in New York City. "I think religion and the arts are intimately related," he explained. "Creation is an ongoing miracle."[4]

The old church stood in the way of Citicorp's new project. When the bank approached Peterson and offered to pay an enormous amount of money to get rid of the old building—which was in structural disrepair and costly to maintain—he saw it as "a fantastic opportunity." "Take it all down," he urged his congregation, "and use the property as a level to build the kind of urban church the times call for."[5] With a business savvy not usually expected of a minister, Peterson negotiated with the bank, allowing the old structure to be razed and an entirely new one built in its place. The bank agreed to set aside nine million dollars to pay for the construction, and the deal was done. And part of the deal was that the church would be a separate free-standing structure.

At that moment Peterson began to think about what he really wanted for the new church. He was familiar with Matisse's chapel at Vence, and he knew that he wanted to create a new kind of church that would serve as a "living room" for New York City—a place that would be an oasis for the spirit, where people could come to celebrate whatever spirituality suited them and become aware of the vitality—what Nevelson called "the livingness"—of life. His vision included an interfaith chapel designed by a major artist. While negotiating with the bank, Ralph Peterson made an executive decision that would lead eventually to Nevelson's chapel.

He knew that his ideas were grandiose, but Peterson had wisely selected for the church's Art and Architecture Review Committee a panel of experts who shared his vision. Nevertheless, his vision needed external support if it were going to be realized.

As noted before, in the late 1960s the Percent for Art program had been established and designated architectural projects were obliged by state or municipal law to include art. Citicorp was participating by budgeting one percent of the construction cost for artworks in the new building. The architects assigned to the large project realized that the only place in the new complex that could incorporate art into the design would be the church. Diane Harris Brown at Pace Gallery contacted Easley Hamner, the thirty-five-year-old architect at Hugh Stubbins Associates in Boston, who was responsible for designing the Saint Peter's portion of the new Citicorp complex and suggested that one of Pace's artists be considered for providing the chapel's "decoration." Nevelson, who had long been one of Hamner's favorite artists, quickly became Hamner's first choice and he recommended her to Peterson.[6]

Pastor Peterson had seen parts of *Dawn's Wedding Feast* at the Whitney Museum's retrospective in 1967 and again in 1973 at the Walker Art Center's exhibition in Minneapolis.[7] Nevelson's installations of white-painted sculpture matched his positive memory of a space of tranquility at St. David's House of Prayer at Korsvägen in Sweden, a building made of white wood roughly hammered together, which was both a meditation hall and a chapel. Peterson chose Nevelson as the right artist to design the chapel.[8]

The Saint Peter's Art and Architecture Review Committee agreed with Peterson and Hamner that Nevelson should design the chapel's interior, and once that decision was made the enthusiasm for the project picked up momentum. "Everyone got excited," said Barbara Murphy, a very influential member of the committee. "It just seemed so right and brilliant."[9]

The next step was a meeting—of the pastor, the architect, Barbara Murphy and the artist—at Nevelson's home on East Spring Street. Arriving on a Saturday morning at ten they rang the doorbell and waited and waited. Eventually Diana MacKown looked out the window, saw the group and, suddenly remembering the appointment, rushed down to let them in while Nevelson got dressed. Meeting the group in the second-floor living room, Nevelson felt instantaneous rapport with Peterson. "It was love at first sight," he said."[10] "It was mutual," she said.[11] She expressed keen interest in the project, and added, "I hope you brought lots of money."[12] Ralph Peterson blanched. But he too was eager to go forward with the deal. What was supposed to be an hour's meeting lasted four hours. Toward the end of that meeting Nevelson threw her arms around Peterson saying, "You old fucker, you're an artist like the rest of us."[13]

Soon afterwards Peterson, Easley Hamner, and Arne Glimcher drove to Great Neck, New York, to see the large white bema wall Nevelson had made for Temple Beth El. They were impressed, and in the men's room at Temple Beth El they agreed on the price Nevelson would be paid to design the chapel. Peterson looked to his congregation for a donor. By 1975, Erol Beker, a Turkish-born industrialist, had stepped forward with a generous gift that entirely funded the cost of the chapel.

In late 1974, Pastor Peterson formally commissioned Nevelson to design the five-sided interfaith Chapel of the Good Shepherd, twenty-nine feet by twenty feet and eleven and a half feet high, with seating for twenty-eight people. She started working on the project immediately, and by January 1975, using a wooden model twenty-four inches long and sixteen inches wide with a removable ceiling, she had completed two maquettes of the chapel. One was midnight blue and, as deemed by most who saw it, beautiful and mysterious. While Pastor Peterson thought that the dark version would be good for meditation, he thought Nevelson's white model was closer to his idea of "a place in which New Yorkers will be able to pray and know that they are alive, a powerful space and a great witness to the Spirit."[14]

Peterson and Nevelson were perfectly in agreement that the chapel should serve as "a 'tap root.' A 'jewel,' a 'symbol' . . . tranquil, a place for peace, reflecting permanence. . . . Its space has to accommodate the kind of prayer privacy we feel alone, sitting apart from others. Drop-in strays should not be herded together."[15] More important than any details, dimensions, or issues of space and money, the mission statement focused on the "dream." "We must not lose our focus 'outward' to the City and the commitment we represent to remain in this City and somehow to make it work better—to become a caring heart in the middle of Manhattan."[16]

For the two years Nevelson and Peterson worked together on the project and there were essentially no disagreements. Peterson assured Nevelson that "every element of the chapel would be her uncompromised choice. Never once will I tell you what anything should look like."[17] Because she wanted to create a "place of purity," she designed all the sculptural elements in white-painted wood on white walls. She designed the altar, the sanctuary lamp, three hanging columns, and the pastor's vestments as well as the placement of the pews. "It was New York City at its best," said Barbara Murphy. "Duke Ellington played at Saint Peter's. And now we had Louise Nevelson, the most famous American art star of the time"[18]

Two projects were going on simultaneously: the Citicorp building and the chapel in the church. Easley Hamner understood Peterson's progressive vision and worked with Hugh Stubbins, the architect for the bank's structure,

to develop a separate identity for the church, which would be sharing many common elements with the Citibank building, though no structural features. Working with the church's design panel and using "Life at the Intersection"— the planning document written in 1971, very early in the process, by Peterson and his team at the church—as template, Hamner looked in on meetings now and then. But when the panel members were close to presenting their plan to the bank, Hamner objected, saying that the space was too much like a church designed for a suburban community or a small city like Stamford, Connecticut. As an alternative, Stubbins proposed a box structure. But both Peterson and Barbara Murphy objected.[19]

The situation was becoming tense and awkward, but the bank gave the architects another month to come up with a new model. As was characteristic of Hugh Stubbins, he quickly and spontaneously arrived at a new design, which he scribbled on the back of a cocktail napkin or an envelope (depending on who's telling the story) while traveling. His new idea, a model of originality, was a cube with a slotted top.[20] It was not a particularly religious concept, but it worked. Stubbins's split wedge seemed to echo some of the novel qualities of the Rock Church, an architectural landmark in Helsinki that Peterson admired. Fortunately for Peterson and the future of the church, Citicorp's CEO, Walter Wriston, supported Stubbins's design.

While the new church was being built, Peterson had approached the rabbi at Central Synagogue—the oldest synagogue in America, which was a block

Photographer unknown. Louise Nevelson with Pastor Ralph Peterson, 1977. Source unknown.

from the new church on Fifty-Fifth Street and Lexington Avenue—about having Sunday services at the temple while Saint Peter's was under construction. The rabbi, Sheldon Zimmerman, welcomed Peterson's request, as such services would not interfere with Jewish services on Saturday. They even held some joint services with both the Star of David and the cross placed together on the bema wall.[21]

That the unveiling of Nevelson's model for the chapel would also take place in the synagogue was classic Peterson. It was also pure Nevelson. "I want to break the boundaries of regimented religion," she explained, "to provide an environment that is evocative of another place. A place of the mind. A place of the senses. I want people to have harmony on their lunch hours."[22]

For Nevelson, the chapel was simply "a holy place," as she told one reporter. To her, there was "no distinction between a church and a synagogue. If you go deep enough into any religion you arrive at the same point of harmony."[23] She also saw it as "a place to go in despair—find a quiet, warm beautiful place . . . where people can solve what bothers them."[24]

At one point Ralph Peterson had been asked about his selection of Louise Nevelson as the chapel's designer. He responded: "God is not a Lutheran. I don't think the background of the artist is as important as the inspiration. Nevelson was chosen because she is the greatest living American sculptor."[25]

Nevelson noted: "It speaks for the truly ecumenical and human spirit of this venture that the pastor and the congregation chose me, a Jewish woman artist, to do these designs. . . . In that New York project, those working on it together have managed to break down all the secular, religious and racial barriers by creating a community of goodwill. I hope other American cities will follow this example."[26] Like Peterson, Nevelson believed in breaking boundaries between religions, institutions, and anything that impeded a vital connectedness between people.

Nevelson's compositions for the chapel stand alone as individual sculptural elements as well as being part of a complete environment. Comparing the actual *Frieze of the Apostles* with the model she made earlier, it is notable that Nevelson imposes a more complex order on top of an already ordered composition—similar to the way she had organized *Sky Covenant* in Boston. She transforms the twelve quiet, boxed rectangles on the right with sweeping horizontals that both unify and enliven them. The thin strips weaving back and forth on the semicircular discs below the rectangle are another device that energizes the whole. Rarely simple in her choices, the artist adds some vertical elements to the right-hand rectangular portion of the sculpture, which provide continuity with the narrow, upward-pointing vertical element in the composition's center. She wisely removes three downward-pointing wood finials that had been in the

model and which anchored and interrupted the overall flow from right to left and back again.

The rectangular structure over the entrance to the chapel is entitled *Grapes and Wheat Lintel.* It is simpler than the other sculptures in the chapel, almost representational, yet its subtleties become evident with close study. The curving arch begins on the bottom left panel and continues two panels later on the lower right. The circular "grapes" of the fourth panel are echoed in the first panel, and the thrusting vertical sheaves show a syncopated rhythm from one end of the lintel to the other.

On the west wall of the small chapel is the very large *Sky Vestment,* which is difficult to see in its entirety because the bottom section is blocked by the pews. More than any other part of the chapel, *Sky Vestment* enforces the overall environmental aspect of Nevelson's design for the room. The huge triangular wall sculpture is particularly dynamic, with its diagonal elements aimed toward the top of the work. What look like giant clothespins crown the groupings of two or four slender shapes of pointed wood orienting the eye upwards. Depending on the viewer's state of mind, someone seated next to this large frieze might feel overwhelmed and small, or captivated and drawn upward.

Hilton Kramer, one of Nevelson's most steadfast admirers, was not enchanted with her work for the chapel. Writing that, "The chapel looks less like a homage to the glory of God than a homage to the glories of Cubism," he considered it an "odd conjunction of art and religion."[27]

A few days after Kramer's review, Easley Hamner wrote Kramer a private letter observing how different were their perceptions of Saint Peter's. "It is difficult for me to believe that most observers, whether knowledgeable about 'art' or not, can fail to respond positively to a visit to the chapel. [It] was intended to provide a place in which even the casual observer would be caused to contemplate that which no one can know. I feel that Mrs. Nevelson has indeed captured that sense of mystery which is part of the core of worship."[28]

In the end Nevelson herself was very pleased with the chapel she had decorated, which was to become one of her few environmental works to find a permanent home. "Being in a space that permits you to contemplate is like being in love. I meant to provide an environment that is evocative of another place, a place of the mind, a place of the senses."[29] To no one's surprise, the chapel has become one of the most popular sites for weddings in the city, particularly international weddings.[30]

The publicly celebrated dedication of her new white chapel took place two weeks after a surprise exhibition, at Pace Gallery, of *Mrs. N's Palace,* her largest-ever environmental wood sculpture—her own sacred and contemplative space. Many critics described these almost simultaneous "openings" as a battle between

two gigantic works of art. In retrospect, the situation could be understood also as a competition between the artist's two ardent supporters, Ralph Peterson and Arne Glimcher. They both loved Nevelson and her work and, judging from the extensive publicity each successfully generated, for the chapel and *Mrs. N's Palace* respectively, it seems they both wanted to be identified as her number-one supporter.

Peterson had worked closely with Nevelson on the overall concept of the chapel, as well as on it details, for several years. Glimcher had worked side by side with her on *Mrs. N's Palace*. When it was time for the work to be included in her forthcoming Pace exhibition, *Nevelson—Recent Wood Sculpture*, Glimcher took the remarkable step of announcing, in a quarter-page ad in the Sunday *New York Times* on November 20, 1977, that: "The Pace Gallery will be closed November 21 thru 24 for the installation of MRS N'S PALACE opening November 26." The Pace exhibition ran to January 7, 1978.

The Pace catalogue, beautiful as usual, depicted large and small black-painted wood sculptures (*Rain Garden Zags* and *Moon Garden Scapes*) and six photographs of the recently installed chapel, as yet without its pews. Also on view were photographs of "Selected Monumental Commissions," including *Sky Covenant* at the Temple Israel in Boston; *Windows to the West* in Scottsdale, Arizona; *Night Presence* in New York City; *Transparent Horizon* at MIT; *Bicentennial Dawn* in Philadelphia; *Sky Tree* in San Francisco; and the maquette for the Louise Nevelson Sculpture Garden at Legion Memorial Square in New York City. There were no photographs of *Mrs. N's Palace*, because it had not been finished by the time the catalog was printed, but it contextualized the work among her other monumental projects and environments.

Working from a cardboard model in a large rental space, a contractor built the basic structure of the "palace." In the following two weeks, with the help of two carpenters and Arne Glimcher, Nevelson constructed *Mrs. N's Palace*. Her largest single piece of wood sculpture, it measures twenty feet wide by fifteen feet deep by twelve feet high. Nevelson covered both the interior and exterior walls with black-painted-wood relief elements that she had been accumulating in her studio over many years.

The entire structure rested on a base of black mirror glass and was dimly lit with hidden fixtures.[31] Sculptural reliefs hung from the ceiling, protruded from the walls, and were grouped on the floor in such a way that they formed narrow corridors. Two schematically abstracted wood figures stood just inside the entrance of the room. According to Nevelson, they were a king and queen, distinguishable by their prominent sexual characteristics.

Less than a year earlier, Nevelson's beloved youngest sister, Lillian Mildwoff, had died after a brief battle with pancreatic cancer. Repeating a past pattern of behavior, Nevelson did not attend her sister's funeral. Instead, she built

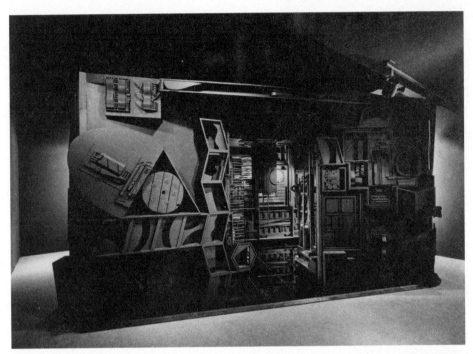

Mrs. N's Palace, 1964-77. Painted wood, mirror, 140 x 239 x 180 in. The Metropolitan Museum of Art, Gift of the artist, 1985. Photograph © Tom Crane, 1977; courtesy of Pace Gallery

a monument that would, as one of its purposes, commemorate a deeply felt loss. Unlike the earlier sculptural environment, *Moon Garden + One,* where the king stands alone in the sepulchral surround, in *Mrs. N's Palace* the king and queen are united for a last voyage into the darkness. The royal couple had been made by the artist many years earlier and saved until a suitable resting place could be found. Now they would be joined forever in a space worthy of their memory—a royal marriage preserved through death. As the artist said in an interview, "I couldn't have finished the king and queen until I found the right place for them, and [placing them] goes into creation, into space, into time, and into shadow That is the fourth dimension."[32]

As the piece neared completion she titled it *Mrs. N's Palace.* "Mrs. N" was Nevelson herself, as she was affectionately known by her neighbors in the downtown Italian community where she had lived for twenty years. The "Palace" was a fitting abode for an artist who had thought of herself for years as a royal person. Turning the scraps of wood she had accumulated into a setting for royal figures was the ultimate "projection of what might have been" a house in which she "would have chosen to live," as she later put it, one that evoked her oldest dreams and unconscious wishes.[33]

Stepping onto the black mirror glass, a viewer enters the remarkable enclosure and becomes part of Nevelson's world. To some, the space inside the room feels astonishingly large, as if one had truly walked into another dimension. To others it feels claustrophobic, as though they have just been seduced into a narrow-sided sepulcher. Most likely both of these sensations were part of the artist's life experience and conflicting aspects of her emotional life. For Nevelson, the imaginary world of her art represented a cosmic consciousness, an inner awareness that allowed her to both transcend and represent the everyday imperfections of the human condition through her art.

Time magazine's art critic Robert Hughes began his review of *Mrs. N's Palace* by describing Nevelson's physical appearance: "Nobody is more recognizable: the fine, blade-nosed Aztec face with its monstrous false eyelashes, like clumps of mink, is as manifestly the property of an artist as Picasso's monkey mask The traditional problem of dandyism is that it usually leaves so little room for work: it *is* the work. Not with Nevelson. She will be 78 next year, and there is no more prolific or respected sculptor in America."[34] He called *Mrs. N's Palace* a "masterpiece."

"When you step inside the 'house,'" he wrote, "some parts of it are invisible: darkness laid into darkness. As the eyes adjust, so the forms gradually appear, and this gradual unfolding of complexity is very moving. . . . There is no way of seeing *Mrs. N's Palace* as a whole. It discloses itself in time, and each passage of shapes is apt to erase and replace one's memory of its predecessor." Calling it both sculpture and shelter, Hughes concluded: "Collection, repetition, unification: these are the elements of Nevelson's poetic but wholly sculptural sensibility."

Most of the press reviews about Nevelson's white chapel and the new black palace in December 1977 and January 1978 focused on a relative assessment of the two works. It was an easy comparison—one room-size set of white-painted sculptures on the walls of the chapel was set off against a room of black-painted sculpture. Almost all the reviewers divided their discussion unevenly—the chapel usually got more attention than the palace. But the palace was nevertheless accorded great praise. In other words, critics saw them as a complementary pair, and they were marketed that way—the nearly simultaneous openings were no coincidence. Lila Harnett, the reviewer for *Cue* magazine, wrote: "Since the Pace show coincides with completion of Saint Peter's Chapel, the two environments invite comparison. White and black, open and sunny as opposed to closed and mysterious. Two sides of the artist? Nevelson leaves it up to the viewer." Harnett discusses the *Palace* only briefly after a lengthy discourse on the chapel.

Nevelson has constructed another very personal environment titled "Mrs. N's Palace" that she hopes to keep intact. She says this is the "pal-

ace" she never had. It comes "as close as any work to what I've wanted all these years." . . .

It is a Nevelson universe created with her distinctive wood vocabulary, and while she dislikes talking about individual works, she is quick to say that this black environment, this "palace," is dear to her. It seems to be a home in which her soul could live, with nooks and crannies to accommodate the secrets of her multifaceted personality. Compared with the more open, luminous white Saint Peter's chapel, this work could harbor her innermost thoughts, protect her past.[35]

Had Harnett intuitively discerned the artist's painful early life, filled with memories and fantasies of loss and fear in Ukraine? Though Nevelson would not ever discuss that part of her childhood, putting a royal king and queen—traditionally parental figures in Nevelson's iconography—at the entrance of this dark palace suggests that the artist has tried to reconcile her past and her present. She has given the unfulfilled individuals she knew her parents to have been an honorary position at the entrance to a transformed home. She now had the tools needed to transform that home into a royal palace.

After paying his customary tribute to Nevelson's "unremitting" productivity, Hilton Kramer, described the palace as—"a work of stunning beauty"—"a sculpture with an interior and an exterior conceived on an architectural scale."[36] He noted that usually after Nevelson's exhibitions closed and the works were dispersed, "All that remained of the whole was a vivid memory. *Mrs N's Palace* is thus the first such environmental construction designed to remain intact."

Since 1943 Nevelson had been creating "environments." At the Grand Central Moderns Gallery in 1958, she had closed off the windows and severely limited the lighting for *Moon Garden + One*. Every exhibition since then—especially when she or Arne Glimcher had control over the installation—was conceived of and created to be a unique, one-off environment. The 1967 Whitney retrospective had an irreplaceable corridor—*Tropical Rain Forest*. Two years later, the installation and the lighting of the show at the Museum of Fine Arts in Houston were both dramatic and virtually unreproducible. Even in the few existing installation photos of the Purchase exhibition, we can see the outsize steel and aluminum sculptures in a cohesive setting.

Fortunately, the two environments created by Nevelson in 1977 have outlasted the moment: *Mrs. N's Palace* is now owned by the Metropolitan Museum and the Chapel of the Good Shepherd at Saint Peter's Church on Fifty-Fourth and Lexington Avenue can be seen whenever the church is open.

For Nevelson, family was family, though longstanding friendships sometimes trumped blood ties. She was always in touch with her brother Nate and

Lee Brian. Louise Nevelson and family at Hokin Gallery, Palm Beach, FL; left to right: Diana MacKown, Nevelson, Neith, Neith's husband, great-grand-daughter Issa, 1978. Archives of American Art, Smithsonian Institution

sister Anita in Rockland. She also maintained a regular, if not always close, relationship with her son Mike, whose three daughters were now spread out around the country. In February 1978, when she was in Palm Beach for exhibitions at the Hokin Gallery, she was able to see her oldest granddaughter Neith, who was also an artist, as well as her great-granddaughter Issa, who lived in nearby Coconut Grove. Of all her three granddaughters Nevelson had spent most time with Neith, who had lived with her for about a year in the mid-1960s before moving to Florida. As her daughter-in-law, Susan Nevelson, recalled: "Louise was never motherly but was always involved behind the scenes."[37]

While Nevelson usually held her biological family at a distance, her friendships with fellow artists were much closer, sometimes appearing instantly and briefly as with Georgia O'Keeffe on a single visit, other times longstanding over decades, as with June Wayne or Marjorie Eaton. Her artist friends were her true family. She became very close to Merce Cunningham and John Cage, as well as Edward Albee and Jasper Johns. Merce Cunningham was particularly special to her because of her longtime interest in dance, and she gave several benefits to support his company.

In late May, Nevelson was interviewed for a downtown paper, the *Villager*: "Nevelson in Little Italy: The Artist as Godmother of a Community."[38] She talked about art, her neighborhood, her life, and her affection for New York City. Her neighbors loved her for many reasons, not the least being her

willingness to fight for the neighborhood and to work with her own hands to improve it.

"I met her when she was literally sweeping the block," said William Katz, a designer, who recalled her words from that time: "My dear, if you want to have a kingdom, you have to build it." Katz went right home and swept the street and sidewalk in front of his house.[39] Another neighbor, Joseph Guidetti, director of the Guidetti Funeral Home next door to Nevelson, observed that, "She has a very dynamic, energetic aura that she throws off. . . . Her energy is endless; like a communicable disease, you catch it. . . . She's a leader." Later in the article he noted: "She's respected by everyone—from the ten-year-olds to the eighty-year-old grandmothers. Everybody knows Mrs. N."[40]

Gennaro Lombardi, owner of Nevelson's favorite local restaurant, observed: "We needed leadership in this community, and we found it with Mrs. N. She's planted trees on the block at her own expense and hoses it down regularly." The reporter could tell how delighted the downtown community was when she had named the largest and most important work in her recent exhibition at Pace, *Mrs. N's Palace.*

The article ends with the tale of a dream that was never fulfilled. Nevelson had a plan to give her two adjoining houses on Spring Street to the city as her legacy. She consulted with John M. Johansen, award-winning architect and one of the Harvard Five, about turning her houses into a museum. During the 1980s, Johansen came up with a plan for the conversion of the buildings, but the project foundered because it lacked sufficient funding.[41]

"I lived in New York nearly sixty years, and it's been one love affair from the day I first put my foot in New York. New York is a city of collage. . . . It has all kinds of people, all kinds of races, all kinds of religion in it, and the whole thing is magnificent. . . . I feel that present, past and future, this city contains the greatest creative minds of our time. I love it and this is only the beginning of what I hope that I can communicate to this great land."[42]

In 1978, Legion Memorial Square, in the heart of the financial district, was turned into a small park, Louise Nevelson Plaza. Arne Glimcher recalls that, "David Rockefeller, whose office overlooked the newly empty triangle of land bordered by Maiden Lane, Liberty Street and William Street, called me one day, saying, 'Wouldn't it be a great idea for Nevelson to do a park there.'"[43] The city persuaded several downtown corporations to renovate the park as a community project.

On June 20, 1978, the City Council of New York changed the name of the triangular-shaped island in the financial district to Louise Nevelson Plaza—the first plaza in New York City named for an artist, not to mention for a woman artist. The new designation became official on September 14, 1978, when Mayor

Ed Koch dedicated the park with much fanfare and the by-now-standard release of balloons. Every detail of the park was designed by Nevelson—the placement of the sculpture, the paving stones, the benches, and the plantings.[44]

Nevelson was aware that, as with many of the buildings in downtown Manhattan, the skyscrapers surrounding the site were built so compactly that they resembled high mountains towering over a tiny valley: "In designing the work I had to consider the scale of the buildings nearby as well as the thousands of people who would use the plaza."[45] She had conceived of the space as a "people's park . . . which would serve the neighborhood as an oasis from the city's hurly-burly."[46]

Her plan included seven black-painted metal structures—one seventy-foot-tall work in Cor-Ten and six smaller (twenty-five-foot-high) ones in aluminum. While she paid attention to how the various sculptures would be viewed at ground level, she gave almost equal consideration to the visual perspective of the thousands of Wall Street employees who would gaze down at it from various floors of the surrounding skyscrapers.[47] Certainly she wasn't forgetting how it would look from David Rockefeller's office, sixty floors above the plaza.

The six small sculptures, which were placed on steel tubes, were designed to look as though they were flying like flags in the wind. Though some of these constructions have a strong aesthetic appeal, taken together they are not quite convincing as flags or even as works to be seen at eye level. This is not the case with the tallest structure in the plaza, which stands at the wide end of the triangle. It is the largest sculpture Nevelson ever made and—to my mind and eye—one of her most successful works in steel.

It reads remarkably well from every angle, always with a dynamism that builds from the bottom up. The tall, curving, square support setting off from the base plays against the gently leaning rectangular block at its side. The thin concave plates atop the tall, square support move the eye upward and into the composition of sharps and flats, which culminates in the piled plates at the top of the taller of the two principal square columns. A tour de force unfolds before our eyes as we walk around the piece to discover a precariously attached—could it be anything but precarious given its size?—pair of steel shapes seemingly suspended in midair. Finally, two thin tubes fly upwards, crossing themselves at mid-level and reaching toward the top of the towering buildings all around them, arriving as high as the fifth floor.

This large piece was recreated and became one of the two sculptural elements in *The City on the High Mountain* (1983–84) at Storm King Art Center.

At noon on Tuesday, December 12, 1978, at 1 World Trade Center, Kitty Carlisle Hart, chair of the New York State Council on the Arts, presided over the dedication of *Sky Gate – New York*, one of the largest wood sculptures Nevelson

had ever made. It was being hung in a prime position—the mezzanine lobby overlooking the five-acre plaza in front of the Twin Towers.

Nevelson had been one of the first artists contacted by Saul Wenegrat, who commissioned all the public art at the World Trade Center, as part of the Percent for Art program. At the dedication, she told the assembled audience that, on a flight from Washington, D.C., to New York City, she had looked out the window at the Manhattan skyline.[48] She transformed the vision of what she saw into a thirty-two-foot-wide, seventeen-foot-high and one-foot-deep sculpture of black-painted wood, which she described as a "'night piece,' representing the 'windows of New York.'"[49] Mrs. Hart observed how fitting it was that Nevelson was selected for the commission, recalling that the artist had once called the Twin Towers, "these two magnificent cubes."[50]

Sky Gate - New York was one of the many casualties of the attacks on September 11, 2001. It was lost along with works by Rodin, Calder, Miró, Nagare, Picasso, Klee, and Lichtenstein. None of the art that was destroyed in the World Trade Center attack was as precious as the 2,997 human beings who perished, but it was precious nonetheless.

In June 1978, Nevelson was interviewed by Emmett Meara, a young reporter from Rockland, Maine. "New York City is at my feet," Nevelson told Meara, who noted that officials at MoMA considered her wood sculpture to be among the finest in the world. "There is nothing that they would not do for me." Nevelson told Meara. "But," as Meara wrote, "smouldering still behind that regal countenance, is blistering resentment against Rockland, Maine." (The header of Meara's piece says it all: "Nevelson still carries bitter memories of Rockland.")

It was the city that she felt had shunned and, as Meara wrote, "ostracized her and left deep scars. She was tall, she was beautiful and talented. And she was Jewish. Even at the veritable top of the heap of the art community in the art center of the world, Louise Nevelson will never forget nor forgive her treatment in the coastal Maine city. 'If I never set foot in Rockland again, it will be fine by me. . . . I cannot be bothered with Rockland. It is not even a dot on the map.'"[51] But of course she had set foot in Rockland many times over the years to visit with her family. And ultimately she made her peace with the town as well.

The artist told the reporter she could still remember the names of the high-school classmates and teachers who snubbed her more than sixty years ago. But she also certainly remembered her champion, Lena Cleveland.

Between 1920 when she left and her return for a celebration in 1979, Nevelson had become a world-famous artist, but as far as Rockland was concerned, she barely mattered. Her accomplishments were only recognized, however belatedly, because the new director of Rockland's Farnsworth Museum, Marius Péladeau, wanted to put Rockland and its museum on the art world's map.

Péladeau understood and sympathized with Nevelson's outsider status since, with his French-Catholic ancestors, he too had grown up as an outsider in Yankee New England.[52] During his first week at the museum, while familiarizing himself with the collection, he saw Nevelson's *Bronze Bird*—a work the artist's sister Anita had donated in 1954—and at once began to plan for a Nevelson retrospective. A short time later he was introduced to Nate Berliawsky and immediately asked him, "What is it going to take to get Louise to the Farnsworth?"[53]

Nate promised to pass this question along to his sister during their weekly call the following Sunday. And sure enough, Louise Nevelson replied that she would be willing to talk to Péladeau. When the director telephoned, he explained that the museum wanted to give her a big exhibition. She responded, "What do we do to get this going?" He immediately offered her a show in 1979.[54]

In May 1977 Péladeau and his wife visited with Nevelson in New York to discuss the proposed exhibition. Péladeau wrote a proposal for the National Endowment for the Arts and received a grant that allowed him to upgrade the project by including many more works than originally considered. Lenders were generous, and plans for a large show began.

Little did Nevelson, Péladeau, or Nate Berliawsky think that these plans would lead to any change of attitude on the artist's part about her hometown. That development would unfold when Nevelson and her big exhibition arrived in Rockland in July 1979. In the meantime, from October 14 to November 30, 1978, Nevelson had her second solo exhibition in Chicago at the Richard Gray Gallery. The show presented some of Nevelson's latest works, including painted wood sculptures from the *Rain Garden* and *Rain Garden Zag* series.

The novelty in the Chicago exhibition was the emphasis on maquettes in steel as potential inspirations for corporate commissions. At least three of the four maquettes would eventually be commissioned as large-scale sculptures. The press release for the show emphasized Nevelson's many recent major public commissions, no doubt encouraging viewers to consider maquettes as models for possible large-scale public sculpture.[55]

Making large-scale public art was exactly the direction Nevelson wanted to go in the late 1970s, as it matched the moment of growing popularity for public art. For her, it was neither about money nor keeping up with an art world trend. She was getting older and knew she had not so much time left to establish her legacy. Monumental metal sculpture, placed in prominent locations around the country, ensured that she and her work would be known and remembered long after she had died. It also pleased her to know that she, as an aging woman, could keep on making sizable and significant works of art.

Nevelson functioned at Lippincott in a different way from other sculptors. As she worked in the shop, ideas would come to her, which could require consid-

erable changes in a sculpture as it evolved. For example, she might start working from a four-or five-foot-high middle-size "model"—as in the works done for the Neuberger Museum show in Purchase—and then "go big." Or she might make changes in the large pieces at their full scale. But over time she often found that the most effective way to add, subtract, or enlarge was to go back to the sculpture's original maquette.

As Don Lippincott put it, "The small maquettes were better for such purposes, because they could be easily moved around and, even more important, you could get your eyeball around them more easily than the mid-size works—which were the same scale as yourself—and imagine how they might look if enlarged to very-large-scale."[56]

An instructive example is the progress of *Sky Landscape II* from its first version as a direct welded aluminum work painted black (eight feet eight inches by four feet ten inches by two feet five inches), which was made in 1976 and exhibited at Purchase the following year.

The second version of this sculpture was a maquette done in 1977 and shown in Chicago at the Gray Gallery. This maquette was used as the model for the third and largest version of *Sky Landscape II* (nineteen feet high) done for the headquarters of Federated Department Stores Corporate in Cincinnati, Ohio.

According to the photos taken at Lippincott by Kate Keller in 1979, one can see that the workers used Nevelson's maquette for guidance in the fabrication of the seven-ton sculpture. Numbers were pasted onto each element, thus enabling the workers to match the smaller version to the large-scale work. Nevelson's presence throughout the process is a reminder that she could and did make changes to sizes, shapes, and positioning as the final work was being fabricated. Working exactly to scale was not what she (or most artists) wanted and would accept.

On January 30, 1979, at a private ceremony in the White House, Louise Nevelson, along with four other female artists—Isabel Bishop, Selma Burke, Alice Neel, and Georgia O'Keeffe (in absentia)—received awards from the Women's Caucus for Art.[57] All the recipients were over seventy-five years of age and were among the few women who had ever been given museum retrospectives. The ceremony was attended by Joan Mondale, the wife of Vice President Walter Mondale and the Carter administration's spokesperson for the arts, especially women in the arts. Afterwards, the honored artists met President Jimmy Carter and Rosalynn Carter.

Later that year Nevelson was again in Washington, speaking about her work and career with Barbaralee Diamonstein at the Smithsonian Institute. Diamonstein had frequently interviewed Nevelson for TV, radio, and print media. In an article written for *Art News* in May 1979, she described how the artist saw herself at age seventy-nine. Never at a loss for wit with a touch of sarcasm, the artist

TOP AND BOTTOM: *Sky Landscape II* (in progress at Lippincott, Inc), 1979. Cor-Ten steel, 240 in. City of Cincinnati © Kate Keller / Lippincott's, LLC

gladly made fun of herself and her "look." "I think candidly that I'm a bit dramatic." Talking about children at the Metropolitan Museum who recognized her, she remarks that without the bandanna and false eyelashes "they'd never know me."

"For all her confidence and joy in working, [Nevelson] confesses that the idea of reaching 80 troubled her. 'I never minded anything before—60 or 70—but to confront eighty is quite a problem' she says. 'It isn't that easy, it takes a *lot* to tango.'"[58] And on the cover of the *Art News* issue in which this article appeared is a large photo taken in 1977 by Hans Namuth of Nevelson standing in front of her white sculpture for the Chapel of the Good Shepherd, wearing a bright-red blouse, a bandana, her trademark eyelashes evident, and sporting one of her huge, sculpted pendants.

Now back to Rockland: Jeffrey Hoffeld at Pace Gallery, who had curated Nevelson's show in Purchase, handled all the details preparing for the coming show in Rockland and was the gallery's representative during the event.[59]

By the time the show opened at the Farnsworth Museum in July 1979, the Rockland City Council, on behalf of the citizens of Rockland, had resolved officially that: "Whereas Louise Nevelson, a childhood resident of Rockland, has attained international renown in her chosen field of sculpture, and whereas she has been acclaimed as 'one of the foremost sculptors of our time,' . . . the Rockland City Council . . . hereby pass this resolve in honor of Mrs. Nevelson, acknowledged as a 'superstar in the world of art.'"[60]

In the run-up to the 1979 exhibition, Péladeau had raised eleven thousand dollars to buy for the Farnsworth Museum a white column from *Dawn's Wedding Feast*—one of Nevelson's works from her groundbreaking 1959 exhibit at MoMA. He had reminded possible donors that the Nevelson show would bring international prestige to the town, as well as numerous visitors whose presence would help the local economy. Moreover, the show would be traveling from Rockland to museums in Florida and Arizona, and the Rockland businessmen would be rewarded with notices listing their sponsorship of the exhibition.[61]

Given how much national and international publicity the Nevelson exhibition had garnered for the town and the museum, and how enthusiastically the citizens of Rockland had supported the three-day event, it is easy to understand why both the artist and Henry "Tim" Russell—the director of Boston Safe Deposit and Trust, the major corporate sponsor of the Farnsworth Museum—were beaming in a photograph taken at the celebratory luncheon on the day the show opened, as well as the gala champagne reception and panel discussion with Barbaralee Diamonstein.

Nate Berliawsky, who had always been a beloved and familiar figure in the town, attended all the festivities with his famous and glamorous sister. She could

Diana MacKown. Louise Nevelson and Nate Berliawsky in Rockland, ME, 1979. Courtesy of Diana MacKown

be seen on *Sunday Morning Live* on CBS, at the Farnsworth Museum, as well as at the festivities that French and Swiss national television networks spent four days filming. During her entire stay the siblings were always together. She was delighted to share her success with the man who had done so much to make it possible. As with his father, Isaac Berliawsky, Nate was able to connect well with his fellow townspeople. It had always been easier for a man, especially a genial businessman, to be accepted in Rockland. Unlike the women in their families, they were forgiven their otherness as Jews in a Yankee Protestant town.

Jan Adlmann, a fellow Rocklander who had become a successful art historian and museum director, was invited by Nevelson to write the essay for the exhibition catalogue.[62] His mother had grown up next door to Louise Berliawsky and had been on the basketball team with her. Adlmann had known Louise when he was a young child interested in art and saw her whenever she came to town. He had also kept up with her later in New York when he lived near her Soho studio.

One of the high points of his catalogue essay was the way he compared Nevelson's work to music:

> As in a musical composition, a Nevelson . . . cannot be grasped instantaneously; its impact must build, and is cumulative. . . . Steady viewing

reveals new harmonies from moment to moment, new counterpoints and new variations. . . . Living with a Nevelson wall . . . might be likened to having one's rooms papered with the score to *The Magic Flute*—new profundities and new felicities constantly renew one's perception, spring wonderful surprises, and replenish satisfaction from day to day.[63]

He ends his essay with a reference to the artist's spirituality: "Nevelson emphasizes . . . that hers has always been a feisty struggle towards 'awareness.' . . . In her quest for transcendence, she has never faltered as one of the modern world's most original advance guards."[64]

Close to twenty thousand visitors saw the sculpture during the two-and-a-half-month-long exhibition.[65] For Nevelson it was "the thrill of her life."[66] She had developed the skill of saying the right thing to the right person at public events, as had been noted by gallerists who were glad to have her charismatic presence at openings. But, on this occasion she was very likely telling the absolute truth.

Posters and photographs of Mrs. Nevelson filled shop windows along Main Street. "The indefatigable Mrs. Nevelson, long known for her dazzling dress and outspoken opinions, seemed to enjoy every minute of her three-day visit," one reporter noted. "Whether conducting a press conference, posing for a CBS film crew and news photographers, or capping off a champagne reception at the museum with a late-night visit to a Camden disco, Mrs. Nevelson's enthusiasm for her homecoming visit never seemed to flag."[67] "As far as I'm concerned," she said at the museum's reception, "life begins at 80 and I'm having a ball.'"[68] All the press reports noted the artist's remarkable energy, warmth, and friendliness; according to one reporter, she had "the same feeling for people as her brother, Nathan Berliawsky."[69]

At one of the events, the artist spoke candidly to the Mainers who had come to see her. "You add a dimension of awareness every day. . . . Otherwise you have no reason for living," she said. She was also very outspoken regarding her childhood in Rockland. "I had every reason to be shy so I learned to project. That's why I studied dance and drama. I wanted my life to be full. You can't take off one skin and put on another. You go with what you've got and you feel right."[70]

Nevelson was talking about feeling "right" in New York, not in Rockland. Sweeping into the room twenty minutes late, as one Maine reporter noted, she graphically described to the assembled media how she and her family experienced life as immigrants in Rockland. "When you come here and don't speak the language, you do become reticent. There were many negatives. I was affected and so was my mother, who retreated within herself." After noting that Rock-

land "hasn't changed all that much," Nevelson described, her home in New York: "It's not static I'm constantly recomposing little things. My home is [always] in a flux."[71] And "I could not have fulfilled my life anywhere else but the greatest city in the world. I needed a wide stage."[72]

"The questions from the media were polite and non-controversial. No one asked her if she resented Rockland for having ignored her work for so many years. . . . She was asked about her philosophy of art and how she related this to today's world." One local reporter pointed out that, "Most of her answers . . . appeared to have come almost directly from her book *Dawns and Dusks*. . . . While most Rocklanders probably are filled with awe of Louise Nevelson, most will readily admit they do not understand her art."[73] This journalist who admitted to *not* being among the cognoscenti wrote that he was glad to have had the opportunity to view it and to meet her in the flesh. He also noted that, "Louise went out of her way to praise Péladeau for bringing her work to the Farnsworth."[74]

The most balanced account of Nevelson's homecoming came from Leslie Bennetts of *The New York Times*, who put the event into perspective:

> She left almost 60 years ago, the headstrong daughter of an immigrant Russian Jewish family, escaping the small town whose boundaries, both mental and physical, had always made her chafe under their restrictions. Later she would write and speak bitterly of the narrow-mindedness and anti-Semitism of the "WASP Yankee town" where she'd grown up.
>
> She returned last week in triumph. . . . The town welcomed her with . . . standing ovations. There were those who wondered why it had taken them so long, but all in all, it was a happy homecoming. . . .
>
> And the sculptor was in high spirits as she graciously accepted the acclaim. "I'd rather be kissed than not, so here I am," she said cheerfully. . . .
>
> Two months shy of her 80th birthday, the sculptor looks like a woman 20 years her junior, and runs around like one 40 years younger. . . .
>
> These days people frequently ask what kept her going through those years of poverty, when money sent by her brother and sisters was sometimes her only income, and more often than not was spent on art materials instead of food.
>
> "It's a miracle that I survived and rose above it. . . . But nature endows you. . . . I felt art and I were one. No sacrifice was too much; it was just more important than whether or not I was sleeping on the floor or getting a good meal. Those things don't really matter to anyone who sees the light. And I was sure I had it.[75]

The article included references to her brother Nate, one of Rockland's "best-loved citizens," and her sister, Anita, who recalled Louise's tenacity. "You couldn't beat her down. I would have given up a million times." The *Times* reporter gave Louise the last word about many Rocklanders' view of her as an eccentric: "Of course they laughed here. But I've lived long enough that I have the best laugh."[76]

Péladeau's support of Nevelson and his success at bringing her back to her hometown as a star and celebrity moved her and inspired her generosity toward the local museum. For several months before the exhibit, he had collected from admirers two to three hundred wood scraps, each one cleaned and labeled with the name of the donor and place of origin. The artist noted that she would use them up "in a couple of days" when she took them back to her studio in New York. Nevertheless, she was touched by the collection: "For me some of these pieces are already a work of art in themselves. It's great from the creative point of view, but it's also tremendous from the humanitarian point of view. . . . This will set a precedent throughout the whole world, that people will not throw things away, that they will cherish and reuse them."[77]

Returning from a trip to see Nevelson in New York, Péladeau filled his station wagon to the brim with the sculpture she was giving to the museum. "Everything you do now is 'News' to the people of Rockland," he wrote to her in September 1979. "Your visit here this summer, and the exhibition, have given the entire mid-coast area a new focus of attention. If there was some neglect in the past in recognizing your great talent, this summer has changed all that."[78]

In the same letter Péladeau referred to plans for the Berliawsky-Nevelson Room at the museum as well as for the Nevelson Archives that had been established at the museum. Nevelson's brother and son had already given decades' worth of materials, and the artist subsequently contributed the correspondence she had not already given to the Archives of American Art. Scholars would have more to consult, and Rockland would be a recognized home for Nevelsoniana.

Péladeau believes that not only did the exhibition and the attendant festivities change the artist's view of her old hometown, it also may have changed Rockland itself. Péladeau is convinced that, before the exhibition and Nevelson's grand homecoming, Rockland had fallen on hard times—nothing more than a "fish-cutting town," with many empty storefronts.[79] The exhibition, the festive celebration, the visit by Nevelson herself with all the attendant publicity, gave the town a boost. Galleries started opening up and the town became several degrees more cosmopolitan.

Péladeau was determined that the recent Nevelson events would turn out to be "just the start of things" between Nevelson and the Farnsworth Museum. And indeed that proved to be true. There would be another Nevelson exhibition

in Rockland in 1985, and she would continue to give her work and correspondence to the museum.

Frank, in one of her conversations with Péladeau, Nevelson said she now wanted to be buried in Rockland in the family plot on Park Street, which her father had created—but not until she was "darn good and ready."[80] Increasingly aware that she could be in the last decade of her life, she could finally imagine the idea of making a final return to the place she had grown up.

A BIG BIRTHDAY

1980 – 1985

"Art was not my most difficult subject. Life was my most diffi-
cult subject."
—Louise Nevelson to Hunter Drohojowska, "At 85, Louise
Nevelson Gets Her Day in the L.A. Sun," *Los Angeles
Herald Examiner*, June 24, 1985

I t could be said that 1980 was the year of "The Nevelson"—a busy, bustling
eightieth birthday celebration for her and her work. The Municipal Art Soci-
ety in New York City turned a fund-raising dinner into a birthday party.[1]
Mayor Ed Koch gave her a cake with candles, which she refused to blow out,
fearing bad luck.

Far from slowing down as she aged, Nevelson was speeding up as though the
awareness of time passing propelled her into ever more productive, adventurous
activity. Her work grew in size and scale and the media she used became more
varied. Her realization of the shortness of time remaining to fulfill her long-held
ambitions seemed to have eliminated whatever remaining inhibitions had held
her back before.

Nevelson was now putting everything else aside in order to focus on her
work. Though her work had almost always been the central and most compel-
ling aspect of her life, the large volume of both work and exhibitions during her
last years was remarkable.

January 1980 began with a travelling exhibition at the Phoenix Art Museum
titled *Louise Nevelson: The Fourth Dimension*. Almost all the works in the show were
on loan from Pace Gallery, and many represented phases of her career that were

rarely seen. The catalogue essay placed the fourth dimension in the theatrical context she had learned about in the 1920s from Norina Matchabelli and Frederick Kiesler—and only hints at the metaphysical aspects.[2] The artist's spiritual inclinations were still not much on public display.

For the next few months Nevelson moved into high gear, preparing for three simultaneous solo shows in New York—at Pace Gallery, at Wildenstein & Co. Gallery,[3] and a big retrospective at the Whitney—as well as another show of her collages in Chicago at the Gray Gallery. Also on the calendar was the installation of a large steel sculpture at Fifth Avenue and Sixtieth Street along with any number of art-world social events celebrating her eightieth year.

In a statement Nevelson wrote for the 1980 Whitney exhibition catalogue (but which was not included in the final version), she describes her thoughts and feelings about her aging:

> I am 80 years old. I've worked very physically all my life. It never dawned on me that there was another way of life. I did what I did and got hooked on it. I could tell you a lot of things that were unfair in the art world. But when you get to be 80, you reach a plateau of maturity. People are so reverential. They say, "I've always admired your work." Well I know that isn't always true. Sometimes I wish they would just say, "Thank you for doing the work."[4]

All reviews of the 1980 shows focus on the same matters: Nevelson's energy and individuality, as well as her continuing ability to grow and create new work which looked fresh and original.

The Whitney exhibition, honoring her eightieth year and the Whitney's fiftieth year, opened on May 27, 1980. It was entitled *Atmospheres and Environments* and consisted of five environments assembled from work still in existence, with some new works added to fill in missing elements: *Royal Voyage* (1956) and *Moon Garden + One* (1958) (both originally from Colette Roberts's Grand Central Moderns Gallery); the all-white *Dawn's Wedding Feast* (1959–60) (originally seen at MoMA); in the gold room, *The Royal Tides* (1961) (originally at the Martha Jackson Gallery); and the room-size, all-black *Mrs. N's Palace* (1977) (originally at Pace Gallery).

For some viewers the entire show was too much, but for Robert Hughes of *Time* magazine, *Moon Garden + One* represented "the full mastery of effect with which Nevelson could and still can, transform a given space. These columns and stacks of boxes with their carefully orchestrated suggestions of altarpiece, shrine, cave and iconostasis, suggest how far her desire for an environmental art has transcended decoration. . . . All this could be melodramatic, without Nevelson's

clear sense of formal diction. She knows exactly how far a space can be loaded with shapes before congestion takes over."[5]

Most reviewers noted that Nevelson managed to combine Cubism and Surrealism with a bit of Abstract Expressionism. Hughes made a coherent story of that trajectory: "Part of the achievement of her work lies in the way in which she adapted the rationale of cubist composition to more mysterious ends. . . . The encompassing ambition of Nevelson's work is to make a continuous surface so full, so engrossing and so minutely articulated with variety of detail that it can work as an abstract metaphor of nature itself."

Richard Roud, a reviewer for *The Guardian*, acknowledges Nevelson as "a great artist in the American vein of the isolated eccentric. . . . [Like Herman Melville,] she stands superbly and dangerously alone, unique out of an historical void. . . . Mrs. N does not belong to any school or movement. She is her own woman."[6]

Master wordsmith, distinguished playwright, and longtime friend of Nevelson, Edward Albee wrote the introductory essay for the Whitney catalogue. In this, his first public essay on Louise Nevelson, Albee addresses what he saw as a serious problem for Nevelson the artist, namely, that "the fame of her persona overshadows that of her work in the general public's mind." In the previous chapter, on the artist's persona, Albee's contention was considered in detail. For the catalogue essay of the Whitney show he noted that, "The very best of Nevelson's individual assemblages, or structures, or sculptures . . . are, variously, exquisite, powerful, remote, primordial, and always intellectually stimulating," Like other perceptive critics he compared these works to Bach: "They do things to the mind akin to what a Bach two- or three-part invention does."[7]

Albee ends his essay with what becomes a headline, "The world is beginning to resemble her art": "Nevelson feels that she began making her 'worlds' as an alternative space, so to speak—to create for herself a fathomable reality in the midst of the outside chaos. What has happened, of course, is that the private has become public, the refuge accessible to all, and, to those who know what a Nevelson looks like, the world is beginning to resemble her art. I hope she's pleased."[8]

Albee is here referring to the phenomenon of Nevelson's transition from being a little-known but respected artist in the 1950s, whose creation of imagined worlds in wood surrounded the viewer, to her becoming one of America's most important sculptors, whose large-scale sculpture in public places and many museum retrospectives reached a broad audience. He touches upon a little understood but central fact about the artist. To many it looked like her avid search for a wide audience was motivated simply by a wish for fame. In fact, her deepest desire was to share her creativity with the world and to encourage

everyone to participate in what she believed was the highest possible human achievement—art. As Nevelson understood it, art was something that should be accessible to all—not just an elite few.

In late 1979, after several years of failing health, Nate Berliawsky was diagnosed with colon cancer, and Nevelson arranged to have him admitted to Memorial Sloan Kettering Cancer Center in New York City. With treatment, his cancer went into remission, but he died of heart failure in September of 1980.[9]

Nate Berliawsky had not only financially supported his sister for almost thirty years, he had done everything in his power to promote her work. He hung his hotel dining room with her early paintings, filled the lobby with one of her premier wall sculptures and, through his good relationship with Marius Péladeau, the new director of the Farnsworth Museum, he paved the way for her triumphant return to Rockland. Nate left his entire art collection, which included twenty-two Nevelsons, to the Farnsworth Museum. It is still unclear how much he had deprived himself over the decades to keep her solvent. Nevelson loved her brother and remained close to him throughout his life. Whenever he was in New York, she included him in the intimate social events with her close friends. His was the only family funeral Louise Nevelson ever attended.

For her big birthday year, 1980, Nevelson had been in twelve group shows, had four solo exhibitions, and had installed two very large metal sculptures; one in New York, the other in Kansas City. Between the beginning of 1981 and the end of 1985 she participated in twenty group shows and twenty solo shows, and seven of her large-scale public works were installed around the country. That is to say, from age eighty to eighty-six she had hardly slowed down at all. Most of the solo shows were at the five galleries which had represented her for some time: Pace New York, Pace Columbus, Makler in Philadelphia, Richard Gray in Chicago, and Hokin in Florida.

She was awarded a few more honorary doctorates from even more prestigious institutions than before, including Harvard College, and she gave an invited lecture at Yale University. Special honors included the Gold Medal Award for Sculpture by the American Academy and Institute of Arts and Letters in 1983 and, in 1985, President Reagan gave her the National Medal of Arts, which had been awarded by the U.S. Congress.

Sometimes she needed to rush from one event to another, but that was no big hardship for this always energetic artist. I shall highlight some of these events and introduce the few novelties among the regular round of Nevelson's usual working life and celebrations of her success.

In October 1981, Glimcher accompanied Nevelson to Paris for a retrospec-

tive at the stylish Galerie de France, which had just moved to a new space next to the Pompidou Center. The show was a financial and critical success. Ann Cremin, writing for *The Irish Times*, noted that the indefatigable artist "stood for more than three hours receiving homage and looking like an old-time Hollywood film star, in amazing eye make-up and [a] bright-blue fox coat to the floor." Cremin also deems the works magnificent, noting especially "a stunning monumental wood wall, *North Floral*," and "a monumental black steel sculpture, *Celebration*, which is both intense and yet seems to float along."[10]

In the *International Herald Tribune*, Esther Garcia paints the usual picture of the artist in full plumage:

> At a reception for her, she makes a spectacular entrance, with her 81 years, her eyelashes and a black sequined dress. She is immediately surrounded. She tells about a dinner the night before at the house of a great family of Parisian art dealers. . . . "The house was exquisite and formal. You could die just for the carpets. Everything was reverence for art and the artist. Very nice, but I had to break the spell. They offered me a cigarette. I told them, I don't smoke. I don't smoke any more, I don't drink any more and I don't even freelance any more."[11]

Something serious had happened. No cigarillos, no alcohol, and no more sex. Though Nevelson was still trying to avoid aging, she was finally aware that if she wanted to keep on at her accustomed pace she would have to limit herself and restrict some of her previous pleasures.

Some people as they age are themselves but more so. For most of her life Nevelson had been outspoken and future oriented. In November 1981, Nevelson went to Westbrook College in Portland, Maine, to accept the college's highest honor—the Deborah Morton Award—given to "outstanding women who have achieved high distinction in their careers." She was acutely aware of the importance of candidly speaking her mind and passing along her accumulated wisdom to young people, especially young women. In his write-up of the event in Maine for the *Portland Press Herald*, reporter Bill Caldwell noted that, "It was Nevelson the woman who stole the show." Her words mesmerized the students: "Be careful about the path you choose for yourself now," she warned the art students, "for what we select in our youth is what we will be when we're older. . . . It doesn't matter what avenue you choose, so long as it is you who does the choosing. Doing that is your true heritage."[12] Nevelson knew full well about the dangers of following either convention or the advice of someone other than her own self. She had paid a big price for her youthful mistakes, and in her old age she was generously trying to advise younger women.

The veteran reporter was as bewitched by her as were the students. Caldwell ended the piece: "I sat with her for an unforgettable hour at lunch in Westbrook College last week. At 82, she is not only a headliner, but one of the most fascinating and sexy women alive."[13]

Four months later Nevelson was honored by the Manhattan Women's Division of State of Israel Bonds for her contributions to the art world and her support of the Israel Bond program.[14] This particular distinction was special for her, and at the awards ceremony she spoke more candidly than usual about her feelings as a Jew. "The Jewish people didn't have a home for 2,000 years. That is why Israel is important. . . . [My family] came to the United States in 1905 because of pogroms, I am sympathetic to people who get beat up."[15] The fact that Nevelson was eighty-one before she publically mentioned the violent events that had sent her family to the New World suggests how deeply buried those early traumata had been. It may also indicate that from the perspective of her advanced age she felt secure enough to look back at her early life and recall some of the fear and horror. Her support of Israel was another instance of her endorsement of the future, especially for people who had been or could be in danger.

In 1982 and 1983 Nevelson created *Dawn Shadows*, a large work (thirty-one feet high, weighing thirty-five thousand tons) in Cor-Ten steel to be placed in front of Madison Plaza, a new office building in Chicago designed by Skidmore, Owings & Merrill.[16] Nevelson's sculpture was based on a maquette (eight feet six inches by six feet by five feet six inches), which had originally been called *Dawn Tree* and shown at the Neuberger Museum in Purchase. It was the fifth of the six very large public sculptures she would design to fit into a particular architectural framework. Earlier ones include *Sky Covenant* in Boston (1973), *Sky Tree* in San Francisco (1977), *Shadows and Flags* in New York City (1978), and *Bendix Trilogy* in Southfield, Michigan (1979).

Nevelson was jubilant when *Dawn Shadows*, which she referred to as "my trees,"[17] was unveiled on May 19, 1983, to the music of Ottorino Respighi, and she pulled the ripcord which released several thousand black and white balloons. "I hope to plant more trees in Chicago,"[18] she said laughing.

She had intended *Dawn Shadows*, like *Shadows and Flags* in New York City, as well as *Sky Tree* in San Francisco, to be seen both from above—in this case, from the nearby rapid-transit platform, as well as the forty-five-story Madison Plaza—or from below, on the built-in seating at the base. According to the *Chicago Tribune* art critic, Alan Artner, both views "emphasize a spectacular relation to the mirrored skin of the building, suggesting that this is a piece not to be looked *at* as much as *through*."[19] Once again we see Nevelson aiming to communicate through her art with the largest possible number of ordinary people—the

secretaries and workers in the offices on high floors, the riders of the rapid transit, and anyone resting on the seats at the base of the sculpture. She was fulfilling her vision as an architectural sculptor.

In October of 1982 Nevelson travelled with Diana MacKown to Japan for her solo show in the grand gallery of the Wildenstein gallery in Tokyo.[20] Particularly appealing to the Japanese were the artist's elegant abstractions in wood and on paper and the fact that, though the show was described as a retrospective, it also included recent works. *L'Oeil,* a prestigious French art journal, reviewed the exhibition respectfully and noted that, in addition to her work in wood, she was also producing large-scale steel sculptures for urban settings.[21] No doubt the information that an artist in her eighties was continuing to create important work in different media appealed to a culture where the elderly are revered.

Shortly after her return from Japan, in November 1982, *Art News* published a feature article on success in the art world. Nevelson offered up a long statement of her complex views on the subject. "Success? It's such a dreary word. . . . Isn't it too bad that in America success always must be measured by your income tax? As far as I'm concerned I was a success when I first exhibited in a group show in 1932. I've lived through a lot of bumpy times since then, but who in this absurd world of ours becomes an artist with the expectation of making money? Only the naïve. To survive, most need a job or private income or a rich lover or husband, or something." In her case that "something" had been a supportive family, which kept her afloat for thirty years.

"Certainly I've had depressions and I've been analyzed—not too deeply— but my terra firma lies within me, which is why I study oriental philosophy. An artist, to a degree, can make what he wants of his life, even with very little money. If you can do that, then you are truly successful."[22] In essence this is the same message she gave to the young women graduates at Westbrook. External success is fine but never as important as finding one's own identity and making what one wants of life. In many ways her goals never changed and rarely did her means of reaching them.

In mid-January 1983 Nevelson had a solo show at Pace Gallery, *Louise Nevelson: Cascades Perpendiculars Silence Music.* That she was working with the charred remains of a church was less notable to the critics than the fact that she was still working at all and could be described as one of our better older artists.[23] Some of the first listings for the show did not mention its title. Instead the following notice was placed in *The New York Times*: "Sculptures made from remnants of the church organ of St. Mark's Church on the Bowery, which was devastated by a fire in 1978."[24] "Salvaged from the fire," the organ pipes that had been stored in the basement were donated by the church to the sculptor. The catalogue for the exhibition was made up of photographs of black-painted sculpture on black paper—a

dramatic restatement of the charred remains, recreated by the artist. This was a new and powerful version of rescuing trash and giving it new life. There were two sets of works: *Cascades Perpendiculars* and *Silence Music*. Both series made reference to the destroyed musical instrument, which added to their dark potency.[25]

The *Cascades Perpendicular* series played off tall, vertical elements against a round wood disc, seemingly the end of an industrial spool.[26] Though Nevelson's use of round shield-like discs on towering vertical forms goes back to the bride-and-groom columns in her 1959 *Dawn's Wedding Feast*, the combination in the 1983 exhibit shows a formal confidence. Broken or whole, the discs provide a contrast to the vertical columns to which they are attached in surprising ways. On one, *Cascades Perpendicular V*, they gracefully mimic the curves of a female body, while appearing completely abstract.

The only extensive review of the Pace exhibition was in *Art News*, and the writer, Ruth Bass, had high praise for the artist. "Obviously Nevelson is still master of her medium, working with power, authority, refinement and grace."[27] A comment in the *Christian Science Monitor* was brief and positive: Among "the season's best shows [was] . . . Nevelson's handsome show of sculpture." The context was a boost for "our better older artists [who] make it clear that the ability to create lively and significant art is not limited to the very young."[28] Yet the people who knew Nevelson up close realized that, though her energy level was still like that of a forty-year-old, she was aging.

At almost the same time as the Pace show, Nevelson was paired with Georgia O'Keeffe in an exhibition at the Nassau County Museum of Fine Art, *Nevelson and O'Keeffe: Independents of the Twentieth Century*. The curator, Constance Schwartz, brought together the work of the two most celebrated women artists of the time under the conceit that they had remained staunchly apart from the isms and art movements surrounding them. Some writers found Nevelson and O'Keeffe to be an odd couple, given that they came from different generations and vastly different circumstances. "They are both tough old survivors with steely wills," wrote Amei Wallach in *Newsday*, "and they both make beautiful art. That is about all they have in common."[29]

The Nevelson works were well selected, many from private collections and infrequently exhibited. The exhibit included a room full of large walls, including *Homage to 6,000,000 I* and *Royal Tide II*. Chosen with an eye for history, a number of excellent pieces from the mid-1950s were combined with a recent sculpture in Cor-Ten steel, *Frozen Laces V*.

The catalogue essay was written by Schwartz, a painter with a background in art history who, like Nevelson, had attended the Art Students League. Her text ends with the stirring words: "The work reflects a grandeur that mirrors the grandeur and majesty of the artist."[30] Along with a packet of reviews of the exhi-

bition, Schwartz sent Nevelson a note: "The crowds that have been pouring in to see this exhibition have been unreal and there does not seem to be any letup. . . . I want you to know that I think of you often and feel as if I have a running conversation with you when I closet myself with your work. I've given about twenty lectures on your work, and Wednesday afternoon there was nearly a riot here since there were so many people who wanted to hear me lecture that we had to do it twice . . . and next week the same thing."[31] Louise Nevelson's renown and popularity was continuing—despite or maybe because of her age.

A few months later, on May 18, 1983, she was in New York City to receive the Gold Medal Award for Sculpture from the American Academy and Institute of Arts and Letters. On May 19 she was in Chicago for the installation and dedication of the enormous public sculpture, *Dawn Shadows*. The following day she was in Charleston, South Carolina, for the opening of her large retrospective show at the Gibbes Museum of Art, another signal honor since she was the first visiting visual artist to be invited to exhibit her work in the celebrated Spoleto Festival USA. Spoleto was one of the country's premier performing-arts festivals, and the Gibbes Museum was the chief venue for visual arts in Charleston.

She described the hectic sequence of events to a Charleston reporter: "They have in New York a very distinguished award some hundred-odd years old. . . . So this year they gave one to me. That was on the 18th. Now I have to be in Chicago on the 19th. So what happened is that I took a few rags from my house, because I never waste time checking through airports So [then] I had to come over here from that trip. When we got here I didn't even have time to do anything. I went over to see my show and then came here [the home of her hosts, John Philip and Llewellyn Kassebaum]."[32] What is evident in her remarks is the artist's delight at being able to report with apparent modesty that she was given a distinguished award in one city which in no way slowed down her hectic trajectory through two other cities, both of which were also honoring her.

The year 1983 was not quite over. Nevelson squeezed in two more big events in December: the publication of Jean Lipman's book, *Nevelson's World*, with an introduction by Hilton Kramer, and a long, lavishly illustrated photo essay on her home and studio in *Architectural Digest*.

First the book. *Nevelson's World* was a "luxuriously produced" volume written by a woman who loved both the artist and her work.[33] Its 244 pages were vibrant, with Nevelson's pithy quotations throughout and reproductions of more than a hundred and fifty of the artist's best work from all periods. Lipman herself noted: "One of the things about Louise's work—as soon as you get a very clear idea of what she's doing, there is something exactly opposite."[34]

The introduction by Hilton Kramer defines Nevelson as "one of those artists

who change the way we look at things." The book "immerses the reader in Nevelson's 'universe' and conveys the experience of her room-size wood sculpture more effectively than could be imagined," said a *Los Angeles Times* reviewer.[35]

Then, as a perfectly timed accompaniment to the book, which invites the reader into Nevelson's world of art, in a lavishly illustrated cover article in its November issue 1983, *Architectural Digest* introduced the reader to the home and studio where Nevelson had lived and worked for twenty-five years. By the mid-1970s she had combined three houses of four and five stories into seventeen rooms with multiple kitchens, large spaces, marble stairways, and steps connecting the nine floors across multiple split levels. "I suppose it's a bit of a luxury to live like this . . . but I find having space gives me the opportunity to keep creating."[36] And creating was the most important thing in the world for this eighty-four-year-old woman. It always had been and would be until she died.

As always, Nevelson was engaged in many projects simultaneously—she called it jumping around. It helped her feel young and energetic even as she was very conscious of her age and aging. That awareness led her, on the one hand, to find safe harbors for some of her work and, on the other, to defy mortality by producing new art in new ways.

Also in 1983 Louise Nevelson started doing something she had wanted to do for years—decades really: design a set for a ballet or musical work. At age eighty-four, thanks to an off-hand remark passed from an art lover to an opera director, she finally got her chance. In the late 1970s, Richard Gaddes, then general director and founder of the Opera Theatre of St. Louis (OTSL) and former director of the Santa Fe Opera, was driving to Taos, New Mexico, with Robert Tobin, a Texas art collector and patron of the arts. Tobin said to Gaddes: "One of these days someone will ask Louise Nevelson to design an opera."[37] Knowing how well Tobin knew opera, Gaddes responded: "Which one would you have her design?" Gluck's *Orfeo* was the answer.[38] A few years later, Gaddes asked Nevelson to design the sets and costumes for Gluck's *Orfeo ed Euridice*. Every visual aspect of the work would be determined by Nevelson.

The OTSL was considered one of America's most popular regional opera houses, and featured English-language productions staged by rising young singers and designers. In late 1982, Nevelson came to St. Louis to discuss the idea with Gaddes. By spring 1983, a contract was signed.

The most striking element of the production, and one of the few to survive, is the "*Love Wall*"—a twenty-foot-by-fifty-foot black wall, with a relief of gold geometric forms, which appears as the backdrop throughout the performance. It is made up of twelve panels, each containing four rectangles within which are shallow shadow boxes containing assorted gold geometric shapes. Characteristically complex and simple, playing with negative space, the *Love Wall* Nevel-

son designed enlivened the entire production. In the third act, befitting the sad dénouement, the two central panels were reversed to reveal black shapes on dark grey. The panels were reversed again when Amor reappears, leading to a happy ending. The curtain is now at the Chicago Opera Theater.

Other than the *Love Wall*, and the way it was lit, there were few other design elements in the set. As a result the production was simple and relatively easy to produce. The shimmering floor on which all the action occurred reflected both the curtain and the singers. The colors of the set and costumes of the main characters were predominantly black, gold, and silver.

Richard Gaddes recalled the experience of working with Nevelson, who had sixty years on most of the production's cast and crew. Though Nevelson was far better known than the Opera Theatre of St. Louis, she never behaved like the star who had condescended to design for this little opera company. "Far from it, she threw herself into it. She was a member of the team, and she was a hoot."[39] It was the first time since their opening season, eight years earlier, that the young company was working with a famous person. Gaddes continued, "It seemed to be a big moment in her life, and she loved it. . . . She was a wild card. She kept changing her mind, but she was lovely. She was a magnet of energy and fun, always getting up to something."[40]

In September 1983, Nevelson and Diana MacKown began to meet with Bill Katz, fine-arts consultant to Opera Theatre, and Willy Eisenhart, art writer and also an OTSL consultant, every Saturday in Nevelson's studio. They gathered around a large black model of the theater and slowly built their conception of the opera. The core team worked together for nine months.[41] Nevelson had created a family setting where everyone had an almost equal voice. The teamwork she loved and kept recreating was much like the one she and her sisters had established as children in the Berliawsky household, with Louise as the leader. This long-standing trait also explains why she and the many assistants with whom she worked over the years had such a good rapport. Whether they were household helpers, ceramists at the Clay Club, specialists in metal fabrication at Lippincott, or installers at museums and galleries, she treated them all as equals, but equals who were subservient to the larger goal of her creativity.

Nevelson called the whole experience of working with singers, dancers, stage directors, and lighting designers "a great delight of my life."[42] She and the director, Lou Galterio agreed on the importance of myth in the opera, and her ideas about the costume designs naturally fit with her ideas about art. A journalist observed cannily: "The costumes and jewelry seem to be extensions both of her art and of her own distinctive, and unusual, choices of dress for herself."[43]

Orfeo and Euridice was performed without intermission, and the opera lasted ninety minutes. The soloists, though good, were young and little known. "On

opening night . . . [Nevelson] was given an exuberant, adoring standing ovation, which she acknowledged with the sort of graciousness and confidence that is exhibited by royal folks."[44] According to the critic for the *St. Louis Globe-Democrat*, the fact that Louise Nelson had designed the sets and costumes made Orfeo "the grandest accomplishment to date of the Opera Theatre of St. Louis."[45]

The *Chicago Tribune* reviewer decided that the Nevelson production would be considered "more an honorable sidelight than a landmark" in Nevelson's career.[46] And it has been. The critic for New York's *Village Voice* noted that the "boldness and barbaric pizzazz of Nevelson's designs . . . nearly upstaged Gluck but wound up as an ally."[47] John Rockwell, of *The New York Times*, was polite but rather dismissive: "The impact of [the set design] was interesting both conceptually and as another landmark in a distinguished artist's career. As a theatrically effective representation of an already static opera, it was less successful." He noted the dated quality to the designs, attributing it to the fact that Nevelson had "studied the performing arts in the 1920s, and her sensibility owes much to the world of modern dance between the world wars."[48]

In retrospect, the company's director Richard Gaddes considers *Orfeo* "one of the most gratifying and rewarding moments" of his career. It was never again performed.[49] As Willy Eisenhart later described it, "It seems a perfect myth for her—the trials and triumphs of an artist."[50]

Ken Howard. Louise Nevelson at *L'Orfeo* at the Opera Theater of St. Louis, 1984. © Ken Howard / Opera Theatre of St. Louis

A little-known event that occurred on opening night was a typical Nevelson gesture. She had decided to give souvenirs to all the staff with whom she had worked so well. She arranged for someone to drive a truck over a large number of beer cans to flatten them. They were then painted gold on one side and black on the other, a piece of string was put through the hole in each and they became pendants to be worn by all, including herself, as part of the celebratory experience. Once again she made everyday objects—discards of civilization—into art, treasured by all who received them.[51]

Nevelson had discovered the beauty of crushed beer cans on a winter visit to St. Martin, where she was staying with Bill Katz. As they were taking a walk she came across a flattened can that had been left to rust on the street. Picking it up she turned to Katz and said, "Does Tiffany's have anything as beautiful as this?" Enchanted with the beauty of the ordinary—especially the traumatized ordinary—Nevelson collected a number of discarded cans and placed them on her bedspread for study. Teeny Duchamp, Marcel Duchamp's widow, who was also one of Katz's guests, was celebrating her birthday, and Nevelson invited her to select one of the cans as a birthday gift. Duchamp readily went along with the plan, having been educated by her husband to seek the miraculous and beautiful in the commonplace.[52]

Nevelson had worked most closely with the costume staff of the St. Louis Opera Theatre. They liked her so much that they found a unique way to honor her. On each of the six nights of the production, a member of the costume shop would create and wear a hybrid outfit combining a typical Nevelson assemblage of fabrics and headgear with some part of one of the singer's costumes, thus merging an operatic character with an ersatz version of the artist. Adding, of course, eyelashes made of black construction paper. On closing night there were eight faux Louise Nevelsons wandering through the crowds. She thought it was hilarious.

Nevelson was invited to dinner one evening at the home of one of St. Louis's patrons of the arts. David Zinman, a conductor working with the Opera Theatre of St. Louis, was also there. Arriving a little bit late, Richard Gaddes walked in with Eleanor Steber, one of America's leading sopranos. Steber had performed at the Metropolitan Opera in New York for twenty years and was a favorite on radio and television for singing popular music. Seeing Steber walk into the room, Zinman rushed to the piano and started to play the music for the aria "Vissi d'arte" from *Tosca*. Steber threw her coat onto a chair and, right on cue, sang the entire piece (magnificently) to Louise Nevelson, who was "blown away" by the unexpected and fitting tribute.[53]

"Vissi d'arte" is one of the most famous arias in opera history. Tosca, the soprano of Puccini's masterpiece, sings the haunting line, "I lived for my art. I lived for love. I never harmed a living soul," as she contemplates her helplessness

at the hands of the evil Baron Scarpia. It is one of the supreme musical paeans to a life in art. "Two superstars meeting like this, and literally the music began within seconds of Steber's walking in the door."[54] That the aging, celebrated Steber would honor the aging, celebrated Nevelson in such a spontaneous manner was extraordinary. The event made for one of the greatest moments of Gaddes's career.[55]

In 1983 and 1984 Nevelson was producing another large sculpture (twenty-one feet high by twenty-three feet wide by fourteen feet), which had the working title *Sky Gesture.*

During the installation at Storm King Art Center in Mountainville, New York, when she saw the sculpture placed prominently—at the top of a ridge that she poetically called a high mountain—in the two-hundred-acre park in front of the museum building, she decided to rename it *City on the High Mountain.* She had started on two separate compositions, and after several months she combined them.[56] And perhaps the "city" she was referring to was New York, since the smaller of the two compositions in the work was a version of the largest piece in her sculpture group for *Shadows and Flags* at the Nevelson Plaza in downtown Manhattan. A careful study of the finished work allows us to see how she constructed *City on the High Mountain* in part out of this previous work. *Shadows and Flags* was remade in a smaller size with some of its original parts deleted and placed alongside the larger more complex section of the sculpture with continuing revisions until the artist was satisfied that the two sections worked together as a blended whole. The two up-thrusting rectangular columns at the base of the old section combine in their new placement to make a syncopated ladder of squared-off elements that reach to the top of the sculpture where they finally meet up with the ball of spikes—its curvilinear frame that stops them in their tracks. She had made the ball of railway spikes ten years earlier. "The ultimate end was when I put that there, I said, 'Finis.' Sometimes it's only a period that finishes a sentence, and that was the period that finished that sentence."[57]

The steel "lace" form in the center was actually a skeleton frame Lippincott and his men found for the artist at the Schiavone scrap-metal yard in North Haven. It was a leftover from an industrial job—a panel of negative spaces left by objects that had been mechanically punched out, fitted close together for economy. Nevelson named these leftover elements "lace" and when she added them to a sculpture she called it "warming up the piece."[58]

Not only does the addition of the "lace" cover the previously gaping hole at the heart of the piece, by adding two curved slats framing the "lace" she tied the whole work together, with the steel cutouts becoming the cohesive circular heart at the center of the work. The ball of rivets she added to the top at the end is a perfect echo of the lacy heart. The rounded form that she also added on the

right-hand column complicates and confirms the balanced play of curvilinear and straight or sharp-edged elements that make up the whole. No wonder it was one of her favorite sculptures, part of what she called her "lace group."[59]

In 1985 Nevelson was eighty-four years old. And she was still getting up at six in the morning, working sometimes three days straight, and explaining to anyone who asked: "Art is a high. Like a runaway car, once you're in it you can't stop."[60] By the end of the year she had been in six group exhibitions, four solo shows, completed two huge Cor-Ten steel sculptures, and had one of them, *City on the High Mountain*, installed at a major public sculpture garden.

Summer was always a busy time for Nevelson. The warm weather suited her, and she continued to tend to her double life. Her work came first and her career—promoting herself and her art through shows, interviews, and carefully selected social events—came second. She could now easily afford whatever help she needed (every serious sculptor needs help). And she could use whatever material interested her. She had all the space she needed, whenever she needed it. The freedom to make the art she wanted, exactly the way she wanted to make it, was a gift of her later years. As Arne Glimcher observed: "She had a good old age."[61]

Late February 1985 saw yet another Nevelson exhibition at Pace Gallery. This time, Nevelson and Glimcher went with transparency, advertising the show as *Louise Nevelson at 85*. If people were going to keep writing about her advancing years, she would show the world that she never ever acted like an old lady and wasn't afraid to let her age be known. About this exhibit, John Russell wrote in *The New York Times*:

> To anyone who thinks of Louise Nevelson's black reliefs as tenebrous, densely crafted and somewhat Gothic in their overtones, her new show at the Pace Gallery will be full of surprises. Black they still are, but the look of the sunken cathedral is quite gone. In its place, vigorous mechanistic forms are espaliered on a bone-white wall. Light flows in and out where once it took a bath in black dust. . . . Where once verticality reigned, long lean shapes are aligned with a diagonal thrust that threatens to blast off through the ceiling . . . these new-style reliefs, which for an artist who has just turned 85 are truly an astonishing achievement.[62]

Russell is describing the first works from the *Mirror Shadow* series, which were indeed an astonishing breakthrough—not just in quantity but in originality. In the first of the series, *Mirror Shadow I*, she extended the elements beyond the grid horizontally and even a bit vertically. By the time she arrived at the second of the series, *Mirror Shadow II*, elements that had remained on neatly horizontal and

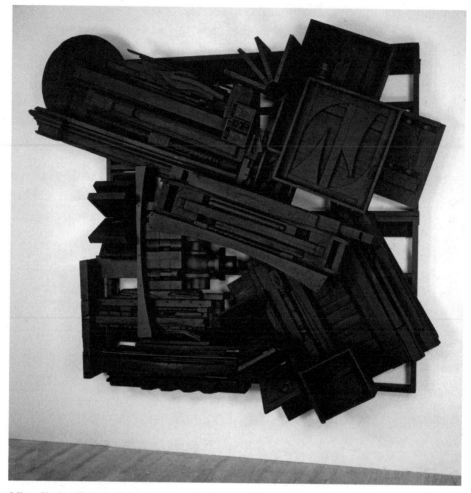

Mirror Shadow II, 1985. Painted wood, 115 x 141 x 21 in. Private collection. Photograph courtesy of Pace Gallery

vertical axes had been thrown completely off kilter, shooting out into rollicking diagonal directions.

Her humor and intelligence on display as usual throughout the series, it seemed as though Nevelson was making fun of her old friend the grid, which she incorporated into the works in surprising ways. It could appear coyly as a background prop in *Mirror Shadow II*, or it could suddenly play an intermediate role as in *Mirror Shadow XVI*, where two grids clearly stand out. One is more transparent than the other, and both contrast in almost every way with the flat circular cutouts all leaning leftwards. The weight of the diagonally oriented elements in front of and behind the two grids is held in balance by the grids' calming stability.

Never satisfied to set off boldly in only one new direction at a time, in 1985 Nevelson also created two remarkable sets of work: *Volcanic Magic* collages and a series of "mixed-media polychrome" wall pieces.

Most of the collages from the *Volcanic Magic* series were completed in 1985. The wood, metal, and paper elements she used were unpainted, and their startling combinations made them the most powerful collage works she had ever done. These new works were literal explosions of wit, grace, and power. She worked without inhibition, free to combine the most incongruous elements—paper, wood, all kinds of wood scraps, cut pieces of plywood, torn pieces of balsa wood, cardboard, chair backs, chair fronts, metal hinges, table tops and table bottoms, and many battered picture frames. The assemblages were enhanced by the colors of the diverse parts. It was as though she had rediscovered a new way to make a dynamic conflict of light and shadow without restricting herself to monochrome. We see in them not only Nevelson's familiar play with horizontal, vertical, and diagonal axes, but the to and fro of circular forms with straight-edged shapes. We also see her wit—as in *Volcanic Magic XX*, in which a raggedy plywood pedestrian takes off behind the chair on which he appears just to have been sitting—and her unconventionality in a work called *Untitled* (1985), which includes a broom and dustpan.

Nevelson's return to color after decades of avoiding it may have been an echo of her early years in art class with Lena Cleveland, or her even earlier years in the home of her maternal grandmother, whose colorful dyes she recalled as one of her first memories. What was behind the outburst of new and wonderful work—breakthroughs and new directions, astonishing output, ease of work, everything going right in the studio? Was she going far back in her life because she knew it was coming to an end? Had the sense of her forthcoming death released the need to go forward as fast as she could?

Perhaps being in her eighty-fifth year, perhaps being honored once again in Rockland, Maine, with a big exhibition planned for September 1985, perhaps knowing that she would receive an honorary doctorate from Harvard in June, but mostly, perhaps, accepting the fact that she could not go on forever, Nevelson began to take care of her legacy. On March 18 a prominent article in *The New York Times* announced that "Louise Nevelson [was] Giving 25 Works to Museums." The artist explained herself: "At 85 I feel fine, but you begin to think of what you have and what you want to do. . . . While I'm here, it fulfills some awareness of my being to know that these things will have a home and will be taken care of. That's a great feeling."[63]

Thirteen years earlier Nevelson had said: "I don't get attached to my work. I'm happy to get rid of it so other people can relate to it. I've given a lot away. I'm not much of a Bible reader, but that part about casting bread on the water

and it will be returned twofold. That is true. It has happened to me many times. I make a statement by giving my work."[64] Indeed, Nevelson had been giving her work, either directly or via her family, to museums for over twenty-five years. That her work was on exhibit in major American museums, like the MoMA in New York, had helped make her reputation—more than a twofold return.

The most important of the gifts Nevelson made that year was *Mrs. N's Palace*, which she gave to the Metropolitan Museum of Art. After it was initially exhibited at Pace Gallery in 1977, "a museum in Germany offered to buy the work for $1 million, but Miss Nevelson declined, wishing to keep the work in the United States."[65] William Lieberman, curator of Twentieth-Century Art at the Met, declared: "It's the best thing she ever did." It's both a sculpture and an environment and as such it was also a representation of home for the artist, which lends added significance to her desire that the work remain in the United States.

The other museums Nevelson chose were places she had shown with success and places for which she "felt sympathetic." She gave to the Cooper Union, the prestigious art school in New York. Bill Lacy, the president of the school, commented: "Her work has had a great influence on artists and architects and all kinds of designers. . . . She pretty much sticks to one color, black or white, but she feels that there are unlimited choices within that framework and has devoted a life to exploring them. She's shown them to be limitless, if you have that kind of imagination and genius."[66]

Nevelson gave the Los Angeles Museum of Contemporary Art (MoCA) six sculptures and five mixed-media collages. When she was in Los Angeles a few months later for the unveiling of her sculpture *Night Sail*, she explained: "Through these years there were a few people that somehow have supported me. I stuck it out through thick and thin and have never forgotten them. These are the people I wanted to return to. Some of them are the top men in art now."[67] She was referring to MoCA director Richard Koshalek, who had been a curator at the Walker Art Institute, where she had met him in in preparation for her 1973 exhibit. She was also recalling the many collectors in Los Angeles who had supported her work through the years.

"I have my own way of looking at things," she told an interviewer about her gifts to the museums. "It's a great feeling that these pieces will go to good places and be cared for. Why should I wait till I croak? And they'll be seen." Nevelson's lifelong wish was that her work would be out in the world and visible. At the same time, however, she was also denying that her legacy mattered to her at all. "I don't give a damn [how I am regarded in the future]. I don't care about art history. It would intrude on my work, on what I do, I don't care what he thinks or what she thinks—I haven't got time for that."[68]

Of course she cared about what others thought. Every artist does. But

through many decades of neglect Nevelson had had to develop thick skin. "It makes you very independent—you *have* to be with this kind of work. I don't say it's been an easy road; it hasn't. I work day and night with it, and all the other things fall by the wayside." Musing on what might have happened had she been born a man, "In the past 25 years I have done four thousand collages alone. And they're only beginning to sell now. . . . If I were a male, I would be in a different place. I'm in a good place now, but I'd be in a different [that is, a better] place."[69] Nevelson was acutely aware that giving away so much of her art reflected her generosity and enormous productivity. But she also knew of the possible downside of her gifts to museums. Women artists sometimes had to resort to giving just to get their work into a prestigious museum collection. As a consequence, the gifts were often not as highly valued as works by male artists that required substantial outlays of the museum's budget. If something had been paid for, it was justifiable to keep it on exhibit so it could earn its keep.

In addition to her gifts to the museums, in 1985 and 1986 she notarized gift agreements giving Diana MacKown sculptures, paintings, and collages. Most of the sculpture she gave Diana was from a period in which Arne Glimcher had little interest—the terra-cottas from the mid-1930s, late 1940s, and early 1950s. In the legal agreements, Nevelson gave Diana MacKown permission to cast and reproduce these works in editions, significantly adding to their potential market value.[70] Nevelson was sure that would suffice to take care of Diana's future economic needs.

For over twenty years both MacKown and Glimcher had been doing everything in their power to assist Nevelson in her work, career, and life. They respected and loved her, and Nevelson treated them as her son and daughter. Knowing that Arne Glimcher needed no financial help from her after she died, she chose to leave her estate to her son Mike. Her guilt for her double abandonment of him was persistent, and she was also aware that Mike had been left nothing by his father. She had left him when he was nine years old by going to Germany to study with Hans Hofmann. She left him again after their closeness in the early 1960s during the crisis of the Janis-Kurzman fiasco. Once she was back on her feet she relied on Glimcher, MacKown, and her art-world friends for closeness. The first abandonment was pointedly geographical, the second was perhaps more devastating coming after their unaccustomed familial intimacy.

In the mid-1970s she had made Mike her only heir and given him as much money as she could. ("I've made sure that my son doesn't have to work," she told a reporter from *The Washington Post* in 1985, "I don't believe in it, it's slavery."[71]) Mike had been among the family members supporting Nevelson during the thirty years before she was able to support herself as an artist, send-

ing her money from the mid-1940s, when he was a Merchant Marine, to the late 1950s. He was following in his uncle Nate's footsteps, trying to keep his mother safely housed, fed, and clothed. The reversal of fortune—with Louise Nevelson sending her son weekly checks—only began in the 1960s, when she had a stable income from her work.

Knowing that he still might never forgive her for abandoning him when he was a child, Nevelson had gone along with his plan to set up a shell corporation, Sculptotek, with himself as the CEO and with her and Diana as employees. It was designed to be a tax shelter so that after her death he would not have to pay huge amounts to the IRS for money earned from her estate. By 1976 Mike, with the help of his lawyer, set up Sculptotek, which was to be managed by them both. MacKown recalls, "I didn't pay too much attention to any of it. Neither did Louise. It was just there, it was presented as a tax thing, and that's how it was done."[72] Many artists' families were doing similar maneuvers in those years to avoid sizable estate taxes, but they didn't always get caught. The IRS ultimately sued Mike successfully. At the same time both Glimcher and MacKown distrusted Mike. MacKown tried explaining to Louise Nevelson that, despite the artist's best hopes that she and Mike could work together to maintain and build Nevelson's legacy after her death, no such thing was likely. Nevelson's conflicted feelings about her son and her guilt about having been a "bad mother" made it very difficult for her to see how much at odds with Diana MacKown he was and would be after she died. Mike saw Diana as one of the chief people who had kept him at a distance from his mother. Too many times she had not let his mother talk on the phone to her son, saying "Louise is busy," acting as the guardian at the gate—protecting the artist from interruptions and intrusions on her valuable time. Unfortunately, MacKown could not have been more correct about the impossibility of their working together.

On April 23, 1985, at a luncheon at the White House, President Ronald Reagan bestowed on Louise Nevelson and eleven other individuals the National Medal of Arts, a significant honor. Nevelson and O'Keeffe were the only two visual artists honored. Nevelson was described as the "originator of environmental sculpture, who assembles bits of material in what she calls a 'unified whole.'"[73] Nancy Reagan pronounced Nevelson to be "one of a handful of truly original and major artists in America."[74]

Ironically, just as Reagan was declaring, "No one realizes the importance of freedom more than the artist. . . . Where there is liberty, art succeeds,"[75] Nevelson had been planning to publically protest the president's plan to lay a wreath at the Bitburg cemetery in Germany, where many members of Hitler's SS are buried. But the night before the ceremony, she decided against it. Elie Wiesel had criticized the president on that subject a few days earlier when he

received the Congressional Gold medal in the Oval Office. She noted: "The event tomorrow is a celebration. I wouldn't want to break that mood. . . . But if something isn't done to correct it, I won't hesitate to make a statement."[76] She may not have spoken up about Reagan's tone-deaf "plan to honor Nazi dead," as Nevelson saw it, but she couldn't resist saying something about his plan to cut funding for the arts.

Looking her usual regal self "in flowing robes and silver jewelry," she was the only honoree to register a complaint about the administration's proposed budget cuts of eleven percent for the arts. Nevelson said "We can't have cuts. . . . Not when the dollar is worth a quarter."[77] Though she appreciated the honor he bestowed on her, it did not make her less outspoken about the slight his administration was giving to creativity.

Six weeks later on June 6, during the 1985 commencement at Harvard College, Louise Nevelson received an honorary degree. She was the only woman among ten individuals to be so honored. That this occurred at all is a complicated story involving the artist's actual accomplishments, the fact everyone knew her time was limited, her dealer's grand gift to the university and, finally, the value of having a tight-knit clan of Harvard alumni on her side.

Arne Glimcher's son, Marc Glimcher, was graduating from Harvard College that June, as was James Solomon, the son of Richard Solomon, president of Pace Prints and Arne Glimcher's best friend. To honor that event—and also to commemorate the graduation of Glimcher's father-in-law, Sumner Cooper, in the class of 1934—Arne Glimcher donated Nevelson's *Night Wall I* to the college.

The first inkling of the possible gift to Harvard of a Nevelson sculpture came in an exquisitely tactful letter in October 1982. Richard Solomon (who had also graduated from Harvard, with the class of 1956) wrote to the college president, Derek Bok. "My question," Solomon wrote, "is whether Harvard would have an interest in receiving a gift of this nature." It took a year for Glimcher, Nevelson, and Bok to come to agreement that the gift of a large (envisioned to be a twenty-foot-long outdoor sculpture) would indeed be a welcome addition to the university.

By December 1984 a maquette of *Night Wall I* had arrived and "won much approbation and inspired enthusiasm." But then began, as Harvard art historian John Rosenfield explained, "the search for a suitable site and a procedure for decision-making. . . . The decision of where to place the sculpture will pass before many people of varying tastes and background before we can submit it to the President. Nonetheless, the piece is so fine and the project so worthwhile that we feel that—with patience and the long view—we will work this out successfully."[78]

Arne Glimcher was not pleased with the idea of a "long view," since he wanted the sculpture to be in place in time for his son's graduation. The site finally selected was in a glade of oak trees at the northern end of the Harvard Law School Quadrangle, between Langdell Hall and Harkness Commons.[79]

The dedication ceremony on June 3, 1985, went off without a hitch, and Nevelson stayed in town for another two days to be present at the graduation of Marc Glimcher and James Solomon and also to receive her honorary degree. Harvard's President Bok declared: "Her creative spirit has transformed the fragments of a familiar world into sculptured wholes, surprising, beguiling, demanding our visual appreciation."[80]

Two weeks later, on Thursday evening June 20, 1985, one of her monumental aluminum-and-steel sculptures was dedicated at the Crocker Center in downtown Los Angeles, opposite the new Museum of Contemporary Art on Grand Avenue, to which she had just made a substantial gift. Mayor Tom Bradley declared it Louise Nevelson Day, in honor of "a sculpture inspired by the sweeping vistas of Los Angeles and the sea that borders the city."[81] After the unveiling, at a reception,[82] Nevelson told reporters, "I'm a woman of great action. I don't sit down and dream, I'd rather move a mountain." One journalist noted that, given the massive size of the thirty-foot-tall, thirty-three-ton *Night Sail*, Nevelson had "indeed brought a mountain to Los Angeles."[83]

In a prime position between the IBM Tower and the main block of the Crocker Center, Nevelson's tall, narrow sculpture presents dazzlingly different views to passing pedestrians, its complexity only unfolding if one walks all the way around the work. Nevelson had explained to reporters that when she had first seen the site, she had been impressed by "the luxury of space, something we New Yorkers don't have." She had looked off over Grand Street and seen, as the reporter of the *Los Angeles Times* remarked, "a limitless vista well suited to a sculpture that would have a floating quality of movement [gliding] silently through space . . . vaguely [alluding] to sails and riggings."[84]

When seen from the narrow back or front, the tallest element, a sinuous snake- or flame-like element,[85] towers high above the rest of the sculpture, stamping its silhouette against the sky. When viewed from the much wider side view, this element disappears and the sail shapes dominate. One large square-rigged element is transparent; its multi-angled grids bisected by what must represent a mast. There is a cutout wedge shape echoing the taller, solid second sail at the other end of the narrow double-rigged boat. Within each of the larger pieces is a lively counterpoint of curves and straight edges. From the two side views, the airy interactions weave harmoniously as the wind whipping the sail of a fast-moving schooner. Yet it is as stolidly stable from front to back as any Nile barge carrying Cleopatra and her treasures.

After the installation, sitting alone on a bench with a glass of wine, Nevelson looked at the sculpture, and said: "It holds its own, but it's not too aggressive. . . . You get a little jaded. I'm fortunate in my life because I never thought I was too bright. It saved me in a certain way. I am still fresh. Something that you never thought was your strength may serve you best. I'm as pleased as I have been. This sculpture has a grace. Instead of being a Beethoven, it's a Mozart."[86]

Nevelson went back to Rockland for three days in September 1985, celebrating her eighty-sixth birthday.

In Rockland she appeared at one event, "swathed in layers of black—a large head scarf, a loose fitting jacket, a dress and a pair of silky black pants that bore a suspicious resemblance to lingerie. . . . Nevelson could have passed for a high-class bag lady. But at the same time the effect was extravagantly glamorous, the look of someone who had little patience with convention, whether it came to designing sculpture or getting dressed in the morning."[87]

Large crowds greeted her for the opening of *The Gifts: 1985*, her three-month-long exhibit in the Farnsworth Museum's Craig Gallery, which inaugurated a fund drive to create the Nevelson-Berliawsky Gallery. The show had been three years in the planning and included works given to the museum by the artist and her family as well as two new collages, two dozen pieces of hand-crafted jewelry, large swatches of fabric used to design the costumes for *Orfeo*, and the two thrones from the set.[88] (The thrones had originally been painted black, but Nevelson had them covered with gold leaf for the Farnsworth.[89]) Her sister Anita and her sister-in-law Lillian were part of the celebration. At the champagne reception Nevelson wore a flowing black and gold outfit. In her honor, museum patrons were dressed in the artist's colors—black, white, and gold, as had been requested on the invitation. A gold harp was played during the reception by a local musician.[90]

Nevelson had defied Arne Glimcher by insisting, over his objections, that she should give yet more work—and good quality work—to the Farnsworth Museum on the occasion of her second large exhibition. (Glimcher was aware of the many slights she had received in Rockland during her childhood.) Louise Nevelson's return to Rockland in her mid-eighties and her generosity to the Farnsworth, the Colby Museum of Art, Skowhegan, and Westbrook College—all Maine institutions—were signs that she wanted to forget and forgive and make peace with the past. But it was a mask, and a mask that sometimes slipped.

When she had learned that Andrew Wyeth was planning to visit her 1979 exhibition, she was thrilled beyond expectation. Maurice Péladeau's wife, Millie, saw this as an indication of the artist's humility. But I think rather her excitement expressed her amazement that she or anyone originally named Berliawsky

would ever be fully accepted in Rockland or by one of the first families of the state. No matter how many times she had dined at the White House in Washington, D.C., she probably never believed that she could "make it" in Maine.

After the 1985 exhibit and celebratory events were over, Nevelson observed: "When I was growing up in Rockland from grammar school to high school, there was no museum. . . . One of the great joys of my life is that we have a first-rate one now, a beautiful building that encloses creative works that can stand with great ones. That is something that I had not expected in my wildest dreams to find in a town in Maine, that jewel that shines."[91]

As 1985 was winding down, in a lengthy interview published in the *Washington Post*, Nevelson described her thoughts on life and art. Not very different from things she had said earlier but sharper and more clear.[92] Finally, when the reporter asked if the years had taken a toll on her physical powers she responded: "I think so, but then it gave me something. It's a balance. You pay a price for everything. And . . . I've learned to take care of things with such economy that I can claim much of my time. I don't go to beauty parlors. I don't do many things. They take time away from the other more important things in my life. My work."

And so ended 1985.

THE END

1985 – 1988

"In the '70s, I looked back on my life and decided to give myself an
emblem. . . . Well, what do you think I chose for mine? The ques-
tion mark. . . . It gave me a kind of peace."
—Louise Nevelson to Suzanne Muchnic, "More Space for Sailing:
The Nevelson Legend," *Los Angeles Times*, June 21, 1985, F19

In January 1986 Louise Nevelson was interviewed by Iris Krasnow, a writer for
United Press International who specialized in celebrity profiles, and took that
opportunity to reflect publicly on her life. Responding to Krasnow's questions
about aging: "All eighty-six feels like is one year more than eighty-five. I think
living is moving. I would never retire," a typical response for Nevelson. But some
of what she told Krasnow was surprising. For example, she claimed that the teach-
ings of the Indian spiritual master Krishnamurti had given her psychological sta-
bility: "The Indian philosophy says there is no world, but each one of us projects
a world. . . . And you're responsible for what actions you do. That has really given
me my strength. Before that, I was torn apart. . . . I had no rudders."[1]

Nevelson had been mesmerized by Krishnamurti when she first heard him
speak at Town Hall in New York City in 1928, and she continued to study his
teachings to the end of her life. Now, in her final years, both the artist and her
interviewer treated the metaphysical subjects that had once seemed so weighty
with a certain lightness:

Nevelson says she has no belief in a Supreme Being and doesn't care
where she's going when she leaves the earth. . . . "I'm 86, and I don't give

a damn what happens to me. . . . Why should I even think about going to heaven? I think that's ridiculous." So where does Louise Nevelson feel she's headed? "Just where they put me, I guess."

Yet, she acknowledges that her steel monuments that grace many of America's cities will cinch her spot in art history and that being famous is "nice." But, she adds, "It doesn't overwhelm me, because it was so long in the making. Does Beethoven care about these things? He's dead anyway. This immortality is a joke. I don't think about it."[2]

Not surprisingly for someone so dedicated to the creative life, Nevelson's close friends and relatives were all involved with the arts, as creators, critics, curators, or collectors. To questions about her friends, Nevelson responded: "I have a group of best friends. . . . For instance, Dorothy Dehner, Dorothy Miller. Then John Cage and Merce Cunningham and Edward Albee . . . Jasper Johns, Rauschenberg. . . . I prefer artists—I find they have another dimension. When I see some of my friends who aren't in the art world, I realize how many blind spots they have. They miss the seeds in the apple."[3]

When asked about marriage she was more than frank: "I was never married in the true soul sense," she remembers. "Marriage is like a chain." She kept her husband's last name for "my son's sake. . . . I don't even like the word 'marriage' too much, because I think we should be free. Candidly, I think to go to bed with a man every night, like a husband, must be a nuisance. I look at couples, and they don't even look like they should go together in bed. Look, in my profession almost all the men around are gay. I think they are more interesting than the couples where, if the husband says something, the wife has to agree and vice-versa."

"As for her own lifestyle, which includes a home she shared with her biographer, right-hand assistant and friend, Diana MacKown, Nevelson isn't concerned what people may think."[4] Rumors had been circulating for years that the two women were lovers. "Look, darling," she said. "What people think doesn't bother me. After all, what do they know about me? They don't even know about themselves."[5]

She also reveals her lifelong ambivalence about motherhood. She calls her relationship with Mike "pretty close," then adds: "But, listen, he's entirely different than I. He's got a lot of his father as well as his mother. And he probably wouldn't battle the way I did. Why should he? He's living in a different time."[6]

Naturally, Mike Nevelson has his own view of their relationship. He says:

I'm prejudiced because I'm her son and I have my own attitude. My concepts are also distorted by my feelings. . . . Growing up I had to take

care of mother but we were not close. We were not close because she was always going off somewhere. Once in a while she would take me to the Art Students League [1929–30]; she would put me in the hat-check room because I shouldn't be seeing the nude models. . . . When I went to sea [1942] I did not stay at her house; but would stay in a hotel and give her some money [all his pay went to her] because she would be with some man. I'd call her and let her know I was in town.[7]

The tight relationship between mother and son that Louise Nevelson mentions in this late interview was partly based on her guilt about having abandoned him fifty-five years earlier when she left for Munich. Mike Nevelson had experienced a second abandonment by his mother in 1963, when Arne Glimcher became her dealer and friend. Before that, she and her son had been corresponding regularly but seeing each other infrequently because Mike lived in Maine and didn't often get to New York. Then at her request, he moved to Connecticut and had three years of closeness to his mother during the Janis fiasco, when—at age forty-one—he had finally achieved the status he long sought: to be a supportive and loving adult son who could truly help her. As he describes it: "My job was to have women be helped by me. I was happy in Maine and my mother begged me to come to Connecticut and move into her house."[8]

The vast majority of children want to become functional, independent adults. But because of Mike's desire to support his mother when he was a young man and again during the Janis disaster he was understandably upset when that opportunity to help his mother and be close to her was disrupted by the arrival of Arne Glimcher, who could give her anything she needed.

Arne Glimcher's entry into her life at that time—and his ability to provide for her in ways that her biological son could not—was devastating. How could he ever compete with a man who could buy his mother a chinchilla coat, give her an exhibition every year, and make her an art-world phenomenon? The friction between the two men vying for her love was almost biblical, and Nevelson's choice of Arne was almost a foregone conclusion. Anyone who could give her the opportunity to make and exhibit her art was guaranteed to win her heart.

"Every time I spoke to my mother," Mike told an interviewer, "I'd ask, 'Can't I send you some money, a fur coat?' She'd always say, 'I don't need it. Don't send anything.'"[9] Each time she told him that, he may have felt worthless in her eyes.

Over the years of her growing success and celebrity, Mike was increasingly shut out of her social activities and the emotional intimacy he longed for. Too many of Nevelson's friends reported that he was a negligible figure in her life in the last several decades. Edward Albee had this to say (somewhat apocryphally):

"I knew Louise Nevelson for twenty years. In all that time, I never once heard her mention her son. I think that says something."[10]

To add to Mike's loss, Diana MacKown came into the artist's life at almost the same time as Glimcher. Between Glimcher and MacKown, Louise Nevelson was very well taken care of. Then, as her celebrity increased, she became friends with successful male artists, writers, and designers—Albert Scaasi, Edward Albee, Bill Katz, John Cage, Merce Cunningham—who were glad to be near the star. They surrounded her and left little room for anyone outside the orbit.

Mike's principal role became to rescue Louise whenever a crisis occurred. As he described it: When her electricity was going to be cut off "she turned over the bill to me to make sure that she had money in the bank to avoid such problems," or when she found "a dead man on her doorstep she asked me to take care of that too." As her son recalls the 1970s and '80s when he was balancing her checkbook, "she called me all the time to keep me involved. I kept fifty thousand dollars in her checking account and she would send me her checkbook by certified mail then I and my wife Marianne [who was an accountant,] would go over it and send it back."[11] Her neighbor, Sal the barber, referred to Mike as the "bambino from the country." And yet, aside from dealing with the various

Diana MacKown. Louise Nevelson
with Merce Cunningham, 1980s.
Courtesy of Diana MacKown

crises and helping her manage her money Mike was rarely included in her life. Some of that appeared to be his choice; for example, he did not attend the big celebrations for her at the Farnsworth Museum in Rockland in 1979 or 1985, though he had been invited to both by Péladeau.[12] After she died, it is easy to imagine that it might take Mike many years to fully recover from his feelings of loss and rejection.

In January 1986 Nevelson jetted off to Paris on the Concorde to attend the opening of her exhibition at the Galerie Claude Bernard.[13] Bernard gave her a gorgeous party with four hundred guests—including Glimcher, Cage, Cunningham, and Albee—and put her up at L'Hotel, an elegant boutique hotel on the Left Bank, in the very suite where Oscar Wilde had died.[14] Nevelson told a reporter for the *International Herald Tribune*: "My hunch is that this show will put me over the hump. . . . I always call my shots, and honestly I tell you this exhibition is going to go! I know it. I feel it."[15] The sixty-four artworks—some of her finest—included nineteen collages of wood, metal, and paper from the *Volcanic Magic* series, all completed in her banner year of 1985.

By the summer of 1986, Arne Glimcher and Don Lippincott had been discussing how much more metal sculpture Nevelson was likely to produce, given that she was now eighty-six. After one such discussion, Lippincott sent Glimcher a letter outlining five works that should be made "as quickly as possible." Evidently both men sensed the time available for her to finish these works was running out.

Four of the possible works described in the letter—including *Night Tree* (Nevelson's first direct work in Cor-Ten), *Night Wall VI*, *Ocean Gate II*, and *Night Gesture I*—had already been created in versions that were forty to fifty percent smaller than the usual monumental size in which they were made as large-scale public works. The fifth work, "a proposal for Singapore," had not yet been created and never would be. At the end of the letter, Lippincott noted that "hopefully next week we will be able to make considerable improvement on the existing 'partnership sculpture,'"[16] which was called *Sky Horizon* (or *Iron Cloud*).[17]

During the summer of 1986, the Guggenheim Museum in New York gave a small show, *Homage to Louise Nevelson: A Selection of Sculpture and Collages*, which included works she had donated the previous year. The bulk of the exhibition consisted of three monumental sculptures: *The Floral Garden* (1962–85), *Dawn X* from the late 1950s, and *White Vertical Water* (1972). *White Vertical Water*, towering twenty feet upward from the ground-floor level of the museum, is a one-off—rarely exhibited but remarkable in its rippling, flowing rhythms.

The Guggenheim exhibition merited a long piece in *Newsday*, "Sculpting a World to Her Vision," by Amei Wallach. Wallach had written about Nevelson several times before and had developed a perspective about her and her work.

This time she wrote: "Unbridled fecundity and a penchant for repeating suc-cessful effects have dulled the initial impact of Nevelson's vision in recent years. However, whatever 'What, again?' feelings we harbor in the face of her ritual repetitions are dispelled by what is taking place in the Guggenheim rotunda," where, Wallach writes, "Nevelson manages to claim that tricky space with six soaring tiers, spiraling to the roof above in a way that few other artists have matched." She observed about Nevelson's persona: "This time Louise Nevelson has dispensed with the eyelashes. . . . No lashes, no coat, no makeup. Just one kohl line under each eye. Just silver lamé pajamas and a wren-colored scarf splashed with black paint. A working scarf. Just a woman of 87 at loose ends, a little—who wants to talk."

Speaking candidly to Wallach, Nevelson observed, "What's the use of think-ing is there a God or isn't there? I've done my job. I suppose it freed me to stop thinking about some things." Regarding her work, she said: "I happen to be prolific and I've shown all over the world." Asked how she deals with thoughts of death, she said: "Well, I think this, I've lived."[18]

In addition to the six solo shows Nevelson had in 1986 (three in New York City and one each in Paris, Lausanne, and Cambridge, Massachusetts), her work was included in seven group exhibitions. Despite her age she remained eye-catching, eccentric, and unpredictable—all of which was noted by *The New York Times* writer, Carol Lawson, reporting on the city's social scene. "Louise Nevelson was undaunted by the summery weather [on May 22]. Dressed in a long black satin skirt, a velvet brocade jacket and a black mink hat she arrived . . . looking costumed for a czarist winter ball." The setting was the palatial Manhattan apartment of Maurine and Robert Rothschild, who were hosting a reception for the Farnsworth Museum. The advanced age (eighty-seven) of the glamorous-looking artist was "a topic of disbelief among the guests," Lawson writes: "I don't understand how she looks like that," noted one guest. "Edward Albee took one look at Miss Nevelson's outfit and gasped, 'Louise, take off that jacket,' he insisted. 'It's summer.' Miss Nevelson stood firm, her creative spirit intractable."[19]

In September, a major exhibition at Pace Gallery in New York paired ten of Nevelson's sculptures, mainly from *Mirror Shadow*, a series she had been working on since 1980 (and that she would continue until the year she died) with paintings by Agnes Martin. The press release noted that the new wall reliefs "represent a dramatic change from Nevelson's classic, internally organized sculpture."[20] Reviewers agreed. William Zimmer of *The New York Times* wrote: "Louise Nev-elson is up to something new . . . There is a new dynamism that wins one's admiration . . . numerous overriding circular [areas]" and "linear elements that counterpoint this roundness."[21]

In fact, these most recent works in the *Mirror Shadow* series (*Mirror Shadow XXIV* and *XXV*) are more daring than the earlier ones. They have nothing to do with Nevelson's former enclosures and everything to do with outrageous outbursts of energetic forms, which are so tightly composed that the rollicking absurdity of squares and circles that barely stay on the wall goes almost unnoticed. The vastly varying forms and textures shouldn't hold together, but they do. The scale of each seems more sizable than it actually is. She purposefully emphasizes dynamic diagonals and yet manages to produce a compositional harmony that is both balanced and aimed toward infinity.

These would be Nevelson's last sculptures in wood. And her last entirely new work in metal, *Iron Cloud*, or *Sky Horizon*, belongs to the same freewheeling, fearless mode as the late pieces from the *Volcanic Magic* and *Mirror Shadows* series. *Sky Horizon* is a fitting finale: begun in April 1984, completed in October 1986, and sold to the National Institute of Health in Bethesda, Maryland, in May 1988. The enormous arrow shaft points dramatically downward, perhaps a reference to what she knew would be her final resting place. Yet there is plenty of "lace" to soften and feminize the work's aggressive masculinity and terminal tension. Always the consummate composer, Nevelson makes the sharps and curves counterbalance each other, their silhouettes as undaunted as she was to the end of her life.

What drove her during this period? Was Nevelson like Violetta, the consumptive heroine of *La Traviata*, who had her last burst of strength and wild hope just before dying in her lover's arms? Or was the octogenarian simply fearless because she knew she might not be around when the reliefs and steel sculpture were finally sold and installed?

On January 6, 1987, the artist attended the opening of *Louise Nevelson: A Concentration of Works from the Permanent Collection of the Whitney Museum of American Art*, at the Stamford, Connecticut, branch of the museum. Four hundred people showed up at the opening reception. Nevelson was in fine fettle, reviewing the show of forty-six of her works on the arm of Richard Solomon, director of Pace Prints. Tom Armstrong, the museum's director, toasted the "special relationship" Nevelson had had with the Whitney over the years.[22] She had participated in thirteen Whitney Annuals, eighteen major group shows, two sizable solo shows (in 1970 and 1980), in addition to her first retrospective there in 1967.

The museum had been steadily collecting her art, and she had reciprocated, giving the Whitney fifty-five pieces over her lifetime. Her patrons and friends, Howard and Jean Lipman, had donated ten works and promoted her repeatedly at the museum,[23] and now the museum seemed on the verge of making a permanent Nevelson gallery in a new wing of the Manhattan museum. (Neither the new wing nor the Nevelson gallery were built.)

One reviewer of the Stamford show called the artist "one of the great meta-

physical architects of this century. . . . She is a latter day icon-maker. If I were ever asked to design a religious space, a Nevelson wall endowed with layers of allegorical, mystical and visual symbolism, would be its high altar."[24]

William Zimmer, writing in *The New York Times*, offered a measured critique of the Stamford show: "Although she is one of the most substantial artists in America, Louise Nevelson deals with themes that are highly delicate and evanescent . . . a distinct combination of staunchness and mystery. . . . Although there is a sameness to Nevelson's work, a searching out of differences between pieces provides real rewards." And: "Nevelson can be merely decorative, as in handmade paper reliefs, . . . but the brand-new, rather irregularly arrayed collages of wood, metal and paper, titled, with customary Nevelsonian drama *Volcanic Magic*, reveal that this artist never slumbers."[25]

The big revelation from this exhibition was that once again, in her eighty-seventh year, Nevelson was striking out in a new direction. It was as though she had rediscovered a new way to make a dynamic conflict of light and shadow but without restricting herself to a monochrome hue.

In the *Hudson Review*, artist and art critic Maureen Mullarkey observed that, "Much has already been written about Nevelson, and her originality no longer seems new. Her emblematic ordering of random forms has become familiar. The subtle harmonies of her fretted, skeletal improvisations are immediately identifiable." Respectfully, the reviewer concludes that Nevelson "represents the kind of ambition that is almost extinct. . . . Her first loyalty was to her own gifts and the perfection of her work. Her achievement is a reminder, discomfiting in its rarity, that excellence is paid for with one's life."[26]

The question about life and death would now come up more and more frequently for Nevelson. It was a lifelong question she posed to herself and it always related to her view of herself as an artist: "My mother asked me when I was very young and I told her that I was going to be an artist. She said, well you must know that art will be a hard life. And I said it isn't how you live, it's how you die. And that's really what I've lived by."[27]

As the year 1987 continued, Nevelson's work was on exhibit in the new Lila Acheson Wallace Wing of the Metropolitan Museum.[28] A few months later, an article in *The New York Times* about plans to expand the Guggenheim and Whitney museums provoked the only letter Louise Nevelson ever wrote to a newspaper. She knew that the Whitney expansion was meant to include a separate gallery for her work and surely hoped that something similar might happen at the Guggenheim Museum. The *Times* titled her letter: "Go, Go Guggenheim." Short and to the point, she wrote: "I love Frank Lloyd Wright's Guggenheim Museum, but I always thought that museums were for art. Let's get this proposed annex building built and put great art where it belongs."[29]

And that was the artist's last public word before she no longer was able to speak for herself.

In the summer of 1987, Nevelson rented a weekend house in Westhampton. She entertained friends from the city, including Sam Green, Bill Katz, and Marisol. Katz, who loved to cook, would arrive from the city with food and make dinner at the house. She visited with old friends who were also at the beach in the summer. Emily Genauer and her husband came over and stayed up talking late into the night.[30] "She had grown somehow recondite," Genauer recalled, "and talked of the mysticism that moved her deeply from her first meeting . . . with its most famous exponent Krishnamurti."[31] "She worked on collages and small compositions," Genauer reported, "and seemed to be fine with the exception of a dry cough every so often." Of all the people visiting her that summer, she had known Genauer the longest, since the critic had reviewed Nevelson's work positively as early as September 1936 in the *New York World-Telegram*.[32]

During that last summer she had a dream about sitting around the kitchen table back in Maine, talking with her mother. This amazed her because she hadn't dreamt about her mother in many years.[33] Such a dream coming, as it did, so close to the end of her life suggests some not quite conscious awareness that she herself was ill and would soon be dying.

But not before she flew to Youngstown, Ohio, in a private plane with Brendan Gill, urban sophisticate and longtime *New Yorker* writer and architectural critic. She was going to the Butler Institute in Ohio to receive the Butler Medal for Life Achievement in American Art. "She talked a blue streak all the way [on the flight] and was in high spirits throughout the ceremonies," Gill recalled, and had "an air of being in the midst of life [as] she presided over the occasion."[34]

Not long after she returned from Ohio she began to feel sick. A check-up in September at Manhattan's Doctor's Hospital revealed a spot on her lung that might indicate a tumor. She had always feared cancer because it had felled her mother, her brother Nate, and her youngest sister Lillian.

She wasn't sure at first whether to have the recommended surgery to remove what proved to be a tumor on her lung, but finally decided that she had more life to live and more sculpture to make. Diana and Mike were with her before she went into the operating room, and Diana recalls that she quipped: "Now the fun begins."[35] The surgery was described as "successful," but she went back to work with less energy. She spent a quiet Christmas Eve dinner at home with Emily Genauer, Merce Cunningham, John Cage, and Edward Albee.[36]

Recalling how much Nevelson had enjoyed the warm weather in St. Marten the previous year, MacKown had rented a small house for them in a quiet part of the island. They left a few days after Christmas. Sitting on the beach shortly after her arrival, Nevelson told Bill Katz that she had been thinking about how

civilized the Dutch were, because in Holland euthanasia was acceptable. Katz, who had not known about her recent surgery, was shocked to see how frail she had become.[37]

A few days later she had lunch at Jasper Johns's home. Johns called Katz and told him he thought Louise should return to New York immediately and be hospitalized. Diana accompanied her on the flight back, and Katz, who had already gone back, picked them up at the airport. They drove straight to Doctors Hospital, where she was diagnosed with a cerebellar tumor. The lung cancer had metastasized, and radiation treatment was advised. Nevelson acceded to the treatment but was exhausted by it and seemed to be dying more each day.

In February 1988, Nevelson went from whispering to muteness. Diana read short stories to her and brought her wood, paper, and glue in an attempt to interest her in working—but without much success. Knowing how little energy she had, MacKown kept most people away. In Nevelson's illness as she had been in her health, Diana was the watchdog at the gate. Nevelson herself made the decision to have "Occupant" instead of her name put on the door of her hospital room to keep from having unwanted visitors.

Nevelson's granddaughter, Maria Nevelson, was studying painting at the University of the Arts in Philadelphia and recalls talking with her grandmother about composition when she went to visit her at the hospital. Nevelson lifted her hands up, as if to instruct her, but then dropped them, exhausted by the effort.[38] She had completely stopped speaking and was not alert most of the time.

Louise Nevelson wanted to die at home and was brought back to her house and moved into what had been Diana's room at 31 Spring Street because it was central. (Diana moved into three small rooms on the third floor.) By that time Mike Nevelson, with his wife Marianne, had moved into the top floor of the 29 Spring Street house and was "monitoring the situation," and seeing his mother as often as possible.[39] Ten days before she died, Diana called Nevelson's two granddaughters, urging them to come to say their last goodbyes. Diana recalls that this upset Mike because he wanted his mother to himself—an experience that had been all too rare during her lifetime.[40]

Arne Glimcher visited her only a few times in the last weeks of her life. He was sure she didn't want him to see her in her fragile state, but he talked to her nurses every morning. Glimcher recalls that, "The day before she died, the nurse asked her if she was afraid. Nevelson wasn't talking, but she shook her head, yes."[41] At his last meeting with Nevelson, which was at her home, "She didn't open her eyes or speak, she just squeezed his hand."[42]

Shortly before she died Diana came into her room and saw a remarkable sight. Nevelson had put both her arms straight up in the air, which Diana interpreted as a gesture invoking some spiritual connection. After her arms came

Diana MacKown. Louise Nevelson with Arne Glimcher, 1974. Courtesy of Diana MacKown

down Diana went to her side and, holding her hand, said goodbye. She then left the room and told Mike that his mother was dying and that he should be with her.

Louise Nevelson died on the morning of April 17, 1988.[43]

■

Any discussion of Nevelson's legacy as a person and artist requires an understanding of the dispute that immediately followed her death. That dispute was extensively covered in the press by journalists who interviewed all the parties involved.

Louise Nevelson had stipulated that her entire estate would go to her son and that he would be the executor. Within two days of his mother's death, Mike had a metal door installed to block Diana's access to the third floor of 31 Spring Street, which housed the studio and the living quarters she had shared with Nevelson and relegated Diana to two rooms in that building. He also barred her from the two adjacent buildings that Nevelson had owned.[44] To his daughter Maria, who had been attempting to be emotionally supportive of Diana, "the metal door seemed cruel—like the Berlin wall."[45] Mike also asked Diana to surrender her keys to the garage and to find another place to keep Black Beauty, the 1976 Ford station wagon that had been his mother's primary means of transportation.[46]

No one was allowed to come into 29 Spring Street, including Mike's three daughters. Everyone staying in 31 Spring—mostly Diana and Maria—wondered what on earth was going on, what was the secret, "what was he hiding?"[47] As they eventually discovered, during this period Mike took every beautiful object from Nevelson's home, every piece of her art—sculptures, collages, paintings, including twenty-five of the terra-cottas and ten other works Nevelson had signed over to Diana in 1985 and 1986.[48] Mike put the art into a truck and drove it to his home in New Fairfield, Connecticut, where it was stored in a barn on his property.[49]

Throughout the last years of his mother's life, Mike kept reaching out to her, trying to be close, and she kept pushing him away. When asked if he ever complained about not being able to contact her on the phone, he responded: "She needed Diana, I suppose. I wasn't going to keep calling. All I knew was, I was spending a lifetime saying, 'Look at me. *Look* at me. I love you.' She'd say, 'Ah, ech.' I'd say, 'Listen, can't we spend a little more time together.' And she'd say, 'I have a meeting at the museum tomorrow, then somebody's coming to interview me.'"[50]

According to her many statements, his mother felt remorse for having left

him when he was a child and for regularly leaving him out as an adult.[51] Did she also feel remorse for taking some of his work—refurbished antique wood pieces—and chopping them up to use in her own work?[52] She had worked hard to create the world in which she could bask in the glory of her creative accomplishments and her creative friends. Mike himself saw the situation poetically, stating: "Nevelson is the moon and Mike is the son."[53]

Yet, Mike Nevelson didn't fit in that world, and she mostly excluded him from it. Furthermore, she kept on talking to everyone about the "guilts of motherhood" and explaining the various reasons why she shouldn't have had—and in fact had never wanted—a child.[54] How could he not have felt anger, sadness, and disappointment when his mother kept saying she was sorry he was born? As time would reveal, the psychological burden she carried as a "bad mother"—and the decisions she made as a result—would have long-term consequences, affecting both her reputation and her artistic legacy.

Nevelson knew that works she had created in the late 1970s and '80s were done under contract to Sculptotek (the shell company Mike and his attorney created in 1976 to manage the income from Nevelson's work), but she probably believed that she was free to give away works she had created earlier, for example the terra-cottas from the 1940s and '50s. She intended for Diana to have them and sell them and, therefore, have some stable income.[55] By leaving work to Diana and giving away twenty-five works to museums in 1985, she was attempting to isolate her acts of generosity from the regret she felt about the repeated abandonments of her son, which likely motivated her to allow Sculptotek to be established.

"Sometime," Mike responded to a *New York* magazine reporter when asked when his mother's remains would be buried. Looking toward his office where a small black granite box sat on a shelf in his Connecticut home, he continued, "For the first time in my life my mother's ashes are here in the house next to me. I've got my mother home at last with me, and I'm not ready to give her up. I'm not running to put her in the ground."[56]

Along with her ashes, the only thing he had left of her after her death was her work. No wonder he was reluctant to share it—especially with Diana, who had displaced him, who had cut his contact with his mother to the minimum, whom his mother had once considered adopting so she could be co-executor of the estate. In response to that idea Mike told his mother: "Diana doesn't like me. If you do that I resign."[57] It must have been too painful for him to think of Diana as a sibling with whom he had to share anything. Now he was going to handle the problem by shutting Diana out completely.

In order to pay the huge taxes on his mother's estate, Mike Nevelson wanted to sell the two houses and garage in which his mother had lived and worked. As

he put it: "The IRS hit me for everything including work I had made; we were wiped out by the gift tax [which] claimed everything that was made was by Louise Nevelson. I owed $442,000 to the IRS."[58]

For that reason he began eviction proceedings to get Diana out as soon as possible. Toward the end of Louise's life, Diana had been paid $250 per week, plus room and board, travel, and health insurance. When her salary was abruptly stopped and she had no means of support, Mike believed the pension he had provided for her in the original Sculptotek plan was enough to take care of her. "When she decided not to work for Sculptotek any more that was it."[59] People who were aware of Diana's role as Louise Nevelson's devoted assistant were shocked by Mike's seemingly heartless treatment.

Dorothy Miller, former curator at MoMA and a friend of Louise's since 1933, claimed that, "Diana took complete care of Louise in the last 25 years, so Louise was totally free to work. She was more than a daughter."[60] Willy Eisenhart said that Louise "absolutely intended to provide for Diana. Diana did everything for Louise, and she freed Louise's mind and spirit. Without Diana, I think Louise would have died a lot younger."[61]

To all of the accusations of Louise's art-world "family"—who didn't know or care about Mike—Mike had a seemingly endless supply of explanations: "If my mother had wanted Diana to have money, it would have been the easiest thing in the *world* to put it in her will. . . . But she *excluded* Diana from the will." And: "If his mother was so unhappy with him—as Louise Nevelson's crowd says—then why, Mike Nevelson asks, did his mother appoint *him* as executor of her estate?"[62] "I'm the executor of the estate and I'm following my mother's will."[63] In addition, he observed: "It was at her insistence that I took over the running of her business affairs. I played a common role as a son."[64]

Mike claimed that, "My mother had this habit over the years of giving things away, without keeping track."[65] He justified his taking the terra-cottas by claiming that the work belonged to Sculptotek and not to his mother, and thus she had no right to give them away. "When I straighten out who has the title to which pieces," he said, "then Diana will get the sculptures."[66]

"Look, my mother didn't care about money," Mike explained, "she didn't care about clothes. She didn't care about family. She cared about her work living on after her. She trusted me to take care of her affairs because she knew that I would die for her if I had to."[67]

In the two years after Nevelson's death, Mike and Diana had a continuing legal battle over the artist and her work. Mike was so adamant about withholding his mother's artwork from Diana that she hired a lawyer, C. Leonard Gordon, to get Mike to return the work Louise Nevelson had given to her.[68] If Mike didn't relent, Gordon was prepared to bring suit against him for punitive dam-

ages. He felt that Diana's claim should include $325,000 to compensate her for her decades of service. Gordon threatened a RICO suit or even a palimony suit, explaining to Mike Nevelson's lawyer that speculation about a sexual relationship between the two women was already "out there" in the mind of the public.[69]

Agreeing with Nevelson's closest friends—Edward Albee, Merce Cunningham, John Cage, Bill Katz, and Willy Eisenstat—about the falseness of that speculation, Mike said: "Listen . . . my mother was a turn-of-the-century woman, a Victorian woman in some ways. She *said* some outrageous things, maybe, but one thing I can tell you: My mother liked *men*. Anyone who knew her at all knew *that*."[70]

In the end, Diana MacKown got back the terra-cottas along with two large relief walls, the value of which was more or less equal to the compensation her lawyer had requested. And that was without a trial.[71] Though Diana had powerful friends who believed that she had been badly treated, she was not interested in pursuing the issue through a lengthy and expensive court case.

The question of money—and who wanted it and who didn't—comes up in all discussions and legal decisions about mother and son. As discussed earlier, Mike Nevelson had established Sculptotek upon the advice of his lawyer, as a way of both helping his mother out with her financial affairs and also a way of avoiding gift and estate taxes.[72] An unnamed relative supported this claim: "Sculptotek was set up because Louise was totally incapable of handling her financial affairs. . . . It was her son's and the gallery's way of helping her. Whatever the problems might have been between Louise and Mike in earlier years, she turned to him because she felt he was the one person she could trust."[73]

This is a remarkable statement given that Nevelson was in her mid-seventies at the time Sculptotek was formed, at the height of her powers, and had completely trusted Arne Glimcher to deal fairly with her financially since 1963. It must also be noted that Arne Glimcher has stated unequivocally that Sculptotek was entirely Mike's idea and that, since Louise had agreed to it, he and Pace Gallery had no choice but to accept the plan of making Mike the master of his mother's money.[74]

All the arrangements Mike had created to protect him from having to pay gift taxes on his mother's estate went for naught. In May 1996 the U.S. Tax Court determined that Mike owed more than one million dollars in back taxes and penalties for the period of 1977 to 1988. In 1996, the Estate of Louise Nevelson, deceased, Mike Nevelson Executor, sued the IRS concerning federal gift taxes, which the IRS had determined were deficient. In plain language, Mike had not paid the taxes on the value of his mother's work—taxes he had owed the IRS for all those years. As executor, Mike had claimed that "he cannot sell the estate's assets in the near future because he will receive less than fair value." He

also claimed that Louise Nevelson's federal gift taxes remained unpaid because he had yet to receive a bill from the IRS.[75]

Both of Mike Nevelson's claims "[were] found to be without merit" in court.[76] But during those eight years Louise Nevelson's work was off the market. While the value of her work was being evaluated by the IRS tax court, neither the estate (Mike Nevelson) nor Pace Gallery (previously Nevelson's exclusive agent) would sell the art. Mike could not have known how damaging that long hiatus would prove to his mother's reputation.

Three years after the tax court decision, in 1999, Mike brought a lawsuit against the company of his former lawyer, Maurice Spanbock (Carro, Spanbock, Kaster and Cuiffo, CSK&C), who had helped him set up Sculptotek in the first place. The Appellate Division of the Supreme Court of the State of New York summarized the issue thus far as:

> Plantiff Sculptotek, Inc., a corporation wholly owned by Mike Nevelson, was created upon the advice of CSK&C for the purpose of organizing the financial affairs of Louise Nevelson, and in an attempt to cause her artwork and the income from it to pass outside of her taxable estate. After Ms. Nevelson's death in 1988, the IRS determined that the corporate entity Sculptotek should be disregarded, as it was a sham corporation used to gift the decedent's income and assets to her son, and that all of the assets of Sculptotek should have been included in the sculptor's gross estate. It further determined that all of the salary paid by Sculptotek to her son, Mike Nevelson, between 1977 and 1988 constituted taxable gifts. This IRS determination was based primarily upon a finding that Sculptotek failed to adequately compensate the decedent artist, whose works generated the bulk of the assets held by the corporation.[77]

The court found that Mike had a right to sue.

Eight long years after Nevelson's death, the dispute with the IRS was over, and "the estate," in the person of Mike Nevelson, could begin to sell her work. He hired Jeffrey Hoffeld, Arne Glimcher's former associate and vice president at the Pace Gallery, to be the exclusive agent to oversee that task.[78] Because of their longstanding enmity, Mike Nevelson wouldn't work directly with Arne Glimcher. Pace Gallery had to return a large number of Nevelson works it had had on consignment, but it was allowed to sell pieces that the gallery owned outright. Hoffeld sold some of her work through other dealers, but, until Mike Nevelson sold the bulk of the estate in 2005, seventeen years after her death, much of Louise Nevelson's work was effectively unable to be bought or sold.

For so many years Arne Glimcher had been *the* Nevelson dealer. When that

changed after her death and the confusion about who could actually represent her unfolded, along with the persistence of scandal attached to so much about her estate, it interfered with what had been an uninterrupted trajectory of success. Finally, fifteen hundred works by Nevelson still in the estate's remaining inventory were sold in a sealed bid auction on November 5, 2005. They were bought and divided in a three-way sale by Pace Gallery (New York), Galleria Gio Marconi (Milan), and Galerie Gmurzynska (Zurich and Zug).[79] In the art world, seventeen years is a lifetime to be kept "off the market." The damage was done.

Was it true—as Mike Nevelson had claimed in the IRS lawsuit—that he would not get enough money from the sale of his mother's artwork to pay the estate's gift taxes? Or did he want to keep everything of his mother's as long as he could, no matter the fiscal consequences? Selling the houses in which she had lived and worked evidently made sense to him, because he needed the money to pay taxes and perhaps also because he had been largely excluded from her life there. Holding on to her work until 2005 also made sense—psychological sense—to a twice-abandoned son whose love for his mother had never been sufficiently reciprocated.

Louise Nevelson's ashes have finally been buried without fanfare in a country cemetery in Acworth, New Hampshire, near the current home of Mike Nevelson, and in spite of her expressed wish to be buried in the family cemetery in Rockland, Maine.[80]

"She died and her work disappeared."[81] It was clear to Arne Glimcher, what had happened. "Mike took everything off the market. He ruined her market and destroyed her reputation. She was the most famous artist in the United States at the time."[82] After her death, Glimcher and other dealers were wary of showing her work because every time there was a Nevelson exhibit, the media concentrated on the scandal—son versus longtime helper, or son versus the IRS—and that sidetracked any attempts to focus on her art. The lawsuits went on until 1999.[83] Publicity, which should have been about her work and her career, was sucked into scandal-mongering.

It will take some time to recover from the near silence of those seventeen long years. A generation of artists has come and gone knowing little of what they have missed in not knowing Louise Nevelson and her work. Ironically Nevelson herself predicted that she would go through a period of being out of the limelight. In her characteristic way she exaggerated her time out of favor. She told Diana MacKown: "I'll be forgotten for 200 years. I'm going under the water."[84]

The scandals and the silence have somewhat slowed her path to lasting fame but immediately after she died Louise Nevelson was memorialized in countless obituaries. Starting with her hometown paper, *The New York Times,* John Russell

wrote: "A pioneer creator of environmental sculpture who became one of the world's best known artists died Sunday evening. . . . Mrs. Nevelson was an artist of the first rank, and among the most arresting people of her time." He concludes with the statement: "Louise Nevelson was never touched by old age. She put it in its place and went on with the only thing that mattered to her: her work."[85]

One of the few obituaries written by a close friend was subtitled "Goodbye, Louise" by June Wayne for *Women Artists News*. Wayne, whose friendship went back to 1963 when Nevelson first went to work at Wayne's Lithography Work-shop, Tamarind, in Los Angeles, was candid about her dear friend's true self.

> She saw that her own success was an act of defiance of the powers-that-be in the art world. Yet she was never more fearful than when she seemed most brazen; her plumage was merely camouflage. . . . In spite of her lusty language, and occasionally lusty behavior, she was as easily star-tled as a bird. She was afraid of crowds and during the quarter-century of our friendship, she never went alone to openings or festive events. . . . When the long obituaries about Louise have been put into perspec-tive, her struggle for acceptance in the art world will emerge as nothing more than a strategy for getting the money to keep making art. She was not seduced by her own celebrity, although the flamboyance seduced the public that adored her. . . . But art that we savour was paid for in fanatical, puritanical singleness of purpose, in renunciation of creature comforts and intimacies for which we can never repay her.[86]

A memorial service was held for the artist in the Medieval Court of the Metropolitan Museum of Art on October 17, 1988. William Lieberman, direc-tor of the museum's Twentieth-Century Art department, described Nevelson as "a great artist, a wonderful woman, an elegant lady and a good and gener-ous friend."[87] One more memorial took place a half-year later. First, a concert *"In Remembrance of Louise Nevelson"* was held at Weill Recital Hall at Carnegie Hall on March 28, 1989. It was organized by Bill Katz, Diana MacKown, and Jasper Johns. Edward Albee introduced *"An Hour of Song"* sung by Jessye Nor-man, accompanied by James Levine. The program included texts by John Cage, Isamu Noguchi, Merce Cunningham, and Prince Michael of Greece.

Three days later on March 31, 1989, an exhibit, *Louise Nevelson Remembered: Sculpture and Collages*, opened at the Pace Gallery. It was Arne Glimcher's farewell gift to Louise Nevelson—a show of some of her last sculptures and most striking collages as well as an elegant package of photographs, a portfolio of remem-brances by dear friends, previously unpublished interviews, and post cards of scenes from her home.[88]

Reviewing the artwork for *The New York Times*, John Russell proclaimed that it was "not 'a memorial exhibition.'" "On the contrary," he wrote, "it speaks for Nevelson as a severe, classical artist who worked with vertical, horizontal and diagonal as her three trusted henchmen. . . . It is strong work, plain work, up-front work, and completely resolved."[89]

For the remembrances, Glimcher chose people who had been close to Nevelson and important to her for a long time: Emily Genauer, Diana MacKown, John Cage, Merce Cunningham, Edward Albee, Hilton Kramer, Barbaralee Diamonstein, Jean Lipman. Each compiled some high points of their relationship.

Emily Genauer wrote about the first critical piece she had written on Nevelson in September 12, 1936, in the *New York World-Telegram*. Genauer and Nevelson eventually became close friends, speaking to each other every few days, traveling together to California, New England, and Greece.

Jean Lipman, who had written *Nevelson's World* a few years earlier, recalled a moment when Charles Kuralt asked Nevelson toward the end of the TV interview how, at age eighty, she could possibly maintain the energy and quality of the work that had made her famous. Nevelson paused for a full minute and said: "Look, Dear, if you can walk, you can dance."[90]

Diana MacKown's brief statement was modest and forward-looking. "It meant a great deal to me when Arnold asked me to assist with this show. . . . It is a joy to see [the work] out in the world. This show will have its own magnificence, and I know the work will cross continents of awareness."[91]

Hilton Kramer, her longtime admiring critic from *The New York Times*, recalled his first visit to her home and studio on Thirtieth Street. "It looked like the refuge of a mad collector. But one came to understand the discipline and ambition and vision governing the creative life that was harbored in this enchanted house. . . . It was in that house that Louise changed the scale of modern sculpture . . . this was her crucial achievement, and it is what she will be remembered for when the glamor is forgotten."[92]

Barbaralee Diamonstein had known Nevelson since 1963. They became close over the years. Diamonstein saw her as "a complex cross between a princess and a peasant, a mother hen in a clerical collar who gave sermonettes and would deliberately lapse into Yiddish asides when she wanted either Barbaralee or Diana to 'get it.'"[93]

Arne Glimcher wrote "Louise Nevelson's life was such an intricate pattern of fantasy synthesized with reality that separation of myth and fact is nearly impossible. A chronology of her life provides the barest skeletal outline of incidents to which she reacted. These reactions, evident in . . . art works, are only the visible and tangible evidence—the key—to the realization that Nevelson's life itself was her greatest work of art."[94]

EPILOGUE

My view of Louise Nevelson has evolved over decades of study. Very early on she learned that life and art are inseparable. She saw and understood the rich and complex world inside and all around us—and with her work gave us the essence of that plenitude and simplicity.

From her earliest studies of nature—the watercolor of trees with their beautiful bark and ominously leaning trunks—to her final works with their daring diagonals and propulsion away from the pages of paper or wood walls, she was aiming fearlessly toward something beyond the here and now.

As she matured as an artist and a woman she came to understand that she was actually searching for the spiritual essence of life, its deeper meaning, its universal truths. At first the titles of her early exhibitions gave viewers a way into the depth of her intentions: *Ancient Games, Ancient Places*; *The Forest*; *Moon Garden + One*; *Dawn's Wedding Feast*.

But those were merely maps, means to orient oneself in the enigmatic worlds she had created. What she really wanted was for the viewer to discover the universal experience of what she called livingness.

Later, evocative titles were not always used to help people connect with her work. She had seen often enough that committed viewers got her messages by simply looking at her work.

When she gave titles to her late works they were symbolic, no longer literal signposts, and impossible to imagine except by taking a leap into the unknown and unknowable: *Mirror Shadow, Sky Horizon, Volcanic Magic, Dawn Shadows, Cascades Perpendicular, Sky Landscape*. As a lifelong Surrealist, she knew that combining the uncombinable would lead to that inevitable leap into understanding the mysteries of life.

Whether she believed she was bringing the fourth dimension with its ideal harmonies down to the here and now of the three-dimensional world with her sculpture, or celebrating the profound and wondrous world around us, she was offering a window into her soul, and perhaps also our own.

ENDNOTES

INTRODUCTION

1 Hilton Kramer, Introduction in *Nevelson's World*, Hudson Hills Press and Whitney Museum of American Art, 1983, p. 15
2 John Canaday, *A stimulating Show of Nevelson Art*, New York Times, November 11, 1970, p. 36.
3 Jan Gelb, interview with author, June 26, 1976.
4 Louise Nevelson in Arnold B. Glimcher, *Louise Nevelson* (New York: Praeger, 1972), 19–20.
5 Nevelson in Glimcher, *Louise Nevelson*, 193.
6 John Canaday, "Art: Nevelson's '7th Decade Garden'; Group of 12 Sculptures Shown at the Pace," *New York Times*, May 8, 1971, 25.
7 John Canaday, "Tribute to Louise Nevelson on the Occasion of the Award of the Edward Mac-Dowell Medal," *The MacDowell Colony: Report for 1969*, August 24, 1969.
8 Helen Meyner "In and Out of New Jersey" *Newark Star Ledger* March 30, 1967
9 Bernadette Andrews, "Showing the World Art Is Everywhere," *Toronto Telegram*, October 19, 1968.
10 *New York Times*, April 18, 1988.

1. RUSSIAN ROOTS 1899–1905

1 Mike Nevelson, interview with author, April 11, 2014. According to her son, Mike Nevelson, his mother's name was Lieken, not Leah.
2 Sholem Aleichem who had grown up in Voronko, a small town near Kiev, eloquently portrayed village life in stories such as "Tevye the Dairyman," which begat the musical *Fiddler on the Roof*.
3 Celia C. Rosen, includes an interview with Nate Berliawsky, *Some Jewels of Maine: Jewish Maine Pioneers* (Pittsburgh: Dorrance, 1997), 59.
4 Louise Nevelson, *Dawns + Dusks: Taped Conversations with Diana MacKown*, ed. Diana MacKown (New York: Charles Scribner's Sons, 1976), 18.
5 Philip Isaacson, "Louise Nevelson At 67," *Portland Sunday Telegram*, May 21, 1967, 7D.
6 Ibid. Philip Isaacson, "Louise Nevelson At 67," *Sunday Telegram* (Portland, Maine), May 21, 1967, 7D.
7 "They Call me Mother Courage," Jean Micuda, *Arizona Living*, March 17, 1972, vol 3 no 11.
8 Louise Nevelson, *Dawns + Dusks: Taped Conversations with Diana MacKown*, ed. Diana MacKown (New York: Charles Scribner's Sons, 1976), 14.
9 Lillian Berliawsky Mildwoff and Anita Berliawsky Weinstein, interview with author, July 13, 1976.

10 Lillian Berliawsky Mildwoff, interview with author, June 14, 1976.

11 The Russian Empire is being used here to refer to what was sometimes called Russia-Poland, as well as the Lithuanian, Belorussian, Ukrainian, and Polish provinces of the Russian Empire.

12 "They bought the trees on the land and would saw it by hand." Nate Berliawsky, interview with author, July 12, 1976. The question of Jewish land ownership is discussed by Michael Stanislawski in "Louise Nevelson's Self-Fashioning: 'The Author of Her Own Life'" in *The Sculpture of Louise Nevelson: Constructing a Legend*, ed. Brooke Kamin Rapaport (New Haven: Jewish Museum with Yale University Press, 2007).

13 Lillian Berliawsky Mildwoff, interview with author, June 14, 1976.

14 Michael Stanislawski, "Louise Nevelson's Self-Fashioning: 'The Author of Her Own Life'," in *The Sculpture of Louise Nevelson: Constructing a Legend*, ed. Brooke Kamin Rapaport (New Haven: Jewish Museum with Yale University Press, 2007), 222. Published in conjunction with the exhibition of the same name, shown at The Jewish Museum, New York, and the Fine Arts Museums of San Francisco, de Young.

15 Michael Stanislawski, *Tsar Nicholas I and the Jews* (Philadelphia: Jewish Publication Society of America, 1983), 10.

16 Ibid., 25.

17 Ibid., 32–33.

18 Ibid., 112. See also Steve J. Zipperstein, "Russian Maskilim and the City," in *The Legacy of Jewish Migration: 1881 and its Impact*, ed. David Berger (New York: Columbia University Press, Social Science Monographs, 1983). The Haskalah movement was an eighteenth- and nineteenth-century movement among central and eastern European Jews, begun in Germany under the leadership of Moses Mendelssohn, designed to make Jews and Judaism more cosmopolitan in character by promoting knowledge of and contributions to the secular arts and sciences and encouraging adoption of the dress, customs, and language of the general population.

19 Stanislawski, *Tsar Nicholas I and the Jews*, 187.

20 Benjamin Nathans, *Beyond the Pale: The Jewish Encounter with Late Imperial Russia* (Berkeley and Los Angeles: University of California Press, 2002), 66.

21 Nate Berliawsky, interview with author, July 12, 1976.

22 Jeffrey Entin, Descendants of Khatskel Berlyavsky, communication, November 13, 2013 Alex Berljawsky, communication, November 13, 2013 .

23 Nevelson, *Dawns + Dusks*, 4.

24 Nate Berliawsky, interview with author, July 12, 1976.

25 Mike Nevelson, interview with author, April 11, 2014. He also recalled that this photograph was kept in the living room in a special Slavic red-painted area that also held a samovar and tea glasses brought to Maine from Russia by his grandparents.

26 Nate Berliawsky, interview with author, July 12, 1976.

27 Beginning on April 14, the confluence of Easter and Passover "sparked an explosion of violence that cut a destructive path through Jewish communities across the southern provinces of the Pale for over two years.... violence spread quickly to nearby cities, including Kiev and Odessa, and soon engulfed hundreds of communities. . . . 1881 inaugurated a new pattern of anti-Jewish violence in which national political events acted as decisive catalysts, and rioting occurred not just in isolated settings but across large regions, for months or years on end." Nathans, *Beyond the Pale*, 186.

28 Irving Howe, *World of Our Fathers: The Journey of the East European Jews to America and the Life They Found and Made* (New York and London: Harcourt Brace Jovanovich, 1989).

29 Judith S. Goldstein, *Crossing Lines: Histories of Jews and Gentiles in Three Communities* (New York: William Morrow, 1992), 44.

30 Nathans, *Beyond the Pale*, 86.

31 Nevelson, *Dawns + Dusks*, 4–6.

32 Barbara and Joel Fishman and Barbara's parents, Sam and Ruth Small, descendants of Louise's maternal aunt, interview with author, December 8–9, 2007.

33 However, recent research suggests that not all such "first-hand" stories of pogroms and marauding Cossacks are accurate. "This is largely a literary motif which is picked up very broadly and then became memory." Michael Stanislawsky, communication with author, March 11, 2014.

34 Nathans, *Beyond the Pale*, 187.

35 Barbara and Joel Fishman, descendants of Nevelson's grandmother, interview with author, July 2008.

36 *Encyclopaedia Judaica* (1971–92; 2nd ed. New York: Macmillan Reference USA, 2006), 15:768–69, s.v. "Pereyaslav-Khmelnitski."

37 Monty Noam Penkower, "The Kishinev Pogrom of 1903: A Turning Point in Jewish History," *Modern Judaism* 24, no. 3 (October 2004): 187–225. See "Jewish Massacre Denounced," *New York Times*, April 28, 1903, 6; there were follow-up articles throughout May.

38 Penkower, *Modern Judaism*, 187–225.

39 "Jewish Massacre Denounced," *New York Times*, April 28, 1903, 6.

40 Mike Nevelson, interview with author, April 11, 2014. According to Mike Nevelson, his grandmother Minna also kept silent about these frightening events. In the same way that many survivors of the Holocaust never shared their experiences, she did not talk with her children or grandchildren about the pogroms that had affected her or members of her family.

41 MacKown had intuited some of Nevelson's traumatic experience as she heard Nevelson describe her earlier years in Russia.

42 Lillian Berliawsky Mildwoff, interview with author, June 14, 1976.

43 Mike Nevelson, interview with author, April 11, 2014. This version of the story comes from Mike Nevelson. An alternative and revealing family story from Lillian is that Nathan, who had become rich and important in Waterville, wanted his younger "greenhorn" brother out of the way. So he bought Isaac a horse and carriage and sent him off to make his way on his own. Lillian Berliawsky Mildwoff, interview with author, June 14, 1976.

44 Nevelson, *Dawns + Dusks*, 6.

45 Ibid.

46 Anita Berliawsky Weinstein, interview with author, July 12, 1976.

47 Sigmund Freud, "Screen Memories" [1899], in *The Standard Edition of the Complete Psychological Works of Sigmund Freud*, 24 vols. (London: Hogarth Press, 1953–74), 3: 322.

48 Sigmund Freud, "Leonardo and a Memory of His Childhood," [1910], *Standard Edition* 11: 83

49 Sigmund Freud, "A Childhood Recollection from *Dichtung und Wahrheit*," [1917], *Standard Edition* 17: 149.

50 Eleanor Munro, *Originals: American Women Artists* (New York: Simon and Schuster, 1979), 135, 136.

51 Arnold B. Glimcher, interview with author, February 5, 2007.

52 Nate Berliawsky, interviewed by the author, July 12, 1976; Lillian Berliawsky Mildwoff, interview with author, July 14, 1976. "That's where we played the most." Lillian Berliawsky Mildwoff and Ben Mildwoff, interview with author, June 14, 1976.

53 Ben Mildwoff, interviewed by the author, June 14, 1976. See also Alvin Sweet, "How Industries and Trades of Maine and Region Grew from Early Times," *Courier-Gazette*, March 20, 1976, Trade and Travel section, 1.

54 Lillian Berliawsky Mildwoff and Ben Mildwoff, interview with author, June 14, 1976.

55 Nevelson, *Dawns + Dusks*, 7.

56 Mike Nevelson, interview with author, April 11, 2014.

57 Lillian Berliawsky Mildwoff, interview with author, June 14, 1976.

58 Mike Nevelson, interview with author, July 29, 1977.

59 Glimcher, *Louise Nevelson*, 27.

60. Judith Goldstein, *Crossing Lines: Histories of Jews and Gentiles in Three Communities* (New York: William Morrow, 1992). Between 1906 and 1917 Isaac Belofski/Berliawsky was listed as grocer and/or peddler in the town records.

61 Lillian Berliawsky Mildwoff, interview with author, June 14, 1976.

62 Anita Berliawsky Weinstein, interview with author, July 12, 1976.

63 Lillian Berliawsky Mildwoff, interview with author, July 14, 1976.

64 Ibid.

65 Anita Berliawsky Weinstein, interview with author, July 12, 1976.

66 Rosen includes an interview with Nate Berliawsky in *Some Jewels of Maine*, 57. See note 2, above.

67 Nate Berliawsky, interview with author, July 12, 1976.

68 Anita Berliawsky Weinstein, interview with author, July 12, 1976.

69 Mike Nevelson, interview with author, July 27, 1977.

70 Anita Berliawsky Weinstein, interview with author, July 12, 1976.

71 Mike Nevelson, interview with author, July 27, 1977.

72 Mike Nevelson, interview with author, July 29, 1977.

73 Mike Nevelson, interview with Laurie Lisle, July 27, 1984, untranscribed audio recording, LN Papers, AAA.

74 Lillian Berliawsky Mildwoff and Anita Berliawsky Weinstein, interview with author, July 13, 1976. Mike elaborates on the story of his grandfather's drunkenness, explaining that for many years Isaac could not become a U.S. citizen because of his record of drunk driving. "He was arrested for carrying a bottle of alcohol on Main Street and drinking. He used to fight with people all the time. He had a bad personality." Mike Nevelson, interview with Laurie Lisle, July 27, 1984, untranscribed audio recording, LN Papers, AAA.

75 "One of the finest gentlemen." Anita Berliawsky Weinstein, interview with author, July 12, 1976.

76 Nevelson, *Dawns + Dusks*, 10.

77 Ibid.

78 Nevelson in Roy Bongartz, "'I Don't Want to Waste Time,' Says Louise Nevelson at 70," *New York Times Magazine*, January 24, 1971, 12–13, 30–34.

79 Nate Berliawsky, interview with author, July 12, 1976.

80 Mike Nevelson, interview with Laurie Lisle, July 27, 1984, untranscribed audio recording, LN Papers, AAA.

81 Anita Berliawsky Weinstein, interview with author, July 12, 1976.

82 Louise Nevelson, interview with author, January 8, 1976.

83 Nevelson, *Dawns + Dusks*, 10.

84 Ibid.

85 Nate Berliawsky, interview with author, July 12, 1976. From the 1940s through the '70s, Nevelson would occasionally "disappear." It was usually after working extremely hard preparing for an exhibition but before the show opened. She would have checked herself into a hospital with nervous exhaustion. Diana MacKown, interview with author, January 25, 2013. She would invariably reappear in time to finish the preparations for the exhibit.

2. ROCKLAND CHILDHOOD 1905–1918

1 Anita Berliawsky Weinstein, interview with author, July 12, 1976.

2 Ibid.

3 Mike Nevelson, interview with Laurie Lisle, July 27, 1984, untranscribed audio recording, LN Papers, AAA.

4 Mike Nevelson, interview with author, July 29, 1977.

5 Munro, *Originals*, 138.

6 Louise Nevelson, interview with author, January 8, 1976.

7 Nevelson, *Dawns + Dusks*, 10.

8 Ibid., 10–13.

9 Lillian Berliawsky Mildwoff and Anita Berliawsky Weinstein, interview with author, July 13, 1976.

10 Nate Berliawsky, interview with author, July 12, 1976.

11 Lillian Berliawsky Mildwoff and Anita Berliawsky Weinstein, interview with author, July 13, 1976.

12 Ibid.

13 William Ralph Kalloch in Laurie Lisle, *Louise Nevelson: A Passionate Life* (New York: Summit, 1990), 25.

14 Anita Berliawsky Weinstein, interview with author, July 12, 1976.

15 Ibid.

16 Lillian Berliawsky Mildwoff, interview with author, July 13, 1976.

17 Ibid.

18 Nevelson, *Dawns + Dusks*, 6.

19 Beverly Grunwald, "Getting Around," *Women's Wear Daily*, November 18, 1976.

20 Lillian Berliawsky Mildwoff, interview with author, July 13, 1976.

21 Mike Nevelson, interview with Laurie Lisle, July 27, 1984, untranscribed audio recording, LN Papers, AAA.

22 Lillian Berliawsky Mildwoff, interview with author, July 14, 1976

23 Ibid.

24 Anita – quote about time to get dressed.

25 Louise Nevelson, interview with author, January 8, 1976.

26 Lillian Berliawsky Mildwoff, interview with author, July 14, 1976.

27 Louise Nevelson, interview with author, January 8, 1976.

28 Barbara Rose, "The Individualist," *Vogue*, June 1, 1976, 122–124, 156–157.

29 Nevelson, *Dawns + Dusks*, 13.

30 Lillian Berliawsky Mildwoff, interview with author, July 14, 1976.

31 Nevelson, *Dawns + Dusks*, 13.

32 Ibid.

33 Louise Nevelson, interview with author, January 8, 1976.

34 Lillian Berliawsky Mildwoff and Anita Berliawsky Weinstein, interview with author, July 13, 1976.

35 Nevelson, *Dawns + Dusks*, 14. Glimcher gives a similar account adding the comment: "I didn't know what 'original' meant . . . but it made me feel very good." *Louise Nevelson*, 29.

36 Nevelson, *Dawns + Dusks*, 24–25.

37 That Nevelson couches her recollection of her first crucial mentor in the context of that woman's fashion sense is revealing. It was an indirect way of honoring her mother's aesthetic sense, which was channeled entirely through fashion—fashion was usually a link to her thoughts and feelings about her mother.

38 Nevelson, *Dawns + Dusks*, 25.

39 Edgar Crockett, interview with author, July 15, 1976.

40 Ibid.

41 Nevelson, *Dawns + Dusks*, 24.

42 Glimcher, *Louise Nevelson*, 28–29.

43 Ibid., 28.

44 Anita Berliawsky Weinstein, interview with author, July 12, 1976.

45 Lillian Berliawsky Mildwoff, interview with author, July 13, 1976.

46 Munro, *Originals*, 139.

47 Ibid.

48 Nevelson, *Dawns + Dusks*, 24.

49 Lillian Berliawsky Mildwoff, interview with author in July 13, 1976.

50 Lillian Berliawsky Mildwoff, interview with author, July 14, 1976.

51 Nevelson, *Dawns + Dusks*, 14.

52 Ibid., 15. Here, as elsewhere, open-spaced ellipsis is in the original text.

53 Lillian Berliawsky Mildwoff and Anita Berliawsky Weinstein, interview with author, July 13, 1976; Diana MacKown, interview with author, August 25, 2008.

54 Nevelson, *Dawns + Dusks*, 15.

55 Ibid., 27.

56 Henry J. Seldis, "Enchanted Forest of Nevelson Wood Sculpture," *Los Angeles Times*, February 10, 1974.

57 Nate Berliawsky, interview with author, July 12, 1976.

58 Nevelson, *Dawns + Dusks*, 7.

59 Anita Berliawsky Weinstein, interview with author, July 12, 1976.

60 Emmett Meara, "Sculptor Louise Nevelson Resents Ostracism in Rockland as Youth," *Bangor Daily News*, June 15, 1978, 5.

61 Glimcher, *Louise Nevelson*, 28.

62 Nevelson, *Dawns + Dusks*, 28. She felt her arms and legs were biggish but not out of proportion to the rest of her body.

63 Ibid., 25.

64 Anita Berliawsky Weinstein, interview with author, July 12, 1976.

65 Jan Ernst Adlmann, interview with author, June 16, 2012.

66 William Langley, "Maine in the Days of the Klan," *Portland Sunday Telegram*, February 2, 1969, 4–5D.

67 Lillian Berliawsky Mildwoff, interview with author, June 14, 1976.

68 Lillian Berliawsky Mildwoff and Anita Berliawsky Weinstein, interview with author, July 13, 1976.
69 Barbaralee Diamonstein, "Caro, de Kooning, Indiana, Lichtenstein, Motherwell and Nevelson on Picasso's Influence," *Art News*, April 1974, 48. Nevelson at seventy-five recalled an incident when she protected a younger girl from a bully—and she wasn't even a friend.
70 Anita Berliawsky Weinstein, interview with author, July 12, 1976.
71 Lillian Berliawsky Mildwoff, interview with author, June 14, 1976.
72 Nevelson, *Dawns + Dusks*, 25.
73 Louise Nevelson, interview with author, July 19, 1977
74 Arnold B. Glimcher, "Interview with Louise Nevelson," 1972, AAA.
75 Marius B. Péladeau, "The Gypsies in Maine," (unpublished typescript, 1976).
76 "Gypsies in Maine," *New York Times*, June 3, 1878, 2.
77 Irving Brown, *Gypsy Fires in America: A Narrative of Life Among the Romanies of the United States and Canada* (New York: Harper, 1924), 3.

3. MARRIAGE AND MOTHERHOOD 1920-1929

1 Nevelson, *Dawns + Dusks*, 24.
2 Rockland High School Graduation Photo, 1918, LN Papers, AAA.
3 Barbara and Joel Fishman, interview with author, July 2008.
4 Nevelson, *Dawns + Dusks*, 30.
5 Anita Berliawsky Weinstein, interview with author, July 12, 1976.
6 Lillian Berliawsky Mildwoff, interview with author, June 14, 1976.
7 Abram Chasins, interview with Laurie Lisle, March 5, 1983, AAA.
8 Nevelson, *Dawns + Dusks*, 31.
9 Abram Chasins, interview with Laurie Lisle, March 5, 1983, AAA.
10 Nevelson, *Dawns + Dusks*, 30; Mike Nevelson, interview with Laurie Lisle, July 27, 1984
11 Nevelson, *Dawns + Dusks*, 31.
12 Anita Berliawsky Weinstein, interview with author, July 12, 1976.
13 Nevelson, *Dawns + Dusks*, 24
14 Abram Chasins, interview with Laurie Lisle, March 5, 1983, AAA.
15 Nevelson, *Dawns + Dusks*, 31.
16 Ibid.
17 Mike Nevelson, interview with Laurie Lisle, July 27, 1984, untranscribed audio recording, LN Papers, AAA. Her parents never became citizens.
18 Louise Nevelson, interview with Arnold B. Glimcher, June 1, 1970, AG Papers, transcript, 26.
19 Abram Chasins, interview with Laurie Lisle, March 5, 1983, AAA.
20 Nevelson, *Dawns + Dusks*, 32
21 Both Anita and Lillian would soon move to New York, staying with the Nevelsons or nearby. Lillian married and raised her family there. Anita went to college and lived there for several years.
22 Anita Berliawsky Weinstein, interview with author, July 12, 1976.
23 Ibid.
24 Nevelson, *Dawns + Dusks*, 34.
25 Louise Nevelson, interview with Arnold B. Glimcher, June 1, 1970, AG Papers, transcript, 26.
26 Lillian Berliawsky Mildwoff, interview with author, July 14, 1976.
27 Nate Berliawsky, interview with author, July 12, 1976.
28 Lillian Berliawsky Mildwoff, interview with author, June 14, 1976.
29 Nevelson, *Dawns + Dusks*, 31; cf. Glimcher, *Louise Nevelson*, 20.
30 Louise Nevelson, interview with Arnold B. Glimcher, June 1, 1970, AG Papers, transcript, 25.
31 Lisle, *Louise Nevelson*, 56.
32 Nevelson, *Dawns + Dusks*, 35.
33 Louise Nevelson, interview with Dorothy Gees Seckler, May–June 1964, Oral History Program, AAA, transcript 208, 10.
34 Louise Nevelson, interview with Barbarlee Diamonstein, "The Reminiscences of Louise Nevelson," November 3, 1977, Oral History Research Office, Columbia University.

35 Louise Nevelson, interview with Arnold B. Glimcher, December 8, 1970, AG Papers, transcript, 1.

36 Abram Chasins, interview with Laurie Lisle, March 5, 1983, AAA.

37 Anita Berliawsky Weinstein, interview with author, July 12, 1976.

38 Ibid.

39 Abram Chasins, interview with Laurie Lisle, March 5, 1983, AAA.

40 Ibid.

41 Ibid.

42 Louise Nevelson, interview with author, July 7, 1976.

43 Louise Nevelson, interview with author, January 8, 1976.

44 Theresa Bernstein and William Meyerowitz, interview with Laurie Lisle, October 29, 1982, AAA.

45 Gail Levin, "Forgotten Fame," in *Theresa Bernstein: A Century in Art*, ed. Gail Levin (Lincoln: University of Nebraska Press, 2013), 17.

46 Theresa Bernstein and William Meyerowitz, interview with Laurie Lisle, October 29, 1982, AAA.

47 Nevelson, *Dawns + Dusks*, 36.

48 Abram Chasins, interview with Laurie Lisle, March 5, 1983, AAA.

49 Mike Nevelson, interview with Laurie Lisle, July 27, 1984, untranscribed audio recording, LN Papers, AAA.

50 Nevelson, *Dawns + Dusks*, 37.

51 Mike Nevelson, interview with author, July 27, 1977.

52 Anita stayed with them for a period of time until they moved to Brooklyn, where Lillian stayed with them, while Anita lived in a nearby apartment with her husband. Their next move was to 108 East 91st Street in 1929–31, again followed by Anita's move to an apartment on 89th Street; Anita Berliawsky Weinstein and Lillian Berliawsky Mildwoff, interview with author, July 13, 1976. Anita had ostensibly come to New York to go to college, and she enrolled at Columbia University Teachers College. Lillian had studied teaching in Maine but worked on earning her teaching credentials in Brooklyn.

53 Lillian Berliawsky Mildwoff, interview with author, June 14, 1976.

54 Nate Berliawsky, interview with author, July 12, 1976.

55 Lillian Berliawsky Mildwoff and Anita Berliawsky Weinstein, interview with author, July 13, 1976. The "International Theatre Exposition," New York, February 27–March 15, 1926, was arranged by Frederick Kiesler and Jane Heap. Several versions of the illustrated catalogue appeared, one of which was published in the *Little Review* 11, no. 2 (winter 1926). Nevelson's two sisters remembered accompanying her several times to this exhibit.

56 "Fourth Dimension Plays for the Masses," *New York City World*, March 15, 1926.

57 Norina Matchabelli and Frederick Kiesler in "Audience are Actors in Newest Theatre," *New York Evening Post*, March 15, 1926.

58 Linda D. Henderson, *The Fourth Dimension and Non-Euclidean Geometry in Modern Art* (Princeton, NJ: Princeton University Press, 1983).

59 Henderson, *The Fourth Dimension*, 339–340.

60. Max Weber, "The Fourth Dimension from a Plastic Point of View" in *Camera Work*, no. 31 (1910).

61 "Fourth Dimension Plays the Latest Wrinkle for Drama," *New York Review*, March 27, 1926.

62 Louise Nevelson, interview with author, January 8, 1976.

63 Norina Matchabelli, "Princess Matchabelli Speaks for the International Theatre Arts Institute," October 3, 1926, Independent Theatres Dinner Program.

64 Louise Nevelson, interview with author, January 8, 1976.

65 Ibid.

66 It is possible that while she was studying with Matchabelli and Kiesler, Nevelson also took some classes in "Body Education" with Dr. Bess Mensendieck, whose views she would have found equally compatible.

67 Louise Nevelson, interview with author, July 7, 1976.

68 Nevelson, *Dawns + Dusks*, 35.

69 Ibid., 34.

70 Lillian Berliawsky, Louise's sister, married Ben Mildwoff and became Lillian Berliawsky Mild-

woff. Ben Mildwoff's sister, Lillian, married Louise's brother, Nate Berliawsky, much later and became Lillian Mildwoff Berliawsky.

71 Lillian Berliawsky Mildwoff, interview with author, July 14, 1976.
72 Ibid.
73 Anita Berliawsky Weinstein, interview with author, July 12, 1976.
74 Nevelson, *Dawns + Dusks*, 38.
75 Jiddu Krishnamurti, "Truth Is a Pathless Land" in *Total Freedom: The Essential Krishnamurti* (San Francisco: Harper Collins, 1996), 1–9.
76 Nevelson, *Dawns + Dusks*, 35.
77 Diana MacKown, telephone interview with author, November 10, 1912; Maria Nevelson, personal communication, 2010.
78 Krishnamurti, "Truth Is a Pathless Land," 1–9.
79 Nevelson, *Dawns + Dusks*, 35.
80 Ibid., 35–36
81 Ibid., 36
82 Lillian Berliawsky Mildwoff and Anita Berliawsky Weinstein, interview with author, July 13, 1976.
83 Nevelson, *Dawns + Dusks*, 36–37.
84 "Accessions and Notes," *Metropolitan Museum of Art Bulletin* 23, no. 11 (November 1928): 279.

4. ART AT LAST 1929-1934

1 Louise Nevelson, Student Registration Record, Art Students League; *The winter catalogue of the Art Students' League of N[ew] Y[ork]* (1929–30).
2 Stuart Klonis, interview with author, August 19, 1976.
3 Lincoln Rothschild, *To Keep Art Alive: The Effort of Kenneth Hayes Miller, American Painter (1876–1952)* (Philadelphia: Art Alliance Press, 1974), 58.
4 Edwin Dickenson, interview with Dorothy Gees Seckler, "The Art Students League: Part I," *Archives of American Art Journal* 13, no. 1 (1973): 9.
5 Louise Nevelson, interview with author, January 8, 1976.
6 Precise information regarding Nevelson's attendance is contained in the student files at the Art Students League, New York.
7 Stuart Klonis, interview with author, August 19, 1976.
8 Kenneth Hayes Miller to Louise Nevelson, LN Papers, AAA.
9 Louise Nevelson, interview with author, January 8, 1976.
10 Lincoln Rothschild, *To Keep Art Alive*, 58.
11 Edwin Dickenson, interview with Dorothy Gees Seckler, "The Art Students League: Part I," *Archives of American Art Journal* 13, no. 1 (1973): 13.
12 Ibid., 60–63.
13 Carol Diehl, "Breaking the Rules: James Rosenquist, Louise Nevelson, George Segal and Nam June Paik on Their Personal Moments of Discovery," *Arts and Antiques*, April 1988, 74.
14 Isabel Bishop, interview with author, August 19, 1976.
15 Dorothy Dehner, interview with author, December 5, 1975.
16 Dorothy Dehner, interview with author, December 4, 1975. Dehner met her future husband David Smith in Miller's class.
17 Louise Nevelson, interview with author, January 8, 1976.
18 Kimon Nicolaïdes, *The Natural Way to Draw: A Working Plan for Art Study* (Boston: Houghton Mifflin, 1941). His book, published the year after his death, outlines his teaching methods.
19 Nicolaïdes, *The Natural Way to Draw*, 2.
20 Louise Nevelson, in Tal Streeter, "Unpublished Interview with Louise Nevelson," November 25, 1959, LN Papers, AAA, transcript, 6.
21 Lillian Berliawsky Mildwoff, interview with author, June 14, 1976.
22 Louise Nevelson, interview with author, January 8, 1976
23 Ibid.
24 Lillian Berliawsky Mildwoff, interview with author, July 12, 1976. Her sister Anita had already left her husband and was living with her baby son at their parents' home.

25 Dorothy Dehner, interview with author, December 5, 1975.

26 George McNeil, interview with Irving Sandler, January 9, 1968 in "The Art Students League Part II," *Archives of American Art Journal* 13, no. 2 (1973): 1.

27 Glimcher, *Louise Nevelson*, 32.

28 Nevelson, *Dawns + Dusks*, 44.

29 Carl Holty, student records, Art Students League, New York. For accounts of Hofmann's teaching, see "Hans Hofmann Student Dossier," Museum of Modern Art; Irving Sandler, "Hans Hofmann: The Pedagogical Master," *Art in America* (May–June 1973): 48–57; Hans Hofmann, *Search for the Real*, ed. Sara T. Weeks and Bartlett H. Hayes, Jr. (rev. ed.; Cambridge, MA: M.I.T. Press, 1967). See also Nevelson, *Dawns + Dusks*, 44; Glimcher, *Louise Nevelson*, 32.

30 Hans Hofmann, "Art in America," *Art Digest*, August 1930, 27.

31 Lillian Berliawsky Mildwoff, interview with author, June 14, 1976.

32 Anita Berliawsky Weinstein, interview with author, July 12, 1976.

33 Nevelson, *Dawns + Dusks*, 40.

34 Ibid.

35 Colette Roberts, *Nevelson* (Paris: Editions Georges Fall, 1964), 70. She cites the family allowance as late as 1964.

36 Nate Berliawsky, interview with author, July 12, 1976.

37 Charles Nevelson postscript to letter from Mike Nevelson to Louise Nevelson, December 12, 1931, LN Papers, AAA.

38 Mike Nevelson to Louise Nevelson, December 12, 1931, LN Papers, AAA.

39 Mike Nevelson to Louise Nevelson, April 24, 1932, LN Papers, AAA.

40 Mike Nevelson to Louise Nevelson, June 14, 1932 , LN Papers, AAA.

41 Mike Nevelson to Louise Nevelson, Tuesday, n.d., 1932, LN Papers, AAA.

42 Mike Nevelson to Louise Nevelson, n.d., 1932, LN Papers, AAA.

43 Anita Berliawsky Weinstein, interview with author, July 12, 1976.

44 Ibid.

45 Louise Nevelson, interview with author, July 7, 1976.

46 Ibid.

47 Lillian Berliawsky Mildwoff, interview with author, July 14, 1976; Lillian Berliawsky Mildwoff and Anita Berliawsky Weinstein, interview with author, July 13, 1976. Her son confirmed this account; Mike Nevelson, interview with author, April 11, 2014.

48 Lillian Berliawsky Mildwoff and Anita Berliawsky Weinstein, interview with author, July 13, 1976.

49 Louise Nevelson, interview with author, July 7, 1976.

50 Louise Nevelson, interview with Arnold B. Glimcher, June 1, 1970, AG Papers, transcript, 16–17.

51 Louise Nevelson, interview with author, July 7, 1976.

52 Roberts, *Nevelson*, 70.

53 Louise Nevelson, interview with author, July 19, 1977.

54 Lillian Berliawsky Mildwoff and Anita Berliawsky Weinstein, interview with author, July 13, 1976.

55 Louise Nevelson, interview with author, July 19, 1977.

56 Louise Nevelson, interview with author, January 8, 1976; Glimcher, *Louise Nevelson*, 35; see also Nevelson, *Dawns + Dusks*, 47.

57 Nevelson, *Dawns + Dusks*, 47.

58 Louise Nevelson, interview with author, January 8, 1976.

59 Louise Nevelson, LN Papers, AAA.

60 Nevelson, *Dawns + Dusks*, 50–51.

61 Poetry in LN Papers, AAA.

62 Diana MacKown, telephone interview with author, January 28, 2012.

63 Glimcher, *Louise Nevelson*, 38.

64 Ibid.

65 Louise Nevelson, LN Papers, AAA.

66 Louise Nevelson, interview with author, January 8, 1976.

67 Marjorie Eaton, interview with author, August 25, 1976.

68 According to her enrollment record for 1932 at the Art Students League she was living at 39 East 65th Street.

69 Marjorie Eaton, interview with author, August 25, 1976.

70 Ibid. By the time they were introduced, Nevelson would have seen his exhibition of frescoes at the Museum of Modern Art in February and March 1933.

71 Ibid.

72 Lillian Berliawsky Mildwoff, interview with author, June 14, 1976.

73 Louise Nevelson, interview with author, July 7, 1976; Marjorie Eaton, interview with author, August 25, 1976. For an account of Rivera's Rockefeller mural, see Sidney Geist, "Prelude: The 1930's," *Arts* 30 (September 1956): 54–55, and Bertram Wolfe, *Diego Rivera* (New York: Alfred A. Knopf, 1939), 323–38.

74 Marjorie Eaton, interview with author, August 25, 1976.

75 Ibid.

76 Glimcher, *Louise Nevelson*, 41.

77 Marjorie Eaton, interview with author, August 25, 1976.

78 Mike Nevelson to Louise Nevelson, June 19, 1935, LN Papers, AAA.

79 Bertram D. Wolfe, *The Fabulous Life of Diego Rivera* (New York: Stein and Day, 1963), 333

80 Malcolm Vaughan, "Rivera's Latest Series of Murals Nearly Finished," and "The Artist as Propagandist," *New York Journal-American*, September 30, 1933.

81 Printed notice: "Diego Rivera is painting a series of murals on American history at The New Workers School," in library file on Rivera at MoMA.

82 Rivera gave public lectures each night of the "Three Day Public Showing of the Mural 'Portrait of America,'" according to the brochure announcement of the event in the Museum of Modern Art library.

83 David Margolis, interview with author, June 11, 1976.

84 Arnold B. Glimcher, interview with author, December 9, 1976.

85 Marjorie Eaton, interview with author, August 25, 1976.

86 Lillian Berliawsky Mildwoff, interview with author, July 14, 1976. After he died, his daughter returned the portrait to Nevelson.

87 Louise Nevelson, interview with author, July 7, 1976.

88 Louise Nevelson in Roberts, *Nevelson*, 16.

89 Marjorie Eaton, interview with author, August 25, 1976; David Margolis, interview with author, June 11, 1976.

90 Nevelson, *Dawns + Dusks*, 57.

91 Marjorie Eaton, interview with author, August 25, 1976.

92 A farewell reception was given on December 5th to thank Rivera for his generosity. Aaron Copeland, Ben Shahn, Lewis Mumford and John Sloan were part of the group of "workers in the arts" who organized the reception.

93 Lillian Berliawsky Mildwoff and Anita Berliawsky Weinstein, interview with author, July 13, 1976.

94 Nate Berliawsky, interview with author, July 12, 1976.

95 David Margolis, interview with author, June 1, 1976. Margolis finished it.

5. THE BEGINNING OF SCULPTURE 1934-1940

1 Roberts, *Nevelson*, 70. Nevelson's friend and dealer Colette Roberts wrote the book in close collaboration with Nevelson.

2 Nevelson, *Dawns + Dusks*, 67.

3 Ibid.

4 Walter Sorell, *The Dance Through the Ages* (New York: Grosset & Dunlap, 1967); Don McDonagh, *Complete Guide to Modern Dance* (Garden City, NY: Doubleday, 1976).

5 Mike Nevelson, interview with author, July 29, 1977. "She went to dance concerts almost every week."

6 Though she had many opportunities to meet Martha Graham, just as she had with Picasso when in Paris, Nevelson only spoke with her idol in 1985 when they were both at the White House being honored by President Reagan.

7 Mary Farkas, interview with author, August 17, 1976

8 Nevelson, *Dawns + Dusks*, 65–67.

9 Mary Farkas, interview with author, August 17, 1976.

10 Mike Nevelson, interview with author, July 29, 1977.

11 Lillian Berliawsky Mildwoff, interview with author, July 13, 1976. As Lillian recalled, "If you're with Louise, you have to create."

12 Mary Farkas, interview with author, August 17, 1976.

13 Roberta Brandes Gartz, "Building Empires," *New York Post*, March 8, 1967, 47.

14 Bongartz, "'I Don't Want to Waste Time.'" See ch. 1 n78.

15 Nevelson, *Dawns + Dusks*, 70.

16 Sigmund Freud, "On Narcissism: An Introduction" (1914), *Standard Edition* 14: 89.

17 Mary Farkas, interview with author, August 17, 1976. Richard Kramer, interview with author, November 28, 1975.

18 Nevelson, *Dawns + Dusks*, 70.

19 David Margolis, interview with author, June 11, 1976.

20 Nathaniel Kaz, interview with author, June 15, 1976.

21 Richard Kramer, interview with author, November 28, 1975. Kramer was the father of Edith Kramer, the renowned art therapist who helped establish the field in the United States.

22 Richard Kramer, interview with author, November 28, 1975.

23 David Margolis, interview with author, June 11, 1976.

24 Lillian Berliawsky Mildwoff, interview with author, July 14, 1976.

25 Alice Neel in Lisle, *Louise Nevelson*, 119.

26 Robert Cronbach, interview with author, June 23, 1976.

27 Not unimportant is the fact that most of these groups were men only, albeit men whom Nevelson had known and remained close to for decades, such as Gottlieb and Rothko (then still known as Rothkowitz).

28 Anita Berliawsky Weinstein, interview with author, July 12, 1976.

29 Ibid.

30 David Margolis, interview with author, June 11, 1976; Joseph Solman, interview with author, September 12, 1976.

31 Lillian Berliawsky Mildwoff, interview with author, July 14, 1976

32 According to Louise Nevelson—in an interview with author, July 7, 1976—her studies with Gross lasted two months. According to Chaim Gross—in an interview with author, June 1, 1976—the duration was two years.

33 Nevelson's family's interest in wood could have encouraged a positive response to his sculpture, which would be borne out in her work many years later.

34 Gross was awarded the Tiffany Fellowship in 1933 and his work appeared in Alec Miller, "Sculpture in Wood," *American Magazine of Art* 21, no. 6 (June 1930); L. R. Davis, "American Wood Sculpture," *Studio* 108, no. 501 (December 1934). See Frank Getlein, *Chaim Gross* (New York: Harry N. Abrams, 1974).

35 Chaim Gross, interview with author, June 1, 1976.

36 Lillian Berliawsky Mildwoff, who was present as a daily witness during these years recalls: "She switched from painting to sculpting in 1934 because she didn't have money to buy paint and canvas." Lillian Berliawsky Mildwoff, interview with author, July 14, 1976.

37 Brooklyn Museum, exhibition catalogue, *Sculpture: A Group Exhibition by Young Sculptors* (1935), 6.

38 Francis V. O'Connor, interview with author, August 16, 1976.

39 See Robert Cronbach, "The New Deal Sculpture Projects," in *The New Deal Art Projects: An Anthology of Memoirs*, ed. Francis O'Connor (Washington, D.C.: Smithsonian Institution Press, 1972), 137.

40 Louise Nevelson, interview with author, January 8, 1976.

41 Alexander Tatti, interview with author, New York, August 18, 1976; Louise Nevelson, interview with author, July 7, 1976. Tatti took over Basky's workshop and has run it to the present under the name Alexander. See also Francis O'Connor, "Questionnaire for Artists Employed on the WPA Federal Art Project in New York City and State," Artists' File WPA/FAP, AAA.

42 Nevelson's association with Basky and Tatti continued into the 1960s, and she consistently relied upon them for technical advice and labor.

43 Nevelson's first recorded exhibit was at the Brooklyn Museum, *Sculpture: A Group Exhibition by Young Sculptors*, May 1–7, 1935. Her contribution was a piece in plaster entitled *Two Figures* (which is probably fig. 65), catalogue in LN Papers, AAA. For Nevelson's account of her experience teaching children, see Louise Nevelson, "Art at the Flatbush Boys' Club," *Flatbush Magazine*, June 1935, 3.

44 Francis V. O'Connor, telephone interview with author, August 16, 1976. According to O'Connor, the teaching would have taken up about fifteen to twenty hours a week and would have left the remaining time free.

45 "Mural Painting Classes At Flatbush Boys' Club," *Brooklyn N.Y. Citizen*, March 28, 1935.

46 Louise Nevelson, "Art at the Flatbush Boys' Club," *Flatbush Magazine*, June 1935, 3.

47 The WPA years were a time when women artists garnered almost equal respect and rewards to those given to male artists. Thomas B. Hess and Elizabeth C. Baker, eds., *Art and Sexual Politics: Women's Liberation, Women Artists, and Art History* (rev. ed. New York: Collier Books, 1975).

48 Dorothy Dehner, interview with author, December 4 and 5, 1975.

49 Francis V. O'Connor, "Questions for Artists Employed on the WPA Federal Art Project in New York City and State," *New Deal Research Project*, June 18, 1968, Artists' File WPA/FAP, AAA.

50 Lillian Berliawsky Mildwoff, interview with author, June 14, 1976.

51 Employment transcript, Louise Nevelson, General Services Administration, Artists' File, New York WPA/FAP, AAA. Nevelson was employed as part of the Temporary Emergency Relief Administration and the WPA continuously from

52 Emily Genauer, "Wooden Sculptures Lauded," *New York World-Telegram*, September 12, 1936. Genauer later learned that these works were plaster. Howard Devree, *New York Times*, September 13, 1936, correctly identified the works as "water-colored plaster."

53 "Artists Take Part in New City Show," *New York Times*, July 1, 1936.

54 "The Critic Takes a Glance Around the Galleries," *New York Post*, June 19, 1937.

55 "Federal Art Teachers Present Exhibition," *New York World-Telegram*, July 23, 1938.

56 Lillian Berliawsky Mildwoff, interview with author, July 14, 1976. Because she was so prolific, Nevelson always had a sizable amount of work from which to select for entry into various shows. She stored the sculpture she couldn't fit into her studio wherever she could find someone willing to give her space. Her sister Lillian recalled storing her sister's plaster and terra-cotta work in her basement for ten years or more.

57 Richard Kramer, interview with author, November 28, 1975.

58 Her work for the WPA was terminated on July 27, 1939. Employment transcript, Louise Nevelson, General Services Administration, Artists' File, New York WPA/FAP, AAA.

59 Francis V. O'Connor, telephone interview with author, August 16, 1976.

60 Howard Devree, "American Water-Colors and Other Exhibitions," *New York Times*, September 13, 1936, X7.

61 Emily Genauer, "New Fall Art Exhibits Featured by Tyros' Promising Efforts," *New York World-Telegram*, September 12, 1936.

62 Nevelson, *Dawns + Dusks*, 59.

63 Bongartz, "'I Don't Want to Waste Time,'" 30.

64 Nevelson, *Dawns + Dusks*, 64.

65 Louise Nevelson, interview with author, July 7, 1976.

66 Alfred H. Barr, Jr., *Cubism and Abstract Art* (1936; repr., New York: Museum of Modern Art, 1974). Published in conjunction with the exhibition of the same name, shown at the Museum of Modern Art, March 2–April 19, 1936.

67 For a useful discussion of this period, see John Elderfield, "The Paris-New York Axis: Geometric Abstract Painting in The Thirties," in Dallas Museum of Fine Arts, *Geometric Abstraction: 1926–1942*, comp. Robert M. Murdock (Dallas: Brodnax Printing Company, 1972); published in conjunction with an exhibition of the same name, October 7–November 19, 1972. See also Irving Sandler, *The Triumph of American Painting: A History of Abstract Expressionism* (New York: Praeger, 1970), ch. 1. Lipchitz's three New York exhibits were: Brummer Gallery, 1935; Buchholz Gallery, 1942, 1943; Laurens showed at the Brummer Gallery in 1938.

68 Mike Nevelson to Louise Nevelson, August 23, 1939.

69 Marjorie Eaton, interview with author, August 25, 1976.

70 Lillian Berliawsky Mildwoff, interview with author, June 14, 1976. Some notebook pages of

dreams from 1936 suggest that she saw the analyst that year. Louise Nevelson, "Dreams" (unpublished journal, April 21–June 21, 1936), LN Papers, AAA.

71 Mike Nevelson, interview with author, July 27, 1977.

72 Nevelson, *Dawns + Dusks*, 72.

73 Nevelson, *Dawns + Dusks*, 71.

74 Ibid.

75 "Germans Execute Hirsch, U.S. Citizen: Youth of 21 Guillotined Despite Repeated American Appeals to Hitler for Clemency," *New York Times*, June 5, 1937, 1, 8.

76 Nevelson, *Dawns + Dusks*, 72.

6. SURREALISM 1940–1946

1 H. D., "Sculptors and Others," *New York Times*, March 10, 1940, 161.

2 Nevelson in Agnes Adams, "Behind a One-Woman Art Show: Louise Nedelson's [Nevelson's] Revolt as a Pampered Wife," *New York Post*, October 16, 1941.

3 Nate Berliawsky, interview with author, July 12, 1976.

4 Nevelson, *Dawns + Dusks*, 75.

5 Ibid.

6 Anja Walter-Ris, "Die Geschichte der Galerie Nierendorf Kunstleidenschaft im Dienst der Moderne. Berlin/New York 1920–1995" [History of the Nierendorf Gallery Berlin/New York 1920–1995] (Zurich: Zurich InterPublishers, 2003), 255. Nierendorf permanently devoted one room of his gallery to Klee and gave him many solo exhibitions (in one season alone he mounted seven Klee exhibitions) and organized a number of important publications about him.

7 See, for instance, "The Digest Interviews: Karl Nierendorf," *Art Digest* 18 (November 15, 1943), 74.

8 See Peyton Boswell's obituary "Nierendorf: Scholar-Dealer" in *Art Digest* 22 (November 1, 1947); as the headline of Boswell's obituary indicates, Nierendorf was a rare combination of shy scholar and sagacious businessman.

9 Lillian Berliawsky Mildwoff, interview with author, June 14, 1976.

10 Jan Gelb, interview with author, June 27, 1976.

11 Mike Nevelson to Louise Nevelson August 29, 1941, LN Papers, AAA.

12 Nevelson, *Dawns + Dusks*, 72.

13 Ibid., 76.

14 Louise Nevelson, interview with Arnold B. Glimcher, December 8, 1970, AG Papers, transcript. See also Karl Nierendorf, letter to Louise Nevelson, September 10, 1941, LN Papers, AAA.

15 Dido Smith, "Louise Nevelson," *Craft Horizons*, May/June 1967, 75.

16 Jimmy Ernst, *A Not-So-Still Life* (New York: Pushcart Press, 1984), 150–51.

17 Nevelson, *Dawns + Dusks*, 73.

18 Agnes Adams, "Behind a One-Woman Art Show," *New York Post*, October 16, 1941.

19 Ibid.

20 Howard Devree, "A Reviewer's Notebook: New Shows; Brief Comment on Some of the Recently Opened Exhibitions in Galleries – Water-Colors by Margules – Group Events," *New York Times*, September 28, 1941, X5.

21 Carlyle Burrows, "Notes and Comment on Events in Art," *New York Herald Tribune*, September 28, 1941.

22 Emily Genauer, "The Nierendorf Exhibit," *New York World-Telegram*, September 27, 1941.

23 "Art Notes," *Cue*, October 4, 1941, 16.

24 *Sculptures by Nevelson* (New York: Nierendorf Gallery, 1942); published in conjunction with an exhibition of the same name, shown at the Nierendorf Gallery, October 6–25, 1942, LN Papers, AAA.

25 "The Passing Shows," *Art News*, November 1–14, 1942, 24.

26 H. D., "Modern Sculpture," *New York Times*, October 11, 1942, X5.

27 Ralph Rosenborg , Interview with Irving Sandler, April 16, 1968. Ralph M. Rosenborg papers, AAA.

28 Joseph Solman, interview with author, September 12, 1976.

29 Lillian Berliawsky Mildwoff, interview with author, July 13, 1976.

30 Louise Nevelson, interview with author, July 27, 1976.

31 Lillian Berliawsky Mildwoff, interview with author, July 14, 1976.

32 Martica Sawin, "The Achievement of Ralph Rosenborg," *Arts*, November 1960, 45.

33 Artist friends like Jan Gelb were surprised at how organized and even tidy her studio was. After seeing the seemingly careless way she worked with etching plates at Atelier 17 in 1953, they were expecting to find a mess in her studio. But it was always surprisingly orderly—another personality trait she shared with Ralph Rosenborg.

34 Louise Nevelson, interview with author, July 27, 1976.

35 *Art News*, November 19, 1942, as quoted in the Nierendorf Gallery catalogue of the exhibition.

36 Diego Rivera and André Breton (and, uncredited, Leon Trotsky), "Manifesto: Towards a Free Revolutionary Art," translated by Dwight Macdonald, *Partisan Review* 6, no. 1 (fall 1938), in Martica Sawin, *Surrealism in Exile and the Beginning of the New York School* (Cambridge, MA: MIT Press, 1997), 22.

37 December 7, 1936–January 17, 1937. See Rudi Blesh, *Modern Art USA: Men, Rebellion, Conquest, 1900–1956* (New York: Knopf, 1956), 177–78. As outrageous as many of the pieces in this exhibit may have seemed to the public, the installation of the show was quite traditional, with none of the theatrical effects of later surrealist exhibits in New York.

38 For a general discussion of Surrealist impact on American art, see William S. Rubin, *Dada and Surrealist Art* (New York: Harry N. Abrams, 1968), 342ff.; Dore Ashton, *The New York School: A Cultural Reckoning* (New York: Viking Press, 1972), 85ff.; Irving Sandler, *The Triumph of American Painting: a History of Abstract Expressionism* (New York: Praeger, 1970), 29ff. See also "Concerning the Beginnings of the New York School: 1939–1943; an Interview with Peter Busa and Matta, conducted by Sidney Simon in Minneapolis in December 1966," *Art International* 11, no. 6 (summer 1967): 17–20; "Concerning the Beginnings of the New York School: 1939–1943; an Interview with Robert Motherwell, conducted by Sidney Simon in New York in January 1967," *Art International* 11, no. 6 (summer 1967): 20–23.

39 Jimmy Ernst, interview with author, July 29, 1976. Nierendorf was friendly with Seligmann and Wolfgang Paalen, publishing the etchings of the former and exhibiting the works of the latter. However, his affiliation with the German Expressionists made him unacceptable to the French Surrealists.

40 Jimmy Ernst, *A Not-So-Still Life*, 186.

41 A rare copy of the catalogue for this exhibit is in the Museum of Modern Art library, *First Papers of Surrealism; hanging by André Breton; his twine, Marcel Duchamp. 14 October–7 November 1942* (New York: NYC Coordinating Council of French Relief Societies, 1942). For a description of the opening night's events, see Blesh, *Modern Art USA*, 167–170. See also Rubin, *Dada and Surrealist Art*, 342ff.

42 For Miss Guggenheim's description of this unconventional gallery, see Peggy Guggenheim, *Out of This Century: The Informal Memoirs of Peggy Guggenheim* (New York: Dial Press, 1946), 318–21. See also "New Display Techniques for 'Art of This Century' Designed by Frederick J. Kiesler," *Architectural Forum* 78, no. 2 (February 1943): 49–53; Cynthia Goodman, "Frederick Kiesler: Designs for Peggy Guggenheim's Art of This Century Gallery," *Arts Magazine*, June 1977, 90–95.

43 Kiesler and Duchamp had known each other since 1925 in Paris, and Kiesler had been suggested by Breton to Peggy Guggenheim as the best possible designer of her new gallery. The installations of Breton's and Kiesler's important exhibitions point to the congruence of Kiesler's lifelong dreams as a designer-architect and Surrealism's penchant for offbeat theatrical involvement of the spectator.

44 Press release MoMA, December 1942. "Museum of Modern Art exhibits gaily ornamented bootblack chair and accessories."

45 "A Shoe Shine Stand de Luxe," *New York Times*, December 22, 1942.

46 The shoeshine box of Joe Milone, also known as Giovanni Indelicato, was recently purchased by the Fenimore Art Museum in Cooperstown, NY, and was written up in the *New York Times*: Eve M. Kahn, "A Shoeshine Box, With a Luster All Its Own, Emerges from the Shadows," *New York Times*, June 9, 2014, C7.

47 Lou Nappi, "Great Contribution to Surrealist Art, Says Noted Woman Sculptor of Joe Milone's Odd Shoe-Shine Box," *Corriere D'America*, January 10, 1943. Nappi cites Nevelson's words about Milone.

48 Henry McBride, "Women Surrealists, They, Too, Know How to Make your Hair Stand on End," *New York Sun*, January 9, 1943.

49 Edward Alden Jewell, "31 Women Artists Show Their Work: Peggy Guggenheim Museum Offers Paintings, Sculpture of Fantasy Realm," *New York Times*, January 6, 1943.

50 Ben Bendol, "Art Events," *Aufbau*, January 15, 1943, 14.

51 Louise Nevelson, interview with author, July 7, 1976.

52 Louise Nevelson, in Tal Streeter, "Unpublished Interview with Louise Nevelson," November 25, 1959, LN Papers, AAA.

53 *Nevelson Drawings*, shown at the Nierendorf Gallery in New York, April 12–30, 1943.

54 Nevelson, *Dawns + Dusks*, 93.

55 Ernst, *A Not-So-Still Life*, 242.

56 Maude Riley, "Irrepressible Nevelson," *Art Digest*, April 15, 1943; *Art News*, May 1–14, 1943.

57 Ernst, *A Not-So-Still Life*, 240. Elenor Lust was the daughter of Dora Lust, Nevelson's old friend— another wealthy divorcee—from her Art Students League days.

58 *The Circus, The Clown is the Center of His World*, shown at the Norlyst Gallery in New York, April 1943. Louise Nevelson's humorous animal sculpture appealed to Ernst and Lust and they decided that its inclusion would enliven the exhibit (Jimmy Ernst, interview with author, July 29, 1976; press release, gallery announcement, LN Papers, AAA). The gallery announcement lists the titles of each piece included in the exhibit and groups them into the three categories.

59 Louise Nevelson, interview with author, July 7, 1976.

60. In 1970 Nevelson described this particular work to Arnold Glimcher and told him not only that she had destroyed all the work (which probably was the case) but also that she had not photographed any of the works (which was not the case). Six years later she told me she had not had money enough to photograph the works.

61 Jimmy Ernst, interview with author, July 29, 1976.

62 Maude Riley, "Irrepressible Nevelson," *Art Digest*, April 15, 1943.

63 *Art News*, May 1–14, 1943, 21.

64 E. A. J., "Comment in Miniature," *New York Times*, April 18, 1943.

65 Edward Alden Jewell, "Art World Victim of Circus Fever," *New York Times*, April 23, 1943

66 Ernst, *A Not-So-Still Life*, 242.

67 Nevelson, *Dawns + Dusks*, 88. Peggy Guggenheim's collection of abstract and surrealist art was on permanent display. Part of the museum was reserved for temporary exhibitions, which for the next five years provided the leading avant-garde New York artists with consistent and exceptionally favorable opportunities to be seen and to see. Peggy Guggenheim sat in the front room, accessible to all visitors, and the gallery with its many openings and parties became a focal point during the years of gestation and first flowering of The New York School. "Here . . . in Peggy Guggenheim's sublimated dollhouse, we saw the noble toys of a whole generation" (Blesh, *Modern Art USA*, 220). See also Dore Ashton, *The New York School: A Cultural Reckoning* (New York: Viking, 1972), 118–22.

68 Mike Nevelson, letter to Louise Nevelson, June 20, 1943, LN Papers, AAA.

69 One can imagine that Karl Nierendorf, a man of meticulous taste and culture, while admiring the wit of the earlier *Circus* pieces, might have found their crudeness repugnant and welcomed the more refined works that followed.

70 Robert M. Coates, "Art Galleries," *New Yorker*, October 14, 1944.

71 Howard Devree, "A Reviewer's Notes; Brief Comment on Some Recently Opened Exhibitions of Contemporary Work," *New York Times*, October 29, 1944, X8.

72 "Art Exhibitions," *Cue*, November 4, 1944.

73 Emily Genauer, Review of Nevelson Exhibition, *New York World-Telegram*, October 28, 144. Cited Glimcher, *Louise Nevelson*, 57.

74 Nevelson saved these two works, and used parts of them eleven years later when she began to make and show wood sculpture.

75 *Bronzes by Nevelson*, shown at the Nierendorf Gallery in New York, April 15–27, 1946. No exhibition catalogue.

76 Louise Nevelson, interview with author, July 27, 1976.

77 Nate Berliawsky, interview with author, July 12, 1976.

78 Marjorie Eaton, interview with author, August 25, 1976. Nevelson's friend Marjorie Eaton was

told a slightly different story—that the day she received her inheritance from her mother, Nevelson saw the ad for the house in the newspaper and bought it that afternoon.

79 Nevelson, *Dawns + Dusks*, 96.
80 Anna Walinska, interview with author, June 25, 1976.
81 Lillian Berliawsky Mildwoff, interview with author, June 14, 1976.
82 Marjorie Eaton, interview with author, August 25, 1976.
83 Ibid.
84 Anita Berliawsky Weinstein, interview with author, July 12, 1976.

7. DEATH AND RESTORATION 1946–1953

1 Mike Nevelson, interview with author, July 29, 1977.
2 "Reviews and Preview: Louise Nevelson," *Art News*, May 1946, 58.
3 Ibid.
4 Louise Nevelson, interview with Dorothy Seckler, May 1964, AAA.
5 Karl Nierendorf to Louise Nevelson, November 25, 1946.
6 Nevelson, *Dawns + Dusks*, 94.
7 Nate Berliawsky, interview with author, September 2, 1976.
8 Nate Berliawsky, interview with author, July 12, 1976.
9 Even her brother, Nate, living in Rockland, who had always taken the side of his beleaguered mother, had trouble mourning their father.
10 Susan Nevelson, interview with author, March 4, 2013. Mike had married Susan Nevelson in January 1945.
11 Sidney Geist, interview with author, June 19, 1976.
12 Anna Walinska, interview with author, May 5, 1977.
13 Nate Berliawsky, interview with author, July 12, 1976.
14 Nevelson, *Dawns + Dusks*, 89.
15 Nate Berliawsky, interview with author, July 12, 1976.
16 Mike Nevelson, interview with author, July 29, 1977.
17 Anita Berliawsky Weinstein, interview with author, July 12, 1976. Anita had wanted to be the patroness of an artist but Rosenborg turned out to be too expensive and a "nuisance." "I was paying his room and board [in Rockland] and he was drunk all the time. All my life I had wanted to be good to some artist."
18 Sidney Geist, interview with author, June 19, 1976.
19 Anna Walinska, interview with author, May 25, 1976.
20 Anita Berliawsky Weinstein, interview with author, July 12, 1976.
21 Ibid.
22 Lillian Berliawsky Mildwoff, interview with author, July 14, 1976. Louise liked to travel with Anita, but she was in fact closer to Lillian and saw her much more often, since they both lived in the city and were part of the downtown art world. The bookish Anita and the genial hotelier Nate were the two country mice, living their lives in Rockland.
23 Louise Nevelson, interview with Arnold B. Glimcher, December 1970, AG Papers, transcript, 5–6.
24 Ibid.
25 The possibility of exhibiting regularly in the annual group shows attracted such sculptors as David Smith, Alexander Calder, José de Creeft, José de Rivera, Ibram Lassaw, Isamu Noguchi, and Theodore Roszak (see Sahl Swarz, *Twenty-Fifth Anniversary Exhibition-Sculpture Center*, March 15–April 18, 1953, exhibition catalog). Nevelson's association with the Sculpture Center extends from 1948 through 1950 (Sahl Swarz, interview with author, September 1, 1976). See also Glimcher, *Louise Nevelson*, 60–63.
26 Louise Nevelson, interview with Arnold B. Glimcher, December 1970, AG Papers, transcript, 5–6.
27 Dido Smith, "A Sculptor Works with Clay: A Visit with Louise Nevelson," *Ceramic Age* (August 1954): 50.
28 Ibid.

29 Ibid.
30 She described herself in these terms to journalists in "Creativity Through Clay Draws Adult Response in Sculpting Class," *Newsday*, November 9, 1956.
31 Barbara Lekburg, interview with author, January 24, 1977.
32 Anna Walinska, interview with author, June 25, 1976. Anna Walinska claimed that she had persuaded Nevelson to paint her terra-cottas black.
33 Dido Smith, "A Sculptor Works with Clay," 50.
34 By the time she arrived at these terra cottas, Nevelson had seen many more pre-Columbian sculptures—on her two trips to Central America in 1950 and 1951.
35 Louise Nevelson, unpublished notebook, 1942. Laurie Wilson archives.
36 Sahl Swarz, interview with author, September 1, 1976.
37 Mike Nevelson, interview with author, April 11, 2014. Lee Leary came from Rockland and her name growing up there was Leah Berlofsky.
38 Jan Gelb, interview with author, July 27, 1976.
39 Anna Walinska, interview with author, June 25, 1976.
40 Alexander Tatti, interview with author, August 18, 1976.
41 Sidney Geist, interview with author, June 19, 1976.
42 In 1953 Nevelson started teaching sculpture in the Great Neck (NY) Adult Program—working with children and their parents in the afternoon and a group of adults in the evening. She had taught once before, in 1935, as the only way to get the WPA stipend she desperately needed. Now she was teaching as a way to meet people in a prosperous suburban area to whom she could sell her work and who could help her make connections to wealthy collectors.
43 Louise Nevelson, interview with author, July 19, 1977.
44 Terry de Roy Gruber, "Louise Nevelson: A Twentieth Century Journey of Achievement," *Flight Time*, August 1977.
45 Mike Nevelson to Louise Nevelson, June 10, 1951, LN Papers, AAA.
46 Mike Nevelson to Louise Nevelson, June 1, 1953, LN Papers, AAA.
47 Mike Nevelson to Louise Nevelson, June 13, 1953, LN Papers, AAA.
48 Paul Kelemen, "America's Middle Ages Seen Anew," *Art News*, March 1944, 8–9, 24. Nevelson has explained that after seeing the replicas of these columns, she decided to visit the original site. For a detailed description of the site, see Sylvanus G. Morley, *Guidebook to the Ruins of Quirigua* (Washington, D.C.: Carnegie Institute of Washington, 1935). For a photographic record, see Alfred P. Maudslay, *Archæology. Biologia Centrali-Americana*, 6 vols. (London: R. H. Porter, 1899–1902). See also C. Bruce Hunter, *A Guide to Ancient Maya Ruins* (Norman: University of Oklahoma Press, 1976), chap. 4.
49 Kings, queens, and ruling majesties are common psychological symbols for parents according to Sigmund Freud, in *The Interpretation of Dreams* (1899), *Standard Edition* 5: 353–54. It is intriguing to note that the Surrealists, who were well acquainted with this work of Freud's, would have been aware of the symbolic meanings of royal couples.
50 Max Weber to Louise Nevelson October 7, 1950, LN Papers, AAA.
51 Max Weber, "The Fourth Dimension from a Plastic Point of View," *Camera Work* (July 1910). Weber's reference to the purity of the "primitive" calls to mind Nevelson's own words about Joe Milone's shoebox.
52 Anita Berliawsky Weinstein, interview with author, July 12, 1976.
53 Nevelson, *Dawns + Dusks*, 105.
54 Louise Nevelson, interview with Dorothy Gees Seckler, January 14, 1965, Oral History Program, AAA, transcript 207, 13.
55 Louise Nevelson in Roberts, *Nevelson*, 16. Emphasis added.
56 Bongartz, "'I Don't Want to Waste Time,'" 12–13, 30–34.
57 Lillian Berliawsky Mildwoff, interview with author, July 14, 1976.
58 Ibid.
59 Mike Nevelson to Louise Nevelson, June 10, 1951, LN Papers, AAA.
60 Student Ledger book Atelier 17, documents Nevelson's work from September 1952 through May 1953 and again in Fall 1954. Peter Grippe papers, Allentown Art Museum. Information courtesy of Christina Weyl.

61 Una Johnson, interview with author, June 23, 1977.

62 Louise Nevelson, interview with Colette Roberts, at New York University, 1968, Colette Roberts papers and interviews with artists 1918–1971, AAA.

63 Nevelson, *Dawns + Dusks*, 107.

64 Jan Gelb, interview with author, June 27, 1976.

65 Louise Nevelson, interview with Arnold B. Glimcher, December 12, 1979, AG Papers, transcript, 38.

66 Dorothy Dehner, interview with author, June 17, 1977.

67 Minna Citron, interview with author, July 26, 1976.

68 LN Papers, AAA.

69 The use of imagery from the archeological past, and particularly the use of such terms as "ancient" and "archaic," often serves as a veil, conscious or unconscious, for the fantasies of childhood. The appearance of so many royal figures in Nevelson's oeuvre suggests that her idealized childhood perceptions of her parents were never entirely relinquished.

70 In fall 1953, Nevelson exhibited a terra-cotta entitled *Portrait of a Queen*.

71 Hunter, *A Guide to Ancient Maya Ruins*, 112.

72 Sylvanus G. Morley, *The Ancient Maya* (Stanford: Stanford University Press, 1946), 262.

73 Matthew G. Looper, *Lightening Warrior, Maya Art and Kingship at Quirigua*. (Austin: University of Texas Press, 2014).

74 Helena Simkhovitch, interview with author, May 5, 1977.

75 Sidney Geist, interview with author, June 19, 1976.

76 Mike Nevelson, interview with author, July 27, 1977.

77 It should also be noted that this is the only royal figure in the series of etchings to be accompanied by a child. Another version of this print obliterates the image of the child and seems to have been attacked with pencil markings (*Figure* [fig. 146], Brooklyn Museum; Print Collection, no. 65.22.27).

78 The sun and the moon deities in Mayaland are called by the native Indian population by such familiar terms as lord, lady, our father, our mother, our grandfather, or our grandmother. (J. Eric S. Thompson, *The Rise and Fall of Maya Civilization* [Norman: University of Oklahoma Press, 1959], 263.) It is still the current custom in Mexico among the Indians to address friends and strangers by the family appellation suited to one's age. Thus all children are called son or daughter, and so forth.

79 Christina Weyl discovered these remarkable images. "Abstract Impressions: Women Printmakers and the New York Atelier 17, 1940–1955," Ph.D. thesis, Rutgers University, 2015. Christina Weyl, "Innovative Etchings: Louise Nevelson at Atelier 17," in *American Women Artists, 1935-1970: Gender, Culture, and Politics*, Helen Langa and Paula Wisotzki, eds. (Burlington, VT: Ashgate, 2016): 127-143.

80 Louise Nevelson, interview with author, July 19, 1977. See also *Dawns + Dusks* Nevelson, *Dawns + Dusks*, 6.

81 Nevelson's friends and acquaintances watched this activity with a mixture of admiration and dismay (Minna Citron, interview with author, July 26, 1976; Anna Walinska, interview with author, July 25, 1976; Helena Simkhovich, interview with author, May 5, 1977; Dido Smith, interview with author, June 21, 1977). The groups in which Nevelson was active in the early 1950s included: Artists Equity; Federation of Modern Painters and Sculptors; Sculptors Guild; New York Society of Ceramic Arts; Creative Arts Associates; New York Society of Women Artists; National Association of Women Artists; League of Present Day Artists; and American Abstract Artists.

82 Nevelson, *Dawns + Dusks*, 105.

83 Robert Cronbach, interview with author, June 23, 1976.

84 For a brief discussion of the Four O'Clock Forum, see Glimcher, *Nevelson*, 73. See also the article by Gordon Brown, one of the sponsors of the group, for some of the artistic positions and opinions of its most vocal members, e.g., Steve Wheeler, Will Barnet, and Peter Busa, "New Tendencies in American Art," *College Art Journal* 3, no. 2 (winter 1951–52): 103–109. Press releases and notices of some of the group's meetings may be found in LN Papers, AAA. For a brief history of the Federation of Modern Painters and Sculptors, see Dore Ashton, "The Federation in Retrospect," in *35th Anniversary Exhibition: The Federation of Modern Painters and Sculptors* (New York: Federation of Modern Painters and Sculptors, 1976), exhibition catalogue.

85 Anna Walinska, interview with author, June 25, 1976.

86 Phillip Pavia, interview with author, June 17, 1976.

87 Robert Cronbach, interview with author, June 23, 1976. Though Nevelson was supposedly "not well known at the time," she was usually among the few artists in group shows to be reviewed. She was in fact quite well known as someone who had won prizes and gotten positive reviews, off and on, since the mid-1930s.

88 Nathaniel Kaz, interview with author, June 15, 1976.

89 Pedro Guerrero, *A Photographer's Journey* (Princeton Architectural Press, 2007), p. 193

90 S. T., "Fortnight in Review: Louise Nevelson," *Art Digest*, April 15, 1954, 24.

91 John H. Lichtblau, review of *Murder and Mystery; Crime Without Punishment: The Secret Soviet Terror Against America*, by Guenther Reinhardt, *New York Times*, November 9, 1952, Book Review, 62.

92 Guenther Reinhardt, letter to the editor, *New York Times*, December 7, 1952, Book Review, 38.

93 Mike Nevelson to Louise Nevelson, December 13, 1952, LN Papers, AAA. In a recent interview with author, April 11, 2014, Mike Nevelson once again brought up the issue of Nierendorf's alleged shady political activities.

94 It is possible that the news about Nierendorf could have knocked him off the pedestal in her internal pantheon and made room for someone new to take his place.

95 Carlyle Burroughs, "Group of Sculptors," *Herald Tribune*, January 10, 1953.

96 Louise Nevelson, interview with author, July 19, 1977.

97 Nevelson gave a bronze version of this work to her son and new daughter-in-law as a wedding present. Susan Nevelson, interview with author, March 3, 2012.

8. A FORGOTTEN VILLAGE 1954–1957

1 "Reviews and Previews: Louise Nevelson," *Art News*, January 16, 1954, 69.

2 Since the 1920s Nevelson had been aware of the importance of public relations. She had observed how Norina Matchabelli and Frederick Kiesler had mobilized press coverage for their new school in 1926. She had seen how Diego Rivera used his renown to make political as well as artistic points during his short stay in New York City in 1933 and how the politically active WPA artists and writers got the word out when necessary to take a stand in the late 1930s. And she was probably aware that both Noguchi and Jackson Pollock had used Eleanor Lambert of fashion fame to do their public relations in the 1930s.

3 Mike Nevelson, letter to Louise Nevelson, 18 March 1954, LN Papers, AAA.

4 Louise Nevelson, interview with Arnold B. Glimcher, New York, 12 August 1970, AG Papers; Anita Berliawsky Weinstein, Lillian Mildwoff Berliawsky, interview, 13 July 1976; Mike Nevelson, letter to Louise Nevelson, 15 November 1955, LN Papers, AAA.

5 Diana MacKown, telephone interview with author, January 5, 2013.

6 Lillian Berliawsky Mildwoff, interview with author, July 13, 1976.

7 *Three Four Time* was evidently kept intact until some time in 1954, when it was dismantled.

8 *Winged City*, although submitted for exhibit and illustrated in the catalogue, is not mentioned in the reviews because it appears to have been replaced by two other wood pieces illustrated in the review: *Little City at Dawn*, *Personages in the Black Forest* (see Frank O'Hara, "Reviews and Previews: Sculpture 1955," *Art News*, September 1955, 51; Robert Rosenblum, "Sculptors Guild," *Arts Digest*, August 1955, 28). *Nevelson: Sculptures, Sculpture-Collages, Etchings*, Grand Central Moderns Gallery, January 8–25, 1955, gallery announcement, LN Papers, AAA.

9 *Winged City* is at the Birmingham Museum of Art in Alabama.

10 Dido Smith, interview with author, June 21, 1977. Nevelson may have already have been working in wood before this time. In late January 1954 she exhibited a black-painted wood figure "as ceremonious as a Kabuki dancer" at the Stable Gallery's 3rd Annual Exhibition. However, according to Smith: "She was financially very strapped. People don't realize now how difficult it was to sell sculpture at that time. She couldn't pay the corner grocer, for instance. And the wood was available. And she'd used it before. And, of course, with the clay, it seems as if it's cheap, to some people, but then you have to have it fired. And that's quite expensive. . . . Compared to just taking the wood and putting a few nails in it, and so forth."

11 The exhibit was originally listed as "Nevelson, Sculpture, Sculpture-Collages, Etchings" in gallery notices and Nevelson was described as a Guest Sculptor. Later both Nevelson and Roberts

began to refer to it as *Ancient Games, Ancient Places* or "Ancient Games and Ancient Places," see Roberts, *Nevelson*, 16.

12 Louise Nevelson, interview with author, July 19, 1977.

13 Ibid.

14 Louise Nevelson, "A Fairy Tale," LN Papers, AAA. See also Roberts, *Nevelson*, 19.

15 Stuart Preston, "Recent Sculpture and Painting," *New York Times*, January 16, 1955, X11.

16 S. B., "Fortnight in Review: Nevelson," *Art Digest*, January 1, 1955, 21.

17 Louise Nevelson, "The Great Beyond," LN Papers, AAA.

18 Dido Smith, interview with author, June 21, 1977.

19 Louise Nevelson, interview with author, 19 July 1977.

20 Colette Roberts, interview with Arnold B. Glimcher, August 6, 1970, Pace Gallery archives.

21 Dore Ashton, "Louise Nevelson Shows Wood Sculptures" *New York Times, February 21, 1956*

22 James R. Mellow, "In the Galleries: Personages at Sea," *Arts*, February 1956, 52.

23 P.T. [Parker Tyler], "Reviews and Previews: Louise Nevelson," *Art News*, February 1956, 48.

24 Colette Roberts, "Nevelson", (unpublished draft for book), unnumbered page, LN Papers, AAA.

25 Roberts, *Nevelson*, 10.

26 Colette Roberts, "Nevelson" (unpublished draft for book), 2.

27 "Departure in dreams means dying. So, too, if a child asks where someone is who has died and whom he misses, it is common nursery usage to reply that he has gone on a journey.... The dramatist is using the same symbolic connection when he speaks of the after-life as 'the undiscovered country from whose bourn no *traveller* returns.' Even in ordinary life it is common to speak of 'the last journey.' Everyone acquainted with ancient rituals is aware of how seriously (in the religion of Ancient Egypt, for instance) the idea is taken of a journey to the land of the dead. Many copies have survived *The Book of the Dead*, which was supplied to the mummy, like a Baedeker to take with him on the journey. Ever since burial-places have been separated from dwelling-places the dead person's last journey has indeed become a reality." Sigmund Freud, *Introductory Lectures on Psychoanalysis*, in *Standard Edition* 15: 161.

28 Colette Roberts, interview with Arnold B. Glimcher, August 6, 1970, AG Papers, transcript, 36.

29 Lillian Berliawsky Mildwoff, interview with author, July 13, 1976.

30 Louise Nevelson, "A Sculptor Speaks for His Time," statement in LN Papers, AAA.

31 The photo shows the gallery as too brightly lit, for the purpose of clearly illustrating the individual pieces and their positioning in the show.

32 *The Forest: Recent Sculptures by Louise Nevelson* (New York: Grand Central Moderns Gallery, 1957). Installation list published in conjunction with the exhibition of the same name, shown at the Grand Central Moderns Gallery, LN Papers, AAA.

33 Nevelson, *Dawns + Dusks*, 128.

34 Louise Nevelson, interview with Arlene Jacobwitz, May 3, 1965, Brooklyn Museum Library Artists' Files, for the "Listening to Pictures" Gallery, transcript, 2.

35 Ibid.

36 Ibid. Cf. Louise Nevelson, interview with Colette Roberts, 1968, Oral History Program, AAA, transcript 207, 19–20.

37 *Tender Being* is in the Evansville Museum in Indiana.

38 Unfilmed material in the Colette Roberts Collection, AAA, courtesy of Richard Roberts.

39 *Wedding Bridge* and *Black Wedding Cake* were included in the press release for the exhibit, but did not appear in the later gallery list or installation photograph, see LN Papers, AAA.

40 Communication with Arnold Glimcher who owns *The Wedding Bridge*.

41 Louise Nevelson, interview with author, July 19, 1977.

42 Nevelson, *Dawns + Dusks*, 4–6.

43 Poetic fragment, LN Papers, AAA.

44 Louise Nevelson, interview with author, July 19, 1977.

45 Ibid.

46 Mike Nevelson to Louise Nevelson, December 1956, LN Papers, AAA

47 Mike Nevelson to Louise Nevelson, January 10, 1957, LN Papers, AAA

48 Louise Nevelson, interview with author, July 19, 1977.

49 Dore Ashton, "Art: Forest Sculptures," *New York Times*, January 8, 1957.

50 Hilton Kramer, "Month in Review," *Arts*, January 1957, 47.

51 Ibid.
52 Louise Nevelson, interview with Dorothy Gees Seckler, January 14, 1965, Oral History Program, AAA, transcript 207, 16.
53 Ibid.
54 Sidney Baldwin "Louise Nevelson, Sculptress," *Peoria Morning Star*, September 5, 1957.
55 In March 1957, Nevelson exhibited a work called *Shadow Box II* at a Grand Central Moderns group exhibition and in May '57 she exhibited *Shadow Landscape* at the Stable Gallery.
56 Glimcher, *Louise Nevelson*, 78.
57 Roberts, *Nevelson*, 21.
58 Ibid.
59 Baldwin, "Louise Nevelson, Sculptress," *Peoria Morning Star*, September 5, 1957.
60 Lillian Berliawsky Mildwoff, interview with author, July 14, 1976.
61 Colette Roberts, interview with Arnold B. Glimcher, August 6, 1970, AG Papers, transcript, 6.
62 Lillian Berliawsky Mildwoff, interview with author, June 14, 1976.
63 "2,000 at Burial of Diego Rivera," *New York Times*, November 27, 1957, 30.

9. MOON GARDEN BREAKTHROUGH 1957–1960

1 Dorothy Dehner, interview with author, December 4, 1975.
2 "Art: One Woman's World," *Time*, February 3, 1958, 58.
3 Colette Roberts, lecture "Louise Nevelson's 'Elsewhere'" (1960s) 3, Colette Roberts papers, AAA.
4 Ibid.
5 Martha Graham's dance *Embattled Garden* (1958) and Louise Bourgeois' *Fôret* (*Night Garden*, 1953) were among the contemporary works.
6 Dorothy Sieberling, "Weird Woodwork of Lunar World: Sculptress Exhibits Her All-Black Moon Garden Landscape," *Life*, March 24, 1958, 77.
7 Colette Roberts to Arnold B. Glimcher, August 6, 1970, AG Papers, transcript, 5. On the back of an announcement for the *Moon Garden + One* exhibition someone had written "blessings and love from Louise and Ted" LN Papers, AAA.
8 Colette Roberts to Arnold B. Glimcher, August 6, 1970, AG Papers, transcript, 27–28.
9 Nevelson, *Dawns + Dusks*, 133.
10 Emily Genauer, "Abstract Art with Meaning," review of Nevelson exhibit, *New York Herald Tribune*, January 5, 1958.
11 Emily Genauer, "Abstract Art with Meaning: Another World"; she is referring to Martha Graham's famous dance *Cave of the Heart* from 1946.
12 *Arts and Architecture* 75, no. 3 (March 1958).
13 Glimcher, *Louise Nevelson*, 79, 84.
14 Hilton Kramer, "The Sculpture of Louise Nevelson," *Arts*, June 1958, 26–29.
15 Thomas B. Hess, "Inside Nature," *Art News*, February 1958, 40ff, at 60.
16 Dorothy Sieberling, "Weird Woodwork of Lunar World: Sculptress Exhibits Her All-Black Moon Garden Landscape," *Life*, March 24, 1958, 70–80.
17 Roberts recalled: "At the time of *The Forest* and *Moon Garden Plus One*, I recall very distinctly, Nevelson's having a tailored suit in a sort of a soft weave, but extraordinarily stylish and what you would say 'in vogue,' [which she wore] during those two years, and only during those two years."
18 "Art: One Woman's World" *Time*, February 3, 1958, 58.
19 Ibid.
20 Louise Nevelson, interview with Colette Roberts, 1968, AAA. Roberts coined the word "elsewhere" to refer to Nevelson's idea of the fourth dimension.
21 Nevelson *Dawns + Dusks*, 125–26.
22 Ibid., 126.
23 Stuart Preston, in his *New York Times* review of this exhibit, finds "narrow coffins, shadow boxes made like traps" (January 12, 1958). The importance this piece had in Nevelson's eyes is evident from the fact that she submitted it later in the year to the Pittsburgh *International Exhibition of Contemporary Painting and Sculpture*, December 5, 1958–February 8, 1959.

24 It is worth comparing *Shadow City* with *Solid Reflections*, an etching alternately titled *The Ancient Garden* and *In The Jungle* for funereal imagery. Some figures look like headstones.

25 Nevelson, *Dawns + Dusks*, 145.

26 LN Papers, AAA.

27 Louise Nevelson, interview with author, 19 July 1977.

28 Louise Nevelson, interview with Dorothy Gees Seckler, January 14, 1964, Oral History Program, AAA, transcript 207, 16.

29 Robert Rosenblum, "Louise Nevelson," *Arts Yearbook: Paris/New York* 3 (1959): 137.

30 *Gaudi*, Museum of Modern Art, New York, December 18, 1957–February 23, 1958; Edith Burkhardt, "The Unfinished Cathedral and Antoni Gaudi," *Art News*, January 1958, 36–37; Anthony Kerrigan, "Gaudianism in Catalonia," *Arts*, December 1957, 21–25. For Nevelson's expressed interest in Gaudí, see Glimcher, *Louise Nevelson*, 99.

31 Robert Rosenbaum observed that: "If . . . her *Sky Cathedrals* and *Moonscapes*—can be simply described as a quantitative multiplication of these smaller parts, their over-all effect involves a more complex qualitative change. Traditionally, the fragile, private quality of Nevelson's imagination implies . . . an equally intimate scale; and to see this personal world magnified to public dimensions is a startling experience for which perhaps only the architectural fantasies of Gaudí or the largest Abstract Expressionist paintings offer adequate preparation." *Arts Yearbook* 3 (1959): 138.

32 With the smashing success of the *Moon Garden* exhibition, Colette Roberts knew it was time for Nevelson to work with a dealer who could invest money to help her reach the next level in her career.

33 Colette Roberts, interview with Arnold B. Glimcher, August 6, 1970 and 1971, AG Papers, transcript, 18.

34 Ibid. 19.

35 Roberts continued to write about Nevelson's work in her column for *France-Amérique*, the French-language newspaper in New York, and worked closely with her on *Louise Nevelson*, the first book on the artist, published in 1964.

36 Dorothy C. Miller, interview with author, September, 2, 1976.

37 Years later, Miller, by then Senior Curator of Painting and Sculpture at MoMA, said: "She appeared like a comet in the American sky around 1958, and the world took notice." Dorothy C. Miller, interview with author, September 2, 1976.

38 Dorothy C. Miller, telephone interview with author, September 2, 1976; and also Dorothy C. Miller, interview with Paul Cummings, April 8, 1971, Oral History Program, AAA, transcript, 298.

39 Lillian Berliawsky Mildwoff and Ben Mildwoff, interview with author, July 14, 1976.

40 "Spring St. House Bought," *New York Times*, September 30, 1958, 50.

41 Lillian Berliawsky Mildwoff, interview with author, July 14, 1976.

42 Martha Jackson had included work by Louise Nevelson in her gallery three years earlier, the earliest example being the Outdoor Sculpture Exhibition, June 5–29, 1956. See letter from Martha K Jackson to Louise Nevelson, LN Papers, AAA.

43 Berniece Gill, "Brush Strokes," *Portland Sunday Telegram*, May 10, 1959.

44 Ibid.

45 Ibid.

46 Press release, "The World of Louise Nevelson," Martha Jackson Gallery, October 1959.

47 Roberts, *Nevelson*, 24.

48 The professional lighting by Schuler Watt may have made a difference, but judging only from the installation photographs, the four-sided reliefs of *Sky Columns Presence* were not so evocative nor as formally powerful as the boxed works lining the wall. While the reliefs added a sense of presence—figures coming to life, which matched the title—I find them less interesting formally than the work she was doing at the same time for *Dawn's Wedding Feast*.

49 Dore Ashton, "Art: Worlds of Fantasy," *New York Times*, October 29, 1959, 44.

50 Dore Ashton, *Arts and Architecture* 76 (December 1959): 7.

51 Dore Ashton, "U.S.A.: Louise Nevelson," *Cimaise*, no. 48 (April–June 1960): 26.

52 Ibid.

53 Mike Nevelson to Louise Nevelson, November 6, 1959, LN Papers, AAA.

54 Mike Nevelson to Louise Nevelson July 15, 1959, LN Papers, AAA. He thanks her for the check and writes about his own sculpture.

55 Mike Nevelson to Louise Nevelson, October 4, 1959, LN Papers, AAA.

56 Mike Nevelson to Louise Nevelson, October 16, 1959, LN Papers, AAA.

57 Glimcher, *Louise Nevelson*, 101. See also Dorothy C. Miller, interview with Paul Cummings, transcript, April 8, 1971, Oral History Program, AAA. Miller evidently did not appreciate the accumulated intensity behind Nevelson's twenty years of waiting for a serious offer from MoMA.

58 Nevelson, *Dawns + Dusks*, 138.

59 Mike Nevelson to Louise Nevelson, June 2, 1959, LN Papers, AAA.

60 Anna Walinska, interview with author, June 25, 1976.

61 Tal Streeter interview, November 25, 1959, LN Papers, AAA. The *Sky Columns Presence* exhibition at Martha Jackson had just come down and she was only three weeks away from installing *Dawn's Wedding Feast*.

62 Nevelson, *Dawns + Dusks*, 144.

63 Glimcher, *Louise Nevelson*, 107.

64 Marvin D. Schwartz, "New York Notes," *Apollo*, February 1960.

65 Thomas B. Hess, "16 Americans," review, *Art News*, January 1960, 57.

66 Dore Ashton, "Louise Nevelson," *Cimaise*, no. 48 (April–June 1960): 36.

67 Glimcher, *Louise Nevelson*, 59.

68 Nevelson, *Dawns + Dusks*, 147. One more instance of the complexity of Nevelson's double identity is her remark upon learning that Giacometti won first prize at the Biennale: "Always the bridesmaid, never the bride," Nevelson, *Dawns + Dusks*, 148.

69 Roberts, *Nevelson*, 29.

70 Nevelson, *Dawns + Dusks*, 144.

71 "Marcel Duchamp," review of exhibit at Janis Gallery, New York, April 6–May 2, 1959, *Art News*, May 1959, 59. While Nevelson was not part of the Duchamp circle until the 1960s, she would have known of his work and activities through Colette Roberts and their mutual friend Frederick Kiesler.

10. GLITTERING GLORY 1960–1962

1 This quote comes from a friend of Jackson's in her *New York Times* obituary: "Martha Jackson Dies on Coast; Gallery Aided Abstract Artists," July 5, 1969.

2 "Martha Jackson Dies on Coast; Gallery Aided Abstract Artists."

3 Rosalind Constable, "Martha Jackson: An Appreciation," *Arts Magazine*, September/October 1969, 18.

4 Louise Nevelson in Harry Rand, *The Martha Jackson Memorial Collection* (Washington, D.C.: Smithsonian Institution Press, 1985), 28; published in conjunction with the exhibition of the same name, shown at the National Museum of American Art.

5 Martha Jackson to Richard Faralla, May 6, 1959, MJG Archives.

6 There would later be a dispute about this representation when Jackson had some of Nevelson's wood pieces cast into bronze in Italy where she tried to sell them. Cordier objected and Jackson claimed that he had only been interested in Nevelson's work in wood. Martha Jackson to Elliot Sachs, September 28, 1961, MJG Archives.

7 Martha Jackson to Daniel Cordier March 16, 1960, MJG Archives.

8 Martha Jackson to Daniel Cordier, December 14, 1959, LN Papers, AAA.

9 John Canaday, "Tenth Street," *New York Times*, January 17, 1960, xii.

10 Lawrence Alloway titled his essay "Junk Culture as a Tradition" for the catalogue *New Forms – New Media I* (New York: Martha Jackson Gallery, 1960); published in conjunction with the exhibition of the same name, shown at Martha Jackson Gallery, June 6–24, 1960.

11 Having discovered similar spiritual inclinations with Dord Fitz, the art educator, gallerist, collector, and all-around booster who had been responsible for inviting her, Nevelson often visited Amarillo to teach, to exhibit and to be one of his favorite New York artists. For more about Fitz, see *The Broadcast Is Always On: The Area Arts Foundation and Dord Fitz* (Amarillo, TX: Amarillo Museum of Art, 2008).

12 Susan Nevelson, interview with author, March 2–3, 2013.

13 Rosalind Constable, "Martha Jackson: An Appreciation," *Arts Magazine*, September/October 1969, 18.

14 Stuart Preston, "Sculpture Display at the Stable," *New York Times*, October 14, 1960.

15 Dore Ashton, "Louise Nevelson," *Cimaise*, no. 48 (April–June 1960): 26–36; Colette Roberts, "L'Ailleurs de Louise Nevelson," *Cahiers de musée de poche*, May 1960, 77–84.

16 Lillian Mildwoff Berliawsky, interview with author, July 13, 1976.

17 The term Jackson used for the largest room in the gallery.

18 Stuart Preston, "Art: On Action Painting," *New York Times*, January 7, 1961. The Enormous Room at the Jackson Gallery was in fact a very large room in which the dealer could display large-scale works.

19 Charlotte Willard, "Women of American Art," *Look*, September 27, 1960, 70–75.

20 John Canaday, "Whither Art?," *New York Times*, March 26, 1961, X15.

21 Ibid.

22 Ibid.

23 Ibid.

24 Louise Nevelson exhibition time schedule, LN Papers, AAA.

25 Press release for the *Royal Tides: An Exhibition of Gold Sculpture by Louise Nevelson*, April 19, 1961.

26 Kenneth B. Sawyer, foreword to *Royal Tides* (New York: Martha Jackson Gallery, 1961); published in conjunction with the exhibition of the same name.

27 Dore Ashton, "Art," *Arts and Architecture* (June 1961): 4–5

28 Brian O'Doherty, "Art: Four Sculptors Manipulate Third Dimension," *New York Times*, April 24, 1961.

29 Jack Kroll, "Louise Nevelson," Reviews and Previews, *Art News*, May 1961, 10–11.

30 *Royal Tide III* was shown first in gold at Cordier's 1960 exhibition. By the time it was placed in the Louisiana Museum in Denmark it had been painted black.

31 Rufus Foshee, telephone interview with author, July 12, 1979.

32 Rufus Foshee, e-mail to author, June 28, 2008.

33 Arnold B. Glimcher, interview with author, July 21, 2008.

34 Arnold B. Glimcher, interview with author, October 3, 2008.

35 Roberts, *Nevelson*, 31–35, at 33 and 35.

36 Louise Nevelson quoted in *Nevelson's World* by Jean Lipman (New York: Hudson Hill Press with the Whitney Museum of American Art, 1983), 144, 148.

37 Nevelson, *Dawns + Dusks*, 144–45.

38 Dorothy C. Miller "didn't like the quality of the gold because she believed that the gold paint wasn't good enough. It was sort of cheesy. Like radiator paint. The color wasn't up to the quality of the sculpture." Dorothy C. Miller, interview with Paul Cummings, April 8, 1971; Oral History Interview with Dorothy C. Miller, May 26, 1970–September 28, 1971, AAA, transcript, 173.

39 Arnold B. Glimcher, interview with author, July 21, 2008.

40 Mike Nevelson to Louise Nevelson, July 20, 1961, LN Papers, AAA.

41 Mike Nevelson to Louise Nevelson, January 24, 1960, LN Papers, AAA.

42 Mike Nevelson to Louise Nevelson, February 7, 1960, LN Papers, AAA.

43 Mike Nevelson to Louise Nevelson, April 4, 1960, LN Papers, AAA.

44 Mike Nevelson to Louise Nevelson, January 6, 1960, LN Papers, AAA.

45 Memo from Martha Jackson, January 1960, LN Papers, AAA.

46 Diana MacKown, telephone interview with author, May 25, 2013.

47 Tom Kendall, note to Louise Nevelson, January 2, 1960, LN Papers, AAA.

48 Tom Kendall to Louise Nevelson, August 23, 1961, LN Papers, AAA.

49 David Anderson, interview with author, August 25, 2008.

50 David Anderson to Louise Nevelson, February 24, 1961, LN Papers, AAA.

51 Martha Jackson to Louis Pomeranz, March 10, 1960, MJG Archives. Jackson could also be the bearer of bad news. When a dealer and collector (Claude Haim) was incensed by what he saw as Nevelson's bad faith in cancelling a proposed large purchase and refused to have any more to do with the artist or her work, Martha let Louise know.

52 Arnold B. Glimcher, interview with author, October 4, 2010.

53 Milly Glimcher, interview with author, November 14, 2008.

54 Rufus Foshee, interview with author, July 12, 1979. See also Foshee, "Louise Nevelson: The Long Road to Acceptance," *Camden Herald*, July 14, 1994.

55 Arnold B. Glimcher, interview with author, October 4, 2010. While they were sitting shiva for their father, Herb asked his newly married youngest brother, Arne, what he would like to do—be an artist, be a beatnik, or run a gallery. Arne chose the last—it seemed like a rhetorical question. And the next day Herb went out to find a venue on Newberry Street and rented it. He thought that would give both his mother and youngest brother something constructive to do with their time.

56 Arnold B. Glimcher, interview with author, March 24, 2008.

57 June Wayne, interview with author, July 26, 2008.

58 Arnold Glimcher, interview with author, October 4, 2010

59 She told Diana MacKown that she went to see Bergler because she was concerned about Teddy Haseltine, her assistant, who was becoming occasionally violent and increasingly unstable. Louise Nevelson, notebook from the 1960s, courtesy of Diana MacKown. Laurie Wilson archives.

60 Louise Nevelson, notebook from the 1960s. Laurie Wilson archives.

61 "Todays Living," *New York Herald Tribune*, August 27, 1961, 4.

62 Staatliche Kunsthalle, Baden-Baden. "Louise Nevelson," September 24–October 22, 1961. Catalogue.

63 Dietrich Mahlow to Louise Nevelson, July 11, 1961, LN Papers, AAA.

64 The work eventually landed at the Toledo Museum of Art in Ohio.

65 The American Embassy in Bonn sponsored these exhibitions in gallery spaces under the U.S. auspices as part of the then current U.S. policy promoting a positive view of America.

66 John Daly to Tom Kendall, December 19, 1961, LN Papers, AAA.

67 Livingness—"the quality of being alive, possessing energy or vigor, animation" is a dictionary definition—was a word Nevelson often used in describing her work.

68 Lipman letter requesting purchase during the show, LN Papers, AAA.

69 William C. Seitz, *The Art of Assemblage* (New York: Museum of Modern Art, 1961), 118; published in conjunction with the exhibition of the same name, shown at the Museum of Modern Art.

70 Martha Jackson to Louise Nevelson, September 20, 1961, LN Papers, AAA.

71 Henry J. Seldis, "Summer Forecast: Warm, Variable Art Climate," *Los Angeles Times*, June 10, 1962, A11; "More Art News," *Los Angeles Times*, June 10, 1962, A29; LN Papers, AAA.

11. ICARUS 1962–1963

1 Memo of shipment of eight sculptures, Martha Jackson Gallery to Reed College, February 6, 1962, LN Papers, AAA.

2 *Los Angeles Times*, May 13, 1962, M24.

3 Rufus Foshee, "The Long Road to Acceptance," *Camden Herald*, July 14, 1994, 9.

4 Rufus Foshee, e-mail to author, April 10, 2008; telephone interview July 12, 1979.

5 I.H.S., "Louise Nevelson," *Art News*, March 1962.

6 Elliott Sachs to Martha Jackson, March 12, 1962, MJG Archives.

7 Louise Nevelson, handwritten note donated by Diana MacKown, Laurie Wilson archives.

8 Ibid.

9 David Anderson, interview with author, August 25, 2008. Decades later, Anderson said the Jackson Gallery "let Nevelson go because we had three people managing her—Tom Kendall, Rufus Foshee and me—and she was a way bigger expense than we were earning from the sale of her work." He further noted that, "It had become nearly impossible to make an accurate record of her work."

10 MJG Archives.

11 David Solinger to Martha Jackson, July 16, 1962, MJG Archives.

12 Rubin v. Kurzman, U.S. District Court, 436 F. Supp. 1044 (S.D. New York 1977); see also Rufus Foshee, "Louise Nevelson: The Magical Decade: 1958–1968," *Free Press*, January 21, 1999.

13 Rufus Foshee, interview with author, telephone interview July 12, 1979.

14 Arnold B. Glimcher, interview with author, October 3, 2008.

15 Ibid.

16 Arnold B. Glimcher, interview with author, July 21, 2008.

17 Milly Glimcher, interview with author, November 4, 2008.

18 Dore Ashton, "Art USA," *Studio*, March 1962, 94.

19 "Nevelson Art Now Showing at Museum" *Van Nuys News*, June 17, 1962. *Royal Tide I* was illustrated in "On View at County Museum," *Los Angeles Times* June 16, 1962

20 Nevelson, *Dawns + Dusks*, 147.

21 Dorothy C. Miller, interview with Paul Cummings, April 8, 1971, AAA.

22 Nevelson, *Dawns + Dusks*, 147.

23 Ibid., 148.

24 William C. Seitz, *Louise Nevelson* (New York: International Council of the Museum of Modern Art, 1962), 5–10; published in conjunction with the exhibition of the same name, shown at the XXXI Venice Biennale.

25 Michel Ragon, "XXXIst Venice Biennale," *Cimaise*, no. 61 (September/October 1962): 26.

26 Milton Gendel, "The Venice Bazaar," *Art News*, September 1962, 53–54.

27 "The Venice Biennale," editorial, *Apollo*, August 1962, 428–430.

28 Guy Habasque, "La XXXIe Biennale de Venise," *L'Oeil*, September 1962, 72.

29 Robert Melville, "Exhibition: The Venice Biennale," *Architectural Review*, October 1962, 285.

30 Rufus Foshee, telephone interview with author, July 12, 1979.

31 Rufus Foshee, telephone interview with author, July 12, 1979. Rufus Foshee, e-mail to author, April 21, 2008. The available records of the Janis Gallery tell a somewhat different story. The first undated advance is for $7,500. The second is for $2,500 on August 7, 1962, and the last is again for $2,500 on October 24, 1962. After that, the listing only includes debits for moving and storage with Santini Brothers beginning February 18, 1963, running through August 6, 1964. The dates suggest that by August 1964 Nevelson had some of her works back in her studio.

32 Marjorie Eaton, interview with author, August 25, 1976.

33 Rufus Foshee, telephone interview July 12, 1979, e-mail to author April 21, 2008.

34 Rufus Foshee, e-mail to author, April 21, 2008

35 "Art: All That Glitters," *Time*, August 31, 1962, 40.

36 Mike Nevelson to Louise Nevelson, September 26, 1962, LN Papers, AAA.

37 Arnold B. Glimcher to Louise Nevelson, December, 1962, LN Papers, AAA.

38 Hilton Kramer, "Art," *Nation*, January 1963, 78–79.

39 Colette Roberts, "Nevelson at Sidney Janis," *France-Amérique*, January 13, 1963, LN Papers, AAA.

40 Brian O'Doherty, "Spotlights on the Stricken Scene," *New York Times*, April 7, 1963, X27.

41 Dore Ashton, "New York Letter," *Das Kunstwerk*, April 1963, 31.

42 During the entire time she was represented by Janis, he only sold one work for her—months before the show—to an heir of the Singer Sewing Machine Company.

43 Rufus Foshee; e-mail to the author, April 14, 2008.

44 Diana MacKown, telephone interview with author, February 3, 2010.

45 Correspondence file, Martha Jackson and Louise Nevelson, MJG Archives.

46 Glimcher, *Louise Nevelson*, 123.

47 Mike Nevelson to Louise Nevelson, May 17, 1963, LN Papers, AAA

48 Martha Jackson to Louise Nevelson, May 17, 1963, LN Papers, AAA. Jackson and Nevelson had already worked out a deal about casting a group of six bronzes in Italy that long preceded the arrangement with Janis. Jackson had contacted Joseph Hirshhorn among other collectors and offered them good prices on these works if they bought early which some of them did.

49 Mike Nevelson to Louise Nevelson, May 21, 1963, LN Papers, AAA.

50 Ibid.

51 June Wayne, telephone interview with author, July 26, 2008.

52 Diana MacKown, interview with author, August 17, 2014.

53 In a case before the U.S. District Court on May 30 1977 about the Kurzman estate, Judge Kevin Thomas Duffy proclaimed that Samuel Kurzman was an attorney and "also a wheeler and dealer in real estate who, for his own personal reasons, often used nominees as record owners or mortgagors of the real estate in which he was dealing."

54 Rufus Foshee, e-mail to author, August 9, 2008.

55 Diana MacKown, conversation with author, January 25, 2009.

56 Norman Carton to Louise Nevelson, March 3, 1964, Louise Nevelson papers, circa 1903–1979, AAA.

57 Arnold B. Glimcher, interview with author, July 21, 2008

58 They would later be taken to Pace Gallery, where two of them would find their way into the homes of Arne Glimcher's brother Herb and his mother Eva.

59 Arnold B. Glimcher, interview with author, October 3, 2008.

60 Richard Solomon, interview with author, February 13, 2009.

12. ARCHITECT OF REFLECTION 1964–1966

1 Even so, the password didn't always work. At her 1961 exhibition at the Martha Jackson Gallery, it was successful with *Royal Tide I* but failed with *Royal Tide II.*.

2 Colette Roberts had been one of the few people to notice the importance of using boxes of equal size as a new direction when she reviewed the Janis exhibition. See Colette Roberts, "Nevelson at Sidney Janis," translation of draft "Lettre de New York" for *France-Amérique*. Colette Roberts papers, AAA.

3 This was not the first time Nevelson had made walls with boxes of uniform size. She had constructed three—*New Continent, Totality Dark*, and *Dawn*—in late 1962 for the Janis show.

4 Mike Nevelson had probably been the carpenter who made those boxes.

5 "The Sculpture of Louise Nevelson," *London Times*, November 16, 1963.

6 Typed transcript of critics' panel discussion on the occasion of Louise Nevelson exhibit at the Hanover Gallery, London, ca. November 12, 1963. Pace Gallery Archives, Louise Nevelson files, New York.

7 "A Construction that Squawks," *San Francisco Sunday Chronicle*, August 2, 1964.

8 Arnold B. Glimcher, interview with author, October 5, 2009.

9 Diana MacKown, interview with author, September 19, 2009.

10 Pace Gallery Archives.

11 Her poem made clear that Nevelson's "religion" was not the issue. It was her cultural heritage as a Jew, who knew that her people could triumph against all odds only if they could escape death. Despite her estrangement from the formal religion of Judaism and her turn to a complex metaphysical belief system, she could, privately, embrace a Jewish "livingness" and "consciousness."

12 Dorothy Dehner, interview with author, December 4, 1975. Dorothy Dehner had known Teddy years before, when he had come to study with her at Bolton Landing in the 1940s, hitchhiking every day from his home in Glen Falls.

13 Tom Kendall, interview with Laurie Lisle, January 26, 1984, untranscribed audio recording, LN Papers, AAA. Some of her other helpers who knew Teddy were shocked at what seemed to be her inhuman response to his death.

14 Diana MacKown was even more spiritually inclined than Teddy had been; she was also highly educated and well-spoken, all of which help explain why Nevelson was so articulate when she talked about the fourth dimension in her 1964 interview with Dorothy Gees Seckler, an art historian and editor at *Art News,* and with K. O., an art-world interviewer, in 1963.

15 *Nevelson*, November 17–December 12, 1964

16 MacKown had grown up in Rochester where her parents taught at the Eastman School of Music and performed in the Rochester Symphony Orchestra.

17 It was not all classical because MacKown often played the Beatles, Diana Ross, and Aretha Franklin.

18 Emily Genauer, "Rouault as Mirror And Prophet," *New York Herald Tribune*, November 22, 1964, 37.

19 Robert M. Coates, "Louise Nevelson," *New Yorker*, December 5, 1964.

20 John Canaday, "Display at Pace Gallery Called Her Best Yet," *New York Times*, November 21, 1964, 25.

21 Louise Nevelson to Richard Stankiewicz, 1973, Oral History Program, AAA. Albany panel. See Lisle, *A Passionate Life*, 244.

22 Arnold B. Glimcher, interview with author, April 13, 2009.

23 Arnold B. Glimcher, interview with author, March 24, 2008.

24 Nevelson, *Dawns + Dusks*, 153.

25 Louise Nevelson, interview with author, August 8, 1979.

26 Louise Nevelson, interview with Dorothy Gees Seckler, May–June 1964, Oral History Program, AAA, transcript, 208.

27 Louise Nevelson, interview with Arlene Jacobowitz, May 3, 1965, Brooklyn Museum Library Artists' Files, for the "Listening to Pictures" Gallery, transcript, 6.

28 Lillian Berliawsky Mildwoff, interview with author, June 14, 1976.

29 Arnold B. Glimcher, interview with author, April 13, 2009.

30 Diana MacKown, telephone interview with author, October 30, 2009.

31 June Wayne, "Louise Nevelson 1899–1988; Goodbye Louise," obituary, *Women Artists News* (summer 1988): 23.

32 "Dame Edith Sitwell, Poet, Dies; Stirred Literary Controversies," *New York Times*, December 10, 1964, 1, 44.

33 Ibid., 41

34 Diana MacKown, telephone interview with author, November 6, 2009.

35 The date December 9, 1964, is written on the gallery registrar's card for the work. Nevelson would make at least five more works also entitled *Homage to Dame Edith*.

36 Diana Vreeland, editor in chief of *Vogue*, to Louise Nevelson, January 2, 1964, LN Papers, AAA. In order for *Vogue*'s article featuring Nevelson's sculpture at Pace to appear at the same time as the actual exhibit, the models were photographed in Nevelson's studio, against the background of the sculpture, months in advance of the show's opening.

37 Since Nevelson created at least eight sculptures entitled *Homage to Dame Edith*, it is not clear to which one Roberts may have been referring. It must have been one of the works made in 1968, which was also titled *Homage to Edith Sitwell*.

38 Louise Nevelson, tape recorded interview with Colette Roberts, 1968, AAA, transcript

39 Victoria Glendinning, *Edith Sitwell, A Unicorn Among Lions* (London: Weidenfeld and Nicolson, 1981. See also the *Times* obituary, 41.

40 "Dame Edith Sitwell, Poet, Dies," 1.

41 It was Sitwell's brothers' closeness to the composer William Walton that led to the successful collaboration that culminated in *Façade*, Sitwell's poetry set to Walton's music.

42 Diana MacKown, interview with author, November 8, 2009.

43 Katherine Rouse, report of interview with Louise Nevelson, January 13, 1966, LN Papers, AAA.

44 "Mansions of Mystery," *Time*, March 31, 1967, 68.

45 Angela Cuccio, "The Rebel Sculptor," *Women's Wear Daily*, December 21, 1967, 4.

46 "Fashion: The sculpture of Louise Nevelson—potent and arcane—photographed at the Pace Gallery with clothes for brilliant evenings," *Vogue*, March 1, 1965, 134–49.

47 Ibid., 134.

48 Milly Glimcher, interview with author, November 4, 2008; Arnold B. Glimcher, interview with author, October 5, 2009.

49 Both women were wearing "snoods" they had bought in Egypt to protect themselves from the sand and sun. The head coverings looked remarkably like one worn by one of the *Vogue* models in the Gordon Parks photos.

50 Arnold B. Glimcher, interview with author, October 5, 2009.

51 Ibid.

52 Arnold B. Glimcher, interview with author, October 4, 2010.

53 Milly Glimcher, interview with author, November 14, 2008.

54 Steve Poleskie, interview with author, November 14, 2009.

55 There are at most five works in this series.

56 Arnold B. Glimcher, interview with author, March 1, 2010. Though she did very well with her show at David Mirvish's gallery, he was in love with David Smith's work and that didn't sit well with her. When she met the Dunkelmans and had a much greater rapport with them, she switched to the Dunkelman Gallery.

57 Harry Malcolmson, *Toronto Telegram*, October 23, 1965.

13. EMPRESS OF THE ENVIRONMENT 1966–1968

1 When initially installed at the J. L. Hudson Gallery in Detroit, Albert Landry, the gallerist, arranged the hundred boxes in a triptych to work within the given space. The work could be set up in other configurations as long as the sequence of boxes remained the same.

2 "Detroit Gallery Shows Nevelson Sculpture," *Toledo Blade*, May 15, 1966.

3 Louise Nevelson, interview with Jeanne Siegel for *Great Artists in America Today*, WBAI, March 6, 1967, printed in *Artwords: Discourse on the 60s and 70s* (New York: Da Capo Press, 1968). 66-69.

4 Ibid., 68.

5 Joy Hakanson, "Museum Speaker is Unique in her Personality and Art," *Detroit News*, June 1966, 1.

6 George Francoeur, "Detroit," *Art News*, October 1966, 58, 61.

7 Charles Culver, "Sight and Sound; Louise Nevelson: Art and the Machine," *Detroit Free Press*, October 23, 1966, 5B.

8 Louise Nevelson, interview with Jeanne Siegel for WBAI, March 6, 1967 in *Artwords: Discourse on the 60s and 70s*, 68.

9 Dorothy Seckler, "The Artist Speaks: Louise Nevelson," *Art in America*, January–February 1967, 33.

10 Diana MacKown, interview with author, February 14, 2010.

11 Donald W. Thalacker, *The Place of Art in the World of Architecture* (New York: Chelsea House Publishers, 1980).

12 Irving Sandler, "Public Art #1," in *Sculpture in Environment* (New York: New York City Administration of Recreation and Cultural Affairs, 1967); published in conjunction with the outdoor exhibition of the same name, shown citywide, October 1–31, 1967.

13 Diana MacKown remembers that Nevelson had been worried about the possibility that the vibration of the trucks rumbling by her house would break the beautiful pots she had carefully carried from Texas to New York beginning in the mid- to late 1950s. By the mid-1960s, "She didn't need them anymore."

14 Patricia Coffin, "Louise Nevelson, *Artiste solitaire*," *Single* 1, no. 4 (November 1973): 42, 54–56.

15 Lipman, *Nevelson's World*, 153.

16 Glimcher, *Louise Nevelson*, 147. Arne Glimcher said that "everybody was playing with Plexiglas at the time," and "she was fascinated with Plexiglas." At first, "She fooled around with dark-gray translucent Plexiglas," but when she realized that it didn't work because,"You couldn't see a damn thing, she went to clear Plexiglas, because she liked that reflection would keep you out of the box or it would make it more difficult for you to enter the box. Nevelson wanted everything on her own terms—including your perception." Arnold B. Glimcher, interview with author, April 13, 2009.

17 Elizabeth McFadden, "Master Industrial Craftsmen Playing Vital Part in New Renaissance Art," *Newark Sunday News*, April 9, 1967.

18 Arnold B. Glimcher, interview with author, April 13, 2009.

19 Arnold B. Glimcher, interview with author, March 1, 2010. The small models in black Plexiglas for the early *Atmosphere and Environment* series do not always exactly match the large aluminum versions. In some cases "models" were made afterwards.

20 *Atmosphere and Environment I* was soon bought by the Museum of Modern Art. In 1967, *Offering* and *Enclosure* went on display at the CBS building at Sixth Avenue and 52nd Street, as part of the city-sponsored show, *Sculpture in Environment*, whose purpose was to put artwork in prominent urban sites

21 Arnold B. Glimcher, interview with author, March 1, 2010. Magnesium was used to make it possible to deliver the work in one piece by helicopter to the Rockefeller estate.

22 I am indebted to Arne Glimcher for noting this remarkable equivalence of different looking works. Arnold B. Glimcher, interview with author, March 1, 2010.

23 *Transparent IV* was eventually made in an edition of twelve for New York State, to be used as rewards or prizes for various state events.

24 Like *Atmosphere and Environment VI*, *Transparent Sculpture VII* is on public display at Kykuit, the Rockefeller Estate in Sleepy Hollow, New York.

25 Henry J. Seldis, "In the Galleries: Nevelson Turns to Greater Clarity," *Los Angeles Times*, December 16, 1966, part V, 12.

26 John Canaday, "Nevelson Puts Green Thumb to Good Use," *New York Times*, May 14, 1966, 20.

27 On December 19, 1964, Glimcher had written a letter to Lloyd Goodrich, director of the Whitney Museum, accepting his "proposal for a retrospective at the new Whitney museum."

28 Dorothy Gees Seckler, "The Artist Speaks: Louise Nevelson," *Art in America*, January 1967, 38.

29 Both Lipmans were influential board members and Howard Lipman was chairman of the

board. Also on the Whitney board were Robert Sarnoff and Roy Neuberger, both of whom were Nevelson collectors.

30 Arnold B. Glimcher to Lloyd Goodrich, February 26, 1965, Whitney Museum of American Art Archives.

31 Louise Nevelson to Jack Gordon, January 14, 1967, Nevelson file, Whitney Museum of American Art Archives.

32 David L. Shirey, "She and Her Shadows," *Newsweek*, March 20, 1967, 110–11.

33 Press release for Louise Nevelson retrospective, Whitney Museum of Art, February 21, 1967, 1.

34 John Gordon, *Louise Nevelson* (New York: Whitney Museum of American Art, 1967), 8, from a tape of private interview with Louise Nevelson by Colette Roberts, spring 1965.

35 Louise Nevelson to John Gordon, January 14, 1967, Nevelson file, Whitney Museum of American Art Archives.

36 Christopher Andreae, "Nevelson's Little Boxes—Or Are They Big?," *Christian Science Monitor*, March 22, 1967, 10. Arnold Glimcher explained that some of the boxes with mirrors in *Rain Forest* wall were left over from the 1964 Pace exhibition. Having started to use blue light by chance with *Moon Garden + One*, Nevelson continued to create atmospheric effects with blue lighting for many decades; interview with author, October 5, 2009.

37 Grace Glueck, "No Little Flowers, Please," Art Notes, *New York Times*, March 12, 1967, D29.

38 John Canaday, "Art: Moore and Nevelson Sculpture in Retrospect," *New York Times*, March 9, 1967, 42.

39 Charlotte Willard, "All Around You," *New York Post*, March 11, 1967, 14.

40 Emily Genauer, "Journal of Art, Louise Nevelson's Sculpture Exhibition has Opening at the Whitney Museum," *World Journal Tribune*, March 8, 1967.

41 Emily Genauer, "A Scavenger's Black Magic," *World Journal Tribune*, March 12, 1967, 33

42 Gregory McDonald, "She Takes the Commonplace and Exalts It," *Boston Globe*, September 10, 1967, 24, 32.

43 Robert Pincus-Witten, "Louise Nevelson, Whitney Museum," *Artforum*, May 1967, 58.

44 Dorothy Gees Seckler, "The Artist Speaks: Louise Nevelson," *Art in America* 55, no. 1 (January–February 1967): 42.

45 Ibid., 41

46 Thomas M. Messer, preface to *Guggenheim International Exhibition 1967: Sculpture From Twenty Nations* (Princeton, N.J.: D. Van Nostrand, 1967); published in conjunction with the exhibition of the same name, shown at Salomon R. Guggenheim Museum, New York; National Gallery of Canada, Ottawa; Montreal Museum of Fine Arts.

47 Angela Cuccio, "The Rebel Sculptor," 4–5.

48 Grace Glueck, "A New Breed is Dealing in Art," *New York Times*, December 16, 1968, 58.

49 "Signs of Tomorrow," *Time*, July 12, 1968.

50 Diana MacKown, telephone interview with author, February 24, 2010.

51 Nevelson was among the many artists who donated work to honor Martin Luther King Jr. to be sold for the benefit of the Southern Christian Leadership Foundation at an exhibition at MoMA in late October and early November 1968. Notice in *New York Times*, October 27, 1968.

52 According to Glimcher, *Zag* is the series she remained with the longest. Interview with author, March 1, 2010.

53 See, for example, Nevelson, *Dawns + Dusks*, 81.

14. MISTRESS OF TRANSFORMATION 1969–1971

1 Louise Nevelson, in Tal Streeter, "Unpublished Interview with Louise Nevelson," November 25, 1959, which had been done as preparation for the landmark Martha Jackson Gallery exhibition in 1960; LN Papers, AAA. Cf. *Dawns + Dusks*, 177.

2 Betty Dietz Krebs, "New Logic for Nevelson," *Dayton News*, May 25, 1969, 6.

3 Grace Glueck, "Juilliard Unveils a Wall Sculpture by Nevelson," *New York Times*, December 19, 1969, 60.

4 Lipman, *Nevelson's World*, 84.

5 Grace Glueck, "Juilliard Unveils a Wall Sculpture by Nevelson," *New York Times*, December 19, 1969, 60. The night before Diana MacKown and Nevelson learned about the Lipman purchase

and the wall's ultimate destination, both women dreamt about the wall. Diana recalls that she saw the sculpture as musical and found traces of violins and cellos in its abstract forms.

6 James R. Mellow, "New York Letter," *Art International*, summer 1969, 48.

7 John Gruen, "Art in New York: Silent Emanations," *New York*, April 14, 1969, 57.

8 Lipman, *Nevelson's World*, 80.

9 According to the exhibition list of the 1969 Pace show.

10 John Canaday, "Louise Nevelson and the Rule Book," *New York Times*, April 6, 1969, wrote that the artist is "in a class by herself," 182.

11 Patty Glimcher, interview with author, September 24, 2010.

12 René Barotte, "Nevelson, le sculpteur qui va . . . au-delà," *France-Soir*, May 13, 1969.

13 Carol Cutler, "Art in Paris Trumpets for Nevelson, Kalinowski," *International Herald Tribune*, May 3–4, 1969.

14 Michel Conil Lacoste, "Nevelson's immaculate bric a brac," *Le Monde*, June 11, 1969, 7.

15 Hilton Kramer, "Can We Place Them with Matisse and Brancusi?," *New York Times*, June 22, 1969.

16 Emily Genauer, "Art and the Artist," *New York Post*, October 18, 1969, 46.

17 Ibid. By little magazines she means specifically those not in the mass media.

18 Grace Glueck, "Deflecting Henry's Show," *New York Times*, October 19, 1969, D28

19 Ibid.

20 Hilton Kramer, "Ascendancy of American Art," *New York Times*, October 18, 1969, 23.

21 Hilton Kramer, "A Modish Revision of History," *New York Times*, October 19, 1969, D29.

22 Robert Hughes, "Sculpture's Queen Bee," *Time*, January 12, 1981, 66–72.

23 "Extracts from Miss Nevelson's Response on Receiving the Edward MacDowell Medal, August 24, 1969," *The MacDowell Colony: Report for 1969* (Peterborough, NH: MacDowell Colony, 1969).

24 Mary Buxton to Arnold B. Glimcher, October 15, 1968, Museum of Fine Arts, Houston, Archives.

25 Ibid.

26 Mary Buxton, Cain interview at Museum of Fine Arts, Houston (MFAH), November 16, 2005, transcript.

27 Ibid.

28 Mary Buxton to Louise Nevelson, October 22, 1968, MFAH Archives.

29 Ibid.

30 Arnold Glimcher to Mary Buxton, March 18, 1969. MFAH Archives

31 Mary Buxton to Arnold B. Glimcher, May 27, 1969, MFAH Archives.

32 Mary Buxton to William Fagaly, June 16, 1969, MFAH Archives.

33 Nevelson had decided that for the Houston exhibit she wanted all the early works to be dated the same year—1955. It is very unlikely that all the works dated 1955 were done that year. Nevelson had only just returned to working in wood in 1954 with *Bride of the Black Moon* and *Winged City*. The styles of the eight sculptures dated 1955 are too various to be made in that single year; more accurately, they should be given a date range of 1955–57.

34 Fred Mueller to Mary Buxton, July 25, 1969, MFAH Archives.

35 Fred Mueller to Mary Buxton, July 31, 1969, MFAH Archives.

36 Mr. and Mrs. George Brown whose foundation gave the work to the museum.

37 Mrs. Frederick A. Buxton to Mrs. George Brown. December 8, 1969. MFAH Archives.

38 Pace to MFAH, October 4, 1969, MFAH Archives.

39 Mary Buxton to Louise Nevelson, October 8, 1969, MFAH Archives.

40 Mary Buxton to Arnold B. Glimcher and Fred Mueller, October 23, 1969, MFAH Archives.

41 Mary Buxton to Louise Nevelson, November 5, 1959, MFAH Archives.

42 Mary Buxton to Emily Genauer, November 10, 1969, MFAH Archives

43 Mary Buxton to Katharine Kuh, November 10, 1969; Mary Buxton to Anthony Bower, November 14, 1969, MFAH Archives.

44 Mary Buxton to Emily Genauer, November 10, 1969, MFAH Archives.

45 Ibid.

46 Ann Holmes, "Nevelson at Museum Sculptural Incantation," *Houston Chronicle*, October 26, 1969, 8, s. 7.

47 Arnold B. Glimcher, interview with author. April 13, 2009.

48 Ibid.

49 This work travelled before it arrived in Philadelphia. It had been on exhibit at the Maeght Foundation in France, then in New York at the Seagram's building on Park Avenue.

50 Jonathan D. Lippincott, *Large Scale: Fabricating Sculpture in the 1960s and 1970s* (New York: Princeton Architectural Press, 2010).

51 Lippincott, *Large Scale*, 14.

52 Roy Bongartz, "Where the Monumental Sculptors Go," *Art News*, February 1976, 34–37.

53 Ibid.

54 Donald Lippincott, interview with author, November 16, 2012.

55 Donald Lippincott to Arnold B. Glimcher, April 15, 1969.

56 Lippincott Inc. invoice no. 102-247, May 7, 1971.

57 A careful study of the worksheets and accompanying photographs at Lippincott's shop revealed this remarkable development.

58 Lippincott Inc. invoice No. 103-222, May 7, 1971, "Execution of 10 sculptures by Louise Nevelson in aluminum painted black" and accompanying worksheet.

59 Joyce Schwartz, interview with author, August, 16, 2010.

60 Glimcher, *Louise Nevelson*, 169–70.

61 Glimcher, *Louise Nevelson*, 169.

62 John Canaday, "Art: Nevelson's '7th Decade Garden,'" *New York Times*, May 8, 1971.

63 J. S., "Louise Nevelson," Reviews and Previews, *Art News*, September 1971, 16–17.

64 Schwartz, interview with author, August 16, 2010; Glimcher, *Louise Nevelson*, 169.

65 J. S., *Art News* September 1971

66 Louise Nevelson interview, July 24, 1975, in Hugh Marlais Davies et al., *Artist and Fabricator* (Amherst, MA: Fine Arts Center Gallery, University of Massachusetts, 1975), 23; published in conjunction with the exhibition of the same name, shown at the Fine Arts Center Gallery, July 24, 1975.

67 Lipman, *Nevelson's World*, 176. Lipman placed the quote across from an image of the largest steel sculpture in Louise Nevelson Plaza.

68 See Patterson Sims's introductory essay in Lippincott's *Large Scale*.

69 Ibid.

70 New York was at the head of such activities. Doris C. Freedman, the city's first director of Cultural Affairs, established public sculpture as a necessary and vital part of city life.

71 Nevelson, *Dawns + Dusks*, 171.

72 Elizabeth Fisher, "The Woman as Artist, Louise Nevelson" *Aphra*, Spring 1970 p. 31

73 James R. Mellow, "Nevelson, More Surprises Ahead" *New York Times*, December 6, 1970, D 29

74 George Gent, "Park Ave. Gets a Nevelson Sculpture," *New York Times*, January 27, 1971.

75 Nessa Forman, "New Nevelson Sculpture Man's Art Grows Beside Nature's," *Philadelphia Sunday Bulletin*, May 23, 1971, Art section.

76 Emily Genauer, "Art and Artist," *New York Post*, December 23, 1972.

77 Paul Todd Makler, *Prometheus (Bound): Prometheus No.'s 1 to 33, 1961 to 1972* (Philadelphia: Makler Gallery, 1972), 11.

78 Ibid., 449.

79 Ibid., 311.

80 Ibid., 312. Hope and Paul Makler, interview with author, June 29, 2009.

81 "Mrs. Colette Roberts, 60, Dies; Gallery Director Wrote on Art," *New York Times*, August 12, 1971

82 Israel Shenker, "Picasso, 90 Today, Assayed by Critic, Curator, 3 Artists," *New York Times*, October 25, 1971, 42.

83 Richard Gray, interview with author, July 29, 2009.

84 Ibid.

85 Jane Allen and Derek Guthrie, "Black Marks for 'White on White,'" review of Nevelson exhibit, *Chicago Tribune*, January 9, 1972, Arts & Fun 14.

15. LA SIGNORA OF SPRING STREET 1972–1974

1 In David C. Berliner, "Women Artists Today: How Are They Doing Vis-à-Vis the Men?" *Cosmopolitan*, October 1973, 224.

2 Eleanor J. Bader, "Women Artists Still Face Discrimination," *Truthout News*, May 10, 2012.

3 "We asked 20 Women 'Is the Art World Biased?' Here's What They Said," *Artnet News*, September 16, 2014. The number may be slightly better than the reported figure indicating 86% of the art at the National Gallery of Art and the Hirshhorn Museum was done by men.

4 Philip Boroff, "Art World Bias by the Numbers," *Artnet News*, September 16, 2014

5 Elizabeth Baker, "Art and Sexual Politics," in Thomas B. Hess and Elizabeth C. Baker, eds., *Art and Sexual Politics: Women's Liberation, Women Artists, and Art History* (New York: Macmillan, 1973), 115.

6 Ibid., 114.

7 Friedan, Betty (1963) *The Feminine Mystique*, W.W. Norton

8 Baker, "Art and Sexual Politics," 112.

9 Donald Robinson, "America's 75 Most Important Women," *Ladies' Home Journal*, January 1971.

10 David C. Berliner, "Women Artists Today," 216.

11 "The Truth About Woman's Role Today," "Do Men Treat You as an Equal?," *Chicago Tribune*, June 4, 1972, E5.

12 *Aphra* 1, no. 3 (spring 1970).

13 Linda Nochlin, "Why Have There Been No Great Women Artists?" *Art News*, January 1971, 41.

14 Louise Nevelson, "Do Your Work," in Hess and Baker, eds., *Art and Sexual Politics*, 84–85. Nevelson's essay originally appeared in "Eight Artists Reply: Why Have There Been No Great Women Artists?," "Do Your Work," *Art News*, January 1971, 41–43.

15 Sam Hunter, "Interview with Louise Nevelson," in *Monumenta: A Biennial Exhibition of Outdoor Sculpture*, ed. Sam Hunter (Newport, R.I.: Monumenta Newport, 1974), 38–41; published in conjunction with the exhibition of the same name.

16 "The Sculptor," *Newsweek* special issue, "Our America: A Self-Portrait at 200," July 4, 1976, 53.

17 David C. Berliner, "Women Artists Today," 218–19.

18 Jean Micuda, "Louise Nevelson, They Call Me Mother Courage," *Arizona Living*, March 17, 1972.

19 During the 1970s Nevelson was sending the increasingly large amount of correspondence and clippings that featured her to the Archives of American Art, which had recently (1970) become part of the Smithsonian Institution and would eventually be available to future scholars.

20 Review in *New York Post*, January 15, 1972, of Ralph G. Martin, *Jennie: The Life of Lady Randolph Churchill*, vol. 2, *The Dramatic Years 1895–1921* (Englewood Cliffs, N.J.: Prentice Hall, 1971).

21 The interview originally published in *Changes* but quickly sold out and was republished in Cindy Nemser, "Interview: Louise Nevelson," *Feminist Art Journal*, fall 1972, 1, 14–19.

22 Cindy Nemser, "Interview: Louise Nevelson," 15.

23 Cindy Nemser, interview with author, October 18, 2013.

24 Here, Nevelson might have been referring to Louise Bourgeois. According to Nemser, "Louise Bourgeois came to all the feminist meetings. At that time she was nothing, and she was hostile to anyone who was not a feminist. She liked to stir up trouble. [Bourgeois] was starved for attention, but because she lived long enough she finally got attention. She outlasted other artists who were much better than she was." Cindy Nemser, interview with author, October 18, 2013.

25 Henry J. Seldis, "Nevelson: A Door to Perception," *Los Angeles Times*, October 22, 1976, G1.

26 Katrine Ames, "Gothic Queen," *Newsweek*, December 4, 1972.

27 Ibid.

28 Cindy Nemser, "Interview: Louise Nevelson," 17.

29 *Aphra* 1, no. 3, 41.

30 Amei Wallach, "Sculpting a World to Her Vision," *Newsday*, August 1, 1986.

31 Lynn Gilbert and Gaylen Moore, *Particular Passions: Talks with Women Who Shaped Our Times* (New York: Clarkson N. Potter, 1981), 75.

32 ". . . And Some of the Women Who Have Made It to the Top in the World's Toughest City," *London Sunday Times*, November 12, 1972, 43.

33 Arnold B. Glimcher, interview with author, June 11, 2012: "Lee Krasner invented this rumor.

Lee was very competitive and Louise was too aloof and too Russian to bother denying it, but, trust me, Louise was a predatory heterosexual into her eighties . . . with younger men, of course."

34 Edward Albee, interview with author April 16, 2012.

35 Diana Loercher, "'Apolitical' Artists Give for McGovern," *Christian Science Monitor*, September 25, 1972, 6.

36 Lawrence Campbell, "Louise Nevelson," *Art News*, December 1972, 11.

37 "A Work of Art for Scottsdale," *Arizona Republic*, February 20, 1972.

38 Ann Patterson, "Sculptress Louise Nevelson – Excursion into Awareness," *Scottsdale Daily Progress*, March 3, 1972.

39 Model Review of the Sculpture Commission, March 1, 1972, City Hall Scottsdale, AZ, LN Papers, AAA.

40 Ibid.

41 Jim Newton, "Sculptor Talks About Scottsdale Commission," *Phoenix Gazette*, March 4, 1972.

42 Carolyn Younger, "Whim & Caprice: 'The Haberdashery of Oddities in the Collection of Curious Things,'" *Napa Valley Register*, August 4, 2011.

43 The exhibit has retrospectively been titled *Louise Nevelson: Columns, Dream-Houses and Collages*.

44 Bill Katz, interview with author, December 14, 2012.

45 A sizable number of Nevelson's collages have mistakenly been given much earlier dates. While she may have previously made an occasional collage, the summer of 1972 was the beginning of her work in this medium, which she would come to favor more and more. Five separate sources—including the artist herself, Diana MacKown, and Arnold B. Glimcher—confirm this time frame.

46 Helen Dudar, "The Eyes Can Touch, Too," *New York Post*, December 9, 1972.

47 Diana MacKown recalls that Nevelson took the material for the collages up to Stony Point that summer with the idea that she would be able to work even though she was away from her studio and home.

48 John Canaday, "Art: Ingenuity of Louise Nevelson," *New York Times*, November 4, 1972, 29.

49 Ellen Lubell, *Arts Magazine*, December 1972, 83.

50 Vivien Raynor, "Louise Nevelson at Pace," *Art in America*, January 1973.

51 April Kingsley, "Louise Nevelson," *Artforum*, February 1973, 87.

52 Louis Botto, "Works in Progress: Louise Nevelson," *Intellectual Digest*, April 1972, 6–8.

53 Ibid.

54 Gilbert and Moore, *Particular Passions*, 3–4.

55 Mike Nevelson, interview with author, April 11, 2014.

56 Dorothy Rabinowitz, "The Art of the Feud," *New York*, September 25, 1989, 94.

57 Marjorie Eaton, interview with author, August 25, 1976.

58 Mike Nevelson, interview with author, July 29, 1977.

59 Diana MacKown, interview with author, January 28, 2012.

60. Mike Nevelson, interview with author, April 11, 2014.

61 Maria Nevelson, interview with author, December 13, 2012.

62 The sculpture would remain on Fifth Avenue until a permanent outdoor location was found for it. It eventually landed at the top of a slight incline on the center mall of Park Avenue at 92nd Street, a site allegedly chosen by the artist and her dealer "as a kind of link between Spanish Harlem and the Upper East Side."

63 George Gent, "Sculptor Thanks the City in Steel," *New York Times*, December 15, 1972.

64 April Kingsley, "Louise Nevelson, Pace Gallery," *Artforum*, February 1973, 86–89.

65 Giorgio Marconi, interview with author, May 24, 2011. Marconi explained to me how he had arranged for the five European exhibitions using works from the show in his gallery.

66 Giorgio Marconi to Louise Nevelson, May 17, 1973, LN Papers, AAA.

67 Giorgio Marconi, interview with author, May 24, 2011.

68 Ibid.

69 Ibid.

70 The large Cor-Ten steel sculptures of the late 1960s and early 1970s, including the *Atmosphere and Environment* series, were not translations from wood to metal. They were Nevelson's first works in metal and grew out of the Plexiglas sculptures, not wood.

71 Martin Friedman, interview with author, July 15, 2011.

72 Don Morrison, "Nevelson's Art Started in a Gutter," *Minneapolis Star*, November 8, 1973.

73 Don Morrison, "Discarded Wood Transformed into Art," *Minneapolis Star*, November 15, 1973.

74 Margaret Morris, news release, *Minneapolis Tribune*, November 7, 1973.

75 "Women at the Walker," *Skyway News*, November 21, 1973.

76 "Artists on Watergate," *Changes*, September–October 1973.

77 "How Has the Most Famous Third-Rate Burglary Affected Your Life," *New York*, October 22, 1973.

78 Pace Prints is in the same building as Pace Gallery and had a collaborative relationship with it but was a separate entity showing and selling graphic work only, often by the same artists in Pace Gallery.

79 Irving Rabb, speech to Congregation Adath Israel Board of Trustees Meeting, Boston, December 20, 1972, 3. Archives at Temple Israel.

80 Greg Downes letter to George Abrams, May 10, 1973, Archives at Temple Israel.

81 Louise Nevelson in *Fact Sheet for Louise Nevelson Sculpture Sky Covenant* (Boston: Temple Israel Boston, n.d.).

82 Rabbi Roland B. Gittelsohn, *Fact Sheet for Louise Nevelson Sculpture Sky Covenant*.

83 Lacey Fosburgh, "A Special S.F. Greeting for Sculptor," *Los Angeles Times*, February 3, 1974.

84 Henry J. Seldis, "Enchanted Forest of Nevelson Wood Sculpture," *Los Angeles Times*, February 10, 1974.

85 Ibid.

86 Frances Beatty and Gilbert Brownstone, "The Permanence of Nevelson" in *Louise Nevelson* (Paris: Centre national d'art contemporain and Weber, 1974); published in conjunction with the exhibition of the same name.

87 Jacques Michel, "Louise Nevelson au CNAC," *Le Monde*, April 1974.

88 Carl R. Baldwin, "Louise Nevelson," *Connaissance des Arts*, no. 266 (April 1974), 58–65.

89 Michelle Motte, "La reine des murs noirs," *L'Express*, April 15–21, 1974.

90 Ivy Dodd, "Thorndike's Louise Nevelson Room Pays Tribute to Rockland Artist," *Courier-Gazette*, April 25, 1974.

91 Mary Sullivan, "Louise Nevelson, One of Art World's Most Noted," *Courier-Gazette*, July 18, 1974.

92 Hilton Kramer, "Art: Nevelson Still Shines," *New York Times*, May 11, 1974, 25.

93 Barbaralee Diamonstein, "Louise Nevelson at 75 'I've Never Yet Stopped Digging Daily for What Life Is All About,'" *Art News*, October 1974.

16: LARGE SCALE 1975–1976

1 Arnold B. Glimcher, interviews with author, June 13, 2011, October 31, 2011. Though Nevelson and Glimcher did not make it to Sapporo, they had done a video that was available to the viewers of the show there.

2 Nevelson, *Dawns + Dusks*, 148.

3 Dorothy Miller accompanied her to Venice in 1962, and Milly and Arne Glimcher were her travelling companions to Iran, India and Japan in 1975.

4 Arnold B. Glimcher, interview with author, June 13, 2011.

5 Ibid.

6 Milly Glimcher, interview with author, December 9, 2011.

7 Kusuo Shimizu to Louise Nevelson, March 3, 1975, N Archives, FAM.

8 Robin Berrington (United States Information Service) to Louise Nevelson, March 12, 1975, N Archives, FAM.

9 Kegoro Kiji, "Louise Nevelson: Her Works and World," *Hokkaido Shimbun*, March 25, 1975.

10 Diana MacKown, telephone interview with author, January 23, 2011.

11 The work is sometimes listed as *Transparent Horizons* though the correct name is *Transparent Horizon*.

12 I. M. Pei, interview with author, October 26, 2009.

13 Deborah Nikkel, "'Transparent Horizons' on the MIT Campus," *Christian Science Monitor*, Arts/Entertainment, 1975. December.

14 "Marty Carlock Guidebook spotlights MIT art collection," *Boston Globe*, January 9, 1983;

Nevelson had a copy of this article and was obviously pleased that the prime photo was of her *Transparent Horizons*, which she underlined and directed and inserted an arrow with her name next to it.

15 Joyce Pomeroy Schwartz, interview with author, February 15, 2012.

16 Adele Tutter, communication to author, January 30, 2011.

17 Diana MacKown, interview with author, September 19, 2009.

18 I. M. Pei, interview with author, October 26, 2009.

19 Joyce Pommeroy Schwartz, interview with author, August 16, 2010.

20 Thalacker, *The Place of Art in the World of Architecture*, 123. See ch. 13, n11.

21 Ibid.

22 Larry Eichel, "Praise from First Lady," *Philadelphia Enquirer*, January 14, 1976.

23 Louise Nevelson, letter to GSA Administrator Solomon, August 23, 1977 in Thalacker, *The Place of Art in the World of Architecture*, 124.

24 Louise Nevelson "Bicentennial Dawn 1975" in *Nevelson Bicentennial Dawn* brochure, ed. Jack Eckerd (Washington, D.C.: U.S. General Services Administration, 1976).

25 Thalacker, *The Place of Art in the World of Architecture*, 120.

26 The Fine Arts in Federal Buildings Program was revitalized in 1972 when GSA renewed its commitment to commission exceptional talented American artists to create artworks as an integral part of each new architectural design. The GSA has worked with the NEA to strengthen the program. See Jack Eckerd, *Bicentennial Dawn*.

27 Thalacker, *The Place of Art in the World of Architecture*, 120–25.

28 Emily Genauer, "Art and the Artist," *New York Post*, January 17, 1976.

29 Nessa Forman, "1st Lady Throws the Switch," *Bulletin*, January 1976.

30 Ibid.

31 Paul Makler, "Nevelson," *Prometheus*, no. 43 (January 1976): 6.

32 "Louise Nevelson: The Stern Sculptor Who Does Boxes within Boxes," *Life*, special report, 1976, 55.

33 In the interests of full disclosure this included some of my own interviews.

34 The artist vehemently claimed in her own handwriting on the frontispiece of the book: "This is not an autobiography. This is not a biography. This is a gift."

35 Grace Glueck, "Art People," *New York Times*, November 26, 1976, Travel section, C18.

36 Ad in *Art News*, December 1976.

37 Ivy Dodd to Susan Richman, December 3, 1976, N Archives, FAM.

38 Wendy Seller to Louise Nevelson, December 9, 1978, N Archives, FAM

39 I had interviewed Lillian Mildwoff three times during the summer of 1976, twice in Maine and a third time in New York. There was no evidence then that she was ill.

40 Ben had lent money to Louise when she was buying her new home on Spring Street in 1958. Soon afterwards he began to pressure her to pay him back. Once she did, she told him to get out and never come back. She was a champion at holding grudges.

41 Diana MacKown, interview with author, October 24, 2015.

42 Editorial, "The Moral Message from La Grande France," *Art News*, March 1977, 31.

43 Grace Glueck, "Art People," *New York Times*, January 21, 1977, C18.

44 Ibid.

45 It continued to be owned by Pace until it was sold at auction in 2001.

46 Hilton Kramer, "US Boycott Vexes French, *New York Times*, January 27, 1977.

47 Editorial, *Art News*, March 1977, 31.

48 Two years later, Nevelson was given an award by the Anti-Defamation League honoring her "commitment to human rights." Louise Nevelson, your soul, your sensitivity, your genius and your courage have endowed our lives with a new dimension – in our appreciation of beauty and in our hope for that world of peace and of justice."

49 Arnold B. Glimcher, interview with author, February 11, 2011.

50 Ibid.

51 "A Tree Grows in a Lobby," *San Francisco Examiner*, February 14, 1977, 6.

52 Ted Sylvester, "Fish 'n Chips," *Bangor Daily News*, March 12–13, 1977.

53 Thomas Albright, "Art is a Conviction – A Way of Life," *San Francisco Chronicle*, February 25, 1977, 52.

54 "A Tree Grew at Embarcadero Center," *San Francisco Progress*, February 16, 1977, 1.

55 Louise Nevelson in Jeffrey Hoffeld, *Nevelson at Purchase: The Metal Sculptures* (Purchase, NY: Neuberger Museum of Art Neuberger Museum of Art, SUNY, Purchase College, 1977)

56 "Centerview Goes to A 'Tree-Planting,'" *Centerview* 5, no. 3 (March 1977).

57 Thomas Albright, "San Francisco; Convulsive but Lyrical," *Art News*, May 1977.

58 Robert Taylor, "Louise Nevelson: A Candid Creator," *Boston Globe*, April 10, 1977, B5.

59 Judith Matloff, "Visiting Artist Louise Nevelson Discusses Sculpture and Life," *Harvard Crimson*, April 1, 1977.

60 Ibid.

61 Robert Taylor, "Louise Nevelson: A Candid Creator," *Boston Globe*, April 10, 1977.

62 Donald Lippincott, interview with author, April 25, 2011.

63 Luisa Kreisberg, "A Crop of Nevelsons Picked for Purchase; Nevelsons on Way," *New York Times*, May 1, 1977, section Westchester Weekly, WC11.

64 Arnold B. Glimcher, interview with author, June 11, 2012.

65 "Lifestyles: Museum Gala to Honor Sculptor," *White Plains Reporter Dispatch*, January 31, 1977.

66 Jeffrey Hoffeld, *Nevelson at Purchase: The Metal Sculptures*, 3.

67 Donald Lippincott to Jeffrey Hoffeld, March 29, 1977, Neuberger Museum Archives.

68 "Nevelson Exhibit This Summer at Purchase," News Report, *Progressive Architecture* 6, no. 77 (June 1977): 24.

69 Jeffrey Hoffeld, interview with author, February 4, 2012.

70 David L. Shirey, "Nevelson the Fantasticator," *New York Times*, June 12, 1977, section Westchester Weekly, WC22.

71 Louise Nevelson, interview with Arnold B. Glimcher, March 3, 1976, on way to Atlanta memorial. In *Louise Nevelson Remembered: Sculpture and Collages*, March–April 1989, Pace Gallery and accompanying catalogue (New York: Pace Gallery, 1989).

72 Hilton Kramer, "Art View," *New York Times*, May 15, 1977.

73 Luisa Kreisberg, "A Crop of Nevelsons Picked for Purchase; Nevelsons on Way," *New York Times*, May 1, 1977, section Westchester Weekly, WC1, WC11.

74 Charles C. Smith, "The Sculpture Factory," *Boston Globe*, August 27, 1978, 35.

75 Nevelson, *Dawns + Dusks*, 167

76 Ibid., 171.

17. "THE NEVELSON" 1967–1988

1 Elizabeth Baker, interview with author, October 3, 2011.

2 Mary Blume, "Louise Nevelson in Paris: At 86, Finally Ready for Satin," *International Herald Tribune*, January 31, 1986. The *Life* article was "Weird Woodwork of Lunar World," *Life*, March 24, 1958.

3 Arnold Scaasi, *Women I Have Dressed (And Undressed!)* (New York: Scribner, 2004).

4 Roberta Gratz, "Building Empires," *New York Post*, March 8, 1967.

5 Milly Glimcher, interview with author, November 14, 2008

6 Beverly Grunwald, "Getting Around," *Women's Wear Daily*, November 18, 1976.

7 Roberta Gratz, "Building Empires," *New York Post*, March 8, 1967.

8 Eleanor Lambert to Louise Nevelson, February 14, 1977, N Archives, FAM; and press release from Eleanor Lambert, Inc.

9 "Here They Are Again, the World's Best-Dressed Women But Who Says So and Why?" *People*, February 28, 1977.

10 Amy Fine Collins, "The Lady, the List, the Legacy," *Vanity Fair*, April 2004. Lambert began the Council of Fashion Designers of America and was responsible also for setting up the Costume Institute at the Metropolitan Museum of Art.

11 Ted Cohen, "Sculptor Is Stunning and Family Stunned," *Beacon: The Boston Herald America*, February 20, 1977.

12 Lillian Berliawsky Mildwoff, interview with author, July 14, 1976.

13 Barbaralee Diamonstein, "Louise Nevelson at 75." See ch. 15 n95.

14 Iris Krasnow, "Close Up: Louise Nevelson," *New Jersey Daily News*, March 23, 1986

15 Mary Engels, "Architect of Reflection," *Daily News*, January 9, 1970, 50.

16 Gwen Mazer, "Lifestyle," *Harper's Bazaar*, April 1972, 112–13.
17 Barbara Rose, "The Individualist," *Vogue*, June 1, 1976. 156.
18 Amei Wallach, "Sculptor Louise Nevelson – Hanging On, Crashing Through, Loving It All," *New York Newsday*, July 15, 1973. For the Maine paper the title was changed to "The Girl from Rockland Who Made It."
19 Barbara Rose, "The Individualist," *Vogue*, June 1, 1976, 122–24.
20 Sarah Booth Conroy, "Nevelson at Eighty," *Horizon* (March 1980): 62–67;
21 Eleanor Freed, "The Queen of Parts," *Houston Post*, October 26, 1969, 12.
22 Bongartz, "'I Don't Want to Waste Time,'" 12–13; 30–34.
23 Ibid., 12.
24 Ibid., 13.
25 Louis Botto, "Works in Progress: Louise Nevelson," *Intellectual Digest*, April 1972, 6–8.
26 Carol Kleiman, "Mastering the Art of Being Louise Nevelson," *Chicago Tribune*, October 29, 1978, 1, 6.
27 David Elliott, "Jubilant Drawings upon the body of nature," *Chicago Sun-Times*, November 2, 1978.
28 Charles Calhoun, Louise Nevelson's Above It All, *Palm Beach Post-Times* February 12, 1978, G-1
29 Charles Calhoun, "Nevelson: Teaching Us Fine Art of Survival," *Palm Beach Post-Times*, November 10, 1979, B1–2.
30 Ibid.
31 Edward Albee, interview with author, April 16, 2012.
32 Ibid.
33 Ibid.
34 Richard Gray, interview with author, July 29, 2009.
35 *San Jose Mercury*, "Big Names on Big Books," December 4, 1983.
36 Barbara Braun, "PW Interviews: Louise Nevelson," *Publishers Weekly*, December 16, 1983, 76–77.
37 Franz Schulze, "*Nevelson's World*," *Chicago Sun-Times*, December 4, 1983.
38 Vivien Raynor, "Louise Nevelson at Pace," *Art in America*, January 1973.
39 Philip Eliasoph, "Leading Lady of Sculpture Puts on Show at Whitney," *Advocate* and *Greenwich Time*, January 18, 1987, D5.

18. THE CHAPEL AND THE PALACE 1977–1979

1 Easley Hamner, interview with author, October 17, 2011.
2 Ralph Peterson, interview with author, November 7, 2015.
3 Ralph Peterson, interview with author, September 16, 2010; Barbara Murphy, interview with author, October 15, 2011.
4 Barbaralee Diamonstein, "The White Chapel," *Ladies Home Journal*, December 1977.
5 "Minister has High Hopes for Mid-Manhattan Church," *Sarasota Herald-Tribune*, August 9, 1974.
6 Easley Hamner, interview with author, October 17, 2011; Diane Brown Harris, interview with author, October, 25, 2011.
7 Ralph Peterson, interview with author, October 11, 2011.
8 Ralph Peterson, interview with author, November 7, 2015.
9 Barbara Murphy, interview with author, October 15, 2011.
10 Ralph Peterson, interview with author, October 11, 2011.
11 Diamonstein, "The White Chapel."
12 Easley Hamner, interview with author, October 17, 2011.
13 Ralph Peterson, interview with author, October 11, 2011.
14 Diamonstein, "The White Chapel."
15 Saint Peter's Church, *Life at the Intersection* (New York: Development Task Force, 1971), 4–5.
16 Ibid., 10–11.
17 Ralph Peterson, interview with author, October 8, 2011.
18 Barbara Murphy, interview with author, October 15, 2011.
19 Ibid.; Easley Hamner, interview with author, October 17, 2011.
20 Easley Hamner, interview with author, October 17, 2011.

21 Ralph Peterson, interview with author, October 8, 2011.

22 Diamonstein, "The White Chapel."

23 Diane Loercher, "Nevelson's Pristine Chapel," *Christian Science Monitor*, December 19, 1977, 27.

24 Diamonstein, "The White Chapel."

25 Barbaralee Diamonstein, "Louise Nevelson: 'It Takes a Lot to Tango,'" *Art News*, May 1979, 72.

26 Henry J. Seldis, "Nevelson: A Door to Perception," *Los Angeles Times*, October 22, 1976, G1.

27 Hilton Kramer, "Nevelsons Enhance Chapel," *New York Times*, December 14, 1977.

28 Easley Hamner to Hilton Kramer, December 22, 1977; Saint Peter's Church archives, .

29 Diamonstein, "Louise Nevelson: 'It Takes a Lot to Tango.'"

30 Ralph Peterson left the church in 1980, only a few years after the completion of the chapel. His vision of the church as a center for cultural activities had outrun the congregation. Nevelson and he had a vision of liturgy as movement, and both saw the arts as a way to understand what it is to be human. The conservative congregation couldn't quite follow him. Though he felt that his work there was unfinished, his friendship with Nevelson endured, and she agreed to be the godmother of his son Christopher.

31 Laurie Wilson, essay in Louise Nevelson, *Louise Nevelson: Atmospheres and Environments* (New York: Whitney Museum of American Art with Clarkson N. Potter, 1980), 162–63.

32 Louise Nevelson, interview with author, August 8, 1979.

33 Munro, *Originals*, 132. See ch. 1 n50.

34 Robert Hughes, "Night and Silence, Who is There?," *Time*, December 12, 1977, 59–60.

35 Lila Harnett, "A Chapel for St. Peter's and a 'Palace' for Mrs. N: A Great Artist Creates Rooms for Posterity," *Cue*, December 10–23, 1977.

36 Hilton Kramer, "Art: A Nevelson Made to Last," *New York Times*, December 9, 1977.

37 Susan Nevelson, interview with author, March 4, 2013.

38 John S. Turcott, "Nevelson in Little Italy: The Artist as Godmother of a Community," *Villager*, May 25, 1978, 11.

39 Bill Katz, interview with author, December 14, 2012.

40 Turcott, "Nevelson in Little Italy," 11.

41 Diana MacKown, interview with author, July 11, 2010.

42 Louise Nevelson comments at the dedication of Louise Nevelson Plaza, September 14, 1978.

43 Arnold B. Glimcher, interview with author, June 13, 2011.

44 When the pear trees she selected at the Brooklyn Botanical Gardens arrived she worried that they would be too small. In time they grew so large that they obscured the sculpture, and, when the park was redesigned in 2006–7, the benches were changed, the sculpture rearranged, and new plantings installed. But the park was still "Louise Nevelson Plaza."

45 Stephen Forsling, "Shadows and Flags: Louise Nevelson Plaza," *Downtown*, November 1982.

46 Ibid.

47 Jan Ernst Adlmann, interview with Louise Nevelson, in Jan Ernst Adlmann et al., *Louise Nevelson: A Loan Exhibition* (Rockland, ME: William A. Farnsworth Library and Art Museum, 1979), 29; published in conjunction with the exhibition of the same name, shown at the Farnsworth Art Museum; Norton Gallery and School of Art, West Palm Beach, Florida; Jacksonville Art Museum, Jacksonville, Florida; Scottsdale Center for the Arts, Scottsdale, Arizona. This attention to the view from above was confirmed by Joyce Pomeroy Schwartz who played an active role in the project and by Donald Lippincott who observed that while she was making the aluminum sculptures at Lippincott she was looking down at the model.

48 Saul Wenegrat, "Public Art at the World Trade Center, in Sept 11th: Art Loss Damage and Repercussions, Proceedings of an IFAR Symposium," International Foundation for Art Research, February 28, 2002.

49 "Louise Nevelson Dedicates Her Sculpture at Trade Center," *New York Times*, December 13, 1978.

50 Kitty Carlisle Hart, speech, "Dedication of Plaque in Honor of Louise Nevelson, 1 World Trade Center," New York State Council on the Arts, December 12, 1978. N Archives, FAM

51 Emmett Meara, "Sculptor Louise Nevelson Resents Ostracism in Rockland as Youth," *Bangor Daily News*, June 15, 1978.

52 Marius B. Péladeau, interview with author, June 5, 2012

53 Ibid.

54 Marius B. Péladeau, e-mail to author, February 27, 2012; Marius B. Péladeau, interview with author, June 4–5, 2012.

55 Press release, "Louise Nevelson Doyenne of American Sculpture, Richard Gray Gallery, October 9, 1978."

56 Donald Lippincott, telephone interview with author, March 12, 2014.

57 Jo Ann Lewis, "Knockouts and Spellbinders Among a Wealth of Women," *Washington Post*, February 3, 1979.

58 Diamonstein, "Louise Nevelson 'It Takes a Lot to Tango,'" 72.

59 Jeffrey Hoffeld, interview with author, December 5, 2011. By January 2, 1978, Hoffeld had left the Neuberger Museum in Purchase, NY, and was co-director with Arne Glimcher at Pace Gallery from 1978 to 1983. He would play a continuing role in Nevelson's life and work, even after she died.

60 Proclamation by Rockland City Council, July 12, 1976, LN Papers, AAA.

61 Marius B. Péladeau, interview with author, June 4, 2012.

62 Jan Ernst Adlmann, interview with author, June 16, 2012.

63 Jan Ernst Adlmann, essay in *Louise Nevelson: A Loan Exhibition*, 31.

64 Adlmann, *Louise Nevelson: A Loan Exhibition*, 37.

65 Marius B. Péladeau, interview with author, June 4–5, 2012.

66 Diana MacKown, interview with author, January 23, 2011.

67 "Nevelson Exhibit Stirs Excitement," *Camden Herald*, September September, 1979.

68 Ivy Dodd, "Warm Welcome Home Given Sculptor Louise Nevelson," *Courier-Gazette*, July 14, 1979.

69 *Black Cat*, July 1979.

70 Robert Newall, "Nevelson 'Defies Time,'" *Bangor Daily News*, July 14–15, 1979.

71 Ibid., 10.

72 Meara, "Sculptor Louise Nevelson Resents Ostracism."

73 Ted Sylvester, "Fish 'n Chips," *Bangor Daily News*, July 14–15, 1979, 28.

74 Ibid.

75 Leslie Bennetts, "For Louise Nevelson, a Down-East Homecoming in Triumph," *New York Times*, July 16, 1979.

76 Ibid.

77 Ivy Dodd, "Langlais Pieces Present for Nevelson Sculpture Project," *Courier-Gazette*, July 14, 1979, 14.

78 Marius B. Péladeau to Louise Nevelson, September 25, 1979, N Archives, FAM.

79 Marius B. Péladeau, interview with author, June 4–5, 2012.

80 Ibid.

19. A BIG BIRTHDAY 1980–1985

1 Elizabeth Bumiller, "Louise Nevelson Breezes into 80," *Washington Post*, October 31, 1979, B6.

2 Laurie Wilson, "Louise Nevelson" in *Louise Nevelson: The Fourth Dimension* (Phoenix, AZ: Art Museum, 1980), 7–19; published in conjunction with the exhibition of the same name.

3 Between 1993 and 2010 Pace Gallery was Pace-Wildenstein during which time the two galleries operated jointly.

4 Initially intended for a gatefold of *Mrs. N's Palace* in *Atmospheres and Environments*, 1980, Frances Mulhall Achilles Library Archives, Whitney Museum of American Art.

5 Robert Hughes, "Tsarina of Total Immersion," *Time*, June 16, 1980.

6 Richard Roud, "A Very Freaky Lady Who Boxes Clever," *Guardian* (UK), August 1, 1980.

7 Edward Albee, introduction to *Louise Nevelson: Atmospheres and Environments*, by Louise Nevelson (New York: Whitney Museum of American Art with Clarkson N. Potter, 1980), 28–29. Full disclosure: the author wrote five essays for the catalogue.

8 Ibid., 30.

9 Soon after Nate was treated and his cancer arrested, Nevelson was moved to create a laboratory (Louise Nevelson Laboratory for Cancer Immunobiology) at Sloan Kettering which was aimed at defining and analyzing the cancer process so as to identify and destroy malignant cells to treat and prevent cancer.

10 Ann Cremin, "Contemporary Art from Around the World," *Irish Times*, November 19, 1981, 10.

11 Esther Garcia, *"International Herald Tribune*, November, 1981.

12 Bill Caldwell, "Rockland's Nevelson: Work of Art," *Portland Press Herald*, November 23, 1981.

13 Ibid.

14 "Louise Nevelson to be Honored by Bond's Manhattan Women," *Jewish Week American Examiner*, February 28, 1982, 14.

15 Joan Shepard, "At 82 She's Still Sympathetic to People Who Get Beat Up," *Daily News*, March 19, 1982.

16 The deal had been brokered by Richard Gray and Arnold Glimcher with the developers Paul Beitler and Lee Miglin.

17 Alan G. Artner, "Nevelson's Engaging 'Shadows'—Intimacy in Monumental Sculpture," *Chicago Tribune*, May 21, 1983.

18 "Nevelson Soars, Aldermen Sink," *Upfront Chicago*, July 1983.

19 Artner, "Nevelson's Engaging 'Shadows.'"

20 The show included thirteen black- and white-painted wood sculptures dating from the mid-1950s to 1981 and another eighteen works including seven collages and eleven works on paper from 1979–1982.

21 "Tokyo: Louise Nevelson," *L'Oeil*, no. 316 (November 1982): 88.

22 Paul Gardner, "Will Success Spoil Bob and Jim, Louise and Larry?" *Art News*, November 1982, 103.

23 Theodore F. Wolff, "American Art Is Doing Well—Although No New Big Ideas Are in Sight," *Christian Science Monitor*, May 31, 1983, 11.

24 "Louise Nevelson", *New York Times*, January 23, 1983

25 Eileen Putnam, "Louise Nevelson at 84: Profile of a Lady in Black," *Maine Sunday Telegram*, January 22, 1984.

26 The artist must have had a collection of such spools since they are featured in most of the *Cascades* series.

27 Ruth Bass, "Louise Nevelson," *Art News*, April 1983, 149–50.

28 Wolff, "American Art Is Doing Well—Although No New Big Ideas Are in Sight," 11.

29 Amei Wallach "An Unmatched Pair of Great Artists," *Newsday*, January 30, 1983.

30 Constance Schwartz, *Nevelson and O'Keefe: Independents of the 20th Century* (Roslyn Harbor, LI: Nassau County Museum of Fine Art, 1983), 16; published in conjunction with the exhibition of the same name.

31 Constance Schwartz to Louise Nevelson, March 18, 1983, LN Papers, AAA.

32 Nicholas Drake, "Nevelson: If You're an Artist You Don't Lose It," *Festival Times Daily*, May 23, 1983, 1, 6.

33 "Nevelson's World," *Umbrella*, January 1984.

34 Kelly Walton, "Louise Nevelson: In Black and White," *Scottsdale Daily Progress*, April 3, 1985, 34–35.

35 Suzanne Muchnic, "Matisse, Nevelson, Bosch and Bacon: art book bounty" *Los Angeles Times*, December 18, 1983, T4.

36 "Architectural Digest Visits Louise Nevelson," *Architectural Digest*, November 1983, 139.

37 Richard Gaddes, telephone interview with author, December 8, 2012.

38 An alternate story about Tobin, Nevelson, and Orfeo is told by Willy Eisenhart, "Foreword," in Christoph Willibald Gluck et al., *In Search of Orfeo* (New York: Bouwerie Editions, 1984). Eisenhart notes that Tobin spoke with Bill Katz in summer 1976 suggesting that Nevelson design the opera.

39 Richard Gaddes, telephone interview with author, December 8, 2012.

40 Ibid.

41 Willy Eisenhart, "Foreword," in *In Search of Orfeo*. 2.

42 Robert W. Duffy, "Louise Nevelson Lived In a Realm She Created Herself," *St. Louis Post-Dispatch*, April 24, 1988, 3E, 15E.

43 Robert LaRouche, "Nevelson's Set Pieces," *St. Louis Post-Dispatch*, June 9, 1984.

44 Duffy, "Louise Nevelson Lived In a Realm She Created Herself."

45 James Wierzbicki, "Sculptor Nevelson Boosts 'Orfeo,'" *St. Louis Globe-Democrat*, June 9–10, 1984, 9F.

46 John von Rhein, "'Orfeo,' 'Bunyan' Reverse Bad Luck of Opera Theatre," *Chicago Tribune*, July 1, 1984, Arts 21.

47 Leighton Kerner, "Sic Transit Gloriana," *Village Voice*, July 24, 1984.

48 John Rockwell, "Opera: Gluck's 'Orfeo' in St. Louis," *New York Times*, June 8, 1984.

49 Richard Gaddes, telephone interview with author, December 8, 2012.

50 Willy Eisenhart, "The Gifts: 1985; The Art of Nevelson at the Farnsworth," *Annual Report 1985* (Rockland, ME: William A. Farnsworth Library and Art Museum, 1985).

51 Richard Gaddes, telephone interview with author, December 8, 2012.

52 Bill Katz, telephone interview with author, December 7, 2012.

53 Richard Gaddes, telephone interview with author, December 8, 2012; Diana MacKown, telephone interview with author, December 15, 2012.

54 Richard Gaddes, telephone interview with author, December 8, 2012.

55 Ibid.

56 The agreement for the sculpture wasn't signed until August 1, 1983, and Storm King didn't pay for it until May 1984, when it was finished and installed. Information from Lippincott worksheet of hours spent on the sculpture.

57 From the video on the work at Storm King Art Center: *7 Modern Masters Reveal Their Creative Adventures, Sculptors at Storm King* ©1992. Bruce Basset Productions, licensed worldwide by Reiner Moritz Associates Ltd.

58 Don Lippincott, telephone interview with author, April 30, 2012.

59 Communication with Diana MacKown, April 15, 2009.

60 Cindy Adams, "Nevelson's nine floors of trash and treasures," *New York Post*, May 3, 1983, 32.

61 Arnold B. Glimcher, interview with author, March 25, 2011.

62 John Russell, "Profusion of Good Art by Women," *New York Times*, February 22, 1985, C1.

63 Douglas C. McGill, "Louise Nevelson Giving 25 Works to Museums," *New York Times*, March 18, 1985.

64 Micuda, "They Call Me Mother Courage: Louise Nevelson." See ch 15 n18.

65 Douglas C. McGill, "Louise Nevelson Giving 25 Works to Museums," *New York Times*, March 18, 1985.

66 Ibid.

67 Hunter Drohojowska, "At 85, Louise Nevelson Gets her Day in the L.A. Sun," *Los Angeles Herald Examiner*, June 24, 1985.

68 Kelly Walton, "Louise Nevelson: In Black and White," *Scottsdale Daily Progress*, April 3, 1985, 34–35.

69 Ibid.

70 Paul Gardner, "New York: Diana Was Always There," *Art News*, December 1990, 57–58.

71 "Louise Nevelson Talks to Joan Galway, Monumental Work With Thanks to No One," *Washington Post*, November 10, 1985, D3.

72 Judd Tully, "Taking Care of Diana," *Nation*, February 1990, 39.

73 Irvin Molotsky, "12 Are Named Winners of a New U.S. Arts Medal," *New York Times*, April 18, 1985.

74 Irvin Molotsky, "Reagan, Bestowing Medals Hails the Free Artist," *New York Times*, April 24, 1985, C14.

75 Ibid.

76 Sarah Booth Conroy, "The President's Medalists: Art's Night Out," *Washington Post*, April 23, 1985, E1.

77 Mary Battiata, "Saluting the Arts Medalists: Reagans Present First-Time Honors," *Washington Post*, April 24, 1985.

78 Rosenfield to Arnold B. Glimcher and Richard Solomon, December 20, 1984. Archives of the Fogg Museum, Harvard Art Museums.

79 Correspondence between Bok, Solomon, Rosenfeld and Glimcher, 1982–85, archives at the Fogg Museum, Harvard University Art Museums.

80 Fox Butterfield, "Volcker and Nevelson Honored by Harvard," *New York Times*, June 7, 1985, D18.

81 Suzanne Muchnic, "More Space for Sailing the Nevelson Legend," *Los Angeles Times*, June 21, 1985, F1.

82 Jody Jacobs, "Farewell to Gotham and Old Friends," *Los Angeles Times*, June 14, 1985, H4.

83 Suzanne Muchnic, "More Space for Sailing the Nevelson Legend," *Los Angeles Times*, June 21, 1985, F1.

84 Ibid.

85 Like Picasso and many other prolific artists, Nevelson reused elements she liked in different sculptures. *Night Sail* contains several such elements—some she had seen as recently as a few weeks earlier at Harvard, where one of the transparent sails and the snake-like vertical element can be found again in *Night Wall I*.

86 Drohojowska, "At 85, Louise Nevelson Gets Her Day in the L.A. Sun."

87 Beth Crichlow, "Nevelson Returns Home for 86th Birthday," *Camden Herald*, September 26, 1985, 8.

88 "Nevelson Gives Swatches of Fabric to Art Museum," *Bangor Daily News*, September 28–29, 1985, 23.

89 "Nevelson Donates Orfeo Fabric," *Camden Herald*, October 10, 1985.

90 Nevelson had been making jewelry for herself and a few friends to wear since the 1960s, but she had never created jewelry specifically for an exhibition. She designed the wood sculpture for the jewelry and had a craftsman cover certain segments or facets with gold or silver metallic overlay. The gold was a reflection both of the new jewels the artist had made for the exhibition, and the thrones from *Orfeo* which had been painted gold before she gave them to the Farnsworth.

91 Walter Griffin, "Rockland Recognizing Value of Nevelson's Art," *Bangor Daily News*, June 20, 1994.

92 "Louise Nevelson Talks to Joan Galway, Monumental Work With Thanks to No One," *Washington Post*, November 10, 1985, D3.

20. THE END 1985–1988

1 Iris Krasnow, "I'm impressed with what I do: That's living for me," United Press International, February 23, 1986.

2 Iris Krasnow, "Close Up: Louise Nevelson," *New Jersey Daily News*, March 23, 1986.

3 Krasnow, "I'm impressed with what I do: That's living for me," 3.

4 Ibid.

5 Ibid. Mike Nevelson stated affirmatively: "There is nothing between Diana and Louise Nevelson." Mike Nevelson, interview with author, April 11, 2014.

6 Krasnow, "I'm impressed with what I do: That's living for me"

7 Mike Nevelson, interview with author, April 11, 2014

8 Ibid.

9 Dorothy Rabinowitz, "The Art of the Feud," *New York*, September 25, 1989, 86.

10 Ibid.

11 Mike Nevelson, interview with author, April 11, 2014.

12 Marius B. Péladeau, correspondence with author, September 5, 2015. Interview with author June 5, 2012.

13 Louise and Diana made three or four trips on the Concorde, to Paris twice and London once. Diana MacKown, telephone interview with author, November 17, 2012.

14 Diana MacKown, telephone interview with author, December 15, 2012

15 Mary Blume, "Louise Nevelson in Paris: At 86, Finally Ready for Satin," *International Herald Tribune*, January 31, 1986.

16 Don Lippincott to Arnold B. Glimcher, June 3, 1986, AG Papers.

17 It had been started in April 1984, completed in October 1986 but was not sold until May 1988. It resides at the National Institutes of Health in Bethesda, Maryland.

18 Amei Wallach, "Sculpting a World to Her Vision," *Newsday*, August 1, 1986.

19 Carol Lawson, "The Evening Hours," *New York Times*, May 23, 1986.

20 Agnes Martin: New Paintings; Louise Nevelson: Mirror Shadows *The Pace Gallery Press Release* September, 1986

21 William Zimmer, "Art: 31 Works by Walter Murch Being Shown," *New York Times*, September 26, 1986.

22 Philip Eliasoph, "Leading Lady of Sculpture Puts on Show at Whitney," *Advocate* and *Greenwich Time,* January 18, 1987, D5.

23 Nevelson's first work to be acquired by the Whitney was *Black Majesty* in 1956. "One of the great joys is to know that the Whitney Museum has so much of my work." Louise Nevelson, essay in *Louise Nevelson: A Concentration of Works from the Permanent Collection of the Whitney Museum of American Art* (New York: Whitney Museum of American Art, 1987), 8. Published in conjunction with the exhibition of the same name.

24 Philip Eliasoph, "Leading Lady of sculpture puts on show at Whitney," *Advocate* and *Greenwich Time,* January 11, 1987, D5.

25 William Zimmer, "Works by Nevelson in Stamford," *New York Times,* January 18, 1987, 30.

26 Maureen Mullarkey, "A Medicine Show and Some Others," *Hudson Review* 40, no. 1 (Spring 1987): 109–11.

27 Louise Nevelson, "A Conversation with Barbaralee Diamonstein," in *Nevelson Maquettes for Monumental Sculpture,* May 2–27, 1980, at Pace Gallery.

28 Theodore F. Wolff, "Metropolitan Museum of Art Big Lift from a New Wing," *Christian Science Monitor,* February 2, 1987, 24.

29 Louise Nevelson, "Go Go Guggenheim," letter to the editor, *New York Times,* July 1, 1987.

30 Diana MacKown, telephone interview with author, December 15, 2012.

31 Emily Genauer, essay in *Louise Nevelson Remembered* (New York: Pace Gallery, 1989).

32 Emily Genauer, "Wooden Sculptures Lauded," *New York World-Telegram,* September 12, 1936.

33 Diana MacKown, telephone interview with author, December 15, 2012

34 Brendan Gill, "Remembering Cousin Louise," *Architectural Digest,* May 1990, 49.

35 Diana MacKown, telephone interview with author, December 9, 2012.

36 Emily Genauer, essay in *Louise Nevelson Remembered.*

37 Bill Katz, interview with author, December 14, 2012.

38 Maria Nevelson, telephone interview with author, December 13, 2012.

39 Ibid.

40 Diana MacKown, phone interview, December 9, 2012.

41 Arnold B. Glimcher, interview with author, June 11, 2012.

42 Arnold B. Glimcher, e-mail to author, November 24, 2015.

43 Diana MacKown, interview with author, November 22, 2015.

44 Rabinowitz, "The Art of the Feud," 90–91; Andrew L. Yarrow, "Nevelson Estate Is the Focus of a Battle," *New York Times,* June 10, 1989, 15.

45 Maria Nevelson, interview with author, October 30, 2013.

46 Rabinowitz, "The Art of the Feud," 90–91.

47 Maria Nevelson, interview with author, October 30, 2013.

48 Diana MacKown, interview with author, December 9, 2012; Bill Katz, interview with author, December 14, 2012.

49 Fay Gold, interview with author, April 13, 2010. Fay Gold recalled selecting Nevelson works for exhibitions at her gallery in Atlanta. The works were all stored in Mike Nevelson's barn in New Fairfield Connecticut.

50 Rabinowitz, "The Art of the Feud," 94.

51 Louise Nevelson, in "The Individualist," *Vogue,* June 1976. Joyce Pommeroy Schwartz, interview with author, February 5, 2012.

52 Mike Nevelson, interview with author, July 29, 1977.

53 Mike Nevelson, interview with author, April 11, 2014. Cf.

54 *New York Post,* December 9, 1972; *Newsday* 1973, June, 15, 1973; in *Particular Passions,* 75.

55 Some of them had been cast in 1985, and Nevelson had overseen the patina process. Bill Katz, interview with author, December 17, 2012

56 Rabinowitz, "The Art of the Feud," *New York,* September 25, 1989, 94.

57 Mike Nevelson, interview with author, April 11, 2014.

58 Ibid.

59 Ibid.

60 Yarrow, "Nevelson Estate Is the Focus of a Battle," 15.

61 Ibid.

62 Rabinowitz, "The Art of the Feud," 84.

63 Yarrow, "Nevelson Estate Is the Focus of a Battle," 15.

64 Rabinowitz "The Art of the Feud," 87.

65 Ibid., 84.

66 Ibid.

67 Ibid., 88.

68 Diana MacKown, interview with author, January 29, 2012.

69 Rabinowitz, "The Art of the Feud," 84.

70 Ibid.

71 Diana MacKown, interview with author, January 28, 2012.

72 Mike Nevelson, interview with author, April 11, 2014.

73 Yarrow, "Nevelson Estate Is the Focus of a Battle," 13.

74 Arnold B. Glimcher, interview with author, November 26, 2012 .

75 Estate of Louise Nevelson, deceased, Mike Nevelson, executor v. Commissioner of Internal Revenue, No. 7754-92 (U.S. Tax Court, 1996).

76 Ibid.

77 Estate of Louise Nevelson v. Carro, 686 N.Y.S.2d 404, 406 (1999).

78 Jeffrey Hoffeld, interview with author, December 5, 2011; Judd Tully, "Nevelson Estate Moves out of PaceWildenstein," *Art Newsletter*, June 11, 1996, 2.

79 Jeffrey Hoffeld, letter to Richard and Paul Gray, October 1, 2005.

80 Maria Nevelson, interview with author, December 11, 2012; Diana MacKown, interview with author, January 23, 2011.

81 Arnold B. Glimcher, interview with author, January 23, 2013.

82 Ibid.

83 Estate of Louise Nevelson v. Carro, 686 N.Y.S.2d 404, 406 (1999).

84 Diana MacKown, interview with author, September 19, 2009.

85 John Russell, "Louise Nevelson, Sculptor, Is Dead at 88," *New York Times*, April 19, 1988, D31.

86 Wayne, "Louise Nevelson 1899–1988: Goodbye Louise."

87 Grace Glueck, "Friends of Louise Nevelson Gather in a Memorial for the Late Artist," *New York Times*, October 18, 1988.

88 The remembrances by her friends were variously dated, depending upon when they were written.

89 John Russell, "Lean, Muscular Energies in Late Nevelson Sculptures," *New York Times*, April 7, 1989, C20.

90 Jean Lipman, essay in *Louise Nevelson Remembered* (New York: Pace Gallery, 1989).

91 Diana MacKown, essay in *Louise Nevelson Remembered* (New York: Pace Gallery, 1989).

92 Hilton Kramer, essay in *Louise Nevelson Remembered* (New York: Pace Gallery, 1989).

93 Barbaralee Diamonstein-Spielvogel, essay in *Louise Nevelson Remembered* (New York: Pace Gallery, 1989). In a recent interview with the author, Barbaralee added the second of the two reasons about how she managed to survive: "I was drunk a lot of the time." Barbaralee Diamonstein-Spielvogel, interview with author, October 25, 2013.

94 Arnold B. Glimcher essay in *Louise Nevelson Remembered* (New York: Pace Gallery, 1989).

SELECTED BIBLIOGRAPHY

Louise Nevelson papers, circa 1903–1979. Archives of American Art, Smithsonian Institution. This collection includes: original essays, poetry and statements by the artist; clippings; correspondence; exhibition announcement catalogues, and lists; oral history interviews; inventories; dealers' records; press releases; photographs and slides (art works and personal); and reviews.

Adams, Agnes. "Behind a One-Woman Art Show: Louise Nedelson's [Nevelson's] Revolt as a Pampered Wife." *New York Post*, October 16, 1941.

Adams, Cindy. "Nevelson's Nine Floors of Trash and Treasures." *New York Post*, May 3, 1983.

Albee, Edward. "The World is Beginning to Resemble Her Art." *Art News*, May 1980.

Albee, Edward, and Laurie Wilson. *Louise Nevelson: Atmospheres and Environments*. New York: C. N. Potter and Whitney Museum of American Art, 1980.

Albright, Thomas. "Art is a Conviction – A Way of Life." *San Francisco Chronicle*, February 25, 1977.

———. "San Francisco; Convulsive but Lyrical." *Art News*, May 1977.

Allen, Jane, and Derek Guthrie, "Black Marks for 'White on White.' " *Chicago Tribune*, January 9, 1972.

Alpert, Bill. "Artpages: The 'Great Lady of Sculpture' Charms Seattle." Linda Farris Gallery exhibition review. *Seattle Argus*, June 30, 1978.

Ameill, Anne. "Searcher for New Image 'Arrives' in Art World." *Denver Post*, December 20, 1959.

Ames, Katharine. "Gothic Queen." *Newsweek*, December 4, 1972.

Andreae, Christopher. "Nevelson's Little Boxes—Or Are They Big?" *Christian Science Monitor*, March 22, 1967.

Andrews, Bernadette. "Showing the World Art Is Everywhere." *Toronto Telegram*, October 19, 1968.

"Architectonic Assemblages." Pace Gallery exhibition review. *Progressive Architecture*, May 1965.

Arp, Jean. "Louise Nevelson." *XXe siècle* (June 1960).

Artner, Alan G. "Nevelson's Engaging 'Shadows'—Intimacy in Monumental Sculpture." *Chicago Tribune*, May 21, 1983.

Ashton, Dore. "About Art: Louise Nevelson Shows Wood Sculptures." *New York Times*, February 21, 1956.

———. "Art: Forest Sculptures." *New York Times*, January 8, 1957.

———. "Art: Worlds of Fantasy." *New York Times*, October 9, 1959.

———. "U.S.A.: Louise Nevelson." *Cimaise*, no. 48 (April–June 1960).

———. "Art." Review of *Royal Tides*. *Arts and Architecture*, June 1961.

———. "Art USA." *Studio*, March 1962.

———. "New York Letter." *Das Kunstwerk*, April 1963.

————. "Louise Nevelson." *Chroniques de l'Art Vivant*, no. 2 (May 1969).

————. *The New York School: A Cultural Reckoning.* New York: Viking Press, 1972.

Bader, Eleanor J. "Women Artists Still Face Discrimination." *Truthout News*, May 10, 2012.

Baker, Elizabeth. "Art and Sexual Politics." In Hess and Baker, eds., *Art and Sexual Politics: Women's Liberation, Women Artists, and Art History* q.v.

Baker, Kenneth. "Scavenged Materials Give Nevelson Reliefs a Lasting Quality." Hackett-Freedman Gallery exhibition review. *San Francisco Chronicle*, June 19, 2004.

Baldwin, C. R. "Louise Nevelson, la 'grande pretresse' de la sculpture Americaine." *Connaissance des Arts*, no. 266 (April 1974).

Baldwin, Sidney. "Louise Nevelson, Sculptress." *Peoria Morning Star*, September 5, 1957.

Baro, Gene. *Nevelson: The Prints.* New York: Pace Editions, 1974.

Barnes, Helen. "Recollections of Incident Here 65 Years Ago Led to Selection of Site for City Sculpture." *Courier-Gazette*, July 14, 1979.

Barotte, René. "Nevelson, le sculpteur qui va . . . au-delà." *France-Soir*, May 13, 1969.

Barr, Alfred H., Jr. *Cubism and Abstract Art.* 1936; repr., New York: Museum of Modern Art, 1974.

Bass, Ruth. "Louise Nevelson." *Art News*, April 1983

Baur, John. *Nature in Abstraction.* New York: Macmillan Company, 1958.

————. *Between the Fairs: 25 Years of American Art, 1939–1964.* Exh. cat. New York: Whitney Museum of American Art, 1964.

Battiata, Mary. "Saluting the Arts Medalists: Reagans Present First-Time Honors." *Washington Post*, April 24, 1985.

Beatty, Frances, Gilbert Brownstone, and Louise Nevelson. *Louise Nevelson: Centre national d'art contemporain.* Paris: Centre national d'art contemporain, 1974.

Bendol, Ben. "Art Events." *Aufbau*, January 15, 1943.

Bennetts, Leslie. "For Louise Nevelson, a Down-East Homecoming in Triumph." *New York Times*, July 16, 1979.

Berliner, David C. "Women Artists Today: How Are They Doing Vis-à-Vis the Men?" *Cosmopolitan*, October 1973.

Billeter, Erika. "Louise Nevelson." *Du* 41, no. 479 (1981).

Blesh, Rudi. *Modern Art USA: Men, Rebellion, Conquest, 1900–1956.* New York: Knopf, 1956.

Blume, Mary. "Louise Nevelson in Paris: At 86, Finally Ready for Satin." *International Herald Tribune*, January 31, 1986.

Bober, Natalie S. *Breaking Tradition: The Story of Louise Nevelson.* New York: Atheneum, 1984.

Bongartz, Roy. "Where the Monumental Sculptors Go." *Art News*, February 1976.

————. " 'I Don't Want to Waste Time,' Says Louise Nevelson at 70." *New York Times Magazine*, January 24, 1971.

Boroff, Philip. "Art World Bias by the Numbers." *Artnet News*, September 16, 2014.

Boswell, Peyton. "Nierendorf: Scholar-Dealer." *Art Digest* 22 (November 1, 1947).

Botto, Louis. "Work in Progress: Louise Nevelson." *Intellectual Digest* 2, no. 8 (April 1972).

Brackert, Gisela. "Louise Nevelson." *Kunstwerk*, February 1961.

Brantley, Ben. "Resurrecting an Artist's Greatest Creation: Herself." *New York Times*, June 6, 2008.

Brenson, Michael. "Art: 100 Modern Sculptures at Storm King Center." *New York Times*, March 18, 1983.

————. "Sculptors Find New Ways With Wood." *New York Times*, December 2, 1984.

Broad, Harry A. "Louise Nevelson: Grande Dame of American Sculpture." *Art and Activities*, April 1981.

Brown, Barbra. "PW Interviews: Louise Nevelson." *Publisher's Weekly*, December 16, 1983.

Brown, Irving. *Gypsy Fires in America: A Narrative of Life Among the Romanies of the United States and Canada.* New York: Harper, 1924.

Budick, Ariella. "Larger than Life: A Show at the Jewish Museum Allows the Life's Work of Louise Nevelson to Outshine the Sculptor's Brilliant Persona." *Newsday*, May 6, 2007.

Bumiller, Elizabeth. "Louise Nevelson Breezes into 80." *Washington Post*, October 31, 1979

Burkhardt, Edith. "The Unfinished Cathedral and Antoni Gaudi." *Art News*. January 1958.

Burnham, Sophy. "Portrait of the Artist as a Woman." *New Woman*, June 1990.

Burrows, Carlyle. "Notes and Comment on Events in Art." *New York Herald Tribune*. September 28, 1941.

———. "Group of Sculptors." *Herald Tribune,* January 10, 1953.

———. "Organized Sculpture." *New York Herald Tribune,* February 26, 1956.

Butterfield, Fox. "Volcker and Nevelson Honored by Harvard." *New York Times,* June 7, 1985.

Cain, Michael. *Louise Nevelson.* American Women of Achievement. New York: Chelsea House Publishers, 1989.

Caldwell, Bill. "Rockland's Nevelson: Work of Art." *Portland Press Herald,* November 23, 1981.

Calhoun, Charles. "Nevelson: Teaching Us Fine Art of Survival." *Palm Beach Post-Times,* November 10, 1979.

Campbell, Lawrence. "Louise Nevelson." *Art News,* December 1972.

Campbell, R. M. "Louise Nevelson's Extraordinary Work." Review of Nevelson exhibit at Linda Farris Gallery. *Seattle Post-Intelligencer,* June 30, 1978.

Canaday, John. "Tenth Street." *New York Times,* January 17, 1960.

———. "Whither Art?" *New York Times,* March 26, 1961.

———. "Display at Pace Gallery Called Her Best Yet." *New York Times,* November 21, 1964.

———. "Louise Nevelson Puts Green Thumb to Good Use." *New York Times,* May 14, 1966.

———. "Art: Moore and Nevelson Sculpture in Retrospect." *New York Times,* March 9, 1967.

———. "Louise Nevelson and the Rule Book." *New York Times,* April 6, 1969.

———. "Tribute to Louise Nevelson on the Occasion of the Award of the Edward MacDowell Medal" (August 24, 1969). *The MacDowell Colony: Report for 1969.* Peterborough, NH: MacDowell Colony, 1969.

———. "Art: Nevelson's '7th Decade Garden'; Group of 12 Sculptures Shown at the Pace." *New York Times.* May 8, 1971.

Carluccio, Luigi. *Nevelson: 76.* Turin, Italy: Galatea-Galleria d'Arte Comtemporanea, 1964.

Caro, Anthony, et al. *A Selection of Works by Caro, Hull, Nevelson, Nicholson, Pomodoro, Rickey: Sigrid Freundorfer Fine Art.* Exh. cat. New York, N.Y: Sigrid Freundorfer, 1987.

Casadio, Mariuccia. "Creation Is Living: Louise Nevelson." *Casa Vogue,* October 2006.

Cavaliere, Barbara. "Louise Nevelson." *Arts Magazine* 52, no. 6 (February 1978).

———. "Sculpture in the Age of Painting, 1943–57." *Arts Magazine,* October 1979.

Celant, Germano. *Louise Nevelson.* Milan: Fratelli Fabbri Editori, 1973.

———. *Louise Nevelson.* Milan: Edizioni Charta, 1994.

Choay, Françoise. "Paris." *Arts Magazine,* January 1961.

Cimaise, Jean. "Une Galerie Americaine." Galerie Isy Brachot exhibition review. *Le Drapeau Rouge,* June 10, 1980.

Clinton, Audrey. "Sculpturing Success Carved from Scrapes." *Newsday,* July 13, 1965.

Coates, Robert M. "Art Galleries." *New Yorker,* October 14, 1944.

———. "The Art Galleries: Louise Nevelson." *New Yorker,* December 5, 1964.

———. "Sculpture at the Whitney." *New Yorker,* January 7, 1967.

Coffin, Patricia. "Louise Nevelson, *Artiste solitaire.*" *Single* 1, no. 4 (November 1973).

Cohen, Mark Daniel. "Louise Nevelson: Structures Evolving." *Review,* May 15, 1998.

Cohen, R. H. "Paper Routes." *Art News.* October 1983.

Cohen, Ted. "Sculptor Is Stunning and Family Stunned." *Beacon: The Boston Herald America,* February 20, 1977.

Colby, Joy Hakanson. "'A Love Affair' with Sculpture." *Detroit News,* July 1, 1979.

Conroy, Sarah Booth "Nevelson at Eighty." *Horizon* 23, no. 3 (March 1980).

Constable, Rosalind. "Martha Jackson: An Appreciation." *Arts Magazine,* September/October 1969.

Cook, Greg. "Poet of Darkness: Recreating Louise Nevelson's '50s Midnight Exhibits." Davis Museum exhibition review. *Artery,* March 19, 2013.

Coutts-Smith, Kenneth. "Nevelson: Hanover Gallery." *Arts Review,* November 16–30, 1963.

Cremin, Ann. "Contemporary Art from Around the World." Galerie de France exhibition review. *Irish Times,* November 19, 1981.

Crichlow, Beth. "Nevelson Returns Home for 86th Birthday." *Camden Herald,* September 26, 1985.

Cuccio, Angela. "The Rebel Sculptor." *Women's Wear Daily,* December 21, 1967.

Cullinan, Helen. "A Place of Peace." *Cleveland Plain Dealer,* November 9, 1978.

Culver, Charles. "Sight and Sound; Louise Nevelson: Art and the Machine." *Detroit Free Press,* October 23, 1966.

Cutler, Carol. "Art in Paris Trumpets for Nevelson, Kalinowski." *International Herald Tribune*, May 3–4, 1969.

Dannatt, Adrian. "Louise Nevelson: Sculpture, the 50s and 60s PaceWildenstein." *Art Newspaper* 124 (April 2002).

Danto, G. "What Becomes an Artist Most." *Art News*, November 1987.

Dault, Gary Michael. "Sous Toronto: Preliminaries – A Critical Notebook II." *Artscanada* 25, no. 5 (December 1968).

Davis, L. R. "American Wood Sculpture." *Studio* 108, no. 501 (December 1934).

Dawson, Jessica. "Louise Nevelson, Finding Her Way." *Washington Post*, October 7, 2004.

Devree, Howard. "American Water-Colors and Other Exhibitions." Review of Nevelson exhibit at the A.C.A. Gallery. *New York Times*, September 13, 1936.

———. "Sculptors and Others." *New York Times*, March 10, 1940.

———. "The Reviewer's Notebook: New Shows." *New York Times*, September 28, 1941.

———. "Modern Sculpture. *New York Times*, October 11, 1942.

———. "A Reviewer's Notes." *New York Times*, October 29, 1944.

———. "Groups and Singly." *New York Times*, May 24, 1953.

———. "Round-Up and Solo" *New York Times*, October 18, 1953.

Diamonstein, Barbaralee. "Caro, de Kooning, Indiana, Lichtenstein, Motherwell and Nevelson on Picasso's Influence." *Art News*, April 1974.

———. "Louise Nevelson at 75: 'I've Never Yet Stopped Digging Daily for What Life Is All About.' " *Art News*, October 1974.

———. "The White Chapel." *Ladies Home Journal*, December 1977.

———. "Louise Nevelson: 'It Takes a Lot to Tango'." *Art News*, May 1979.

———. *Inside New York's Art World*. New York: Rizzoli, 1979.

Dickenson, Edwin, interview with Dorothy Gees Seckler. "The Art Students League: Part I." *Archives of American Art Journal* 13, no. 1 (1973).

Diehl, Carol. "Breaking the Rules: James Rosenquist, Louise Nevelson, George Segal and Nam June Paik on Their Personal Moments of Discovery." *Arts and Antiques*, April 1988.

———. "The World of Mrs. N." Jewish Museum exhibition review. *Art in America*, January 2008.

Documenta III. Exh. cat. Cologne: M. DuMont Schauberg, 1964.

Dodd, Ivy. "Thorndike's Louise Nevelson Room Pays Tribute to Rockland Artist." *Courier-Gazette*, April 25, 1974.

———. "Warm Welcome Home Given Sculptor Louise Nevelson." *Courier-Gazette*, July 14, 1979.

Driver, Morley. "A Strange Wall, One You Can't Get Over Easily." *Detroit Free Press*, May 29, 1966.

Drohojowska, Hunter. "At 85, Louise Nevelson Gets Her Day in the L.A. Sun." *Los Angeles Herald Examiner*, June 24, 1985.

Drohojowska-Philp, Hunter. "Still Making Things Happen." *Los Angeles Times*, September 17, 1995.

Dudar, Helen. "The Eyes Can Touch, Too." *New York Post*, December 9, 1972.

Duffy, Robert W. "Louise Nevelson Lived In a Realm She Created Herself." *St Louis Post-Dispatch*, April 24, 1988.

Eichel, Larry. "Praise from First Lady." *Philadelphia Enquirer*, January 14, 1976.

Eisenhart, Willy. *The Gifts: 1985; The Art of Nevelson at the Farnsworth*. Exh. cat. Rockland, ME: Farnsworth Library and Art Museum, 1985.

Eliasoph, Philip. "Leading Lady of Sculpture Puts on Show at Whitney." *Advocate* and *Greenwich Time*, January 18, 1987.

Engels, Mary. "Architect of Reflection." *New York Daily News*, January 8, 1970.

Ernst, Jimmy. *A Not-So-Still Life*. New York: Pushcart Press, 1984.

Esplund, Lance. "Museums: Beyond the Box." Review of Nevelson exhibit at the Jewish Museum. *New York Sun*, May 3, 2007.

Forman, Nessa. "New Nevelson Sculpture Man's Art Grows Beside Nature's." *Philadelphia Sunday Bulletin*, May 23, 1971.

———. "1st Lady Throws the Switch." *Bulletin*, January 1976.

Forsling, Stephen. "Shadows and Flags: Louise Nevelson Plaza." *Downtown*, November 1982.

Fosburgh, Lacey. "A Special S.F. Greeting for Sculptor." *Los Angeles Times*, February 3, 1974.

Foshee, Rufus. "Louise Nevelson: The Long Road to Acceptance." *Camden Herald*, July 14, 1994.

———. "Louise Nevelson: The Magical Decade: 1958–1968." *Free Press*, January 21, 1999.

Foster, Ann T. "Louise Nevelson's Worship Environment for St. Peter's Church: A Transformative Space." *Arts: The Arts in Religious and Theological Studies* 11, no. 2 (1999).

Francouer, George. "Detroit." *Art News*, October 1966.

Friedman, Martin. *Nevelson: Wood Sculptures.* New York: Dutton, 1973.

Freed, Eleanor. "The Queen of Parts." *Houston Post*, October 26, 1969.

Freud, Sigmund. *The Standard Edition of the Complete Psychological Works of Sigmund Freud.* 24 vols. London: Hogarth Press, 1953–74.

Garcia, Esther. "Nevelson, the Old Master at 80." *International Herald Tribune*, October 1981.

Gardner, Paul. "Will Success Spoil Bob and Jim, Louise and Larry?" *Art News*, November 1982.

———. "New York: Diana Was Always There." *Art News*, December 1990.

Genauer, Emily. "Wooden Sculptures Lauded." Nevelson exhibit. *New York World-Telegram.* September 12, 1936.

———. Review of Nevelson exhibit. *New York World Telegram.* October 28, 1936.

———. "The Nierendorf Exhibit." *New York World-Telegram*, September 27, 1941.

———. "Nevelson Exhibit." Review. *New York Herald Tribune.* January 15, 1955.

———. "Abstract Art with Meaning: Another World." *Herald Tribune.* January 5, 1958.

———. "Rouault as Mirror And Prophet." *New York Herald Tribune*, November 22, 1964.

———. "A Scavenger's Black Magic." *New York World Journal Tribune.* March 12, 1967.

———. "Art and the Artist." *New York Post*, October 18, 1969.

———. "Art and the Artist." *New York Post*, December 23, 1972.

———. "Art and the Artist." *New York Post,* January 17, 1976.

Gendel, Milton. "The Venice Bazaar." *Art News*, September 1962.

Gent, George. "Park Ave. Gets a Nevelson Sculpture." *New York Times,* January 27, 1971.

———. "Sculptor Thanks the City in Steel." *New York Times*, December 15, 1972

Getlein, Frank. *Chaim Gross.* New York: Harry N. Abrams, 1974.

Gibson, Michael. "Paris: Fifteen American Artists." *International Herald Tribune,* January 5, 1974.

Gilbert, Lynn, and Gaylen Moore. *Particular Passions: Talks with Women Who Have Shaped Our Times.* New York: Clarkson N. Potter, 1981.

Gill, Berniece. "Brush Strokes." *Portland Sunday Telegram*, May 10, 1959.

Gill, Brendan. "Remembering Cousin Louise." *Architectural Digest*, May 1990.

Glimcher, Arnold B. *Louise Nevelson.* New York: Praeger, 1972.

———. *Louise Nevelson.* 2nd rev. ed. 1972. New York: E. P. Dutton, 1976.

Glimcher, Mildred, ed. *Adventures in Art: 40 Years at Pace.* Milan: Leonardo International, 2001.

Glueck, Grace. "No Little Flowers, Please." Review of exhibition at Whitney Museum of American Art. *New York Times*, March 12, 1967.

———. "A New Breed is Dealing in Art." *New York Times*, December 16, 1968.

———. "Hanging Henry's Show." *New York Times*, August 3, 1969.

———. "Deflecting Henry's Show." *New York Times*, October 19, 1969.

———. "Juilliard Unveils a Wall Sculptured by Nevelson." *New York Times*, December 19, 1969.

———. "Art Notes: The Ladies Flex Their Brushes." *New York Times*, May 30, 1971.

———. "Art People." *New York Times,* January 21, 1977.

———. "The 20th-Century Artists Most Admired by Other Artists." *Art News*, November 1977.

———. "Art: Whitney Turns Into Nevelson Land." *New York Times,* June 6, 1980.

———. "Friends of Louise Nevelson Gather in a Memorial for the Late Artist." *New York Times*, October 18, 1988.

Goldberg, Paul. "Atrium Renewal, Adding Art Chases Away Most of the Zen." *New York Times*, December 17, 1995.

Goldstein, Judith S. *Crossing Lines: Histories of Jews and Gentiles in Three Communities.* New York: William Morrow, 1992.

Goodman, Cynthia. "Frederick Kiesler: Designs for Peggy Guggenheim's Art of This Century Gallery." *Arts Magazine.* June 1977.

Gordon, John. *Louise Nevelson.* Whitney Retrospective. New York: Praeger, 1967.

———. Alexander Calder / Louise Nevelson / David Smith. Exh. cat. Palm Beach, Florida: Society of the Four Arts, 1971.

Gratz, Roberta Brandes. "Building Empires." *New York Post*, March 8, 1967.

Griffin, Walter. "Rockland Recognizing Value of Nevelson's Art." *Bangor Daily News,* June 20, 1994.

Gruber, Terry de Roy. "Louise Nevelson: A Twentieth Century Journey of Achievement." *Flight Time*, August 1977.

Gruen, John. "Art in New York: Silent Emanations." *New York*, April 14, 1969.

Grunwald, Beverly. "Getting Around." *Women's Wear Daily*, November 18, 1976.

Guggenheim, Peggy. *Out of This Century: The Informal Memoirs of Peggy Guggenheim*. New York: Dial Press, 1946.

Habasque, Guy. "La XXXIe Biennale de Venise." *L'Oeil*, September 1962.

Haenlein, Joy L. "No Longer Is Fame Fleeting for Louise Nevelson." *Advocate and Greenwich Times*, January 11, 1987.

Hakanson, Joy. "Museum Speaker is Unique in her Personality and Art." *Detroit News*, June 1966.

Hammel, Lisa. "Louise Nevelson Has a Plan for Living: A House That Is One Large Sculpture." *New York Times*, April 28, 1967.

Harnett, Lila. "A Chapel for St. Peter's and a 'Palace' for Mrs. N: A Great Artist Creates Rooms for Posterity." *Cue*, December 10–23, 1977.

Henderson, Linda. *The Fourth Dimension and Non-Euclidean Geometry in Modern Art*. Princeton, NJ: Princeton University Press, 1983.

Henning, E. B. "Sky Cathedral–Moon Garden Wall by Louise Nevelson." *Bulletin of the Cleveland Museum of Art* 64, no. 7 (September 1977).

Hess, Thomas B. "U.S. Art. Notes from 1960." Review of *16 Americans* exhibit. *Art News* (January 1960).

Hess, Thomas B., and Elizabeth C. Baker, eds. *Art and Sexual Politics: Women's Liberation, Women Artists, and Art History*. Rev. ed. 1971; New York: Collier Books, 1975.

Hobbs, Robert C. "Louise Nevelson: A Place That Is an Essence." *Woman's Art Journal* 1, no. 1 (Spring/Summer 1980).

Hoffeld, Jeffrey. *Nevelson at Purchase: The Metal Sculptures*. Purchase, NY: Neuberger Museum of Art, SUNY, Purchase College, 1977.

Hofmann, Hans. "Art in America." *Art Digest*, August 1930.

———. *Search for the Real*, ed. Sara T. Weeks and Bartlett H. Hayes, Jr. Rev. ed.; Cambridge, MA: M.I.T. Press, 1967.

Holmes, Ann. "Nevelson at Museum Sculptural Incantation." *Houston Chronicle*, October 26, 1969.

Howe, Irving. *World of Our Fathers: The Journey of the East European Jews to America and the Life They Found and Made*. New York and London: Harcourt Brace Jovanovich, 1989.

Hughes, Robert. "Night and Silence, Who is There?" *Time*, December 12, 1977.

———. "Tsarina of Total Immersion." *Time*, June 16, 1980.

———. "Sculpture's Queen Bee." *Time*, January 12, 1981.

Hunter, C. Bruce. *A Guide to Ancient Maya Ruins*. Norman: University of Oklahoma Press, 1976.

Hunter, Sam. "Public Sculpture." *National Arts Guide* 2, no. 3 (May/June 1980).

Hurlburt, Roger. "Sculpture Exhibit Demonstrates Best of America's Own." *Sun-Sentinel*, February 27, 1991.

Hutchinson, Peter. " New York: Totemic Abstraction." *Art and Artists*, May 1962, 30–31.

Imperatore, Catherine. "From the Collection: Louise Nevelson's White Column." *Women in the Arts* 20, no. 4 (Holiday 2002).

Iovine, Julie V. "Animal Instincts." *Art and Auction*, December 2006.

Isaacson, Philip. "Louise Nevelson At 67." *Portland Sunday Telegram*, May 21, 1967.

Jacks, Shirley. "Louise Nevelson: The Art World Royal from Rockland." *Maine Sunday Telegram*, April 24 1988.

Jacobs, Jody. "Farewell to Gotham and Old Friends." *Los Angeles Times*, June 14, 1985

Janis, Harriet, and Rudi Blesh. *Collage: Personalities, Concepts, Techniques*. Philadelphia: Chilton, 1962.

Jewell, Edward Alden. "31 Women Artists Show Their Work." *New York Times*, January 6, 1943.

———. "Comment in Miniature." *New York Times*, April 18, 1943.

———. "Art World Victim of Circus Fever." *New York Times*, April 23, 1943.

Johnson, Patricia C. "Nevelson Leaves a Legacy of Monumental Sculptures." *Houston Chronicle*, April 19, 1988.

Jones, Alan. "At Home with the Improbable: Reading Louise Nevelson." *Arts Magazine* 64 (November 1989).

Kelemen, Paul. "America's Middle Ages Seen Anew." *Art News*, March 1944.

Kerner, Leighton. "'Sic Transit Gloriana.'" *Village Voice*, July 24, 1984.

Kerrigan, Anthony. "Gaudianism in Catalonia." *Arts*, December 1957.

Kiji, Kegoro. "Louise Nevelson: Her Works and World." *Hokkaido Shimbun*, March 25, 1975.

Kimmelman, Michael. "Provocative Exhibitions at Museums and Galleries That Are Near New York City." Whitney Museum of American Art's Stamford, Connecticut Branch. *New York Times*, August 5, 1988.

Kingsley, April. "Louise Nevelson, Pace Gallery." *Artforum*, February 1973.

———. "New York: The 'Primitive' and Some Recent Sculpture." Pace Gallery exhibition review. *Burlington Magazine* 131, no. 1036 (July 1989).

Kleiman, Carol. "Mastering the Art of Being Louise Nevelson." *Chicago Tribune*, October 29, 1978.

Klein, Michael. "Louise Nevelson: Sculpture and Drawing from the 1940s." *Sculpture*, March 1999.

Kozloff, Max. "The Further Adventures of American Sculpture." *Arts Magazine* 39 (February 1965).

Krainak, P. "Art in Urban Spaces." *Inland Architect* 27, no. 4 (July/August 1983).

Kramer, Hilton. "Month in Review." *Arts*, January 1957.

———. "Art." *Nation*, January 26, 1963.

———. Sculpture of Louise Nevelson. Exh. cat. Chicago: Devorah Sherman Gallery, 1960.

———. "Sculpture of Louise Nevelson." *Arts Magazine* 32, no. 9 (June 1958).

———. "A Triumph of Constructivism." Pace Gallery. *New York Times*, January 28, 1968.

———. "Can We Place Them with Matisse and Brancusi?" *New York Times*, June 22, 1969.

———. "Ascendancy of American Art." *New York Times*, October 18, 1969.

———. "A Modish Revision of History." *New York Times*, October 19, 1969.

———. "Episodes from the Sixties." *Art in America* 58, no. 1 (January/February 1970).

———. "Art: Nevelson Still Shines." Review of Nevelson exhibit at the Pace Gallery. *New York Times*, May 11, 1974.

———. "Nevelson Sculptures Weave a Magic Spell." Pace Gallery. *New York Times*, February 18, 1976.

———. "US Boycott Vexes French." *New York Times*, January 27, 1977.

———. "Art View: Sculpture–From Boring to Brilliant." Neuberger Museum. *New York Times*, May 15, 1977.

———. "Art: A Nevelson Made to Last." PaceWildenstein. *New York Times*, December 9, 1977.

———. "Nevelsons Enhance Chapel." *New York Times*, December 14, 1977.

———. "Art View: Nevelson's Dazzling Feats." Pace Gallery. *New York Times*, May 11, 1980.

———. "Nevelson: Her Sculpture Changed the Way We Look at Things." *New York Times Magazine*, October 30, 1983.

———. "The Sculpture of Louise Nevelson." *Dialogue*, April 1984.

Krasnow, Iris. "Close Up: Louise Nevelson." *New Jersey Daily News*, March 23, 1986.

Krebs, Betty Dietz. "New Logic for Nevelson." *Dayton Daily News*, May 25 1969.

Kreisberg, Luisa. "A Crop of Nevelsons Picked for Purchase; Nevelsons on Way." *New York Times*, May 1, 1977.

Krishnamurti, Jiddu. *Total Freedom: The Essential Krishnamurti*. San Francisco: Harper Collins, 1996.

Kroll, Jack. "Louise Nevelson." Reviews and Previews. *Art News*, May 1961.

Lacoste, Michel Conil. "Nevelson's immaculate bric a brac." *Le Monde*, June 11, 1969

Lanes, Jerrold. "New York: Louise Nevelson." Review of Nevelson exhibit at Martha Jackson Gallery. *Artforum* 8, no. 6 (February 1970).

Langley, William. "Maine in the Days of the Klan." *Portland Sunday Telegram*, February 2, 1969.

LaRouche, Robert. "Nevelson's Set Pieces." *St. Louis Post-Dispatch*, June 9, 1984.

Lawson, Carol. "The Evening Hours." *New York Times*, May 23, 1986.

Lebel, R. "L'irruption des femmes dans la sculpture." *XXe Siècle* (June 1968).

Levin, Gail. "Forgotten Fame." In *Theresa Bernstein: A Century in Art*, ed. Gail Levin. Lincoln: University of Nebraska Press, 2013.

Lewis, Jo Ann. "Knockouts and Spellbinders Among a Wealth of Women." *Washington Post*, February 3, 1979.

Lichtblau, John H. Review of *Murder and Mystery; Crime Without Punishment: The Secret Soviet Terror Against America*, by Guenther Reinhardt. *New York Times*, November 9, 1952.

Lipman, Jean. *Nevelson's World*. New York: Hudson Hills Press in association with Whitney Museum of American Art, 1983.

————. "Recalled Encounters: Memorable Meetings with Artists and Collectors." *Archives of American Art Journal* 31, no. 1 (1991).

Lippincott, Jonathan D. *Large Scale: Fabricating Sculpture in the 1960s and 1970s.* New York: Princeton Architectural Press, 2010.

Lisle, Laurie. *Louise Nevelson: A Passionate Life.* New York: Summit Books, 1990.

Loercher, Diane. "Nevelson's Pristine Chapel." *Christian Science Monitor,* December 19, 1977

Lorber, Richard. "Women Artists on Women in Art." *Portfolio* 2, no. 1 (February/March 1980).

M., W. "Louise Nevelson at Whitney Museum." *Arts Magazine* 45, no. 3 (December/January 1971).

Mahlow, Dietrich. *Louise Nevelson.* Exh. cat. Baden-Baden: Staatliche Kunsthalle, 1961.

Maine, Stephen. "Arts and Letters: Welcome to the Junkyard." Review of Nevelson exhibit at the PaceWildenstein. *New York Sun,* July 19, 2007.

Makler, Paul Todd. *Prometheus (Bound): Prometheus No.'s 1 to 33, 1961 to 1972.* Philadelphia: Makler Gallery, 1972

Marchiori, G. "La XXXIe Biennale de Venise." *XXe Siècle* (December 1962).

Marconi, Giorgio. Autobiografia di una galleria: Lo Studio Marconi 1965/1992. Milan: Fondazione Marconi, 2004.

Marshall, R. *50 New York Artists, a Critical Selection of Painters and Sculptors Working in New York.* San Francisco: Chronicle Books, 1986.

Mathieu, Georges. *Exposition de Louise Nevelson, Sculpteur.* Exh. cat. Paris: Galerie Daniel Cordier, 1960.

Matloff, Judith. "Visiting Artist Louise Nevelson Discusses Sculpture and Life." *Harvard Crimson,* April 1, 1977.

Maudslay, Alfred P. *Archæology. Biologia Centrali-Americana,* 6 vols. London: R. H. Porter, 1899–1902.

Mazer, Gwen. "Lifestyle." *Harper's Bazaar,* April 1, 1972.

McAvoy, Suzette Lane. "Louise Nevelson: Farnsworth Collection." *American Art Review* 6, no. 5 (October–November 1994).

McBride, Henry. "Women Surrealists, They, Too, Know How to Make your Hair Stand on End." *New York Sun,* January 9, 1943.

McCoy, Garnett. "Poverty, Politics and Artists." *Art in America,* August/September 1965.

McCracken, David. "Nevelson's Legacy." *Chicago Tribune,* October 13, 1989.

McDonagh, Don. *Complete Guide to Modern Dance.* Garden City, NY: Doubleday, 1976.

McDonald, Gregory. "She Takes the Commonplace and Exalts It." *Boston Globe,* September 10, 1967.

McFadden, Elizabeth. "Master Industrial Craftsmen Playing Vital Part in New Renaissance Art." *Newark Sunday News,* April 9, 1967.

McGill, Douglas C. "Louise Nevelson Giving 25 Works to Museums." *New York Times,* March 18, 1985.

McNeil, George, interview with Irving Sandler. "The Art Students League Part II." *Archives of American Art Journal* 13, no. 2 (1973).

Meara, Emmet. "Sculptor Louise Nevelson Resents Ostracism in Rockland as Youth." *Bangor Daily News,* June 15, 1978.

————. "Former Rockland Artist Ignited 'Quite a Furor.'" *Bangor Daily News,* January 6, 2007.

Mellow, James R. "In the Galleries: Personages at Sea." *Arts,* February 1956, 52.

————. "Sculpture Swings to a New Industrial Look." *Industrial Design,* March 1967.

————. "New York Letter." *Art International,* Summer 1969.

Melville, Robert. "Exhibitions: The Venice Biennale." *Architectural Review,* October 1962.

Meyner, Helen. "I Want People to See That Art Is Everywhere." *Newark Star-Ledger,* March 30, 1967.

Michelson, Annette. "The Venice Biennale." *Arts Magazine,* October 1962.

Micuda, Jean. "Louise Nevelson, They Call Me Mother Courage." *Arizona Living,* March 17, 1972.

Miller, Alec. "Sculpture in Wood." *American Magazine of Art* 21, no. 6 (June 1930).

Miller, Dorothy C., ed. *Sixteen Americans.* Exh. cat. New York: Museum of Modern Art, 1959.

Mock, J. Y. "Louise Nevelson." *Apollo,* December 1960.

Moholy, Lucia. "Switzerland." Review of Nevelson exhibit at Gimpel Hanover in Zurich. *Burlington Magazine* 106, no. 732 (March 1964).

Molotsky, Irvin. "Reagan, Bestowing Medals, Hails the Free Artist." *New York Times,* April 24, 1985.

Monumenta: A Biennial Exhibition of Outdoor Sculpture. Exhibition catalogue. Text by Sam Hunter. Newport, RI: Monumenta Newport, 1974.

Morgan, Ann Lee. "A Chicago Letter: Louise Nevelson." Review of Nevelson exhibit at Richard Gray Gallery. *Art International* 25, nos. 9–10 (November–December 1982).

Morley, Sylvanus G. *Guidebook to the Ruins of Quirigua.* Washington, D.C.: Carnegie Institute of Washington, 1935.

Morrison, Don. "Nevelson's Art Started in a Gutter." *Minneapolis Star,* November 8, 1973.

———. "Discarded Wood Transformed into Art." *Minneapolis Star,* November 15, 1973.

Morrison, Harriet. "From an Abstract Environment." *New York Herald Tribune,* April 16, 1966.

Motte, Michelle. "La reine des murs noirs." *L'Express,* April 15–21, 1974.

Muchnic, Suzanne. "Matisse, Nevelson, Bosch and Bacon: art book bounty." *Los Angeles Times,* December 18, 1983

———. "More Space for Sailing the Nevelson Legend." *Los Angeles Times,* June 21, 1985.

Munro, Eleanor. "Explorations in Form." *Perspective USA,* Summer 1956.

———. *Originals: American Women Artists.* New York: Simon and Schuster, 1979.

Nappi, Lou. "Great Contribution to Surrealist Art, Says Noted Women Sculptor of Joe Milone's Odd Shoe-Shine Box." *Corriere D'America* (New York), January 10, 1943.

Nathans, Benjamin. *Beyond the Pale: The Jewish Encounter with Late Imperial Russia.* Berkeley and Los Angeles: University of California Press, 2002.

Nemser, Cindy. "Monumenta: Where Are the Women?" *Feminist Art Journal* 3, no. 3 (Fall 1974).

———. *Art Talk: Conversations with Twelve Women Artists.* New York: Simon and Schuster, 1975.

Nevelson, Louise. "Art at the Flatbush Boys' Club." *Flatbush Magazine,* June 1935.

———. Recent Works: Nevelson, Trova, Paolozzi. Exh. brochure. Detroit: J. L. Hudson Gallery, 1966.

———. *Louise Nevelson: Prints and Drawings, 1953–1966.* Brooklyn: Brooklyn Museum, 1967.

———. Nevelson, Louise. "Nevelson on Nevelson." *Art News,* November 1972.

———, and Diana MacKown. *Dawns + Dusks: Taped Conversations with Diana MacKown.* New York: Charles Scribner's Sons, 1976.

———. "Ma vie." *L'Oeil,* no. 299 (June 1980).

NEVELSON, LOUISE—EXHIBITION CATALOGUES

Sculptures by Nevelson. Exh. cat. New York: Nierendorf Gallery, 1942.

Nevelson. [Royal Tides]. Exh. cat. Text by Kenneth Sawyer, Georges Mathieu, and Jean Arp. New York: Martha Jackson Gallery, 1961.

Louise Nevelson. Exh. cat. Staatliche Kunsthalle, Baden-Baden. 1961.

Louise Nevelson: First London Exhibition. Exh. cat. London: Hanover Gallery, 1963.

Nevelson. Exh. cat. Turin: Galatea – Galleria d'Arte Contemporanea, 1964.

Louise Nevelson. Exh. cat. Text by William C. Seitz. New York: Pace Gallery, 1964.

Louise Nevelson. Exh. cat. Text by the artist. Düsseldorf: Galerie Schmela, 1965.

Louise Nevelson. Exh. cat. Paris: Galerie Daniel Gervis, 1967.

Louise Nevelson. Exh. cat. Chicago: Arts Club of Chicago, 1968.

Louise Nevelson. Exh. cat. Text by Mary Hancock Buxton. Houston: Houston Museum of Fine Arts, 1969.

Louise Nevelson. Exh. cat. Paris: Jeanne Bucher Galerie, 1969.

Louise Nevelson: Recent Wood Sculpture. Exh. cat. Text by Ana Unal. Ohio: Akron Art Institute, 1969.

Louise Nevelson. Exh. cat. Philadelphia: Makler Gallery, 1971.

Louise Nevelson: Works from 1955–1972. Exh. cat. Milan: Studio Marconi, 1973.

Louise Nevelson. Exh. cat. Stockholm: Moderna Museet, 1973.

Louise Nevelson. Exh. cat. Berlin: Neue Nationalgalerie, 1974

Lousie Nevelson. Exh. cat. Text by the artist. Florence: Galleria d'Arte Spagnoli, 1975.

Louise Nevelson. Exh. cat. Tokyo: Minami Gallery, 1975.

Louise Nevelson. Exh. brochure. Bombay: Jehangir Art Gallery, 1975.

Louise Nevelson. Exh. cat. France: Musée de la Ville de Paris, 1974.

Louise Nevelson: Sky Gates and Collages. Exh. cat. Text by the artist. New York: The Pace Gallery, 1974.

Nevelson. Exh. cat. Text by Joan Vita Miller. Greenvale, NY: C.W. Post Center Art Gallery, Long Island University, 1974.

Nevelson at Purchase: The Metal Sculptures. Exh. cat. Jeffrey Hoffeld; text by the artist. Purchase, New York: Neuberger Museum, 1977.

Louise Nevelson: Recent Works. Exh. cat. Text by the artist. Chicago: Richard Gray Gallery, 1978.

Louise Nevelson: A Loan Exhibition. Exh. cat. Texts by Jan Ernst Adlmann, Marius B. Péladeau, and Dorothy B. Miller. Rockland, ME: William A. Farnsworth Library and Art Museum, 1979.

Nevelson: Maquettes for Monumental Sculpture. Exh. cat. Interview by Barbaralee Diamonstein and text by David Shirey. New York: The Pace Gallery, 1980.

Nevelson and O'Keeffe: Independents of the Twentieth Century. Exh. cat. Roslyn Harbor, NY: Nassau County Museum of Fine Art, 1983.

Louise Nevelson: Cascades, Perpendiculars, Silence, Music. Exh. cat. New York: The Pace Gallery, 1983.

Louise Nevelson: A Loan Exhibition. Jan Ernst Adlmann, et al. Rockland, ME: William A. Farnsworth Library and Art Museum, 1979.

Nevelson: Wood Sculptures and Collages. Exh. cat. Text by David L. Shirey. New York: Wildenstein, 1980.

Louise Nevelson: Atmospheres and Environments. Exh. cat. Edward Albee and Laurie Wilson. New York: C. N. Potter and Whitney Museum of American Art, 1980.

Louise Nevelson: Sculptures and Collages. Text by Carter Ratcliff. New York: Wildenstein, 1981.

Nevelson and O'Keeffe: Independents of the Twentieth Century. Exh. cat. Roslyn Harbor, NY: Nassau County Museum of Fine Art, 1983.

The Art of Louise Nevelson at the Farnsworth. Exh. cat. Rockland, ME: William A. Farnsworth Library and Art Museum, 1985.

Louise Nevelson. Exh. cat. Poem by the artist and Diana Mackown. Paris: Galerie Claude Bernard, 1986.

Louise Nevelson: Sculptures and Reliefs. Exh. cat. Text by David L. Shirey. Switzerland: Galerie Alice Pauli, 1986.

Homage to Louise Nevelson: A Selection of Sculpture and Collages. Exh. cat. New York: Solomon R. Guggenheim, 1986.

Louise Nevelson: A Concentration of Works from the Permanent Collection of The Whitney Museum of American Art. Exh. cat. Text by R. Feinstein. New York: Whitney Museum of American Art, 1987.

Louise Nevelson Remembered: Sculpture and Collages. Exh. cat. Interview by Arnold B. Glimcher. New York: Pace Gallery, 1989.

A Friend Remembers Louise Nevelson: A Concentration of Works from the Collection of Diana MacKown. Exh. cat. Texts by the artist and Dan R. Talley. Jamestown, NY: Forum Gallery, 1991.

Louise Nevelson. Exh. cat. Japan: Wildenstein Tokyo, 1992.

Louise Nevelson: Large Outdoor Metal Sculptures. Exh. cat. New York: The Pace Gallery, 1993.

Louise Nevelson: Silent Music. Exh. cat. Text by Germano Celant. Cologne: Galerie Gmurzynska, 1995.

Louise Nevelson: Skulpturen, Collagen, Zeichnungen. Exh. cat. Text by Jeffrey Hoffeld. Zurich: Galerie Lutz and Thalmann, 1998.

Louise Nevelson: Sculpture and Drawings from the 1940s. Exh. cat. Text by the artist. New York: Joan T. Washburn Gallery, 1998.

Louise Nevelson: Sculpture and Collages. Exh. cat. Text by M. Klein. Philadelphia: Locks Gallery, 1999.

Louise Nevelson. Exh. cat. Cecília de Torres and José Sommer Ribeiro. Lisbon: Fundação Arpad Szenes; Vieira da Silva, 2000.

Louise Nevelson: Wall Reliefs and Collages. Exh. cat. Text by Jeffrey Hoffeld. San Francisco: Hackett-Freedman Gallery, 2004.

The Sculpture of Louise Nevelson: Constructing a Legend. Exh. cat. ed. Brooke Kamin Rapaport. Texts by Arthur C. Danto et al. New York & New Haven: Jewish Museum with Yale University Press, 2007.

Louise Nevelson: Assemblages 1973–1986. Exh. cat. Vancouver: Buschlen Mowatt Gallery, 2007.

Nevelson by Night. Exh. brochure. Winter Park, Florida: Cornell Fine Arts Museum, Rollins College, 2008.

Louise Nevelson: Collages. Exh. cat. Texts by Mauro Panzera and Maddalena Tibertelli de Pisis. Florence: Galleria il Ponte, 2009.

Louise Nevelson: Dawns and Dusks. Exh. brochure. New York: PaceWildenstein: 2009.

The Way I Think is Collage. Texts by Robert Indiana, Bill Katz, and Anthony Haden-Guest. Zurich, St. Moritz, and Zug: Galerie Gmurzynska, 2012.

Louise Nevelson. Exh. cat. Texts by Bruno Corà et al. Milan: Skira Editore, 2013.

Louise Nevelson: Collage and Assemblage. Exh. cat. Text by Germano Celant. New York: Pace Gallery, 2015.

Newton, Jim. "Sculptor Talks About Scottsdale Commission." *Phoenix Gazette*, March 4, 1972.

Nicolaïdes, Kimon. *The Natural Way to Draw: A Working Plan for Art Study.* Boston: Houghton Mifflin, 1941.

Nochlin, Linda. "Why Have There Been No Great Women Artists?" *Art News*, January 1971.

O'Connor, Francis V. *Federal Support for the Visual Arts: The New Deal and Now.* New York: Graphic Society, 1969.

————. ed. *The New Deal Art Projects: An Anthology of Memoirs.* Washington, D.C.: Smithsonian Institution Press, 1972.

O'Doherty, Brian. "Art: Four Sculptors Manipulate Third Dimension." *New York Times*, April 24, 1961.

————. "Spotlights on the Stricken Scene." *New York Times*, April 7, 1963.

O'Hara, Frank. "Reviews and Previews: Sculpture 1955." *Art News*, September 1955.

Oxenaar, R. W. D., and L. Nevelson. *Louise Nevelson, Sculpturen 1959–1969.* Otterlo: Rijksmuseum Kröller-Müller, 1969.

Palazzoli, Daniela. "Louise Nevelson, Galleria Marconi, Milano." Exhibition review. *Domus* 524 (July 1973).

Panero, James. "Gallery Chronicle: Louise Nevelson: Dawns and Dusks." Review of Nevelson exhibit at the PaceWildenstein. *New Criterion* 27, no. 7 (March 2009).

Patterson, Ann. "Sculptress Louise Nevelson – Excursion into Awareness." *Scottsdale Daily Progress*, March 3, 1972.

Péladeau, Marius B. "The Gypsies in Maine." Unpublished typescript, 1976.

Penkower, Monty Noam. "The Kishinev Pogrom of 1903: A Turning Point in Jewish History." *Modern Judaism* 24, no. 3 (October 2004).

Phillips, Lisa. *The Third Dimension: Sculpture of the New York School.* Exh. cat. New York: Whitney Museum of American Art, 1984.

Pincus-Witten, Robert. "Louise Nevelson." Whitney Museum exhibition review. *Artforum* 9, no. 58 (May 1967).

Plumb, Barbara. "Life Style with Art." *New York Times*, November 3, 1968.

Pogue, Jan. "It's a Woman's World This Week." *Philadelphia Enquirer*, March 2, 1984.

Preston, Stuart. "Abstract and Figurative." Review of Nevelson exhibit. *New York Times*, January 16, 1955.

————. "Art: On Action Painting." *New York Times*, January 7, 1961.

Price, A. B. "Architectural Digest Visits: Louise Nevelson." *Architectural Digest*, November 1983.

Putnam, Eileen. "Louise Nevelson at 84: Profile of a Lady in Black." *Portland Sunday Telegram*, January 22, 1984.

Rabinowitz, Dorothy. "The Art of the Feud." *New York*, September 25, 1989.

Radcliffe, Donnie. "The AMA Honors Sculptor Louise Nevelson: Lobbying with and for Art." *Washington Post*, March 11, 1983.

Rafsky, Sara. " 'La Nevelson' Speaks from the Beyond." *Art News*, May 2008.

Ragon, Michel. "XXXI Venice Biennale." *Cimaise*, no. 61 (September/October 1962).

Rand, Harry. *The Martha Jackson Memorial Collection.* Washington, D.C.: Smithsonian Institution Press, 1985.

Raynor, Vivien. "In the Galleries: Louise Nevelson." *Art News*, September 1961.

————. "Louise Nevelson at Pace." *Art in America*, January 1973.

————. "A Rich Array of Summer Art, from Newburgh to Newark." *New York Times*, August 15, 1986.

Riley, Maude. "Irrepressible Nevelson." *Art Digest* 17, no. 14 (April 1943).

————. "Fifty-Seventh Street in Review: A Sculptor's Portraits." *Art Digest*, November 15, 1943.

Rivera, Diego, André Breton, [and Leon Trotsky], "Manifesto: Towards a Free Revolutionary Art." trans. Dwight Macdonald, *Partisan Review* 6, no. 1 (Fall 1938).

Roberts, Colette. "L'Ailleurs de Louise Nevelson." *Cahiers du Musée de poche*, May 1960.

———. "Nevelson at Sidney Janis." *France-Amérique*, January 13, 1963

———. *Nevelson.* Paris: Pocket Museum; Editions Georges Fall, 1964.

———. "Lettre de New York." *Aujourd'hui*, September 1966.

———. "Retrospective au Whitney Museum." *Aujourd'hui*, October 1967.

Robertson, Nan. "Artists in Old Age: The Fires of Creativity Burn Undiminished." *New York Times*, January 22, 1986.

Robinson, Donald. "America's 75 Most Important Women." *Ladies' Home Journal*, January 1971.

Rockwell, John. "Opera: Gluck's 'Orfeo' in St. Louis." *New York Times*, June 8, 1984.

Rose, Barbara. "Art." *Vogue*, August 1974.

———. "The Individualist." *Vogue*, June 1, 1976.

Rosen, Celia C. *Some Jewels of Maine: Jewish Maine Pioneers.* Pittsburgh: Dorrance, 1997.

Rosenblum, Robert. "Sculptors Guild." *Arts Digest*, August 1955.

———. "Louise Nevelson." *Arts Yearbook: Paris/New York* 3 (1959).

Rothschild, Lincoln. *To Keep Art Alive: The Effort of Kenneth Hayes Miller, American Painter (1876–1952).* Philadelphia: Art Alliance Press, 1974.

Roud, Richard. "A Very Freaky Lady Who Boxes Clever." *Guardian* (UK), August 1, 1980

Rubin, William S. *Dada and Surrealist Art.* New York: Harry N. Abrams, 1968.

Russell, John. "Gallery View: The Fall and Rise of Millet's Reputation." Pace Gallery exhibition review. *New York Times*, February 29, 1976.

———. "Today's Artists Are in Love With the Stage." *New York Times*, October 30, 1983.

———. "Profusion of Good Art by Women." *New York Times*, February 22, 1985.

———. "Louise Nevelson Dies at 88: Enduring Force in Art World." *New York Times*, April 18, 1988.

———. "Lean, Muscular Energies in Late Nevelson Sculptures." *New York Times*, April 7, 1989

Sandler, Irving. [I.H.S.] "Louise Nevelson." *Art News*, March 1962.

———. "Public Art #1." In *Sculpture in Environment.* New York: New York City Administration of Recreation and Cultural Affairs, 1967.

———. *The Triumph of American Painting: A History of Abstract Expressionism.* New York: Praeger, 1970.

———. "Hans Hofmann: The Pedagogical Master." *Art in America* (May–June 1973).

Sawin, Martica. "The Achievement of Ralph Rosenborg." *Arts*, November 1960.

———. *Surrealism in Exile and the Beginning of the New York School.* Cambridge, MA: MIT Press, 1997.

Scaasi, Arnold. *Women I Have Dressed (And Undressed!).* New York: Scribner, 2004.

Schwartz, E. "Two from Nevelson: A Stunning Chapel and a Palace for the Child in All of Us." *Art News*, February 1978.

Schwartz, Marvin D. "Sixteen Americans at the Museum of Modern Art." *Apollo*, February 1960.

Sculpture: The Tumultuous Quarter-Century. Exh. cat. New York: Sculpture Center, 1953.

Seckler, Dorothy Gees. "The Artist Speaks: Louise Nevelson." *Art in America* 55, no. 1 (January–February 1967).

Seiberling, Dorothy. "Weird Woodwork of Lunar World." *Life*, March 24, 1958.

Seitz, William. *The Art of Assemblage* New York: Museum of Modern Art, 1961.

———. *2 Pittori, 2 Scultori: Louise Nevelson, Loren MacIver, Jan Müller, Dimitri Hadzi* Exh. cat., Venice Biennale. New York: International Council of the Museum of Modern Art, 1962.

Seldis, Henry J. "Summer Forecast: Warm, Variable Art Climate." *Los Angeles Times*, June 10, 1962.

———. "More Art News." *Los Angeles Times*, June 10, 1962.

———. "In the Galleries: Nevelson Turns to Greater Clarity." *Los Angeles Times*, December 16, 1966.

———. "Enchanted Forest of Nevelson Wood Sculpture." *Los Angeles Times*, February 10, 1974.

———. "Nevelson: A Door to Perception." *Los Angeles Times*, October 22, 1976.

Senie, H. F. "The Perils of Public Art: Louise Nevelson plaza." *Sculpture* 26, no. 6 (2007).

Shapiro, Lindsay Stamm. "Review of Erol Beker Chapel of the Good Shepherd in St. Peter's Church." *Craft Horizons* 38, no. 2 (April 1978).

Shaw-Eagle, Joanna. "American Women in Sculpture." *Harper's Bazaar*, August 1981.

Shenker, Israel. "Picasso, 90 Today, Assayed by Critic, Curator, 3 Artists." *New York Times*, October 25, 1971.

Shepard, Joan. "At 82 She's Still Sympathetic to People Who Get Beat Up." *Daily News*, March 19, 1982.

Shirey, David L. "She and Her Shadows." *Newsweek*, March 20, 1967.

———. "Nevelson the Fantasticator." *The New York Times*, June 12, 1977.

————. "The Museum Director's Dilemma." *New York Times*, November 27, 1977.

Sidney Janis Gallery, and C. M. Singer. "Orchestra Place Is Home for the Metal 'Trilogy' Sculptures." *Detroit News*, April 12, 2000.

Siegel, Jeanne. *Artwords: Discourse on the 60s and 70s.* (from interviews for *Great Artists in America Today*, WBAI, 1967). New York: Da Capo Press, 1968.

Smith, Charles C. "The Sculpture Factory." *Boston Globe*, August 27, 1978.

Smith, Dido. "Sculptor Works with Clay–: A Visit with Louise Nevelson." *Ceramic Age*, August 1954.

————. "Louise Nevelson." *Craft Horizons* 27 (May 1967).

Smith, Roberta. "Review: Louise Nevelson, Pace." Review of Nevelson exhibit. *Artforum* 14, no. 6 (February 1976).

Sorell, Walter. *The Dance Through the Ages*. New York: Grosset & Dunlap, 1967.

Soutif, Daniel. "The Four-Corner Game." *Artforum* 27, no. 1 (September 1988).

Sozanski, Edward J. "Restoring Women Artists to Their Place in History." *Philadelphia Enquirer*, March 4, 1984.

Stanislawski, Michael. *Tsar Nicholas I and the Jews*. Philadelphia: Jewish Publication Society of America, 1983

————. "Louise Nevelson's Self-Fashioning: 'The Author of Her Own Life.' " In *The Sculpture of Louise Nevelson: Constructing a Legend*. Exh. cat. q.v.

Stroup, John. "Tunnard and Nevelson." *Art Digest*, November 15, 1944.

Sullivan, Mary. "Louise Nevelson, One of Art World's Most Noted." *Courier-Gazette*, July 18, 1974.

Sweet, Alvin. "How Industries and Trades of Maine and Region Grew from Early Times." *Courier-Gazette*, March 20, 1976.

Sylvester, Ted. "Fish 'n Chips." *Bangor Daily News*, March 12–13, 1977.

————. "Fish 'n Chips." *Bangor Daily News*, July 14–15, 1979.

Tallmer, Jerry. "Louise Nevelson Non-Stop: For Her It's All Material." *New York Post*, November 30, 1977.

————. "Sculpting Images Into Our Dreams." *New York Post*, April 19, 1988.

Taylor, John Russell. "Louise Nevelson." Review of Nevelson exhibit at Wildenstein Gallery. *London Arts Review*, May 8, 1981.

Taylor, Robert. "Events in Arts: Wood Sculpture Exhibited." Pace Gallery. *Boston Herald*, April 5, 1964.

————. "Louise Nevelson: A Candid Creator." *Boston Globe*, April 10, 1977

Tillim, Sidney. "Month in Review." *Arts* (February 1963).

Thalacker, Donald W. *The Place of Art in the World of Architecture*. New York: Chelsea House Publishers, 1980.

Thompson, J. Eric S. *The Rise and Fall of Maya Civilization*. Norman: University of Oklahoma Press, 1959.

Tillyard, Virginia. "Louise Nevelson. New York, Guggenheim Museum." *Burlington Magazine* 128, no. 1004 (November 1986).

Tully, Judd. "Sons and Mothers." *Art and Auction*, September 1989.

————. "Taking Care of Diana." *Nation*, February 1990.

————. "New York: Nevelson Negotiated." *Art News*, November 1995.

————. "Nevelson Estate Moves out of PaceWildenstein." *Art Newsletter*, June 11, 1996.

Turcott, John S. "Nevelson in Little Italy: The Artist as Godmother of a Community." *Villager*, May 25, 1978.

Vaughan, Malcolm. "Rivera's Latest Series of Murals Nearly Finished" and "The Artist as Propagandist." *New York Journal-American*, September 30, 1933.

Vinson, R. J. "*Le Pasteur, le sculpteur et la renovation urbaine.*" *Connaissance des Arts*, no. 302 (April 1977).

Vogel, Carol. "Inside Art: All White and All Nevelson." *New York Times*, April 20, 2007.

————. "A Bold and Modern White House." *New York Times*, October 7, 2009.

von Rhein, John. " 'Orfeo,' 'Bunyan' Reverse Bad Luck of Opera Theatre." *Chicago Tribune*, July 1, 1984.

Wallach, Amei. "Sculptor Louise Nevelson – Hanging On, Crashing Through, Loving It All." *New York Newsday*, July 15, 1973.

————. "An Unmatched Pair of Great Artists." Review of Nevelson exhibit at Nassau County Museum of Fine Art. *Newsday Magazine*, January 30, 1983.

————. "One Art: Sculpting a World to Her Vision." *Newsday*, August 1, 1986.

Walter-Ris, Anja. *Die Geschichte der Galerie Nierendorf Kunstleidenschaft im Dienst der Moderne. Berlin/New York 1920–1995*. Zurich: Zurich InterPublishers, 2003.

Walton, Kelly. "Louise Nevelson: In Black and White." *Scottsdale Daily Progress*, April 3, 1985.

Warnod, Jeanine. "Les Peintres abstraits américains évoluent dans le néant." *Le Figaro*, December 19, 1973.

Wayne, June. "Louise Nevelson 1899–1988; Goodbye Louise." *Women Artists News*, Summer 1988.

Weber, Max. "The Fourth Dimension from a Plastic Point of View." *Camera Work*, July 1910.

Weyl, Christina. "Abstract Impressions: Women Printmakers and the New York Atelier 17, 1940–1955." Unpublished Ph. D. thesis, Rutgers University, 2015.

Whittett, G. S. "London Commentary: No Stranger to No Paradise." *Studio*, January 1964.

Wierzbicki, James. "Sculptor Nevelson Boosts 'Orfeo.' " *St. Louis Globe-Democrat*, June 9–10, 1984.

Willard, Charlotte. "Women of American Art." *Look*, September 27, 1960.

————. "All Around You." *New York Post*, March 11, 1967.

Wilson, Laurie. *Louise Nevelson: Iconography and Sources*. City University of New York, 1978.

————. "Bride of the Black Moon: An Iconographical Study of the Work of Louise Nevelson." *Arts Magazine* 54, no. 9 (May 1980).

————. Louise Nevelson: The Fourth Dimension. Exh. cat. Phoenix: Phoenix Art Museum, 1980.

————. *Louise Nevelson: Iconography and Sources*. New York: Garland, 1981.

————. "Louise Nevelson: Personal History and Art." *American Journal of Art Therapy* 20, no. 3 (April 1981).

————. "Light and Shadow in the Life and Work of Louise Nevelson." *Journal of the American Psychoanalytic Association* 59, no. 1 (2011).

————. *Remnants: Louise Nevelson and Aaron Siskind*. Exh. cat. New York: Bruce Silverstein Gallery, 2013.

Wolfe, Bertram D. *The Fabulous Life of Diego Rivera*. New York: Stein and Day, 1963.

Wolff, Theodore F. "America Is Doing Well–Although No Big New Ideas Are In Sight." *Christian Science Monitor*, May 31, 1983.

Women's Caucus for Art Honors Bishop, Burke, Neel, Nevelson, O'Keeffe. Exh. cat. Washington, D.C: Middendorf/Lane Gallery, 1979.

Yarrow, Andrew L. "Nevelson Estate Is the Focus of a Battle." *New York Times*, June 10, 1989.

Younger, Carolyn. "Whim & Caprice: 'The Haberdashery of Oddities in the Collection of Curious Things.' " *Napa Valley Register*, August 4, 2011.

Zimmer, William. "Agnes Martin/Louise Nevelson." *New York Times*, September 26, 1986.

————. "Works by Nevelson in Stamford." *New York Times*, January 18, 1987.

Zipperstein, Steve J. "Russian Maskilim and the City." In *The Legacy of Jewish Migration: 1881 and its Impact*, ed. David Berger, Social Science Monographs (New York: Columbia University-Brooklyn College Press, 1983)

ACKNOWLEDGMENTS

First, I shall always be grateful to Louise Nevelson, whose numerous meetings with me provided the inspiration and the groundwork for this book.

I am extremely grateful to the many members of Louise Nevelson's family, living and dead, who shared recollections of their time with their sister, sister-in-law, mother, or grandmother as work on this biography has proceeded. These include her siblings, Nate Berliawsky, Lillian Berliawsky Mildwoff, and Anita Berliawsky Weinstein; her sister-in-law, Lillian Mildwoff Berliawsky; her granddaughters, Maria Nevelson and Neith Nevelson; her great-granddaughter Issa; as well as some more distant relatives: Barbara and Joel Fishman, Jeffrey Entin, Elaine Crasnick and Alex Berljawsky. I give a very special thanks to her son, Mike Nevelson, whom I was able to interview both in 1977 and again in 2014 and who made it possible for us to reproduce Nevelson's art in this book.

The two people closest to Nevelson for the last twenty-five years of her life, her dealer Arne Glimcher and her assistant Diana MacKown, have given me invaluable assistance, opening their archives and meeting and speaking with me frequently over the years. Milly Glimcher was also generous with her time and assistance, as were many members of the staff at Pace Gallery, including Joyce Pommeroy Schwartz, Diane Brown Harris, and Judy Harney. At Pace Prints I thank Richard Solomon. In addition I had the good fortune to meet with David Anderson, the son of Martha Jackson, Nevelson's dealer in the late 1950s, who not only told me wonderful stories about the artist's time with his mother but also opened his archives at the University of Buffalo. Rufus Foshee, who worked with the artist at Jackson Gallery, was equally generous in sharing his memories and archival material. Other gallerists and museum curators who added greatly to my understanding were Georges Fall, publisher of the first book on Nevelson; Dorothy Miller, a close friend and ardent supporter from MoMA; Giorgio Marconi; Jeffrey Hoffeld; Richard Gray; Lotte Jacobi; Hope and Paul Makler; and Martin Friedman. Marius Péladeau, former director of the Farnsworth Museum, and his wife Millie were instrumental in helping me understand Nevelson's last years and her changed relationship to her hometown, Rockland, Maine.

Among the scholars who have read and/or discussed the research I have done on Nevelson over the past forty years, my first thanks go to Rose-Carol Washton Long, my dissertation advisor and ever supportive friend; Vera Camden; Valerie Fletcher; Phoebe Jacobs; Luba and Richard Kessler; Carol Neumann de Vegvar; Susan Sheftel; Jennifer Stuart; Nellie Thompson, Joann Turo; Francis V. O'Connor; Lora Urbanelli; Elizabeth Vercoe; Christina Weyl; Aaron Rosen; Mary and John Gedo. I am also grateful to Marc Grossman, the brilliant doctor who literally saved my life and also happily turned out be a Nevelson collector.

In a special category is Don Lippincott, who not only answered every question I asked but

generously loaned me all his files on Nevelson's metal sculpture done at Lippincott Sculpture Fabrications workshop in the 1970s and 1980s. I am likewise indebted to his son, Jonathan D. Lippincott, who designed this book.

I conducted hundreds of interviews with Nevelson's friends and artist colleagues as well as journalists and scholars who wrote about her. I am grateful to all and can only mention a few here: Edward Albee, Jan Adlemann, Dore Ashton, Elizabeth Baker, Will Barnet, Louise Bourgeois, Minna Citron, Edgar Crockett, Merce Cunningham, Dorothy Dehner, Barbaralee Diamonstein, Majorie Eaton, Jimmy Ernst, Mary Farkas, Jan Gelb, Sidney Geist, Connie Goldman, Peter Grippe, Chaim Gross, Robert Indiana, Una Johnson, Bill Katz, Lillian Kiesler, Richard Kramer, Ibram Lassaw, Herbert Lust, Cindy Nemser, Steve Poleski, Irving Sandler, Arnold Scaasi, Louis Shenker, Dido Smith, Leon Polk Smith, Helena Simkhovitch, Anna Walinska and June Wayne.

The many people who were involved with Nevelson in her work on the Chapel of the Good Shepherd at Saint Peter's Church in New York City are in a special category. They include Pastor Ralph Peterson and Pastor Amandus Derr; architect Easley Hamner; and congregant Barbara Murphy. Similarly, I thank the people who worked with Nevelson on her designs for *Orfeo* at the Opera Theatre of Saint Louis and offered many anecdotes about the event: the director Richard Gaddes and the artistic administrator Mark Tiarks.

My many discerning students in the Graduate Art Therapy Program at New York University and at the Institute for Psychoanalytic Education affiliated with the New York University Medical Center also deserve my thanks. As is usual I may have learned more from them than I taught when I lectured about Louise Nevelson.

Two fact checkers and copy editors protected me from making grave errors: Nana Asfour and Neil Mann. Five other important behind-the-scenes helpers to whom I shall ever be grateful are Andrea Monfried, Jacques de Spoelberch, Victoria Meyer, Harry Burton, and Tuomas Hiltunen. But greatest thanks go to my two sterling editors. The first is Kitty Ross, both a friend and a superb freelance editor who has been on the case from the time I began think about writing this biography. The second is Elizabeth Keene at Thames & Hudson, whose astute observations and extraordinary efforts have made this manuscript into a beautiful book that is both reliable and clear.

Not least among the many to whom I owe a debt of gratitude are the archivists who preserve historical materials and make them available to scholars. Jon Mason at Pace Gallery stands supreme in his unfailing helpfulness. I also thank Marisa Burgoin and Elizabeth Botten at the Archives of American Art; Amy Mobley at The Museum of Fine Arts, Houston; and Anita Duquette at the Whitney Museum of American Art. Michael Komanecky, Lora Urbanelli, and Bethany Engstrom and Angela Waldron at the Farnsworth Art Museum in Rockland, Maine, provided invaluable assistance, as did Sandra H. Olsen at the University of Buffalo Art Galleries.

To the list of supporters over the long haul I want to add Cathy Hardman and the best of all possible husbands, Fredi Strasser, who nodded sagely when I first told him that I could finish this book in six months. I am forever in his debt for his patience, support and wise observations over the many years this endeavor has predictably taken.

INDEX